Tawna Draney Pete Zanetti Dave Hansen Alice Shoemaker Maury Brown Malcolm Smith Stuart Healy Angie Hendrix Ty Dr
a Moulton J.R. Jones Carolyn Hiscox Scott Jones Craig Ferris Jim Karst Judy Karst Clare Axtell Richard Kaumo Lisa Keele
in Clara McIntyre Russell Brown Chandi Morgan Kandi Banks Chris Shannon Carmen Singleton Ruth Beebe Mel Smith Syd
na Taylor Nate Laubach Elizabeth Tolerton Roy Tophia Linda Kirkbride Jo Van Alstyne Joseph "Pete" Kristy Leslie Otto Dav
Dixon Brian Bengtson Theola Ervin Sheila Bricher-Wade De Lamb Tim Davis Nimi McConigley Eric Jessen Gregg Trosper
ox Shane Call Kevin McKinney Homer Alley Sam Mavrakis Paul Canoso Pat Johner Richard Clark Ron "Suds" Clingman Jaso
mann Charlie Howell Ken McCartney Ronn Jeffrey Richard Klein Larry Sandvick Ken McCartney Jerry Spence
Larson Don Davis Brian Bridgeforth Lael Eddins Gary Brown Brian Roc Rodriguez Barbara Madse
Ken Fellon Jerry Spence Jake Korell Joan Smith-Sonneborn Helen Withers Roberts Brad Barlow K
Craig Ferris Joan Lineberry Gregg Draney Glenna Madden Win Hickey T.J. Clark Nycoca Hairst
as Fahey Kenny Sailors J.R. Jones Tanya Schlaht Craig Latham Charley S Junge Emma Gardner Jeannette Maxwe
ley Gardner Roy Takeda Cally Draney Tennyson Draney Wilma Taylor Nate Laubach Elizabeth Tolerton Michelle Sullivan W
e Darwin St. Clair Ken Rolfsness Charlie Howell Craig Latham David Klein Pat Guymon Cary Hamilton Brian Hanify Howar
rix Ty Draney Dan Lill Fred Hiscox Sandra Utter Brent Blankenship Bill Hosokawa Carolie Howe Ken McCartney Ronn Jef
vilar Bob Tomingas Ewing Kerr Trudy Keyser-Caswell Jim Cotterell Garrett Klein Clara McIntyre Russell Brown Richard Kl
ger Bill Lamb Joni Draney Dessie Bebout T.A. Larson Brian Bridgeforth Scott Freeman Betty Evenson Bill Lineberry Earl
orie McCartney Nadine McCleod Ralph McWhinnie Bob Daniels Tommy Harkness Mark Garrett Maria Moreno Walt Geis Ra
v Ralph Olds John Ostlund Mike Sullivan Larry Birleffi Tom "The Tireman" Ourada Edward "Stovepipe" Pette Nancy Freuden
red Briggs Dick Cheney Ron Roberson Steve Bartek Mark Robert Jim "Tex" Garry Don Davis Lael Eddins Gary Brown Brian
chlaht Craig Latham Charley Scott Mark Junge Emma Gardner Jeannette Maxwell Chandi Morgan Kandi Banks Luella Gall
Roy Takeda Cally Draney Tennyson Draney Wilma Taylor Nate Laubach Elizabeth Tolerton Roy Tophia Linda Kirkbride Jo V
Clyde Ice Emily Kingston Boots Allen J.J. Bay Catherine Harris Minde Draney Sam Mavrakis Vicki Dixon Brian Bengtson Th
Bama Ruby Mercer Echo Roy Sam Runyan Jessica Russell Betty Sable Magen Draney Kimle Dunlap Thomas Fahey Kenny S
men Singleton Ruth Beebe Mel Smith Sydney Spiegel Asa Spratt Kevin Haas Frankie Addington Moore Sam Switch Dudley Ga
' Kristy Leslie Otto David Villescas Kat Voiles Mel Wambeke Elsa Byron David Romtvedt Penny Wolin David Russell Clyde
Eric Jessen Gregg Trosper Mary Ann Budenske Warren Jaycox Joshua Russell Leone Olds Mark Setright Tina Burke Lynn B
ingman Jason Cochrane Kevin Conkle J.R. Connell James "Tip" Cox Steve Johnson Ruth Dalgarn Bob Decker Angela Smith V
rolyn Hiscox Scott Jones Craig Ferris Jim Karst Judy Karst Clare Axtell Richard Kaumo Lisa Keeler Everett Desmarteau So
Klein Larry Sandvick Ken Fellon Jerry Spence Jake Korell Joan Smith-Sonneborn Helen Witherspoon Lukas Kotzakis Kurt Rob
rdeman Shawn Schaffer Joan Lineberry Greg Draney Glenna Madden Win Hickey Susie Body Karla Marker T.J. Clark Nycoc
re Gerry Dull Gene Gressley Shelley Wilson Judi Morris Clark Moulton Margaret Murie Bob Nelson Neltje Richard Collier Jo
elissa Pierce Sage Draney Jake Clark Larry Poelma Steve Johnson Renee Askins Kathleen Ramee Dick Randall Alfred Redman
ckwood Mike Hayes Helen Rodriguez Barbara Madsen Kristin Hogarth Norma Rodriguez Lucille Alley Lisa Rotellini Jim Ba
n Charley Scott Ardath Junge Emma Gardner Jeannette Maxwell Chandi Morgan Kandi Banks Luella Galliver Chris Shanno
s Kotzakis Kurt Roberts Brad Barlow Kim Krueger Bill Lamb Joni Draney Dessie Bebout T.A. Larson Brian Bridgeforth Sco
y Karla Marker T.J. Clark Nycoca Hairston Lorie McCartney Nadine McCleod. Ralph McWhinnie Bob Daniels Tommy Harkn
keda Cally Draney Tennyson Draney Wilma Taylor Nate Laubach Elizabeth Tolerton Roy Tophia Linda Kirkbride Jo Van Alsty
n J.J. Bay Catherine Harris Minde Draney Sam Mavrakis Vicki Dixon Brian Bengtson Theola Ervin Sheila Bricher-Wade E
Tina Burke De Lamb Tim Davis Nimi McConigley Eric Jessen Gregg Trosper Mary Ann Budenske Warren Jaycox Joshua Rus
Paul Canoso Pat Johner Richard Clark Ron "Suds" Clingman Jason Cochrane Kevin Conkle J.R. Connell James "Tip" Cox Ru
na Draney Pete Zanetti Dave Hansen Alice Shoemaker Maury Brown Malcolm Smith Stuart Healy Angie Hendrix Ty Draney
ton Carolyn Hiscox Scott Jones Craig Ferris Jim Karst Judy Karst Clare Axtell Richard Kaumo Lisa Keeler Everett Desmarte
Richard Klein Larry Sandvick Ken Fellon Jerry Spence Jake Korell Joan Smith-Sonneborn Helen Witherspoon Dan Junge Luka
ill Lineberry Earl Hardeman Shawn Schaffer Craig Ferris Jake Clark Larry Poelma Renee Askins Kathleen Ramee Dick Ra

D0873961

THE WIND IS MY WITNESS

A WYOMING ALBUM

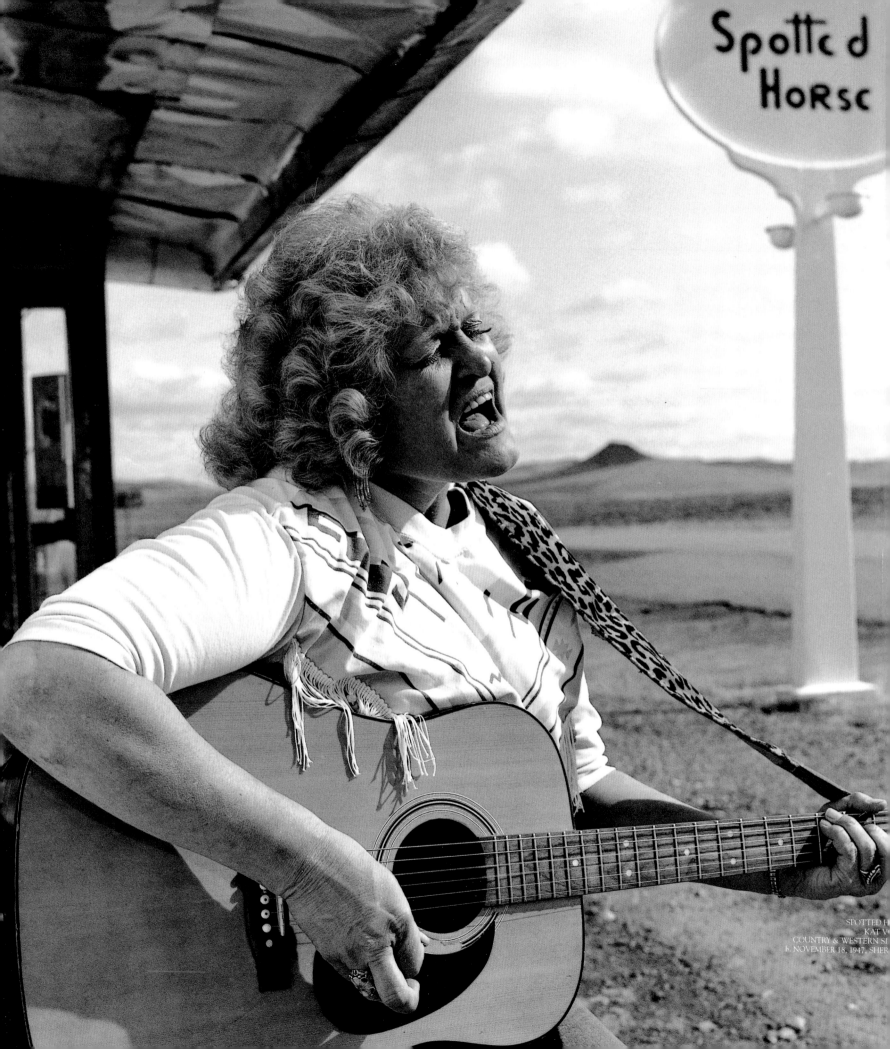

SPOTTED H
KAT V
COUNTRY & WESTERN SI
b. NOVEMBER 18, 1947, SHER

THE WIND IS MY WITNESS
A WYOMING ALBUM

MARK JUNGE

IN COOPERATION WITH THE
WYOMING DEPARTMENT OF COMMERCE

ROBERTS RINEHART PUBLISHERS

Published by Roberts Rinehart Publishers
6309 Monarch Park Place
Niwot, Colorado 80503

Distributed to the trade in the United States and
Canada by Publishers Group West

Published in the UK and Ireland by
Roberts Rinehart Publishers
Trinity House, Charleston Road
Dublin 6, Ireland

Photographs and text copyright
© 1997 Wyoming Department of Commerce

Jacket and book design: Kim Dunlap

International Standard Book Number 1-57098-
149-3

Library of Congress Catalog Card Number 97-
67699

All rights reserved.

10 9 8 7 6 5 4 3 2 1

Published with grants from
Cheyenne Light, Fuel and Power
Norwest Bank Wyoming, N.A.
Thunder Basin Coal Company
Union Pacific Foundation
U.S. West Communications
Wyoming Centennial Commission
Wyoming Council for the Humanities
Wyoming Council on the Arts
Wyoming Department of Commerce
Wyoming State Historical Society

Printed in Hong Kong

C O N T E N T S

P R E F A C E

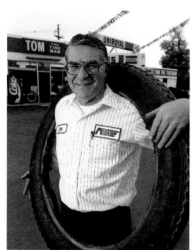

Tom "The Tireman" Ovrada
b. September 14, 1927, Boise, Idaho

... who kept the project rolling,
so to speak.

Wyoming oilman, Maurice Brown, has adopted the motto, "Wyoming's greatest resource is its people." If that statement is true, then it is proper to document these people, their faces, memories, knowledge, humor, and opinions. Various attempts have been made to portray Wyoming people. Historian C.G. Coutant addressed the topic "lives of important men" in his book, Progressive Men of the State of Wyoming (Chicago: A.W. Bowen & Co., 1903). The work was done for subscribers who paid to have flattering biographies and portraits included in the prestigious tome. Coutant's book is a valuable research tool, but it does not contain all of the people whose biographies deserve to be included. Rather, it contains his clients, and it includes the lives of only a few women. Progressive Men is not history. It is promotional bombast in a biographical framework.

Although it may be unfair to judge Coutant's work by late twentieth century standards, the fact that it deserves mention at all indicates how few books have been written about Wyoming people. Another book containing biographical sketches of Wyomingites is Jean Mead's Wyoming in Profile (Boulder, Colorado: Pruett Publishing Co., 1982). The publication, Living In Wyoming, Settling for More by Susan Anderson and Zbigniew Bzdak (Oakland: Rockridge Press, 1990), contains biographical and autobiographical material as well as excellent photography. But it is also selective and features only a small sample of the population. The book you are reading is not a comprehensive work, either. It is the abbreviated illustration of a large oral history project.

Stretching over a period of ten years, the Album project involved travel along 43,000 miles of interstate and state highways, county roads and country paths in a 1984 VW Jetta and a 1978 Ford pickup with a self-contained camper. Nearly all of the interviews were conducted in Wyoming, but a dozen were conducted in Arizona, California, Colorado, Illinois, Nebraska, New York, New Mexico, South Dakota, Utah and Washington, D.C. A total of 450 people were interviewed, most of them between the years 1989 and 1992. The interviews comprise a collection of more than six hundred, ninety-minute tapes. Since the inception of the project at least two dozen people who appear in this book have died, and at least one business partnership has dissolved. It is futile to speculate on divorces, separations or remarriages.

Approximately seven thousand black and white photographs were taken with a medium-format, Hasselblad 500C and a Pentax 6 x 7. A small number were taken with a large format, 4 x 5 Sinar-P, and some with a 35mm Nikon F3. Color slide portraits were taken with a 35mm Nikon F3 loaded with Kodachrome 64 film. In the short period of six weeks during the summer of 1990, Tim Davis, an American Studies scholar working with a small stipend from the Wyoming Council for the Humanities, conducted thirty-seven interviews and took more than one thousand 35mm, black and white photographs.

To the people of Wyoming
… and T.A. Larson who introduced me to them.

I am grateful to Wyoming state government and private corporations for funding the project and the book. The Wyoming Council for the Humanities provided the first major grant in 1987 and a small stipend to Tim Davis for his work in the summer of 1990. Additional funding was provided by the Wyoming Centennial Commission, the Wyoming Arts Council, Wyoming State Historical Society, U.S. West Communications, Norwest Bank Wyoming, Cheyenne Light, Fuel and Power, and Thunder Basin Coal Company. Publication stipends were provided by the Union Pacific Foundation and the Wyoming Department of Commerce. The largest contribution to the project came from the Department of Commerce, which included salary, support services and travel funds for approximately three years.

Many individuals gave their time and support to the Album, but some deserve particular recognition: Tim Davis for his enthusiasm for the project and his excellent work during the summer of 1990; State Photographer Richard Collier for his companionship and artistry, and for patiently enduring my interference with his work; Sheila Bricher-Wade, once my subordinate and later my supervisor in the State Historic Preservation Office, for her reassurance that the project was valuable and for sharing her family with me; David Kathka, former Director of the Wyoming Archives, Museums and Historical Department for advice and help during a time when administration of state historical programs was under severe stress, and for reminding me that just because a person works in a bureaucracy doesn't mean he has to be a bureaucrat; Mike Massie and Bob Young, administrators of the Wyoming Council for the Humanities, whose faith in the project was Biblical in its steadfastness; attorney and former aide to two Governors, Nancy Freudenthal, for her perceptions of state government and for saving my job; former Governor and First Lady Mike and Jane Sullivan for buoying me up with encouragement, and for their accessibility and candid interviews; Becky Evans, consultant to the Wyoming Centennial Commission, for facilitating a grant at a critical time; Rick Rinehart for being the only one among half a dozen publishers who felt the book was worth the effort it took to produce; Gene Bryan, Director of the Wyoming Department of Commerce, for arriving at just the right time to take the Album under his wing and seeing it through to publication. Without his patronage, it would still be a box of materials sitting behind someone's desk.

Others deserve recognition, and I thank them for reasons they will understand: Melinda Brazzale, Val Brinkerhoff, Celeste Colgan, Shari Damrow, Kim Dunlap, Linda Fabian, Priscilla Golden, Mary Guthrie, Dick Hartman, Win Hickey, Cathy Lujan, Tom Marceau, Darryl Miner, Kathy Murphy, Craig Satterlee, Pete Simpson and Gary Stephenson. Finally, my deep appreciation goes to the Wyomingites who allowed themselves to be interviewed and photographed, and who gave themselves and their memories ... Here's to the next one hundred years!

Mark Junge
b. June 5, 1943, Chicago, Illinois

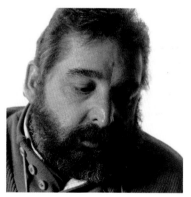

Richard Collier
b. October 17, 1952, Chester, England

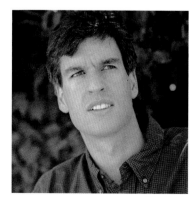

Tim Davis
b. April 7, 1958, Boston, Massachusetts

I N T R O D U C T I O N

We're the last of the history actually being made in this new country. This is a new country. It's only two hundred odd-years old, America. We're a very innocent country. And the history's still being made right here in Wyoming. We're kinda the last bastions of it. Don't you feel that?

—*Dorothy Richardson*
Wyoming State Museum Docent

History as an object lesson is a troublesome concept. It may teach lessons about life, but it seems far more interesting as narrative. I don't try to justify it as something that is necessary for social salvation. Since retiring from state government, I no longer feel compelled to defend history as a profession, or argue that it is something which is in the state's best interest to preserve. Nor do I feel obligated to repeat Santayana's warning about the dire consequences of forgetting our past. I am bored with chanting the historic preservationist mantra about destroying our heritage and losing our orientation to the future. I have discovered that life continues, that some people appreciate history, and those who don't may not even recognize the historical nature of their own lives. Tired of fighting antediluvian attitudes, I prostrate myself before Clio's altar, plead that history is art and confess that some art is better than other art. As an expression of my faith in history as art, I offer this album.

The purpose of the *Wyoming Album* project was to document the lives of Wyoming people. Its twin objectives were to establish an archival record of taped interviews and photographic portraits, and to publish some of that material in a book. Project methodology was developed over time. Its chronology is vague because thoughts did not develop in strictly logical or sequential fashion. Ideas were sifted, weighed and changed. The entire process was long and disconnected. At the risk of losing the reader in my meanderings, a summary follows.

In 1986 I began planning a book containing photographs and oral testimony of Wyoming people, a type of state self-portrait. The 1990 Wyoming Centennial celebration provided a good excuse for obtaining support. Toying with the idea that a Centennial portrait should contain one hundred citizens, I approached the editor of a Midwestern university press. Would he be willing to publish a book containing one hundred of the most outstanding Wyomingites? He recoiled at the suggestion, saying he wouldn't touch it with a ten-foot pole ... too political. Figuring that the concept was not too democratic, after all, and that there was nothing sacred about the number *one hundred*, I fished for another idea. I approached the Wyoming Council for the Humanities. Members of the Council were willing to consider funding a documentation project, but a purpose and methodology had to be clearly defined. They needed assurance that public money would not be used for a coffee table mug book. It had to promote an understanding of Wyoming history.

I mulled over the concept of an album, conjuring an image of a typical family album. The logjam in my brain began to break apart. Distilling a distinctive format from the mishmash that family albums seemed to display was a minor problem and could be solved by a creative designer. The primary task was to establish an underlying structure that would support and enhance historical information gathered in oral interviews. Wrangling with form and function, I jotted down what seemed to be common denominators of family albums. It quickly became apparent that their photographs reflect fundamental social institutions such as the family, religion, education, labor and recreation. Edward Steichen recognized this social framework when he created *The Family of Man* (New York: Museum of Modern Art, 1955), an exhibit and book containing poignant images that portray life from the cradle to the

grave. I was aware that Steichen had been imitated by others who were not his equal, but concluded that his concept was still a useful model. *Album* chapters could be arranged to mimic the chronological flow of human life, and interviews could be structured to allow Wyomingites to apply color to state historical themes and subthemes. The result would be a legacy of voices and images, artifacts of the late twentieth century in the mode of a family album. Although the *Wyoming Album* is a forced concept it is an exaggeration to assume that residents of the state belong to a group resembling a family as an artifice it allows us to take a closer look at our cultural environment.

Individuals were selected according to their ability to answer questions that the book chapters posed. What was life like in days gone by? How does it feel to grow up in Wyoming? What kind of work do Wyomingites perform? Because we identify and evaluate people by their work, it seemed reasonable to compile a list of occupations. Reviewing a Bureau of the Census index of occupations, I realized that even an abbreviated list of jobs was too long. Besides, the *Album* was not intended to be a survey of labor. Retirees, as well as people who weren't old enough to have occupations, had to be represented. Wyomingites also needed to represent the peculiar historical and geographical characteristics of their state. The decision to portray the whole population and its culture made the project vastly more difficult and time-consuming. It was evolving into a *magnum opus*.

Pondering how to prevent the *Album* from becoming a ponderous document, I phoned Audie Blevins, a sociologist at the University of Wyoming. Blevins suggested that perhaps what I was attempting to do was define some sort of Wyoming ethos. In a few moments he was able to capsulize what I had been thinking but for some reason could not articulate. Breaking free from academic compulsion, I admitted that the work would not be a comprehensive representation of Wyoming people. I understood that my own perspective was hopelessly biased. But I was relieved from the task from performing a one-man, lifetime, ethnographic survey. Whatever the outcome, I believed that the intrinsic value of the tapes and photographs would be valuable to future generations.

Selection of interviewees was time-consuming but not difficult. I tapped the minds of colleagues and friends for suggestions, collected personality profiles from magazines and newspapers, and asked businesspeople and government officials for leads. Readers may think that some people in this book do not represent Wyoming as well as others might have, and I would agree. Some were chosen on the spur of the moment. Others who should have been selected were not because of my own ignorance or lack of time. One person told me that the *Album* would not be complete without a member of the Simpson family from Cody. I agree. It just didn't happen. Occasionally somebody asked why I chose a particular person, indicating that so-and-so was a better choice. If I had a good answer probably it was specious. A friend remonstrated that he would not buy the book if a particularly infamous Wyomingite was included. "Why are you including him?" he demanded. "He's a convicted felon!" Figuring that convicted felons constituted a segment of the Wyoming population, I continued unfazed in my search for the Wyoming ethos.

Eventually, I came to realize that if a Wyoming ethos exists, it emanates from a larger pool of participants than only those with ranch backgrounds. The images that we adore do not fairly represent us at the turn of the twenty-first century. Actually, who we are is not easily definable, and our image problem is also problematic in that it is continually in flux. The people in this book are part of that historical process. The attitudes they represent probably are not much different from those held by people in other states. German foreign exchange student Nils Jaschik told me that he believed Wyomingites were no different from other people in the world except in language. How different are we from people in other states if we say that we are conservative and don't like paying taxes? The expression mouthed by people, "If you don't like the weather in Wyoming, wait a few minutes, it'll change," applies to the rest of America and probably most of the habitable planet.

There are no easy guidelines for understanding Wyomingites, as the testimony of the people suggests. Cliches relating to them, like weather predictions, are circumstantial and float on the wind. What seems likely, however, is that we who live in this state are shaped by our environment. The Wyoming environment has at least several characteristics that define us. One is the wind. The wind is palpable. You can hear, feel and smell it. You can watch it push tumbleweeds, drive snow and bend trees. It forces people to tie things down and to angle forward as they walk. The changes in barometric pressure that flow with the wind can drive you crazy or keep pollution down, whatever suits your temperament. Another is open space, a cherished commodity in a state known for its wide-open spaces. A third is low population, less than half a million. The population of Wyoming is the lowest in the nation. It is a point of pride among citizens to be ranked at the bottom. We are happy that our numbers are low. Pinedale fast food restaurant owner Tom Harkness admitted "The day after I moved in they should have dynamited the road shut and not let anybody else live here."

Low population has advantages. For one thing, our governor is accessible. Many have met him personally. He is listed in the phone directory, and we see no reason why we can't walk into his office and visit him. We know his strengths and weaknesses, although his weaknesses are known more by word of mouth than by what we read in the newspaper. Low population means that the degree of social separation between people is small. If you stop for coffee at a small-town cafe, at least one person in the room will know at least one person you know. The familiarity of the state's people with one another, despite great geographical separation, gives rise to the expression, "Wyoming is a small town with long streets."

From the earliest days of Wyoming Territory, low population meant freedom from the rules. We can make social mistakes and still survive. It required the town mercantilist, perhaps, to also act as banker and mayor. The necessity to perform more than one task, or to perform it without help from others, results in the attitude that you can do anything you set your mind to. In more populated places competition sometimes precludes one from carrying out his or her heart's desire, but here you can do anything. Wyoming breeds the kind of confidence expressed by the daughter of ranch foreman and irrigator, Junior Herman. She said, "My dad can make water run uphill." And we can do what we please with property, or at least we think we can. In rural Wyoming homesteads are littered with machinery, construction materials and the bric-a-brac accumulations that scatter out or pile up over years of inhabitance. One speculates that some law entitles each of us to our own spare-parts salvage yard.

You can become a big fish in the little Wyoming pond. You can even become governor ... unless you are a woman. Nicknamed the "Equality State," Wyoming was the first governmental

entity in the world to give women the right to vote and hold office. But it is apparent that historically the state's citizens do not believe the tag means much. The act granting equality was an aberration, and the facts of life today actually demonstrate inequality. For example, the wages of today's women workers are considerably less than what men earn. The number of women in our legislature is small relative to their numbers in the population. In 1994 we finally sent our first woman to Congress.

Low population promotes a certain amount of tolerance. People are allowed to own their eccentricities, and personality aberrations are accepted if not understood. If you are teased, it is an indication that others care for you. Wyoming, according to Michelle Sullivan, insulates people and accepts them as they are. Another reason for this type of rough equality, regardless of sex, race or creed, is environment. Photographer Penny Wolin asserts that if you are stuck in a snowbank, you don't care if the person who pulls you out is a Jew, Black, or cowboy, you just want out. The outdoors has that quality. It is egalitarian. Cowboy poets Tina Burke and Echo Roy had to perform the same ranch jobs as their male counterparts. And when the going got rough they had to "cowboy up" the same as others. For Jackson Hole pioneers Clark and Veda Moulton, the environment was more exacting. You worked or you died.

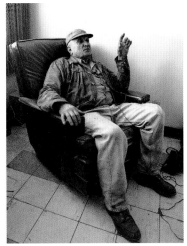

Paul Canoso
b. September 24, 1916, Diamondville

Paradoxically, whatever claim one makes for Wyoming, the opposite can be stated. We are friendly because of low numbers and space between us, but on the other hand isolation contributes to loneliness, xenophobia, alcoholism, suicide and other types of socially deviant behavior. Wyoming pride of independence is curiously mixed with low self-esteem. We are aware that a small number of people equates to lack of power in Congress, so we reelect our senators and representatives. We sense that we lack sophistication and are behind national trends, although some say they like it that way. Our sense of rejection dates back to when Wyoming was an obstacle to people traveling to places further west. Even today it is irritating to know that the nation flocks to Yellowstone and Grand Teton National Parks, not caring what the rest of the state contains, that our people do not all live in wilderness, or that we don't all ride horses. Our feeling of inferiority is not alleviated by the knowledge that the world needs our coal, gas, oil, trona and other natural resources. We realize our dependence and that without them our standard of living would drop and our individual tax burdens would rise. We are also aware of the "boom and bust" syndrome in our mining history. Compounding our frustration is the fact that Wyoming is nearly last in the alphabetical list of states.

Wyoming has changed, both materially and psychologically, since the Album project was begun. It is changing as I write these words. But some things remain the same as they were when I arrived in the state thirty years ago. I can still smell the corn tamale flavor of sun-cured grass in the damp of a spring evening. My soul still can ache with longing when the pungent aphrodisiac of wet sage touches my olfactory nerves. I still can see telephone poles silhouetted against almond-orange skies. Memories remain. I still can recall a primeval night in the Wind River Canyon, enfolded by blackness, car tires humming on silent pavement and headlight beams bouncing off ripples in the river. If I never again venture beyond this writing desk, these sights, smells and sounds have been branded into my brain. What created them, I hope, will always be found in Wyoming.

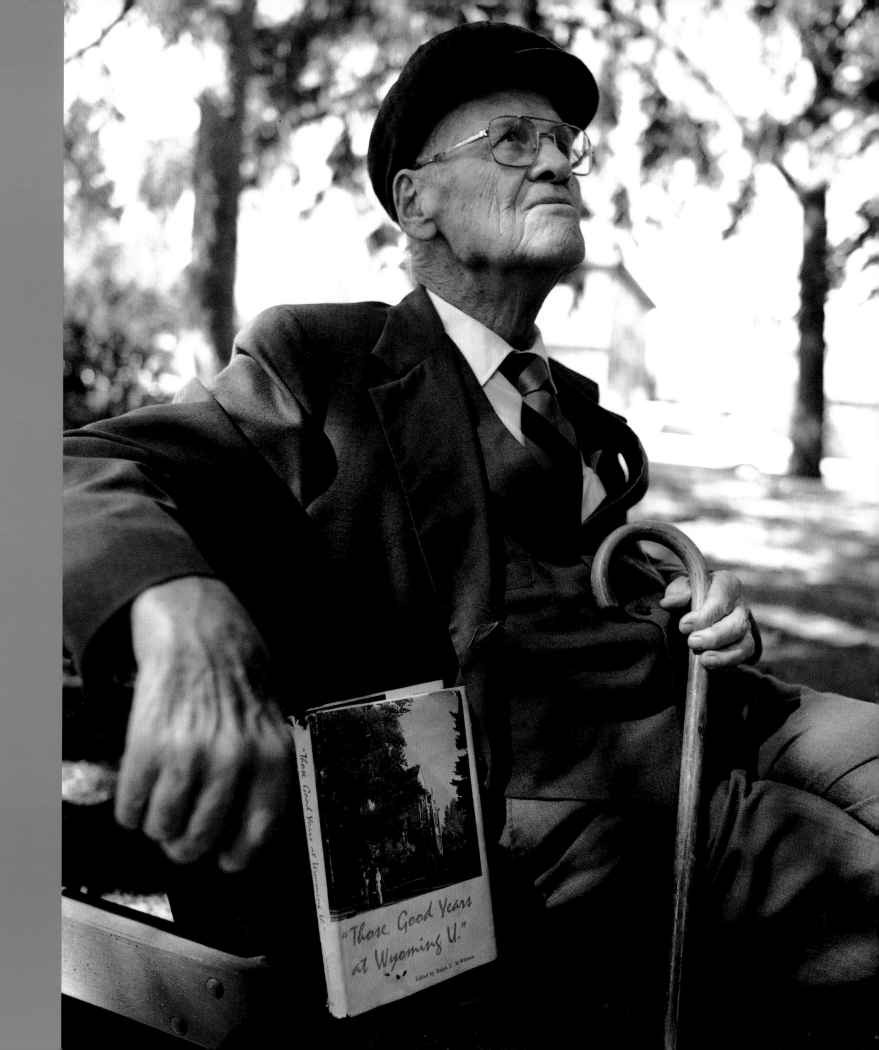

author: People have said that you've got a phenomenal memory.

McWhinnie: Well, I don't think phenomenal. At least, it isn't as good as it used to be.

author: Do you have a good memory?

McWhinnie: Well, I can remember what other people didn't sometimes.

author: How is it that you remember those things? Is it an interest, or does it just come naturally?

McWhinnie: I don't know. It's there. I haven't made any effort.

LARAMIE
RALPH McWHINNIE
REGISTRAR, UNIVERSITY OF WYOMING
b. MARCH 14, 1898, SOUTH OF DOUGLAS

MERRILL FARTHING

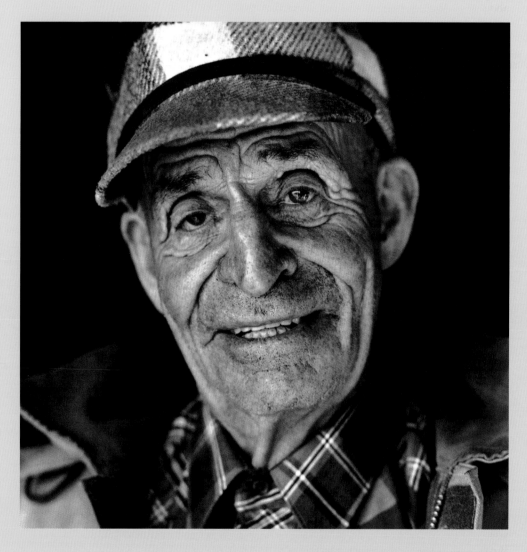

I got a story . . . I guess you can put it in. I always have said that my great-grandfather was kind of a fun-lovin' person and he had a taste for the better things in life. He went to bed with the minister's wife and the minister come home and caught him. While the minister was looking for his shotgun, why, my great-grandfather stole the sheriff's horse and beat it to the steamship line. He just stopped long enough to collect his pants because at that time they thought it was a necessary part of your apparel. Now you can go anywhere and all it says on the door is "Shirt and Shoes Required." Pants are just optional. But anyway, he had fond memories of the sheriff and the minister shaking fists at him when he left the old country. They settled in New York—Buffalo. They can cut out what they don't want. I just say he was traveling for his health 'cause the minister was going to shoot him.

FARTHING RANCH
b. DECEMBER 23, 1903, CHEYENNE

Well, when I was five or six years old, we was going out to haul ties and we had a runaway. And I was in a big wagon. Threw me out in front of the wagon, and one wheel broke my leg here and another one went over my wrist here. I was only about six years old then. Next time I got a broken leg we was playing polo. My brother was riding a stud and he kicked. He broke my foot here. With one foot he broke that. And here . . . well, you see where this leg is knocked out? You can feel the bone there. He kicked me there with the other foot. Then, third time, I was riding a horse and he turned on a slick meadow and threw me under him. See, you go this way 'cause the horse's feet go this . . . He broke my leg right there. That was the third broken leg. Then on the ribs, let's see. I roped a calf and the rope come under his tail. He threw me off, and I think he stepped on me and he broke my ribs here. Next time, let's see, the same horse worked my ribs twice . . . how did he do that? I think he kicked me the third time. The horse broke my ribs twice. I broke my own ribs once. I was gonna break ice out here along the road, and it was dark. I was coming out from town. There was snow on the ground. I was walking downhill pretty fast and I fell like this, and I didn't get my hands out good enough and the fence post stuck up about this high off the ground. It went right through here, took my ribs. It shattered 'em and, like I say, the damn things went down, punched a hole in my lungs. And then this air bubble. I don't know whether you've ever had one or not. Let the air outta my lungs. And you get an air bubble here under your skin. That sets you up quite a little. But that time I had to walk a ways to get in the pickup to get home so they could take me to the hospital. Oh boy! When you get hurt in the wintertime, you know, you can't lay there too long or you freeze. Boy, I haven't had it easy.

You banged your nose a couple of times.

Well, yeah. First time, like I say, a horse fell with me, hit face first or something like that. Next time I was wrestling with a calf, came down, and he threw his head up, broke my nose. Then they got that set crooked. I was kinda glad when they broke it a third time. Third time, I had a

pony tied to a post up here and he reared up and hit me with his foot. Broke my nose. Then I had this ruptured appendix in the blizzard of '49, and they finally got me to the train with a team and a wagon or sled or something. See, it closed the highways and the railroads. You wouldn't remember that. Even closed the Union Pacific for a week over here. It closed this railroad but we made it on the last train in. I guess they telephoned on the railroad telephone and the doctor met the train at about three o'clock in the morning. They operated on me at five. I made it to town. But that was the last train. If I hadn't made it I wouldn't be here. 'Cause I'da died. I couldn't even keep water down me. They put me on the train, I guess, in the baggage car, and nobody come near me. The people, the conductors and brakemen, thought I was dying and they just left my wife and I alone. She was with me.

At that time, you know, they didn't have so much penicillin and sulfa. They lost a lot of people they could save now. I don't trust those fellas yet. I been operated on, well, for this hernia operation, ribs and everything else. . . . And you get bills from people. I swear they was never there. You been up there [hospital], haven't you? You know how it is. You're passed out and next day or two you get billed. [Laughs] Hell [Laughs again], do you think they were there? I don't think they was ever there, some of those people, but you can't argue with 'em. You was there but you didn't have a thing to say.

Oh, you take chances out here. Especially with horses. You mess around horses long enough, you're gonna have broken bones. Yeah, that's why if they was using horses like they do automobiles, the undertakers and the hospitals couldn't take care of 'em. You can turn a motor off a pickup or tractor or anything else. You don't turn a horse off. My father had broken ribs. My brother got a broken leg. We've had I don't know how many broken legs here.

You generally go to a doctor. But it used to be quite a job 'fore you had cars to get to a doctor 'cause the only train come once a day. My mother could cure most anything. She thought if a little bit done a little, a whole lot'd do a lot more good. My sister says mother braided her hair so tight if

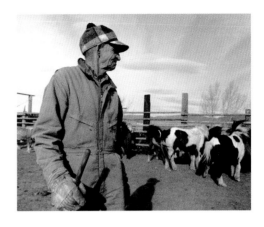

While I'm at it, as long as we're gonna take up time, we've had these Shetland ponies right at one hundred years. We raise more than anybody in the United States because we've been at it for right close to one hundred years. Some of the time we had, oh, up to six or seven hundred mares. We had so many ponies we was known all over the country and had write-ups in the Saturday Evening Post. *When they had the news on in the movies a long time ago, the* Pathe News, *they come out and take movies of 'em about 1928 or '29. We had probably seven or eight hundred ponies at that time.*

That's about the only thing the Farthing Ranch was known for was the ponies, Shetland ponies. None of 'em probably forty inches tall. At that time they bought 'em for the kids, and over in England they'd buy those little stout ones and use 'em in the mines to pull the carts out because, see, they didn't have very high tunnels. They come from the Shetland Islands, and that's between England and Iceland, you know. The Shetlands is where they originate. And we've still got 'em.

her mouth was open she couldn't get it closed. [Laughs] And when she rubbed you with anything, you'd swear the hide was fallin' right off. You got well. The cure was worse than the disease. Yeah, she was quite a doctor. But hell, these people lived. Now they take 'em to the doctor for everything. And hell, lots of people never saw a doctor.

E. LUELLA GALLIVER

UNIVERSITY OF WYOMING

When I first came, it was cigarettes. Then it was beer. And then it was whiskey. And then it was boys and girls together. Do you see the development?

The girl that was pregnant, we got her out of the dorm fifteen minutes ahead of time. The president said, "How come?" And I said, "Last summer, on the ranch, on the haystack." [President:] "Good, that lets us off the hook." Isn't that precious?

There was a case of a young girl dating a married man, and they got caught out in a blizzard, so they'd had to stay overnight. That was a scandal. So I got the president. The president said to me, "What have you done about Helen Mulloy? What have you done about Major Luck?" He was the married man who had dated this coed. She came and said to me, "Oh, Dean, what would you do?" I said, "I know damn well I wouldn't get mixed up with a married man!" Years and years later I got a very pretty Christmas card of the two people with a happy family of three, and that was Helen. He got a divorce and she married him. Years later I got this Christmas card from somewhere in England, and they were happily married and everything had turned out very well.

One of the crimes one year was the publication of a yellow sheet which scandalized everybody: "The Father, the Son, and the Holy Goat." Well, the Father, of course, was the President, and the Son was the Dean of Men, and the Holy Goat was the president's confidential secretary. She was horrified to be so labeled. Well, it was a big jam. We knew who it was. Gene Cross and his girlfriend. They were dismissed. And her family just created a terrific stink. They came in, "I'll have you know we are not without influence." I said, "Neither am I." Pure bluff. That was pure bluff.

They still come and say to me, "Oh, Dean, my mother was one of your girls." And I still get a Christmas card from somebody: "Oh, we so hoped she would be kind and understanding." And I was. I had such a nice relationship. Isn't that a nice memory?

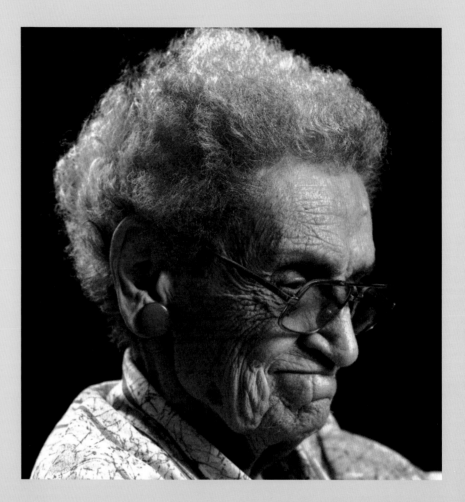

We discovered the president had been so shocked at finding people necking in their cars together. There were no rules and regulations. It was the Engineers Ball. At intermission the hall was emptied. He said, "What has happened to everybody?" We got outside and he went up to a parked car and found them necking. Horrified! Well, I don't know how many hours and hours we spent formulating social rules for social behavior. We called ourselves the Purity Squad.

LARAMIE
b. NOVEMBER 7, 1899, CLARE, MICHIGAN

JUDGE EWING T. KERR

U.S. DISTRICT COURT

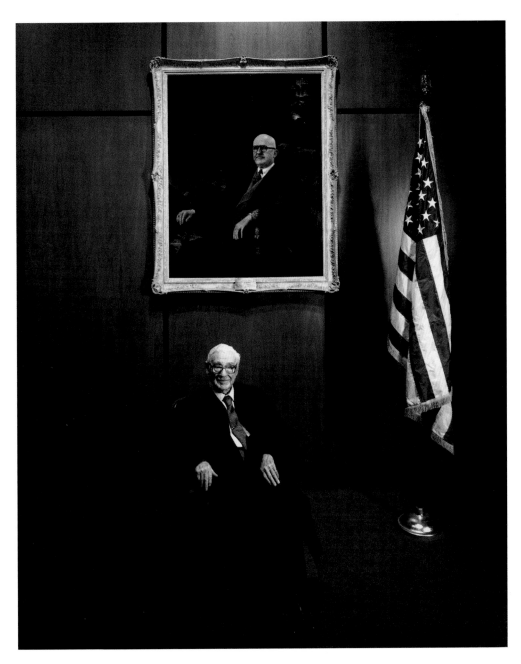

I will say this. I'm proud of this. We have a record in Wyoming. The first eighty-five years of statehood we've had three judges. Judge Riner served from 1890 till 1921. Judge Kennedy was appointed in '21 and served till '55. And I was appointed in '55 and took senior status in '75. That made eighty-five years, three of 'em.

I was just interested in politics. I'm still interested but the lawyers and the litigants don't know that. I'm interested in politics today and so was my predecessor. Every federal judge since 1890 has been state chairman of the Republican Party. That included Riner. Kennedy was chairman when he was appointed, and I went out as chairman before I was appointed.

Judge Kennedy didn't take senior status . . . or you didn't have senior status then. He retired after he was eighty. He was waiting for Eisenhower to be elected. He didn't want to be succeeded by a Democrat. And so far there hasn't been a Democratic U.S. judge in the history of Wyoming in its almost one hundred years.

I've enjoyed being a judge all the time I've been on. That's the reason I'm still on the job. If I'm still able to hold court at ninety-one, I'll still be down here.

CHEYENNE
b. JANUARY 21, 1900, BOWIE, TEXAS

SUNSET COTTAGES

RUTH DALGARN

TOURIST COURT

This is something. Unless you have been here, walked in my shoes, you really can't understand this. The months go fast and the weeks go fast. But the days drag, and the nights are endless. Weekends are particularly bad because Pat [husband] traveled. As a signal inspector, Pat traveled and he was only home, lots of times, on Saturday and Sunday. So the weekends are really bad. It just seems like Sundays last forever. But the time, it goes by a minute at a time. It just seems like when you get up in the morning, it's an eternity until it's ten or eleven or whatever time you want to go to bed.

The Sunset Cottages was originally built in the early 1930s when Highway 30 was a transcontinental highway from New York into San Francisco. There was a group of highway department employees who built these tourist courts. Tourist camps they were called at that time—one in Pine Bluffs, one in Medicine Bow, and one in Evanston. Along the highway, as I recall, people who were traveling along U.S. 30 had to arrange to be in one of the major towns: Laramie, Cheyenne, Rawlins, or somewhere where there was a hotel. There was no place where they could stop and stay the night, fix their own meals. This was the purpose of the tourist camps, because most of them had kitchenette-type things . . . you know, a gas plate. The original units of the Sunset Cottages in Medicine Bow even had dishes, and pots and pans, and a teakettle with a two-burner gas range. That way people could travel with their camping gear and fix their own meals and be inside. The highway itself was such that they couldn't travel too many miles in one day.

Of course, my motto here at the Sunset was, "What you hear here, what you see here, what you do here, leave it here." I even fired one gal over that, because nothing made me any madder than to go uptown and, "Hey, I heard so-and-so rented a room from you last night." I felt that it didn't make any difference who rented the room, long as they had the money. That's all that was necessary. It was nobody's business who was in what room. In fact, I always turned my cards back so they couldn't read the names of 'em.

They will probably just corrode unless somebody comes in and buys them to keep them going. Right now there are six of the original cottages setting on this land. But nobody is interested enough to preserve them. It's one of those things you think, "Oh, if they could just talk, they could tell all kinds of stories."

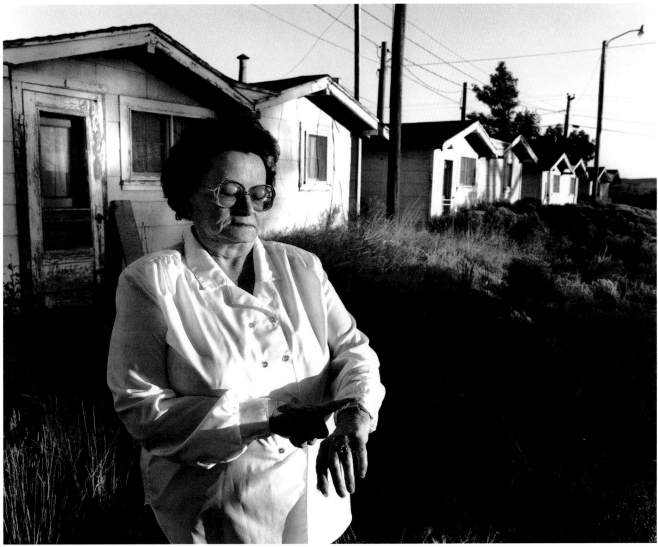

MEDICINE BOW
b. OCTOBER 30,1924, ALTAMONT

What I did do—I'm on the record, I guess—I re-created major league baseball out of the Plains Hotel studios for six years, to as many as sixty-some stations in this part of the country. I'll tell ya how that came about. These were the days of antitrust, and they were on baseball for its monopoly in a way that they are today, but it was worse. We had a senator. All Wyoming remembers. Senator Joe O'Mahoney was a trustbuster, good friend of Tracy McCracken, Democratic buddies. Bill Grove concocted the idea. He says, "I think Tracy, through Senator Joe, can get us the rights to broadcast. Do you think you could do it?" And he says, "I'll whip up a gadget for you." I said, "Sure." This sounds fantastic but it's true. We got the rights for major league baseball. We got the American League first, then we got the National League for an eight or nine, ten-state area exclusively to broadcast, to recreate, major league baseball out of Cheyenne, Wyoming.

Bill Grove put up a gizmo about the size of this table, maybe larger. I wish I had it today . . . where at three or four turntables I had pedals and I had the steady noise background. I could bring up the applause. I could bring up booing. And I tell ya, we got it going. It was pretty realistic. I would have people next day tell me, "How'd you get back so soon? From the game?" I never left the Plains Hotel. And I had the crack of the bat—the United Press roll, the tubing underneath it? A pencil would give me the sound of the crack of the bat.

I had a Western Union telegrapher. What a character. Gosh, I gotta think of his name in a minute. He's gone, of course. He'd be sitting there and I'd be here with all my gizmos, and it'd come in: Musial,

.342, up, top of the first." Well, I'd have my chart here of the infield and the positions. I'd have that chart when they were on defense, see? The Yankees were on defense. Then I'd have the steady background and . . . "Top of the first inning. The first batter is Musial. Musial, of course, bats on the left side. The infield is swung around wide to the right. Stan is hitting .343. Comes the first pitch by Jones. It's a little wide of its mark. Ball one." Little pause. "Glad to have you with us tonight. The New York Yankees and the Detroit Tigers coming to you from Briggs Stadium in Detroit. The next pitch is low. It's ball two. Vic Raschi on the mound. Here's the next pitch." . . . Cracking sound, crack of the bat. "A ground ball hit up on the right side! Rizzuto off to his left in time for the out. One away." But all I was getting from Western Union was "ground ball left" with "shortstop to first, out," see? I'd have to fill all that in. Then I'd get caught up with 'em and it'd drive me crazy. Maybe there'd be a delay and I had to have pitches fouled off. I'd always start thirty minutes behind but in my impatience I'd catch up with 'em about the third inning.

One time . . . I don't know if you're familiar with where the studios were? In the Plains Hotel? That was really pajazz up there, boy. Big glass windows. And people'd knock on windows when I'd re-create it. There was some party my wife was looking forward to going to, and I had the St. Louis Browns. I'll never forget right there at the Plains Hotel on the upper floor. They'd come by and pound on the window. Fourteen innings. So in the fifteenth inning I signed it off and had the Browns win. It came out the next day it went seventeen innings and the other team won. I'll never forget that one.

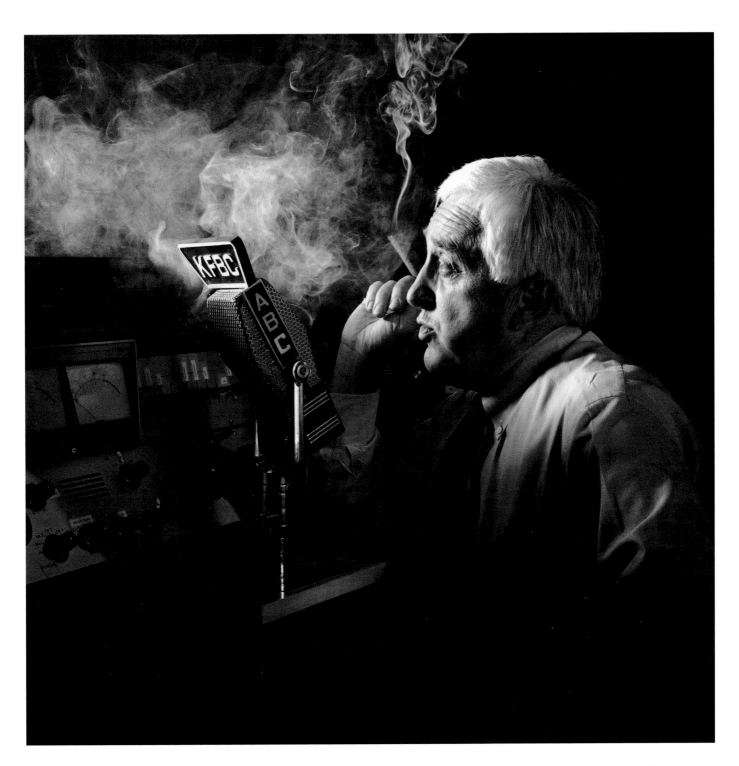

I think there are many who doubt the importance of it all [sports], that it isn't going to change our culture or lifestyle or never will. I think that those people are silenced in the successful years. I think—at the risk of being very prejudiced—it's been a very healthful, salutary thing for the state of Wyoming. It brings people together. It gives us something to talk about. I was noticing this story the other day telling about Wyoming. It was a national story in the Washington Post. There was one line in there that told how rough things are out here. It says, "The only thing they got going for them now is their winning football and basketball teams. What's the value of all that?" I hate to say this, but I just can't picture Wyoming without it.

CHEYENNE
b. APRIL 17, 1918, HARTVILLE, WYOMING

CLARK & VEDA MOULTON

MORMON ROW, JACKSON HOLE

m. JUNE 10, 1936 LOGAN, UTAH
MOULTON COLLECTION

CLARK: *You know when the pioneers came here in 1896—this is a long story—when the pioneers came here in 1896, they were lookin' for a homestead where they could settle down, build a cabin and a barn, and raise kids, and cattle, and horses, and cows, and whatever you do on a farm. And that was their sole object. But when they looked over there at those mountains (Tetons), they were a beautiful, snow-covered pile of rock. Pay no attention to 'em, it's just beauty. And now, after the Park Service got it, they're a beautiful, snow-covered pile of gold. That's the way we describe it to everyone. And that's what's happened to it. The price of the land is inflated.*

CLARK: We can't take the credit for the first Mormons to come to the valley. No, because we get into trouble with Uncle Nick Wilson and the Cheneys and those down there. But we take the credit for the first Mormons north of the Grovont River, or Gros Ventre River, whichever you're gonna call it.

Well, you see, my grandparents came west with the Willie Handcart Company. They come through South Pass and they spent three nights there at South Pass when there was fifty-six of 'em died. There was nine in the Moulton family and they all lived. And they came to Utah. They was rescued and came to Utah. They spent a winter or two in Salt Lake and then they went to Provo, and they lived in the old Indian fort there for a winter or two. Then they went from Provo to Heber City, Utah, and Charles Albert Moulton decided he wanted to take his family and come to Victor, Idaho. He filed on a homestead on Fox Creek. And, of course, Uncle George Moulton was there, too—his brother. They had two farms, and my father and his two brothers got tired of herdin' sheep for little or nothing, so they saddled up their horses and came to what they heard about was some good land east of Blacktail Butte in Wyoming. In 1905 they came here and filed on a homestead apiece: Wallace next to the Butte, John out by the pink house, and Alma where we are. They fenced it in one big piece first. Then they later came every year and done some cabin work and some plowing to prove up on it. In April they came into Jackson over Teton Pass, and up around what we call Dry Hollow to Kelly, and crossed the bridge, and came down the lane over here and settled in the old cabin. It was a one-room cabin with a dirt roof, no windows, and a dirt floor. It'd been vacant all one summer and all one winter, and my mother cried tears because that's what she had to settle for, you see. She was a Blanchard from Victor, Idaho. And she, little scalawag, got right in, pitched, and done everything she should do. We lived in that cabin for several years before we moved into another house.

I came here nine months of age. They had a team of horses and behind they had a cow tied on, and mother's saddle horse, Sally. Mother rode her bareback all the time—Mother's pride and joy. They had to plow the fields to raise a crop, so they had a sulky plow. A sulky plow is a one-bottom plow with wheels and things to pull it by. It took three horses to pull the plow in this sod. So Dad traded Mother's saddle horse off for a third horse. And she never forgave him. That was the worst thing he could do was to trade Sally off. Mother held it agin' him all of her life. Sages were tall and lotsa times the plow would clog with these big sages, and the plow'd fly out of the ground.

I was the first son in the family. There was five in our family—six, we lost a sister. There was only two boys and four girls in T. Alma Moulton's family.

What was your job?

To go out and go ahead of the plow with the grubbing hoe and cut the big, tall sages. The smaller ones turn in, but the bigger ones clog the plow. So I got the job of cuttin' the sages out ahead of the plow. You'd cut that sage off and then you piled 'em up and burned 'em at night because it's a lot of fun to burn 'em at night. That was the entertainment at night for the kids. It made a beautiful smell. Smell wasn't offensive. But, you see, it takes a long time to plow twenty acres, one furrow at a time. A twelve-inch furrow. Now [there are] these big plows, sixteen and eighteen- inch furrow, seven of 'em behind the tractor. You'd try to do that in the summertime and then

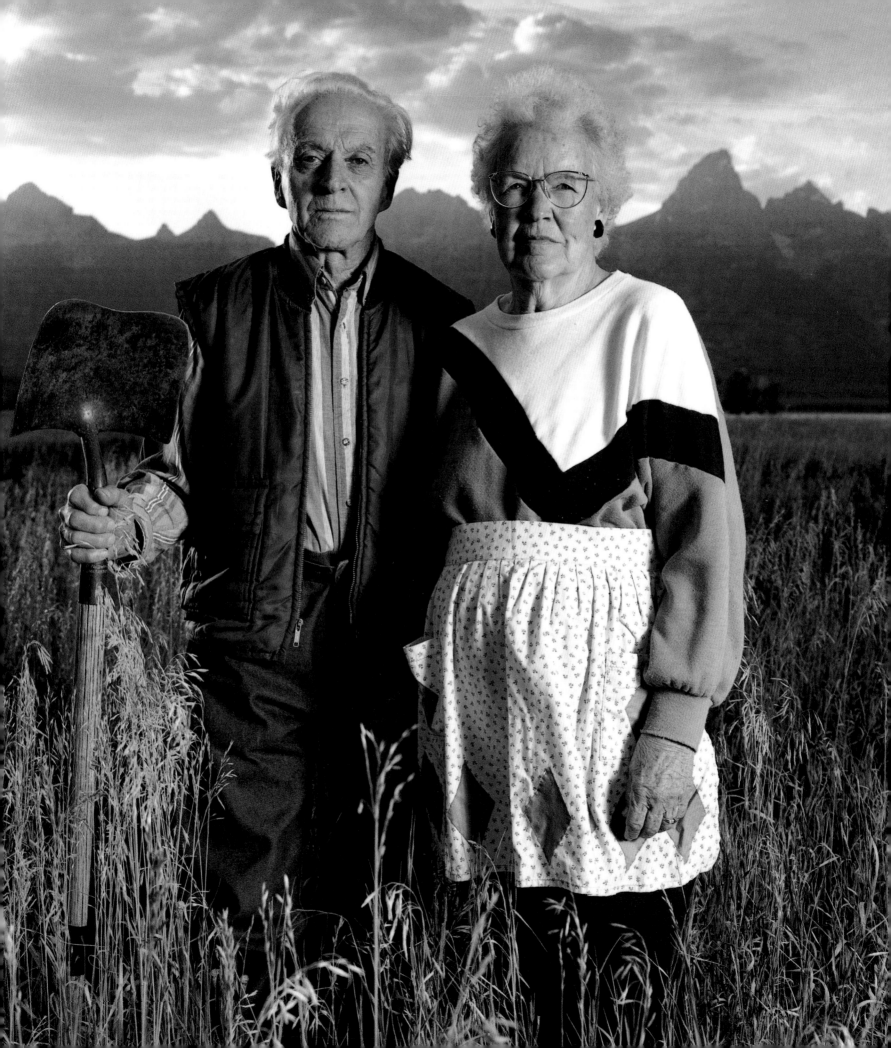

you'd let it lay over and it rots. And the next spring is when you plant your crop.

So, then after a number of years of dry farming, they started to build a canal to Gros Ventre River, some six miles away. That was their next project. Veda's father, James I. [May], they had a ditch out of the Gros Ventre, too. Come right through the town of Kelly. They done it with horses and slip scrapers or fresno scrapers. See, a slip scraper is one of these that you have a handle on. You got a team in front of it and you scoop it up, and then you bear down on the handles and you take it to where you want to dump it. Then you lift up the handles and it catches and you dump. The fresno was built for two or four head of horses. It had a bucket and a handle in what you called the double trees. You held up on it to load. You plowed it first, wherever you wanted your ditch or your road. Then you'd guide the horses up, and you'd take it up on the top, and you'd raise up and it'd trip, unload your load. You pushed down on the handle and went back and got another load. I followed them things for miles.

Everything was handworked. All you had for carpenter tools was a good saw and a axe. Your axe was always sharp, and your saw. That's the way you got your winter's wood. Now, when you wanted to go to town in the wintertime, you hitched up the horses to the sleigh. You traveled the same road every day. The mail traveled the same snow road every day. When you went to your haystacks, you traveled the same road to the haystack every day. When that haystack was gone, you broke a new road into another haystack and that's how you got feed for your cattle.

VEDA: We didn't have all the automatic things then. Course, my mother always had hired girls. I was the middle one of the family of eight. There was three girls and five boys. I had five brothers older than I. I was the oldest girl. My mother had a hired girl until I got old enough to take over the helping with the baking, and the cooking, and the cleaning and all those things. But every summer she had a hired girl that came and helped because Dad hired help, too, you know, for help on the farm and the ranch. I helped with the cooking and I cleaned

house. My first job when I was just a little thing was to dust. I guess 'cause I was short I could just [laughs] do all the dusting and my mother would go around and inspect. I had to make sure that everything was clean. He [Clark] still gives me a bad time. "Well, you found something to clean, did you?" But I'm grateful that she was fussy about having everything just so. I probably resented some of the things that she insisted I do as I was growing up, but now I'm grateful and I understand.

My mother taught me how to cook. I had to cook because we had all the hired men and the brothers older than I. I never had to work out in the field. I never learned to milk a cow like so many of the other ladies around did, but I never had to. My mother—I don't know whether Mother could milk a cow or not—was busy in the house. But we had brothers that did all that work.

CLARK: Before we got rural electrification we had a wind charger out here. You can see one of 'em over here at the neighbor's place. We have one. My folks had a Kohler plant first. You could pump water, and milk the cows, and we had lights, but you didn't run a refrigerator. So Veda and I had a wind charger and thirty-two-volt batteries in the basement. Whenever the wind blew it charged the batteries.

VEDA: It's the only time I can ever remember enjoying wind.

What did you do if you didn't have a refrigerator?

Well, we hung it [meat] in the wintertime. It was alright. In the summertime we hung it out in a screened porch, out in front where you came in. Had milk and butter out there, and the wind kind of kept it, and it cooled off at night. But if you butchered a beef or had a piece of elk meat in the summertime, you'd wrap it in canvas in the daytime and hang it out at night, and you could keep it for ten or fifteen days that way.

CLARK: Well, it's pretty hard to describe [the settlers' life] 'cause everything was sacrifice and physical. Everything you done was so physical, you know. Like the cattle drive and the winters. You see, in the early days you had a kerosene light and when you went to bed you blowed the kerosene light out. If you got

up in the night and you looked over there, and there was a light at one o'clock in the morning in the window, you knew someone was sick. Now if you get up at one o'clock in the morning and look over there and the yard light's on, someone's just gettin' home. He's been into town. [Laughs] And so, if someone was sick the next day, you went to check to see who was sick.

VEDA: Or else you went that night.

CLARK: And poaching an elk? When your kids got hungry you got a piece of meat for 'em. There were days like that, yes. Everybody'll admit that. You ask Earl Hardeman about it and he'll back me up on it. There was times when you needed a piece of meat to feed the kids. You only got paid once a year and that's when you took them cows to Omaha. Anything else was a bonus. Sometimes you worked on the road, sometimes you worked for the Forest Service building fence or something.

VEDA: You trapped.

CLARK: Trapped coyotes, beaver, and what have you—sold their hides.

VEDA: When we were first married, that's about the only money we had was you'd trap in the winter and bring home a little. That was just fifty-three years ago.

CLARK: The year I went to high school I had three dollars spending money. I was a senior in high school and I had three bucks for spending money. You could get in the show for twenty-five cents, and I think I went to two shows all that time I was a senior.

How was it you got together?

CLARK: On a hayride. Moonlight night. I planted a kiss on her and ever since it's been tragedy.

VEDA: That's what he tells me. Well, you know how it is when you're a teenager. I thought if I could just get out of this valley, I would never marry a local boy. I would never marry a farmer. I'd had all that I could take, you know, with all these brothers and all this work and all this cooking. So I went to school. My folks always sent us kids out to Idaho or Utah to school 'cause they

wanted us to take seminary and get music lessons and that. So after about four years, my choices just changed entirely. Well, I'd had all the dates, and all the boyfriends and everything, and I just decided the hometown boy was the best one.

CLARK: You know, I never had trouble with "cry-baby-cry." You know what a "cry-baby-cry" is, don't you? Well, the boy, he goes to college and he falls madly in love with the town girl. And so they marry. And she's from back in Nebraska somewhere and he's from Wyoming or Utah. As soon as they get married he gets a good job in Chicago because he's got a degree. So he moves his family to Chicago, and his wife doesn't like it, and so that's what a "cry-baby-cry" is. She cries until he brings her back to her hometown.

VEDA: We never went through that.

CLARK: We never went through that because when she got ready to cry, she could go down the road here a mile and in two hours she'd be back. [They laugh.] So that's the story of our life.

CLARK: But Veda and I's done things together all our life. We love to dance. We love to huckleberry. That's part of the winter supply in the early days. The mothers, and whenever the father could get time off in July and August, they went and picked huckle-berries in the forest. They'll only grow in the pines. The mothers would can the huckle-berries like you'd can peaches and that was basically the winter's fruit.

When you get through here, we'll take you on the tour of the farm and show you what we do together. When we go to the bank, buy a CD, we go together. When we do any business we go together. Right hand knows what the left hand's doing.

Why do you work so well together?

Well, we respect each other. That's some of our church training. The very sub-ject in priesthood meeting this morning was on the ability to honor one another and respect one another. Sometimes you have a little disagreement over something or what-ever it is. Like we said earlier, Veda's got a bad case of scrub-a-dub-dub all the time. She's gotta be scrubbin' something. The

kitchen's got to be menaculously clean. The cabins has gotta be clean. They gotta be right. Very particular about things being right. And I have a lot of talents, too. I can plant, I can handle livestock, I can crawl up on a big piece of machinery and drive it just like an expert. I've done that. I can carpenter. I can do things like that.

VEDA: Farmers can do anything. They have to.

CLARK: Electricity is the best blessing that ever happened to us. You know—a story I tell on her—years ago we didn't even have a well. We had the water run by. We dipped it out of the ditch and brought it into the house. So there was a Youngstown kitchen sink salesman came along. We didn't even have a well. We didn't even have pipes in the house and she bought a Youngstown kitchen sink.

VEDA: Youngstown double sink.

Why did you do that?

VEDA: Because I had hopes.

CLARK: [Laughs] So then the process was gettin' a well drilled. Pete Woodard was the plumber downtown. So he come up and connected up the well with the kitchen sink and we've had running water ever since.

VEDA: And I still have the same sink and I love it.

How do you like living here on Mormon Row?

VEDA: Well, I wasn't too impressed, you know, as I grew up in my teens and every-thing. But then as I got a little sense in my head and everything, I loved it. I love it now.

CLARK: Well, I'd fight for it. I just loved the experience, during my lifetime, of the sacri-fice and the struggle. Everything was physi-cal, whatever you done: bundle-pitchin', hay pitching. I fed cows until I could hardly get to the house. Three or four loads of hay every day to those cows. I fed Jim Boyle's cows up here for eighteen years straight run-nin'. I had 'em from December till March, three or four hundred head of 'em. I'd dig hay for 'em. And her father and the boys—in the wintertime you spent your time with a pitchfork and hayrack feedin' cows. You fed the cows five months out of the year

with a sleigh and hayrack. You started to feed in November and you never quit till the fifteenth day of May. Snow wasn't off the ground.

Has this Mormon Row changed? Is it still Mormon?

VEDA: Well, there's no one along here.

CLARK: Yeah, we're it now.

VEDA: We're it. [Laughs]

How does that make you feel?

CLARK: Very proud. We'll not give up that. If we hadn't held onto that, Mormon Row'd been forgot ten years ago. You wouldn't a heard anything about it. But this [Mormon Row] sign out here, Clark and Veda's too darn stubborn to let it ever drop.

VEDA: Long as we're here.

CLARK: Long as we're livin' it's gonna be Mormon Row.

*Cover photograph
Bill Willcox*

JACKSON HOLE
CLARK: b. OCTOBER 7, 1912, VICTOR, IDAHO
VEDA: b. APRIL 23, 1914, GROVONT

During World War II, Bill Hosokawa was an inmate at the Heart Mountain Relocation Camp near Powell, Wyoming, and edited the newspaper, Heart Mountain Sentinel.

DENVER, COLORADO
b. JANUARY 30, 1915, SEATTLE, WASHINGTON

Being in prison isn't much fun, whatever way you look at it. What you could do was limited. You're within barbed wire. You settled into a routine which was rather dull. In my case I remained very active running the paper and doing other things, but physically, of course, we lived in these rude barracks and we had to go to a mess hall to eat. We went to a central sanitation building, which might be fifty yards away, for toilet facilities, for showers. You woke up to the mess-hall gong. So it was not a normal life. The discomfort was comparable to that faced by young men in the military. If you were young and single, that was no big deal. If you had young children, if you were old, it was quite uncomfortable. We did everything possible to keep the people busy, interested. All sorts of hobby shops. We played softball. There were English classes for the older people and there was a lot of visiting back and forth. You could stay up as long as you wanted. There was no curfew.

I think that there was a sense of camaraderie in that we're all in the same boat. There was no rich, no poor. We came from varied backgrounds. People could look at the Japanese/American and say, "Oh, they all look alike." But they were different. Some were ambitious, and some were angry, and some were philosophical, and some said, "I'm gonna get the hell outta here as quickly as I can." Others would say, "What the hell, they're gonna feed me."

The emphasis was on Americanization. You are in the camp because you're Japanese. We want to make you an American. But the young people, most of them, spoke no Japanese. Born in America, the product of the American school system. There was no more reason for us to speak Japanese than a second or third-generation Italian or German would speak Italian or German.

Some of us were 110 percent Americans. And there were some who were not. If there were some who said, "Look, we've got to become Americanized," or

"We've got to do this, we've got to salute the flag," there were others who said, "You think you're so damn good, why don't you walk out of the gate? If you think you're an American, stand up for your rights!" Very hard to answer.

There were a lot of shower-room arguments, lot of late-night discussions. Families were split by this. One son would say, "I'm gonna join up." And another son would say, "Well, you're a damn fool." The alternative was, sit in the sanitation room where the toilets were and gripe and talk to each other.

I felt that if we wanted any kind of a future in this, our country, our only country, we had to take that extra step to demonstrate that we were worthy of this country. It would have been easy to say, as many of them did say, "If you want me to fight for my country, open the gate. If you want me to serve this country, let my family go back to the West Coast." And that was awfully hard to argue, I guess, that kind of logic. But there were others who said, "We've got to make the best of this. After the war we will win our rights. How can they turn down people who have shed blood for this country?" And that's the way it turned out.

The main thing—let me rephrase that—a very important thing, was that Japanese Americans lived in oriental ghettos on the West Coast. And we were blasted out of these ghettos. Many, many of these people moved east of the Sierras, east of the Cascades, for the first time. If you were stuck up in Heart Mountain, Wyoming, and you had a chance to go to Chicago, or Philadelphia, or Des Moines, or Indianapolis, you found out what the rest of America was like. And a third of those people never moved back to the West Coast. They liked what they saw. They found opportunity. Kids with Phi Beta Kappa keys who had been polishing apples and stacking oranges in a fruit stand on the West Coast because there were no other jobs available

suddenly found themselves heading departments of big corporations back east, utilizing the education and the smarts that they had, which they were unable to do because of the barriers of discrimination on the West Coast. There was a shortage of manpower, and guys in the Midwest and the East who had never seen an oriental before would take these people on. And because they didn't have that basic anti-oriental prejudice, they'd say, "Hey, this guy can do the job. Give him more responsibility."

Japanese Americans today are very well established. There are four Japanese Americans in Congress. A Japanese American is a federal judge. Lots of 'em in the state and local justice system. They are police officers, presidents of universities, great physicians, surgeons, scientists. They're leaders in their field, businesspeople, financial advisors to some of the big corporations. They've, quote, made it, unquote. But if they would walk down some parts of town, they'd look just like a fresh-off-the-boat Vietnamese boat person. The average guy can't tell a Vietnamese from a Thai from a Burmese from a Chinese from a Japanese from a Korean.

Do you think this whole episode could be reenacted in American society?

Yes, I think it can. We got an indication of that during the Iran hostage crisis, where the Iranians picked up fifty, sixty people from the U.S. embassy. And almost immediately, anybody from the Middle East with an olive complexion was in jeopardy in this country. There were rednecks with baseball bats out to get an "A-rab." We had a case here in Denver where some kids had too much beer and they knew there was an "A-rab" living in that apartment house, and they got some baseball bats and went up to get him. This guy had a rifle, and he was trying to protect himself and his family, and he killed one of the kids. He was never charged, but look what it did to his life. There are voices of reason, but there are just enough wild-eyed, super-super patriots so that this sort of thing could happen again.

It's happening in various places today. Several years ago there was a Chinese kid killed in Detroit by an automobile worker

This happened up in Wyoming. I was the guest at a party at a very nice home in Casper. One of the guests was a well-known political figure. He was trying to be friendly, and he came up to me and he said, "Mr. Hosokawa, how long have you been in this country?" I looked him over—he was somewhat younger than I—and I said, "Sir, I think I've been in our country about twenty years longer than you have."

who thought this Chinese kid was Japanese, and he was going to restore the balance of trade by beating up the kid with a baseball bat.

But there are people who still haven't sat down and shared a meal with an Asian American, never went to school with them. There are many people who are completely color-blind in this respect. I was up in South Dakota one time speaking to a writers' conference. If anybody noticed that here was a person with an Asian face telling

'em how to write better in English, it didn't seem to occur to 'em. But after a while a little old lady came up to me and said, "Mr. Hosokawa, how do you spell your name?" I said, "It's right here on my name tag." She looked at it, says, "Oh! You must be Polish!" Completely color-blind, see? So there are people like that.

There's a word in Japanese, *gaman*. It means "to endure." Japanese say, *Gaman shiro.* You must endure. Hang tough.

CLARE AXTELL

I thought that my father and mother never had a disagreement. When he came up here to visit me, long after Mother was gone, I said to him one day, "Papa, why did you and Mother ever get along so perfectly? You never quarreled." "Oh," he said, "you don't know. We took lots of buggy rides." But he said, "We never quarreled before our children." And I was brought up just that way. I didn't know a husband and wife ever quarreled or ever disagreed. I didn't know about the buggy rides. [Laughs]

I was the dumbest girl that ever hit this place. That's a fact. We had one saloon in Albin [Nebraska] and I wasn't even allowed to walk on that street. I always went to the street across, walked there. I didn't know that a woman ever had a drink. I found out they do up here.

My father smoked a Meerschaum pipe or cigars. I loved the smell of those cigars. No cigarettes. I never saw a cigarette. He was a dyed-in-the-wool Democrat. [Laughs] Yes, he was a strong Democrat and when William Jennings Bryan came to Thermopolis, why, my father, of course, was the leading Democrat in that part of the state. So we entertained Billy Bryan. Took him to the Episcopal church on Sunday. And our house. I don't remember having many flags. I don't think they had many flags then. But we had bunting by the yards, by the bolt, and our whole house was decorated in red, white, and blue bunting for the occasion when he was running.

You know, he was known as the "silver-tongued orator." Boy, he **was** a silver-tongued orator. That man could get up and give the most beautiful orations of anyone I've ever known. And very clear. You could hear him for blocks. I went to church with him. Well, of course, I thought anyone in the Democratic Party was wonderful. I thought they knew everything. They knew every law and they knew just what to do to save the country. [Laughs] And that's "16 to 1" [ounces of silver to gold]. I had a button. I wore my button to school, "16 to 1."

So when I got here and Mr. Axtel asked me, right when I first got here, he asked me what party I belonged to. I said, "I'm a Billy Bryan Democrat." He said, "Omigod, don't tell anybody that up here. They're all Republicans." So from then on, I was a good Republican.

Up here I've had an embarrassing position at election time. Right here in the Home there were several ladies who didn't know too much about the candidates. And, of course, I always instructed 'em right here. So just a few years ago Winifred Stewart Dickey, she came in. She said, "I don't know much about these nominees. I wish you'd tell me something about 'em." So I gave her the history and told her who I thought she should vote for. Election day they voted here in the Home in the basement. So I went down and voted. I was there visiting with the election board, and Mrs. Dickey came in and she voted. As she came out of the booth I was sitting right there with the board. She said, "Clare, I voted for everyone you told me to." I was so embarrassed I could have crawled under the desk. That was an awful thing. I didn't want anybody to know who I was for. I've had several embarrassing things over here trying to get votes for the Republican Party.

The system has changed. People have changed. I voted for one Democratic governor and I'm sorry I did because that got them started. We'd been having Republicans so long I really thought they needed a change. People here didn't know I voted differently, but I did 'cause I thought we needed it.

They didn't believe in a woman having a career. It's alright for 'em to teach school, but they didn't want them out, to have a career. I didn't know a woman ever had a career, really. I just fell into it.

They wanted me to start an abstract office. They transcribed records from the two counties. This was a part of two counties, you see, Fremont and Hot Springs. "Well," I said, "I don't have the money to buy the transcribed records to set up an abstract office." They wanted $2,500. I was out of work with the courthouse, or would be, so I went over to the bank to see if I could borrow the money. A.K. Lee was the head of the Thermopolis State Bank. He said to me, "I wouldn't loan you five cents. Did you ever hear of a woman making good in business?" I said, "Alright," and I walked out. I got over to the courthouse. They said, "Well, when are you going to start?" I said, "I'm not gonna start. I can't get the money." "Well, we'll back you." I said, "No, I won't take anything from anybody because you would expect more. You would expect me to do your work first if you were the ones that helped me get it. I will not be under obligation to anyone." And I said, "I'm not starting."

Well, the next day they came back—Illinois Pipeline—with sixteen men. This was their headquarters. Every month they wanted to file on this property, see? Because they felt that there was oil around here. So they came in and they said, "Well, you can get the money at the bank." I said, "Who signed up for it?" "No one." I said, "Well, I will not take it if you people are standing good for it." The lawyers all were desperate too, you know. So they said, "Well, you go over to the bank. The money's there." So I went over and I looked at the note. It wasn't endorsed. No one had signed for it. So I finally signed it. I got the money and I got the transcribed records. They were in a barn in the south part of town. The man who had had this work done, he had epilepsy

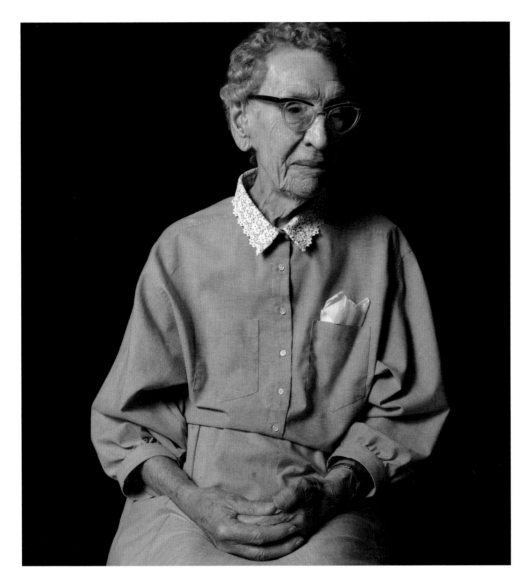

and he was not able to open the office. So that was all being wasted, see? Well, I started and I worked day and night on those records. Every Monday morning I took down my week's income and paid it in the bank. And finally I paid the note off long before it was due. I took my check down and I said, "I want to pay off the note." They said, "Alright, we'll get your papers." I said, "But I want to see Mr. Lee." "Well, he's there in the office." So I went in. I planked my check down. I said, "I want my note back." I said, "Did you ever hear of a woman making good in business?" "Well," he said, "you're an exception." I said, "But you wouldn't let me try."

I paid him off and I never spoke to him after that. I was fed up on their thinking a woman couldn't do anything. He was typical. A woman had no career. They were not supposed to do anything. Well, it was me! He was refusing me! And I was alright . . . I thought I was alright. [Laughs]

Wyoming has been outstanding. We've had the first woman governor, we've had the first woman [state] senator, we were the first to put women to vote. We've done a lot, and I'm not gonna quit now. As tired as I am, I'm not quitting. You gotta go out and fight, anyway. I'll fight Jehovah's Witnesses as long as I live because they're not working for the government. That's where you live. That's where you have your liberty. And we're all proud to be here. We wouldn't move to any other country.

I'm 102. I think it's terrible. You get so useless. I can't do anything I want to. I can't get out and do anything. Why live? I think it's too bad to live to where you just can't do anything for other people. I've done for others all my life and look at me now. I just sit. I just am thankful that I still have my mind, although it doesn't compare with what it was two years ago. Doesn't compare with it. I can't . . . I'll start to say something and the word leaves me. I never used to be that way. That just come on the last year or two. Terrible. No, you're out of place, really, with the way of the world. The world has changed. It's not the same at all.

I live by faith, I guess . . . and hope in eternal life.

They have the different candidates, you see, come here to the Home to meet all the people. And we had quite a crowd for one of them. I was in there and I didn't like what the man said. At that time he wanted to sell this building. He thought that it was too much expense to the state. I didn't like what he said. So right away, of course, I voiced my opinion. His wife happened to be standing right by me. She said, "You don't know him. He's my husband." And I said, "I'm sorry for you. But I don't like him and I hope he doesn't win." [Laughs] It just popped out. I just love politics. I'd get out and fight for one that I liked. And if I didn't like 'em they found out.

PIONEER HOME, HOT SPRINGS STATE PARK, THERMOPOLIS
b. APRIL 23, 1887, BOONE COUNTY, NEBRASKA

KENNY SAILORS

The great legendary Joe Lapchick, who played with the original New York Celtics and coached at St. Johns University for many, many years, when he retired he credited [Hank] Lusetti with the man who started the one-handed shot and he credited me with the man who brought the jump shot into the game of basketball. When people started asking me if I'd started it, how would I know? I don't know if I'm the first guy that ever shot a jump shot. I doubt it. But evidently the shot that's being shot today is basically the shot that I was shooting when I went to the Gardens, went into the East in the big arenas to play in those years.

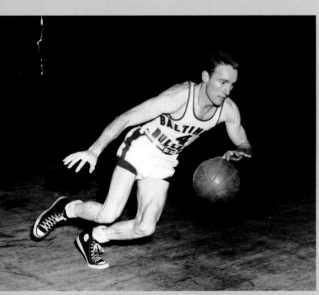

ANGOON, ALASKA
b. JANUARY 14, 1921, BUSHNELL, NEBRASKA
SAILORS COLLECTION

I really learned to play on a dirt court. With the school we played in a little gymnasium there at Hillsdale. But my brother was a good high school ballplayer and he played for Hillsdale. We had an outside basket put up on the windmill. He and I used to play and he taught me quite a bit about basketball. I was five years younger than him. In the process of me playing him, lots of times one on one and practicing against him, why, I got frustrated not being able to shoot the ball. He used to kid me a lot and make fun of me and call me a "little runt," and why couldn't I hit the basket? So I got to jumping in the air and throwing the ball. I had to find a way to get it up over him, and of course out on a dirt court, your dribble wasn't too effective because you go off to the side once in a while or it'll get away from you. I discovered that to get the ball up over him I had to really get up in the air, so I jumped for height. I actually jumped for height before I shot the ball. Now I don't imagine that was much of a jump shot in those days, but it was effective occasionally. I got the ball up over him and from that, on through the years—I couldn't tell you exactly how—it developed into the shot that I was shooting when I got into high school and on into the University of Wyoming, which is the one-handed jump shot that people tell me is the same shot that they're shooting today.

I've got clippings at home where they refer to it—sportswriters did—in all kinds of ways. Some of 'em called it a "leaping one-handed shot." Others called it "that shot put–type shot." Looked like I was shooting a shot put. I've gone places where writers talk about me "hanging in the air," . . . "hanging in the air and making up my mind whether I'm gonna hit the post or shoot that crazy—I forget what they called it— shot put–type shot. All kinds of things they called it. They never referred to it as a "jump shot" until later.

I did have some problems when I went into the NBA with the first coach that I played for. That was Dutch Denhert, an old-time . . . in fact, he was one of those original Celtics that played with Joe Lapchick back in the twenties and the early thirties. They had a great team. I guess, probably, the greatest team in the country in those days before the Globetrotters started. They called themselves the Celtics and that's where the Boston Celtics name, I think, came from. But that was Joe and Denhert. Well, they were up in years. They'd seen me, no doubt, when I'd come into the Gardens to play. And Denhert, I don't know whether he'd ever seen me before or not, but this was after the war. The first team I played with in the NBA was Cleveland, the Cleveland Rebels. I just got out of the marines and had come back to Wyoming for just, I think, one semester, and then went right into the NBA that fall. So when they hired me it was the front office that did it, it wasn't the coach.

He didn't know me, really, from Adam, Dutch didn't. When I got out there in the first practice and started dribbling and shooting my jump shot and driving, he never said anything for a while. Finally he called me over to the side and said, "Sailors, I don't know where you got that shot, or who taught it to you, but I want to tell you something." He says, "It'll never go in this league." He said, "You're gonna have to develop a good two-handed set shot." Of course, everybody in the East shot set shots at that time, and I can see where he understood and believed that. They thought—a good coach taught—that both feet had to be on the floor when you shot a shot. And I can see that. He also said, "You know we don't dribble the ball like you guys from the West." He said, "We don't dribble the ball. When we come up the court with the ball, we pass it back and forth. I want to see that ball passed more, and," he said, "I want to see you working on a good two-handed set shot."

Well, I didn't have much to say. As a result I sat on the bench the first half of that season. About mid-season, fortunately

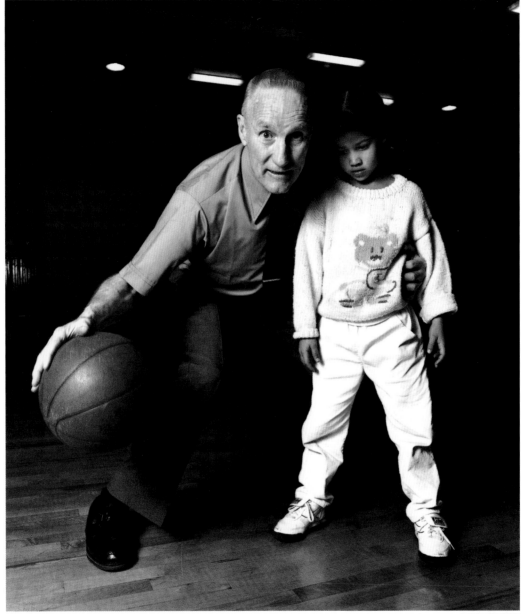

RANA WRIGHT
b. AUGUST 29, 1984, DENVER, COLORADO

for me, they were not winning too many ball games and the front office sent Dutch on the road scouting, which is just a nice way of getting rid of him. They brought in one of the guys with the front office who had been a former coach there in the Cleveland area. He came in and took over the club. And I started playing, and a couple of other kids that hadn't been playing started playing that Dutch hadn't been using, and we did pretty well. We ended up in the play-offs that year.

EDGERTON
b. MAY 4, 1914, WHITEWOOD, SOUTH DAKOTA

CLIFF PICKERING

GAS STATION

The reason that they had to have it at night, because all the men in that time were all working for the company, and they didn't get off of work until four thirty, five o'clock. So if they had a ball game in the afternoon they wouldn't have nobody there. And the people wanted to see the game. So somebody come up with a good idea of puttin' some lights up, which was a wonderful thing, so that when after they get off of work, they could go see the game.

Night Football Game in Salt Creek

Gleaming softly clear, like a pure white oasis in a black desert, the Midwest Gridiron stood out of the night of November 19th [1925] a stage setting for the first night game of football ever attempted, at least in the west and as nearly as is known, in the Country. Giant electric lights, twelve of them of one thousand and four of two thousand candle power, were trained on the field from all sides and corners, while one great light was set on the top of a neighboring rig.

Casper High vs. Midwest High lined up. The whistle of the referee sounded shrilly in the frosty night air, the pure white oval soared high and there began one of the most spectacular and novel athletic events ever arranged. The crowd of well over a thousand were stirred with the giant outdoor overhead lighted drama, with every play and every player brought out in cameo clearness, reminding all of nothing ever witnessed before. The two teams fought with the Midwest lads gamely battling against the versatile, experienced Casper Eleven on every play. The local school rooters yelled and pleaded as only a cohort unit can do that is carried out and beyond itself, rising to new heights of sincerest loyalty and animation. Final score, 20 to 0, favoring Casper did not take the victory away from Midwest, for the spirit of the team, the spirit of the supporting schoolmates called out all that was natural and reasonable and that little bit more that is super-supreme and attained is a victory.

The Midwest Review
Vol. VI, No. 12, December, 1925, p.14

DUDE RANCHER
ALICE SHOEMAKER

A "dude" is a good word. To my mind a dude is a very special person 'cause they come out here for a week at least. We don't take 'em for less than a week. So they get to know us, and something about the area, and want to. Most of 'em are vitally interested in every flower and every animal and every mountain and every lake. They want to learn about the country, and they want to know about the history and the people. They are travelers. Tourists just go booming through in an automobile. To me "tourist" is a dirty word and "dude" is the nice word.

This ranch is really the oldest dude ranch there is. The people over at Sheridan claim it—Eaton's. But in 1917, Charley Moore started taking teenage boys on pack trips through Yellowstone, and that's a form of dude ranching. Then by 1928 he'd have boys out here all summer. And the roads got better and cars got better, so people would come out to pick up their son and see the country. They'd go touring, in other words, and pick up their son here. Then there had to be a place to stay. So Charley built a cabin or two, and then he had to build a dining room and a kitchen, and it grew from that.

Charley was born in Fort Washakie and grew up there and went east to school. His father was the post trader, and there was a Captain Torrey who was the commander of the troops at the post. J.K. Moore and Captain Torrey got the idea of runnin' cattle up in this country on public land to raise beef for the government to feed the Indians. 'Cause in those days they issued beef to Indians on the reservation. That's how Torrey Creek and Jakey's Fork got named. It was from J.K. Moore when he ran cattle up here from Fort Washakie.

He spoke Shoshone, Charley did. He grew up with the Indians. When we bought the ranch, Charley and Marion had a house here that they loved. They loved this ranch and they loved this country, and the agreement we made with 'em was that they could be here every summer, and live in that house, and give us the benefit of their

advice and assistance. It was a lovely tool to keep the people that had been coming to CM to keep coming. Which worked. It really worked very well. The transfer just went like silk. All the people that loved Charley and Marion knew they'd be here. Then they learned to know us, and they found the ranch was still goin' along great so they kept coming.

We have a big recreation building up above here we call the Roundup. He [Charley] would go up to the Roundup every Sunday evening and just rear back and start reminiscing. He told about stage trips from Lander to Rawlins and back, and in the wintertime and the cold weather. He told Indian stories. He told about goin' huntin' with his—I don't know, it was his brother, I think; he had an older brother we called Uncle Jim Moore—and an Indian. They went up Torrey Creek hunting, and in the night a mountain lion screamed. Charley was just a little boy, maybe ten or twelve years old. He cried when this lion screamed. It frightened him and he cried in the tent that night. So he said all the rest of his life when he met that particular Indian on the street, the Indian would go "sniff, sniff, sniff" at him. Charley, he would have been right with *Dances with Wolves* [film]. He had great respect for the Indians.

I had one brother fourteen months younger than I am and another one eighteen years younger. But my dad raised the brother that was close to me, and me, exactly the same. I mean, he took us both hunting and

CM RANCH, EAST OF DUBOIS

left: SAM SWITCH
b. MAY 7, 1961, BROOKVILLE, PENNSYLVANIA
ALICE SHOEMAKER
b. MAY 20, 1912, STEAMBOAT SPRINGS, COLORADO
right: JOEL ELIOT
b. FEBRUARY 1, 1958, DOWNEY, CALIFORNIA

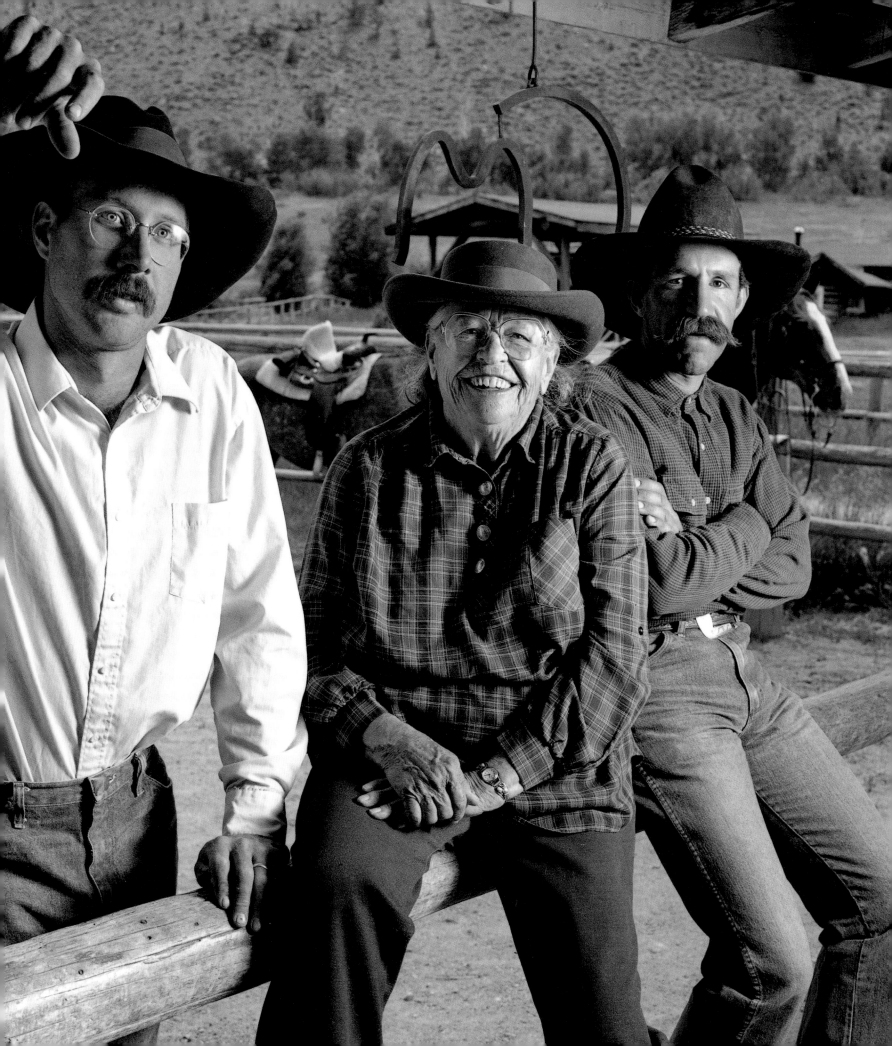

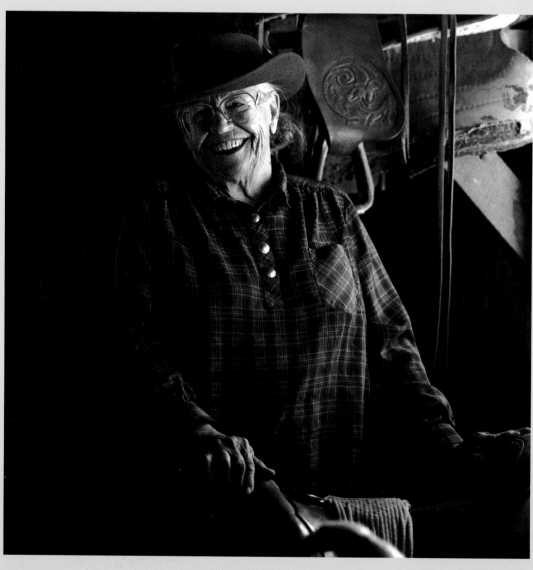

fishing. He taught us both to shoot. He taught us both to ride horses. He encouraged a lot of competition all the way from boxing to wrestling to shootin' marbles and everything else. So I grew up a real tomboy. My mother was a very feminine, dressy, socializing woman, but my dad raised me the other way. One of the great joys of my life was to be allowed to go places with Dad.

I had my own huntin' camp for twenty-five years that I ran. It was the greatest situation that you can imagine for people that like that sort of thing because it was inside the wilderness, up East Fork. Everything that was there had to be packed in on horses —everything. We had to cut wood with crosscut saws and axes. No machinery of any kind. It was two hunters and one guide and me. We'd go out for a week at a time to hunt elk. I cooked and packed elk, and chopped wood and carried water. Well, the guide had to get the elk shot. That's the hard job.

I was often the only woman in the camp with ten or fifteen men. It never bothered me a bit, and as far as I could tell, it didn't bother them. Because I knew how to behave. People say that men won't work for women, but I hired guides for my hunting camp year after year—tough, outdoor, mountain men that were good hunting guides. And I never had any trouble with 'em, or they had no trouble with me. I think the theory that men won't work well for women is bunkum. It just isn't true 'cause they will if the woman handles it right . . . well, not be arrogant, not be bossy, be a little bit tactful, consult about decisions, what any executive has to do all the time. But some people don't have sense to.

I very, very rarely ever had a man make an indiscreet pass at me. I had lots of good friends and companions that I enjoyed a lot. But that was it. Course, Les [husband] was always there in the background. I don't know that an unattached woman could have done all the things I did. Everybody that I associated with knew Les, knew we were married, knew it was a good marriage, so it kind of erased the questions. You know, I've discussed this with hunters, because they are out in camp, and they see me and . . . oh, a man'd say to me: "I wish my wife would do things like this." And I'd say, "Well, she probably would if she had a

chance. You don't invite her to go huntin' with you. You don't teach her to shoot. You don't buy her a rifle." I would say things like that. But then they would say to me, "Aren't you afraid to be out in the mountains with all these men?" I'd say, "No." Because of the western traditions of life in the West. Men that homesteaded or ranched or did anything out here in the early days often had to leave their wives at home alone, maybe with small children, maybe all alone. Any guy that bothered 'em, there was gonna be retribution. And it wasn't gonna be a long trial or anything. It was gonna be quick and sudden. And that tradition still hangs on, or did when I was active. Western men just don't bother unwilling women. I don't know whether that's true in the East or not, but there's a good reason for it in the West. Women were respected.

A lot of people think that dude ranching is just something glamorous to do. But I feel that an old, established ranch that's been successful for—what?—'28 to '88 is darn near sixty-five years. It's something to be proud of. And it means a constant effort to do right by the people who pay their money to come visit you.

Many of our guests say to us, "How do you gather up such congenial people?" Because they almost invariably all enjoy each other and make friends that they still see when they go back east, and have a great time together. Our answer has always been, "When you get people who want to come to a simple place like this and live in a simple little log cabin, and ride horses and go fishing and spend time with their family, they have a lot in common to begin with. So it makes a congenial group."

Both Les and I enjoy people. I learned early in life that the more demands there are on you, the more you enjoy your life. The worst thing that could happen to you is to get up in the morning and have nothing you have to do. So I like all the activity and the interest in the people. I can't think of anything I would have liked as much. I can't think of any way I could have spent my life that I would have had as much satisfaction and enjoyment out of as I have this.

R O B E R T N E L S O N

I was reported to be the youngest bank president in the United States at the time [1936]. I always said I started at the top and worked my way down.

POWELL
b. APRIL 28, 1910, POWELL

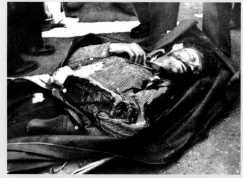

EARL DURAND
LAING STUDIO, POWELL

From my perspective I've never heard or read of a bank robbery that was more spectacular and killed more people. I don't know that there ever was one in the United States. I would guess that this might be the worst in the sense of the devastation, the killing, the dramatics of it. Most bank robbers go after money. That's, I think, the big distinguishing thing between [Earl] Durand and the average. The others wanted to get in and get the money, and get out as quickly and as inconspicuously as possible. And he didn't. He was just the opposite. He didn't try in any way to hide. He didn't try to get away, I don't believe. I guess he fully expected to be killed in that bank or outside because he had done all the shooting, and he must have known that everybody in the county knew about it. I think the money was a minor item, and his idea was just a spectacular, glorified end to a mountain man's career. I never could figure out anything else. I doubt if there ever was any other bank robbery with that kind of a scenario.

He was a local boy and he'd lived in a tent at his father's farm. He liked the outdoors. He envisioned himself as a mountain man. He went up in the mountains for a month at a time all by himself. Lived off the fat of the land up there. So he was not one of the normal people. I had known him—not well—but off and on for years. He had long hair when nobody else had long hair. He just was different and visioned himself as a Daniel Boone type or whatever. The Tetons were a helluva long ways from here, so that [nickname "Tarzan of the Tetons"] was ridiculous. That was just hype, is all that was. They didn't call him Tarzan here at all. That was worked up by the media somewhere. The magazine articles that were written about it were not glamorized but they weren't correct, either,

in some ways. They didn't do a lot of research on it. The newspaper articles such as these were more factual than anything.

First I had any inkling of a problem with Earl Durand was when he was arrested by the county sheriff or deputy for poaching elk out of season. This was probably in March of 1939. He was put in the Park County jail in Cody. First we'd heard about anything happening. There had been a robbery a few days previous to that, of the Powell Feed Store, and several guns had been reported stolen. Whether he did that or not, I don't know. That's a possibility. He was arrested and put in the county jail. When the jailer came to feed him, he reached through the bars and evidently grabbed the man—Noah Riley was the jailer—or grabbed his keys or something and got out of the jail cell. Then he commandeered somebody to drive him to Powell. He went out to his father's farm.

Then when the local county deputy sheriff, D.M. Baker, and the local police chief, Chuck Lewis, heard about it, they assumed that he might have come to his home. So they went out there to pick him up. That's when he shot both of them in the yard as they were approaching the house. Killed both of them. Then he commandeered a neighbor, Art Thornburg, whom they'd known for years, to take him up to the mountains. Art, of course, did. Earl had a rifle, and a pistol, and a sack of food is about all he had with him. This was March. He knew where he was going, I guess, because he knew the mountains pretty well. Made him take him up into the Beartooth Mountains. Well, then, of course, this story spread like wildfire. This was all known by the people. So they formed a local posse here to go up and see if they could catch him. That posse included

Argento and Linaberry. One of them was from Meeteetse and one from Cody. They went up with the intent of capturing him in the Beartooths.

In some way he hid out from them and shot those two posse men up there. They never did catch him up there. That's the time Montana sent in a unit of their National Guard with a howitzer that's supposed to have blasted him out of the mountains. I guess that never took place because he slipped out at night, and got around them and got away from them. Bill Monday was a pilot. I don't know about the bloodhounds. Bill Monday was ferrying people back and forth but there was no place to land a plane up there.

Anyway, Earl Durand slipped out of the place he had been hiding, around the posse, and came down to the bottom of the mountain and commandeered, I think it was, Louie Moore, a Cody musician, to drive him to Powell. Everyone here thought he was still in the mountains, expected him to be, didn't see how he could get out.

So about one o'clock on that day of March, I was in the bank at a desk. My desk was out in the open next to the lobby, and there were a number of customers in there. Three or four or five, I don't know. He walked in the front door with his rifle and I think he said, "Hello, Nelson." He knew me and I knew him. Whether he said, "This is a stickup" . . . I don't know what he said, but we all panicked at the time because we hadn't expected him and, of course, here's a man with a gun coming in. You're scared. I remember he wore a pair of engineer-type overalls, the striped, denim overalls. I remember that for some reason. He had this sack with him that I guess he'd carried provisions in. Big canvas grain sack. He came in, and I don't recall exactly what he said. That article in the paper recorded it better than I can remember.

He made all of us that were in the bank, several of our employees . . . there was Johnny Gawthrop the teller, and Maurice Knutson the cashier—I don't remember who else was there—and several customers including Earl's dentist. He'd just had a tooth job done fairly recently. He lined us up against the lobby wall, face to the wall with our hands up, and started

shooting with the rifle. Made a helluva noise in that relatively small room. Nobody knew what he was shooting at because we were all facing the wall. Doc Stahn, the dentist, tried to get down on his hands and knees and crawl out at this time. Earl saw him and made him get back up there. They spoke to each other, knowing each other. Well, after Earl got us lined up, he shot I don't know how many times. Seemed like quite a few. He was shooting out the windows on the west side of the building. There were a lotta bullet holes in the windows. And, of course, the bullets went out into the street and across the street.

One of the interesting parts of it was that George Blevins, who was a reporter for the Billings radio, KGHL—George was also a clerk at the Powell Drug Company across the street from the bank—was in the drugstore at the time. He got on the phone in the back end of the store and reported this to the radio as it was going on. One of the bullets that Durand fired had gone through the front window of the drugstore and back in through that telephone booth. That's how close it was. So right while this was all going on, it was being reported to the radio and they recorded it, of course, on the program and stuck with it as long as it lasted. For instance, my wife heard it on the radio for the first time, knowing it was going on. And others, of course, similar. People in the community, that's the way they found out about it. They found out right now because they all listened to KGHL. So here's a robbery going and they didn't know for sure who it was. They thought it might be a gang. There were so many shots fired, I guess the supposition was it was a gang. No one knew more than that, and they thought Earl Durand was still holed up in the mountains. Anyway, people panicked in the community because of hearing it and knowing it was going on. So a number of men got their guns and came down and hid out around the corner of the bank. That included Tipton Cox. There were two men got up on the roof of the bank. I remember that. They were all over the corner, assuming that there was a gang in there. They were gonna do their civic duty.

Inside, after he fired these shots through the windows, Earl got Maurice

Knutson the cashier and told him to open the safe. The safe was under time lock during the day. It was the normal procedure. Maurice said, "It won't open until three or three-thirty," or whenever. Earl told him he'd shoot him if he didn't open it. Maurice . . . I don't know exactly what he said, but he convinced him that it was under time lock and that he couldn't open it. Then Earl came up to the teller cages—we had two teller windows, I believe —and grabbed whatever money was in the teller cages. Currency. It wasn't a great deal. I don't remember how much. And put it in this sack of his.

Then he figured that was all the money he could get, so he tied several of us together: Maurice Knutson and myself and John Gawthrop, the young teller. I thought he tied us with leather thongs, which at the time I thought he'd stolen off the posse people up in the mountains that he'd killed. Anyway, he tied us up and began to march us out the door. Now, the front door, facing south, had a vestibule, double-glass doors. There were two doors on the outside and then a vestibule and then two on the inside. It was in March so the doors were closed. It wasn't very warm. He got us into the vestibule—the three of us tied together with himself—and was gonna shove us out the door and take us as hostages for getting away. That's when people had gathered all around the bank and started shooting. Local people. People up on the roof shot two holes in the cement sidewalk right in front of the bank. Sort of a panic type of thing, I guess. They weren't shooting at anybody because he never got out the front door. But others shot through the glass door, and they were shooting indiscriminately because there were four of us in there, three of us from the bank. Any one of us could have been hit, but Johnny Gawthrop's the one that got hit. In the vestibule. And no one ever knew or tried to find out who did it because it was just done in the situation where they thought they were shooting at a bunch of bank robbers. Johnny got hit and also Earl Durand got hit in the stomach. That's when the claim was made that Tipton Cox, who had holed up across the street in a service station, had been the one that shot him in the stomach. Maybe so.

So Earl was hit and went down on his hands and knees. He wasn't killed but he was hit. I'm not sure. You're standing there with bullets coming through the door. I didn't think very clearly, but I suppose both Maurice Knutson and I, who were there with him and did not get hit, were very close to where the bullets came in 'cause there were a number of holes in the door. Anyway, Earl got down on his hands and knees. He crawled back into the bank and dropped his rifle. And I picked up his rifle. I remember that. I tried to shoot him and at the same time, or probably sooner, he had pulled his revolver out and shot himself in the head, right inside the vestibule on the lobby floor.

He seemed cool and collected. He wasn't jumping around or anything. He seemed to know what he was doing, what he wanted to do. As to his motives, I've often speculated on that. He knew that everyone in the county would know he was in there. So he wasn't there just for money and a getaway, because obviously he'd shot out the windows and all these things with no thought of hiding in any way. So it seemed obvious that he was there more for the so-called glory or whatever. That's not a good word. It was a grandstand play. I guess he visioned himself as a desperado-type mountain man and wanted to go out with a big image.

He was a loner. He was antisocial. He was that sort of thing. He may have been polite. I don't remember him well previously, but I remember seeing him skating several times on the gravel pit down here. He stood out because he dressed differently than others. I don't recall his actual clothing, but he just didn't look the same as other people. He wanted to be different. It seemed he was creating an image. And he was always alone.

I don't know that he wanted to be an example for law and order. I wouldn't guess that. He wanted to be an example of a desperado, a Jesse James type or something, I think. But I'm speculating. I never could sort it out except feeling that he was just trying to make a spectacular exit. And, of course, why anyone would want to do that, I don't know the psychology of it.

We had reporters, even over in Europe. I don't know where the London paper is right now but it was in the London paper. All over the United States. They put Tipton Cox on a national television show. I've forgotten the name of the show, a talk show–type thing. I didn't see it. Various magazines printed articles about it. There were movies made. We got a lot of interviews, I guess. I don't remember all of them. For a while, my immediate reaction was I didn't want to think about it or hear about it. I don't have any nightmares about it or anything. I maybe did at that time, right away. I was very uptight about it, obviously, right afterwards.

There were people in Billings that wanted to erect a statue to Earl Durand somewhere to attract tourists. Then they coined the phrase "Tarzan of the Tetons." Well, of course, he was a long ways from the Tetons. I don't know who coined the phrase, but anyway, make a big thing out of it for the glamour of it, I guess you'd say. I was a little disgusted. To glamorize something like that. I think it's been glamorized in their minds as though this is a great big thing that created a lot of publicity. I would think maybe sometimes that overrides the feeling that he was a criminal that caused the death of five people and himself. Including him, it killed six people and surely it affected families and people involved. You bet.

There were apologists for him thinking that he was a special-type person and should be treated specially. There's still some people that are, I guess, apologists for him, that said he was mistreated by the law and they should have realized that he lived on elk and that they shouldn'ta put him in jail. Well, what the hell! [Laughs]

CODY
JAMES "TIP" COX
b. NOVEMBER 15, 1921, DODGE CITY, KANSAS

I created the humpy, the humpy dry fly. And that goes back. Them fish was takin' that humpy fly. Humpy, humpy, humpy. Everybody was trying for the humpy. That one winter our family tied ten thousand humpies. Well, jeeminy! We was selling humpies and the flies then was thirty-five cents and three for a dollar. And now the humpy is a dollar and a quarter, dollar and a half-one little humpy. Well now, Joe—one of the boys—a couple years ago he came up with a double humpy. He was just trying to figure out what in the hell to tie and all of a sudden he created this double humpy. Now with the single humpy we're getting fish like, eighteen inches, sixteen, fifteen, or like that, and it's been working good. But Joe came up with that double humpy. And them fish—and there's pictures to show ya—they're from eighteen to twenty-two inches. With a double humpy. It's a bigger fly. But it looks like a little field mouse on the water, floating around. And 'fore you know it there's a big ol' yellow belly underneath there, and he comes up and man! He hits that fly! He thinks it's a mouse. I know he does! And that fish will hit it. So that is the way it was. Our fly season hasn't started yet, but we got 'em all tied up. We're ready for the fly fishermen this year.

This Herbie Steingraver, he was a good person, a nice person. And the Steingraver family, Herb and Walt and their folks. But Herb, he was with the engineers all the time on the surveying outfit. And he drank a lot. Well, Saturday night you go to town and everybody drank, you might say. All that crew of forty men. Everybody drank. I was the kid of the outfit and I carried the whiskey all the time. Hell, I think I broke this damn finger carrying a jug of whiskey. Because they grabbed that jug and you had your finger wrapped in there. They tried to get that jug so damn fast, they got my finger and twisted the damn thing.

Herb couldn't go to work Monday. He was too sick. Somebody else was in there who was sick, too, in the bunkhouse. Anyway, I was on the job and all that. What happened, I was five minutes ahead of everybody. My job at five o'clock was to blow the siren—Whoooo!—up and down that dike [Jackson Lake Dam]. Then everybody would go to the Reclamation headquarters and go over to the shower room and get cleaned up, wash up, and get ready for dinner. Well, that gave me five minutes ahead of the gang. When I blew that siren I was always ahead of 'em.

Anyway, I bought me a pair of boots. At noon when I'd come in for lunch, I'd grab up them boots and I'd polish hell out of 'em, see? Then it was time to go back up and go to work. I'd put my boots back underneath the bunk like that. Ol' Herb and whoever, so-and-so, it was. I forget. So, anyway, we went to work and during the afternoon them bastards wasn't that sick. They went out to the cow barn and they got a gallon can, and got some of that old cow manure, running cow manure. Then they come back and they got my boots.

They just poured that old cow manure right down in each one of the boots. Then set it back in position like that, you know. So that was the way it was set up. Then at five o'clock here I am, I blew that siren, run down the hill, run in and grabbed my pants, my shirt, and my boots and I ran over to the shower. And hell, I had my shower and everything and I set down on the bench and got my pants on and the shirt on and, hell, here comes the gang. Here they come. About forty of 'em in there. And damn, you know, here I am, I swing around and grab one of my boots. Gosh damn, I start putting that bastard on, see? Anyway, I started putting that bastard on just like this and I pulled and pulled. I felt something and it was kind a funny. Anyway, I reached and got the other and pulled that on and stood up and walked around and I thought, "Geez, what in hell's wrong?" I sat back on a bench and I started taking that boot off, and gosh almighty then you run your hand right down into it. Why, hell, I come out with a goddamn armful of cow manure and my hands all full of cow manure. And man, I'm telling you that shower room exploded. Of course, the other boot was the same. Well, all I could do is, "You dirty bastards, I'll get even with you!" That's how you talked, too. See, I'm with a bunch of renegades, outlaws, and everything like that. It was quite a crew.

Then after that, they started calling me "Boots," "Boots," "Boots." Then it got all over the valley: the joke, the joke, the joke, the joke on the kid up at the Reclamation [camp]. And that name stayed with me. That crazy name stayed with me. Nobody knows me by Leonard R. or Raymond Allen. They don't know me. Nobody knows my real name like that. You know, that was a fun bunch.

Me, I'm just as common as any of the old boys are.

JACKSON
b. MAY 10, 1910, INDIANAPOLIS, INDIANA

HOUSEKEEPER

THEOLA ERVIN

See, all these was what they called the "red-light district." Those were the sporting houses. Those madams, I mean, they were sharp. They looked nice, their hair fixed and everything. All of 'em were straight down the street. Right straight down Front Street. These were ladies that run these houses, some of 'em was Belgian Jennie, and some of 'em was called One-Armed Martha, and then there was one named—what was that woman's name?—Butcher Knife Lill. They say she killed her husband or somebody in California. She come here. So they named her Butcher Knife Lill. That's what she went through all her life, was Butcher Knife Lill. Then there was Diamond Tooth Billie. Mary Casson and the Ruby Room. She's still living. She runs a motel now. I worked for 'em. I served drinks at night and then I'd go back and clean the girls' rooms during the day. I made more money in one week then, than I draw a check for the whole month on Social Security. I made real good money.

Mary Casson. She run the Midway Bar. Right up over the Midway Bar, that's it. She had one arm. She was a madam. And there was, they called her Lill and Humpy. This guy, he was real short and he had a hump in his back and they called him Humpy. That's the only name I ever knowed, was Lill . . . and Humpy. His wife's name was Lill and they called him Humpy. Now what his name was I don't know. He was a madam, too. [Laughs]

The black prostitutes came along later. Now back in the '40s there weren't too many. Mostly all were, like, Italian girls or—very few Jewish—but there was very few black girls. Now there was a black girl, what did they call her? Black Beauty. And she worked where the Townsend Club was at. Then there was a girl named China Doll. She was a real pretty black girl. But those girls, they didn't stay like these other girls. These other girls was established. They was here one year to the next. But these black girls, they was in and out, see? Black guys had nothing to do with 'em. [Laughs] They sure wouldn't. And they'd call 'em dirty names. [Laughs] Really. They made their money off the white guys. The black girls did.

And a lotta those businessmen, I won't call their names. They had regulars, uh-huh. And they paid big money. All the lawyers. A lot of 'em. I could name 'em but I won't call names. [Laughs] The attorneys and all of 'em. They were all in together, just like that. I used to serve a lot of 'em down there. I used to serve 'em drinks and they'd go with the girls, you know? But there's a lot of 'em right here in town right now. Oh, sure. I knew a lot of 'em. I knew a lot of 'em uptown here. [Laughs] Oh, gosh, yes. There was a lot of businessmen. They made their livin' off the railroaders and the ranchers, and, just like I say, the coal miners and the business-men. A lot of ranchers, uh-huh. And they were nice. They'd give you big tips. I mean, that's what we were lookin' for, you know, the tips. My mother, she did the cooking 'cause I never could cook. So she cooked in the evenings for different ones. Then I used to do those shirts for those pimps. And I think I got ten cents for each shirt.

Front Street, it's a ghost town. There's nothing down here. How many people's living down here on Front Street right now? There's Peter Johns and Rose Thompson. Only that's it. I mean the rest of those houses, they're all gone. No more, huh-uh. Right after they closed the houses down, then they started to operating in the trailers. North of town, and all over town, see?

We've lived here on Front Street all of our lives. The blacks. I mean, you couldn't rent a house across the tracks, you know. Like over here on the South Side. This wasn't no "South Side." I mean there just wasn't no houses over here, just a very, very few. They didn't cater to no blacks because, like I say, it was very prejudiced here. The Green Mill, he had a sign on that door that said, "No Niggers and no dogs." Okay? You know what broke that up? The troop trains came through here with a bunch of black soldiers. They went over there to be waited on, to get a drink. They seen that sign and they tore it off the door, and they went in and sat down. And they demanded to be waited on. That's what happened. You couldn't swim in the swimming pool. They wouldn't let my daughter swim.

It's different now. You can go anywhere and you can sit down beside 'em. And I tell you what else, too. You used to couldn't try on a . . . you know, like you go in to try a dress? We couldn't do that. Huh-uh. We could buy it, but we couldn't try it on. Uh-uh. See, that's different now. All that's different now.

I don't pay it no mind. I just pray for 'em. I pray for 'em, that's all.

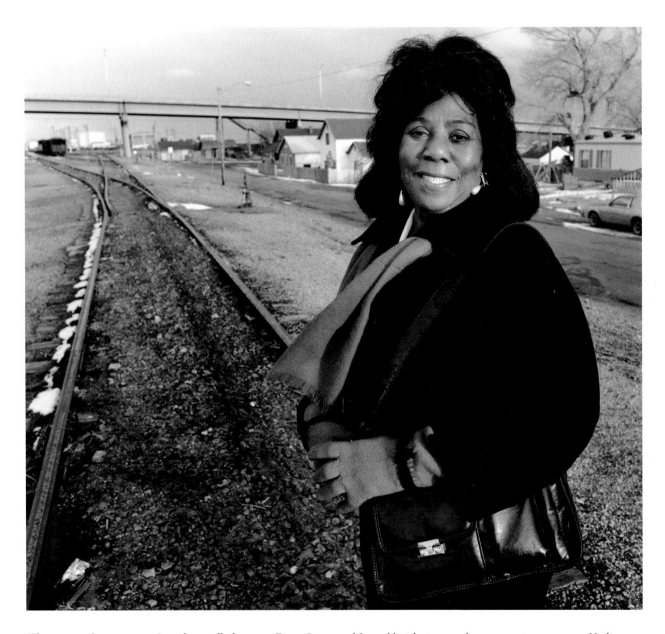

There was a lotta money. I used to walk down on Front Street and I would pick up enough money to pay my rent. Yeah, um-hmm. See, they'd get drunk and some of 'em'd get into fights and they'd lose their money, and I'd come along and find it. I used to get up early in the morning just to walk down the street and pick up all the money. My daughter picked up a purse. Her friend was a little white girl. And they went all through life together. This little girl, she seen this purse laying there and she kicked it. And my daughter, she kicked it. Well, they kicked it all the way up the tracks. Then, I don't know, one of 'em decided—I don't know if it was Emma Jean or Iris—decided to pick it up. When they looked inside it was $300. They didn't go to school that day. Come home. They showed me that money and I asked 'em where did they get it at. They said they found it. Well, you could see that it was layin' in the dirt and the mud. And we counted it up and there was $300, so we divided it. Right on Front Street. Everything happened, was over on Front Street.

RAWLINS
b. JULY 29, 1920, CHEYENNE

KIRK KNOX

TV & RADIO ANNOUNCER

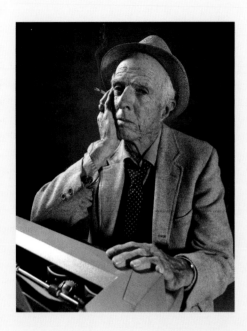

Honest to God, you'd die laughin'. She cries when I leave the car to go in the Safeway store or the newspaper. I had a third of a pound of bacon I had taken over to a friend's house last Sunday and I left it under the seat of the car. I said, "She'll never get that out from under there." Ha-ha! She got it. She ate it all. So a friend says, "Oh, it'll make her sick." I said, "I hope it does make her sick, the rotten devil." [In a whisper] It didn't make her sick. She was fine. Rugged dog. I'm big on dogs, as you know. The more I see of people, excluding a rare one, the more I like dogs.

CHEYENNE
b. EXIRA, IOWA

I came to Cheyenne by sheer accident. I stayed here by sheer accident. I don't hate Cheyenne. It has never struck me as the place where I should be. I see myself sort of as an exile here. If I had an impetus to be someplace, I'd probably be there. Unfortunately, as I said to Pete Maxfield at lunch today, all the people who are of any consequence in my life are here in Cheyenne.

I did the first newscast on Channel 5. That was the first time I sat down in front of a camera, and the red light came on and I went. I did it for four years after that, almost every night, seven nights a week. Anchor and everybody. I was it. That was it. I wrote the news and I did it, 1953 to 1957.

Makeup? What's that? [Laughs] You gotta be jokin'. I just walked in there and sat down and did it. You mean, stuff on your face? Oh no, no, no, no, no, no. This was raw television.

I was kind of a paid guest on Cheyenne Today on KFBC for years with [Larry] Birleffi. And Birleffi and I played off each other well, if I do say so. The only time in all the time I've had anything to do with all the parts of the media, he said somethin' one day that I thought was so absolutely stupid, I said, "Larry, you're crazy as hell!" I forgot that we were also live and direct. Well, you know, it passed by. Nobody cared. They use words on radio now that would have got KOLT, KOA, or any other unmentionable radio station in the U.S. of A. kicked off the air when I first began with radio.

I have done everything. I interviewed Robert Taylor in the old Mayflower when it was the class place in Cheyenne—him and his wife, Ursula Thiess, who he had just gotten married to and was honeymoonin' in northern Wyoming. Barbara Stanwyck, by sheer accident, on a Twentieth Century lot in Hollywood. I guess it's because I reached

for it. It's because these things are the chocolate cream pie that makes up for the horrible boredom of being at a city council meeting which has become worse, worse, and worse. It's a debating society with little logic or sense. Not too many perceptive people on it and that's to use a kind word. Worse yet, their council committee meetings and any public hearing on any subject whatsoever is an abomination to civilization and mentality and anything else . . . boring to the core.

It would probably be, absolutely be, idiotic to do a major critique of Frontier Days, which I think is something which should be done. And I think people oughta be broad-minded enough to let you do that. God knows, they've been broad-minded enough to let me do everything else. I was raisin' hell about Vietnam when it was unpopular to do so. Nobody ever said a word to me about that. However, you know, the sacred cow is Frontier Days. I mean nothin' eclipses that, does it?

I think it's kind of a pain in the fanny, myself. I think it's clichéd. I don't think it's good for the animals. I think it's redneck. I think it's unintelligent. And ever since they brought rock people at night . . . I mean, who'd want rock? I wouldn't demean music by putting the word "music" behind rock. It ain't music. They used to have arrangers and people who could play things. These people were nothin'. That includes the Beatles. They're nothin'. They're all nothin'. Bunch of bums [Laughs] . . . appealing to another bunch of bums.

I don't mean to be obstreperous. I am not one of these "theory" people. I write and anybody can take that however it slices. I write for me. I wouldn't change it to write more understandably. I'm always sayin', "If they don't understand it, let 'em get smarter."

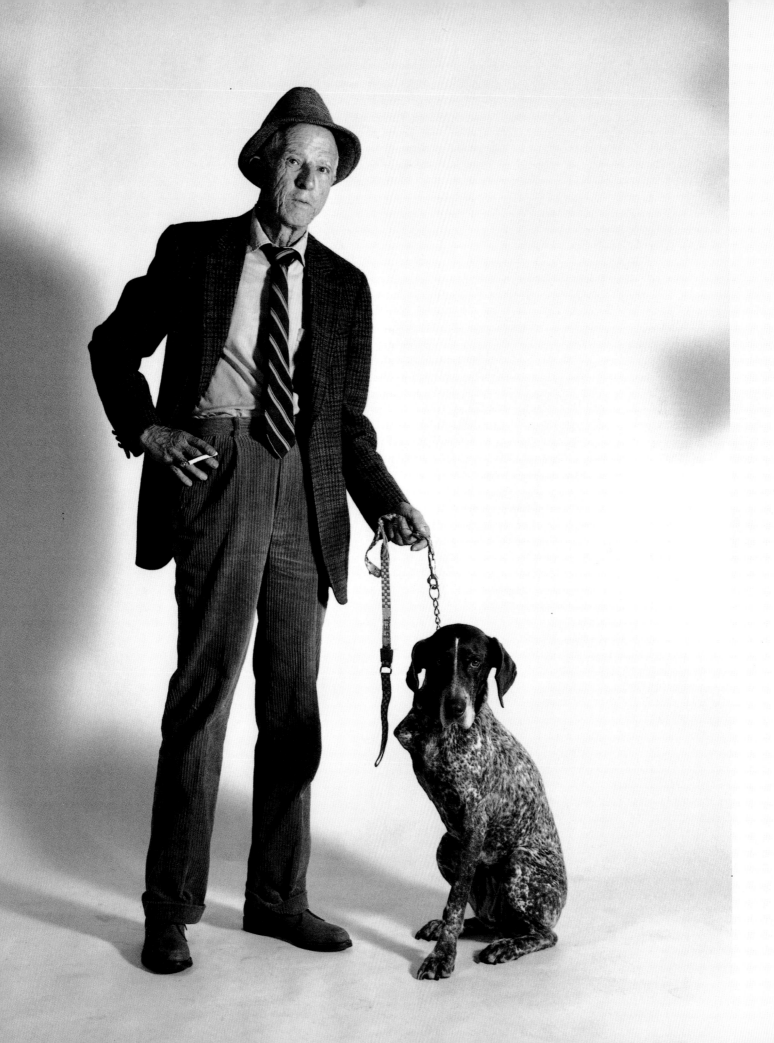

Beebe reminisces about an incident on July 20, 1889, in which James Averell and Ella "Cattle Kate" Watson were hanged near the Sweetwater River by cattlemen. The cattlemen claimed the two were rustlers and that Watson accepted cattle in return for sexual favors.

Now this is the story that I was told. My mother told me and I suppose my father told her. They were all on the roundup over on what they call Dry Creek and they saw these six people ride off that afternoon. They didn't think very much about it. Their ride was over for the day. The next morning they were on their horses ready to make their run. Ella Watson was raising a little boy. What was his name? I can't think what his name was. But he ran into camp that morning and named every one of those men out. He said, "They came down yesterday and hung Jim and Ella." And Dad didn't believe it. Mr. Bothwell was sitting on his horse right beside Dad, and Dad turned around to him and he said, "Why, you didn't hang 'em, did you, Bothwell?" He said he never answered him and he just looked at the ground. He [Dad] said he found out he'd better be listening instead of talking.

I think they were hung on either July the 20th or August the 20th in 1889. They say there were only two women in the West that were hung. And that seems to be the thing that they emphasize, is the hanging of this woman. I think there'd been lots of men strung up, you know. You take, all over the West, I mean. I know they had been hung, but very few women.

Through my mother—as I say, I never heard my father mention it—he [Dad] said he was one of the people that was chosen to evaluate her property. He said, in the pasture there was about twenty scrawny little calves following one old cow, was all the livestock they could ever find around there. And they were sure that cowboys had just gathered some unbranded calf up and had taken it to her.

Well, I don't think they were so irked over that, as these articles that Averell was publishing in all the papers about trying to keep people from taking up homesteads. The Casper paper and the Rawlins paper. You see, that Homestead Act had just been enacted, well, I think it was in 1865. And people were just beginning to come from the East and taking homesteads up. You could only take 160 acres at that time, but if enough of them came the cattle people were afraid they were going to spoil their range, you know.

Then DuPont . . . there's a spring that he got soda. It was a promotional thing altogether. But they called it Johnstown. They had a newspaper. They had a brick schoolhouse and, oh, they had quite a settlement down below Independence Rock at that time. I think that he [Averell] wrote to that paper. Of course, don't think it went too far. It was just a little paper. But then he was writing in it and everything, how the cattlemen were trying to restrict people from these homesteads. And that was what bothered them.

They told 'em [Averell and Watson] to leave the country. They would let 'em loose if they would leave the country. Then they threatened to drown them in the Sweetwater River. And Ella Watson was supposed to have told 'em that there wasn't enough water in the Sweetwater to give a hog a good bath. They couldn't drown them there. They hung them, I think, over at a little place, it's called Spring Creek, that comes out down beyond Independence Rock there. She was very, very defiant with them. Then finally she saw that they intended to, that they had gotten worked up to the point that they were going to do it, and she asked 'em if she couldn't go in the house and take a bath and put fresh clothes on. And one of them told her, where she was going she wouldn't need fresh clothes. Now whether those statements are true or just go with the times, I don't know. You know, I never mentioned it in those books.* It was never mentioned because I went down to Suns and told them that I was going to write a book, try to write a history of the Sweetwater Valley and its occupants, and how they came there and different things that happened. Oh, they just jumped on me and they said, "You can't write a book!" I taught school for thirty years, but they said, "You can't write a book. No, that's impossible." And just shoved me off. I went home and I said to my sister, "Why don't they think I can write a history of it?" She said, "Because they think that you're going to expose that Cattle Kate thing again." So I went back down and told them that I didn't intend to mention Cattle Kate, that I was gonna leave that part out. And they went to their museums, they got papers out, they got history of different things out that the first Mr. Sun had compiled, and they helped an awful lot with my book.

They think that that is the only thing to do, is to let it die. But it's not going to die because it's history. History doesn't die. I think it will grow bigger and bigger, It has grown bigger. They [Suns] were the only family. All of the rest of 'em sold their property and left. They stayed and prospered and done well, so I said I thought the Lord must have forgiven 'em, taken care of them, because they had prospered as the years go through. But they always had these things slap them in the face.

* Ruth Beebe, *Reminiscing Along the Sweetwater* (Boulder, Colo.: Johnson Publishing, 1973); Ruth Beebe, *Skeletons from the Past* (Boulder, Colo.: Johnson Publishing, 1980)

Jim Averell, he had that clock. He brought the clock with his bride when they were married. It's been right on the Bar V Ranch, or this ranch, for 104 years. It has kind of the spirit of the West in it.

MUDDY GAP
b. SEPTEMBER 12, 1895, BAR V RANCH

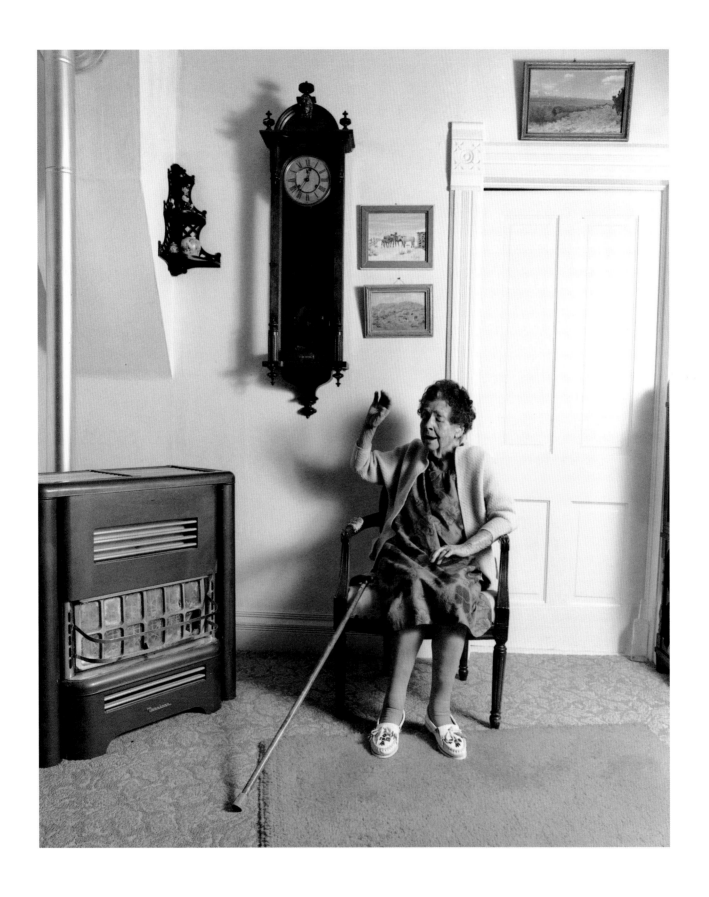

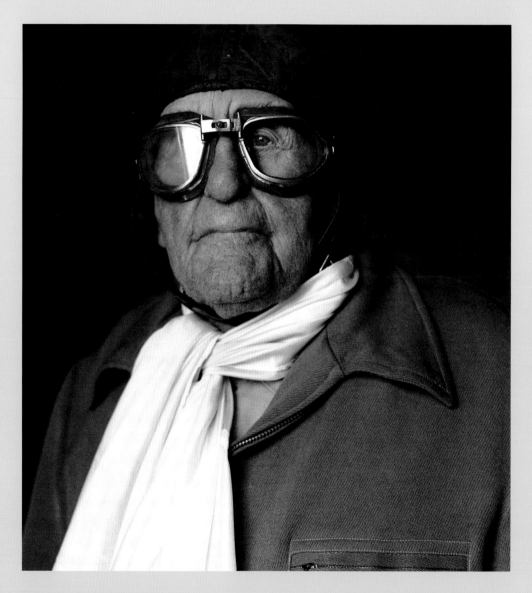

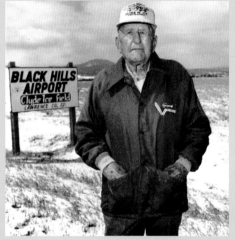

PINEDALE
b. MAY 28, 1889,
HAND COUNTY, SOUTH DAKOTA

Everybody had a milk cow or two. They had to 'cause you didn't run to Safeway with two twenty-dollar bills and come out with a pocketful of groceries in those days. Well, they took cattle in from the whole area around there. My mother and my dad, and me when I got big enough, would herd those cattle. We done that for the first several years for a dollar a head for the whole summer. Drive 'em over there to water once a day, then spread 'em out over the prairie. One year—I remember that very well, I was about nine or ten years old by then—they had five hundred head of cattle there to herd. No fence, no pasture. You had to herd 'em. I used to lay out there watching 'em. We'd have a saddle horse and go out there, and if they got too far we'd kinda keep 'em rounded up, you know. I used to watch the cranes flying. I remember I used to wish the cows had wings so they'd be big enough to ride on. It was my first thought of flying.

In 1918, when the guys come back from the war, the old guys, the old pilots were starting out barnstorming, running around taking people for rides. Well, I was the first one over there when he landed out in that pasture. This was at Miller, St. Lawrence, right in Hand County. So I got a couple of rides with him and I liked it, and I went along selling tickets. I was in the automobile business at that time and I heard about an airplane that a guy in North Dakota had won selling subscriptions for the St. Paul paper. At that time they had built so many Jennies and Standards, you know. Did you ever see a Jennie? Well, they were wood and covered with cloth. That Standard was upside down in a pasture in North Dakota. They just flew it up there and set it down in his pasture, and he didn't know enough to tie it down. He didn't know anything about airplanes. He'd never had a ride in one. I've never been able to figure how he could win selling subscriptions up there in that scattered country where he lived.

I was selling cars at that time, had several used cars. I went up there and told him I'd trade him two automobiles for it, used ones. They were worth about $700 apiece. Of course, he didn't know a thing about the airplane. It was laying out there upside down, so sure, he'd be tickled to death to do that. So that's the way I got started.

I got this guy that I'd been selling tickets for to come up and fly it back to Hand County. He didn't want me to get started, see, because I'd been selling tickets for him and keeping him in the air pret' near every afternoon at $5 a passenger, $10 for three or four minutes around this stubble field. I couldn't see any sense in giving him all that money, but I didn't really have any idea of starting to fly without any help. Well, that evening he got in his and started to come back to where we wanted my airplane. He put two guys in there [my plane], two great big guys. I was in a stubble field—soft, you know, been plowed—and I taxied around. He told me to go ahead and take 'em to this other town. He said, "Go ahead and take 'em off" right in front of them! I got him off to the side and I says, "My God, you know I never flew an airplane. How do you expect me to take 'em?" He said, "Well, if you don't need the money, leave 'em set there." So he

got in his airplane. He had a bigger motor and he took smaller guys. He took the little ones 'cause he knew I couldn't get speed enough to even get the tail up in that stubble field.

Well, I run down through there till I see the fence coming and I shut the motor off and turned around. I thought, "I'll try it again." I got a little too close to the fence and I turned a little sharp and rolled one tire off. We had motorcycle wheels on 'em in those days. You had to pry 'em on with a little iron. Well, I brought 'em back and I said, "I can't get off with that tire off." I didn't want to get off, anyways. So they kinda almost called me nasty names 'cause it was too late for them to get to that ball game by car. I'd been working day and night, so I just crawled under the wing and went to sleep. A nice afternoon.

He [the barnstormer] got back there and he was mad because I hadn't fixed it. It was on Sunday and the service stations were all closed. Course, I tore the tube up when the tire rolled off. So we went uptown, found a tube for a Model T Ford. It was too big but we folded it up and got it in there, and pumped the tire up and he took off.

Well, I thought I'd taxi around. I knew how to start the motor and all. You had to pull the prop. I thought I'd taxi around a little and learn how to taxi on the ground, anyway. The air got better and I was empty. And the first thing I knew, I looked out and I was about ten feet off the ground. So I thought, "Well, I might as well go on to Miller."

We were landing in a big field there, half-mile square, and I figured I could get it down some way. But we had a headwind. It was beginning to get dark. I was about halfway. I didn't want to try to go in there after dark because I remembered that they'd made hay and stacked the alfalfa all over this field. It was getting dark, and that green hay on a green field . . . I knew I couldn't see 'em. I'd plowed this field that I was thinking about. It was a half-mile across and a mile long. Half of it was wheat and the other half corn. So I thought, "Well, I'll get down just as low as I can over that corn." 'Cause it's green, see? And the stubble field would be yellow where they'd cut the wheat. So I just slid over the cornfield and eased the

motor back, and it settled and we was running on the ground. I didn't come down like you're supposed to. But it worked. The wind was blowin', and I tied it down.

The wind was blowing the next morning and I got him to come out and bring it in. We decided till I learned to fly, he'd take one trip in his and the next trip in mine. And me selling tickets. Then we split whatever we took. Well, he took a couple out. We was setting there right on the edge of town and he wanted coffee. He was a coffee-hound. He had to coffee about ever' so often, and he jumped in the car and went uptown. The people had all left, there wasn't anybody around there, and I was just standing around. A little guy came up, wanted to know if we was taking people up, and I said, "Sure, we are." Because it was my airplane's turn, and I figured he'd be back. Well, I got this guy rigged up with goggles and helmet and got him in the seat, killing time till this guy would be there. Well, he didn't come and he didn't come, and I finally thought, "Well, it worked when I came in here. Why can't I make it do it again?" So I went back there and told him not to touch that little lever, or little gas set along the side with a little knob on top. I went around and got the motor started, sneaked in there and got the blocks out, and went around, and got in and took off. I gave him a nice, ten-minute ride. The railroad was right alongside. They used to have telegraph wires along the side, you know . . . come back over the telegraph, eased the motor back, and just held it there. It just settled and I was running in that alfalfa stubble.

I seen that guy, oh, it musta been ten years later. He asked me if I remember taking a little guy for a ride up there on an alfalfa field by Miller. I said, "I sure do." "Well," he said, "I was that guy." I said, "I thought you were." But I didn't tell him that I hadn't ever taken anybody up. I've always wished I had of told him that he was my first passenger and I'd never had any instruction. But it works! You could do it right now with any of these airplanes.

JOSEPH "PETE" KRISTY

Well, the best thing that happened to me in life was when this Depression come on. We would work one day a week in the coal mine and then you would be, I think, subsidized. I forget now if it was seven or eight dollars a week. You got extra on that. You could go down and buy groceries, two of these bags—as much as you could stuff in them—for two dollars. Then you could go fishing for the rest of the week, and then get ready to come back Monday and go to work for one more day. That was my best days. Everybody was griping about the Depression. I thought I was getting along fine. The wife and I would go out to the mountains and fish. But, two big bags of groceries! Today I don't think you could get by with forty bucks.

SHERIDAN
b. FEBRUARY 6, 1909, DIETZ

My dad was a coal miner. He come to Dietz, I think it was, about 1906. He come from New York. He come from Poland. My mother used to say, boy, was she ever crazy for moving out here in this wild country! More money, making bigger wages, you know.

In my dad's day it was all hand-loadin'. They loaded by the shovel, shoveled it on. Yeah, they'd come home. Gee whiz, he'd be just black as the ace of spades. Just the eyeballs. Yep. Dirt, sweat, you know, that coal dust. They used carbide lamps then. But prior to that they had these oil lamps. He got banged up, head cut open. Course they didn't have the hard hats in them days. All they had was a piece of canvas and piece of tin over here where they hung the lamps on. And a lot of 'em wouldn't wear their lamps. They'd just set it out on the side in the wall of coal to give 'em light. But that was tough work, heavy work, handwork. Everything hand.

There was all kinds of people in Dietz. There was people of all kinds in there, all nationalities. And seemed like they get along pretty good. You'd be surprised. There was Swedes in there, there was Englishmen in there, there was Scotchmen in there, and the Poles, Yugoslavians, and you name it, it was there. There wasn't too many Greeks. I don't know. I think the Greeks, they had a little different idea. They were more business, you know. They had it up here, where the old coal miners had it here in the arms. Lot of 'em would talk good English. Some of 'em would talk broken. Then you take the Poles and the Yugoslavs and the Russians, they pretty well understood it. The Czechs, they used to call 'em Bohemian, but it's Czechs now. I could talk Czech just as good as Polish at that time. And even Mexican. You're going to school and the Mexicans worked on the railroad. This boy, he'd tell you what this is in Mexican—you know, a

dish or a cup or shovel. Then we'd tell him in Polish. But he was learning Polish. We was learning Mexican. Then after they finally left, well, you forget it all.

When I went to school I was registered as Krzyston, but then in the coal offices these officers, bookkeepers, and so on, they cut a lot of these names down. They figured, "Oh well, shorter and easier to take care of." I was underground. Mechanic, motorman, boss. When I first started, I was trapping. Trapper and then nipper and so on, on down the line. I didn't work at the face. They wanted these guys here that'd get up and go, you know. When you wear out a pair of shoes, leather shoes, in two weeks, well, you know you're not standing around.

All that coal is so dry and dusty. Jeeminy, criminy. Everybody thinks coal is black. But you grind coal up, it's brown. Yeah, you'd have to soak up good. Then we always had them washcloths to really rub it. Gets in your pores. Or, if you got a cut on your hand or get popped from coal on your face, and you didn't know it, and you're in that coal dust, it would get under your skin and you'd have a black mark there. It took years to get it out of your lungs, too, for a long time. You'd spit it out for years after. I'd have guys—once when I was running the motor—that come in on the mantrip. And one guy just got off of the thing there, and he stood around and he looked around and boy, he was scared. He was really scared in there. I kinda felt sorry for him. He come up to me, says, "Hey," he said, "when is the next train goin' out?" I said, "What do you mean?" "Oh," he said, "I wanta get outta here, quicker the better. I'm getting outta here. I'm not stayin' in here." I said, "Well, after this trip is loaded get over here, get on top of the motor and lay down, and it'll take you out if you want to go out." So he did. He never come back.

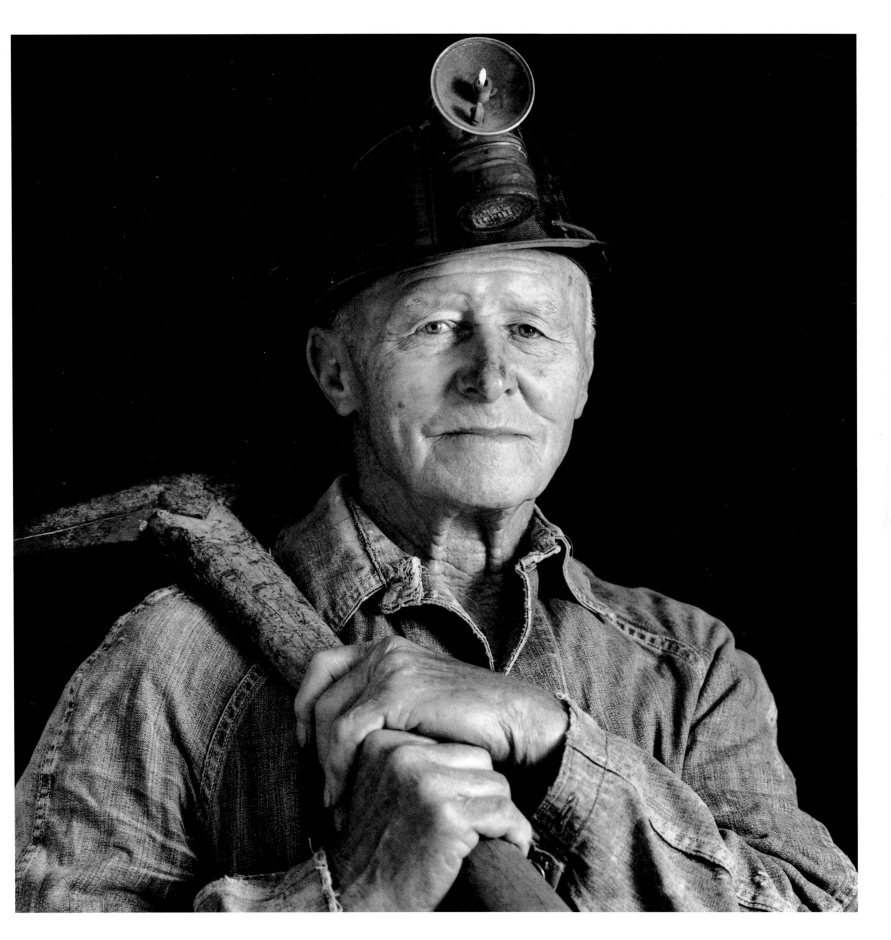

ROYAL TOPHIA

CEMENT FINISHER, SINGER

Now that group, Louisiana Blue Wings, it was from Chicago. I went all over with them. But then I'm getting pretty old, getting forgetful about things too, you know. When you get seventy-nine years old, soon to be eighty, you can't remember a lotta that stuff.

Just regular groups. Social thing. And mainly they liked music, you know. We studied mostly all the chords and put 'em into songs, mostly spiritual songs. We was always together singing someplace during those days, yeah. We had different jobs. Some was carpenters, manual laborers, cement finishers.

When we'd get off from work, we always was together, probably, doing somethin'. Wonderful groups. We thought we'd go the right way. Have picnics. We'd have barbecues and whatnot. My old dad, he used to play the piano, and my uncle would play the guitar and violin. We'd get out on the porch, bring the piano out, and we'd have a barbecue and all the neighbors. I came up in a mixed neighborhood all my life and we never had any problem. But then, if one had a porch to build we'd build it, and if they had a boat to build . . . My daddy was a boatman. We'd get in a ship and run to another. We came up that way.

In New Orleans, for instance, and also California, we had stations. WWL and several others that we used to sing every weekend, live. You'd record songs there with them and then they'd have the other songs recorded, too. The Louisiana Blue Wings. The Robinson Humming Birds was another one. They used to sing every week on a Wednesday and also on a Sunday

morning. We'd have, oh, about five or six different groups there to sing. They had fifteen minutes or half an hour on radio. During that time you had about fifteen different groups, too. You had women's groups and all. Wasn't no money involved. You'd go from one church to another or one city to another. They'd have big rallies and things like that. We'd meet bands there. Whatever city you'd go in you would always meet different groups there. Sometimes you'd have something like a contest. You'd sing one song, they would sing one. One group would try to outdo the other. It all started back in olden time with that "do re mi fa so la ti do" music. You make your own harmony. It was the thirties and forties, about the forties.

One that just died was in the family: Mama Emma from New Orleans. She played in the Dixieland Band. I have records of her in there. Mama Emma, she was paralyzed and played with one hand, still playing in the band. No, I never sang with her. But Mama Emma, she was recognized as one of the oldest Dixieland bands they had in New Orleans, Louisiana.

You got a lot of enjoyment out of that. I talked to one of the radio announcers here and I asked him, I said, "Would you like to play some of our old Mama Emma's songs and some of those spirituals that we used to sing?" He said, "Oh, boy, my boss would fire me!" He seemed to like it, too, I'd say. But I tell ya who did want to play some of 'em: old Butch Hudson at the mortuary, at the undertaker parlor. He told me he'd play one or two of 'em. I never pushed him to it, no.

You take like, Louis Armstrong, they had a band. They'd go behind when someone would die? Yeah, funerals. They'd go marching right behind 'em and boy, they'd be playing "Nearer, Oh My God to Thee" and all that. And when they leave the graveyard the first thing they sing, "Didn't He Ramble?" and "The Preacher Cut Him Down." Boy, and everybody'd start to play blues and singing and havin' a good time. I'd be marching in the band with 'em. Things like that. New Orleans, Louisiana. And Fats Domino. Well, during that time he used to go in a little place they call—right out of New Orleans—Shrewsbury, places like that. We'd just have bands like they have here. Every weekend they'd have probably a pick-up band and Fats Domino, same ol' Fats Domino. Hasn't changed his music a bit during those times. Different ones would sing and have fun with him. Yeah, knew all those. Let's see, was it Preston? And several others. They were singing with Louis Armstrong. It was 19— . . . it was about, oh, around '25, something like that. Same thing like we do with the quartets. They'd all get together and have a concert, and one would be playing against the other, and then they'd vote on who was the best band or who was the best this and that. You had music all around you during those days. Every weekend you had a big outing someplace. That was a wonderful life during those days.

I was a hard worker, worked hard all my life. Kinda makes you think about the things you used to do and you can't do. Well, you can't do 'em all your life, anyway. You're lucky to be around.

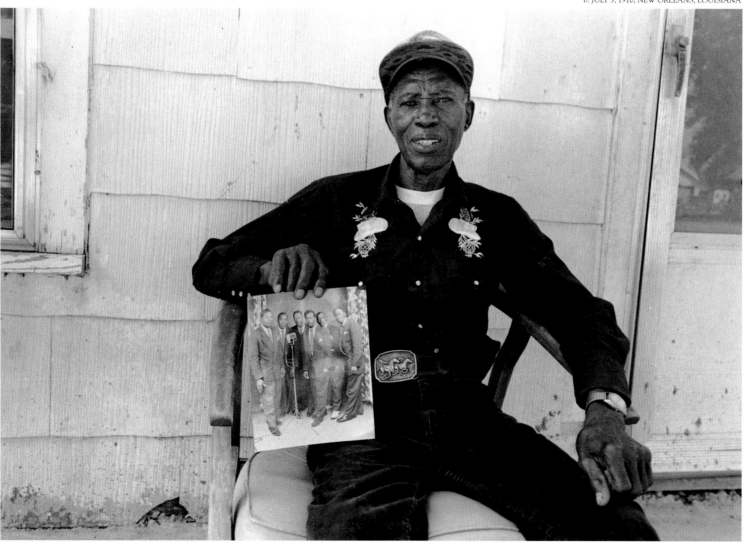

When I came [to Lander] I think there was only two. I used to kid the guys all the time about being fifty percent of the black population because there was only two of us here then: Walker Mann and Roy Tophia.

LANDER
b. JULY 3, 1910, NEW ORLEANS, LOUISIANA

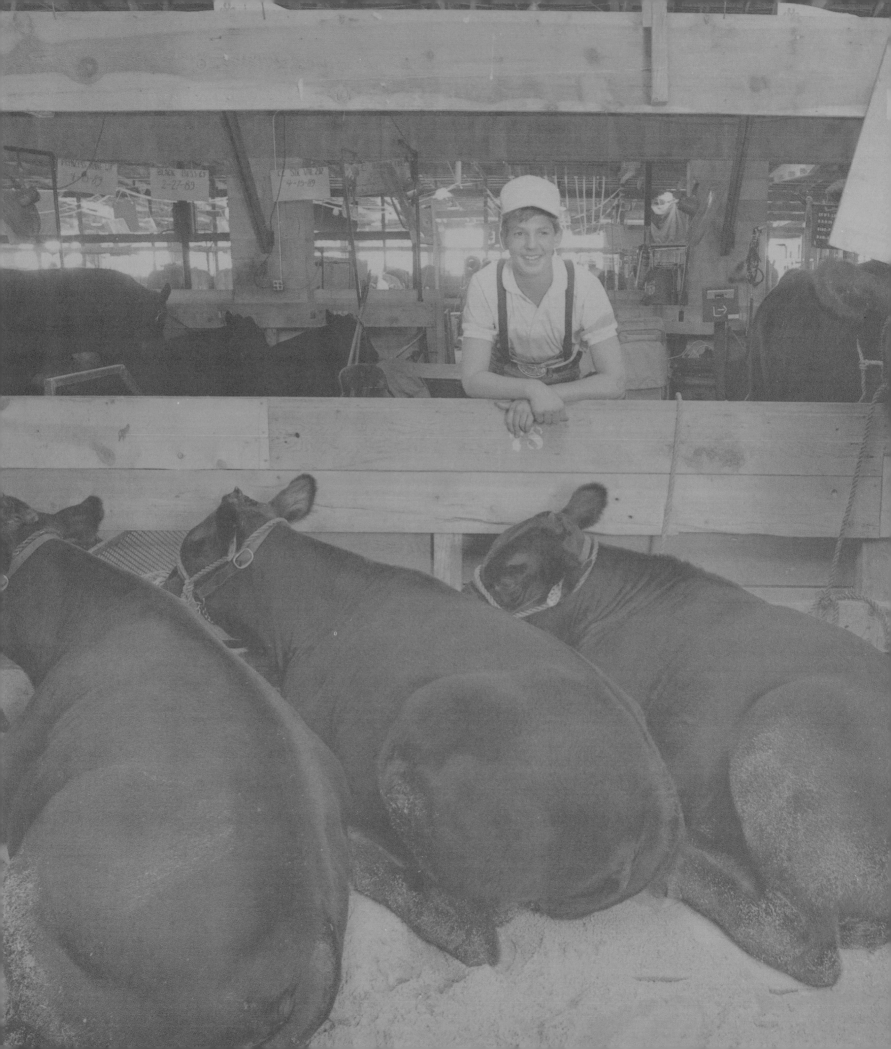

You always get those moments when you're thinking, "What am I gonna do when I'm so and so?" I said this one time. My dad asked me what I wanted to be when I grow up. I said, "Well, I think first I'll be a man." That's probably what you have to do at least one time in your life.

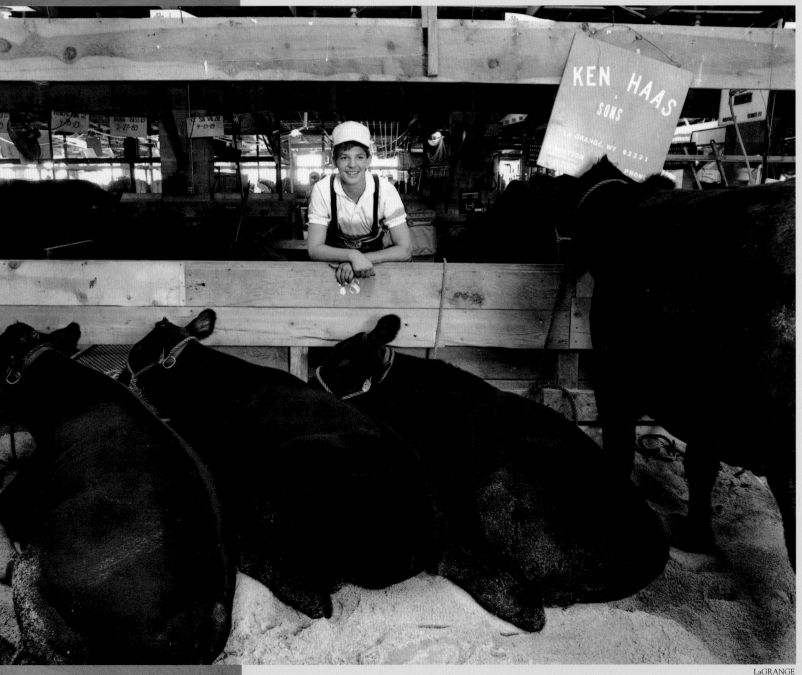

LaGRANGE
KEVIN HAAS
WYOMING STATE FAIR PARTICIPANT
b. JANUARY 18, 1977, TORRINGTON

BRIDGEFORTH & ROCKWOOD

PLAYMATES

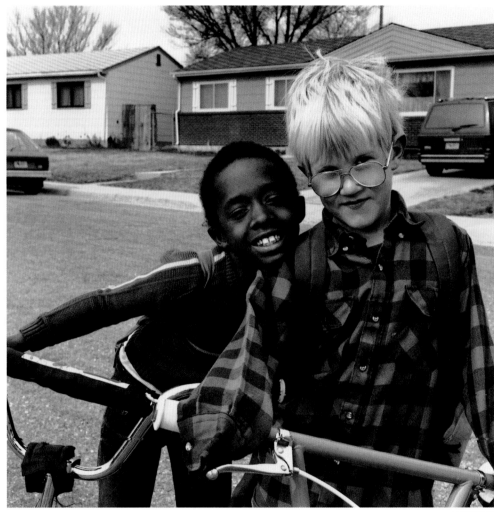

CHEYENNE

left: BRIAN BRIDGEFORTH:
b. DECEMBER 4, 1979
WARREN AIR FORCE BASE, CHEYENNE

right: BRIAN ROCKWOOD:
b. SEPTEMBER 9, 1981
CUMBERLAND, MARYLAND

Has anybody ever said to you, "Gosh, you guys are so different"? I mean, your hair is completely white. Brian, yours is completely black.

BRIAN B.: No.

BRIAN R.: But if they saw you, they'd say your hair's completely sticking up.

So color does not make any difference with you two guys, as friends?

BRIAN R.: Hh-uh.

BRIAN B.: No.

Do you ever think about it?

BRIAN B.: Hh-uh. We never thought about it.

BRIAN R.: I've never thought about it until now.

BRIAN B.: Me neither.

You're kidding.

BRIAN R.: Hh-uh. Never even noticed his color.

Do you think that's good?

BRIAN R.: Yes.

KEN FELLON
TEENAGER

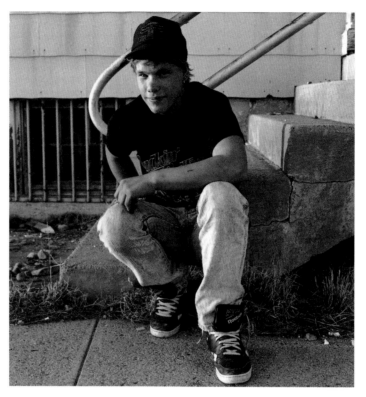

This town is more devoted to oil field.
That's all it is and we need a boom really bad.

MIDWEST
b. NOVEMBER 27, 1973, CASPER

Darrington. One hundred miles kinda northeast of Seattle, up in the sticks. Rains a lot. Logging town. Lotta drunks. It was okay. I like Wyoming better. I don't have to put up with the rain. Just something about Wyoming. I was always getting in trouble with my dad 'cause I'd go to school and talk about Wyoming. He'd say, "Aw, you don't need to be worrying about Wyoming. You need to worry about now, where you're at now." Always told him, "Yeah, I'm gonna end up back in Wyoming." That's where I'm at. It's probably where I'm gonna stay.

Me, I'll probably go over and see my girlfriend. Everybody else looks for the parties. Don't have to look too hard. Cops seem to find 'em, too. Can't go in the bar. But you can go out and party with friends. Cops just come out and make you dump it out, go home. Cops don't like me. I went out with one of his—the cop's—daughters,

so ever since then, they don't really kinda like me. He don't like nobody being around his daughter. And I used to cause a lot of trouble. My dad, he gave me a good rap around here, too. He beat up a cop. They considered him the hell-raiser of town, you know. Badass. Big head honcho. Big stud.

I could be on the honor roll. It's just that I don't wanna be. I just wanta be different, express myself the way I wanta be. Just like to wear 'em [earrings]. Be my own person. A few call me a faggot. I go, "Yeah, I must be, huh?" I don't like fighting, so whatever they wanta think. They can think whatever, so long as I know the truth. I quit fighting. Strainness on the body. Don't need them battle wounds.

I don't know much about this town. Just like to party and work in the patch. I'm trying to settle down. Gotta grow up sometime.

DRANEY FAMILY

DAIRY FARMERS

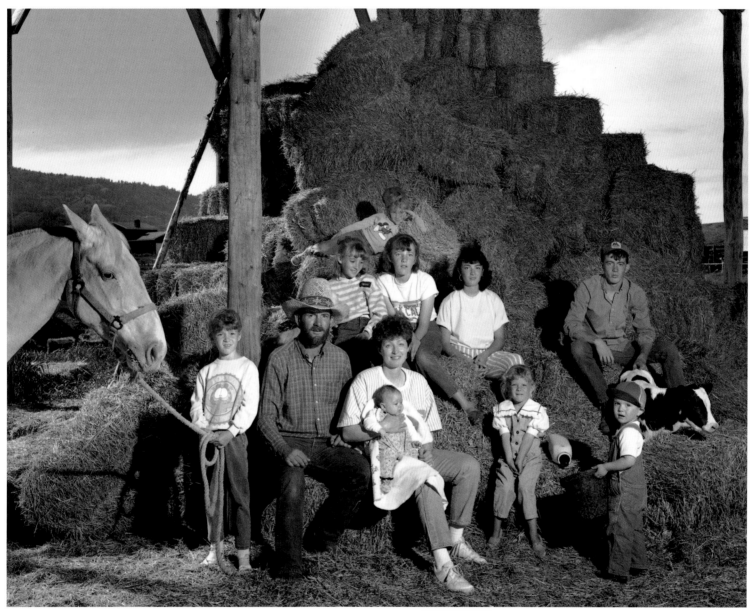

WEST OF AUBURN

parents: GREGG: b. NOVEMBER 28, 1949, AFTON
LENNA: b. SEPTEMBER 17, 1952, AFTON

top row:
MAGEN: b. JANUARY 28, 1984, AFTON

middle row:
JONI: b. JANUARY 26, 1980, AFTON
MINDE: b. JUNE 6, 1978, AFTON
TAYA: b. MAY 19, 1976, RICHLAND, WASHINGTON
TY: b. MAY 14, 1974, LOGAN, UTAH

bottom row:
TAWNA: b. OCTOBER 24, 1981, AFTON
SAGE: b. APRIL 25, 1990, AFTON
CALLY: b. OCTOBER 13, 1985, AFTON
TENNYSON: b. APRIL 8, 1988, AFTON

GREGG: *I'm sure we have problems, but as far as I'm concerned, it's a perfect Mormon family, too. I don't mean to sound egotistical in saying that. I'm just saying that this is exactly what I want my family to be. You know, that's why I moved here. That's why I take my kids to church. That's why I do all these things that I do. That's why I get up at five o'clock in the morning and go milk and all these things that I do—because of my family. There are places where I can make a lot more money. There are places where I could work a lot less hours, where I could have leisure time and extra money. I came here to raise my family. That's the reason I'm here. Call us lucky, call us blessed, whatever you want, but as far as I'm concerned we're right where we want to be in terms of location, in terms of development of my family, in terms of the things that they are involved in doing, and our relationship. So any expectations that exist from other people don't bother me at all. We run our own life, basically, I guess is what I'm saying. But we're where we want to be. We're doing what we want to do.*

GREGG: My grandfather grew up in Plain City, Utah. Samuel Ebenezer Draney. He came to this country and homesteaded this area here, along with six or seven brothers. His first wife had seven children, and then she died in the flu epidemic. Then he married my grandmother, who was a girl working for him at the time, helping him raise those small children. And she had sixteen children.

Dad's still alive. We're partners on the farm. He's seventy-one now and he doesn't work like, probably, he used to, but I can't keep up with him and I'm a lot younger. His early life was all spent with horses. Until probably in the forties they farmed with horses, and he's still a pretty good horseman. We still use horses, at least for feeding in the winter. When it's forty-five below here in the winter, my horses will always start. I don't have to worry about my diesel

jelling, or freezing gas lines, or anything. I just hook up the horses and feed and that's all I have to do. On a good year you're talking three and four feet of snow here.

They had a rough time. They grew up in a little house. There was never any money to speak of. Up here to the south of us is an old salt flat. Can't see it from here over the mountain but we could take you up there. Very interesting historical place. They would spend any time they had hauling aspen wood down by the cord—hundreds of cords of aspen wood—boiling the saltwater and making salt to sell the sheepmen or the cattlemen. That was cash. They might make forty, fifty cents a day. I know one of the stories I was told as I was growing up, about their family, was that when the twins died, there wasn't money in the house to buy a coffin, to buy clothes to wrap them in. It was a matter of getting the timber out and building the coffins and burying their children. It was hard growing up. I think it was probably a lot harder for the girls than the boys. You may have noticed as you come up the road a little ol' log building down here. That was a schoolhouse. They rode their horses every day to school, or they would get up early enough to walk up here on the hill and ride down on their sleigh. If it was crusty they could ride to school on the sleigh by walking a mile and getting up on the hill, and then ride clear to the steps of the school.

LENNA: I come from a family of fourteen, and in my dad's family there's eleven and in my mother's family there's eleven. I was a Call.

GREGG: I married a Call girl.

LENNA: We have a reunion every two years. We all come and stay over at the ranch and just have a good time, plan a lot of activities. My mother . . . our last baby . . . well, I guess it was her ninety-second grandchild.

GREGG: I think I said something to the effect that it runs in the genes. My father had twelve children. His father had twenty-three children. So large families, it just seems to be part of growing up. You know, I love big families. When I was growing up—course, we're isolated up here to an

extent—my best friends were my brothers. Everything we did was with my brothers. We went riding, we rode in the rodeos, we would go hunting, we'd go fishing, and I can honestly say that as I grew up I never had a best friend besides my brothers. All those things we did together. And we're still that way. We try to get together and do things, plan things that we can do together.

I think that the large family is tied very closely to our faith simply because we are taught, and we believe, that there are spirits on the other side waiting for bodies. Married couples provide that body. The spirit joins that body and you have a person. That person has things to do here on earth and we need to teach 'em how to accomplish that. So it is tied very closely with our faith.

LENNA: We haven't ever really decided on a number. There's a lot of things to take into consideration. How many you can take care of? You just don't think, "I'm just gonna have a whole bunch of kids and whatever happens, happens." You have to, I think, have a plan and know that you can, at least hope that you can, take care of 'em. You know you have to keep the house in order, and feed 'em, and put shoes on 'em, and train 'em. There's really a lot to it. It's not just, "We're gonna have a lotta kids 'cause we think we need to have a lotta kids."

I don't think we planned exactly how many. I mean when we were first married we didn't say "Okay, we're gonna have nine kids, then we're gonna quit." We always said you can choose not to have kids but you can't always choose to have them. There might be other things come in. So we didn't choose a number, particularly. But I think that together as we went along and had these children, we never felt like they were all here. So we went on to number nine. And there's a different feeling now. That's partly a personal thing and I think it may be tied somewhat to tradition a little bit. But I think it goes beyond that. I think it's a spiritual thing, and I think that you have a feeling as a couple as you talk and you pray about it, and as you think and plan you reach a point where you say, "Hey, you know, our family's complete."

BRICHER-WADE

SHEILA

HISTORIAN

The masks? I don't know. I've collected 'em. I think that in high school I spent a lot of time in masks, although people didn't see them. So now I can display my masks because I'm not wearing one anymore.

CHEYENNE
b. MARCH 11, 1956, CHEYENNE

I was almost born at six o'clock Mass. My mother had to go to Mass before she could go have her baby. So she went to the chapel at the hospital 'cause she was already in labor. I was named after the nun who helped deliver me. They wanted to name me Kate but I wasn't big enough. I was only ten pounds, eleven ounces, and they thought a Kate should be larger than that. [Laughs]

My stars were crossed from the beginning.

My patron saint is Celia . . . Celia and Teresa. Celia is a derivative of Sheila. Celia was one of those very wealthy saints who, somewhere in the Middle Ages, gave up everything, followed St. Francis, and gave everything to the poor and became a beggar. Phyllis is my confirmation name and that was Philip. I took that because my sister was

Sister Mary Philip when she went to the convent. Dymphnia is the patron saint of the mentally ill and theater people. I chose her as my patron. And Saint Anthony, I prayed to Saint Anthony a lot when I was a kid, the patron saint of lost articles. St. Jude was the patron of hopeless causes. We prayed to St. Jude a lot.

You grow up and you're steeped in this religion. It's everywhere. In our family we did not do anything outside of the church or the family, and our family was Catholic. So it was your world. It was your life. When I switched from Catholic school to public school in the ninth grade, I really did not know that there were people out there that didn't go to church on Sunday. A real judgmental kind of thing. And that may have been partly my age, but I didn't know how to deal with people who weren't Catholic.

I remember once finding some bowling trophies in my parents' closet and being quite shocked and stunned by this. 'Cause my parents didn't do anything outside the home except church. My father ran the dishwasher at Holy Trinity and my mother was a member of Altar and Rosary. My father was a member of Knights of Columbus. Those are the only things that I know of that they ever belonged to.

We didn't do any social things outside of family and church. That was it. We didn't go to movies. Every Friday we had Novena. I remember Friday nights really well, 'cause on Friday nights we got to have popcorn and sometimes a half a can of soda. Shasta Creme Soda. We could split one. My parents still don't eat meat on Friday. We always had fish on Friday. Tuna with cream sauce, fish sticks. We couldn't afford fresh fish, so fish sticks and tuna. Chicken on Wednesdays, always chicken on Wednesdays. Meatloaf on Thursdays.

And we had to pray. That was one of my mother's favorite things. When we would do things we would say the rosary. She would lead and she had her rosary voice: "In the name of the Father and of the Son and of the Holy Spirit, Amen." She would put her rosary voice on and you would . . . "Oh, no! Not that!" Every summer we would go to South Dakota or Montana to see my mother's sister or my father's family. And so in the car, fourteen-hour drive, when the kids

would start fighting or whatever, my mother did not pull out toys that she had purchased at the Safeway store for just such an occasion. My mother pulled out her rosary and we prayed out loud. And we would pray. Sometimes we would say ten, twelve rosaries on the way to wherever we were going.

Before dinner we would pray. After dinner we would pray. Then we would all get up from the table. We would go into the living room. We would kneel. We had a rag rug in the living room. We would kneel, all of us in a circle with our fifteen-decat rosary. My mother or my father would lead, and we would take turns saying the joyful or the sorrowful mysteries, or whatever. We would all pray together every night. When I got a little older, after my sister had gone off to the convent and some of my brothers were off doing whatever, they did allow us on a few occasions to say the rosary in the kitchen while my mother was doing the dishes if people had things they were gonna go do.

I remember during the Cuban Missile Crisis for some reason I thought that if I put my head like this and prayed really hard, prayed really hard, I could make that not happen. My mother told us if we prayed hard enough, the Russians wouldn't start a third world war. I was twenty-three years old before I figured out that I had not been responsible for the end of the Cuban Missile Crisis. It wasn't until the Russians invaded Afghanistan, and I felt responsible and had to go into counseling, that I uncovered this thing from my past where I realized that my whole childhood, I had believed that I prayed hard enough to stop the Cuban Missile Crisis.

We used to burn palms when it would hail. And we never lost our garden to hail when I was kid. We would see those white streaks in the sky and we'd run in the house and get all the palms from behind all the crucifixes. 'Cause we had a crucifix in every room, at least one. On Palm Sunday we would get palms and put the palms behind it. See, all the decorations in our house were religious: the Sacred Heart, St. Christopher, saints, and madonnas, and crucifixes. Anyway, the palms would go behind the crucifixes, and then we would pull those palms out and set 'em on fire when we would see the streaks in the sky. And the hail almost always went

around. When my mother wasn't there, we lost eighteen windows and seven chickens. **There was no one there to burn palms!**

It was something I got from my mother. I still want to go to church on Palm Sunday to get palms so they have palms to burn. I remember the smell. There was a feeling of being able to do something about it. That's part of what we got. When nothing could be done you could pray. You could burn palms. You could get on your knees and say the rosary. There was something to do. And then if it did happen, you knew that you did everything you could do. This was supposed to happen. That's where that acceptance comes from. But I really do think that's a good thing, because you didn't have that sense of helplessness that people have. People talk about Catholics worshiping saints. That wasn't it at all. It was that you asked them to intercede. You asked them to put in a good word, see? And if it didn't happen, then you didn't deserve it, or you hadn't earned it, or it didn't need to happen, or whatever.

We went to Catholic school. The nuns would tell you things, and you would believe them, and then you would find out they weren't true. Well, you didn't ask questions. I mean, you weren't allowed to ask questions about things. You just took whatever information you were given. I didn't begin asking questions. I just started figuring things out in my own mind as I got into, I think, junior high.

I was in the CYO [Catholic Youth Organization]. When I was in eighth grade I was very cocky and full of myself. Then we started going on CYO trips and you would start talking to kids from other places. Kids were a lot more worldly than I was about things. These kids were out having sexual experiences and things like that, you know. God! They weren't growing hair on their knuckles, and their eyeballs weren't falling out of their heads, and there weren't bolts of lightning coming out of the sky and striking them dead. So it was like, "Well? So, was it all a lie?" Because I was a very literal child I truly expected to see these things here and now. [Smacks fist in hand] If you pray hard enough, the Russians will not invade Cuba and we will not have a third world war. I believed that. I prayed hard

enough! It didn't happen! Whoo! Am I responsible?

I had gotten a car when I was a junior in high school. I had a little Volkswagen. And the first thing I did when I got my Volkswagen was, I went out and bought a garbage can, and some air freshener, and a couple of wrenches, and a screwdriver, and some cables and chains. And I put a phone book and a box of Kleenex and some other stuff in the back.

The phone book seemed like a good idea and over the years we used it. We used it to look up people's addresses when we couldn't remember, when we were out riding around. But when I was in college I sold that car to my good friend, Karen. At various times I had been cleaning out the taco bags and all that shit, because I was one of the few people that had a car and I used to haul eighteen people around at once, you know? My car was always a mess, which it still is. And when I was cleaning out the car to sell it to Karen, she said, "Sheila, why the fuck do you have a phone book in your car?" "Well, yeah, we use it for addresses." She goes, "No, really, you have insisted on carrying this phone book around with you since you've got this car. What is it?" 'Cause I wouldn't ever part with that phone book.

So I started thinking about it and came up with it a few days later. It took me awhile. In the fourth grade, Sister Leontina had called us all in from recess one day, and we got this little lecture from a priest about maturing, how one day we were going to start having periods and this and that. Then they called all the boys in and told the boys that the girls were getting to an age where their bodies were getting babies. If they were grumpy they were just having their periods, so the boys should just know that if the girls were grumpy, that's all it was. They didn't have to worry about it. Then the nuns called us all in and told us we were no longer allowed to play on the equipment on the playground because we might hurt our female organs. We were going to have to now stay in from recess. I remember, this was just when I was just becoming interested in gymnastics. I wanted to learn to do those things that those girls in the Olympics did on those bars and stuff. They wouldn't let us play on the bars anymore because they might hurt our

female organs. It was like, "Don't they have female organs?" [Laughs] And they were from places like Rumania, where I knew they were Catholic! So I couldn't figure out what the deal was. This bothered me, but I never asked anybody because you didn't ask. They also gave us this lecture about things we needed to know as we got older. One of the things that we needed to know—it took me a long time to remember this, but I do remember—was that when we got into high school we might be traveling in large groups in a car sometime, and something might happen that someone might need to sit on a boy's lap. And if you ever had to sit on a boy's lap, you should be sure and put a phone book in his lap first. I was a literal child. I was always an overachiever. I always wanted to please people, so, by God, when I got a car I had a phone book in it.

There are lots of little things that I spent time searching my past for. It's like, "Why do I do this? Where did this come from?" You wouldn't believe how much of it I can trace back to Catholic school, to things that nuns told me, stories that nuns told me. These weird little things you develop. I can remember this one lady. Her name was Miss Mary. She was a substitute. She used to come and tell us these stories. All of her stories were just very graphic and very horrid, and they had these horrible, terrible endings. You know, this guy slapped his teacher, and then he grew up and he went to work in a mine, and this car full of coal ran him over, and just as it ran him over, there was the head of the devil in the cable car and it said, "This is because you slapped your teacher." And it cut off his arm. So they buried him, but always this arm that he had slapped his teacher with would stick up out of the grave. This is, like, second, third, fourth grade, right? A year or so ago, when I was doing the cemetery tours, I remember walking through there and looking for an arm sticking out of a grave. These things you carry with you that you can't explain. They're really stupid.

You don't question. You accept. One of the things that you learn as a Catholic is acceptance. That's both a positive and a negative because Catholics learn how to accept things. It's called faith, having faith. There's this sort of a resignation, okay? You

can pray for anything. You can pray for this, you can pray for that, but if you don't get it, well, it wasn't supposed to happen. God has other plans for you. God knows best. He loves you, and whatever is supposed to happen will happen for you. I don't know why we didn't ask questions. They would say, "Does anyone have questions?" But everybody knew you weren't supposed to ask. We'll have to look for it sometime, the catechism from when we were kids. One of the chapters is about marriage, and there's this little addition problem at the beginning of the chapter: "One good Catholic marries another good Catholic, equals smooth sailing on the sea of life." [Laughs] Oh my God!

Van, my ex-husband, had been divorced. His first wife was Catholic and they were married in a Catholic church. Talk about a guilt trip! When I went for it, I went for the gusto! I mean to tell you, I literally went through a very serious period of mental illness. I became so emotionally distraught I would go to work and lay my driver's license on the table in case someone called and asked who it was because I would forget during the day. At one point I forgot how to speak English. I was watching the TV and I couldn't understand them, and it was in English. I knew it was in English but I couldn't understand what they were saying. It was awful. I started running in the cemetery, and jogging, and trying to get my shit together. I went through a real severe period of depression, and I know now that it was from the guilt. When the Russians invaded Afghanistan, I felt so guilty I almost had to be hospitalized. I became so distraught, and so depressed, and so upset, and no one could figure out why. So I started seeing a counselor and we started talking about why it was. And what we came up with, after a very long time of talking about these things, was I thought it was my fault 'cause I didn't pray hard enough. 'Cause I had quit going to church, I had married a divorced man. There was a price to pay for all of that. It was a very, very difficult time.

When my marriage ended and my husband ran away, I was wracked with guilt. I couldn't be with my family for a long time. Because I felt guilty. I had failed. I mean, of all the things we grew up knowing, we knew [slaps her hand] divorce was an evil and

wicked thing! I never heard one person say that. We just knew it. We knew it because when my cousin married someone who was divorced, my mother was a lot sadder than any time I'd ever seen her when somebody died. I remember she came in and she said [Whispering], "Herb got married. She's divorced." She didn't have to say anything. We knew. That was a really horrible thing to be. What had happened to Herb was a really horrible, terrible thing. My mother adored his wife. She loved that woman. She thought she was the neatest lady. [Whispering] "But she was divorced."

I had talks about religion with my mother. Mostly we get into it now over abortion. "They just abstain. They just shouldn't have sex." Well, there are a lot of people who don't believe that. It's been going on for thousands of years and that has not worked. "Just say no to sex" does not work. Whether you believe it should or not. [Laughs] You can't explain anything to her. You get to a certain point, my mother doesn't want to deal on that level. It's an issue of faith, it's an issue of belief, it's an issue of "shoulds." Religion provides lots of "shoulds" for how you should live.

I don't think they [parents] think about it. They just accept it. It just is. I mean, they believe. I don't think we believe. This whole concept of belief has something to do with it. I think we just got to the point where we just didn't buy into it. I mean, you can't control people the way you used to control them because people know differently. You can't tell 'em, "God will strike you dead!" Because they look at what's going on around them and ain't nobody getting struck dead! [Laughs] You can't sell this Sodom and Gomorrah stuff anymore.

I'm sure they know that I don't go to church anymore. I think my mother's figured it out. But we basically have an agreement: "If you don't want to know, Mom, don't ask. 'Cause I'll tell you. And if it's not what you want to hear, your feelings will be hurt." It's not to hurt them, it's not because I don't love them. It's because I have to be true to myself, and that's something they gave us. Now, how or why, I think that's as much my mother as my father. I have to credit her with that. She was her own person. I remember as a kid my mother doing things

that mothers in the fifties and sixties were not supposed to do. My mother wore high-top tennis shoes and walked to church in my brother's basketball shoes. This was when women were wearing polyester double knit only, and had short hair because they were over thirty. My mother was wearing high-top basketball shoes to walk to church 'cause they were comfortable. We had a paper route for a while. The whole family had a paper route. We said the rosary in the car on the way to Sun Valley [Cheyenne subdivision] to do the paper route. Anyway, my mother would get the rubber band boxes for the paper route—these big boxes of rubber bands? We'd go in the back room and my mother would start the rubber band fight. Then we'd all clean it up. So she was her own person, too. I think that had to do with the fact that she was a middle child and she had to get attention, a middle child in a family of fifteen.

My parents were wonderful people. I mean, they were wonderful. You wanted to do anything to keep them happy with you. They were not awful to us. They were always wonderful. They dedicated their whole lives to us. And we all grew up with this desire to do anything for them. It wasn't that we were trying to please them because we didn't get their affection or attention, it was that we were trying to please them because they had set such a fine example for us. It's really hard to explain. That has been a positive and a negative. My father was emotionally centered, a quality that my brothers had trouble emulating. They did everything they could and it wasn't enough! It wasn't that my father was expecting it of them. It was that we all expected it of ourselves. And, see, I'm not sure where that came from. My parents were always so supportive about things. I remember one time I had a job I couldn't stand. I was a waitress and they were making me wear skirts this short, V-neck down to here. I was just real uncomfortable and I went and told 'em [parents] I wanted to quit. My dad said, "You will spend one-third of your life at work. Don't ever do anything you don't like!" I don't know why I was shocked. He'd never given me any reason whatsoever to think that he would say anything but that. But I was. Then he gave me this little talk about loving what you do, and then doing your best job because you do, and how we

would get by. 'Cause I was worried about the money. 'Cause my parents never had a lot of money and I was always really conscious about that. He said, "We'll take care of you until . . . " I mean, I was, like, seventeen years old. And here I was thinking I had to support myself. They never told me that. I had just accepted that responsibility and was afraid that I was a failure for not doing it.

And that's the thing about growing up Catholic. You can't ever stop. You can stop believing some of the stuff they told you. I don't believe you can ever stop being a Catholic because it's like an ethnic or cultural . . . it's something that you get from the time you're a child. I was hearing the rosary before I was born. It's rhythmic. I mean the rosary is soothing. It almost has a hypnotic effect. It can relax me and I go back . . . it's like a chant. It doesn't have to be that you really believe or are even thinking about what you are saying. Mass was the same way. We had all the words to everything memorized. We didn't know what they meant half the time. Until I was older they were in Latin. I try to recall it and I can't. But if I'm in a room full of people who are doing it, I can fall right into it. So it's a group thing. There's a lot of support there. There's a certain stability in it. It's a lot of what they say that's garbage. I mean, Catholicism is a real good one. It's old. The traditions are tried-and-true in a lot of ways. Some of their beliefs don't match up with modern attitudes, but a lot of those traditions are the things that everybody's looking for. Except they don't know how to sing. And I don't really understand why. Only the Irish Catholics can sing.

I still consider myself a Catholic. I think I still have faith. I think in my own way I still pray, although I don't sit down and recite the rosary unless I'm forced to. It's sort of a polite thing to do because it's a funeral or a wedding or something like that. It didn't hurt me. It's a lot of who I am, and what I am, and how I am—growing up in that big, weird Catholic family and having all of that support. I see what it does for my mom and her sisters, people who've never had a lot, but have had really wonderful and joyous lives and who can accept death in ways that an awful lot of modern people can't. They had an incredible work ethic, and I know that

I got a lot of that from watching my parents working for the church. That whole sense of being responsible for something, and being responsible citizens, and doing the right thing, and caring about people. They never were very judgmental about people who weren't Catholic. There was always sort of a superiority. We all knew **we** were tops, but it really wasn't **their** fault. So there were really good things that came from it. On the other hand, I don't buy into this crap of "If you don't go to church on Sunday, God is going to strike you dead." Well, I haven't been going to church for years and years and He hasn't struck me dead.

I know where I'm from. I have a real good sense of it. And that's something that came from a big, weird, Catholic family. Reunions. We had reunions. My grandmother's birthday, Fourth of July, every year. We were with all those people. We knew we were loved, we knew we were cared about, we knew where we were from. We never had to sit around and wonder about our roots. It was there, all those women making all that food and taking care of us and running around. That's where I'm from. That's what I am. I'm both sides of my family. My father's family is bigger. And that is probably one of the best things. Being Catholic, I don't think, was a bad thing. It's just that I was so literal and bright and inquisitive and imaginative, and needed to have my own way. There's a part of it that can be stifling if you let it. It's not for my parents, but it is for me, so I don't accept that part. I really have given that [guilt] back.

It's not mine. It's not my rock to carry in my bag. It's their rock. They gave me everything they knew how to give me. They did everything they could do. It's kind of like burning the palms. They did everything they could do. I didn't turn out the way maybe they hoped or thought I should. But I'm here. And I think I'm a decent person. I don't think they can deny that. At least I'm not out there blowing people up.

GILLETTE

left to right:
ERIC JESSEN: b. JULY 24, 1975, CASPER
EMILY SMITH: b. MAY 13, 1973, SHERIDAN
JEFFERSON J. BAY: b. JUNE 6, 1974, POWELL

J.J.: Started when I was five.

EMILY: We've got, like, shoeboxes full of medals and trophies and stuff.

ERIC: When you're a little kid and you get a medal, it's like, "Alright!" But now it's just like, "Phttt! Throw it in a box."

What is the best thing to you about swimming?

EMILY: Winning.

J.J.: Being in such good shape. 'Cause it gets every muscle in your body in shape. You can just swim, run, bike; you can play basketball, all that kind of stuff. You know you're in shape for it all. Gaining space on 'em, kicking some butt. That's probably the best, sends little chills up you, you get moving and . . . yeah!

EMILY: Like J.J., I like the thrill of competition and being able to reach your goals. Competition, meets, but also practice— knowing that you can get through it without dying.

Think we're gonna see your name in a record book a couple of years from now?

J.J.: Yeah.

ERIC: Don't mean to brag, but . . .

J.J.: I mean to brag. It's gonna be in there.

ERIC: I think we'll do pretty good. There's some people that can beat us, but they're gonna be gone.

J.J.: We're still coming.

ERIC: Yeah, and we're only ninth-graders.

COACH BRAD BARLOW: We've had several good seasons. Before '85 I think they'd only had one or two winning seasons that I'm aware of. I came here in '79, '80, but overall I think the tradition is here and it's been good. If you want to go clear back to 1954, they won the six-man state championship here. And I think in 1951 they were runners-up or somethin' like that. So, they've had good football here. Where there's small communities, whether they be mining or farming, or whatever they are, it's a focal point for the community.

When the mines shut down, a lot of people moved out. We went without football for a year. And that was tough. When they came back and proposed going to this nine-man type of situation, I wasn't thrilled to death about it. I had never seen a nine-man game. I had no idea what went on. You know, the old traditional type of attitude. But once we got into it, I've thoroughly enjoyed it. I think it's a great game. For the small schools, especially in a state like Wyoming, it's fun for the fans, it's fun for the kids playing the game. There's a lot of points scored. And because you play it on a regular, eleven-man field, but you don't have as many kids, the possibility of scoring points is there. Plus, the smaller schools don't have the overall depth that some of your bigger schools have. It goes in cycles where every few years you're gonna get some good group of athletes come through and be real successful. It gives these small schools a chance to be successful and score points and have fun playing football. And the crowd will naturally pick up on that and have fun along with the kids that are playing the game.

back row, left to right
PAT JOHNER: b. DECEMBER 6, 1972, LARAMIE
DON DAVIS: b. AUGUST 13, 1973, RAWLINS
SAM RUNYAN: b. APRIL 2, 1973, SALT LAKE CITY, UTAH
JARED BRIGGS: b. JUNE 23, 1973, RAWLINS
BRETT FLOUTIN: b. DECEMBER 7, 1972, PITTSFIELD, MASSACHUSETTS.

middle row, left to right
KEVIN CONKLE: b. MARCH 30, 1973, PAONIA, COLORADO
JASON COCHRANE: b. APRIL 4, 1973, PARK RIVER, NORTH DAKOTA
NATE LAUBACH: b. APRIL 4,1973, LARAMIE.

front
BRENT BLANKENSHIP: b. JULY 23, 1973, TAZEWELL, VIRGINIA.

Wyoming has a big prejudice against goats. Beef people do not like goats, especially. And in Sheridan we have big beef growers. It's just socially unacceptable for them to have a goat near their place. It's a social thing. In past years—not this year, we finally got it stopped—people would come in from the beef barn and tear down all the decorations from the goat barn. They'd come by and insult the goats.

I like goats. They have characters. We live out of town and they're good friends to have around. It feels good to have a goat when we go in the goat barn in the morning and have 'em blat at you, "Hey, ma!" And also it gives me a lot of experience on raising my own children when I get growed up. They're a twenty-four-hour job.

Goats are really common. We have one girl, she got the goats for tying kids for rodeoing, then she got attached to 'em. She's one of the learning disability children. She got attached to her goat. And now they can take the goat and put it in with the horses. If they get all riled up, it calms 'em down. Some ranchers have goats. If they have a bum calf they'll get a goat and feed the calf. "Women of the Oregon Trail" . . . I did a thing on it. They had herds of sheep come over on the Oregon Trail. Well, along with the sheep they brought the goats to feed their bum lambs, and they ended up all over in the West and in Wyoming.

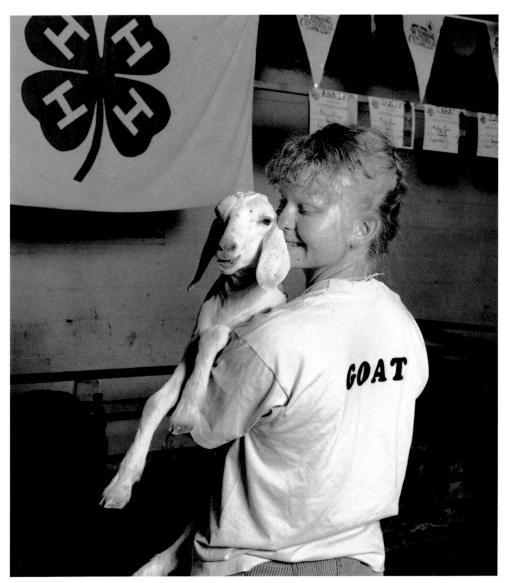

SHERIDAN
b. OCTOBER 30, 1971, SHERIDAN

KRISTIN HOGARTH

DEPUTY PRESS SECRETARY

SENATOR MALCOLM WALLOP

I'd been applying all over the country for reporting jobs. I'd just gotten all my resumés done, hadn't sent them out yet, and I called my parents and talked to them, like, every day for that week, interviewed everyone I could think of about what I should do, and finally I thought, "You've always wanted to go to Washington. Go for it." I mean, the pay was lousy—$16,000. I would have been so stupid not to take the chance to come out here. So I came out here. I was a receptionist making $16,000, living in a studio apartment that cost me $480 a month. That wasn't food or anything. I got promoted after about three months to legislative correspondent. That involves getting mail from constituents and answering it. I liked it 'cause I learned the entire legislative process, how to follow the bill from the very start to the very end. 'Cause people will write and ask you about the most bizarre bills and you have to find out what they are, who sponsored 'em, why they're good for Wyoming, why they're bad bills, what Senator Simpson's position was on the bill, and you have to answer these people, the constituents.

I strictly deal with the press now. That's the major difference [between legislative correspondent and deputy press secretary]. I come in the morning. My job is to read the newspaper. I have to know everything that's going on. So I come in, I sit down . . . well, Janice and I, the press secretary, we split 'em. I read the *Washington Times* and the *Wall Street Journal*, and she reads the *Washington Post* and the *New York Times*. Then we get Wyoming clips from the state and we have to read all those also. So I come in the morning, and I read and have to know everything in case he asks me. I set up interviews. I write weekly columns on Wyoming issues that go out to all the Wyoming newspapers. I write the column and we send it in the mail to every Wyoming

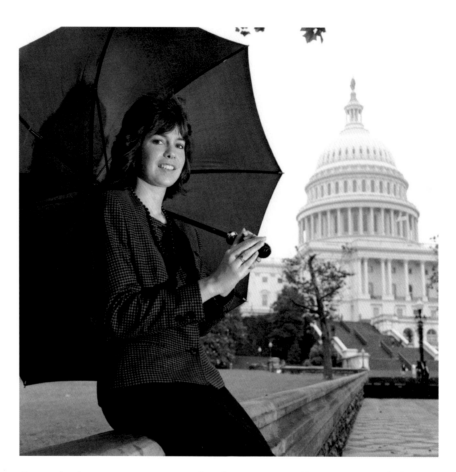

I wanted to be an actress growing up. I used to unwrap my Christmas presents before Christmas, and wrap 'em back up, and act surprised to see if I did a good job.

WASHINGTON, D.C.
b. SEPTEMBER 6, 1976, CASPER

reporter. I've written one on Earth Day, and on brucellosis, one on taxes.

People on the East Coast have no concept. I'm constantly defending Wyoming out here because people don't understand it. They're just ignorant. People who have grown up on the East Coast really get to me sometimes because they're like, "Oh, Wyoming, yeah, what do you guys do there?" I'm like, "Everything you do here and we ski a lot more." That's what I tell 'em. They think we don't have movies. They just think we

don't have anything. A lot of 'em do not know where Wyoming is. They don't realize how close we are to Colorado. That just amazes people. I say, "Yeah, we're an hour and a half away from Denver." . . . "You are?" They think everyone lives in the middle of nowhere and that we're all ranchers.

My mom said one night, she goes, "I say a prayer every night for you before I go to bed." Then they came out to visit. And she goes, "Now I say two."

STEVE GOOD
AIRCRAFT MECHANIC

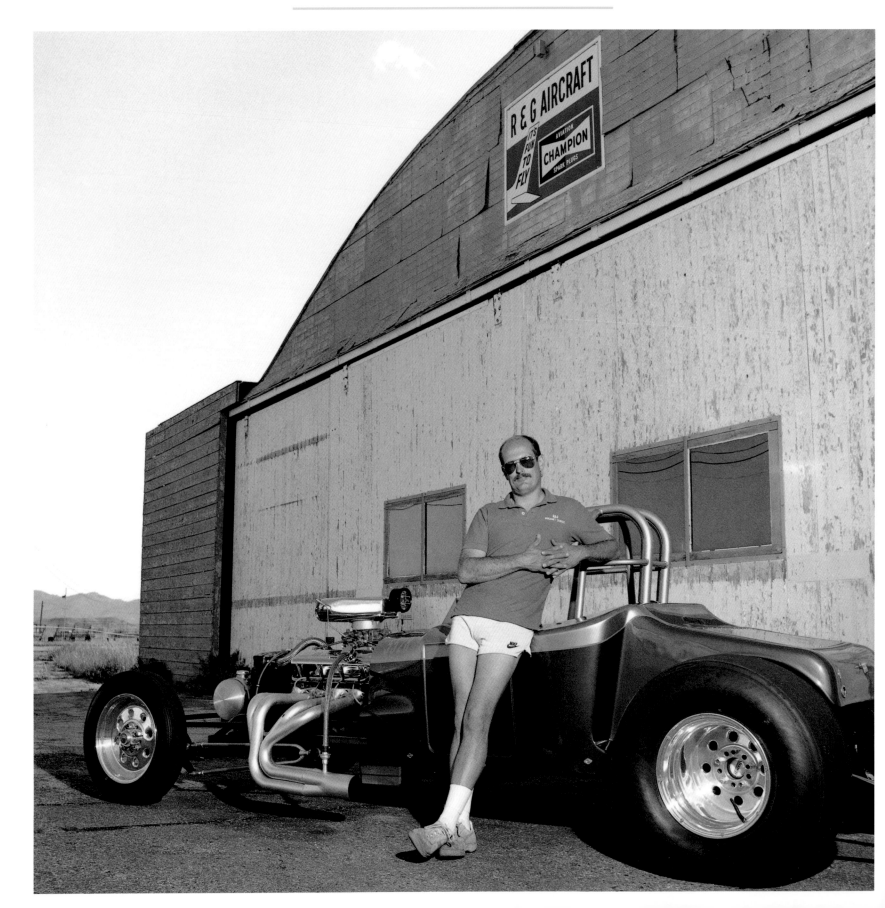

My dad started a business right here at this dragstrip, R & G Aircraft. You can see the sign right over there. That shop building over there. Started up in 1951 and I was raised right here, literally. This was my hangout spot. I come down here with my friends or by myself, hung out at the airport, and pretty much fell in line with what my dad was doing, and now I'm doin' the same thing.

DOUGLAS
b. OCTOBER 12, 1951, BELLE FOURCHE, SOUTH DAKOTA

I think I just kinda grew into it. I started really young, like about nine, ten? I think I started drawing a paycheck when I was thirteen. First paycheck, my hourly wage was thirty-five cents an hour. My job was cleanin' up. I liked bein' around airplanes. I enjoyed when I started flyin' 'em. I was a licensed mechanic before I was a licensed pilot.

I started flying when I was fifteen. I was mechanicking during high school years. I wasn't a licensed mechanic but I was doing things for him [father] as an understudy, and he was signin' 'em off in the logbooks and whatnot. And then went to college for about a year and a half. Didn't really like it. Went to the navy for four years, entered antisubmarine warfare, P-3 airborne, antisubmarine warfare. I didn't ever think I'd come back to Douglas. But the navy gave me four years to kind of settle down. I was kind of wild.

My older brother was the one that got caught. I was the one that did basically everything he did, only I didn't get caught. Consequently, I guess I was unsettled. High school's kind of a bad time in a guy's life, or any person's life. He's not a grown-up and he's not a kid. He's just kind of in the middle there trying to be one of the two. The day after I graduated I left Douglas, went to Casper, went to school. Got a job up there. Didn't really care for college that much and then I joined the navy. The navy life more or less settled me down. Then I came back to the place where I never thought I would come back, and worked in the same spot, doing the same things I did before, doing the same things that my dad did.

I think it's kinda like trainin' a dog, if you've ever trained a dog. If you get a dog real early and start trainin' him when he's fifty days old, there's a period in a dog's life—about four months—that you can really burn in a lot of good desire to retrieve, good desire to do what you want him to do, and to learn the things you're tryin' to teach him. It's the same thing with a kid, I believe. If he gets in there in the thick of something, and starts learning, and starts building confidence, then it's kinda rooted into him. All cases aren't the same, but lotta times they will come back. Like ranch kids.

You can get it [mechanic's license]

two ways. You can go to a school and receive your training through an accredited school. Or, you can get on-the-job training for three years and then you go take the test. That's the way I got mine. I've had employees from various schools who . . . all their knowledge is book. Plus their retainage factor isn't . . . A life of hard knocks with hands-on training, you can't beat it.

I like to work with my hands. Love it. That's where my talent is, in my hands. It's not in my ability to sit down and write novels or something like that. I like anything that's got a motor on it. I like boats, airplanes, motorcycles. I have a ton of motorcycles, race cars. That's my main thing, is those types. I sold my boat to finance my race car. I had 'em both at one time. I could have afforded it, but I wasn't using the boat like I used to and my interest is here. Boating took second.

You have racers, you have nonracers. There's people that come down here [Douglas International Raceway] and work in this raceway concession who could care less! Here's this gorgeous car out there, standing right in front of 'em, and they don't even pay it a mind. They're not interested. There's people like me who just drool on it. You have the interested, you have the people that are not interested. Well, this state is agriculture. They could care less. They go down, they get their rocks off by team ropin', steer jerkin', rodeoin'. Which is fine. I don't downgrade them, but when I get out here I like this, you know. I'm not a cowboy.

In the navy that was my nickname, "Cowboy." We had a flight crew of twelve people and a lot of eastern, big-city types. All types of people, all walks of life. I get my little, two-bit *Douglas Budget* weekly newspaper in the mail, and they pounce on that! "I get it first!" [Laughs] And they just can't believe it. Little articles, "Wandering with Wilda," "Roundabout with Lola Bartus," "100 Years Ago Today," blah, blah, blah, blah. "Sue Ann went over to Mary Lou's Sunday afternoon at three o'clock for a couple hours for some conversation." Makes the paper! Guy winning a cowboy hat in the paper. And the guy says, "Hey, Cowboy, get over here. Do people really still wear cowboy hats there?" Whew! Give me a break!

My parents didn't rodeo, really. Whatever we get involved in, they get involved in. High school rodeo was the first time I'd ever rodeoed. When I was a freshman I started, and we just traveled across the state. Before that we showed horses. I think I liked the speed. I liked all the action. I wasn't into the show stuff 'cause it was all slow, or else boring work, and this was just exciting.

I can't sit at the rodeo. I can't watch it. It makes me nervous. I have to do something. But besides that, I just thrive on it. It's like somebody else wanting to watch basketball on television or something. You know how they have just an obsession. It's like an obsession for me. You know, I can't even really imagine life without rodeo. I've been doing it for so long that I don't know what I would be doing.

I don't like being told what to do, exactly. I like to train my own horse and do things the way I want to do 'em. I don't like people making me do a set pattern. I think that women should get the same as men do. In the rodeo we get three events, they get six events. I just don't think that's right.

I've always been different. I don't follow people just because it's something to do. If I believe in something else, then I go for it. I don't worry about what everybody else thinks.

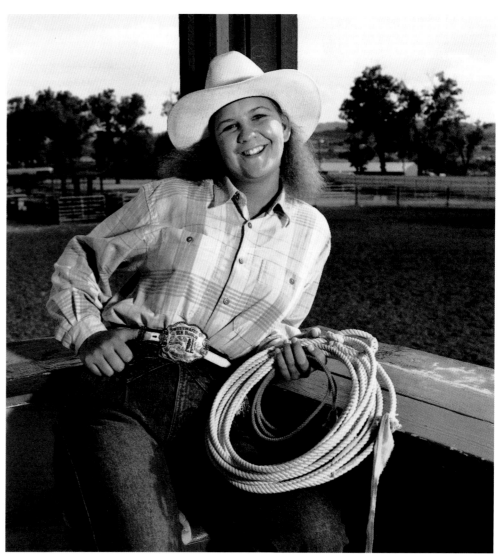

ROCK SPRINGS
b. MARCH 14, 1972, ROCK SPRINGS

DEAN SCHLATTMANN
HIGH SCHOOL RODEO

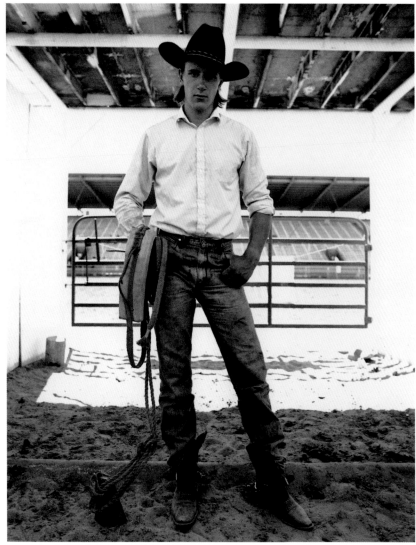

BASIN
b. NOVEMBER 2, 1971, NEWCASTLE

Oh boy, I started riding 'em when I was thirteen or fourteen . . . and I'm eighteen? Probably started when I was fourteen. I'll bet I been on a hundred head a year, each year, or almost a hundred head. I'll bet I been on probably three, four hundred head.

I got more of a future in this than I would playing football. 'Cause it's just you out here. I think there's a lot more people that, if you wanta ride bulls and make it to the toughs, you can, than people dreaming about goin' to . . . Well, per ratio there's more kids that dream about going to be a pro football player and don't, than there is cowboys that dream about being a world champion. I'd like to win the world in high school and then I'd like nothing better in the whole world than to be a world champion.

Most of your big boys have got a daddy with a million dollars. You gotta have money to go down the road, you know? I mean, everybody gets in a slump and if you ain't got money behind ya to keep going until you get out of the slump, might as well go home. And we don't have that kind of money. I rodeo on what I win. You pay entry fees and they pay ya. I think this and Nebraska's the only states that do that anymore. I wouldn't high school rodeo if they didn't pay checks. I couldn't. I'd WRA rodeo—Wyoming Rodeo Association. Because I wouldn't have the money. I mean, it takes money to drive a million miles a summer and eat. We stay in a camper and poor–boy it. We eat sandwiches so we can keep goin'. Some people drive big trucks and stay in motels and their kids never win, but we couldn't do that. If you didn't pay fees and win money, I'd WRA rodeo so I could. They just give ya gift certificates and stuff at State [High School Rodeo]. I won, like, $3,000 this year. Bronc ridin', to win a check, was $60. The bull-ridin's $110, somethin' like that. Mainly there's the same number of people that keep goin'. And the bareback ridin' was $100. So I did pretty good this year. That's the most I've ever won. You're rated on points, so I just kept track of that to see how much I won. I probably paid almost $1,000 in fees, and then if you take out traveling and all that, probably that's $1,500 with fees and traveling and all that stuff. That's the way pro rodeoin' is. It takes everything you earn to keep goin'.

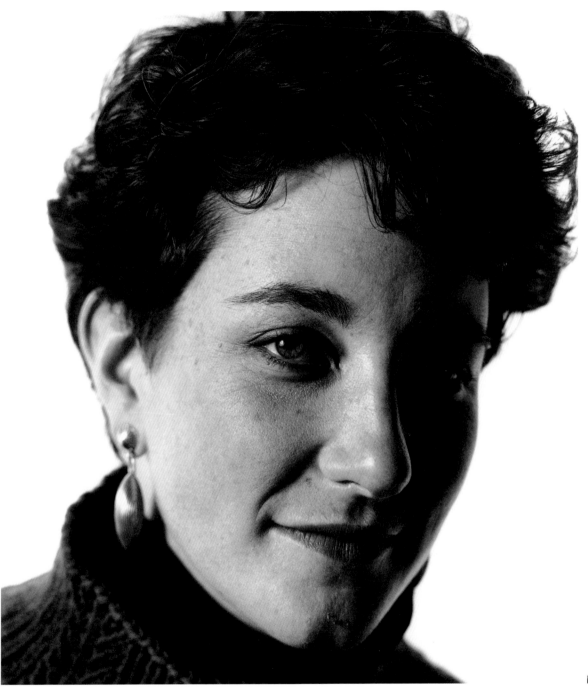

Dad being elected governor has taught me a lot about people, and it has made me perhaps a little sadder about how things work. And hopeful at the same time.

JACKSON
b. MAY 30, 1964, LARAMIE

I think it [Casper] was very much Middle America. I don't really remember it as being this way, but my junior high and high school years would have been during the oil boom. Casper was a very busy place, lots happening, which meant that there was a certain amount of danger as well, with everything that comes with a boomtown. I felt as though, living in the middle of Wyoming in the middle of America, that we had a pretty sophisticated upbringing. Just the fact that there is a symphony in Casper, and a college, and all of the intellectual people that came with that. I remember it as being very Nirvana-ish, very much a beautiful old neighborhood with great friends, and being able to ride your bicycle at five minutes to six to the Grant Street Grocery and pick up something for dinner. I mean I don't remember really ever having any fear living in Casper.

From the standpoint of insulation, sometimes that allows a child to gain a certain amount of confidence, and consequently you face the world with a much different view of security. I'm not always so sure that the view of the real world is good to have at the age of fifteen or whatever. It's such a confusing place, anyway. I think, as the world becomes a scarier place, that Wyoming is much more valuable from that insulated point of view.

One of the advantages would have to do with confidence and really feeling like you were somebody in Wyoming. Because there are so few people, you really do believe that you can do anything you want and it can get done. It's reasonable here to do that. So I think confidence is a great benefit. And respect of people, all sorts of people. I think acceptance is something that is a great gift of Wyoming people. Everybody's

unaccepted for about the first three years and once you get past that, it doesn't matter if you're eccentric or ordinary or whatever. You're basically put up with and loved, whether you're liked or disliked. I think that's a great benefit. There's a great pride in that. Pitfalls, I think, would also have to do with insulation of culture. Not necessarily arts and humanities, and books, and thoughts and stuff like that, but cultures, whether they're black or white or Hispanic or whatever. I think we are, in general, a white state and we have a wonderful history. But at the same time, I think about growing up someplace like Louisiana or even California. That can be a hurdle that we have to get over in the world that we're living in because it's becoming so small.

We're very lucky to live in a place where the governor of a state, or the senators or whatever, can be not escorted all the time. Just as a side note, though, it works for you and against you sometimes. Because the Wyoming people are so proud of that fact, that sometimes when you really do need help—not from the standpoint of security as much as maybe somebody driving you, or support staff who could help with certain problems of being governor—those are things that are sort of scoffed at because, "Well, if the governor's just like every other position . . ." So you're expected to be a good ol' boy and do everything, just be a regular old person, but at the same time you're expected to be this superman, too. So sometimes I think that the distance of a Mario Cuomo [former governor of New York]—the other, opposite extreme—might be nice every once in a while.

I'll tell you a great example. Dad was here in Jackson. He is very good friends with Bruce Hauser, who is the head of Sawmill

Creek, which is a great band. They've been good friends for a while and Sawmill Creek was playing out at the Mangy Moose, which is—for history's sake, 'cause maybe it won't be there—this wild bar out in Teton Village. There was a line to get in, of about fifty drunk Canadians. And Dad just wanted to go in and say hello to Bruce and leave. He wasn't trying to get special attention or anything. He just wanted to get in. A friend of mine went up to the head of the line just to tell the bouncers that the governor was standing in line and he just wanted to go in and say hello to Bruce and leave. These bouncers just were obnoxious. They said, "I don't care who he is. He's gonna stand in line just like everybody else." It was one of those things that was so humiliating, and I'm sure if whoever owned the place would have known, they would have been embarrassed, too. That was a sort of an uncomfortable position, but Dad is so good at it, you know.

In fact, somebody told me there's something called the politician almanac, which is a Washington publication, and Dad was coined as being the most sincere and least pompous of all the governors of the United States. I think there are not very many times where you really run into a situation where he gets upset about not having the respect, or whatever, that he needs. There have been a few funny times when he'll be talking to somebody from out of town and they'll say, "Well, what do you do?" And he'll say, "Well, I'm governor." [Laughs] And they kind of look back . . . "Whoa!" Personally, I think he's gotten a little bit cocky over the four years that he's been governor, but I think he tries to stay in balance in it all. And it must be hard.

My name is "Itsy-bitsy, teenie-weenie, little Lisa Rotellini." And everybody in the whole Girls State has been singing my song.

BUFFALO
b. JULY 8, 1974, BILLINGS, MONTANA

And when you start saying, "I will obey, by the Constitution" I mean, the Constitution! That just rings through your head and you think, "You know, this is me, I'm supporting the Constitution. I going to live by the Constitution, I'm going to govern by the Constitution." It's so special. It really is. You finally realize what America stands for and how beautiful it is, and how special.

That piece of paper makes America what it is today. It allows us to do what we're doing right now. And for you to share what we're saying right now. It's so beautiful. All these girls . . . to get together and share feelings, share opinions about issues. You can't do that any other place.

There's such a strong bond with all these girls, and I bet you if guys were here, there'd be so many problems. We have all made such good friends. I just feel that when girls are with just girls, they'll open their minds, they'll expand. They'll go beyond what they normally would. They'll do whatever they want because they know we're all girls, we're all here together, we're all doing the same thing. They're gonna try to reach their goals. With guys here I think it would

interrrupt all their decision making and they would kinda hold back 'cause they're afraid they'd say something stupid and they'd laugh.

I tell you what. I love politics. I think it's great, I really do. I look forward to the elections every year.

Would you like to be the first woman governor in Wyoming elected on her own?

Oh yes, I would love to do that.

Do you think it's coming?

Not in Wyoming. I'm not putting down Wyoming at all, but there's a lot of people here that believe—I know my grandfather's the same way—that men are still superior to women. He won't say that but you can kinda see that. And I see a lot of that in Wyoming still. But I think women are moving up and the men better beware because we're coming.

What sort of skills would a woman bring to the governor's chair?

Determination, independence. You need to be witty. You need to be able to take a stand and don't put up with anybody's gruff. Have pride in yourself. They're just as capable as a male. I think that's what bothers me so much. There's certain qualities that women are more capable of than a male, and vice versa. Sometimes they'd be physical and emotional capabilities. There's so many people that say, "Oh, women can't do that." And that's what just boils up inside a lady, is just, "I'm gonna prove to them." I think that's what it is. It's the strongest one. "I want to prove to America that women can do it."

I'm a very decisive person. I can make a decision. All I need is the facts. And I think that goes true for a lot of people. We just need a chance. We need to be able to prove to people we just need a chance.

I don't think it's gonna happen in Wyoming. You know, we've got the farmer that still wants his wife to cook him dinner

while he's out on the ranch. I see that a lot. I see a lot of professional men in Buffalo who expect their wives to have food ready and dinner on the table before they come home. Lucky my family's not like that. If my mom's not home, my dad immediately starts dinner. Or he'll take her out once in a while. You know, my mom helps mow the lawn. They share chores.

I think you're gonna see a lot more women making a lot more progress. I think you'll see 'em in the courts. I think you'll see 'em in the House and Senate. It'll be slow, not just "boom." But you're gonna see more. I know we complain about having equal rights. I don't complain about equal rights. I just want to be given a fair chance to be all the best I can be and experience anything I can. And have the opportunity to be a judge or be in the House, be in the Senate.

What's it like at this age?

I think statistics kinda speak for that, especially in Wyoming. I don't think people are educated about pregnancy, and something needs to be done. Another thing that bothers me about our age is the technology. I'm scared that there's not going to be as many jobs due to technology. Drugs is really scary, it's getting worse. It just kinda bothers me, especially about the environment. I mean, you hear people, like, "Oh don't worry about it. It takes so many years to do this anyway, so just don't worry about it. Just go out and make money." That just seems to be the American way: get rich and get rich fast. Mass production is the key for a prosperous future. I mean, I'm excited for the future, too, because there's also a lot of jobs opening up. Because we're finding new things. And what's also good is, you have to be educated in order to survive. That's also kinda bad 'cause there's a lot of people who cannot afford colleges and that's rising. It's not even balanced. I don't know, it's scary right now, it really is.

IAN SHAW

1991 GOVERNOR

WYOMING BOYS STATE

I would really love to be governor. But I don't know if I'll ever be qualified enough 'cause for me to be governor, I think I'd have to know so much more than I think I will by the time I'm that age. I have still to figure out exactly what I'll be satisfied with. I want to get a doctorate in astrophysics. If I went and helped but didn't do anything ever profound, but just was happy, I think I'd be satisfied with that. However, sometimes I think that maybe I could do better than that and actually do something profound and make a big difference. I've always had this interest in astrophysics. However, I have this unnerving feeling that I'll end up in law school and politics

LANDER
b. OCTOBER 4, 1971, LANDER

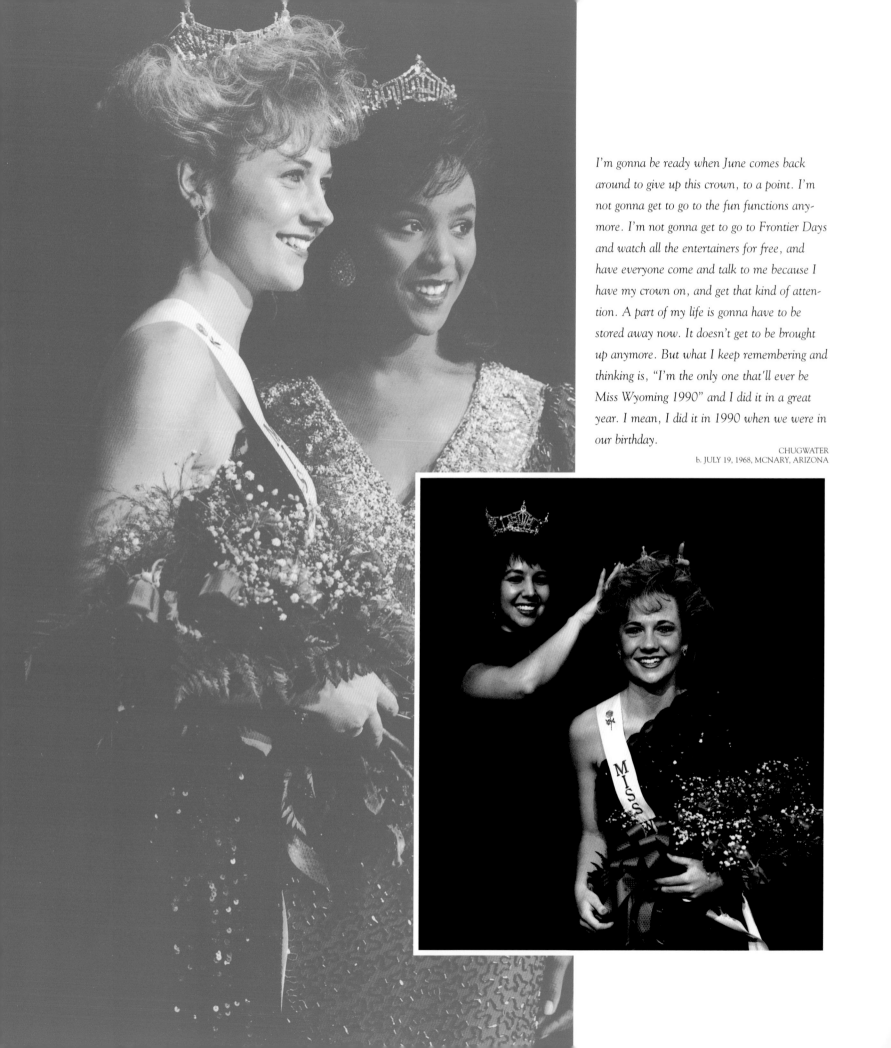

I'm gonna be ready when June comes back around to give up this crown, to a point. I'm not gonna get to go to the fun functions anymore. I'm not gonna get to go to Frontier Days and watch all the entertainers for free, and have everyone come and talk to me because I have my crown on, and get that kind of attention. A part of my life is gonna have to be stored away now. It doesn't get to be brought up anymore. But what I keep remembering and thinking is, "I'm the only one that'll ever be Miss Wyoming 1990" and I did it in a great year. I mean, I did it in 1990 when we were in our birthday.

CHUGWATER
b. JULY 19, 1968, MCNARY, ARIZONA

CAROLIE HOWE

1990 MISS WYOMING

Even though I'm real cowboy, cow-person, cowgirl-oriented, I don't think that Wyoming is necessarily all western. There are lots of people here who've never had a pair of boots on. My pageant system, the Miss Wyoming pageant system, better represents their way of life than Miss Rodeo Wyoming represents their way of life. Miss Rodeo Wyoming is fantastic, by the way. I don't know if you've talked to her—Sandra Utter—she's one of my best friends. She's from Wheatland. So Miss Rodeo Wyoming and Miss Wyoming are both from Platte County, which—whooo! they like that! I mean they think that's a pretty big deal. But I don't think that Wyoming is just the old range with the roaming wild Indians, and horses and things like that. I think lots of people have a vision of it being that and that's okay because it's kind of a romantic vision of Wyoming. It's still a "Wild West." I mean we've gone to state photography conventions and things like that in Arizona, and state FBLA [Future Business Leaders of America] things in Albuquerque, and they ask us if we have indoor toilets. "Do you guys have canned foods? Paved roads?" We're going, "Look, we're not the Wild West." People wanted to know if we had paved roads in Wyoming and we told 'em, "Nope, we don't, we still drive the old wagons, and the wagon wheels, the whole nine yards."

It's tough to walk around Atlantic City with a badge on that says "Miss Wyoming" because nine-tenths of your reporters aren't even gonna look at you. They figure, "They've been in the top ten once, ever. They've never won the thing. They're doing something wrong. There's no reason to even waste our time interviewing them." It's tough to be Wyoming, too, because you're number fifty. You're the last to eat, you're the last to go to the restroom, you're the last to do everything. I mean, they do it by numbers and you're the last. I

was the last in the parade. Every year they switch it. They go Alabama to Wyoming, and then next year, Miss Wyoming will be first in the parade and they'll run it backwards. But in everything else that you do, eating and going to the restroom, you're last. [Laughs] It doesn't matter. You better not drink much 'cause it's gonna be a long time before you get back to the bathroom.

Lots of the girls in the southern states get nose jobs, and boob jobs, and fanny jobs, and things like that. We all use adhesive because what you have to realize is you have to walk. That runway is about a quarter of a mile long and you have to walk all the way down there and all the way back. I mean, by the time you got back, your suit could be seriously riding and your fanny would be to the crowd. And there it would be and it could be on national TV, da-da-da-da! There it is. So everyone uses that. What it is, it's sports spray that they use before they wrap ankles and arms and things like that. That keeps that prewrap stuck and it's real sticky . . . works great!

Miss Louisiana 1970 lives in Wheatland, Wyoming. Real good friends with her. Just a darling, darling lady: Carol Cook. She was just horrified because in 1970 it was more of "If you got it you got it, if you don't you don't" kind of thing. Nowadays, you can get it. Whatever it is you don't got you can get it, and if you got it you can get rid of it. She went back to "Miss Louisiana" three or four years ago, and she's sitting in the audience and there's all these people saying, "Well, you know, that girl in there, she would be perfect if she had a nose job. If we could just thin her nose down a little bit. That girl, right there, she'd be great if we could just give her a little bit more jaw. Well, that girl's almost . . . but her boobs are not quite big enough." Or, "That girl's butt's too big. We could just do liposuction on her hips." They were dissecting these girls,

saying, "She's almost perfect except for . . . and we can do this. . . ." Carol was just horrified. To me that is not what Miss America is. It's not a matter of, "How much money can I spend to make myself look perfect?" It should be more of "Who am I on the inside?" and "What can I bring to this organization?"

It was definitely worth it. What I would give to be able to say, "I was Miss America, 1991," or "I was fourth runner-up," or "I was in the top ten." I mean, that would be fantastic. But I think when I look at it realistically, ultimately unless you win it doesn't matter. Ten years from now, five years from now, no one is gonna know who the first runner-up was, who the second runner-up was, who the third runner-up . . . no one even knows who the swimsuit winners were, who the talent . . . it doesn't matter.

Will they remember me? The big fans of the Miss Wyoming pageant? Yeah, they'll remember me. They'll say, "Oh, in '87 it was Terrilynn Hove, in '88 it was Wendy Willis, in '89 it was Alisa Mavrotheris, in '90 it was Carolie Howe, in '91 it was whoever." Unless the pageant really spreads like we're pushing for it to right now, no one's gonna remember unless, like I say, they're a big fan of the Miss Wyoming Pageant and the Miss America Scholarship Pageant.

Being Miss Wyoming is wonderful. You get tons of publicity for certain things. Sometimes it's tough, though. When you go into a school system . . . to substitute for a day? And all the kids are going, "Pssst! That's Miss Wyoming. That's Miss Wyoming, that girl is." I'd like to sub as Carolie Howe, or Miss Howe, not as Miss Wyoming. So that makes it kind of tough. Yeah, I would love it if in ten years somebody came up to me and says, "Aren't you Carolie Howe? . . . Weren't you Miss Wyoming in 1990?" That would be fantastic. Whether or not it will happen . . . it's real iffy.

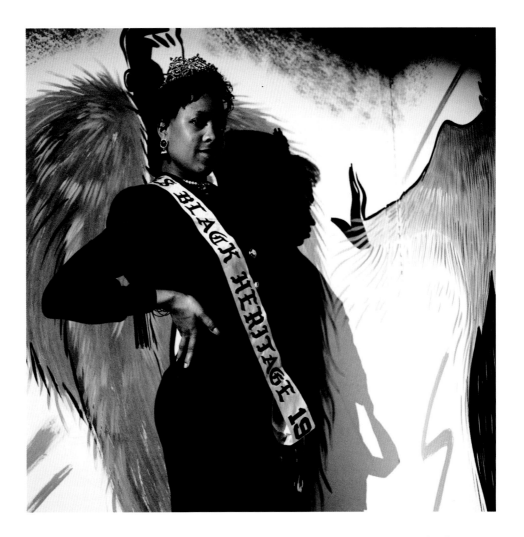

I disagree with people saying, "You guys owe us this, you guys owe us that" from the slavery days. I disagree with that. But we're trying to set something up for ourselves, too. You know what I mean? It's not prejudice or nothing. It's for ourselves. I think it's very important for you to know your own heritage and for you to be around your heritage. And if I could, I would tell these females—especially females 'cause I believe every female should have her own independence— I would tell 'em, "Get out into the world."

CHEYENNE
b. MARCH 28, 1973, CHEYENNE

SANDRA UTTER

1990 MISS RODEO WYOMING

If it had a swimsuit competition,
I wouldn't be in it.

WHEATLAND
b. SEPTEMBER 27, 1967, WHEATLAND

TANYA SCHLAHT

1990 LADY-IN-WAITING

TETON COUNTY RODEO

I do a grand-entry run. I ride my horse wild around the arena and salute. I guess there's always been a lady that's represented a rodeo, and that lady should look good, ride well, be pretty, and communicate well. What makes a good run is to hug the fence and then use the whole arena. Your horse should be movin' out as fast as he can go. And you should be a good rider, and smile the whole way, and make sure your hat doesn't fall off, and wave. You've gotta control your horse, know how to control it, make him do what you want to do, and still be up there looking pretty.

JACKSON
b. MAY 24, 1969, BELLFLOWER, CALIFORNIA

MAIN STREET

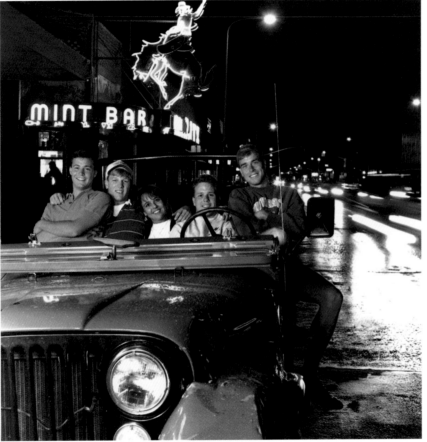

SHERIDAN

left to right:
SHAWN SCHAFFER: b. APRIL 16, 1968
SHERIDAN

CARY HAMILTON: b. MARCH 12, 1968,
IDAHO FALLS, IDAHO

SHELLEY WILSON: b. AUGUST 7, 1963
WABASH, INDIANA

DANNY WILSON: b. APRIL 26, 1967
CELINA, OHIO

STUART HEALY III: b. JUNE 10, 1969
AUGSBURG, GERMANY.

Taking a couple of Mains.

See's who out. Friends and stuff. Everyone usually takes a Main at night just to see who's out, just to see what's going on, and maybe you stop somewhere along the bar on the side of the street or somethin', and go to a party . . . see who's around.

What else is there to do in Sheridan?

Bad question.

It's what Wyoming is: drinkin'. That's about it.

Well, there's going to the mountains and stuff like that—fishin', hunting. But at night you just go out. There's never an organized place. You either go to the bar or you don't go out. It's just the way it is in Sheridan.

It's really bad. Well, there are a lot of towns in Wyoming that are like that, you know?

I think it's great, I mean the way the old buildings are still up and everything. There's still signs on the side of the buildings that say "Brown Palace Cafe" over there by Olie's. It's kind of cool and that.

Well, this is one of the only main streets, I mean, this is a real Main Street when people say "Main Street," you know? This is a Main Street. It's not a strip. Like, in Casper they have CY [Avenue] or whatever, where it's just a big, long strip. This is, like, eight blocks. And it's Main. This is Main Street. The name of it is Main Street.

By God, it's Main Street. [Laughs]

I think you got your point across there.

What I'm trying to say here, my point is . . . it's Main Street, dammit.

We got it.

That's why you cruise Main . . . see what's going on, see if there's a party.

Pick up some chicks!

Yup!

Do girls willingly go into your car?

Oh, come on, you know that one, you dog!

I think, since you're talkin' about the historic value, a lot of kids don't appreciate it, but when you go away and see a town that's totally urbanized and everything's new, you come back and you can really appreciate this 'cause the aesthetic value is wonderful.

People talk about how great the malls are in big towns . . . and they're nice. It's improvement in America. But you can come back here and get back to where it started from, the way it was one hundred years ago, and you can still see that, like these guys said.

My school's by Chicago and that's just the same exact thing. It's a huge metropolitan area. There's no Main Street. But then you

get back a week, you love to see it, and you go down it a couple of times. And in a week you're, like, "I want to get back to where I was," you know? But still, this is somethin' that'll always draw you back. This is a great place.

Just that everybody knows each other. Everybody knows everybody.

And sometimes that's a drawback.

'Cause you can't get away with shoot.

Everybody's related.

Yeah, it's great.

We're talking about inbreeding here.

When do things start picking up on Main Street?

Six-thirty, seven o'clock. Even all day. Just whenever you have a free second, you see who's on Main.

In fact, just today I went over to see Danny. He gave me a ride in his jeep. Included in the ride you have to take a Main.

I've been out of high school for eight years and there is a guy that I went to high school with. I'm walking down Main, driving down Main . . . he's still dragging. Oh, he's even older than I am. He's like thirty-five.

The guy in the gray pickup with a red stripe down the side with blond hair? Chevrolet? And he's always looking at you like he's gonna kill ya?

The "King of Draggin'".

Who?

J. . . . We would come over—okay—Fifth Street? You come off the interstate over here by the Information Center and you come down the Main Street. And that side of Main Street you don't really drag, way over there past Sheridan Center, Super America. But we would come down there and it'd be the Bronc Bus, and it'd be about, like, three in the morning. We'd all be coming in from Cheyenne or somethin'. J. . . . would be driving by, dragging Main Street all the way down.

Some old guy backed over him.

He had scars all over his face, I saw that.

And he's still dragging Main.

That neck brace he had looked like the kind you'd put on so you could go up to Judge Wappner and . . . "He killed me. I've been out of work because of this!" And then you get outta there, you go, "Yeah! God bless America!"

I remember when my sister was in high school. I don't know how old I —still in grade school—and she'd have to baby-sit me. She put me in the back of the car and I'd have to duck down behind the seats so no one would see me while she was dragging Main. She didn't want to be seen with a little boy.

Shelly and Mimi, they'd come and pick me up and give me a ride home like that. Well, they dropped me off two blocks away from the house.

'Cause if we went home, then we'd have to stay home.

Yeah, Main Street was important in high school, big time. Oh, yeah.

You get out of school. In high school there was nothin' going on, you know? Jump down to Main Street and drag Main till five, go eat, and then come back out.

Every time you come home, even still, when I've been away at school, when you get to town, before you go home, you gotta drag. You gotta put Main Street in your route to get home. You might not drag it up and down, but you gotta go down. And that's just kind of the reacquaintance time with Sheridan. It just kinda gets ya back in the mode.

When you're at school and they say, "Whatta you guys do?" And you say, "Oh, well, we take a Main every once in a while." They're like, "Main? What are you talking about?"

It's good to go away so you can appreciate this, 'cause I don't think you appreciate it until you go away.

One interesting thing that's been on my mind is, a couple of years ago I helped a guy remodel a building on Main Street, and upstairs it was an old whorehouse. I mean, this whole Main Street was all whorehouses at one time. It was just really interesting to

see that, 'cause it was still set up. There's little rooms that were probably ten by ten, and there'd be four of them and a bathroom in the middle. You never think about that, but when you're standing in the place . . . that was what this town was based on. There was a guy, I guess he just died about ten years ago. He was a Chinese fella. He walked up and down the streets and when the cowboys'd come to town, it was his job to tell 'em which houses were still open.

He lost a bet with a guy and the bet was he'd never wear a coat again. This guy, in the dead of winter, twenty below zero, would be running around with a white shirt on.

Always had a white shirt and starched, primped, perfect.

His name? I have no idea. But I think he died probably ten years ago, would you say?

That's true. You know, I stood up in that building, and you just look at Main Street and that's what this town was. And that's what every town was in the West from what I was told.

I mean you can go into the Ritz. Sam Jr. and Sam Sr.'ll both say, "Hey, how ya doing, Cary?" or "Dan," or "Shawn," or . . . they know everybody!

Any stories about Main Street?

My biggest pet peeve was when the queen came here. I mean, here's a lady that knighted Ronald Reagan, okay? Now, we know that somethin's wrong with her if she knights Ronald Reagan. But the main point is that the lady comes down Main Street and they have a parade for her. And this is a lady that has . . . I know that this isn't gonna be . . . but I just want to get this out of my system. This pisses me off. 'Cause this is a lady that is representing a country that was a goddanged, that has been the worst . . . I mean Hitler is a preschool teacher compared to some of her family. She comes into Sheridan and these people were on the street going, "Yeah, we love you," waving flags and stuff. God dang it! I've always wanted to say that. That's my little pet peeve.

C A D E T S

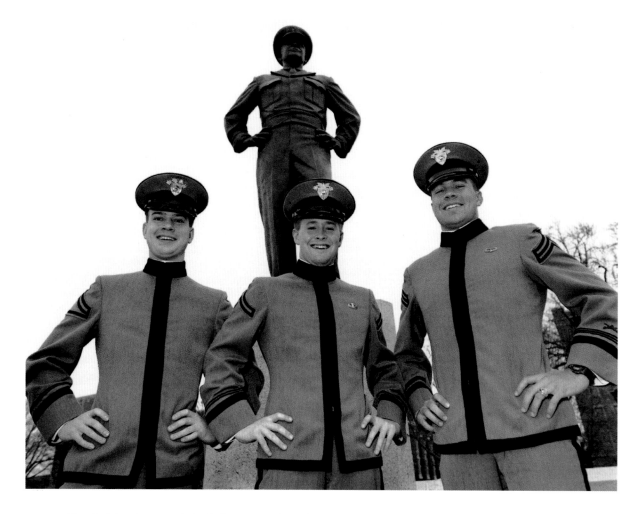

CHRIS: *There's definitely a story behind almost everything that a cadet does.*

JERRY: *These uniforms. They wore these back in the 1800s, some version of this. I mean they changed a little bit, but for the most part this is what the cadets wore a long time ago.*

KURT: *Don't especially like 'em at this point. Starched, high collar. It rubs you raw. It's really hot when you get into a lecture or something. But the good point of it is, you can use the collar to rest your head on when you go to sleep.*

WEST POINT, NEW YORK

left to right:
CHRIS SHANNON: b. FEBRUARY 21, 1970
ROCK SPRINGS

JERRY DULL: b. JANUARY 3, 1970
GOOSE AIR FORCE BASE, LABRADOR, CANADA

KURT ROBERTS: b. FEBRUARY 9, 1969
LARAMIE.

JERRY: I kind of feel privileged, but it's different being from Wyoming in here 'cause you take a lot of crap for just being from such a small state. They don't think we're really a state. They think we're really backwards out there.

KURT: I play it up, too. Whenever somebody tells me that, I say, "Yeah, my dad just got running water in his house last week"—stuff like that. They don't know what to believe. It's great.

CHRIS: People tend to underestimate Wyomingites, seems like. They think that maybe you went to a single–room school with kindergarten through twelfth grade, and the teacher would come and everybody'd give her an apple. After school everybody'd ride their horses home and milk the cows. It's funny after a while. You learn to live with it. I think that we all go through the first same impression. Very disillusioned. You think West Point's such a great school and it's so prestigious just to be here, but then you find out how hard it is. You got all these upper classmen yelling at you and calling you "dirtbag" and many other names that I don't think would be appropriate for the tape. It's really hard and you want to go home. You don't realize how bad you miss Wyoming until you're away from it. I didn't just flat-out bawl, but I'd say there was a few tears shed.

KURT: You give up everything. You give up your way of life. You give up your freedom. You give up all sorts of stuff. But it's not so bad.

CHRIS: They give it all back when you get out, most of it.

KURT: When you're a senior in high school, most people who come here were captains of teams or at least well respected, well known. And therefore they're feeling pretty confident about themselves. When they come here, if you have 1,000 or 1,400 people who are feeling confident about themselves, they're not gonna join together and mold into one cohesive unit. You just have to break 'em down and say, "You're in a new environment. You're expected to do this and this and this. The only way you can do

that is if you team up. And we're gonna help you team up."

JERRY: We'll be better off in the long run for it. I went back to the university—Chris did too—over spring break. I look at me and where my friends are at. They're probably gonna get through college, but I'm gonna get through in four years. I figure I'm gonna have a job when I get out. It'll be the army. I think in five years I can see where I want to go. I'm giving up a little bit but I'm saving money. I'm not partying and wasting my life away getting fat and lazy in college. I feel like I've accomplished something in the three years I've been here. While I'm at West Point I feel like I don't know what I'm doing, but when I go home I can kinda feel like I've accomplished something, which is kinda nice. But when you're here everything sucks, 'cause you have so much comin' down on top. I think it's worth giving up what I did. The worst part's kinda getting behind me.

KURT: I'd say that the biggest advantage of West Point is simply the camaraderie and the friends you make here. I love it but I hate it. And I love it because I've got some really good friends here and they're the best friends I've ever had. They help you through so much. Like when I was really down on the place a few week ago, I had a friend who lives upstairs, just a bubbly type of person. He came down just out of the blue and put this card on my desk. It cheered me up like I couldn't believe. And you'll have friends who'll do that for you here. The downside of West Point is location, without a doubt. Horrible location and they don't have any white capped mountains here. The East Coast has no mountains; they have hills. The humidity, the fog, the weather. In the summertime this was something I had never experienced before. The humidity was so intense I couldn't see across the Hudson River. It was hazy and humid and it was like a sweat box, a steam room, if you will. And there was no escaping from it. From the time you wake up till the time you try to go to sleep, 'cause you couldn't sleep. I couldn't sleep because it was so hot.

I remember talking to a guy at the University

of Wyoming who was a graduate of West Point. I don't remember his name, Captain somebody. Anyway, he told me what it would be like. He told me he remembered endless hours standing in the hot, beating sun on the plain, the apron out there, just wanting to collapse. I said, "Yeah, right, I've been out in the sun before." I had no idea what he was talking about till I got here.

GERRY: Rackin' is vital. I've racked for fifteen minutes, and if you've got fifteen minutes you can fall asleep and feel refreshed and take off, go to close. "Fifteen minute power naps" we call 'em.

KURT: The essence of cadet life is to get sleep. For instance, the way they run you, they just load so much stuff on you that you don't have time for some things like sleep. Last night I got an hour and a half of sleep. Gerry also, I'm sure, has had some sleepless nights just 'cause we don't have time for those worthless little things like sleep. Certainly you're less effective, but you just have to drive on until you get something done. Personally, I go through many periods of nonproductivity just because the only thing that's keeping me awake is massive amounts of caffeine. Sometimes maybe it'd just be better to go to sleep so that I could be more productive when I got up. But then I run into the problem that I don't ever want to get up. For me it's better to just stay awake. Even though I struggle through the nonproductive stages, I eventually get most of the stuff done. It's the funniest thing here: People run back from class 'cause they have an hour before the next class; just to go to bed. Any time of the day. I thought it was funny. The first day I got here really early. It was called "R day" for "Reception Day." I got here really early, got all the stuff done that I needed to get done, and they said," Roberts, go up to your room and wait but don't sleep." I thought that was funny. I just laughed at the guy. I got hazed for it but I laughed at him 'cause I thought," Why would anyone ever want to sleep in the daytime?" I know now why you want to sleep in the daytime.

THE TWO OF US

LEONE: Course, you know people don't say to your face what they say behind your back. But I think they consider us both quite eccentric. All of 'em consider us different. We don't fit the mold. But I think probably my hairdo, my mode of dress, Ralph's love of these whiskers. I think we were different and I think they classed us as eccentric. Now, at one time when I first came down I felt that I should compromise what I'd grown up with, what I'd learned, what I was. I should compromise and be like people thought I should be. But after a while, with being around people, especially learning to be in public business, I discovered that I would rather be myself than become what people thought you should look like or be. I would rather have my own identity.

RALPH: Well, we get along just fine. And after that many years we must know each other so much, I guess we take each other for granted. Pretty steady. We don't change very much from the norm. We have our characteristics, and our ways, and our ideas and that's pretty much it. We don't vary much.

DOUGLAS
RALPH OLDS: b. APRIL 28, 1912, LEWIS, IOWA
LEONE OLDS: b. JULY 8, 1932, DOUGLAS

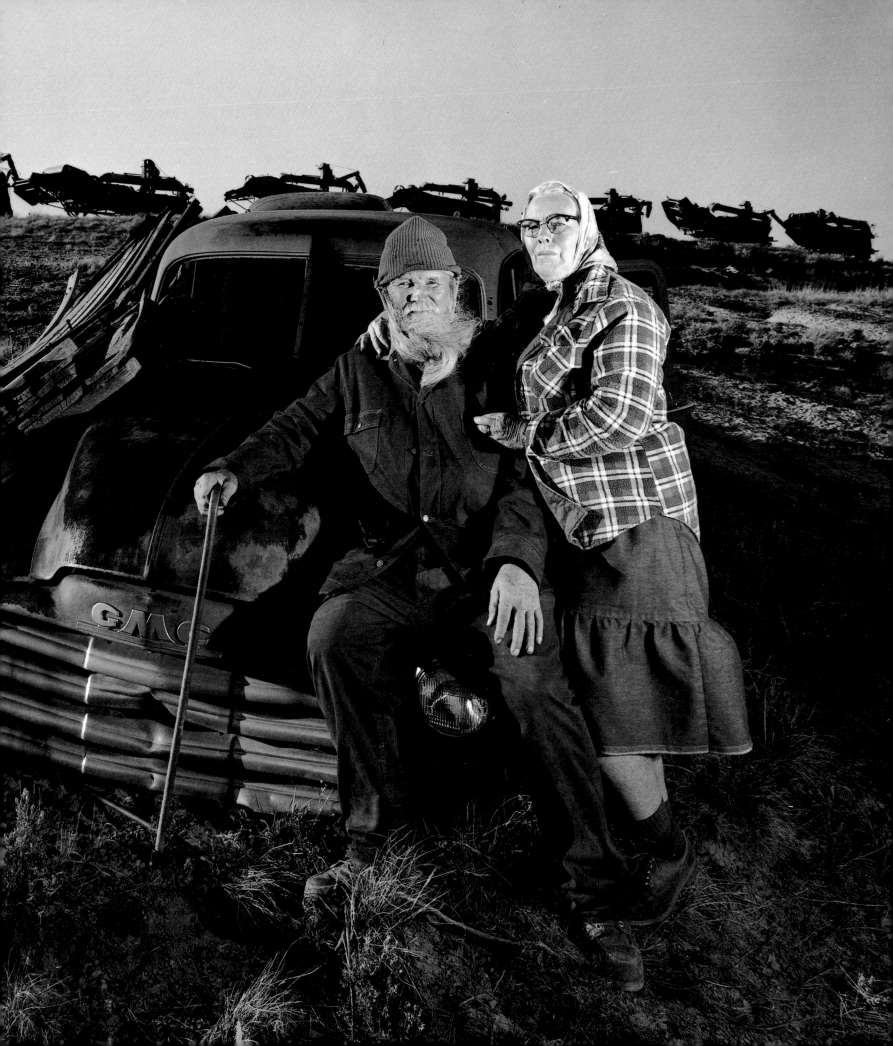

MORGAN & WILDE
CHANDI & BEVAN
GREEN RIVER HIGH SCHOOL

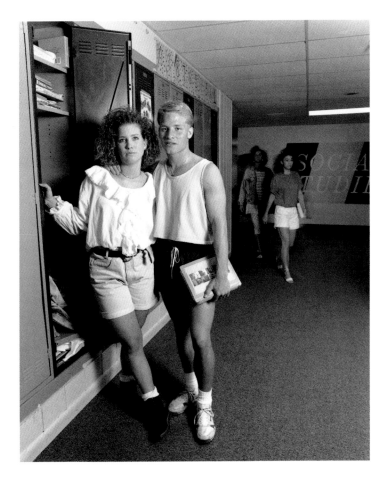

CHANDI: When we first started going out, it was kind of on-off. I'd call it like a puppy love, probably. But then after being away from him, you realize that there's more there than, like what people say, just "dumb feelings." I don't know how to explain it. But now it's, like, when you're away from him, you like really miss him and he's like a part of me.

BEVAN: If I want to skip a class she always makes me go. She gets mad. Or if I get a bad attitude about sports. If I say something like, "Well, I'm gonna get my butt kicked [in wrestling] this week," or "I'm not gonna do very good," she'll get mad at me and tell me I better have a positive attitude 'cause if I don't get a better attitude, then I will get my butt kicked. It makes me think, and I

know I've got to compete. I think, "Man, if I don't do this, Chandi's gonna get pissed off at me so I guess I do this." It makes me feel good because, I mean, my parents aren't together. They're separated and my dad's pretty close to me, but I don't get to talk to him a lot. And my mom doesn't really understand a lot of things, so if I didn't have her around it'd be pretty hard.

CHANDI: He's different than most guys. When you see him with a group of friends it's basically the same. It's like how guys hang out, I guess. But then when you're alone it's a lot different. He's emotionally different. Where some guys always have to act tough and stuff, and be the masculine kind of guy, it's like he understands your feelings, I guess, is what I'm trying to say.

GREEN RIVER

CHANDI MORGAN
b. DECEMBER 19, 1972, GUAM

BEVAN WILDE
b. JUNE 15, 1973, EVANSTON

DAYTON

LUCILLE: b. MARCH 3, 1921
LOWER TONGUE RIVER

HOMER: b. MAY 3, 1913
LETHBRIDGE, CANADA

LUCILLE: That's why the Ground Observer Corps was set up, was for the aerial defense of the country. At that time—it was shortly after World War II—the country had a feeling about the possibility of Russia invading us through the North Pole. So we were trained as members of the Ground Observer Corps. We had to be able to spot any type of plane from the side view, the front or the rear, what type of plane it was, and where it came from. We had a direct line to Sugarloaf Mountain in Cheyenne and we called every time we would spot a plane. We would report what type of plane it was, which direction it came from, which direction it was going. And this was manned twenty four hours of the day. We used this tower as an observer spot. It was the highest building in Dayton.

HOMER: My opinion of it then, I went along with it. I was a soldier and I didn't see that it was gonna do any good. But I was just newly out of the service and I wanted to meet some of these guys. That's why I got involved. And, as always, Lucille and myself

was involved in stuff. The mayor asked me if I wanted to be, and he was a good friend of mine, and I said, "Yes, I'll do this whenever I can." That pin says five hundred hours, so I must have put some time in it.

LUCILLE: When we moved the bell tower from that area, when we determined that we were going to restore it as a town historical marker, we moved it down in the park. We had a sign erected on the building that it was used as a bell tower and that it was also used by the Ground Observer Corps against a possible Russian air attack. Well, that's when we got the flak. Oh, just a lotta people made comment, "Well, they're gonna fight the Russians from the bell tower," and things like that. So we took that part of the sign off, the bottom part, that it had been used by the Ground Observer Corps, and that's all we stated. We didn't say that it was against fear of a Russian attack because it was too hard to explain to people that just didn't understand why and had never heard of the Ground Observer Corps.

HOMER: You know, it might have been just a bunch of hierarchy in the service that didn't have nothing to do and established a few little programs to make themselves look important. That's very possible.

LUCILLE: Well, I suppose when we look back we can feel that possibly there's something to that, too. That seems kind of foolish, but yet at that time we were dead serious.

HOMER: I think the people on that bell tower were as serious as those people in England were when they got out their rakes and their hoes. I think these people really believed in this. And that entered my mind, that the English said that they'd defend their land with their pitchforks, and their rakes, and their shovels and whatever. I think people were halfway afraid of the Russians at that time. I know I sure in hell was, and I dealt with 'em in Korea when they were ornery, mean people in uniform. I don't know about the people themselves, but the people I dealt with in uniform, they were mean people.

OIL ROUGHNECK
KEN McCARTNEY

Like, you tell an older person that your wife works. "Oh, your wife works, huh? My wife woulda never worked." People my age in their thirties, where you both have always worked, well, then they accept it more, I guess. It's more acceptable nowadays than it used to be. It used to be you got married, you supported your wife, and that was the way it was done. But I'm glad my wife has her career, that she doesn't really depend on me. Like my mother. My mother never worked a day in her life. And it seemed like she depended on people a lot more. Because if things were goin' bad and you wanted to get outta something . . . that would stop that, you see? Where, me and Lorie, it would never happen that way. If we ever did split up she knows how to work. She knows how to support herself. She doesn't have that fear like a lotta women have.

We have a very good relationship. I have to do my share of the cookin', cleaning, and whatever. And raisin' the girls. I do my share. There's a lotta men that wouldn't wash dishes, or vacuum, or mop the floor or somethin'. It never bothered me any. I ain't got that macho "Oh, I ain't gonna do that! That's woman's work!" Aw, that's bullshit. No, if the floor needs mopped I'll mop it. If the dishes need done I'll do 'em. You gotta do it. I've done it for years. I don't mind doing it, but I like to cook. I'm a very good cook. I cook just about anything. I can throw a meal right out: roast beef, pork chops. What do you want? Scalloped potatoes? Spaghetti? My girls, they like me to cook.

Gotta find a woman that wants to be married to start out with, that likes to be married. I love being married. If I wasn't married to Lorie I'd be married to somebody else, 'cause I like being married. I like to have the companionship, somebody to know that I can go say, "Hey, I got this problem and let's talk about it." Ya know? She's not only my wife, she's my friend, and she was

I live with three women. Sometimes I say, "Oh, Lord, what did I do to deserve this?"

my friend before she was my wife. Lotta people are married and their wife isn't their friend. It's their "wife." They call 'em "my old lady." I don't do that. She's not my "old lady." She's my wife. You gotta have a certain amount of respect for each other. We get along fine. Always have. We've been married darn near seven years now, and maybe one dispute in seven years, so I'd say we got it pretty well under control. If she's got a problem I got a problem. I think it's the other way around. If I have a problem with something in the world, then obviously she does, too, because if I'm not happy, then it reflects, doesn't it? Sure does. Yeah. We probably got one of the best relationships around.

GILLETTE
b. SEPTEMBER 3, 1957, ST. MARY'S, IDAHO

92

LORIE McCARTNEY

BLACK THUNDER COAL MINE

as some of the men out there, but there's not a whole lot that I can't do and won't do.

He [husband, Ken] is kind of hard to get along with when he works night shift. He's kind of owly. It really makes it a lot harder when he's workin' on the rigs because then he's workin' shift work, and I'm working shift work, and then we really don't see each other lotta times.

They give him a hard time. "I don't even know why you work. Your wife has a good job. You should just stay at home all the time." And he could, but yet, ya gotta do somethin' with yourself, you know? I think sometimes it bothers him, but I guess it's just a fact of life that I was lucky and fortunate enough. And it has no bearing because we consider everything to be shared. Whereas, if yours is yours and mine is mine . . . we don't have that kind of a situation. Our income is our income jointly and what we have we have together.

He cooks 'cause I'm not home. At five-thirty I leave the house to go to work on night shift and I usually don't get up early enough to where I could cook anything, so he's gotta cook. He usually does the laundry and stuff, him and the girls, before I get days off, so that I don't have to spend all my time off doing domestic chores. I think it's great. I feel that it's not all a woman's responsibility, you know. You wear clothes and get 'em dirty, and you eat and dirty the dishes, and it's just something that I think should be shared, especially where both of you work. If I stayed home it'd be different. Oh, I help him out if he needs it. I don't pack his lunch or anything like that. I figure he doesn't pack mine. Whenever we clean or something, we just kinda make it a family thing. Let's get after it and get it done, and everybody pitches in, and we all get with it and it's over with, you know? So nobody really has to carry any kind of big burden.

Well, I've operated D-9 dozers, 9-L dozers—which is just a new style of dozer. I've operated D-8s, 10s, 11s—those are all track dozers. I ran a 988 rubber tire, a 988 loader, a Dart loader—which is a bigger loader. 16G blades, 637 scrapers, haul trucks—all the haul trucks that they have out there— water trucks, shovel, backhoe, and now I'm a dragline operator.

I think it really leads back to the way I was brought up. Because my brother and I were really close. And when he got a new truck I got a new truck, which is kind of strange. I still played with dolls and stuff like that. But no, I've never really wanted to be a man. I've always prided myself because I can do a man's job and be a woman. I try hard and I don't expect for anybody to carry me. I'll admit that I'm not physically as strong

GILLETTE
b. JUNE 22, 1959, NEWCASTLE

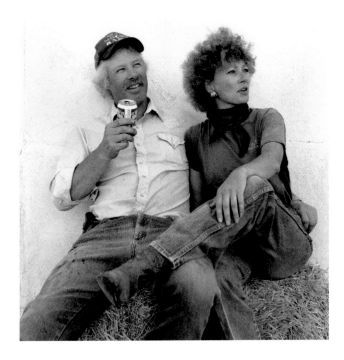

FRANKIE: *Our first date, we went to a branding. We laugh about that a lot. His father and family and everyone was there, and we had a great time which—here, we go again, you know—I was just in heaven, going to a branding. I think it's because I come from a ranch background myself—my mother, my family, are from ranch families way back. It's just kinda what I grew up with. I like horses— always have—and ropes and saddles, and spurs and boots. It just makes you feel at home.*

We're a team. We just pick up the slack for each other. I think that's what's neat about ranch people. Everybody does that.

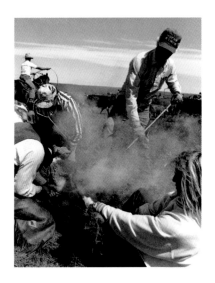

BILL: My aunt said they [Moores] were always very prolific. They liked to chase women and the women liked to chase men.

FRANKIE: They're a wonderful family. They're good, down-to-earth, hardworking people. They're there for you or for each other.

BILL: I think it'll turn out well, there. Frankie and I've both been to see the varmint, there, and she'll be forty and I'm in my forties, so we've already been to see the varmint, so to speak, so I think this one'll turn out real well. "Been to see the varmint?" It's an old Louis L'Amour . . . an expression from the old days. When you go to see the elephant or have been to see the varmint, you've already been and seen what you wanted to do, and did who you wanted to do, and what you felt like you thought you had to do to prove your mark. I've felt like I've already proved myself in life, there. I don't know what I did to prove it, but, anyway, I feel real comfortable with my surroundings and real comfortable with the people I'm around and those kind of things.

FRANKIE: We go way back. I think. Since we're older, you're pretty down-to-earth about things. We've lived some years, we've had a lot of experiences. I think we really know what we want and I think we're very fortunate. I think that we've started at a better place than maybe you would if you were younger. And you just skip a lot of the crap— I don't know what the word would be—but you bypass the crap and just get into the good stuff. I think we're gonna be very happy.

Not to say that it's gonna be a perfect marriage. You're gonna have bumps. I don't care how close you are. You've gotta be realistic. But I think we'll be very fortunate that we've had those experiences. What is the word I'm looking for? We've already been through that, and it's like premium time for us. We're not playing games anymore. You know, we're living the life that we want to, and we're not gonna put each other on. This is it. This is as good as it gets, and I don't think you could get any better.

CONVERSE COUNTY

BILL MOORE
b. JANUARY 10, 1946, CASPER

FRANKIE ADDINGTON MOORE
b. NOVEMBER 16, 1950, PAMPA, TEXAS

GOOSE HUNTERS

MAURICE & RUSSELL BROWN

FATHER & SON

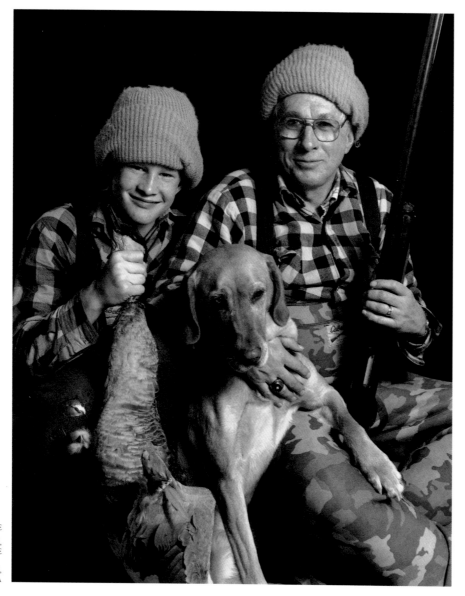

CHEYENNE

left: RUSSELL: b. DECEMBER 20, 1973,
CHEYENNE

right: MAURICE: b. JUNE 23, 1933,
GARRETSON, SOUTH DAKOTA

MAURY: It's great to know that you got your son with you, and he's interested in hunting, and know someday—probably when I get too old to hunt—that some of my flesh and blood'll be hunting here. That's kind of a warm feeling. I hope I'm able to hunt for years and years, and I hope that he'll just get better and better because I'm gonna need some help one of these days.

RUSSELL: I can't shoot worth a lick, and he's a good shot. He's the first one to break a hundred straight at the trap club, handicapped—a hundred straight.

It's fun to hunt with him. We used to have these brush broomstraw lids to the goose blind that you pushed up, and every time he came up his glasses fell off, and his hat went back, and by the time he got out of there he couldn't hit anything.

We're gonna go out hunting tomorrow. I'll probably have to shoot my dad's for him, again.

MAURY: I doubt it, unless I let him shoot it for me.

RUSSELL: He only shoots 'em when they're walkin' fast, though.

ANNELISE & STEPHAN DOMHOFF

MOTHER & SON

ANNELISE: I cannot help it. I'm German and I see potential in him. But he is so *Klutzkopf*, you know. I said, "You can do much bigger." . . . *Klutzkopf, ja,* bullheaded.

STEPHAN: It's the German in me.

ANNELISE: I said, "You can do much more. You can do much bigger." I am more freer and Stephan is more conservative.

STEPHAN: I'm more old German. I was born at a different time. I'm more disciplined, I think.

ANNELISE: Stephan is very disciplined and I'm not very organized. I'm sloppy. He says always, "Don't even tell anybody you are German."

STEPHAN: Oh, no, no, I wouldn't say that.

ANNELISE: "It's unbelievable," he said. "You can't be German!" But I was thinking, "Today, I'm just doing this and tomorrow I'm going to clean up." Nobody has ever shown it to Stephan, nobody's ever told him, but when we fired a kiln—after everything is unloaded—he goes in with a vacuum cleaner and vacuums everything. People come and ask us, "Are you working here? Do you ever fire?"

STEPHAN: But see, when you leave those little crumbs on the floor, and you have that swirling gas in there, and reduction—and I mean it swirls through there—it could pick that up. When it sticks to a glaze and it cools down, you get a "nuggie" on the pot and I don't like that.

ANNELISE: It goes against my grain. I am more impulsive and I do things on the spur of the moment, or when I have an idea, or . . .

STEPHAN: That's great! My mom has all the freedom in the world.

ANNELISE: And Stephan is so organized. He organizes me and disciplines me.

STEPHAN: It doesn't work 'cause my mother doesn't listen. I do what I think is right and my mom goes her way, and it works beautifully.

ANNELISE: I don't dare to be so sloppy any-more, like when I was alone.

STEPHAN: It doesn't matter anymore. If she does it and I don't like it, then I clean it up. I just go ahead and do it.

ANNELISE: No, really, I have to say it rubs off on me and I can see I'm a little bit more organized.

STEPHAN: Mom is more of the artist. I'm more of a potter, a craftsman. But then I'm business-oriented. My mom thinks of pottery and art and what's wonderful. 'Cause we need to have that. But then I take care of the business end of the thing.

ANNELISE: He has a better business head than I do.

STEPHAN: My mom consigned for years and years. It just wasn't working out so I said, "Stop, and we'll just build a building, and we'll sell it here."

ANNELISE: I think it has to do something with upbringing. Stephan has no problem to say, "You owe me twenty dollars, you owe me fifty dollars." I have problems with this. It was in very poor taste to talk about money, the way I grew up. In very bad taste. I can never remember that my mother ever talked about money. It was just not there. And so I still have problems with that and, well, I let the people have a pot. But Stephan, not. He grew up in America, you know. And money is like the daily bread or water, or whatever. He has no problem with that.

STEPHAN: It's not the point.

ANNELISE: Ja, it's the point.

STEPHAN: No, it's just that I have to survive, too. We lower our prices so low that we don't make a great, great living. I mean, we survive comfortably but there's a lot of things we do without. I don't cheat the people, so I don't want to feel cheated in return.

ANNELISE: Well, I just was thinking. It is a happy mesh, Stephan and I.

ANNELISE: *Sometimes I can hardly [wait to] get up in the morning because I know, "Oh, today is my good. I feel it so strongly." Then I don't do anything. I just go into pottery and start throwing. The clay and I are one. But if I don't have it, then I go in the garden and I read. I have to take care of the flowers.*

STEPHAN: *You know when you've got it. You can't tell anybody. You just know it. The clay flows. The clay really flows right from your fingers. 'Cause clay most of the time is very unforgiving. For every inch you get you have to actually fight with clay. But when you get a day . . . it just comes, like, out of your fingers. It just flows like butter from my hands. Everything is just together. It just comes. And that's when you don't stop. You just keep going and going.*

THERMOPOLIS
ANNELISE: b. JANUARY 3, 1928,
HEINRICHSWALDE, EAST PRUSSIA
STEPHAN: b. JULY 24, 1957,
PORT ALBERNI,
VANCOUVER ISLAND, BRITISH COLUMBIA

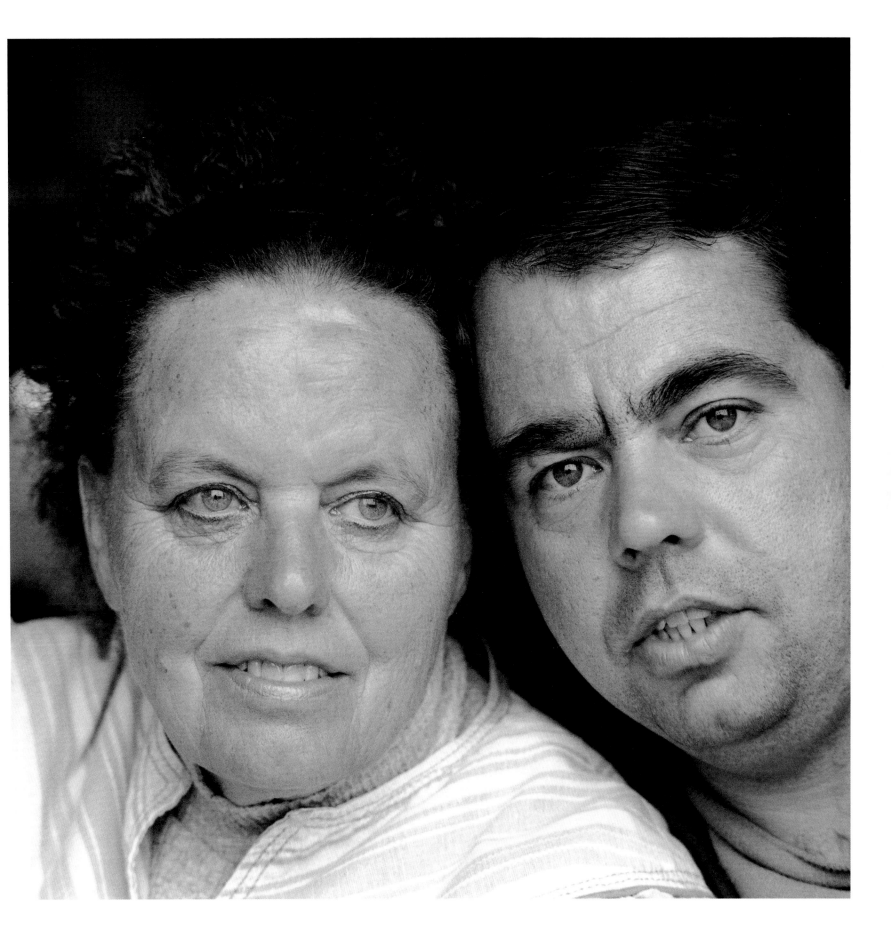

OUTFITTERS

JAKE & TJ CLARK

FATHER & SON

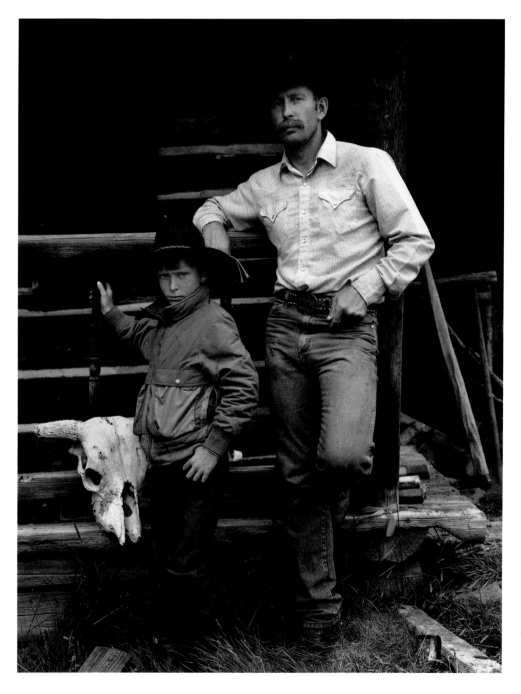

He loves it. Hell, he rides colts for me, breaks colts. I start 'em and then he just takes right off and rides 'em. Ask him how many mules he'll lead in a string. He's got a big story, you know. He'll tell you he can lead as many as you can tie together in a line. He can ride anything with hair on its back. He is a good little hand. But he's been raised that way, see? This boy's mountain-wise. He can go a lot of places. I do this with a new hand: I send TJ up to show him some country, and TJ takes him in there and shows him where to go . . . because the boy's been there. I mean, we started him riding when he was less than a year old, and he's been riding by hisself since he was two-and-a-half, three. He'll lead six, eight head of mules all over. He's just like another hand. He just ain't big enough yet. He just ain't strong enough, you know, to pack 'em and stuff, but he's a damn hand.

POWELL
left: TRAVIS JAMES: b. JULY 21, 1977, POWELL
right: JAKE: b. JUNE 19, 1950, BASIN

CODY & CHUCK JENSEN

BROTHERS

What's the best thing about the Jensen family?

CODY: They help me and they do a lot for me.

What's the worst thing?

CODY: They scream at me a lot.

Why do they scream at you?

CODY: Because I'm a brat.

CHUCK: The only thing I remember really, really good is when he was only two or three years old, he was just barely big enough to be able to hold onto the handlebars of my bike. But he really liked to go riding. I was over in the field riding really slow with him, and when he was that little I had to put him down in between my legs on the tank and then squeeze his legs together against the tank to kind of seat-belt him in there. When you go through corners and there's a rut, the way you ride those is to stick your foot out and really charge through them. When you're going really slow through 'em, they're hard to ride. They try to catch the tires. We were going through a rut over in the field, just playing, and I tipped over. I wasn't going but three or four miles an hour, but I just barely caught and tipped over and he hit his head a little bit. I brought him back and he was just screaming bloody murder. Here he is, just a little three–year-old baby. I thought Mom was gonna shoot me. And as soon as he stopped crying he wanted to go out and ride some more. [Laughs] Mom said, "No more, not today."

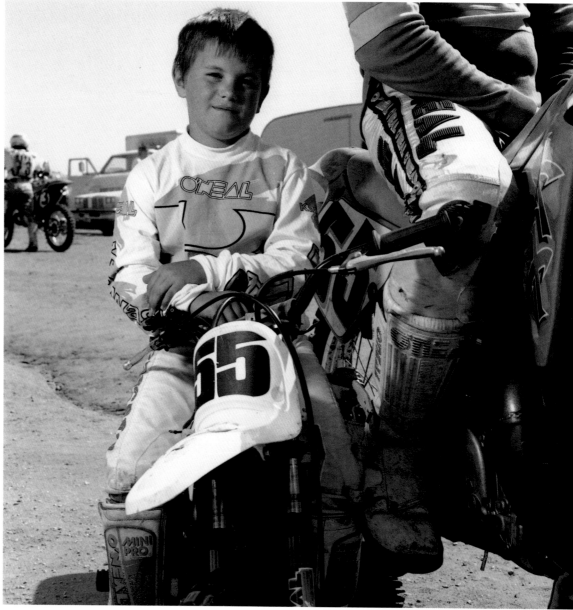

CHEYENNE

left: CODY JENSEN
b. SEPTEMBER 15, 1983, CHEYENNE

right: CHUCK JENSEN
b. JANUARY 13, 1969, SALT LAKE CITY

SISTERS

DESSIE BEBOUT & SOPHIA SVILAR

DESSIE: My mother had all of us at home with a midwife. Fact is, I think she had Eli in the morning and that night she was working, taking care of her boarders.

SOPHIE: Same morning! No, same morning, Dessie, don't you remember? She had him four-thirty or five o'clock and she was up making lunch, and crawled back in bed before the boarders got up so they wouldn't see her.

DESSIE: And I think that's the reason they were so hale and hearty—because they got up and they moved.

SOPHIE: Remember years ago, they'd make a woman stay in bed for what? Nine days? Now they get 'em right up. But mom was up and at 'em.

DESSIE: She was a remarkable woman. She definitely was. I would describe her as the most . . . the ideal, an idol. She was kind to everybody.

There wasn't anybody she mistreated, and she always had the "If you can't say something good about them, you don't say anything." But there's good in everybody if you'll just look for it.

SOPHIE: Well, one thing about Mama and Papa. Nobody knew 'em as "Mr. and Mrs. Svilar." They were "Mama" and "Papa" to everybody. If you walked in and said, "How are you, Mr. Svilar?" he'd look at you kind of funny, 'cause everybody called him "Papa."

DESSIE: We were all baptized, so the Pope [Patriarch] came up from Chicago to baptize the two of us, and on the way back to

Chicago he jumped out of the train window and committed suicide.

SOPHIE: I said, "We were more than he could handle."

DESSIE: Papa just shook his head. He couldn't believe it. And I told Sophie, I said, "The Pope out of Chicago!" This was horrible.

SOPHIE: Guess we were more than he could take. [Laughs]

DESSIE: I'll never forget that. I'm sure we weren't the cause of it, but . . .

SOPHIE: We joked about it many times.

SOPHIE: Dessie and I had more squabbles, I think, than anybody.

DESSIE: Oh, just kids growing up. Naturally you're gonna squabble.

SOPHIE: We had to share. And we didn't share too good once in a while.

SOPHIE: We'd draw a line down the middle of the bed. If she got over on my side it was murder, and if I got over on her side it was double murder.

DESSIE: Then, she's bigger than I.

SOPHIE: Could you believe it? We'd draw a line down the bed.

DESSIE: I always got the raw end. Although you did protect me. If anybody started a battle with me, Sophie'd take my battle up, see?

SOPHIE: I was in a lotta scraps after school.

DESSIE: We talk about it quite frequently, you know.

SOPHIE: In fact, one incident: This Stella Hardesty. They were practicing basketball. At that time it was outside in the middle of winter, you know? No gym. And Ruby, the older sister, was real wiry. She was quite a ballplayer, kinda like Brandy. She took the ball away from Stella, and Stella got mad and hit her, and I jumped in. I waited for Stella to come off the court and I just whaled the hell out of her. I was in grade school and she was in high school. I'll never forget that. Then she got permission to leave school ten minutes before I did. I said, "We're not through. I'm gonna get you after school." For a whole couple weeks there she got permission to leave school before I did, ten minutes before I did. [Laughs] Oh, it's funny what kids'll do. And, poor soul, she's dead now. But we used to talk about it and laugh.

DESSIE: She even got a bang out of it.

Very, very close [family]. And that's what I'm trying to do with my family. I have Eli, Ruby, Nick, Bess, and Mike and they're inseparable. Because I think it's the finest quality you have, when you have a close-knit family.

. . . And my father always said, "Now, Dess"—living in Shoshoni, Papa'd always say—"Remember every year you must give to the church because you've got to have a place to marry and bury from."

SVILAR'S RESTAURANT, HUDSON

left: DESSIE BEBOUT
b. AUGUST 15, 1920, HUDSON

right: SOPHIA SVILAR
b. APRIL 15, 1919, HUDSON

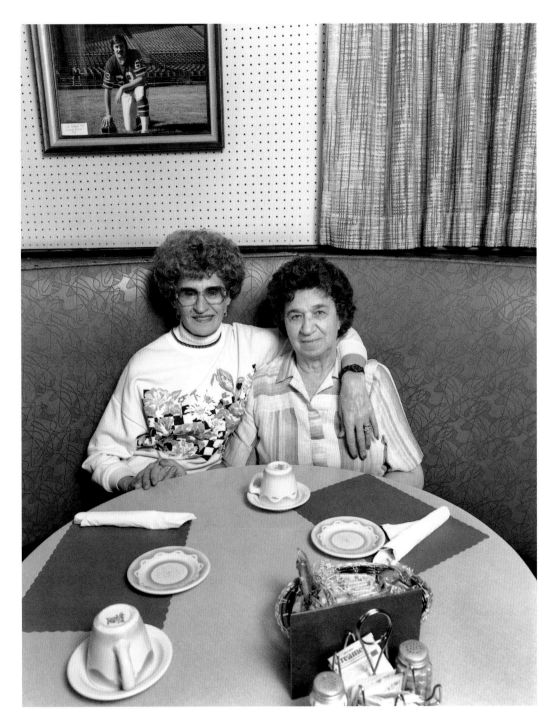

DESSIE: *Now, like in Sophie's instance, she loves people. And people love her. People come from all over just to see Soph. I have 'em call me at Shoshoni: "I stopped in Hudson and she wasn't there." They were so disappointed. So this has been your life, Sophie.*

SOPHIE: *All my life.*

DESSIE: *I think it's beautiful*

RANCHER
S U S I E B O D Y
C R O W N - S R A N C H

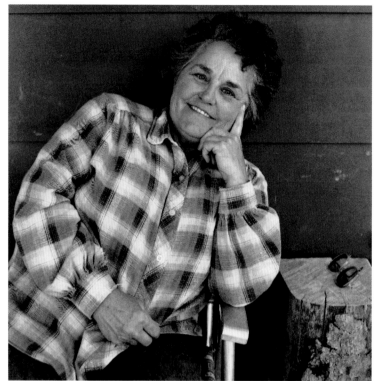

I had two Italian boys stay here for a while and then one left. I asked 'em why they wanted to come over here, and it was from watching television and movies and books. They wanted to be cowboys. They wanted to come to the American West. Wyoming was really their choice, but someone in Italy told 'em the name of a person in Texas. So when they came to this country, they came to Brownsville, Texas. And this man couldn't help 'em. He had retired and lived in town.

They both were business-men in Italy, had small businesses of their own, intelligent, and they had some money when they come over. They bought a pickup and drove the full length of Texas, New Mexico, Colorado, and Wyoming, stopping at places they could find along the way. They were asking for work and . . . "Nope!" Whether it was because they were Italians, they didn't wanta bother—I don't know why. I guess no one even offered 'em as much as a cup of coffee. When they come in here they asked me for a job and I said, "No." And "You sure you don't need help?" I said, "Oh yeah, I need help, but I just can't afford to pay it." You know, just kinda joking 'cause I like to joke. So they kept talking, and kept talking, and finally it dawned on me. You know, here these boys were just so discouraged. They wanted to be on a ranch so bad. I said, "Well, now, if you boys'd like to stay here while you look for someplace to find a job, a place to stop and stay, why, you're welcome to stay here for a while." They impressed me favorably. Wasn't worried about it or anything. They seemed like such decent young men, so discouraged, wanting so bad to be on a ranch, and nobody'd give 'em a little chance. So I told 'em that they could. They wanted to know if I had a place for 'em to stay and I says, "Yeah, that bunkhouse." I says, "Not mod-ern or anything, but you're welcome to stay there for a while, if you'd like. Well, when I said they could stay, they said, "We take, we take!" They said, "You have to think about it?" And I says, "No, I don't have to think about it. I just want to give you a chance to find . . . "We take, we take!"

That's how it started. They loved to be horseback. They both had horses in Italy prior to coming over here. So they did know, basically, how to ride. But it didn't make any difference what I was doin'. They just loved it here and they was just willing to do anything: clean the shop, fix fence. What really got their goat—I had never thought to mention it—they'd never been around calving. The first time they saw a cow eating afterbirth, it just about got 'em. "Why didn't you tell us they did that?" [Laughs] I never even thought about it.

Well, they both left and one (Val Valerio) came back and stayed longer. He is trying des-perately to get a green card or a work permit, or be able to stay in this country. Of course, I have a little outfit and can't really afford to pay wages that are required now. I couldn't help him get a permit to work in this country, so he went to this other ranch and they are attempting to help him now. I loved having him here and I miss him now that he's gone. He went back to Italy for Christmastime to visit his family. He'd been over here just over a year, and he called me Christmas Day from Italy and said, "I just had to call my American mom and wish her a Merry Christmas," and it was neat. He's just a real fine young man and I really enjoy him.

He's gonna be successful one way or the other. He is that determined. He may have to go back to Italy and start over. But I've been satisfied that he will, some way or other. It seems so funny to me that this country makes it so easy for some people to come in, even some undesirables, but a real fine young man like that, that really wants to work and accomplish . . . he's havin' such a hard time. It really seems a shame.

BATES HOLE
b. SEPTEMBER 29, 1931, CHEROKEE, IOWA

RANCH HAND
VAL VIGNATI
CROWN-S RANCH

One thing I always said, told everybody, "I don't know nothing. I know that I'm gonna make a whole lot of mistakes because I don't know what I have to do." People starting to get mad, telling me I'm wrong. I won't argue. I won't tell you, "Who? Who do you mean?" I won't get mad because he told me I was wrong. Because I need to learn. Course, in working the livestock and everything, you can tell me that cows fly and I'll believe that. If they say that, probably it's true. Maybe when they get old they can start flying, I don't know.

No, I'm not here for the money. Not at all. I really like the kind of life. Up here it's quiet. You don't have the life in the fast lane like in the city. I used to worry about, "Lock your door!" "Watch the car!" "Watch the radio!" and do this and do that. "What time is it?" And I can't stand that. I mean, I got really sick about that. I don't even wear a watch anymore. I don't care. "What time is it?" "Four minutes?" "Oh, I gotta see that guy half an hour." Rush here, go there. Then go home, and the phone, and the call, and the taxis.

I like Wyoming people. I feel sorta like Wyoming. You know, I went to Texas for a few months and the only place where I want to get back was here. I know I got homesick for Italy. I got homesick for here. It's the land, the people, everything around here. I mean, I don't know what it is but it's the land. Oh, the land, of course, I think it's beautiful . . . so quiet. And then the people, too. I think I like the people. There's only one person I don't like. It's a neighbor up there. Otherwise everybody's so nice and kindly.

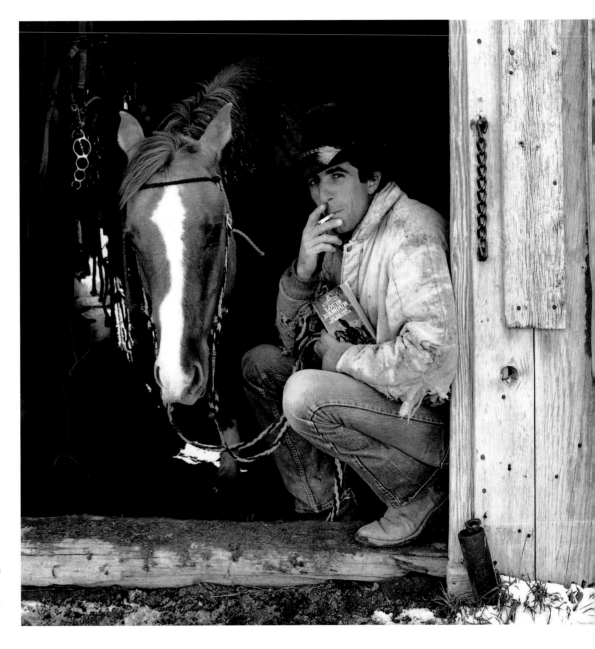

BATES HOLE
VALERIO VIGNATI
b. JULY 27, 1961, LEGNANO, ITALY

SCOTT FREEMAN & MARK ROBERT

UNIVERSITY OF WYOMING

MARK: I was fooled, see. I got the warm weather when I come up here. I came up in May, and the day was beautiful and I had a great time up here. Had a couple people take me out, and had a really good time. Coach Kinneberg offered me the most in terms of amount of scholarship, so I decided to go ahead and go with it. But a little side note: When I left, it started to snow. I already signed my letter of intent.

SCOTT: I'm from Denver. We've had to clean snow off of our field. It's not that big a deal for me. I mean, it's hard on the arm and the player to come up here and throw when it's really cold, and hopefully no one gets hurt. But it's the same thing in Denver. We start snowmen in the outfield and roll 'em to the fence to get the snow off the field. It's just one of those things you learn to get used to, I think, being from the Rocky Mountain region.

MARK: I heard a story. I haven't personally experienced this, but a friend I know plays for San Diego State. They came up here, oh, I guess it was three years ago? Something like that. Anyways, they were playing on a day when the wind was blowing about—I don't know—probably between sixty and seventy miles an hour. The windchill factor was around ten and it was blowing snow and everything. The outfielders had sweathoods over their heads, with their caps over their hoods, out in the outfield playing in a game. They wore batting gloves on both hands. Anyways, this one guy hit a ball that started out about over second base, and my friend was playing left field. The ball blew from over second base all the way over to left field and close to the line. It blew all the way over. He put his glove up, and the ball came down and went off his head, and went to the fence. The guy got a triple out of it.

SCOTT: There's been times when it's been kept in, and times when it's been blown out

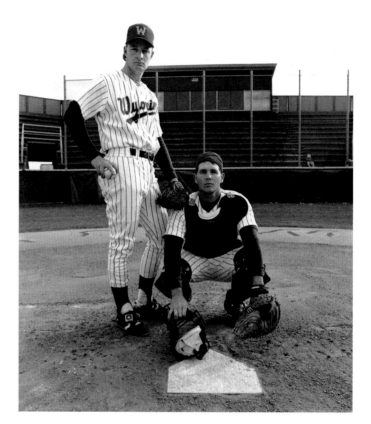

by the wind. I think it all evens out in the end, eventually. We played San Diego State one year and were taking BP [batting practice] before the game, and nobody's wearing sleeves or anything. Everybody's got their sleeves rolled up trying to get some sun. It's just a beautiful day. And, like, ten minutes before the game starts, here comes the clouds start rolling in. Everybody puts their sleeves on. And about halfway through the game I'm out there on the mound and snow's coming down. Like, you can't see home plate 'cause snow's comin' down? We play for a little while, and then just stop and wait for it to stop snowin'. Then the grounds crew gets out there and cleans it off like they did the rain today. We get back out there and start playing again, and about two hours later the sun's on its way back out.

LARAMIE

left: SCOTT FREEMAN
b. JANUARY 24, 1969, DENVER, COLORADO

right: MARK ROBERT
b. OCTOBER 18, 1968, SAN DIEGO, CALIFORNIA

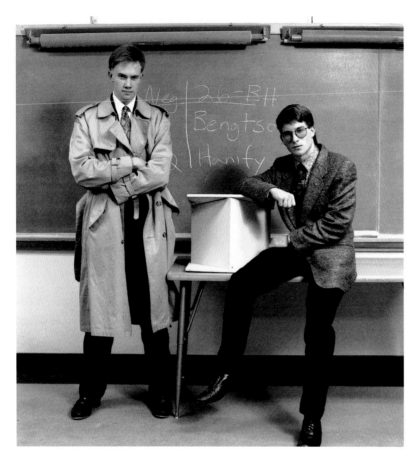

BENGTSON: I think one of the biggest things about C-X [cross examination] debate is, we have to work together as a team. We have to complement our own weaknesses and we have to work a certain case together. We have to work our philosophies so we're not contradicting all of our arguments in any way. I probably am more oriented towards the type of judge that would be very mechanical, would listen to each of my arguments as I'm talking fast. Brian probably could slow it down and explain a little bit better, but I might be able to get more arguments out.

HANIFY: 'Cause there's also a little speaking thing that I do. It's called extemporaneous speaking, where they give you a topic and you have thirty minutes to prepare a five- to seven-minute speech. I've done that forever and I do pretty well in it. I'm very persuasive in it, and very smooth and flowing, usually. Brian is very quick-thinking—you know, subpoint one, two, three—and I'll say, "Look, judge, if you look at what you have in this round, you have this and you have this." And that's what I do. There are judges that like that.

BENGTSON: I've learned a lot about how Brian organizes his thoughts and how he thinks. I think if two debaters are together a lot, they're thinking about the same things quite a bit. Right now I probably could tell you in a debate room what he's gonna think, and he probably would know what I'm gonna think.

HANIFY: Oftentimes. But now and again he'll tell me to do something and I'll go, "Oh, I didn't see that before." There are times in which we can predict each other, but there's also times when they can point out something that was just in front of our face and we couldn't have seen it.

HANIFY: You pick up traits of the other person. You're around him so much there are things you start saying that sound like that other person.

BENGTSON: And there are also things that you just don't like about the other person, that begin to irritate you a little. Between Brian and I there's not a lot of hostility at all. We antagonize each other quite a bit, but jokingly.

HANIFY: We poke fun at each other a lot.

BENGTSON: Brian does it more than I do.

HANIFY: Oh, that's 'cause he takes it.

HANIFY: This is the best high school activity that you can do.

BENGTSON: You will learn more, if you take debate, through researching than any other class or activity, and you'll become more of a well-rounded person in debate than in any other activity.

HANIFY: We're not anti-jocks or sports. We're both big sports fans. But sports just don't have something. We learn a vast amount, but we also learn about just speaking.

BENGTSON: It teaches you a lot about life, that life isn't fair, and that you can achieve your goal if you just stay at it.

WORLAND
left: BRIAN BENGTSON: b. AUGUST 7, 1972, CHEYENNE
right: BRIAN HANIFY: b. JANUARY 19, 1973, WORLAND

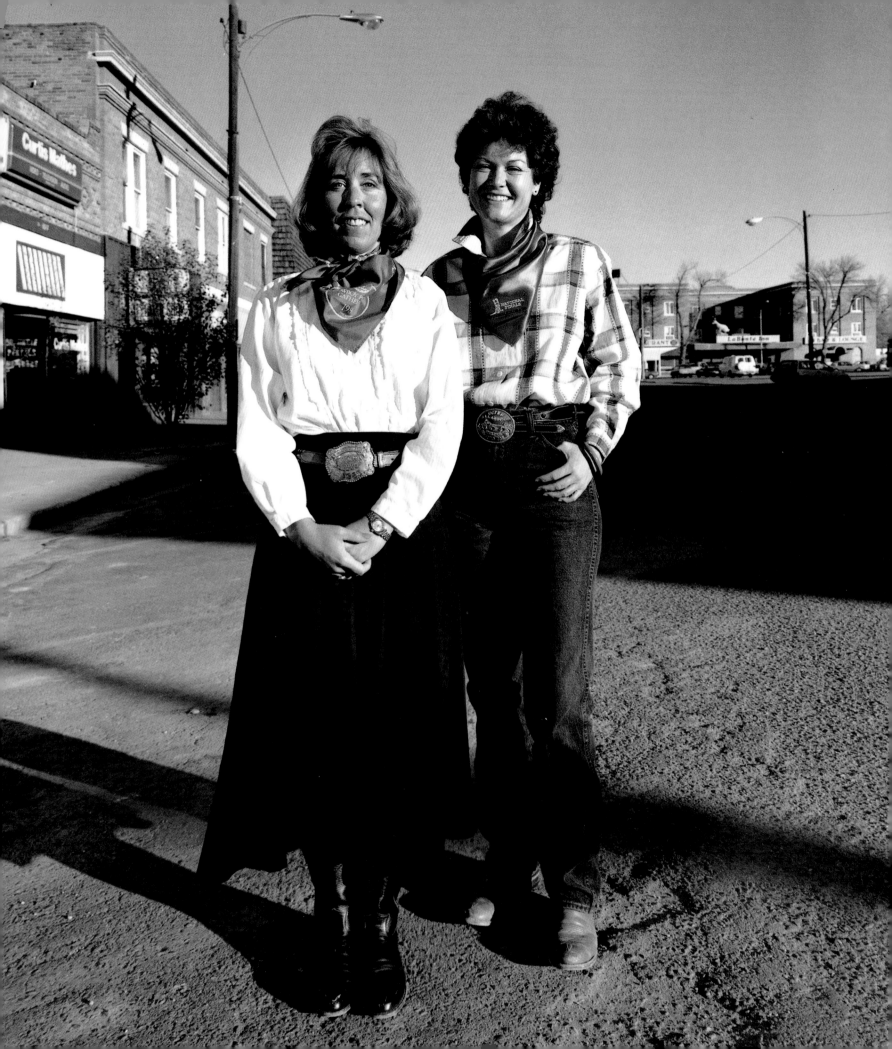

TINA BURKE & ECHO ROY

TINA: *We both married into a Catholic faith which we both took very seriously. We took that vow very seriously, and we took that faith very seriously, and we raised our children in that faith. We both went through a divorce within a short time. We both moved to town. We both came from very strong, very proud ranch backgrounds. We were both very, very proud of that. It was a lot of what we were. And I think when we left the ranch—I can't speak for Echo—I felt like I had lost a great deal of my identity. I had lost a part of myself when I moved to town. It was hard. The parallels continued. We each lost our father. We know what's it like to not be able to have our fathers to go and talk to. We've had a lot of cancer, we've had a lot of trials. And now, someplace down through the years, we both wrote poetry. I wrote mine through inspiration.*

ECHO: I wrote mine through desperation, I think. I started writing poetry, probably, in the early eighties. It was when my marriage was falling apart. And I just started writing and walking to deal with that frustration. A lot of the first poetry I wrote was more what you would call free verse. I did write a few pieces, however, and I didn't realize I was writing cowboy poetry. I was just writing and it happened to have rhyme and meter. It was about things that I had experienced and knew. I had never heard the term "cowboy poetry."

When I started visiting with Tina, she had a trauma in her life. I just called her one night and said, "I'm here if you need me." She called me a few weeks later and said, "Would you like to go to a cowboy poetry gathering with me?" I said, "I have not a clue what they are." She says, "Well, come along, then." And she took me to Cody, Wyoming. We spent three of the most wonderful days sitting and listening to old-time cowboys sing their songs and recite their poems. I've been hooked ever since and it's been about a year and a half ago.

TINA: I think there's some absolutely marvelous cowboy poets in Wyoming, and I think the tradition is very strong. The ethic of cowboy poetry, the things that it has to be: it has to be rhymed, it has to be metered, and it has to be written by authentic cowboys. And there are plenty of authentic cowboys in Wyoming.

ECHO: To be authentic it has to be from someone who has been there, lived it, experienced it, felt it, known it. It's our way of saying what we really feel and think about our life. If you've not done that, granted, you can maybe sit down and put some words on paper. But the feeling isn't there, the emotion isn't there, unless you've lived it.

TINA: Every poem I have ever written had to do with a specific incident. Every poem I've ever written is an absolute true story. It's not just some hypothetical fiction. You know, I see a beautiful mountain and I think someday I'll write a poem about it. No, huh-uh. It's my life. Anybody can just read my poems and that is my life. Something that happened to me at Laramie Peak—I could sit down and write a story about what happened, but I couldn't sit down and write about Laramie Peak.

ECHO: A cowboy is an ethic, a feeling, a mentality, a way of life. He chooses that way of life. There's a very fine line there between someone who just one day wakes up, and he's thirty-two years old and decides to be a cowboy, and is athletic enough to be able to do it, and can afford to buy the horse and do it. There's a difference between him and someone who was raised with all of it around him and who has experienced all of it. And I don't just mean in an arena. I mean someone who has been out in the middle of a pasture in the middle of the night pulling

DOUGLAS
left: TINA BURKE: b. APRIL 13, 1954, CASPER
right: ECHO ROY: b. APRIL 1, 1949, DOUGLAS

a calf, building fence, stacking hay when it's 100 degrees, docking lambs, watchin' your grass burn up.

TINA: I would say that there's a great deal of rodeo cowboys who have real strong ranch backgrounds. I just grew to love rodeo, but all of my cowboy experience came from ranch work and living on a ranch, from the eighteen, nineteen years that I've spent in Carbon County on my parents' ranch and then the other thirteen years that I spent involved in ranching when I was married. I didn't just see it, I did it. I fed the cows.

SIDE BY SIDE

We welcomed the storm, as a sure sign of spring:
Green hills follow a late April snow;
But death came on the wind as it howled from the north,
A blizzard—the worst, I hope, we'll ever know.
For three days the cows fought against it,
Until the hair had been beat from their hide.
With their backs humped up and covered with ice,
They suffered there—side by side.

They stood with their backs against the barrage;
Protecting the young, best as they could.
The rain turned to snow, then the snow into drifts;
The calves began to drop where they stood.
The fence held the cows for the first couple of days,
As the storm came in waves like the tide;
By then the lead had been pushed to the ground,
And they perished there—side by side.

The cows moved out from in front of the wind,
Blindly they fought from the blast;
Each fence line and cutbank for miles and miles,
Claimed the ones that gave up at last.
When the storm finally broke, we followed their tracks,
For a ten mile stretch, and we cried.
Back down that trail, we brought them home,
Poor cows, tiny calves—side by side.

We spent long hours horseback, and many on foot,
Looking for just one more calf left alive;
The loss was shared by our neighbors and friends;
How we prayed, that we all would survive.
Calves without mommas, and cows without calves;
On the feed ground we tried to pair up a few;
Some cows wouldn't claim their own tiny babes,
And the next cow would leave, taking two.
The twenty-hour days all ran together;
We tried to forget the good cows that died.
We asked God to give us the strength to go on,
As we collapsed each night—side by side.

—Tina Burke

ECHO: I don't mean to take away from the word "cowboy." When you say "cowboy," you're thinking of a man, right? You're thinking of a man and you're thinking of someone who looks the part. You're not thinking of where he's coming from, where he's been, and what he's done. He or she. And when I say "he," I mean people. Because Tina and I consider ourself cowboys.

TINA: Not "cowgirls" because that's got a connotation that I don't like. I feel like if you're a cowboy it's a way of life. Cowboy is a job description. And I feel like we worked hard to earn that distinction. That you could go out and be a cowboy on an outfit. They don't hire "cowgirls." If they want somebody to come and work for 'em, they put an ad in the paper for a cowboy. That's a job description.

I know that when I've gone on stage, this is the one thing that I have fought—if you want to say fought—and it's been a very easy battle, really. But there've been an awful lot of people who have looked at me, like, "Oh, are you sure? Are you sure you've really been there? Are you sure you've done it?" Because I always wear a dress when I go on stage. But that's part of the way I was raised. My mother insisted. If we were country people, she insisted that I wear a dress when I went to town. We dressed up. And that was the only thing I knew how to do. So when I went to town . . . and the first time I ever did cowboy poetry, I put on a dress 'cause I thought it was the thing to do. I thought it was only proper. People looked at me and thought, "Well, she can't be a cowboy 'cause she's standing there in a dress." So then my poetry had to prove that I was a cowboy. I never, ever had another problem.

ECHO: I think the thing here that a lot of people miss . . . in fact, I wrote a poem about it, and it's the way Tina and I were both raised. When I was growing up there was never a differentiation between me and my brothers. We were four kids. We were hands. And if Dad needed a job done he didn't say, "Son, you go out and do this. Daughter, you stay in the house and cook." That was never, ever done. If he needed four people to go out and ride for him that day, and he had four children, those four children went out and rode, and it didn't matter which one was a girl and which one was a boy if he needed hay stacked in the summertime. The poem's called "Equal Rights." I mean, you know the difference between boys and girls, granted. But Dad did not measure people by their sex. We were measured by what we could do. And if I was better at one thing than my brothers, it didn't matter that I was a girl. Whoever could get the job done and get it done right. We weren't raised that we were girls and they were boys. We were raised that we all worked on a ranch, and a job had to be done, and whoever could do it and get it done . . .

DAD BELIEVED IN EQUAL RIGHTS

In this modern day and era of ours
With women's rights and the E.R.A.
I wish my dad were alive
Cause I'd sure like to hear what he'd say.

Whether God had made you a boy or a girl
When there was work to be done
It made no difference to Dad
He taught me right along with his sons.

Growing up in the country
On the prairie where the buffalo roam
As winter set in and the cows needed fed
He never made me stay at home.

As dockin' time came round at the ranch
And hands were needed to hold
He didn't have to ask me to help
It was expected without my being told.

When at summer's end in the meadow
And it was time to stack hay
I don't ever recall his saying,
"You're a girl, please get outta the way."

And at gathering time in the fall
The horses were wrangled to ride
He never said, "Honey, this is man's work
And today you'd better stay inside."

On a ranch there's always something to do
And we'd often beat the sun to its rise.
Dad didn't measure his hands
By their gender, ability, or their size.

As is true of the cowboy ethic and way
You can prove your worth with try,
That's how he raised us all
And it was never questioned with a why.

Now there is a difference and he knew
So right here I'd like to state
To prove that Dad was a gentleman
He'd sometimes say, "I'll get the gate."

—Echo Roy

TINA: Now, my family was slightly different. Because there was a great differentiation between men and women. Mine was a very old-world, Finnish family. And this is what's strange. I find it slightly hysterical, because it was the women who really were the ones

that laid the laws down and held it all together. But in our family it was a given that the women never went out. I mean, we did go out and work, but the men made the decisions. Maybe after a pillow talk the women said, "By God, I don't think that's right," and the next day the men would come to the breakfast table and say, "Well, I think I changed my mind. I think we'll do it different." But it was always the men who said. Even now I face a lot of discrimination within my own family, the fact that I do cowboy poetry. I have people in my own family who won't speak to me because I'm a woman and I go on stage. They're embarrassed.

ECHO: Tina was one of 'em that kind of broke the ice for the rest of us 'cause she's been at this for four or five years. She was the first woman on stage at Elko, Nevada, at the academy awards of cowboy poets, if you will.

TINA: I consider it the national finals of cowboy poetry and I was the first woman to ever go on stage. For the night show—it's the big finale. They'd always had wonderful men cowboy poets for the first two years. I was there the third year. I was asked, "Do you think you could do this?" Sheer terror! In front of 3,500 people live, and TV cameras and stuff. I was terrified. I didn't dare tell 'em I didn't have the foggiest idea what I was doing, that I'd never been backstage. I didn't know what all those ropes and pulleys and all that stuff was. I didn't dare.

It came back, again, to the cowboy ethic. You don't give up. You don't know how to quit. When you should, when you should say, "I don't know how to do this. Wait a minute, 'Uncle.'" You don't know how to do it. You just "cowboy up." That's the term. You just "cowboy up," and I just walked out there. All I could think was—and I think I thought "Wyoming" at that point—"I don't dare let Wyoming down. Wyoming's the Equality State. Might as well put the first woman cowboy poet on stage." Because Baxter Black was the emcee that night. He says, "We've got a little gal here from Wyoming." Then I'll never forget his words as I walked offstage. He said, "Well, I think Wyoming should be proud."

I never once, ever thought that I was a woman. It wasn't until after I was on my way home that I began to think, "Gosh, I was the first woman." I never thought about it. All I could think was, "I didn't dare let Wyoming down."

ECHO: Tina and I started out years and years ago together, workin' in a [rodeo] crows nest. But neither one of us competed in the game. We're just not the hands a'horseback that the other people are. Tried it, and I just don't have the skill it takes to do it. So you follow your husband around and you sit in the stands all day watching this. And team ropin's a lot like sex. Helluva a lot of fun to be doin', not a helluva lot of fun to watch. It's an old team-roper joke, sorry. After a while you can only watch so many runs. So Tina and I both became involved for the very same reason. It helps make the day go faster and you're part of the group. You're doing something. You're actually working while you're there. There's a certain group who wonder why two single women follow around ropers. So I wrote this for them. And it's called "Here's to Groupies." I guess that's a statement from Tina and I both to the world.

TINA: That's our statement.

HERE'S TO GROUPIES

Hangin' round the rodeo crowd
When you don't compete at their game
Makes those who don't understand inquire
And attach these cute little names.

Well, buckle bunny I'm not
It's just with cowboys I relate best.
They talk my kind of language
And I've followed their circuit since leaving the nest.

Even though I can't rope or ride too well
It's the life I grew up with and know.
Life has dictated other choices for me
And those talents He didn't bestow.

Then Tina took me to a gathering
There were cowboys and poets all around.
They made me feel right at home while there;
The two make a winning combination I found.

So whenever you see me hanging round
At a roping or a gathering for poetry,
Think what you will of me my dear
The truth is I'm just a cowboy groupie.

—Echo Roy

TINA: I love cowboys. I'm in love with a cowboy now. What did I tell you that I heard the other day? Did I tell you this? That

there's three things that get more respectable with age: politicians, public buildings, and prostitutes. I said I think old cowgirls would fit in there somewhere, too.

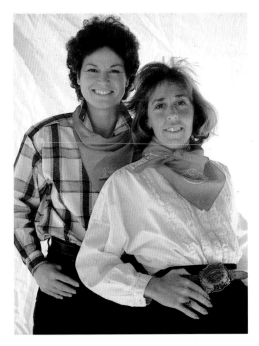

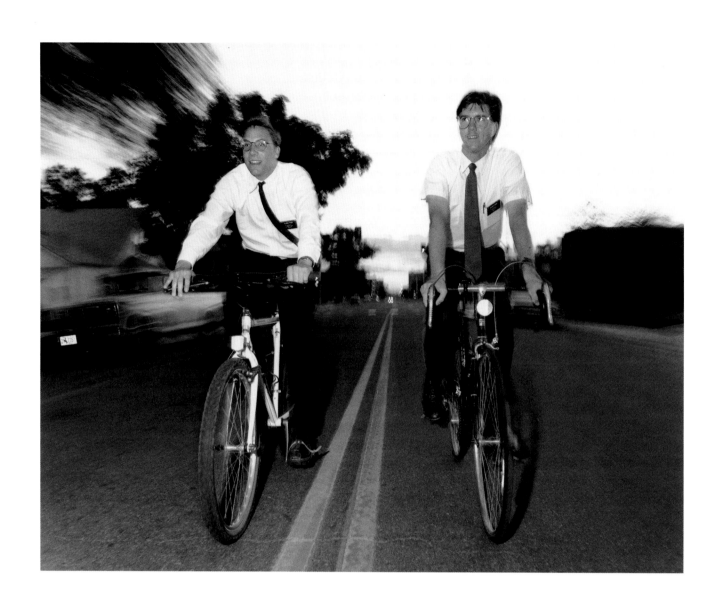

ELDER JAYCOX: *It's a cheap form of transportation, I think, is the major reason why we use them. There's a joke about "Why do you dig eight feet deep when you bury a Mormon missionary?" "'Cause you have to bury his bike along with him." I mean, it's kind of dumb but I can see where they could get that.*

CHEYENNE

left: ELDER JAYCOX: b. AUGUST 4, 1970,
ORANGE COUNTY, CALIFORNIA

right: ELDER PUGH: b. JULY 26, 1968,
LOGANSPORT, INDIANA

ELDER JAYCOX: Oh, yeah! We glow in the dark. We do.

ELDER PUGH: They want us to be . . . a lot of missionaries would try to get away with extreme dress, dress in anything.

ELDER JAYCOX: You know, going in Megadeath T-shirts or something. I think it is the same theory: Why does a businessman come in with the suit and tie? It won't matter, but I think the point of us dressing like this is that people are going to take us seriously. But there are gonna be some people that say, "Well, you know, you guys don't look like missionaries." If we were to go in collars, Catholic collars and everything, then they're gonna pay attention. I mean, wouldn't you? If you had a guy that looked like a Catholic monk come to your door?

I served down in Aurora [Colorado], and I've had little kids come up to me and say, "Are you guys FBI?" [Laughs] That's the truth. If we came up to people's doors in Aurora there'd be three reactions: They would not be home, they would be home and hide, or they would certainly come to the door. I think it gets people's attention if nothing more.

ELDER PUGH: You get used to it, though. You get used to people staring at you. People look.

ELDER JAYCOX: I've had companions that have gone home who say, "Well, I feel weird now 'cause I'm not wearing my tag and I'm not wearing my white shirt and tie."

Different areas I've been in, you get real good reception. Some towns I've been in, you knock on a door and they'd let you in. Or you stop somebody on the street and even if they didn't want to hear anything about it,

they'd be real polite. On the other hand, I've been in areas that they'll scream out the windows of their car. I had some guy in Littleton [Colorado], I mean, he started preaching from the Scriptures from his car. We were just walking down the street and this guy pulled over. He was going kind of slow, rolled down his window, and he just picked up this book. We figured it looks like Scripture—you know, the Bible. He was talking to us and telling us where this certain scripture was, and that you didn't need the Mormon faith. All's you needed to do was just believe, and if you didn't believe, then you were going to hell. Then he told us we were going to hell and he drove off. [Laughs] You know? And we didn't get a word in edgewise. The man was different.

ELDER PUGH: You hear a lot of missionaries say—both of us are an exception—"Ever since I was three years old I wanted to go on a mission." I didn't even have hardly any thoughts about a mission until I was around nineteen years old, and didn't go until I was twenty-two. So I'm a little older than most of 'em. But my parents never pressured me to go. It was kind of loose. When I started talking about going, thinking about going, people would encourage me to go. But I was initially the one that brought it up.

ELDER JAYCOX: See, I've been out almost two years. He's only been out a year. We get transferred around a lot. I've had fifteen companions other than him. We didn't actually come out at the same time. They don't pair missionaries together and then keep them for two years. They transfer 'em around a lot.

I've had companions at times that I just did not get along with at all for one reason or another. Well, just to give you an example: I had a companion who, all he did was sports. Basically, his whole life was sports. And I'm not a sports person. I'm kind of an analytical-type person. I like books. I'm a bookworm. And you know how those kind of personalities clash. On the other hand, there have been things that fit perfectly.

ELDER PUGH: I think we all have the same problems. You have to be with this person all the time, twenty four hours a day. Basically, we're told to always be together. And if you don't like something about them, well, you can either just be annoyed or you can learn to adapt. I think that's a really important thing in the missions, is learning to accept people. You can't always get your own way. I like to think I adapt well.

ELDER JAYCOX: I think we all like to think that. [Laughs]

ELDER PUGH: I haven't had anything that extreme. Most of the things that I see that bother me are the little things, just little habits.

ELDER JAYCOX: Whether or not he puts the cap on his toothpaste or not. You know, the little tiny stuff. I mean, the little tiny stuff matters. It's just like a marriage because you're with 'em for twenty four hours a day. You're always looking at this guy. It goes back to preparation for mission. I had a guy who had been off his mission for two or three years, married, had a kid. He said a mission is the best thing I could have ever done if I wanted to get married. Because you learn to adapt, you learn to get a different perspective.

MIKE & JANE SULLIVAN

GOVERNOR & FIRST LADY

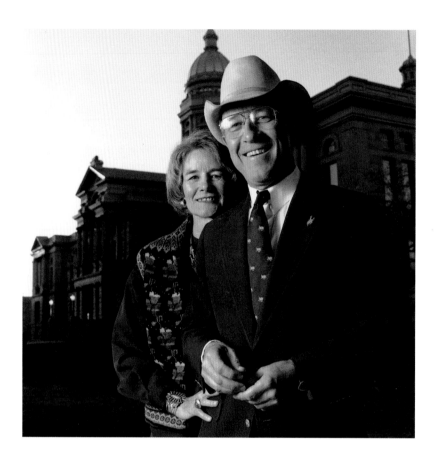

JANE: *He's a great person. He believes in affection for the family. When anyone has a problem, and we're a communicating family, he will always say—one of the kids'll be sad or something— he'll say, "Uh-oh, time for a group hug." He's a very thorough person, but he's a good listener. He doesn't tend to be a problem-solver for us. It's an interesting thing because the kids or I, we can all get together and talk about a problem and Mike never says, "This is what you ought to do." Never says that. If we're having an argument he never says, "Well, this is what I want." And I think that he kinda governs that way, too. He has great expectations of other people.*

MIKE: *This is really a partnership and she's the hardest-working, nonpaid state employee that exists. In fact, I heard Bill Clinton say during one of their interviews that, "You pay for one, you get two." Pay for one, get one free, and that's certainly the case. I don't think anybody appreciates it, the work that the first ladies, that the wives of the governors, do almost anywhere. But certainly here. She has her own staff. She runs the house. She is required to appear and speak, and she replaces me in a number of places, but it's a full-time job. Extremely important. I don't know how I could perform in this job without the support, and comfort, and the work that she provides.*

CHEYENNE
MIKE: b. SEPTEMBER 22, 1939, OMAHA, NEBRASKA
JANE: b. FEBRUARY 28, 1939, RIVERTON

JANE: Mike and I were both involved in student government. That's where we first started working together. Actually, I think for a while I was dating Mike's roommate. But we knew each other from student government and we had a lot of mutual friends. That threw us together a lot so we had a major friendship going before we ever knew we were romantically interested in each other.

MIKE: We'd known each other for two and a half years before we even dated, I think. It developed as a friendship. I would say it's certainly been good for us. I can say we enjoyed much the same things. We enjoyed people. I guess you'd have to say we enjoyed politics to a degree because we both were elected from our colleges—Jane in education and me in engineering—to the student senate. We had previously been in college honoraries. It certainly wasn't the first time I met Jane, but one of the first memories I have, we were in a sophomore honorary together. She was nominated to be president, I was nominated to be president, and Russ Donnelly was nominated to be president. And I remember standing in the hallway of the student union while the group voted. I suggested to Jane and Russ that I'd vote for Russ, and he could vote for Jane, and Jane'd vote for me, and we'd all be alright. That was fine with Jane but it wasn't with Russ. He was going to vote for himself. So I said, "That's just fine. I'll vote for Jane. Jane, you vote for me and we'll be in the same place." And we did. I won.

JANE: My dad came down and said one weekend—it was football season—"Who do you have a date with?" I said, "Guy by the name of Mike Sullivan." I also had the reputation of dating all the athletes. And that was an era in Wyoming's history that they were not, you know, the highest caliber mentally. They were known as the "animals." But my brother, you see, was a wrestler at the University of Wyoming. And he was my buddy. And his buddies were my buddies. My brother kept tabs on me, too. We had a place that we went outside of Laramie called Nine-mile. Everybody drank beer at Nine-mile. And if my brother was there, I knew I better not drink beer. He was an athlete and he took good care of himself. So

I didn't drink, either. The sorority, that was nice. I was a Tri Delta, and they had rules, and I was kind of a rule-follower. That might be a Catholic upbringing. I believed in following the rules.

My dad said, "Who do you have a date with?" I said, "Mike Sullivan." So the next week he came back—another football game—and he said, "Who do you have a date with?" And again I had a date with Mike Sullivan. In the meantime he had checked to see who Mike Sullivan was. He said, "Well, you know, he's a Catholic." I think it was the first Catholic I'd ever dated. His dad was also a Democrat, Mike's dad was. And my father was a Democrat from Park County, which, they always said, "If they had more than two Democrats vote in Park County, they threw the whole election out." My dad and O.E. Bever were the two Democrats in Park County.

He liked that idea. And he knew Mike's parents. It's a typical Wyoming story. The Sullivans and my dad had been in college about the same time. There's very, very strong University of Wyoming ties in this state. So when people talk about old families in this state . . . you can get into the ranching families and all those ties, but you can also get into who was at the University of Wyoming at what time. I would bring my annual home and my dad wanted to know, "Is this so and so's son? Is this so and so's daughter?" To this day, as we travel the state, Mike and I both experienced that "I knew your dad, I knew your mom, I knew them. We were all in school together." That's a Wyoming thing. That's a family.

You know, I could write a book. Maybe someday I should. No I won't. About the complexities of Mike Sullivan and the things I've discovered about him over the years, or the things I've come to appreciate. He has a wonderful mind. He's smart. When we campaigned I had the chance to be with him all day long when we got thrown into this. And just the conversations that we had driving down the road, of analyzing an event that we'd just been to, or what he'd see and what I'd see. He just saw everything in so much more depth than I could see it. Or, he would understand people. I know him as a

very thorough person. One of our friends was talking to me one day, and we were talking about the different people who had given time to being the governor. The thing that I know about Mike Sullivan is that he—and I think that is so unusual about the governor—was a first-class lawyer. He didn't need this job. He made a tremendous income, was at the peak of his career that we had all as a family worked for twenty years to get there. He was respected by all of his colleagues, was asked to represent Gerry Spence on something. Gerry's a good friend of his, was a neighbor. Often they were opposing each other. I mean, they opposed each other most of the time. I guess part of my conversation now is a bragging-type conversation, but there was no question or arguing that Mike was a first-class lawyer. He was recognized by his colleagues in the legal profession both nationally and locally as being a first-class lawyer. And he liked that brain game. He liked the intricacies of it and the thoroughness of it, and that's one of the reasons that he was a good lawyer. And he gave all that up. But the other thing about him is that his integrity is absolutely spotless. He has no desire to amass a fortune. But he's been like this since he was a child. He just wants to use his mind. He didn't ever have a great drive to do this. It's just kind of something that has led him because of his personality. It just evolved. He didn't have that fire in the belly that everybody talks about. It was alright, he'd try this, but he didn't need the job.

Some of the people that know him, some of the lawyers in the state that know him as a colleague, that worked with him, know what he gave up. And, you know, I thought he was crazy. I couldn't believe that we'd all, as a family, worked so hard to get where we were, that we finally got the bills paid. You know, we could finally get the kids in college and give 'em an extra ten bucks. Because our other ethic was that we always paid our bills and we didn't live very high. But it was because we didn't need it. I mean, it didn't matter. I tease him every once in a while and say, "I don't know why you couldn't have done this when Wyoming had some money."

JOAN: *It's theory. That's all we can say that it is, that it was created by a meteorite shower. Where these places are throughout the country are basically all in the same latitude. There's a few that are north and there's a few that are south of the same latitude.*

BILL: *But some people flat don't believe it. Ninety-nine percent of the people go in there, they have a ball. You always got that one percent that wants to give ya a little static once in a while. One time this guy came up. "I don't know how you get away with it," he said. "That's a ripoff." Finally I turned around to him and I says, "You know what Barnum and Bailey said?" He says, "What's that?" I says, "There's a sucker born every minute and two born to take him." And boy, he stormed out. That's what he wanted to hear, so I just figured, "Hey, get rid of you in a hurry." If you make up your mind in advance it's a hoax, that's what you're gonna get. But if you make up your mind you're going down to have fun, you'll have a lot of fun. You may not believe everything, but you'll have a lot of fun.*

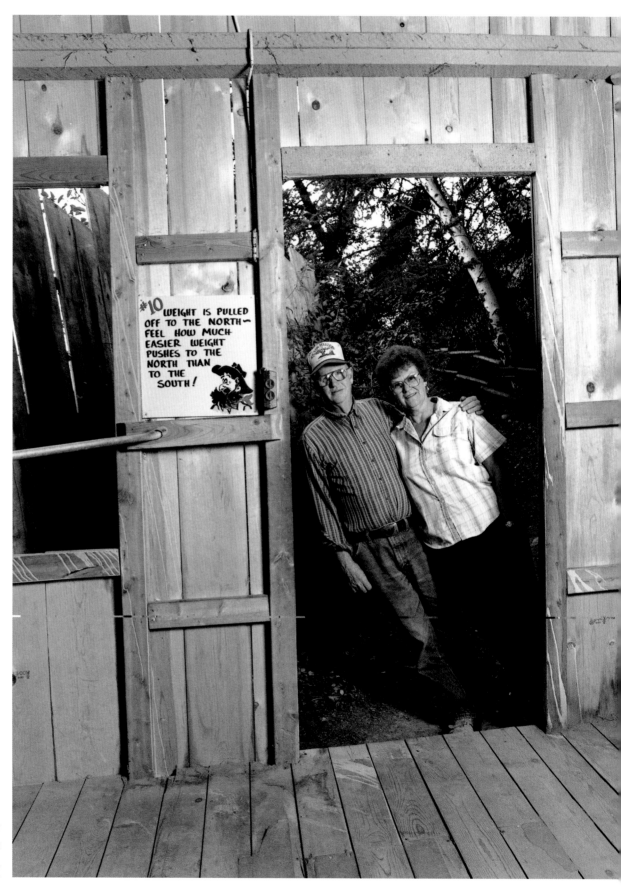

HOBACK JUNCTION
JOAN: b. DECEMBER 6, 1931,
NEWARK, NEW JERSEY
BILL: b. MAY 2, 1933,
HEMPHILL, WEST VIRGINIA

114

BILL: You ever traveled with a bunch of kids for about eight hours? When they get here they're pulling their parents' hair out. They stop here. They go through and I tell 'em, "You'll have more fun here for less money than anything you do on your vacation. Now, you can enjoy the scenery but there's no comparison to this here."

JOAN: Mainly, to just get rid of the tension, if nothing else. It gets 'em out of the vehicle. They run a little bit, they go through some of the exhibits, they enjoy themselves, they come out, they're relaxed, they're laughing with each other and joking and talking. And that's the whole thing that you need is to relax this bunch of people that have been traveling in a closed quarter that are about going . . . Agh!

BILL: There was two couples came in one time. One lady was an absolute bitch. She was makin' everybody . . . she was tellin' . . . "Ah, nothing to that. I don't want to go through that." The other three wanted to go. Finally I just said, "Hey, why don't you three guys go down and leave this ol' grump up here with me." And man, her mouth flew open and everybody else said, "That's a darn good idea!" They paid and went down. She heard them down there having so much fun she couldn't stand it. So she reached in her pocket, paid the fee to go down, and when she came back up she apologized. She said, "I wanta apologize to you." I said, "Well, what for?" She says, "You made me aware of how I was spoiling their vacation." I'm the type of person that I never toss the first stone. Once they do it, or if I feel like there's injustice bein' done, I have to tell ya about it.

This one guy came in and I never will forget his name. I only met him for five minutes at the most. His name was Elmer. And his wife was a big, fat lady . . . Ya ever seen these laughing people at a carnival? She was the one that made the original recording, I'd swear to it. But anyhow, they go down there. She goes in the house but Elmer won't go in. She says, "Oh, c'mon, Elmer, it won't hurt ya!" He says, "No, I'm not goin' in there. There's juice in that house!" Lotta old people used to call electricity "juice." See, you never heard that term. [Turns toward Joan] You can tell he's young.

JOAN: One was a real chuckle. We had a bunch of people down. It was a big family. They got in there and they started to laugh, and they had grandma with 'em. Well, grandma got in the chair and she couldn't get out. She was laughing so hard she could not move. Well, you have a hard time getting up anyway out of this chair. The rest of the family were laughing so hard they couldn't help her out. And none of them can move. And I thought, "Well, it's a different kind of laughter. I better go down and check out what's goin' on." So I get down there and of course the laughter is so contagious I start laughing. I'm tryin' to help the elderly lady out of the chair and she's a heavy lady. Well, unbeknownst to me she wet her pants while she was sitting in the chair. She was mortified! Because she was laughing she couldn't move! So she came up and asked me where the restroom was and I told her, and she came back in and said, "You know, I'm embarrassed and humiliated but I've never had so much fun in my life." She said it was totally worth it.

You know, you're talking about something that's been here for, let's say, forty, fifty years. I won't say it's a landmark but a lotta people consider it that way, least that's what they tell us. So you would be zoning out a business. Let's just go back a step, and say, "Okay, the Wort Hotel can't be there anymore." And that's a landmark in Jackson. You don't have the right to say that.

BILL: Nobody has that right to say whether somebody has a right to exist or not exist. If you like individual rights, it must be preserved no matter what. I mean, that's what makes us what we are, you know? When we become robots and answer to the system, you have no rights left. What's the purpose then? So, you know, individual rights, you really got to watch very carefully.

When our forefathers came here, they set this valley up and they lived here because they wanted to live here. And they didn't necessarily say, "Well, it can't change." They believed in individual freedom. People thought they had that. When I came here in '70 I could do as I damn pleased. Now, you know, I've gotta answer to everybody, which I object to someone telling me what I can do and what I can't do with my property very much. It's not right. I don't know all the answers but I don't think some group of people should set up and say, "You can have this but you can't have this." Or, "You can have cereal this morning, but you can't have it tomorrow morning." You know, this is the way it's goin'. Or, "You can't drive that truck there. It's over five years old." And there's gonna come a time when maybe you can't drive a vehicle that does [burn gas and oil]. But still we got to protect our rights, fight it down to the wire.

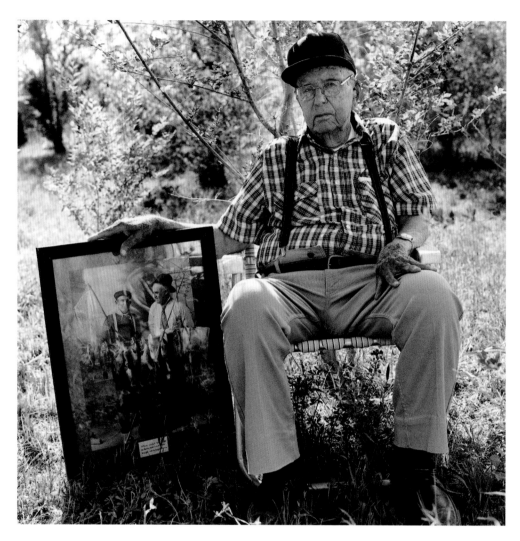

How did you two meet?

FRED: At a motorcycle rally.

CAROLYN: At Pismo Beach [California].

FRED: I rode motorcycles. When I was workin' for the Bureau of Water and Power I had a motorcycle. At one time I had the hottest Harley in Southern California. In those days high–speed motorcycles were the thing.

CAROLYN: Pizmo Beach is a long, sandy strip. And they were racing there. Dealers and their wives would chaperone groups to these rallies. This particular one, they were racing up and down on this beach. I talked him into taking it for a ride up and down the beach. Then I think I pestered him the rest of the time for a number of years. I just loved him at first sight. I said that's the one that I care about, and that goes all these years. He thought I was a nuisance. Just something he couldn't get rid of. [Laughs] I was determined about it. I cared about him. I didn't know whether he cared about me or not. But I guess he did. I didn't know.

What's it been like to be married sixty-six years?

FRED: Terrible. [Laughs] Well, we've had our ups and downs, but all in all our life has been pretty good, pretty fair.

CAROLYN: It isn't the kind of love that you have in the beginning, but you care. It's a love, but it's different. It's just part of you, that's all. It's the way you live together. It changes. It changes gradually. But all through the years you had to learn to adjust, each one of you, because each one has faults. There's nobody that doesn't. If you talk to someone and they say, "Our marriage has been perfect," you know very well they're either blind or they're telling you a lie. Because in life it isn't that way. There's things that happen and you have to learn to adjust to it. He's had to do a lot of adjusting with me. I've had to live with him. Sometimes now I blow my top and tell him what I think of him, and that I love him just the same. [Laughs] Sometimes I could take a club to him, but then I wouldn't do it.

BYRON

FRED: b. NOVEMBER 25, 1901, WATSONVILLE, CALIFORNIA

CAROLYN: b. OCTOBER 25, 1906, DENVER, COLORADO

The people that won't adjust are the ones that just quit. They get divorced and break up their homes. But you have to learn to adjust and you can do it if you try. There's plenty of good things you can think about without thinking of all the problems—this one does this and this one does that. We're all individuals. You just have to work it out, that's all. Both people have to be willing to work it out. It isn't a one-person deal. But one person can do a lot.

FRED: You just simply have to learn to give and take. It depends a lot on disposition. That's one reason people don't get along. Different makeups, finances. Everything empties into it. But if you're not willing to compromise, you won't make it, anyway.

CAROLYN: Just like he said, you have to be willing to adjust and know that this person is themself. This one is himself, I'm myself. Okay. We have to learn to adjust to each other because maybe our makeups are different, like he said. [It's] how you handle things. We don't all do it perfect, but we have to learn to adjust to each other, help each other, and be tolerant.

You're a person of yourself. But living together and having to do things together, you'll find out that some of his personality will brush off on me and some of mine on him. But not the majority, because you are your own person. But you have to understand that the other person is also that. It's part of me to think what he needs. And if he needs too much that he won't do it himself, I tell him off. And he tells me off once in a while when I go off my rocker. I've got a temper and he has, too. But we're still here, you see, because it has come from tolerance.

If things are goin' rough you're gonna have to go through it. You'll go through it. It'll be rough. It's how you handle it. You're gonna have to handle it. You'll never make sure whether you did right or not. And you can do a lot worse, believe me. We haven't had that in our life, but then we see it all the time. You could do a lot worse.

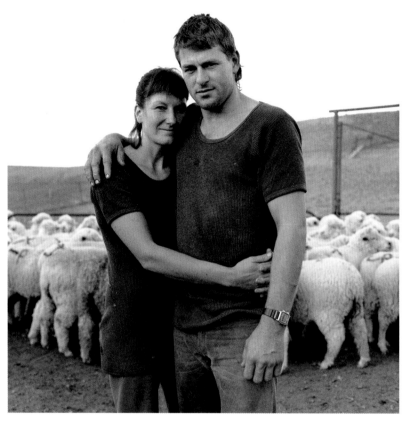

MALCOLM: *Yeah. I've got a good back. You know, some people are lucky, I suppose. Pretty strong lad I am right now.*

ANGELA: *He is pretty tough, yeah. That is being honest, yeah.*

EAST OF MIDWEST
ANGELA: b. APRIL 24, 1960, TIMARU, NEW ZEALAND
MALCOLM: b. JULY 18, 1956, WAGIN, WEST AUSTRALIA

MALCOLM: So Angela said, "What about we take off, go on a world trip?" And I said "Well, why don't we?" Angela's sort of the ambitious, pushy one. Aren't all women? [Laughs] Yeah. But I sort of follow on, and it's been great. I'm really glad that we've done this trip. I'm sad that we left the kids behind, but if we didn't leave the kids behind we couldn't have worked. And you know, a trip like we're gonna do would cost $20,000. If we can just work along the way and cut it in half . . . We're really lucky that I work and shear.

ANGELA: This was a good place to get extra money and have a really good look at one country rather than travel like a tourist. You can go some places and you never really know what they're like. This way you meet the people, and you talk to the ranchers and you see how they're living.

MALCOLM: We're legally working here. See, ten, twelve years ago shearers used to come over and work illegally. But very few Americans shear sheep. There's only one American man and one girl on our rig. And there's not many others on the other rigs. They're mostly Kiwis—New Zealanders—here. Not as many Aussies. More Kiwis and very few Americans. That's why they make it legal, so you can get work permits now to come and work. Because the sheep wouldn't get shorn. It is hard work. But you sorta get used to it? As long as you don't go out there and sort of "bust your gut," you know? Just sort of plod along. Shear 160, 170, or whatever you'd like? You're makin' good money at that, without killin' yourself?

ANGELA: I know this might sound funny, but we got to the state line at Nebraska and we went into a bar and had a drink, and we'd only been in Wyoming. And all the rats seemed stand offish and a little bit rude—the people? I don't know. We thought it was just that particular bar, but the next town that we went into, and worked for a few days at Scottsbluff, they were not near as nice as the Wyoming people. Then somebody said, "Well, maybe 'cause it's less population that the people are a little more friendly?" But I think they're lovely people in Wyoming, yeah?

MALCOLM: What I couldn't get over is . . . in the shops? You go out and buy something and when you walk out the people'd say . . .

ANGELA: "Ya'll come back now."

MALCOLM: "You all have a good day now, ya hear?" Back home they wouldn't give you the time of the night.

ANGELA: You're lucky to get a little assistance from the little hussy in the . . . oh, they're so rude back in Australia.

Now, Wyoming, we knew that we were coming to wide-open spaces. We were sort of prepared for that. More probably the city sort of things shocked us a little bit, yeah. I mean big cities, but we've been exceptionally lucky. Things have fallen into place for us. I think everything has been meant to be that has happened. Otherwise we wouldn't

be here today. We've had no hiccups and hassles. As long as you're very careful in the big cities. And out here, well, hell, the way they leave cars unlocked and things outside. That's another thing: The Aussies are delinquents and vandals, aren't they, Malcolm? That's something that we've really noticed more that we've come away, is that people are far more trusting here. Like with vehicles and like that big Pamida store yesterday. They leave all your manures and fertilizers in the bags and everything outside . . . just stays outside. That wouldn't last five minutes in Australia. It would be pinched. Everything's bloody pinched!

MALCOLM: And they leave their cars running and walk into the shop? Couldn't leave the heaters on your car, I suppose, on a cold morning or something. If that was back in Australia the car would be gone. It wouldn't be there when they come out.

ANGELA: And I wanted to see cowboys. I wanted to meet a ridgy-didge cowboy. And you know what? I still haven't yet. I was in a bar one night and I wanted to go up and ask these two guys that I'm sure were real cowboys, "Are you a cowboy?" I hadn't had one drink enough yet to do it, so I didn't. But sometimes you can. You know people take the wrong impression. I like to be friendly to most people, but you sort of might get somebody mad in a bar, and they might sort of take the wrong impression, you know what I mean? I was expecting to see a lot more cowboys. But what I can gather, there's a lot of people that dress up to make up like a cowboy, am I right? But I want to meet a ridgy-didge cowboy.

MALCOLM: When I come here, just traveling around, I couldn't get over the cars. They got beautiful, big ol' cars here. And there's wrecked cars everywhere lying around. Everywhere! Oh, couldn't believe it!

ANGELA: You just cross the state line and there's a big difference, isn't there? There is, there is. [Laughs] Hell, yeah. As soon as we got into Wyoming again, we knew.

MALCOLM: There was one big car yard I seen in Nebraska but it was a car yard. It wasn't just a big paddock there where they're all parked up. Well, you go to a ranch. We went

to a ranch just out of Worland. Man! It was so rough! There was just junk going everywhere. There was a really good pickup, bogged, and it just looks like they've gone out and bought another one because this one was bogged there.

ANGELA: Yeah, bogged right up to the rims. So they just . . .

MALCOLM: . . . went and bought another one, by the looks.

ANGELA: There is a lot of junk found in Wyoming, and that's true. The homes seem to be nice inside but outside they just . . . junk everywhere!

MALCOLM: And no gardens! You miss no gardens. Oh, and no trees in Wyoming. No trees! When we first come here I thought, "There's not a tree in sight!"

ANGELA: And I thought Aussie was vast.

MALCOLM: Australia, you have a few trees, you know. And cold! You know we come from temperatures of over 100 degrees at home. And to walk out of the plane in Casper, and I reckon 50 below when we arrived, with the wind factor. Jesus Christ! I thought, "Christ, we should get on the plane and go home!" But apparently it's not as cold as what it was ten years ago, I reckon. And the snow. I couldn't get over the snow 'cause I'd never seen the snow before. Never seen snow before I come here. Hopped off the plane in Casper and grabbed a big handful. And then Angela grabbed another big handful and threw it at me? Never seen it in me life, no. It's fantastic! Oh, when I picked it up I just threw it down again! It was, like, cold? [Laughs] I reckon some of the Aussies have a look, and kick it and roll in it and go stupid, you know? But I didn't quite go that far.

MALCOLM: Kiwis are great. [Laughs] Angela's special. She's special. Angela is a fantastic wife. She's been really good to me, you know? Worker? Well, not many wives will probably do what Angela has done. I said to Angela, if she wanted a world trip, "Well, you may have to come out and work a bit?" And she said, "I don't mind." If you ask Angela to do something there's no effort. She will just do it and then we'll get on our world trip, you know?

Describe Malcolm.

ANGELA: The best person I ever met. Oh yeah, he's got a big heart. Yep, definitely. He's a family man. He's always supported us which is pretty important, I think. Malcolm's one in a million. He's everybody's friend and would always give and do for somebody. He probably taught me not to be so selfish? And I was probably a little bit selfish, I think. He's taught me to be generous and give, which is a good thing to learn in life. Some people never learn that, you know.

MALCOLM: Like, if you went to a hotel and that, I'd rather buy two out of my turn than to try and skimp on buying a beer or something for someone, you know? Sometimes you go to a hotel and get in a "school," we call it. You have two or three guys, or four guys. And you have a few beers there. And you each have a buy of beer. Well, some of the guys sort of go to the toilet when it's their buy, you know? You get them. You don't worry. But I would rather buy two out of my turn. I'd rather buy an extra beer for all the guys there and everybody be happy rather than do that, you know? That's just not on, in my eyes. I had one of the best upbringings a kid could ever have. I probably have been spoiled.

ANGELA: Your mother—with love though, nothing else. Malcolm comes from a family of a lot of love. It's his mom all over. She's just a real workaholic. But *her* mother lived till she was ninety-six, eh? Ninety-seven, Grandma? She was just a real tough pioneer woman, and I think it's in Eva's blood and it's in Malcolm's blood. I think that's the beauty I love in Aussies? The "dinky di." That's Aussie talk—"dinky di"—tough people. That's ridgy-didge. [Laughs] That's what I like. They're just real salt of the earth. That's an easy way of saying it. They're salt-of-the-earth people, Aussies?

MALCOLM: Most Aussies. There are some good and bad in every country. Well, soon's we finish work we're off up through Jackson, through the Yellowstone National Park, is it?

ANGELA: Well, it's Denver, Miami, Kentucky, London, France, Greece—hopefully back to London, Dubai, Arabia, Kuala Lumpur, Perth. So we're only halfway. You gotta dream. That's what life's all about. If you don't dream, you've got nothing. And nobody can take your dreams away from you, yeah.

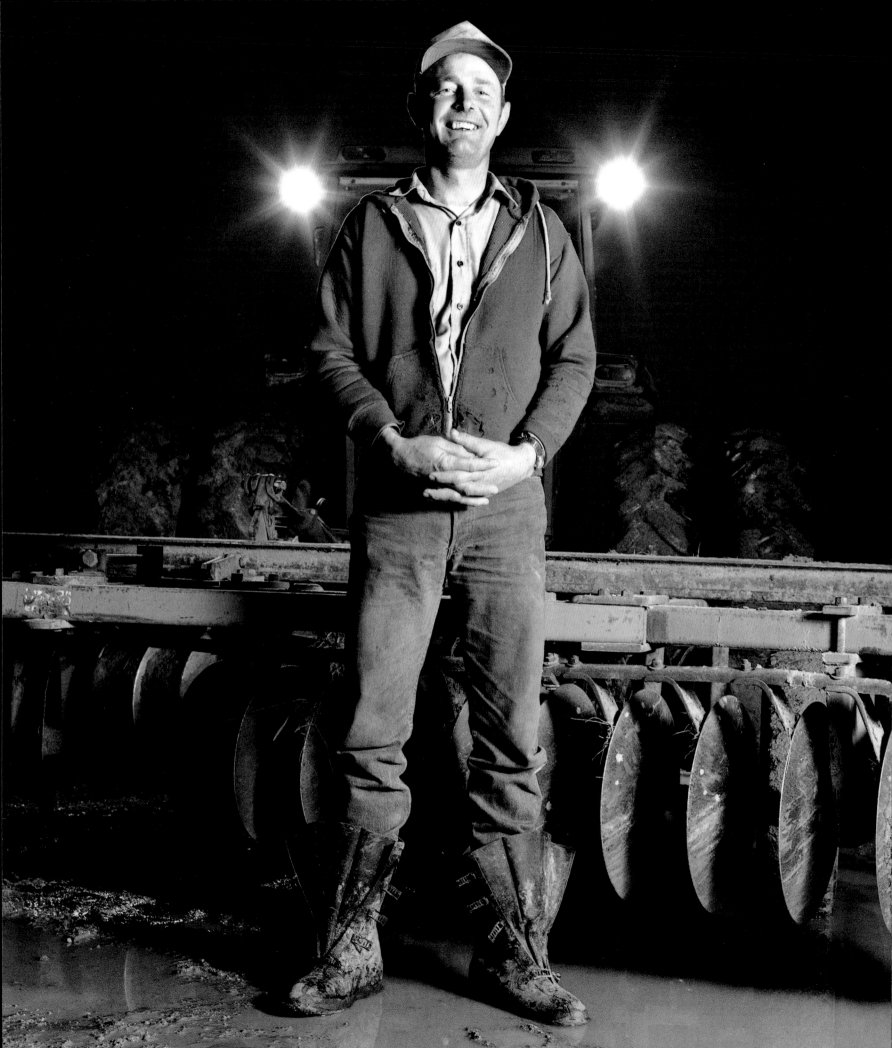

My religion teaches that the Good Lord gives us everything that we have on this earth including the strength to do our jobs every day. But the Good Lord also helps those who help themselves.

I'm here to steward the land through my tenure. And stewardship is maintenance and improvement. I feel the need to produce for this country. I have pride in my production, in agriculture's productivity, in the personal goals that I achieve. I can have diverse goals: I can have tons per acre, I can have dollars per acre, I can have profit per acre, I can have community responsibility. I can reach out in different areas in different ways through different enterprises and, like I said before about God giving you the strength to do things, he gives me the ability to express myself politically, productively, financially. And so I am destined to be here. But destiny carries a responsibility of being all you can be, too.

DEAVER
MEL WAMBEKE
BEET FARMER
b. OCTOBER 22, 1948, POWELL

They won't know Alan Simpson from a hole in the wall. Who were the leaders in the world when Rembrandt and Michelangelo and Da Vinci were alive? Can anyone remember? Or even Toulouse Lautrec and Degas. Who were the leaders? They remember the artists, but who remembers the leaders unless you're a historian? Except for Buffalo Bill and Custer, who's better known than Remington or Russell? The politicians last a few years and then they're gone unless they become president or governor. But do you remember the names of all the governors? I remember Cliff Hansen. I don't know any governors before Cliff Hansen. But you know the names of the artists.

WAPITI VALLEY
b. APRIL 28,1926, NEW YORK CITY

I like wrinkles and people with character. So I'm always looking at hands and shoulders. New York is great. And yet I never had the urge to paint New York. I think what happened is, I was too close to it. When I came out here, all those sublimated memories of childhood, of cowboys and Indians, Vikings, knights—all of the things kids grow up with—all of a sudden were real. Instead of looking at Norman Rockwell [*Saturday Evening*] *Post* covers of neighbors that he made into historical characters or town characters, here were real people, people who drove stagecoaches, who homesteaded. And I never thought they existed. I thought that was history. I never thought about it. I didn't know Wyoming was made a state in 1890. And all of a sudden here are people that are part of the history of Wyoming. It's like a jigsaw puzzle and I'm slowly getting all the pieces together: the mountains, and the Indians, the trappers, the homesteaders. It's a short period of history. It's about a hundred years.

You don't have New York with four or five hundred years of history. So it's controllable and there aren't that many people. It excited my imagination. When I see an Indian or a cowboy that looks great . . . I saw a guy in Dairy Queen yesterday, great-looking guy. He looked like he'd wipe you out if you asked him if you could take his picture. But I'm always looking, even though I've got enough pictures for fifty lifetimes that I'll never paint. I'm always looking for another one and whenever I go to a powwow or a rodeo or a branding, even at my age, my antennas go up and I have boundless energy.

Here's what I think. This is important. Lynn and I have discussed it. I've never fit in a niche. People think I'm a western artist. I don't. People think I'm a photo-realist. I'm not. I was accused of working on photographs when I was an illustrator thirty years ago 'cause they don't believe I can do what I do. I think that people tend to like the Russell, Remington, Frank

McCarthy, Howard Terpning, historical, shoot-'em-up painting, Hollywood-type of western. I basically do real people. I chicken out a few times and do things that are, you know, more romantic. Lynn calls 'em my "Uncle Tomahawks," 'cause people like chiefs. But basically I do real people as they are, or living out their fantasy as a mountain man, or an Indian during a powwow. And I think what I do is a lot more valid. When I started painting western people, which I grew into, I started looking at western books, and I realized no one ever did the people as real people that look like they go to the bathroom or have bad days. They posed in Washington for Morris and people like that. They did controlled portraits to hang in a museum or in Washington. But no one went to the reservation and painted just an Indian. They did the chief. They did Red Cloud or Sitting Bull, but they didn't just do a guy that maybe had a drinking problem or something. They did very romanticized cowboys and Indians. My people

are real, actual people. And there's a responsibility. It means so much to some of these people to be in a book or have a print made. God, I did one of my neighbors: Buck Norris, Crossed Sabres Ranch. He's a real shy guy and all of a sudden he's a celebrity. He was getting love letters from women.

The Cody Art League would get some of these old-time cowboys to sit and pose for them, a semi-amateur art class. No one ever thought of doing a serious painting of them. And here I come to Cody, and here's Bill Cody's two grandsons. Here's George Washington Brown who had a very interesting historic past. I met several people that came over in covered wagons and homesteaded. I didn't know that existed. I thought that was all in the history books. I didn't know how old Wyoming was. Why would I? You know, the cattle drive period lasted twenty years, the mountain man period lasted twenty years, and Gunsmoke lasted nineteen years. I mean, they're short periods.

There have been more mountain men and Indians painted than existed.

I'm painting today. What I do today will probably be history in one hundred years because of the quality of the work. There aren't people that drove twenty-four-horse teams. There are no people left that homesteaded. I caught the tail end of all the interesting people out here. It's today! It's today! They're phasing out the outfitters. They'll probably phase out antler hunting and trapping, and it's becoming a thing of the past. And so I feel a certain urgency. I feel an urgency to paint all these old people. I painted Grandma Slack. Ninety-five years old. Never had lived in a house with anything but a wood-burning stove and a hand pump. Ninety–five years old! And a marvelous old lady. She came out here when she was seventeen on a covered wagon. Where am I gonna meet anyone in New York like that, that can excite my imagination?

I was the one who wanted to bring home every sparrow that had a broken wing. I used to do surgery on my teddy bears. I'd bandage them up and put little stitches in them, and I often made my mother ready to pull her hair out. I was destined to be a veterinarian. I'm absolutely convinced of that.

WORLAND
b. JANUARY 22,1958, DULUTH, MINNESOTA

All I know is that I have always had an ability to be around animals and handle animals in situations where I feel a very mutual rapport. I've had repeated experiences with animals whose behavior and temperament is best described as marginal. In those circumstances I've never had any kind of aggression problem with animals like that. I've been told repeatedly, now that I'm practicing, "Well, my cat doesn't like strangers." Or, "My dog is very temperamental around people he doesn't know." I have not experienced any difficulty in handling those animals. Why that is, I have a very difficult time understanding. I don't think it's scientific at all. I suppose it would depend on how far out in left field I'd like to go. Perhaps I was a healer in a previous incarnation. Perhaps I

was an animal, one of these various species I work with. It's very hard for me to put my finger on. I have a very strong sense of this rapport. It's very real for me. It's very difficult for me to articulate. It's especially difficult to articulate in the role I am currently filling as a medical professional, a scientific professional. In my opinion it has no scientific background. It has no scientific explanation. I can't say it's genetic. I can't say it's the environment in which I grew up.

I feel these ways about animals because I felt this way about animals my entire life. And for me, perhaps, they are an emotional substitute for children. I have no desire to be a parent. I don't anticipate at any time in my life I will be a parent. I'm thirty-one years old. I feel confident that, at thirty-one

years of age, it's completely within the realm of reason and rationale for me to make that decision. It's been an unconscious decision to this point. I know that many of the emotional bonds that I feel for the animals in my household and the animals with which I work in my profession—extremely powerful emotional bonds—rival the most intense emotional bonds I have with other people in my life. I am by no means a social hermit. I am by no means dysfunctional in my relationships with other people.

I know that I anthropomorphize to quite a degree. In other words, I interact with an animal as though that animal were another human being. But I don't expect that animal to relate to me as another human being would relate to me. I do believe very strongly—and people who work with the issue of the human companion animal bond will tell you the same thing—that this is a very real emotional attachment that is a two-way attachment. In other words, the animals in our lives, those animals that mean something to us as individuals, are bonded to us in a very real way. That attachment becomes very unmistakeable and very clear if you've ever observed anyone interacting with these animals. Now, the difference is that we are cognitive and they are not. We understand the bond for what it is.

Let's label this opinion. I work a lot with animals. I work a lot with people. And I work a lot with people and animals in a given context. I've done quite a bit of reading on the human companion animal bond, and I try and apply what I have learned through my reading and through my personal experience to what I do in my veterinary practice. I think, finally, now, people who recognize that this bond exists are gaining credibility. For a long time we were pooh-poohed as, "Oh, well, you know, these are child substitutes. These are people substitutes. You're putting too much on this relationship." I really believe that's incorrect. The difference as I see it is that human beings are able to cognitively distance themselves from that bond and say, "I recognize that this bond exists." In other words, we can intellectualize that bonding that we feel. An animal, on the other hand, doesn't have that cognitive ability. The bond is there. They merely feel it.

Think about the fact that a person can walk into a room where there is a cat, and that cat knows instinctively whether that person likes cats or does not like cats. Why is that? I can't explain that. I don't know if it's chemical. I don't know if it's an energy aura about you. I know that animals have an ability to pick up on our emotional state of mind, in what would be to us a very irrational and a very unreasonable—in other words, difficult to intellectualize—manner.

Some of the things that attract me to Wyoming and keep me here are the same things that frustrate me about Wyoming. Independent spirit. Independence can work both ways. When one wants to be complimentary, one says, "That person is independent." When one wants to be derogatory, one says, "That person is pigheaded." There are two sides to every issue and the independence issue is a very important one. Freethinking is another. One person who is a freethinker, to someone else, is radical.

If I do nothing else while I'm here in Wyoming, for however long my tenure will be, I hope that I can change the standard of practice of veterinary medicine in my area for the positive. If I do no more than increase the standard of quality for the practice of veterinary medicine, and also raise the consciousness of the animal-owning population in the area, I'll feel like I've really done something. I think that's really exciting.

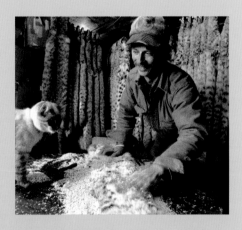

I'm fascinated by cats. I love cats. Well, you can see I have six housecats. I got three down here in the barn and three that live up in the house with us. I don't know. There's somethin' about cats. I like the way they move.

They're so sleek. When I skin 'em out the cat has such an excellent muscle tone. They're a very athletic animal versus, say, a fox which, really, once you skin him out he's just skin and bones. That's all there is. And then cats … well, you never really tame down a cat, not even a housecat. He's never really tame. He's not gonna do exactly what you want. And that's kind of my spirit, too.

They never knew that life, so they don't know what they're missing. I've taken animals from the wild, brought them in here, and made them better. I have through careful breeding, produced an animal that cannot come from the wild. You cannot get cats like this from the wild. I've got a product that is a step higher than the wild. And it might be a tad selfish but it's a business. That's the American way, is to create a business. Now, you're giving human characteristics to these animals. They feel bad 'cause they can't run around? They don't know. They've never been out running around. They don't know the difference.

Well, I never feel guilty. I'm harvesting an animal. When I do harvest the animal I put it up as best I can. I respect the animal. And I present the fur in the best fashion that I can. I use the fur as a living. I make my living off the land, off Mama Nature.

I have way too much respect for animals. I would definitely go out of my way, out of season, to make sure that the animals were not being harassed. If I knew of anybody doing things out of season, harvesting animals out of season, I'd go out of my way to make sure that that person was stopped. There's a time and a place for everything. You have to give the animals some room during their time when they're having their young.

You don't go out there and harass them animals. You let 'em raise up their young. You let 'em mature and prime. I have a lot of respect for animals. You know, somebody would say, "Well, how can you respect 'em? You harvest 'em, you skin 'em, you work with 'em." Well, yeah, I spend many hours down here working with furs, putting 'em up. I love to work with 'em. I love to raise 'em. I don't get attached to 'em. But I work directly with 'em.

The people in the big cities have grown away from understanding nature. I think most people in the big cities think life in the wild is like Walt Disney has it on film. The bear plays with the cougar kitten, and the rabbit nuzzles up against the fox. I think a lot of people have a Disney-type picture of Mama Nature and the wild. I just wish more people were aware that is not the case. That is not the way it is. Mama Nature is very cruel. I think more people need to understand that animals do have to have their populations controlled. It's being seen right now. Take the raccoon populations, for instance. Everybody says, "Oh, cute little raccoon!" But as population builds up they start getting into the garbages, they start getting into people's places. And when the population gets to such a point and there's nobody out there harvesting 'em, nobody's controlling the population, okay, then you get rabies, distemper, mange . . . and that's a very terrible way to die.

Man's already screwed up stuff enough. Man has already stepped in. People say, "Oh, just let the animals be." Well, we can't. Just through civilization, moving animals out, a certain predator is not there anymore. Another animal has been kicked aside due to civilization coming in, and another animal is allowed to flourish because he can adapt to man. There again, the raccoon is a real good example. He can adapt to man real well. And they're very prolific. Beaver can, too. You'll see a lot of destruction with the beaver. A beaver can come in and start damming up the culverts, and he can start flooding out the ranchers' cornfields and flooding roads. Man has to control. I wish more people understood that the animals have to be controlled by man. And trapping is one of the best means of controlling 'em.

I just feel a lot of people are misinformed in what they're believing. If they would perhaps listen to the other side of the story or take the time to find out what the other side of the story is . . . come out and visit a farm. Go talk to a trapper. Go run his

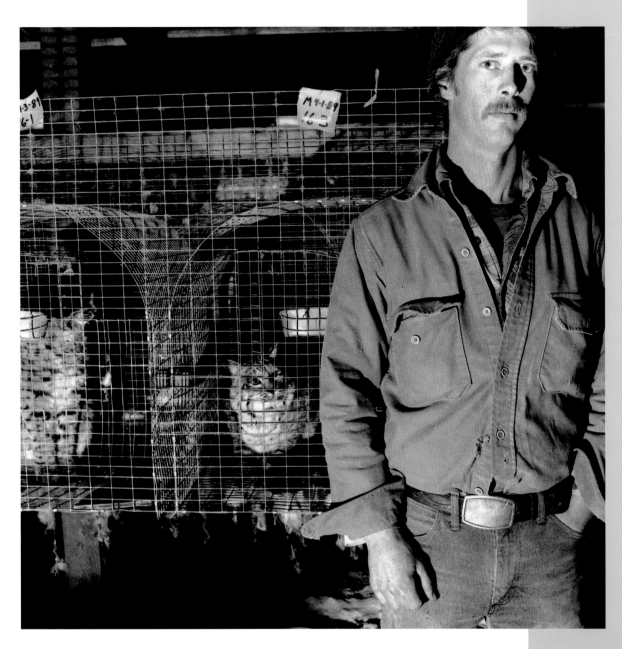

line with him. Get off the pavement once in a while, and get out into nature and see what's really going on out there.

I don't advertise. I don't toot my horn. I do it because I enjoy it. I do it because I like it. I do it because I've done it all my life. I enjoy working with fur. I enjoy working on the prairie. And if someone with similar interests wants to come out and talk with me, I'll talk with anybody, even if they have dissimilar interests. Even an "Anti." If they want to come out here, I'll talk with 'em, sure. Everybody has the right to their own opinion. But I think that before they

go getting all hostile and saying that what I'm doing is wrong, they should hear both sides of the story. A person shouldn't make an opinion or form a very strong opinion by only looking at one side or only hearing one point of view.

Nobody's appointed me to speak for anybody. I speak what I think. I speak what I think. We're not a bunch of torturous people. We harvest the animals. We treat the animals with respect. We know the animals a whole lot better than any of the bunny-huggers would ever even think of knowin 'em, 'cause we have to know 'em.

What do I call myself as a person? Well, I fall under two. I am a trapper as well as, I guess you'd call it, a furrier. A fur rancher and a furrier. I got a fur coat business as well, so I fall under three. I make custom-made fur coats. I'm a furrier, a trapper, a fur harvester.

SOUTH OF GILLETTE
b. FEBRUARY 8, 1960, SILVER BAY, MINNESOTA

HORSE BREAKER

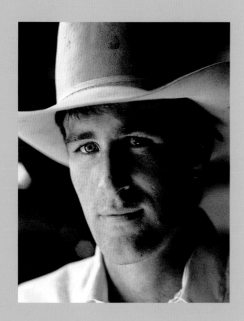

I can take a horse that's pretty raw material and I can turn it into something that's really a useful tool and that understands me. When I get on it, it's like just one. I can make it do things that neither one of us ever dreamed of doing. And I can see it. It's all right in front of me. I can see exactly how good of a job I did. If I did not do a very good job, I can see that my horse isn't working for me. If I did a superb job I can see it.

SHELL
b. OCTOBER 1, 1964, GREYBULL

I like to start 'em when they're two. They're still young, and their minds are clean, and they haven't had a whole lot of things done with 'em. Just like a little kid learns to read easier than somebody that's, say, fifty years old. It's the same theory. You can get 'em when they're ready to learn, and they're pretty willing, and they haven't had time to form a lot of habits that you might or might not have to break 'em of. I just put 'em in the round corral and the first thing I do that's logical: you should be able to walk up to 'em anywhere and they should stand and face you. So we start from there. They stand and face me. If they run around, that's fine. When they get tired of running around I'll encourage 'em to run around a little more. When they get tired of it, they come to me, and when they come to me they relax and that builds your foundation. From there, once they start to trust you, you can do just about anything with a horse.

A horse is a lot better at reading you, in most cases. I don't think that's necessarily true with me anymore 'cause I've had experience, but ninety percent of the time the horse is so much better at reading the person than the person is at reading . . . I mean, [laughs] these old town, broke horses that come out here, they've got those people figured out. They know when that person is serious and gonna make 'em do something, or whether that person's scared of 'em, intimidated. They know exactly what they can get away with. You can see it. They know exactly what they're dealing with, and the older they get, the cagier they get.

Some horses are smarter than others, and sometimes you get so frustrated with the dumb one you just want to belt him one. [Laughs] Just like some people that have worked for you do some of the dumbest things and you cannot figure out where they ever get it. You know, how can they do something that stupid? And you just lose your patience. But it's not really their fault. They just weren't born Albert Einsteins. You kinda gotta take it easy with 'em.

Horses are just like people. They're all different. Some are smart, some are dumb, some are wild, some are nasty to work around. I think you can apply the same philosophies. Just the way you treat 'em. You know, if you go out and try to run over the top of 'em and force everything down their throat, you're gonna get about the same reaction as you would with people that are working for you. If you've got five or six people working under you and you just walk out and say, "This is the way it is and I don't care how it was before. Now you're under me and this is what we're gonna do. When I say 'jump,' jump!" Or you can use a little encouragement and try to get 'em to want to do it. That's the whole key. You have to get 'em to want to do it for you. The horse that feels like he has to do it I don't think will ever be as good as the horse that really wants to do it, and really wants to do it right, and really wants to please you. Just like a dog. And people, I think, are the same way. If somebody really wants to do a good job for you, it's a lot better than if he thinks he's gonna get fired if he doesn't do a good job. He's gonna do what he can get by with. People, horses—I don't care what they are—if they don't want to do it and you're not treating them right, they're gonna do just enough to get by. But if you can get their attitude developed to where they really want to do the best they can for you, then you have something.

It's a good feeling to have somebody or something really want to do something right for you. I don't care who you are, whether it's somebody working for you that just wants to do a super job for you. You're a teacher . . . and maybe you had some students that just wanted to do an excellent job—had a research paper, took some interest, really just busted their butt to do a good job—because they knew you'd appreciate it, and they wanted to show you that they were pretty good at it. It's the same thing.

I think there's some really good horsemen around but I think they're getting fewer, and scarcer and scarcer. It's mostly people's attitude anymore, I think, more than anything. For one thing, horses aren't a chief source of transportation or recreation like they used to be. And people don't take as much pride in it. There's a real misconception: Anybody that has ten acres in their backyard figures they can raise a horse. I get people come to me and they give me a two-year-old horse and say, "Break it." I say, "Okay, all I've got time for is . . . I'll put thirty days on it, you'll be able to ride it." They come back, they want to pick up a horse that's three years old, and they want an eight-year-old, sound-broke gelding that they can put their kids on. Well, there's no such thing in thirty days. I don't care what horse it is. I mean, I've got one out there like that now, but he's one in a million. Horses are like teenagers. You don't say, "Well, now, don't drink"—tell them once or twice and then they don't ever do it. You never have to tell 'em again, right? Bullshit! You know. You raised kids. You know how many times you got to tell 'em. My old man had to tell me several times, and sometimes he had to take some steps and take my keys away, or whatever. Horses are no different. But it's generally not a horse problem. It's a people problem.

It's funny. It all goes back to education, I think. That's my theory on it. People don't listen or they don't want to learn. Because I think anybody can be good at those things. But most of 'em either think they know too much already, or they don't give a damn, or they don't want to take the time to stop and look at anything. There's hundreds of those guys around. You see it

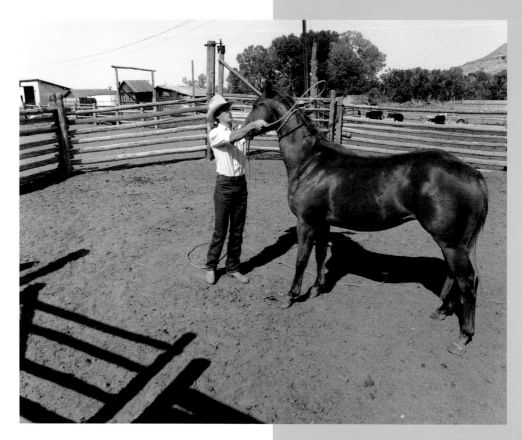

especially with horses, because you cannot only see what they're doing, you can see the end result. I get so many of them that I can almost take a horse now and tell you exactly what they did to 'em.

I don't think that there's anything that I can't understand, and I don't want to ever think that there is. There's a lot that I don't now. I've got a long ways to go. I mean, it's like anything. The more you learn about something, the more you realize that there's a lot that you don't know. You can read a paragraph on nuclear physics and you probably think you know more than if you read the whole book and realized how much there is that you don't know.

There's always something leveling you. Just when you get to thinking you're pretty sharp, you end up with something that stalls you a little bit, makes you think. I think it makes a better person out of you eventually. I mean, I'm as cocky as the next guy probably, maybe more so. But I also know that there's things out there that are gonna stonewall me, too.

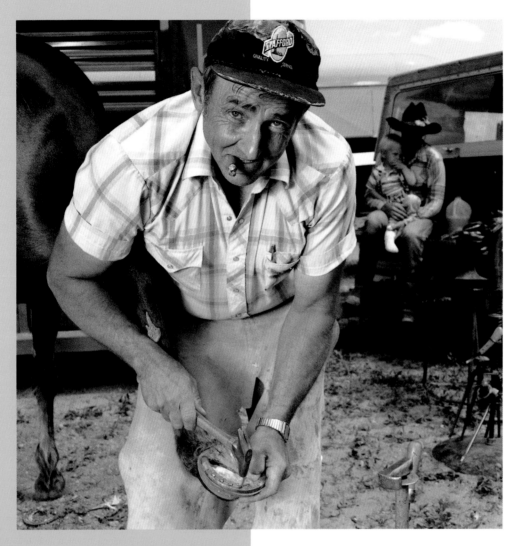

ORIN JUNCTION
b. JANUARY 11, 1940, MULLEN, NEBRASKA

A horse wasn't made to wear shoes. Man made him thataway when he domesticated him. Yeah, I guess if he was made to wear shoes he'd maybe been born with 'em.

I shod six today and that's about a normal day. An average of thirty-five minutes a horse if I'm just there not BS'n, or gettin' my picture taken. [Laughs] But if I got four or five, and they're just standing there waiting for me, I can go through on an average of thirty-five minutes.

I generally just start in slow. A horse's got two sides to his brain, and they have to be broke on both sides. And all horses are broken more on the left side than they are

the right, 'cause that's the side they're saddled from, that's the side they're haltered from. You can teach a horse to pick up his left feet and if that person that halter broke that colt, if he picked up his left feet each time he haltered him and never touched his right feet, he's gonna be scared to death of you when you get over to his right feet. You gotta teach both sides. I generally start at the left front foot.

A horse is a lot like a kid. You gotta make 'em mind. You take, oh, a year-old colt. He's about equal to a ten or twelve year-old kid. But you let him walk over the top of ya all the time, he's gonna be just like that kid. By the time he's fifteen years old, well, he's in the reform school or somethin', you know. And this horse is a damned outlaw. But you can do it with a firm hand. You don't have to beat hell out of him. If they bump into you, well, you jerk 'em with the halter a little, or swat 'em a little with the back of your hand or somethin'. You don't pick up a post and beat on 'em.

Bad horses are the ones that have to have a leg tied up on 'em to handle, and I haven't done any of them for ten years. When I first started I used to think I had to do every dirty, rank S.O.B. that they threw at me. And I would. But I refuse one or two a year that are just too obnoxious, will get ya hurt. And they's too many good ones around to get hurt over a $32 horseshoeing job, you know.

One of the plus things I like about this job: If we have a racehorse or two every year, if I wanted to go to the races tomorrow, last week I wouldn'ta scheduled any horses to shoe tomorrow. I'd a went to the races and I didn't have to kiss anybody's ass to get the day off. The independence of it is one of the things I really like. I think I can do it another fifteen years.

RON ROBERSON
STOCK DETECTIVE

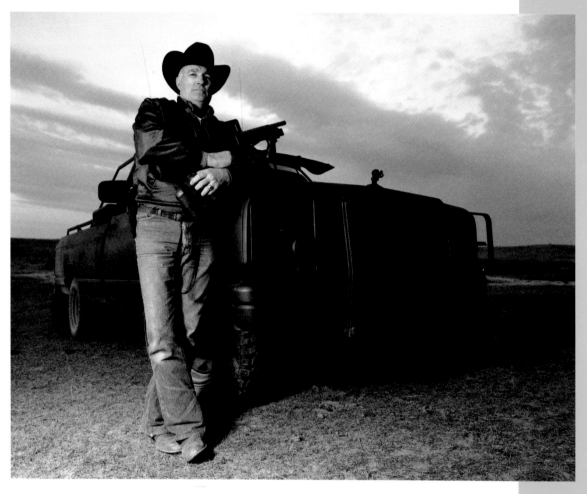

When I was a youngster I saw people steal from my folks and get away with it, and I resolved that someday I'd do something about that. I just kinda had a commitment to these people, the ranchers that are taking it in the . . . every day. I'm just kinda committed to helping 'em. And then I get a kick out of doing what I'm doin'. I enjoy it.

The job I'm doin' combines the good parts of two loves in my life: cowboyin' and being a cop. As a ranch cowboy, when it was forty below zero, and there was a bad blizard, and things were going to hell in a handbasket, you had to get out and fight it to do your job, just the same as you would on a good summer's day. But with what I'm doing now, when it gets rough like that I can take a break. As a cop I had to satisfy a computer someplace and keep other people happy that I was meeting my quotas and doing all these things–you know, filling all the squares in with "Xs." As a private agent I don't have to worry about prisoners in jail and what's going on in some other jurisdiction. That's not part of my job and I can just do the things I need to do.

I don't ever feel isolated. I feel remote at times but I never have felt cut off. I'm so at ease with the country, whether it be on the Oregon Coast, or whether it's on the riverbank on the Cheyenne River in a dry season. It's part of the world that God created and I just enjoy being there. I don't like crowds of people. I've lived in some pretty big metropolitan areas and I don't enjoy that ram-jam atmosphere. It's not for me.

I'm sort of an outcast. I'm not a conventional lawman and I'm not accepted entirely by the law enforcement community, so I kind of refer to myself as a black sheep. So that's what I call my pickup.

NORTH OF BILL
b. MARCH 25, 1938, RAPID CITY, SOUTH DAKOTA

WALT GEIS
BRAND INSPECTOR

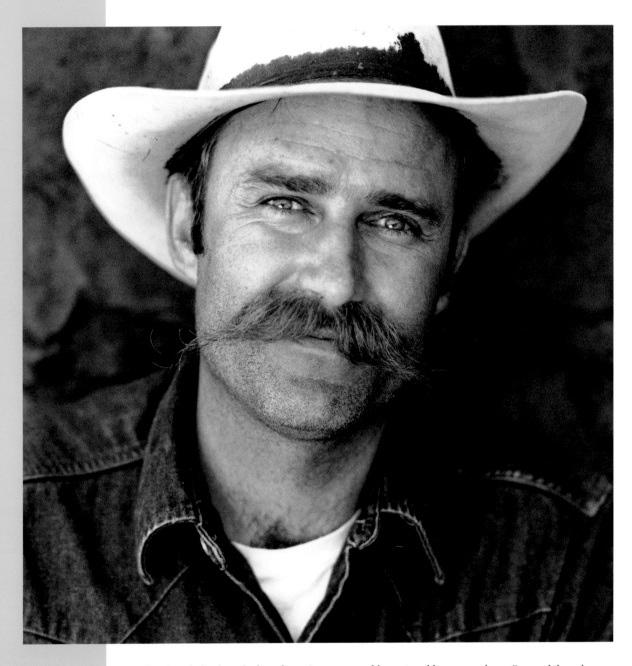

Really, the whole idea of a brand is, it's a return address, just like an envelope. Same philosophy.
Put your address on. A brand clearance to haul a horse or cow across the county or across the state
line is the same thing as carrying the registration for your car. I mean, you wouldn't think of goin'
to California for a vacation without the registration of your car.

SHOSHONI
b. OCTOBER 2, 1955, WORLAND

I loved the people and I loved working the livestock. One reason I wanted to be a brand inspector was 'cause everywhere I go it's shipping day. Everybody's havin' a good day. Shipping day. Boy, that's . . . Hey, man! You pull out all the stops on shipping day. It's fun. The hired men all put on their best pair of pants that they don't have all the patches in. And they wear their chinks. And today's payday. Everybody's in a good mood on payday! They worked all year and now we're gonna see what the cattle weigh, and we're gonna see how much money we're gonna make, how much money we're gonna have to operate on next year. You know? So a lot of it's filled with curiosity, especially now that cattle's worth so much. Four or five years ago when prices were down, in the fifties and sixties, it was a pretty glum day because they knew there wasn't gonna be enough money to pay the bills they already had. But now that steers are selling anywhere from a dollar to a dollar and a dime a pound, it's exciting again.

I represent all the neighbors. So it pays for me to not just know the man whose cattle I'm looking at, but it also pays for me to know all the people that he neighbors. It's my responsibility to be there, to represent the neighbors. The neighbors rely on me because I represent them. The rancher that's shipping the cattle, it's my job to see to it that every cow he ships belongs to him, that he's not shipping any of the neighbor's.

The biggest problem I probably have is telling when people are serious and when they're BS'n me. That's probably one of the hardest decisions that I have to make on a daily basis. 'Cause a lot of ranchers, they're free. They pretty much do what they want to do when they want to do it, and they pretty much go where they want to go. They're just that breed of people. They're just not one bit past pulling a prank on a guy at all. And they're not past leaving a stray in there just to see if you're doing your job. I had a guy one time . . . I missed a stray calf. He knew he was in there, and he made the trucker unload the truck, and he got the calf off. But I had missed it. He said, "Did you go out drinkin' beer last night?" And I said, "No." "Were you up late last night?" And I said, "Yes. I was up late doing book work."

He said, "Well, you must be asleep 'cause you just missed a stray calf." I said, "No I didn't." He said, "You sure as hell did." And he had the trucker unload the truck and, sure as hell, there it was. It makes you feel about a half an inch tall and you could just dig a hole and climb in it right there. I do have to be honest and say, and he had to admit, that it was a very poor job of branding, that the neighbor hadn't done a very good job of branding his calf. But it was there and he knew that it was not his calf.

The agricultural world has not changed that much because they're gamblers. Agriculture was built by gamblers. They're gambling on the weather, they're gambling on the spring, gambling on the fall. So when you have people that are gamblers, they're pretty free people. I mean they're doing what they're doing because they love it, not for the money. Because one year they can make a killing and the next year lose more than they made in the last two years.

I'm still young. I'm going strong. I love it. I do. I really do. 'Cause it's got the best of both worlds. Number one, I can pretty much set my schedule the way I want it. Number two, every day's shipping day. I love shipping day. I was raised loving shipping day. And I like livestock. I really do. To me a pretty, beautiful sight is to see somebody trailing cattle with a cow and a calf, and a cow and a calf, and a cow and a calf. The cows are all good mothers, they got their babies right at their sides, and up the trail they go. To me there isn't anything more beautiful than that. If you got a whole bunch of good mothers—and I mean they got that baby trained and, boy, he's right by their side—to me there aint' nothin' prettier than that. That's life. 'Cause everybody likes good. Nobody likes bad. So consequently we don't deal with the bad. We have a tendency as human beings to put bad on the back burner. And then we're madder than heck when bad boils over. We're just madder than heck. Well, how did this happen? Why did this get let go this long?

As long as I'm physically capable, I'd like to stay in this job as long as I can. I'd like to retire doing this. I really would. To me it's more than a job. It's a career.

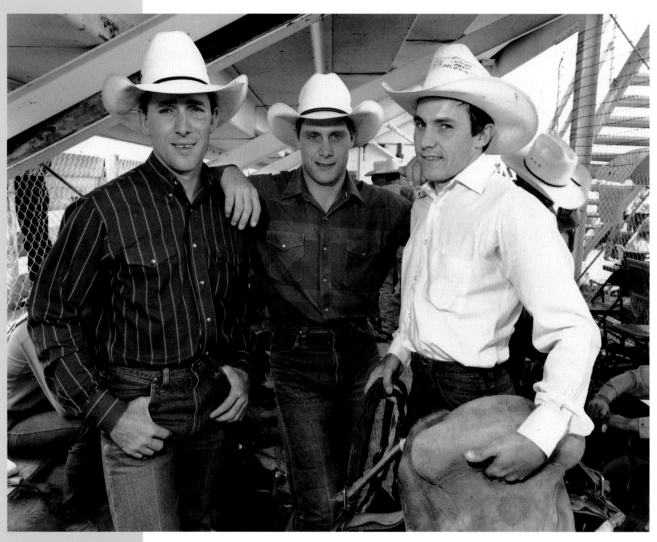

WYOMING

CHEYENNE

ETBAUER BROTHERS
left to right
ROBERT: b. JULY 10, 1961, HURON, SOUTH DAKOTA
DAN: b. JULY 3, 1965, HURON, SOUTH DAKOTA
BILLY: b. JANUARY 15, 1963, HURON, SOUTH DAKOTA

DAN: *I wanted to live the life Robert wanted to, and I wanted to have the couth that Billy had. I never had my sights set on just one person. Billy is really conservative, tends to business real good. And Robert, he's outstanding with that, too. But it was just when I was around them, how I learned.*

I'm just starting. I can't see nothin' but up. With my brothers behind me and helpin' me, and my family and everything, the only one that'd be holding me back right now is me. And I don't want to go nowhere but up, so. … Rodeo's so unpredictable you just never know. I want to be a world champion. You know, this is being kinda conceited and maybe even kind of an idiot, but I want to be able to walk into a rodeo ground or where a cowboy is known, and I want to be able to walk and say, "Hey, that family of bronc riders right there? That's some of the best that ever lived." That's what I want. That'd mean more to me than anything. I know world champions that don't have that respect and I want it. And that respect is a long ways down the road, you know?

134

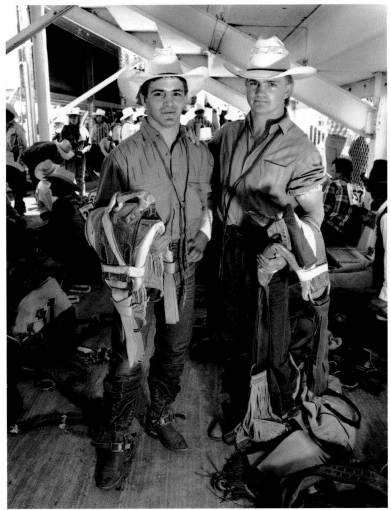

Clockwise

GARRETT BROTHERS
MARK: b. AUGUST 19, 1965
GETTYSBURG, SOUTH DAKOTA
MARVIN: b. JULY 28, 1963
BELLE FOURCHE, SOUTH DAKOTA

NORRIS GRAVES: b. OCTOBER 16, 1920, LARAMIE
GRAVES RANCH, UPPER RED FORK, POWDER RIVER

CRAIG LATHAM: b. APRIL 13, 1967, CASPER

LARRY SANDVICK: b. MAY 15, 1966
DICKINSON, NORTH DAKOTA
SHANE CALL: b. JULY 14, 1967, ASHCROFT, B.C.

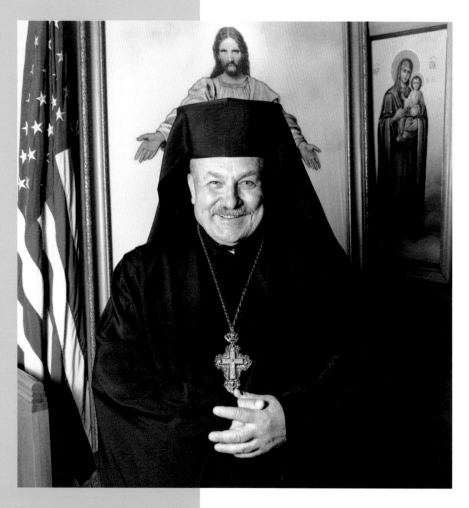

I am registered a Democrat,
tell you the truth. But when I
vote, I vote both ways
because both good. I vote for
the person, you know.

ROCK SPRINGS
b. OCTOBER 20, 1932, IRAKLION, CRETE

My dream was someday to come to this country, United States. My dream was since I was young boy. I had dream: someday I hope come live in United States because I like very much United States of America. I tell you why. Because during that war, War Second, in Greece, after that war we have civil war in Greece. But I'm sure you know. The late great president, Harry Truman, sent to Greece military and economic aid and saved the Greeks from Communists. I remember during that war I was young boy but I remember America. They sent help to Greece, and I love this country very much—very, very much. I'm very proud to be American citizen. When I came first time

here, I made the sign of the cross, and I pray and say, "Thank God I came and my dream became truth, because I like so much." I was very, very happy because—my goodness!—at that time I did not speak but just few words, and American people they are warm people, they are friendly.

During the War Second, you know, my family was poor. I told you, poor. But I remember when my mother bake Christmas bread, or Easter, we have quite a few families more poor than my family. And my mother told me, "Take this loaf. Give to this neighbor." I remember I was probably ten, eleven years old. But these little things I never will forget. My mother baked bread because the bread was very expensive at the time. Very. Hard to find wheat to bake. When we bake bread we eat greens, like greens stew. I want to eat more bread because when you eat greens—you know, stew?—you need more bread. Must eat more bread. And never in my life I won't forget one family across from my home—our family with four children, poor family—and my mother told me, "You eat one piece bread. Enough for you. Don't eat no more bread." I say, "Mama, why? I need more bread." "No, because this family does not have bread eat tonight, their supper." But people, they show appreciation. Believe me. In 1972 when I went in Greece, this family they treat me wonderful . . . say, "I never forget you." They told me, "Was young boy and you bring the bread in our house."

I try to show kindness to everybody. My bishop told me one time—his name was Bishop Miletus; he died years ago—"You are good to everybody but no very good to yourself. You do everything for the people but take care of yourself." I say, "That's alright." Some people sometime they say, "Father, you do too much for the people, and some people they no show appreciation." I told them, "I don't care if you show appreciation or not. I show kindness to everybody regardless if they appreciate or not."

ELIZABETH TOLERTON
DANCE INSTRUCTOR

I introduced professional dance to Wyoming. I came here in '52, started teaching. Professional dance, as such, people didn't know. So I really did bring it to Wyoming.

When I saw it [other dance instruction] I said, "Oh, my God, I will never teach." The teaching I saw was very poor. And then the mommies sat in, and they just made little dances up. The mother said, "Now Susie, it's the wrong foot." In my school the mothers only come when they're invited.

It is an entirely different atmosphere. My school is, well, it's a professional school. It's run like I was taught in Europe. And it's not only the dance—that's a big part—but also the other, what goes with it: manners, courtesies, decorum, refinement, appreciation, whatever. Many of the children just come and do that to get some more poise or refinement, good coordination, musicality. Because if they would want to dance professionally, they would have to be in here from four, five hours every day. But many of them are lawyers. They took cotillion—poise and gracefulness—before they go to college.

To speak good English first. Because they just butcher . . . I don't know what the schoolteachers have to live with. But that is one thing that I think should be enforced more strictly. English is such a nice language. It is not only the slang I'm talking about, but it's the grammatical errors that the children use. I think they hear it at home. "It ain't" . . . "and that" . . . and "Where is it at?" I say, "The 'at' is not necessary" "Where is **it**? Finish!" They look at me. "It don't matter." . . . "It **doesn't** matter!" Things like this. So I do correct them. I say, "Look, it took me a long time to learn to speak English correctly so don't confuse me!" [Laughs]

It's all in your mind. I don't think about age. I wouldn't ask you how old you are. You're you and I don't care if you're thirty or if you're fifty. It's the individual, I think. If you have the oomph, or whatever—

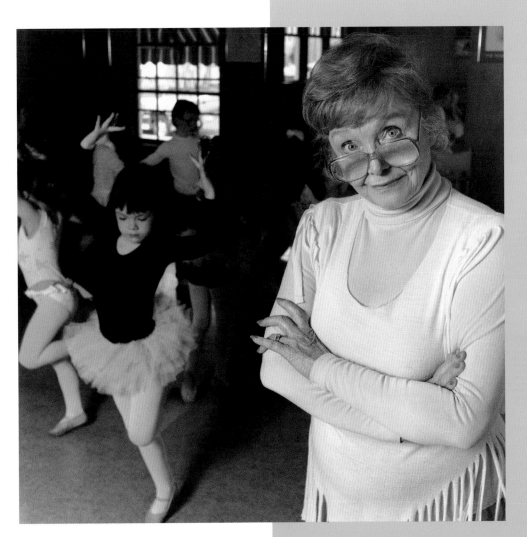

If I tell my age . . . you know they always say, "If a woman tells her age, she will tell everything." She cannot keep a secret.

CHEYENNE
b. ELTVILLE, GERMANY

pizzazz—in life. . . . I think that people, when they're twenty-five, they're old, they act old, and they look old because they act that way, even when they walk. You can see on the street. I can see on a person, how they walk, if they have a certain zest of life. I think so. You can think old when you're young. Or you think young when you're old.

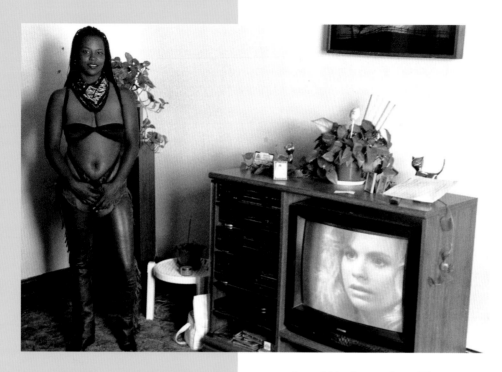

I never dreamed in my whole life I would become a stripper. That was the last thing on my mind when I was growing up. I wouldn't want to do this all my life. Right now it pays my bills, my car, and it takes care of my two daughters and keeps a roof, and food and clothes on them.

ROCK SPRINGS
b. 1962, LOS ANGELES, CALIFORNIA

It could be fun in there. If you can make it a fun job, if you like your job, you'll be okay. If you don't like it . . . I haven't had none of the guys' wives come up and get ignorant with me. If anything, they come up and they compliment me. It's a job. Me and the other dancers that's on the stage here and in any other state, we're trying to make a living just like everybody else. We might be up there taking our clothes off. Because we're taking our clothes off don't mean the dancers are doing something wrong. It's just that individual.

Like I tell a lotta girls: "If you get up there and do your dancing with respect, the guys will respect you. But if you get up there and do anything that looks sleazy, they're not gonna have no respect for you." Do a skit. Just don't get up there, or as soon as the song starts, pull off your clothes. Give these guys something for their imagination. "Well, what's she gonna do next?" You know. And it took me to where I am today to learn

that. You know, it's not all about getting up there, snatching your clothes off, and letting a guy see your body. Guys like to see a show. You need eye contact. Don't get up there with a attitude. Don't get up there drunk as a skunk. It's your eye contact and your costume and your attitude.

I was watching one of the dancers last night, and if I knew 'em, I would've went and said somethin'. "Don't come out without your top for the first time. You take your top off too fast." Coming down to Wyoming's what learned me that. 'Cause when I first came down here in '86 I didn't know what I was doing. I didn't have the costumes that I have now. And, I mean, I have costumes. Then I was dancing in T-shirts and panties. I was dancing in tennis shoes. I have to have a five-inch heel to dance in now. If it's not a five-inch heel I cannot dance.

They didn't like me when I first came up here in '86 'cause I didn't know what I was doin'. I wasn't smiling. I didn't know how to approach the guys. So I waited for a little bit and I told my agent, "Do me a favor. Send me up there. I have the attitude, I have the costume, and I've got the dances down pat." They sent me back. I walked out of here with $1,700 in tips, $500 in pay [a week]. That's just my tips. And when I got home I said, "Well . . . I wanta know what the report was in Rock Springs." They said, "They ain't never had a black girl that could hold a crowd like me as long as they been open." I said, "Okay, that's all I wanted to know." It makes me feel good. 'Cause anywhere, I don't care whether you're black, white, purple, green, or yellow, somebody's gonna have something negative to say. And I learned that, you know: "Tune it out. Let 'em say whatever they have to say. Just tune it out." And that's what I do, I just tune it out now.

NORMA RODRIGUEZ

MAID

I like cleaning. I do. I just like it. I like cleaning and I like cooking. There was an old lady that worked in the restaurant. She's not there no more. She got sick and she was in the hospital. I don't know whatever happened to her but I really liked her a lot. She used to tell me, "You know, seeing you come in all the time for your pop, you always cheer me up." And I go, "Yeah? Why's that?" She says, "Cause you're always smiling." She goes, "And you're always with a cheerful talking." She goes, "I've even had customers say, 'That little Mexican up there'—well, it must be me 'cause I'm the only little Mexican up there—always has a smile." So I really like it. I figure if you do your work right the way they want it, nobody's yelling at you. In other jobs you could do it right and they still yell at you.

One time . . . this man was an old man. He said, "I'll pay you some money if you come tonight, show me a good time." And I looked at him. I go, "What do you think I am, a grandma or somethin'?" He was so old. He goes, "No, I'm serious." He goes, "I'll give you some good money, fifty dollars." I go, "Nah." I told him, "I don't do that." So I went upstairs during lunch break and I'm talkin' to the girls. One of the girls says, "Send him to me, I'll do it." I looked at her and I go, "You'll do it?" She goes, "Heck, yeah." And I go, "Oh, if I see that little man I'm gonna send him to you!" just to see if she'd do it. "So if I see that little man walkin' down the hallway. I'll go, 'Hey, there's a maid around the corner, she wants to talk to you.'" And I did send him. And she did do it. She told me she did do it. And that crazy little old man went and did it.

I always was brought up, "We're all the same." I used to read a lot of the books when I was small. Like Noah? I always remember the story of Noah. How only him and his family lived through the flood. And I go, "You know what? We're really all related somehow. Some are the blacks, some got Chinese eyes, but we're all colored because they're the only family that lived. Why this prejudice?"

CASPER
b. FEBRUARY 9, 1954, LOVELAND, COLORADO

I always wanted to be on a farm. It's not so much that I want to be a farmer. It's that I want to live on a farm. I want this nine-hundred-acre lot that I'm sitting on. I want the privacy or the freedom that it affords me. Unfortunately, I didn't have the assets to just write the check for it. And that means mortgage. And in order to support the mortgage you have to farm it. So I became a farmer. Now, at the time when Karen and I started looking around for a farm, we were looking for forty acres and a couple of cottonwood trees. Just to be able to get out of town. The uranium boom was booming. Inflation was roaring. Near the town of Riverton, forty acres and a house cost the same as four hundred acres and a house in the Pavillion area. So we committed to the twenty-three-mile commute, which, if you're from Ohio, a twenty-three-mile commute is nothing. And there's not even any traffic.

It wasn't until I was in Wyoming working on the ranch in Casper that I woke up to the idea that, "Hey, a person doesn't necessarily have to work in the big city in order to support their farm. Some people own a farm and it supports them and they don't have to live in the city." Okay? I can remember making real rude little sketches: If I had 200 cows and they raised 180 calves and I could sell them for 200 apiece, that sounded like an endless amount of money, and you could conquer the world with that.

I'm a farmer. It's taken me a few years to accept that, but that's basically what I am. I didn't understand it. You have to be a farmer to understand what one is. We grew up hearing the phrase "dumb farmer." You know, "You did that like a dumb farmer." I sit there with a quarter of a million dollars, on a half a million dollars' worth of real estate, grossing a couple hundred thousand dollars or more a year. I do this with large amounts of capital. I do this with large

amounts of other people's labor. I have to do a lot of physical work, also. But it's nothing like what our ancestors did. I buy diesel fuel. I do not do it with my back. I do it with diesel fuel. You know, farms used to be eighty acres. That's because that's all they physically could do. Now some farmers farm thousands of acres. John Deere tractors provide that labor, not the farmer's back. Not too many years ago a fellow with a strong back and a weak mind could survive in farming. That is not true anymore. He has to compete with people that run IBM computers, that run sophisticated machinery up and down the fields.

Most of my neighbors are extremely sophisticated people. There aren't any dumb farmers surviving. There are still vestiges of people that are living on a place that their fathers got paid for. But the last downturn saw a lot of people that had taken dad's investment that he'd wrestled out of the soil, had mortgaged to the hilt, and then lost it. Agriculture is an extremely competitive environment. If you make one or two wrong decisions you're history. The dollars are too big. I have a neighbor by the name of Kenneth Westlake. And Kenneth is more than seventy years old, somewhere between seventy and eighty. I visit with Kenneth a lot because he helps me get a historical perspective on what I'm trying to do and what's happened in the valley before me. I don't care where you are farming, you're farming upon somebody else's shoulders, the people that were here before you, the people that broke this ground out of sagebrush or learned what grew here.

There's not particular brilliance in what I do here. An awful lot of it's been very carefully worked out by somebody even a hundred years ago. You have to think historically. Farming is a very cyclical business. It booms, it busts, it booms, it busts. I would

like to think that it would just keep booming but I know it won't. So when I talked to Kenneth, I would say to him, "Kenneth, what did you used to sell a ton of hay for back in the forties or thirties?" "Oh, maybe fifteen dollars." "What did it cost you to raise a ton of hay?" "Oh, maybe five." "So you were selling something for fifteen that cost you five?" "Yeah, but we didn't have very many tons to sell." Because he was doing it with his back or with a team of horses. I, on the other hand, have hundreds of tons, thousands of tons, to sell, but if I can get seventy dollars for a ton of hay, I've probably got sixty in it, maybe sixty-five, some years maybe seventy-five if the yields are down. The margins that I operate on are very slim compared with the margins that they operated on. Right now the only crop that we've got that has a decent margin is sugar beets. But at the whim of Congress the sugar beet crop could be done away with. It's a high-risk crop. [Laughs]

In some ways I feel a little picked-on. Here I am trying to raise alfalfa and hay for cowboys to feed cows, but we all know we can't eat beef anymore 'cause our cholesterol will go up and we'll die of a heart attack. The federal government's doing its best to tax the beer industry out of existence at the moment by raising the cost of a six-pack of beer. And sugar, which has been picked on for years, is something that might bring about hyperactivity in children, or one thing or another. Sugar's definitely been slammed. I sit here having a hard time believing sometimes what I hear. Here's your choice: Would you rather eat a natural sweetener that comes out of this plant, or would you rather have something that starts in a hole—petroleum product—funneling through a chemical plant?

I think it's a little more spiritual. The part of grasping and holding something is a visual experience. In other words, I can climb the butte in back of the house here and look out over this farm. And I do that fairly regularly. I can sit up on those rocks and look out over the fields, and it's not a lot different than painting a picture. It's a

palette in dirt, so to speak. I used to have this farm broken into fifteen-acre chunks so that I could see yellow barley, green alfalfa, brown sugar beets in the spring. It takes a long time before those fields green up. Different colors, different hues. And I find that very satisfying. Not necessarily good economic sense, sometimes, but it's a very tangible thing. This afternoon when I went down to visit with the combiner . . . sitting up on top of the combine I could stick my hands down into the grain tank, and that's a physical product. I can feel it. I can taste it. I can smell it.

I think having worked for myself wrecks me for ever being a good employee. Having to make all of the decisions that I have to make, be they right or be they wrong, they're mine and I live with them. Living with other people's decisions when I know they're wrong is tough. I can't keep my mouth shut. And I think that's the essence of being a good employee, is being able to keep your mouth shut. [Laughs]

When I bought this farm I paid a little more than eight hundred dollars an acre. I bought a water right. I didn't buy a piece of dry dirt. A piece of dry dirt in this valley isn't worth ten dollars as far as I'm concerned, for agricultural purposes. So when you say I didn't buy the water, I gave almost a quarter of a million dollars for the right to have water comin' down the ditch.

PAVILLION
b. AUGUST 8, 1946, CLEVELAND, OHIO

KINGSTON
EMILY

This is something that we aspire to, is the Supreme Court. Ultimately, I'll be there. [Laughs] I hope so.

WASHINGTON, D.C.
b. APRIL 30, 1962, DETROIT, MICHIGAN

There are probably two to three thousand justice attorneys, I think. There's a lot of women attorneys here. There are still more men than women, but it's almost half and half, really. I've had a couple of people say, "So, are you a paralegal or are you a secretary in some office?" That happened more times in Wyoming than it does here. Here people almost assume that you're a lawyer because almost everybody is in D.C., frankly. [Laughs] There's so many of us. But I've actually had more people assume that I'm a lawyer first than assume something else.

The mentality here is different. It's very political here. People are driven a lot by whatever political thing is going on at the time. The city is very transient. I probably know three people that grew up here, total. Everybody comes from out of town, and they all come to work for the government, essentially. And it's southern. I mean, this is still a southern city. There's a serious amount of racism here which is frustrating for me because I don't see Wyoming as having that. And maybe that's simply by virtue of the numbers. You know, there aren't that many black people in Wyoming. But I grew up in a family where that doesn't make a difference. You come here and there is a racism that's ingrained. And it's not just white to black; it's black to white. Unfortunately, there's a definite feeling in the blacks. They don't want to deal with whites, either. It's real hard for me to deal with that because that's not something that I've ever experienced before. I've never experienced outward racism.

I miss being able to walk down the street and knowing everybody. It's really a nice thing. The other side of that is, everybody knows what you're doing all the time. I wasn't particularly fond of that. I remember a couple of situations where everybody knew what you were doing all the time, and things would get misconstrued by other women who had decided that you couldn't succeed, professionally, in Wyoming as a woman, that you had to stay within a certain position. I had decided that wasn't true for me. I was gonna do more than that. I didn't want to be pushed into some position that I thought was acceptable. That was kind of a jealousy thing.

I don't think Wyoming is the Equality State. I think it's getting better. I think there's more acceptance. The thing is, most of the people that I dealt with were all older, for the most part. And this old boy mentality is really in that older group of people. It's not that it's intended as "Let's keep the women in their place" kind of thing. It's just something they've been used to for years.

JUDI MORRIS
FIRE LOOKOUT

It's kind of strange. We have this little sheet here that says what to do in case of lightning, and it talks about getting into a low area, avoiding high spots . . . and here I am. Last summer—I can't remember the date—there was a horrendous storm and I could see it coming in. It's kinda neat. You can watch a weather pattern just kind of move towards you at this level. And this gigantic, black steamroller cloud was virtually crushing Saratoga. It was just rolling this way. I could see it coming. I could see lightning, too, and I thought, "Uh-oh." So I battened down the hatches and just sat here and watched it. About a minute before it got here, it became terribly calm. I thought, "Oh, no, this is something really big." Raised in Michigan, I knew about tornadoes and how you sometimes have this really quiet time before the tornado hits. I thought, "This is it!" So I sat in this chair and just watched it come in. I grabbed my notepad and started taking notes on what everything looked like and what was happening. People were scurrying around down below because they were worried about flash flooding. It was raining really hard, and they were trying to get people out that were in low camp areas. So I was listening in on the radio to see if I could be of service, and all of a sudden the storm hit. The windows started rattling and shaking, and I grabbed my sleeping bag and wrapped it around me in case some glass broke. Then there was this horrendous green flash of light and the lightning rod got struck by lightning. I was sitting in the chair you're sitting in—this wonderful ol' chair with four insulators, one on each leg—next to this little wooden table sitting in four glass ashtrays. So you see, it's very well grounded here and a perfectly safe place to be. It's just noisy and kind of scary if you don't like storms. You'll notice, though, that I've chosen to sleep in the wooden bed, not the metal bed with the insulators on it.

I found out that I needed time alone. That time alone was healthy for me. I'd been afraid of it before. I thought I was wasting time when I wanted to sit down and read. I felt like I had to be productive every minute of my life, you know? And that, "Oh, no, I have to fix dinner. I have to do this. I have to do that. I can't go off and just watch the trees or go for a walk." There was always guilt involved with that. Now I realize I'm a happier, more fulfilled person when I do have those moments in my day. I can be more productive when I have that. A lot of people don't want to be alone. They don't want to think, basically, or be confronted with all the things that you face when there's time to just think about your life and yourself.

KENNADAY PEAK, MEDICINE BOW NATIONAL FOREST
b. JULY 21, 1944, STEVENS POINT, WISCONSIN

ALFRED REDMAN

TEACHER & COACH

WYOMING INDIAN HIGH SCHOOL

The majority of our kids here come from one-parent families. The majority of these kids' folks are divorced. I think the last survey they took last year of our kids, 63 percent were from one-parent families. Because of divorces. One year we won state championship, we had nine out of the twelve kids that were from broken homes. And they worked their asses off. I don't know if I was a father figure to them or what, but I've never had a bunch of kids that worked that hard before. Their talents weren't as great as some of the teams I've had before but, damn, they worked their asses off. And these kids they're starting to, too.

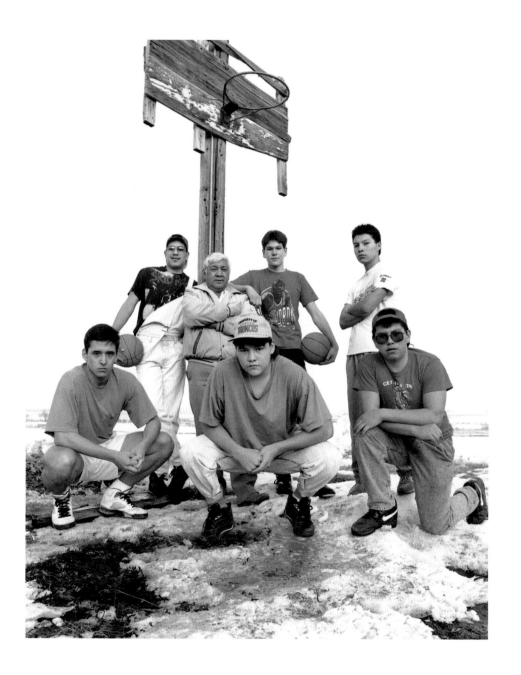

I was really interested in the kids playing sports. I seen a lot of good talent go down the drain. They weren't being played to their full potential. They didn't have that drive that I thought they should have had, because I know the kids. They had the talent and the ability to be good basketball players. They were playing and that was it. There was, really, hardly any drive for them to be a tough, good basketball team. The previous guy [coach], he won some games. He went to state two years in a row. But he couldn't win the big ball game in state tournament. That's when I probably decided, if I'm gonna be head coach I'm gonna be a tough son-of-a-bitch. 'Cause you need to be in damn good shape in state tournament.

I tell 'em, I says, "You work your ass off and you know you're gonna play. I don't care if you score or don't score. If you rebound, you're gonna be playin'. Little guys: if you hustle on defense don't worry about scorin'. You'll get your points. Just hustle." That one kid that made one free throw, Gregg Trosper, he hasn't been playing much but he's been hustling in practice. I started him tonight and he played damn good. He only scored one point, but he worked so hard that the kids on the bench knew they had to work harder than he did to play more.

The first thing is respect. I want you to respect me. I'll respect you. So if you got that, you got half the battle won. But you gotta work hard. Not only on court. In the classrooms, too. You respect all the teachers. And play teamwork. Teamwork is what we stress, too. If we didn't have teamwork we wouldn't be where we're at now.

That's what all the kids used to say when we were playing. They'd say, "We're a family." We do everything together. When we'd eat, everybody went at the same time. When we went to shows everybody went whether they liked the show or not. They went to the show because we were a family. We were together. Then a couple of times at the end of the season there's always somebody that wants to break it up. We tried that. It kind of hurt the team. But we talked about it and we got back together.

Every year as a team we set a goal and say, "We're gonna make it to state. Then after that we'll play one game at a time." My goal is to be a good teacher and hopefully get some kids to make a better life for themselves, either through education or going out in the world and work. I want to do a good job. I tell the kids, "I want to be the best damn coach that ever lived." I know it's gonna be tough. There's a lot of good coaches in the world. But I tell 'em that. I says, "I work at it. I want to be the best." And hopefully other kids will think, "I want to be the best. I want to go out and do something."

Maybe they'll say that.

ETHETE

WIHS BASKETBALL
TEAM, front row, left to right:

LYNN BURNETT: b. OCTOBER 13, 1973,
HAYWARD, CALIFORNIA

GARY BROWN:
b. MARCH 12, 1975, RIVERTON

GREGG TROSPER:
b. AUGUST 30, 1973, LANDER.

back row, left to right:

CHARLIE HOWELL:
b. DECEMBER 27, 1974, RIVERTON

AL REDMAN: b. JULY 21, 1936, ETHETE

CRAIG FERRIS: b. APRIL 9, 1977, LANDER

GARY ANTELOPE:
b. AUGUST 5, 1975, RIVERTON

rest of team:

STERLING HOWELL:
b. JULY 2, 1976, RIVERTON

MARTIN GUTIERREZZ:
b. APRIL 22, 1974, LANDER

ASHLEY ADDISON:
b. APRIL 3, 1974, OGDEN, UTAH

JARVIS SHOULDERBLADE:
b. NOVEMBER 18, 1974,
CROW AGENCY, MONTANA

DENNIS SHOULDERBLADE:
b. JANUARY 11, 1977,
CROW AGENCY, MONTANA

DAN FRIDAY:
b. SEPTEMBER 24, 1974, LANDER

MAC YOUNGBEAR:
b. MARCH 14, 1975, TAMA, IOWA.

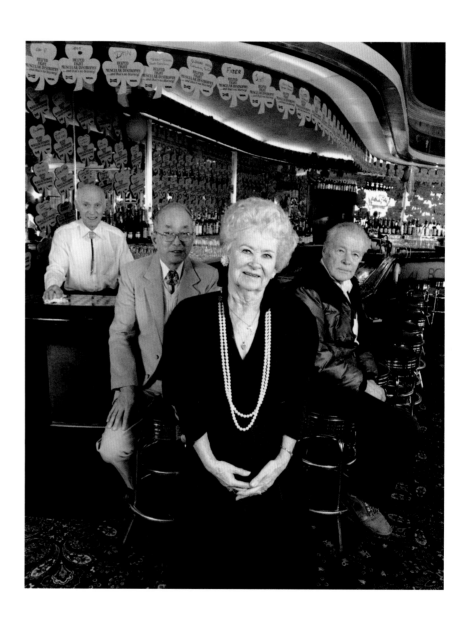

JACKSON

left to right:
STEVE BARTEK: BARTENDER,
b. JANUARY 19, 1916, ROCK SPRINGS

ROY TAKEDA: CONTROLLER,
b. APRIL 29, 1926, INDIO, CALIFORNIA

WILMA TAYLOR: COCKTAIL WAITRESS,
b. OCTOBER 22, 1917, MELVILLE, NORTH DAKOTA

BOB TOMINGAS: MECHANIC,
b. JUNE 11, 1916, ADON

WILMA: The Silver Dollar Bar was put in the Wort in 1950 and I started in 1952. Somebody called me one day and said, "Do you know they wrote a song about you?" I said, "What?" They said, "Queen of the Silver Dollar." And I said, "Oh, my word, that song's been around for a long time, and they didn't write that about me." So that's just a nickname. I've heard a lot of stories and I've seen a lot of things. A lot of 'em I didn't want to see, but when you're working . . . you know, I've had so many people say, "Why don't you write a book?" And I said, "I don't dare. I probably would be sued for the rest of my life." It's a funny thing about the bar business, the fact that people will confide in me when they probably wouldn't confide in anybody else.

McCONIGLEY
NIMI

NEWS DIRECTOR, KGWC TV

I tell you how it works for me. I can see this would be a disadvantage for a lot of nonwhite women in this state because it's very much a macho state. It's a white state. In spite of what they talk about the equality of women in this state, I don't think it's a very equal state for women. But in my case, in my particular job, not only is it not a disadvantage, it works as an advantage for me. And I have parlayed it to its fullest. That's partly because I am me, and that's the way I cope with my own challenges in my life, and that's why I've got as far as I have. But I've also discovered that to be different is an advantage. You know, you can be lost in the shuffle and just be one of twenty other people.

I think I stand out and get attention. So I get noticed. Let's say Alan Simpson is holding a press conference and all the media is in town. Say, for instance, Secretary Baker meets Shevradnadze in Jackson Hole and five hundred journalists are there, and they look around the room to answer questions. And there I am sitting in a sari with a spot on my head. I mean, gee, how can they overlook me? You know, if I put up my hand and twenty other people put their hand up, apart from the courtesy of giving attention to a foreigner, which is an innate American deference, they look at me. I'm different. I'm noticed in a crowd. I stand out in a crowd. If people have talked to me once, they remember me. If Simpson does a press conference and goes back to Washington and twenty people have asked him questions, he's more likely to remember this Indian woman with a strange accent. And if I couldn't back that up with knowledge and ability, I'd probably fall on my face. But I do have that advantage. I'm qualified, I'm able. And I'm not sounding pompous or boasting to say this. The reality is, I'm qualified. I can hold this job with any man, white or otherwise. I hold the job with equal ability, but I have that edge of being different.

I'm doing it for the right motive, which is, basically, to make a credible, viable, responsible medium in town which the community needs very badly. If I can parlay this into making the station more effective, more valuable and more credible, I don't see anything wrong with it. That's the only thing I'm after, really.

Tomorrow I will be married nineteen years. And I have two children who are fifteen and fourteen who are just absolutely super kids. I mean they're straight-A kids that are talented, that are good together. I have no problems other than they're wonderful children. I mean, they're as good as you can get anywhere. I have a very happy husband. We have a very strong, secure, well-based family life. All of that comes from my Indian conditioning that I was raised with. I was raised in a family that no matter how smart or clever or successful I was, I was a woman. I was an Indian woman who was raised to be a wife and a mother and to give to people. My mother always said to me when I was a child, "You are like the bamboo tree. You have to bend and give so you don't break, and you come back." That was the concept of womanhood I was raised with.

Today, even though I'm news director, at home I'm still a mother and a wife. I can still take the shoes off my husband's feet when he comes from work in the evening. I still get up in the morning and go out and get the newspaper, and get a tray of tea for him and bring it to his bed. I still cook the meals at home. I still am the pivot and the center of my family, and that has never changed. It's like the old, oriental, biblical tradition: You go where your husband goes, and his people and his life are my people and my life. I've lived that very simply, and it works for me. It's no conflict that I can be the big dragon lady at work and I can go home and I'm part of a complementary whole.

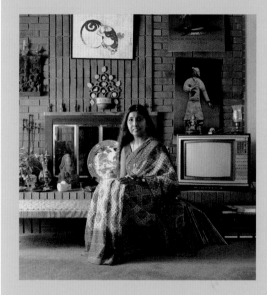

It's like looking at a glass and saying it's half empty or it's half full. I learned early it was smart to say it was half full and not half empty. It's a philosophic attitude I have adopted for survival for myself, and it's worked for me. I've never really stopped long enough to wonder where I am, either here or there. I've always found that being different has helped me.

CASPER
b. DECEMBER 12, 1939, MADRAS, INDIA

ASA SPRATT
RANCHER

Dockin' the tails. And that's cuttin' 'em off. We've got a newfangled deal. Don't have to use a fire and a hot iron anymore. Propane-heated knife, more or less. I guess it'd be kinda like an emasculator. It don't really cut 'em. It kinda pinches 'em, and it's hot to where it sears as you cut through, and it don't bleed. If you just took one of the tails and cut it with a knife, it'd bleed to death. People do that a lot. Most people do their dockin' like that. Just take it and cut 'em with a knife. You lose probably five to ten percent that way. But this is the best way we've found. Not too many have these. In fact, we couldn't find one for a couple of years. This is a good outfit.

LOST CABIN

left: TJ SPRATT: b. MAY 17, 1962, THERMOPOLIS
right: ASA SPRATT: b. MARCH 5, 1965, THERMOPOLIS

The family, we're pretty much cowboy people. We like the cows. That's all we've ever done is cows. We're not footmen, you know what I mean? We like horses. We have a hundred head of horses and we love horses.

Bottom line: money. Sheep make a lot of money. Everyone has their financial probems, but sheep year after year tend to make a lot of money because you have two separate products you can sell off of sheep: You have your lambs and you have your wool, and one market will be good and a lotta times both markets. You have two completely dif-ferent products to sell off of one animal. That's why they're better for making money, probably, than cattle.

We're just tired of the headache, basically. No one likes 'em. We don't like the work. The sheep work is fine, but taking care of the help isn't very fun. It's a lotta work and it's just a constant deal. You're tied down completely to your work with sheep and cattle both. Someone has to be here.

We can't get legal help. We can't get American people to come herd sheep for work. The unemployment rate's as high as

148

it's ever been, and then you take and put ads out, you apply at the Job Service, you ask around. No one will do it. I don't know why. It's the easiest thing you could do. It's been probably six years since a person come walking into this ranch looking for a job, that would do anything for money. I mean, when times were a little tougher . . . like when my dad was younger he said people come walkin' up this road all the time, would do absolutely anything for money. And now, sure, they'll come work. But they want to be a cowboy or they want to drive the tractor. They don't want to herd sheep. They just don't come around anymore.

For a working person looking to make money, I don't know how you could have a better job without a college education. You pay 'em five, six hundred dollars a month, you furnish everything that they could possibly need—I mean everything. They don't need anything, they don't buy anything. They have a small income tax, social security tax, take the rest of the money and put it in the bank. I don't know where you get a job that you could put five or six hundred dollars a month in the bank clear profit. It's terrible lonesome job. You know, there's no one to talk to. There's really not much to do except sit and watch sheep. It wouldn't be a good job for someone who likes to talk, or visit, or see town, or girls, or beer. I mean, all our sheepherders are over . . . the youngest one's fifty. Up to seventy. And no family, no wife. They have kids. I'm not sayin' they're not intelligent people, but they're uneducated to the point that they can't get a better job elsewhere, I guess you'd say.

I said there's no American people come walkin' up the road, but wetbacks'll come walkin' up this road all the time. They're like America used to be. There's herds of 'em to do . . . I mean, they'd clean your horse trailer for a dollar, you know? And the thing is, I know there's a problem with the wetbacks next to the borders in the big cities and stuff, but if they come this far, clear to Wyoming looking for work, they're usually pretty good people. Because they want out of the wetback area. They want to be treated like people. They want to do an honest day's work for an honest day's pay, and they want to get away from all the stuff that everyone dislikes

seein', I guess you'd say. And they're good people. Other than it's highly against the law to hire them. You can't hire 'em. You can, but if you was to get caught you'd pay ten to fifteen thousand dollars in fines for hiring these people. Possible jail sentence. Our government has cracked down on the employing of illegal aliens, discouraging them for coming here 'cause [if] they can't get work, maybe they'll go home. You used to just come get the illegals and haul 'em home, cuss 'em out.

Hopefully we'll sell the sheep this fall. Get completely out of that. And then we're tryin' to, I guess, get situated. My brother and I are tryin' to start going ahead with the ranch. I guess you'd say it's kinda changin' hands again. It's hard for someone . . . well, you take, if you pass it all the way down from my grandpa to my dad, that's a hard transition because he knows how things are supposed to be run, and he knows what he's doin', and he's done it and it works. When my dad's a young guy growing up he's got his ideas and he wants to try 'em. Well, you know, we all get along great. But as the transition takes place it's hard for one to take ahold and the other'n to kinda move back. They don't get out, really. They just kinda move back and let the new generation come through. And that's a hard transition. We're right in the middle of that now. Changing the land over, and the cattle over, and the loans over, and it's a hard process.

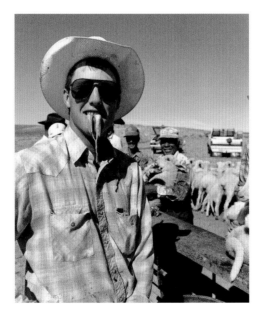

Well, I'll make some people mad here, I suppose, but the first couple of years we did it, we did it the way they've done it for hundreds and hundreds of years. It's not as gross as it looks, I guess you'd say.

The testicles have to come out. I'm sure it gags everybody. [Laughs] There's all kind of little tools and stuff to take 'em out. But we've tried a couple of 'em. They don't work very good. I'm sure with the first sheep that was how they did it. I'd almost bet on it. Jesus himself, probably, castrated a lamb or two, don't you suppose? Well, they had to get the testicles out to stand to eat the little slimy buggers. Someone had to take 'em out. He mighta held the lamb, but someone took the testicles out. You just don't see that in the Bible, do you? Jesus down there licking lamb?

DELIA LAMB

DUBOIS

TELEPHONE EXCHANGE

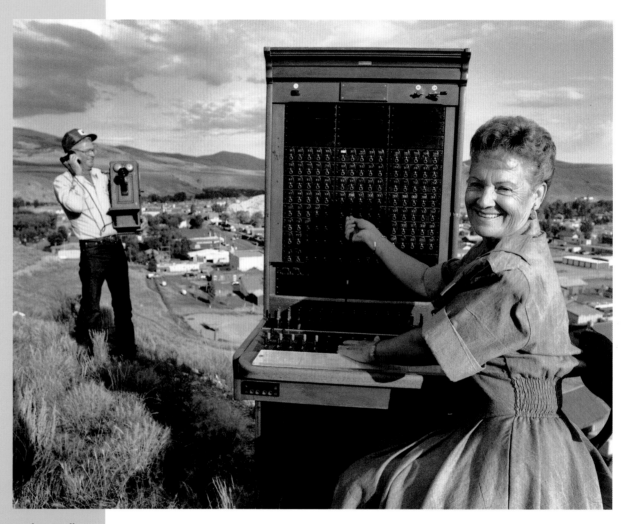

DE: *It was a forest service line with a small switchboard down at a ranch, and a Mr. Holt who had some telephone background. Mr. Holt managed to get the switchboard and get the permits from the Forest Service, and put a switchboard and the lines together in Dubois.*

DUBOIS

DE LAMB:
b. NOVEMBER 11, 1927, CASPER

BILL LAMB:
b. JULY 25, 1925, HURDLAND, MISSOURI

The old gentleman that owned this was Abe Boland. When we came in, Bill [husband] was well trained in safety. U.S. West, Mountain Bell, the telephone companies are very high on safety. And there were no maps. No one knew anything. The lines were around. Noboby knew who belonged on anything. So Bill would go out and climb a pole and ring me on the switchboard and say, "What line am I on?" He started building records. He found out where the lines went, and who operated on them, and how they got from there into the switchboard. That was one of his first major

jobs, was finding out where the lines went in town, because nothing was on paper. And he's very good at this. So he drew schematics and routes and that kind of thing. He was out in a rural area one time and hit a pole before he climbed it, and the pole fell over. He looked at the pole and it had been stuck in the ground and rocks put up around it, lots of little bitty rocks. This country's full of rocks. That's the way Abe built his lines. He would prop a pole up against an old pickup and then he'd stack enough rocks on it to keep it upright. Then he'd tie his lines to it. He wasn't a telephone man, and if he

150

couldn't get a hole there, he'd just rock it up and there it'd stand. Well, of course, he knew which poles wouldn't hold him. But Bill had to learn it the hard way.

Abe was terrific. He was just the most wonderful person. They said he rode into this country with the Hole-in-the-Wall Gang, was a gangster, eventually turned into a law enforcement officer in Riverton, and then was in law enforcement and the telephone company up here. Wonderful person.

But anyway, a boy in World War II had a brother here and they both got money from deceased family members. The brother here would get the check and when the check came in from the trust, or wherever it came in from, he'd send the check off to his youngest brother. So this boy in the service would call in and he'd try to get ahold of Gordon, his oldest brother. Well, Gordon wasn't at home. So Abe would say, "Jim, it's alright. Gordon said he got your check and he mailed it yesterday." [Laughs] They'd call in and ask for so-an'-so and he'd say, "Well, she isn't here." And the operator would say, "I am calling for . . . "—say, Jane Doe—and he would say, "I know you're calling for Jane Doe, but she isn't here. She went down to Lander today. You'll have to call back." He was giving all the information on a person-to-person call but the operator couldn't charge that person unless they reached their party. It just made the operators furious with him. And an operator would say, "I want your supervisor." And he'd say, "You've got him." [Laughs]

When we purchased it, I believe the rates were $1.50 and $2.00 a line and they were all rural lines. Business was $2.00 and the residence was $1.50. We had 140 subscribers. It was imperative that we live here because we didn't have any money to pay rent or live in another house. So the operators moved to their residences. The one that was staying here twenty-four hours a day had another place and she lived down the river a little ways. Bill and I moved into this. We stayed in the bedroom. We told the Public Service Commission that we would give twenty-four-hour service. That had never been done. Mr. Boland and Mrs. Boland turned off the switchboard whenever they

wanted. When Mr. Boland went out for coffee he closed the switchboard down, and went over town and visited around. He was also the sheriff here at one time. They had part-time help that came in and helped them. But we couldn't afford to pay anything. We had to make our payments to our lender so we didn't have any extra money. Bill hunted, and I did the cooking, and we just lived here. He did all the outside work, and I took care of the switchboard and did all the books. I had owned a personal typewriter, a typewriter stand, and an adding machine for years. That's all I needed was an adding machine and a typewriter. I sent out all the statements. We did everything. We did the billing. Before I came up, Bill's operators at Lander trained me for two weeks on switchboard protocol. So I learned to be an operator. They were such great gals. If I had a question I'd just ring them and they'd tell me what to do.

I could come out in the kitchen and do work, or do work at the desk, and still answer all the calls at the switchboard—140 subribers. After they found out someone was here . . . you see, the populace here wasn't used to anybody answering them. They'd ring and ring and ring, and it was easier for 'em to walk over or drive over and get the message than it was to use the telephone. Well, when they found out that we were on the switchboard and when they called they got somebody, an operator, they utilized it a great deal. So it was very, very busy. It was very busy when the children got out of school. There were periods that were busier than others. There were some dead periods. Most of the calls after night came from the bars, that kind of thing.

We had a tie and timber operation here run by J.N. Fisher, wonderful person. He was from Wisconsin, one of the sharpest men, and still is today. But he objected to our updating the telephone office here. He said, "You have taken away my service and charged me more." 'Cause our rates went up when we put in the mechanical switch. What he did was use me as his personal secretary. He would call and say, "Get me so-and-so in Appleton. The last name is spelled . . . " Then he'd hang up and run off to his mill somewhere. So I'd call Information, I'd get the information, I'd have his party on the

line and ring back and he wouldn't be there. I'd say, "Bud, your party's on the line . . . Bud, your party's on the line." Well, I had no way of knowing he had hung up and run off to his mill. An hour later he'd call in. He'd say, "Skinny, did you get so-and-so? Did you get Joe?" I said, "I had him on the line and you weren't there." "Oh, well, get him again." Well, of course, I had the route figured out by this time, so then I'd send him all the way through because at that time you had to have routings to know how to get through the lines. You'd go from operator to operator to find out how to get in there. He would, maybe, give me four calls. "Well, now I want these people," he'd say. I would get them, and he'd say, "I'll take anyone that you get first because they're all busy people." Well, it saved him a secretary.

We were all party line when we came in. Everybody listened in on everybody's conversation. It had pluses and minuses. It had a lot of pluses—the neighborhood line—and people visited. If I wanted to tell a story I'd ring everybody on the line and I'd only have to tell it once. "So-and-so is hurt; their house burned down. We need help. Please bring food and clothes." You could get that out and usually everybody on the party line were the ones that were closest to any emergency. So they had aid immediately. When they called in they would say, "Dee, we've got a fire at . . . " And I would ring the fireman. If the doctor was needed in an emergency, if we needed an ambulance, we needed help . . . I wasn't here too long before I knew who to call to go get help.

In my short period of time that I was on the switchboard here, I don't know of any incident that became mean or nasty or vicious. Now, if it did, it never got to me. But if you're on a party line—and you use any kind of logic or common sense—anything that is strictly confidential, you'll get to a private line and make the call from it. And I think most people have that kind of intelligence. When you live in Wyoming, and you live in hard times and hard country, the contact with those neighbors was pretty important. I don't think you got that upset with your neighbors. People today would have an absolute fit but not back in those days.

In the olden days I used to be able to tie a fly in sixty seconds, from forty to sixty seconds. I can still tie 'em but not that fast, of course. I got my desk out front there where I can watch the girls as they walk by. So that, plus fishing and hunting, is what I'm thinking about. That's why I got these half-ass glasses so I can see good over 'em.

SHERIDAN
b. JUNE 18, 1918, MONARCH

During high school days the three of us [brothers], after football practice we'd have to run home 'cause my dad was bootlegging. We missed the bus, of course, so we'd have to go three miles out to Lakeside. We'd spend the evening bottling beer or making wine so we could operate the next day. One early morning before we got on the bus, there was a guy come up. He knocked on the door and wanted a half a pint of whiskey. My dad didn't know him so he wasn't going to sell it to him. So my brother Gus says, "Heck, I know the guy. He drives a bus." So we sold it to him and that night when the three of us got through with football practice and went home, here was a guy, a revenue officer by the name of Frunkhauser. I still remember that. And he had a couple of guys with him. They went down in our basement. We had fifty-gallon barrels of wine and I don't know how many cases of homemade beer, and he took our own axe and knocked the heads out of the barrels, spilled it all on the floor, busted all the beer bottles on the floor, and put my dad in jail for a month, plus the fine. But the cops knew my dad real good so they let him out. During the daytime he'd go home to bottle some more beer, brew some more wine. Then he'd have to go back and spend the night in jail. So us three brothers, after we got through with football practice we'd go up there and keep him company, and take a shower in the jailhouse with him, and then we'd go home. The only thing they didn't find: We had a chicken house. It had a false floor in part of it, and we had a lot of whiskey hidden in there. So they didn't get that.

My dad had a pool hall where King's Saddle Shop is at now, a pool hall and a gambling joint in the back. Then they decided to come up and build the Ritz and have another pool hall and gambling joint here. That was in '45 when they started that. Just a little after they started that, I got out of the service and came in, too. There was a whorehouse in Thermopolis called the Ritz so my dad called it the Ritz. He couldn't write any English. All he could do is sign his name, and he decided that was a good name so that's why he named it the Ritz.

Gambling was done illegally, too. We had to give the city $104.70 a month in fines. The chief of police would call you and say,

"Your fine's due." It depended on the county attorneys. Once in a while it'd be closer to two or three months—you know, during election time when the new county attorney got in. Then eventually it opened for several months and we had to pay this $104.70 every month. The $100 was fine and the $4.70 was court costs. So when I got back from college in the summer, and I'd be racking balls or dealing cards, we'd get a phone call from the chief of police: "Come down and pay your fine." I'll show you the picture of my dad paying a fine in 1938 out front. But anyway, my dad would give me the sack. It had to be cash. So I'd carry it down to the police station and the chief would say, "Raise your right hand." I didn't know why. Hell, I never did ask whether it was legal or Illegal. Anyway, I'd pay the fine. He'd say, "Are you guilty?" And I'd say, "Yes, I guess I am." I'd pay the fine and walk out.

During the course of the four years that I came back from college till they closed gambling, I'd say that I had to go down and pay the fine probably fifteen, twenty times. My brother did—Paul—and my dad did, too. Whichever was handy we'd go down and pay it.

There was a guy by the name of Moore that was a stool pigeon for the insurance companies, worked for the post office. He'd go down to the police station and when he found a guy that was on the police blotter, like in my case, he'd put our names down. So when I got out of the service I tried to buy my first vehicle. It was a Jeep. I tried to get Sam Rotellini to insure it for me. He said, "Hell, yes, I'll insure it." Three days later he called me, crying on the phone. He says, "I can't insure you. You're classed as a racketeer." So there was several years I couldn't get any insurance.

But going back to the old gambling days . . . this is kind of a nasty story but I'm gonna tell it, anyway. This girl, her name was Angie. I'm not gonna give you her last name in case some relatives are still living. Came from California. Beautiful gal. She was a prostitute. She was working. I don't know whether you remember the Ideal Hotel that was down there by Carroll's Furniture Store? She moved from there to where Woolworth's

is now, the upstairs, and they called it the Ideal Hotel. Eventually she became the madam. Then one time she come in the Ritz here and she says, "My brother, Frank, is coming from California. Take him fishing. Take him hunting. But don't tell him what I'm doing." So I went to the airport and got him, picked him up, and showed him a helluva good time for a week. Then after that I was her brother. Anything I did was free. Anytime. I'd walk up there, she'd say, "Take your pick." You know? And what I used to do—believe it or not—in the afternoon when it was quiet racking balls, dealing cards, I'd grab an empty box from the Ritz like I was delivering merchandise, walk out on Main Street, walk down the street a block, walk upstairs, do my job, pick up the same empty box, and come down Main Street, and walk back in the Ritz and go back to racking balls or dealing cards.

Henry Burgess, who's a lawyer in town now, he was trying to get elected as county attorney. I'll never forget this. The back end here was packed with people gambling. They had a knock on our back door and here was Henry's mother. She says, "For Chris'sake, Harry [Sam's father], don't vote for my son tomorrow. He'll close you tighter than a drum!" I mean, his own mother! So he got elected the next day and the following day we were completely closed, gambling was.

Then we had the pool hall. When it was quiet, if I didn't have to deal cards or rack balls I'd tie flies. Sell 'em for a dime to a quarter apiece. So when gambling closed we remodeled and made a sporting goods store out of it. I always fished and hunted all my life, anyway. In fact, we've got a cabin up on Red Grade we've had for forty-some years. That was my life, besides football and the rest of the athletics, and stuff like that— just fishing and hunting. When we come back from our Yukon trip we had a lot of movie trips that we had taken. So we give it to Grunkemeyer filmmaker George Grunkemeyer, Vacationland Studios, Sheridan to edit for us. And he was one of the main starters. He wanted me to be fishing and hunting and I loved the outdoors, anyway. So between making these movies and all of that stuff, that's why I decided on the sporting goods business.

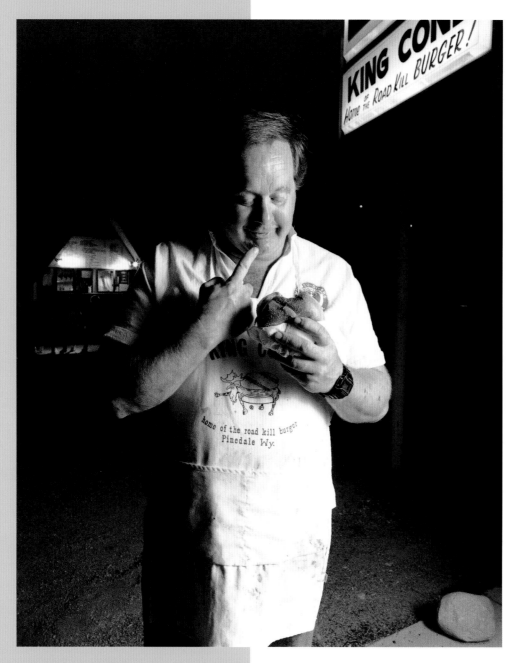

I ate here once. I'll never do it again. I got sick and missed three days' work. So I call out now and have my food delivered.

PINEDALE
b. AUGUST 14, 1945, WATERLOO, IOWA

The roadkill burger came shortly after I opened, I guess. I just looked around and decided that everybody needs something to catch other people's eye. Well, I guess it goes back further than that. I was using Curly-Q french fries and one of my competitors we'll leave unnamed told one of my friends that my french fries looked just like it did when she wormed her horse. So I thought that was kinda funny. And rather than get mad about it I decided to capitalize on it. From there it took off to tater tots that looked like moose turds. And, course, the food had to be roadkill and picked up off the highway. If you leave it out there until the maggots get on it, it's cheaper because you don't have to buy onions.

It's a fun idea. I suppose occasionally you get sick of hearing the same questions, too. "What's the roadkill of the day?" I probably don't hear that more than six or eight times a day from people who think it's an original question. You got stock answers: "Whatever we pick we mix it. It's not divided. We just throw it all in and grind it together. That's why no two burgers ever taste the same. Damn few people ever ate two of 'em. I've been here ten years now and I got almost half a page list of survivors."

Every now and then I get people from the East to leave here truly convinced that I sell stuff that I pick up off the highway. Twice I've been turned in to the Game and Fish for selling game animals. And, of course, the local authorities think it's pretty good so they usually tell me when it happens. I had one lady . . . as close as I can remember to a direct quote was, "I don't care how in the hell you get it, it's illegal to sell wild game in the state of Wyoming or any other state!"

Anything that's ever been here has been my own idea. It's never come out of the books. It's never come off one of the advertisements. Everybody that they've named

a burger after is dead, or died shortly thereafter. I name mine after stuff that I make 'em out of. "World-famous and almost edible."

If you want to start ripping people off, wait till business is good and then cut back on 'em. Most restaurant businesses that I've seen go broke . . . things get tough, it gets hard to make their payments, they raise the price on the food and cut the size of the portion. When business gets poor I figure that I give away more. I'm giving more kids ice cream cones. I make the hamburgers a little bit bigger. I put a little more milk in the milk shakes. When business is poor there must be a reason for it, so you don't take something away from the people. You give 'em more. More for their money. That's evidently what they need or business wouldn't of got poor. When times are tough what do you look for? For a bargain? I give 'em a bargain. Give 'em as good a deal as you can. If you want to screw everybody one time through, I guess you can get away with it, but one time through and they don't come back.

If you can't have fun, why do it? Go out and get ya a "nine to five." Work in the mill that you hated when you were a kid and stay there. Because if you're gonna be miserable you might as well be miserable working for somebody else as miserable working for yourself. You know when you work for yourself you work for the biggest asshole in the world, so if you're gonna be miserable doing that, you might as well be miserable working for somebody else.

I guess one of my dreams is, when I started this everybody told me it wouldn't work. I mean, my kids, ex-wife, banker, friends, neighbors, relatives. "Can't do this. It won't work." Well, this has been kind of a dream to do one like this.

When I was a kid and I lived in Iowa, they had a guy that had a corner grocery store. They called him Willie Bamfield. A lot of people didn't like old Willie. And after Willie died I heard people cussing him . . . and "Good thing the old bastard's gone," *et cetera, et cetera*. Well, we didn't have a lot of money when I was a kid, and when we'd go into the grocery store old Willie always made sure that I had an ice cream cone, a piece of candy, or a pop-up or something.

And I guess one of my dreams—and I've done that here—I give away a lot of ice cream cones. See a lotta kids smiling when they leave. Maybe someday when I'm gone, maybe some of those little kids'll say, "I remember him. He give me an ice cream." Except they won't be little kids anymore.

Somebody had to help me once. Basically, the judge told me I could go to work for these people and their little drive-in restaurant or I could go to prison. The people that took me in, after I got straightened around a little, I asked 'em what I could do and they said, "Someday if you ever get a chance, help somebody else out. It's worthwhile."

I guess maybe it's nice to show other people that have a tendency to give up that you can go ahead and do it. Teachers, when I was in school, used to pick me out of class and tell some guy that came in—I didn't even know who he was—and I quote, "This little bastard here will never make it to be twenty-five. He'll spend the rest of his life in prison or dead." So it's nice for some of the kids that are out there . . . it doesn't have to be that way. Just 'cause people tell you that doesn't mean it's so.

It [Wyoming] attracts too damn many. Whoops! I'm not supposed to say that, am I? I said [speaking into the microphone], "It attracts too damn many." That's not a good businessman's viewpoint. A businessman's viewpoint is I'd like to see Pinedale go to 80,000 people and that's financially great. My true viewpoint is, the day after I moved in they should have dynamited the road shut and not let anybody else live here. Not very many people admit that. People live in Wyoming because they're different. Not just Pinedale. Anywhere in Wyoming. People in Wyoming are individuals.

You've put four hours in on me, so I expect to get a lot of free advertising, a lot of kickbacks, a lot of payoffs. I think that I oughta be some way made rich off of this and get a lot of money under the table for my input. My prime motivation was to bullshit an old bullshitter and I think I got the job done.

JIM "TEX" GARRY
STORYTELLER

I've always been lazy enough to follow my instincts instead of my thoughts. 'Cause it's generally a lot easier to do that. I generally refer to myself as a storyteller.

There's sort of an illogical logic to it all. There have been a lot of times in my life when I thought that I knew where I was going, when I was actually going somewhere else. But I had enough sense to listen to the voices and go there.

I don't know how to describe it. It's like the greatest sense of discovery I'll ever have in my life. 'Cause I've tried writing screenplays, poetry, essays—on and on and on—trying to find my voice to do the interpretive work. And it was like somebody knocked you over with a feather . . . "you idiot, your voice is your voice." The storytelling was such a powerful medium for me. So I came out of it just blown away with not a clue as to what to do with it. Two days later I got a phone call from the Buffalo Bill Historical Center over in Cody. They had decided to start doing live programming that summer in their theater. Peter Hassrick, who's the director of the museum, was in the audience that night. They called to see if I wanted to come over there and tell stories. I went over for two weeks, which stretched into six weeks, and I really haven't been fit for honest work since. I've just had to keep telling stories.

I worked over in Jackson Hole six years for the Turner family, Triangle-X Ranch, as some of everything. I wrangled horses, I guided in the wilderness, I did raft trips, I cooked . . . just sort of did everything you can do on a ranch. One of the main attractions at Turners' was this just wonderful collection of old timers who worked for them, who I spent the winters interviewing, and just listening to their stories, and learning the country, and learning the people. What I found is that the stories in the West primarily are about places and about people who fit into those places. To me, that's been a major

part of interpreting a piece of country and one of the most overlooked parts.

I got over here in the mid-seventies, into the Powder River Basin at the point when populations were just mushrooming. Gillette's 1960 census was, I don't know, 2,500 people; 1970 it was 6,000; 1980 it was 21,000. In the mid-seventies when I got over here it just looked like this country was gonna be overrun. I interviewed people who were talking about Gillette and Sheridan both being 100,000 people by the turn of the century. It was booming, and to me a lot of the old cultural ways looked like they might be lost. I sort of realized then—one of the things that scared me—was that maybe one of the real endangered species nobody was looking at was cultures, the ways we had lived with land rather than on the land. And so I started moving more and more into collecting—originally just folk material, whether it was a rope maker, a saddle maker, somebody who was still branding out in the open . . . you know, just old ways. But what I discovered when I started really seriously collecting was that I was hearing stories. No matter what I was collecting, or what I was interested in, everything had stories that went with it.

A lot of 'em are humorous because so much of this country is humorous. This is such a hard place that you really have to laugh a lot. And that's true of everybody who tries to live with this land. Most of the Indian stories I have are humorous because they have a wonderful wit. They enjoy humorous stories. Ranchers, they laugh at things that are not at all funny. But if you don't laugh at 'em you're in trouble. I had an old cowboy tell me one time, said, "Anything you can laugh at can't hurt you. It can still kill you but it can't hurt you." And I think there's a whole lot to the stories in this part

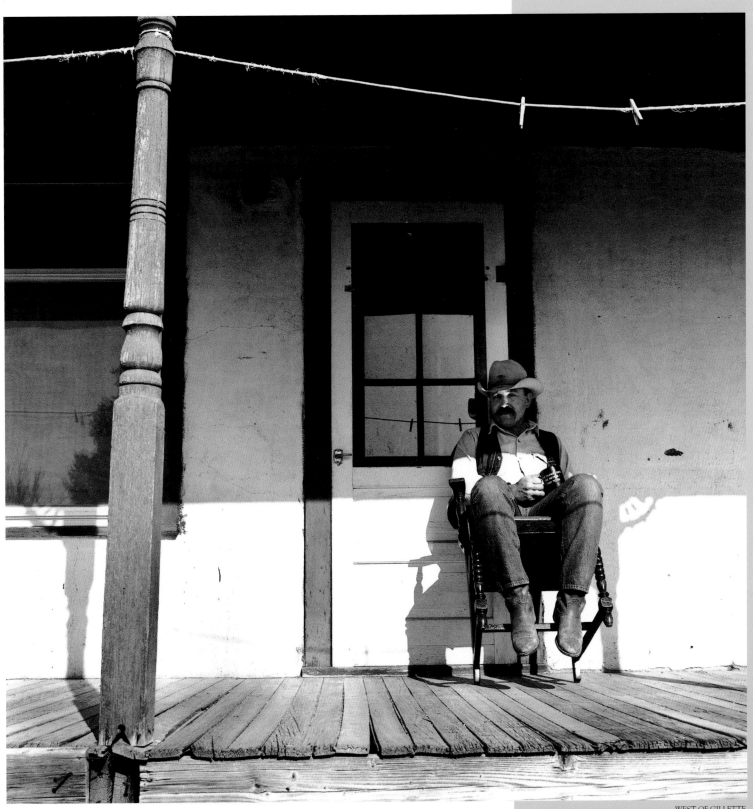

WEST OF GILLETTE
b. APRIL 28, 1947, TAYLOR, TEXAS

of the world that are that way. The stories that could very easily be heartrending, tear-jerking, sad stories instead are very funny because there's so many of those stories that if you didn't make them funny, you'd have to leave. You couldn't stand it.

Jack Davis was a wonderful storyteller because you never knew with Jack which of the stories had really happened and which hadn't, and it didn't matter. Jack said one time that he hated cold weather. He was born down in Arizona down under the Mogollon Rim, down in the Tonto Basin. And he came up here and fell in love with mountains, with the Absarokas and the Winds, and spent the last thirty-odd years of his life, spent the summers up there, and—Oh, God—for twenty years before that he spent most of 'em up there. I finally asked him, "Jack, how did you get to Wyoming? Anybody who hates cold weather, how did you come to Wyoming?" He said, "Aw, I was the oldest kid in the family. I was about fourteen. We was in the third year of really bad drought. I had a lot of younger brothers and sisters. It hadn't rained any in the winter or spring. I figured that by the next winter it was gonna be serious, and if I left home there'd be one fewer mouth to feed and be easier on every-ody. I had a buddy in about the same shape, so he and I caught a bunch of wild mules. And we got 'em in the corrals, and roped 'em, and got blindfolds on 'em, and roached their manes, and belled their tails, and fitted 'em with halters and saddles. We figured we would work with 'em a little bit 'fore we started out, but we wanted to pack 'em full to get a little extra weight on 'em so they wouldn't cut up too much. One day we got all of 'em roped and blindfolded, and halters on 'em, and saddled 'em up, and packed 'em up, and screwed the packs down tight, tied the lead rope of one directly into the tail of the one in front of it. Then each one of us got on a big, stout, fast horse that we

thought could either outrun or outpull those mules, dallied up the lead ropes, and between the two of us we had enough little brothers to put one on each mule. We told 'em when we said "Go!" to throw the blind-folds up and get out of the way. But what we hadn't realized is we had one extra little brother, and he wanted to have something to do, so when we said "Go!" and they threw all the blindfolds up, he opened the corral gate. Jack said, ". . . time the dust had set-tled we was so far north of there we just came on to Wyoming." And I'm sure that's not how it really happened, but if you had known Jack, you could believe it. God, he was a character!

I mean, everybody likes to tell stories. Wyoming's probably the easiest place in the world to find storytellers. Getting up early in the morning is the way to do it. Any town in Wyoming, you just look around until you see a cafe, or sometimes it's not a cafe. In Sheridan it's a sporting goods store, the Ritz, which has a lunch counter. But there's a cafe. And parked down in front of it there'll be two or three, or half a dozen, or ten or twelve local cars—that county—with two- or three-digit numbers on their license plate. Ah-hah! This is where the old people get together and tell lies. Well, once you've found a place, you find that it's all through the day. They just have shift changes in the place. There's certain people that are in there at a certain time every day, and they sit there and tell stories, and if you're interested they're just delighted to tell 'em.

What I found to be the real secret in an area: When you go in to collect, you have to know a fair amount about the place. So I go to the library and go through old news-papers, get the maps out and learn all the place-names, and basically get sort of a vague, broad, general history of the county in hand. The simple thing is that if people think you don't know anything, all they're gonna tell you is the broad brush strokes. If you seem to know something, then they get into the real juicy parts. So the more you know, the more they'll tell you.

Basically, I've found two types of really important resources: one of them are the storytellers, and the others are the local

historians. The local historians are incredibly valuable and they've got everything you want to know in the way of facts and figures. They can't tell the difference between a laundry list and a story. That's a problem. But they've got the material and those are incredibly valuable resources. And those people, when I can get them isolated, I tape 'em because the information is stuff I can't remember. It's just like reading a list, but it's wonderful information and it's very useful. And it's the sort of stuff, when somebody starts to tell me a story two weeks or a month later, I'll go: "Oh, God, yeah, I remember something about that." I'll remember one or two things and I'll use those as prompters.

One of the other things I find that's really valuable: If you know enough to ask stupid questions. You say something and . . . "Oh God! Who told you that? That's the biggest bunch of hooey! Lemme tell you what really happened." And you know already what really happened but you want to hear this guy's version of it. So one of the things I find is that generally more than one person knows the story, but they don't all know the same story, the same version. They know different pieces of the story.

What I'm trying to get people to do is look at their own history, their personal history, their family history, their community history, as something very important. But it's also to go beyond the history. One of the main points I make is that history has to be factual. Folklore or literature, whether it's written or spoken, does not have to be factual but it has to be true. Historians get to pick and choose their facts. There's nothing that says you have to use all of them. When I tell stories they have to be true. So I tell people that all the stories I tell are true even though I'm not sure they've all happened yet.

That's another problem with history. We forget that history runs in both directions. There's history that we haven't gotten to yet, and things may happen up there, and if we think of the story before we get there, well, that's okay. If the story is true you can tell it. And it may happen next year.

One of the things I do with old people when I start to interview 'em and try to get them placed in that continuum, I have three

questions I routinely ask: whether or not they can remember the first time they rode in an automobile, listened to a radio, talked on a telephone. And if they can remember two of those three things, it means they were born and spent their formative years in a totally different world than what exists now. If you spend your first five years in one world and moved to another, you're an outlander from the time you move on.

I love stories that have multiple endings. I love "asides" in stories. Many of the stories out here, the story is really nothing more than a vehicle for all of the asides, which is what you really want to talk about. But they aren't a story by themselves. They have to have some vehicle to carry 'em.

If I hear it, and it's a story I can tell, I'll remember it. I won't tell it the same way it was told. One of the problems with history is that it doesn't always work out like it should've. And literature can. When somebody forgot to use the really great zinger line at the end, you can supply it. That's the art to it, and that's the difference between being a collector and a teller. I feel like I'm both.

I've had all sorts of people tell me they can't tell stories. And what I've found, and what they mean, is, they can't tell stories in public. But we all tell stories amongst our friends. You go home and "Well, what'd you do today?" You tell a story. Unless you're a teenager. And then you say, "Nothin'."

Wally McCrea has a great line. He says, "There's two things that make a good storyteller. The first is material." He waits for you to say, "And what's the second?" Between "What's the" and "second," he comes out with "timing!" . . . interrupts you with that word. It really makes the point. Yeah, it's material and timing, the same thing that makes a good comedian.

The best place in Wyoming to collect stories is in the legislature. There's not anybody down there that's not a great storyteller.

Somehow we've lost the linkage between tax dollars that support government and the services that are there for the citizens. They expect snow removal. They expect fire protection, and police protection, and solid waste disposal. They expect public education. They are also nodding through the "excellent education" speeches of the president and the governors. And yet they've kind of lost the link between that and "someone's gotta pay for those." So they're out there advocating "no new taxes" and pretending. It's kind of like that old saying: "Don't tax me, don't tax you, tax the fellow behind the tree." It probably rhymed wrong but there isn't anybody behind that tree anymore, you know? This is a very closely connected world in which we live. Industry now realizes it and brings in the workers at the mines to talk about taxes. They don't fly in their corporate CEOs or their utility purchaser because that doesn't work. They bring in the guy that's going, "Gosh, you know, if this line has to shut down, then I'm out of work." There aren't services that don't demand pay. And I think that that's a bigger problem than the concept that people think government ought to be run like a business. There are a lot of inconsistent messages the public sends to their elected leaders.

My proposition is that people ought to talk about taxes and they ought to talk about the regressive nature of some taxes— who pays the overall, cumulative tax burden. People sort of talk about taxes as though they were all interchangeable. Well, obviously if they have a tax on cigarettes and you and I don't smoke, we're not going to pay that tax. If they have a property tax and 75 percent of our property tax revenues come from the mineral industry, you and I are going to pay less of it than if there's a sales tax and you and I are out there buying groceries just like everybody else that lives in the state of Wyoming. So my approach is, people don't know enough about their tax structure, where tax monies actually come from. It's sort of like, "Well, let's just put 'em all in a bag and pick one." Well, the mineral industry knows what most people don't, which is: if there's a property tax and that's what's imposed, they're gonna pay a heckuva lot more than the moderate- to low-income people in the state of Wyoming, some of which don't even own any property that's taxable. So they're here lobbying against the property tax. And so what's going to be the option? The sales tax!

Most jurisdictions collect almost all of their money on income and sales tax. And then they have a property tax. Those are the three legs of the tax system. That's where the money is: excise, property, and income. The real problem with the Wyoming tax structure is that we are imbalanced. We are standing on a two-legged stool because we do not have an income tax. I would look at whether or not there's any way to craft something like a state "pickup" income tax. If we had an income tax, you would get a credit for that in the federal income tax system. Wyoming citizens pay more to the IRS— because we do not have a state income tax— than states with a state income tax, because that's a deduction.

It's kind of like something a benevolent dictator needs to come and do, because you've got an anti-tax mentality and the income tax is like a four-letter word in Wyoming. Other jurisdictions are facing that. You know, Wyoming's been called "the

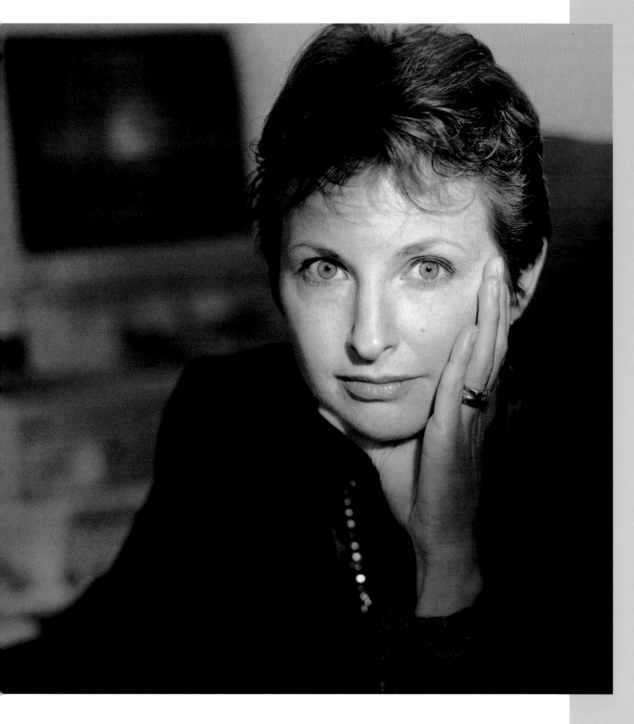

I don't really know when I acquired it, but it's one of the principles that has helped me work in administration for both governors . . . almost a sense of, "I was looking for a job when I found this one, and I will land on my feet. If the governor is not reelected, big deal. I will land on my feet."

CHEYENNE
b. FEBRUARY 5, 1954, CODY

tax nirvana" because it looks like we never have to face that issue which has become real for other jurisdictions. The two toughest jurisdictions to govern in are the jurisdictions where they have to look at imposing a new sales tax when they have none, and imposing an income tax where they have none. Once you get the foot in the door, people do complain and politicians are defeated on tax

increases. But starting those taxes! It's, like, they had to happen in the 1930s or we've somehow missed the window of time and we never can open it again.

I'm not very optimistic that anybody can make much of a difference except, perhaps, a leader who does not wish to run for anything else. That is his cause and he, somehow, through some fluke, gets elected.

J.R. & SCOTT JONES
GRANT STREET GROCERY

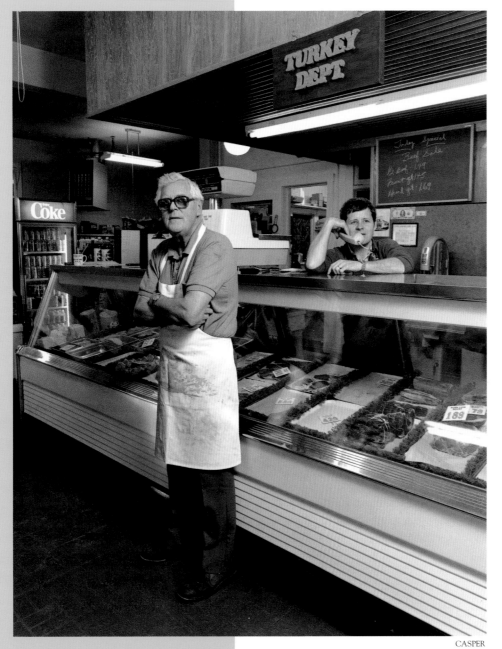

CASPER

left: J.R. JONES: b. SEPTEMBER 29, 1925, PORTSMOUTH, OHIO
right: SCOTT JONES: b. JUNE 25, 1951, PORTSMOUTH, OHIO

J.R.: We deal with everybody personally and supermarkets deal with 'em with computers and scanners. So it's whatever you want to do. If you want to go stand in line for forty-five minutes or an hour, then that's your business. But I wouldn't do that if I never owned Grant Street Grocery. I wouldn't ever go stand in line. I wouldn't stand in line for anything.

SCOTT: He's from a whole different era or generation than I am, and he's pretty set in his ways. It's kinda hard to get him to change sometimes. You know, as we were growing up we called him the Archie Bunker of the world. He's pretty prejudiced and he's pretty mind set. New people don't know how to take him until after they've come in three or four times. And then they settle right in. We do a lot of kidding in this store and a lot of joking back and forth. It's kind of a give-and-take on the banter, and you kind of have to jump in there where you can. Some people don't like that. Consequently they don't come back. But this store has a personality and, sure, I guess you can be vanilla and try and please everybody, but that doesn't always work, either. I guess if we're gonna own this store, for better or for worse, we're gonna run it with our personalities mixed with the personalities that come in this store. I guess in business you can hurt yourself that way, too. I'm not saying you can't. I know that. And I don't mean to run people off, but I guess if they want to shop at Grant Street they get what they get, that's it. I think for the most part people do come back because people like to be talked to. They like you to talk to their children. Children like to be talked to. So when they come in and they've got some small children, we try and treat them like they're there, too. We kid with them and talk to them.

162

J.R.: We have a delivery boy. We deliver groceries all over the city. The delivery business keeps us going. We have most of the senior citizens and we really have a lot of young people. They both work and they don't have time to go to the supermarket, so they just call in and then we take their groceries out to 'em. Two dollar charge. They kind of worrry about what we're doing because they can't get out of those places, a lot of 'em. They depend on us.

SCOTT: There's a lot of 'em, we could almost sit down and write the order out before they call. I think, too, some of those older people like the contact with somebody else. They don't get out of their house, or they don't get out of their apartment, so they like that three-times-a-week contact. They could order all they need one time each week and get by, but I think they like being able to see somebody, even if it's the same person all the time.

We are like an extended family. You know, people in the neighborhood leave their house keys here in case they get locked out of their house. 'Cause they know we'll be here. We've baby sat people's children here. When an emergency's come out and they've had to leave, we've had people bring their children here. And I like that. I like people. It's all about people.

J.R.: Mr. Cheney, the Secretary of Defense, was one of our customers 'fore he moved to Washington, and when he comes back he gets things for his mother and father who still live here. Then Governor Sullivan lived a block and a half away. He was a good customer and he still comes in to see us. Jack Sidi, he comes to see me, buy things. He's the Auditor of the State. And we've had some people, I'd say, that's pretty prominent in Casper who started out workin' at Grant Street when they was in high school.

SCOTT: I can remember two Christmases ago, Mike [Sullivan] came in on Christmas Eve and didn't buy anything. He just came in to talk. 'Cause he was in town. 'Cause this is where he used to shop and this is where he grew up.

J.R.: On Christmas we have what we call a special Polish tea. It's made by a Polish butcher that used to work here for about twenty-five years. People call us from all over the city wanting to know if we're gonna have Polish tea the two days before Christmas. So they all come in and we kind of like have a party. Everybody comes in and sees us. It's kind of a little strong drink. This guy has his own recipe his mother gave him from Poland and he mixes it up and brings it down for us. He puts a lot of booze in it. It'll KO you if you don't watch it. And then we heat it. It's got cinnamon in it and brown sugar and spices. But it's good. It'll warm you up.

In the holidays we don't sell nothin' but the fresh turkeys. We don't sell frozen turkeys. We sell fresh turkeys, and there's a difference between a fresh turkey and a frozen turkey when you eat it. We have all of our turkeys sold in advance. People order in, two or three weeks ahead of time. And we had the Polish tea. One Christmas about three or four years ago, two women come in and they wanted to pick up their turkeys, plus they wanted some kind of special cut of meat, which, we'll cut you any kind of meat or make you any kind of a roast you want. So I asked 'em if they'd like a little cup of Polish tea and they said, "Sure," they'd try it. So they got a basket and was goin' around shopping and come back by and said, "Could we have another Polish tea?" And I said, "Well, yeah, you can have all you want." So they left. And pretty soon a guy came and he just walked right around the meat counter to the butcher shop. So I stopped him, said, "Hey, can I help you? What's going on?" He said, "Yeah, you could help me." And I said, "Well, good, what do you need?" He said, "I need whatever you gave my wife awhile ago." So I said, "Well, there's been so many people in here I wouldn't know what I gave your wife. You'd have to tell me." He said, "Well, I've been married twenty-five years, and my wife came home about a hour ago, bombed, the happiest she's ever been in her whole life, and I said, 'Where you been?' And she said, 'I've been over to this little grocery store picking up the turkey and drinking this Polish tea.'" So the fella said, "What I'd like is a water glass full of Polish tea." That's a true story.

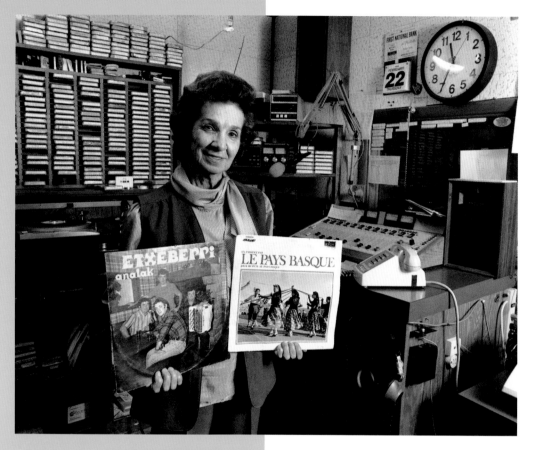

together down here and at six o'clock we were on the air. It went like gangbusters to start with. Everybody wanted on. Everybody was listening. We got lots of comments. We were a community station. It was our station. Everybody felt like it was our station right from the start and that's what we liked. We had to train 'em a little bit about advertising on radio. They'd only had newspaper around here for a long time.

Probably about two weeks after we went on the air somebody said, "I want to have a Basque program." I said, "Well, that's a good idea. How do you want it done? How shall we handle it?" He gave us some ideas and then other people picked up on it. I said, "Let me see if I can get a sponsor." They said, "No, don't get any sponsors. We want to sponsor our own program. We don't want the sponsors saying what kind of program we're gonna have, what's gonna be on it. We want to do that ourselves." So they've been contributing every year.

We talk Basque. I can speak it and understand it but not as fluently as I used to. Use it or lose it. We translate some of it into English when we dedicate songs to different people. We usually do that in English, too. And birthdays and anniversaries, and people that are in the hospital we always play something for and update how they're doing, and things like that. And then any other news. We intersperse news with music all the way through. We have had—it's diminishing, I think—my Basque library of music. People borrow them. I've got a lot of album covers without the records in them.

It's a service to the Basque people. That's reason enough, isn't it?

You know all Basques are noble. You knew that, didn't you? We're peasant stock, maybe, but they are nobles, all Basques are. One time way back in history when Basques were ruling themselves, and they paid a certain tax or whatever to be able to do that, the decree came down from the kings that said, "We want you to put out this tax for everybody except noblemen." The answer went back: "All Basques are noblemen." And we didn't pay the tax.

BUFFALO
b. MARCH 15, 1923, BUFFALO

There was a woman over the mountain—in Worland, is it?—that was pretty high up in radio. Her husband was a stockman. And I thought, "Well, if she can, I can." It wasn't until after we had been married and had a number of children, some fellows from Sheridan had talked to my husband about starting a radio station here in Buffalo. They had done some of the groundwork, and my husband told 'em that I would probably be interested. He couldn't care much about it. But anyway, they got in touch with me. So we went into partnership and got a station going: KBBS, "Buffalo's Basque Station."

We started the station in 1956. We got our okay from the FCC at about five o'clock one afternoon. So we all gathered

EDDINS
LAEL

Star Valley here is kinda unique because I don't think there's a canyon that doesn't have water running out of it. It's just phenomenal. We have no treatment, nothing. And it's probably some of the best water in the world. We have a company right now that's looking about bottling it. They want to eventually be very competitive with people like Perrier. Our water tested better than Perrier's. It has more iron and it's got everything the health food people want right now. It's got a little fluoride. It has less dissolved solids than Perrier water does. It's just perfect water. We've got quite a filtering system set up in the way this stuff travels through the ground because it's very pure water. I was just thinking the other day: since 1979 we have not had to notify the people that we've had any problems with our water. That's very unusual, even in a system that's treated.

You gotta realize this is an old Mormon town and it has the ten-acre blocks. So we have thirty-one or thirty-two blocks in town not counting the new subdivisions, but in the basic, whole town. And it was designed so you could have a barn out back, and a garden, and a pasture, and keep a milk cow. Well, those are all gone but the ground is still there. Drive through town, and you look in the center of a block and there'll be fifteen sprinklers. That's where our water goes.

Our problem in town is wanton waste. We have no water meters. We have no restrictions on the amount of the water that people can use in town, and so our average will run 2,500 to 3,000 gallons per day per person. Not per outlet. Per person. We're consuming three to four million gallons of water a day in a town of 1,400.

You got about ten percent of those people that don't understand the whole panorama of the thing. I get approached with the same thing: "There's water running down the creek. Why have you got us on

rationing?" Probably the biggest thing that I've been hammered about this summer: "How are you gonna sell water when you got us rationing right now during the day?" They don't understand the fact that after I reach four and a half million gallons I can't put any more water in the pipe. It's not because they don't have the water, it's just because they've got three sprinklers running outside and they want to take a shower at the same time. They don't have enough water pressure to tip 'em over in the shower. We've created the problem ourself because it's always been there. And so we use a lot of water. The town is as much to blame as the people are that use it because we bill water out quarterly. It's $20 a quarter. [Laughs] We have people come in here and they can't believe it. You get all the water you can use. It's not treated. The water, on average, is coming out of the spring at 39 degrees so in the middle of the summer you're drinking water downtown that's probably 45 to 50 degrees—hurts your teeth—and all you want. Plus you got four sprinklers going.

I foresee long-range problems, I really do. I foresee, just the way things are going, that water is gonna be worth a lot more down the road ten years than it was twenty years ago. For example, I think you're gonna see the price of water become a lot more important than the price of gasoline one of these days. You can't drink gasoline. You can't live on it. We're becoming known as a generation of people that have a tendency to waste and destroy a lot of things. I think that right now we're at a hingeing point where we're starting to get a lot of people involved in these things that can truly see that we have a problem. If we don't get a handle on it we're gonna be in trouble.

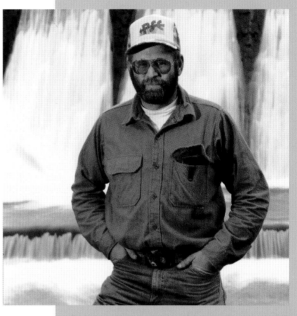

You never talk water or politics, or religion with your friends. There's been more fights over water than about anything there is. And they do that right now. They're still having the same problem. One guy'll go open the ditch and if he has it a day or two, or longer than the other person does, then . . . I mean, there's been a lot of people shot over water feuds.

AFTON
b. DECEMBER 12, 1944, AFTON

TAKING A BREAK

There's a lot more stress, I think, than there used to be. I think the more complex the world gets, it's just gettin' more stressful day by day. I wonder if people'll be able to take it in another twenty years. You know, money, stress, and married couples don't get along as well as they used to. It's just a heckuva lot more stressful than it used to be. That's what I think, don't you?

CARPENTER

LARRY POELMA
STOCK CAR RACER
b. JUNE 18, 1949, CHEYENNE

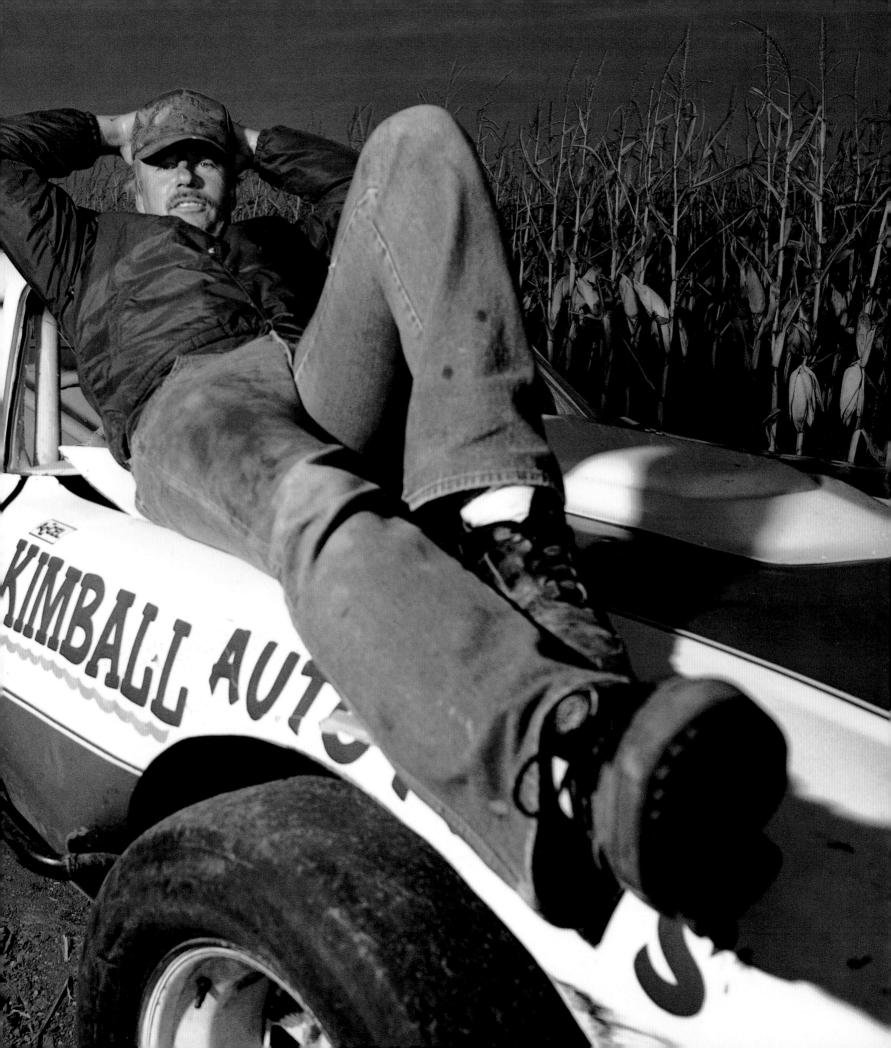

CENTENNIAL
WAGON TRAIN
LOST CABIN

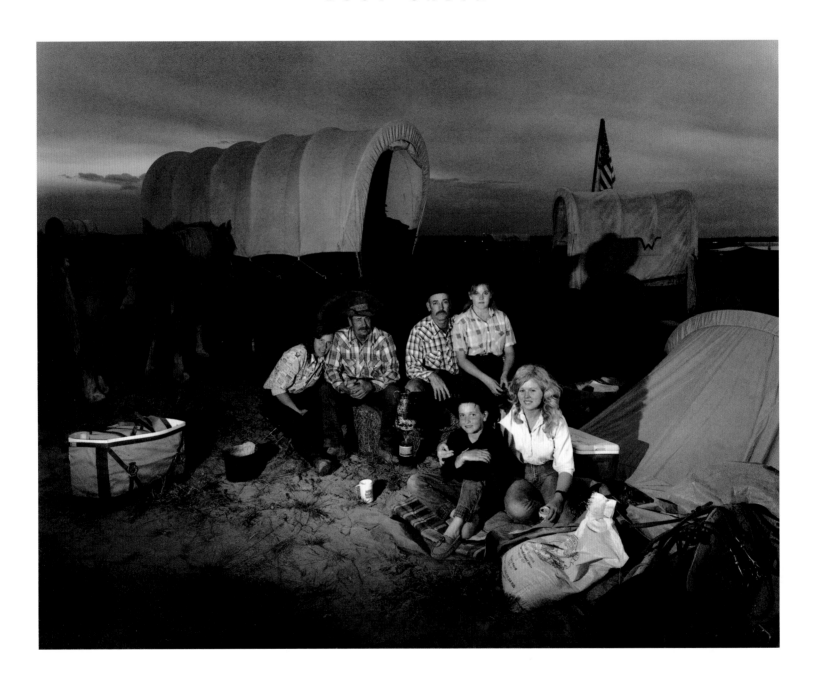

left to right:
JUDY KARST: b. JULY 6, 1947, GREELEY, COLORADO

JIM KARST: b. APRIL 17, 1934, WELLINGTON, COLORADO

DAVID RUSSELL: b. MAY 24, 1949, YOUNGSTOWN, OHIO

JESSICA RUSSELL: b. AUGUST 12, 1976,
GRAND RAPIDS, MICHIGAN

JOSHUA RUSSELL: b. OCTOBER 19, 1979, DENVER, COLORADO

NADINE McCLEOD: b. MARCH 4, 1949,
LANGDON, NORTH DAKOTA

DAVID: Well, for me it was a couple of things. One, I like the outdoors a lot. The whole business with horsepackin' and being in this kinda flavor. But I really wanted my kids to have this kind of experience. They're kinda city kids and I've been strugglin' with 'em to get 'em into a little country. There's been some battles about this, you know. They're real hesitant to go, but they get out, and they do just fine and they love it. And that's what I wanted them to experience. The other thing for me, personally, was to do something that I'll never get a chance to do again. You know, this is a onetime shot. It's not gonna happen again.

NADINE: I thought my druthers would sooner been just take off with the horses up in the mountains away from the crowds. But it's kind of enjoyable. See, some people try to keep with the feeling of the Centennial, but a lot of the things you have to do . . . like propane, ride on the roads, everybody's got their cookstoves, and there's trucks and vehicles roaming all around. It just took away from the feeling of authenticity right away.

DAVID: Well, I think water trucks running through the camps is pretty strange. I think that bringing in the hay, it's necessary to pull something like this off for the size. But you've got a PX wagon coming in every night, a big semi that brings food and groceries and ice and all that.

NADINE: Wait till tomorrow morning when the trucks come out sucking up the water. Oh, the racket!

DAVID: You know, it's just kind of bizarre.

NADINE: I think you relate a lot closer to it [history] going back in the mountains on a horse. You are solely reliant on yourself. I mean, if somebody gets hurt the helicopter's in to pick 'em up. I'm sure in the old wagon trains, too, knowing that you're the only train crossing an area, and if you go separate, you have Indians waiting for you. And if something breaks you fix it there.

DAVID: I look at it a little bit different from that. I think it's a combination of going back to the roots of Wyoming. I also think it's very reflective of Wyoming's way of life—very independent, self-sufficient.

NADINE: Oh, see, I don't feel this is independent and self-sufficient. Well, maybe a little independent but not self-sufficient at all.

DAVID: I was raised back east, and I know there's a very strong contrast between eastern and western people. You try and get somebody from back east doing something like this . . . I mean, it would be impossible. So that's what I'm talking about. It's very reflective of the West and Wyoming. I think it's incredibly worthwhile, to me, when I saw my two kids get out there on those horses tonight and ride around by themselves.

NADINE: In a couple days we'll start going up, climbing, and that may get things interesting. Last Tuesday they had to cross a draw and go through some water. It was steep down and up, and two of the wagons ended up with broken tongues. That would slow things up. Then they had to be winched out. Again, one hundred years ago . . . a winch? Somebody probably drove in with a new truck.

JOSHUA: I thought it was gonna be fun.

JESSICA: I didn't. I thought it was gonna be really lame. Because it just seemed dumb . . . a bunch of wooden wagons around. But it's pretty fun.

JUDY: We decided that it would be an adventure that we've never been on. We've drove a lotta cattle and just decided that this would be a good thrill, somethin' that I ain't done yet. We just celebrated our twenty-second anniversary on the fourth. That's what we come on the wagon train for. This is our honeymoon and our celebration. First honeymoon we get in twenty-two years.

JIM: This is the about the first vacation that I've ever taken in all the years I've worked. I've run many as four or five big ranches. Runnin' to Laramie or runnin' to Denver or something like that is all we've ever done. We've run up to maybe a few places, and spent a night in a motel somewheres, and go right back home.

How close is this to a pioneering experience?

JUDY: [Laughs] Quite a ways. I mean, the pioneers didn't have somebody bringing hay in, they didn't have porta-potties brought in or water brought in. It's similar to it when we circle up, and you get to know your neighbors and the people next door and everything. You're in your own little town, but as far as having the conveniences, we got it made.

JIM: I'd say it was about 50–50. I've worked horses with my dad when I was real young. I was out there, four or five years old, messing with horses and everything like that. And all my life I've had horses, saddle horses, broke horses. I used to break horses in the spring. I'd go to the sales, and buy saddle horses, and break 'em, and take 'em back to the sale and resell 'em just to make money.

JUDY: I guess I've always been raised western. I thought I was born in the wrong time. I shoulda been born back in the time when they had wagon trains.

Is this the proper way to celebrate the Centennial?

JUDY: Yeah. It's a good way. I don't know whether it's a proper way or not. I think for Wyoming it's a fitting way. This is kind of what we are . . . crazy.

AMANDA KAUFMANN

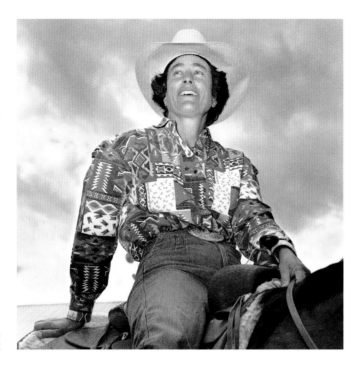

I think it's really typical Wyoming. In this state we're lucky enough to all still be close enough to the land and therefore to feel some kinship with ranch people. And this sport, it's almost like you can in a way go back in time a little bit and be a cowboy. It's the cowboy in you.

JOHNSON COUNTY
b. DECEMBER 10, 1941, MT. KISCO, NEW YORK

What we were doing today was having a cow cutting contest. It originated on the ranches when people used to cut out cattle from a herd. Maybe they had a different brand or they belonged to the neighbor. They found that there were a lot of horses that had a lot of cow sense and were really suited to going in and moving a cow out. They were very quick and athletic. So they started having contests to see whose horse was the better. Over the years it's evolved into what you saw today, which is a series of classes set up for horses or riders to compete against other horses or riders that are of their equal level.

It's not an ideal spectator sport because it's a very subtle sport. There's a lot of things happening out there and the untrained eye doesn't see them. It's fun for me because it's a real challenge to try and do these things in the two and a half minutes I'm given, with everybody watching. But I don't think it's the ideal spectator sport. I think what would impress someone that isn't a horse person is the real active horse that gets out

and does a lot of very fancy work. Once you've seen that, everything else looks boring.

When you get a cow eyeball-to-eyeball, and that horse is going back and forth, and you're helping him along a little bit with your legs, it is thrilling. He can move so fast. The challenge to you is to help him do it right, not to interfere with him. It is a thrilling experience. If anybody offers you to ride a cutting horse, take 'em up on it because it's literally the horse against the cow, eyeball-to-eyeball, and it does feel good. [Laughs] It's a real joy to get on a horse that you can trust to be at the right place at the right time when things are going that fast. And he's very honest and very, very reliable. Your heart beats. When you get all done, you feel really drained. It's a really intense experience. It takes a lot of concentration and a lot of doing things right to get it to come out right.

Your timing has to be very good. You watch some of these people and they get along obviously better than others. It's because their coordination and their timing is probably a lit-

tle better. I don't think in this sport it's particularly tied to age 'cause there's a lot of older people that do it and do it very well.

You know, little girls always love horses. I think women have the potential to be among the best horse people in the world just because they have that feel for how to get a horse to do something. Not in all people. But you look at the number of little girls that like horses. They just have a feel for it.

I can be pretty involved with a lot of different things, and I can go out and ride and it just puts you back on a one-on-one level trying to accomplish something. You're communicating with an animal, and even if you're just riding for fun, you're communicating with an animal. He has a personality and he enjoys what you're doing. If you're working on an event like cutting, you're trying to get him to do something right and, when he does it, it's a real "attaboy" situation and you pat him and tell him he did right. You continually work on what you're doing.

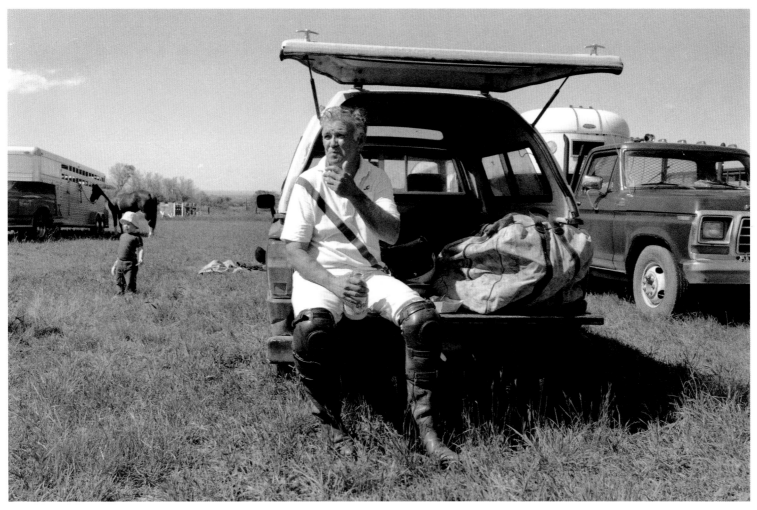

SHERIDAN
b. OCTOBER 30, 1925, PORTLAND, OREGON

There was a gal out here from Time Magazine *a few years ago, and she was interviewing me because I had a big cattle operation in Montana where the mines were going, and she thought it was so terrible that they were gonna dig up the coal. We got that straightened out with her and I said, "Well, come out Sunday and see the polo field." She said, "They play polo in Wyoming? You mean like in Long Island?" And I said, "Yeah, like 'Longuylin.'" So she came out and did an article about it. It's a little off-color, but she interviewed a friend of mine, the*

Tyler family out of Pierre, South Dakota, which is very strong, and has been for thirty or forty years, in polo. She was interviewing Lyle who is a character in his own right—had about a three-day beard and scruffy, stump cigar in his mouth, his whites were not all that white— and she braced him right away: "Well, tell me the difference between this polo and Long Island." He said, "Lady, it's the shit on the boots." And she put it in Time Magazine: *"They're working people and they do this for recreation."*

LISA KEELER

I think a lot of people, when you talk about dog trial, assume it's obedience. They do obedience with border collies because they work so nicely, but I think a lot of people have misconceptions. A lot of obedience people will probably strangle me to say this, but from what I've seen of obedience, I think obedience is you're makin' a dog do something. It may want to do it because you're askin' it to, but it's not a natural thing. It's not a natural thing for the dog to sit down and shake, or to sit down and stay right there behind you. Whereas, the working dogs, the border collie or whatever, this is what they've been bred for generations and generations to do is to work livestock, to herd livestock. In a sense it's obedience because they mind, and they want to please, and all that. But what we're doing is we're taking the dog's natural ability and developing it.

We're not completely forgetting that and doing something else with them.

Border collies have a herding instinct. It's a natural instinct to work livestock. And if you bring that out properly it is amazing to watch. Some of these dogs here, people haven't paid anything for, but if you were to sell 'em you would get anywhere from two thousand to three thousand. Most everybody here that will run today has livestock, so they are working dogs. Especially the people that have kids. They are pets to a certain extent. They are companions. The border collie is very versatile. They're a good human dog. They're very nice to be around, good disposition. They want to please. You can train 'em to retrieve. You don't train to work. A decent dog just works. You just put English to it. It's natural. If you have to train

a dog you're wasting your time because there's too many good dogs out there to be bothered trainin' one. You just need to put a bit of fine-tuning on it, a bit of polish on it.

You can't just take the next guy's dog here out and run it. Because the dog has got to respect you and they've got to want to please you. If you have that, that dog will die for you. I mean it will run in the heat, it'll run itself completely out. It's completely loyal. Those feelings . . . the handler and the dog have to have those to have success. You know, with time you understand what are the dog's little quirks out there, and if they're having a problem, if they're not quite sure of themself, and all that. So you tell a dog, "It's alright. I'll do what I can to help you but you've gotta do your share." It's real neat.

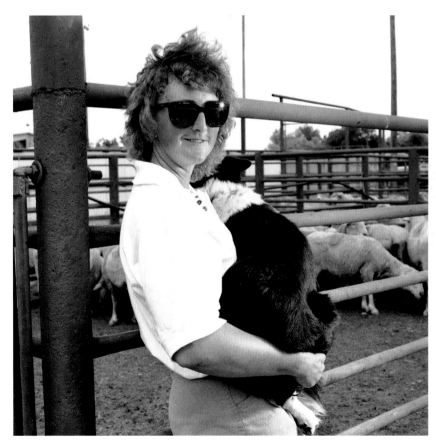

KAYCEE
b. MAY 13, 1965, NEWCASTLE

TOM HORN LOOK-ALIKE
KEN ROLFSNESS

A number of years back when my daughter was—I'm guessing now—probably around age six or seven, she went out and got the newspaper off the front steps and brought it in the house. She was just kinda glancing through the newspaper and all of a sudden she come running in to my wife and saying, "What's daddy's picture doing in the paper?" My wife Carol took a look at the picture and she said the first thing she thought, too, was . . . well, what's my picture doing in the paper? She started reading and it was an article on Tom Horn, and the picture that they were talking about was a picture of Tom Horn. But that would have been probably fifteen years ago and even then they said I looked enough like Tom Horn to be Tom Horn. A year ago, I still looked enough like him to be him, I guess. [Laughs]

For the first annual "Kick and Growl" they had a Tom Horn look-alike contest. I entered and won first place.

Well, that's kinda neat. I look like someone from history. But I never really got into doing any real reading on Tom Horn himself until I won the look-alike contest last year. Since then I've been doing some reading and some research on it myself.

I kinda feel, like they say on some of these other people, that he was probably born about fifty years too late. My feeling is, he was more the wild and wooly–type guy. 'Cause he worked as a branding detective, and Pinkerton man, and army scout, and all kinds of things. I think that if he felt that someone—especially when he was working around here—was breaking the law in the

sense of rustling, he had no qualms of shooting these guys and just eliminating the problem that easy.

If he was alive today he would probably be with one of the law enforcement branches, whether it was on a state or local level, or even federal level. He would probably make one darn good officer for drug enforcement or something like this.

I probably shouldn't say this, but he would probably save us a heckuva lot of money in trials.

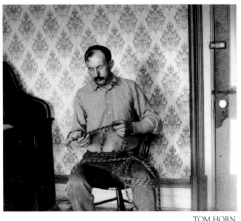

TOM HORN
WYOMING DIVISION OF CULTURAL RESOURCES

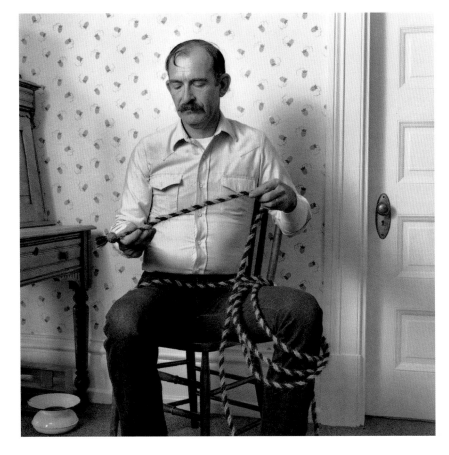

CHEYENNE
b. SEPTEMBER 9, 1943,
BOWMAN, NORTH DAKOTA

JOHNNY: This is the only place in Casper that they can come with their friends and talk their language. They can speak Spanish here and be comfortable without being nervous about trying to talk in English.

There's a lot of people that don't even understand. They just know that it's *Cinco de Mayo*. There's a lot of people that don't know that it's Mexican Independence. They just grew up knowing that it's a Hispanic holiday and everybody celebrates. In Denver there are more Hispanic people. It's more recognized than it is in the state of Wyoming. In fact, it's not recognized at all. There's no celebrations, no parades, no anything.

Young people don't get involved at all. In fact, they're just, kind of . . . I don't want to say, I'm being prejudiced . . . they're Americanized, you know. They just forgot their heritage. And I'm guilty of that, too. But most of the older people like my uncle and Helen [Rodriguez], these guys were here longer and know what it means more than I do, or any young people. It's hard to get 'em

to get into it anymore. They just don't care.

I learned a lot. We have a sign out there that explains how the G.I. Forum started, and why we are doing this, and what it means. Dr. Hector Garcia is the founder. He founded it in 1948, I believe, because a Mexican-American soldier was not given the right for a proper burial, a military burial . . . because he was a Mexican. He was denied that. So Dr. Garcia thought that was wrong and fought for that, and started American G.I. Forum, where all the Chicanos could get

together and fight for things like that—the equality—not just for us but for everybody.

That's television that does that to the people . . . makes 'em scared of the place. When you think of Mexican people, you think of knives and guns and bad guys. White people won't come here because they get nervous unless they've lived in this neighborhood and they know what this place is about. It's about like anyplace else, you know. That kind of bothers me, too, because people look at this place and don't want to come here

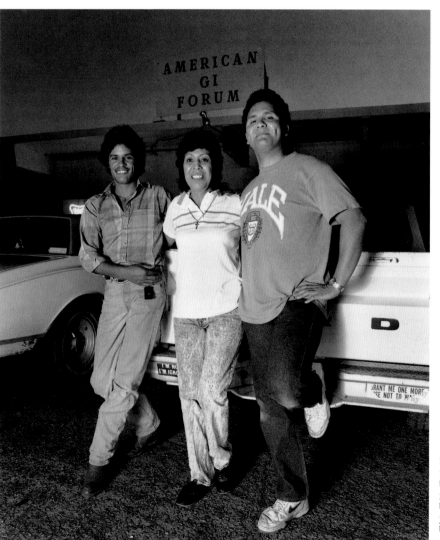

'cause they make a reputation on a place. And it's a nice place to come and get together. It's a variety. You got young people, old people, and now we're gettin' different races—whites and blacks come in here from all over—so you get a big mixture of people.

There's a lot that we can show the community we can do. 'Cause we're hardworking and we like to help. We like to do things to make a community better, whether it's our neighborhood, or the town, or whatever.

left to right:

DAVID VILLESCAS:
b. NOVEMBER 14, 1968, MEXICO

MARIA MORENO:
b. AUGUST 4, 1939, ZACATECAS, MEXICO

JOHN PACHECO II:
b. DECEMBER 22, 1963, CASPER

not in photo:
HELEN RODRIGUEZ: b. JULY 9, 1949,
FORT COLLINS, COLORADO

DARWIN ST. CLAIR

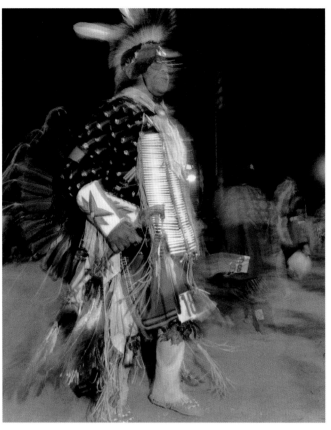

FORT WASHAKIE
DARWIN ST. CLAIR (SHOSHONI)
b. AUGUST 4, 1933, FORT WASHAKIE

Well, a powwow is a lot of social dancing. It's a social gathering. It's where you meet new people, make new friends. And there's a lot of contests. Some of it is big money. I remember powwows where the first-place winner won $1,500. We didn't have these when I was growing up. It's what they called social dancing. You just went out there and had a good time and there was no competition.

In a year I usually hit about ten. We'll have one every week from now on for the rest of the summer, pretty much. See, we have this one here, and then we'll have one next week, and we'll have one the following week. Then we'll be going out of state. Like Fort Duchesne, Utah. I used to go clear, as far as, down into the Navajo country—Window Rock. They have a big fair, rodeo, and a powwow. A lot of people travel all over. We travel all over, all of us—the Arapahos, the Shoshoni. There's powwows goin' all over throughout Montana, South Dakota, North Dakota.

I was pretty much the first one. Our whole family dances. My grandchildren, they both dance. All three of my kids dance. The two boys are fancy dancers and my daughter is a traditional dancer. They're the ones that wear the buckskin. I'm in the senior division of fifty and over. I've won my share. I used to be a fancy dancer at one time. I'm a traditional dancer and that's more of the slower, more of a classical, type of dance. That's the way they used to dance years ago. Lot of body movement and you just dance slower. The songs are slower.

You gotta get a technique of your own. You can't try to copy somebody else and try to do just as well or just as good. You just get out there and dance and practice. You get a recorder, and you play it at home, and you practice. Mainly it's your footwork and your timing. That's the most important thing.

And your rhythm. If you can get your rhythm and timing all put together, you can do pretty well.

At my age, now, it's good exercise. It is. I'll probably be sore tomorrow. I skipped a week. I didn't do it last week. See, they had a powwow up there towards Dubois, up at Crowheart. I didn't make that, but the week before they had one at the Indian High School. The back of my legs were just so sore I couldn't hardly walk for about three days.

There are not many Shoshoni families that dance. At one time there used to be. We used to have a lot of dancers. We don't have no singers. If we have a lot of singers, then we don't have no dancers. You know, I've danced up there when I was the only male and the only adult, and the rest of 'em were kids. We've lost it somewhere along the line. I think it's sad. I think we should try to keep that because we've been doing it for years.

EDWARD "STOVEPIPE" PETTE

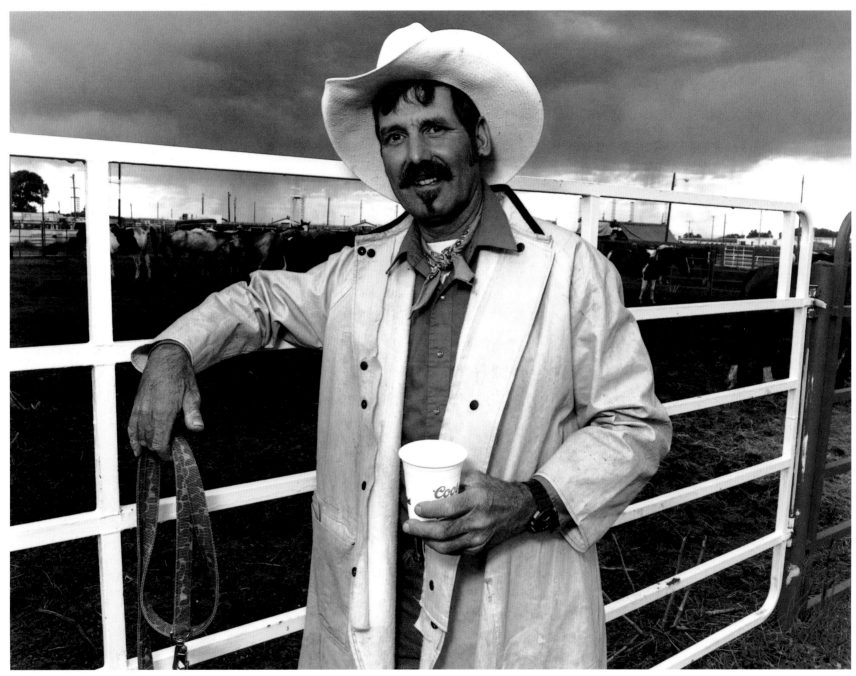

Oh, a little short, fat guy that weighed about three hundred pounds stuck it on me one day and it just kinda stuck. I used to be very skinny for my length and he said, "Whataya say there, Stovepipe"? And it just kinda stuck. I use it in the rodeo 'cause it was a name everybody kinda liked. So I thought, "Well, they'll remember it." So when I signed up for the rodeo I just used "Stovepipe." Nobody knows me as anything but "Stovepipe" around Cheyenne. That's it.

CHEYENNE
b. FEBRUARY 19, 1941, LONG ISLAND, NEW YORK

I was born in Long Island, New York, about as east as you can get. Dad was working for Grumman Aircraft during the war, and finally, about 1947, we got a TV. All they had on TV was old western movies and stuff. The old man used to tell me—we'd sit there watchin' these old western movies—"Now that's Wyoming." He'd tell me about when he was in Wyoming in the thirties and I just, really, all my life, wanted to be a cowboy. Finally, the opportunity presented itself for a job out here, so I took it and I came out to beautiful, wonderful Wyoming. I bought me a ticket for Frontier Days and I saw this wild horse race. I never saw a wild horse race in any other rodeo and decided, right then, that was gonna be my event 'cause I thought that was the best doggone event in the rodeo.

Cheyenne Frontier Days. I guess, bar nothin', it's about the greatest thing I've ever seen. You know, if you see things in your life, then it makes you go do 'em. When I bought my first ticket here I figured, "Well, this is a big one." I didn't expect to see what I saw. I think a ticket was five bucks in those days, and I got a good seat up in the mezzanine section right over the track. That rodeo was absolutely the greatest thing I've ever seen. I've never seen anything in my life like that. And it kinda burned me 'cause right then I wanted to get in it 'cause it was that good. I'd been to a lot of rodeos in California . . . and I just sat there and kept buying tickets. I kinda wanted to get in it but it didn't move me enough to do it. But when I saw Cheyenne Frontier Days and I saw that wild horse race, I went out looking for a wild horse race team.

I don't have any vacation this year 'cause I just started working . . . so I had to talk pretty hard to get the two weeks off, and don't get paid for it. I drive 1,300 miles to get out here. I can't go to any of the meetings or the cleanup days during the year that they have to get the rodeo grounds prepared for the show. So I tell 'em kinda what I want, and sometimes I get it and sometimes I don't. But, you know, I do it because I'm glad to do it. It's just like building an airplane fighter. Everybody would like to be the pilot or to be the guy that tests the plane, but you might have to put the engine together. But

if you at least work on the plane, even if you paint the star on a wing, you're part of that thing and it doesn't matter. And when you're part of something that's really good. Like I say, the closer you can get to the pilot's seat, the better you feel, you know?

I got my dog with me this year 'cause my dog was born here. He's twelve years old. Never know if he's gonna come back. I bring him back every year—General Patton. He's got a camouflaged neckband and leash, and he's part Airedale and part Cheyenne. I don't know what he is. I park under the pine trees out here behind the stock pens. Just kinda live off the land, so to speak. We got a nice shower. If you get over there early enough or late enough, you have pretty good hot water in there. I belong to the Contestants Committee so I get to go use their restroom. They got a mirror in there so I can shave.

Right now? I'm, uh . . . I got a bad job this year. I got what they call "stock patrol." And that's watching back in the corrals where they got the bulls, and the wild horses, and the broncs, and steers and everything, watching that somebody doesn't open a gate and let the stock out. Last year I was working the north gate where all the bucking horses go back to the strip chutes. I've hauled ice. I've helped stood on gate duty. I used to run the clown gate where the pickup men come out.

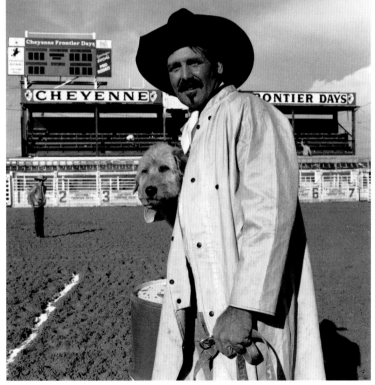

You know you gotta keep coming out here and working the assignments, and ya hope as time goes on, you get a little bit more responsibility as you go up the ladder. And eventually, if ya get enough responsibility or enough responsible jobs, they'll make ya a

Heel—if you know enough guys and everybody likes ya and thinks you're a good person. The Heels really do a helluva job. You know, I'm just a worker out here, but they really back the rodeo up and they make sure it's run right.

I'll be coming back 'cause Cheyenne's kinda home to me. You know it's pretty nice to be treated as good as I was for bein', really, an outsider, but I was kinda adopted here. When I was wild horse racing they really treated me like a homeboy. I felt like a home favorite all the time, and I wished I coulda won the saddle for 'em, 'cause if I ever would've, I'd just set it in the museum. 'Cause I really like Cheyenne. Cheyenne's a real all-American town. It's not a bunch of wimps running around. Everybody can tough it a little bit and make the best of things. You help one another, and if you see a guy stuck on the side of the road you pull him out of the ditch. You throw a chain on his axle and yank 'em out. You'll die out there in Los Angeles before somebody'll help ya 'cause everybody's afraid of ya. Cheyenne's a real good town and that's my favorite town in the world. I aim on livin' here the rest of my life.

FIRST ALL-FEMALE TEAM

CHEYENNE FRONTIER DAYS RODEO

TRUDY: You know, I don't think it's women's rights. We just happen to live in the Equality State and it just sorta fit in. It was just, you know, we live in a great state.

KARLA: It's not like we're going out there and burning our bras.

PAT: This is the 1990s. Nineteen-ninety is our Centennial year. This whole country was founded on men and women, not just men. I was raised in California my whole life. I loved western history when I was in school, okay? When I came out here and I started getting into drill performances and stuff, we went by some of the women that helped found this country. And if it wasn't for women, this country wouldn't all be here because it took both men and women to build it.

HELEN: I think we are reincarnated from pioneer women, I really do. You know, "Annie Get Your Gun." I mean, c'mon! Annie Oakley! There was a helluva lot of pioneer women that came across this country. There's been a lot of 'em that handled a team coming across from St. Louis.

Women have trained horses. Women have broke horses. My grandmother homesteaded in Kansas. I can remember as a kid going down to her place and having to go out, harness horses. Her and I would work the field with horses. She used to tell me, "You know, Helen, if there's one thing you ever do, I hope the hell you do what you want to do." And women back—clear up to 1970—I hate to say it . . . it was always "Dear, will you make the coffee?" Dear, will you do this?" [or] "I have a rodeo today. Don't bug me. I have to get psyched up. Don't talk to me." The whole nine yards. I have worked a

quarter horse circuit, I have worked the standard quarter horse circuit, the American Stock Horse Association. And I don't know how many times the wives go out, they clean the horse, they bathe the horse, they clean the horse up, they get the horse ready to trailer, they trailer the horse. The husband comes up, he checks his gear. The wife has made his clothes. She goes out, she warms the horse up. He gets on the horse, goes out, wins the trophy, comes back, everybody's talking to him. The wife puts the horse back in the trailer. The wife hauls it home. The wife feeds it. And this goes on. This goes on to this damn very day.

My husband—a year ago I kept telling him, "Honey, I'll shank for ya. There's no problem." And he kept saying, "Oh, your knees won't hold. Your ankles won't hold. You've been busted up too long. You're thirty-six years old. You're a grandmother." Blah, blah, blah, blah. He's forty years old and I'm telling him, "What are you talking about?"

TRUDY: We just want to know that other women can do whatever they want to do. You put your mind to it, you can do whatever you want to do. We surprised a lot of people.

KARLA: It gives the other women an opportunity. It's, "Hey, they did it, why can't we do it?" We were the ones that instigated it.

PAT: I'm hoping that we'll get more women teams out there. I really do.

PAT: You know what one nice thing is? We all started out friends and we're still friends. We're still gonna be friends.

HELEN: I think if one of us got seriously hurt, it would probably be the end of the team.

PAT: This is going to go on for each one of them, for as long as they can, for as long as they're willing, and as long as they say, "Stay."

HELEN: And until all of us say, "I think we've done it long enough." I would like to be here six years from now at the hundredth anniversary of Cheyenne Frontier Days.

TRUDY: So would I. But we're not looking that far ahead. We go from rodeo to rodeo.

PAT: This was my dream, and I really wanted to do it bad, and I have three ladies that are doing it for me, and I love 'em to pieces for it. This was the ultimate experience.

KARLA: *I'm a rider.*

TRUDY: *I'm a shanker. I hang onto that horse and get it [halter] up there and get his head down when she gets ahold of him. I've gotta get his head down, get his head down into the dirt.*

HELEN: *My job is the mugger. I've gotta get on that horse's head and stay there, stay like super-glue. No matter how I do it. She's [Pat] our resident nag—"RN."*

PAT: *See, we're equal opportunity. We have two married, two divorced.*

left to right:

TRUDY KEYSER-CASWELL
b. NOVEMBER 28, 1958, BROOMFIELD, ILLINOIS

HELEN WITHERSPOON
b. MAY 16, 1954, DENVER, COLORADO

PAT GUYMON
b. AUGUST 1, 1960, TORRANCE, CALIFORNIA

KARLA MARKER
b. JANUARY 27, 1965, MARYSVILLE, CALIFORNIA

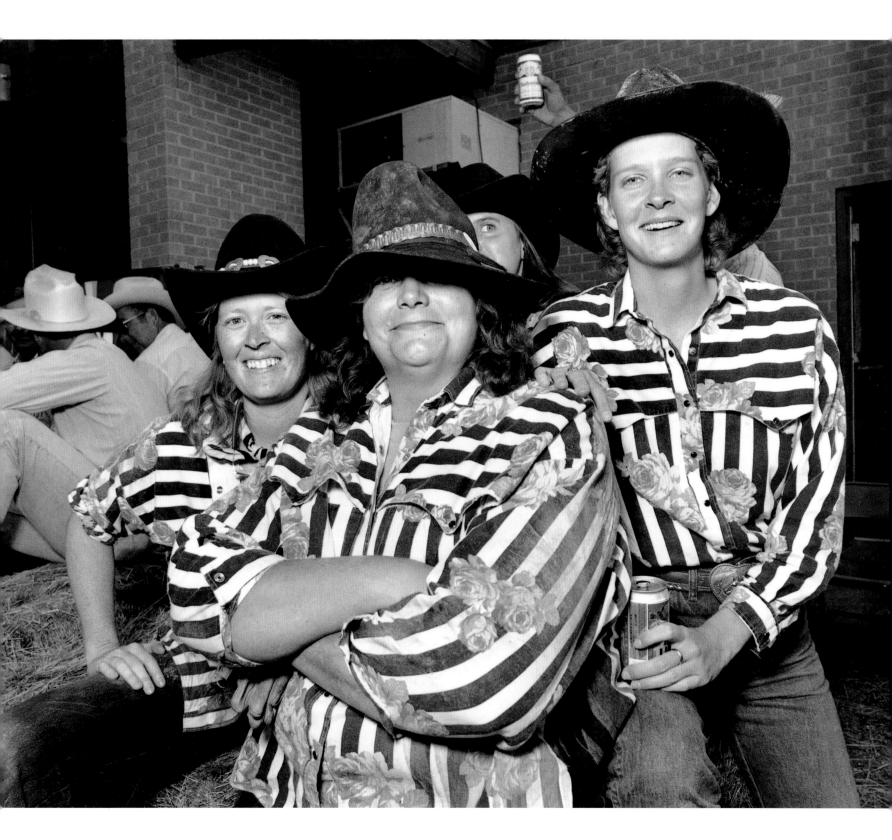

Wyoming is still our home, always will be. We love Wyoming. We're true Wyomingites. My wife was born and raised in Wyoming. Her father was the sheriff of Platte County for thirty years, one of the longest elected officials that they've ever had in Wyoming: Bill Sutherland.

I suppose there are people here in this locality, some people that are actually retired here that say, "We're no longer snowbirds. We are transplanted natives. We're natives and you're a snowbird. You just come down in the wintertime to get out of the snow and the wind, and mostly the wind, and the cold in Wyoming." I couldn't give you a figure, but a lot of people in Arizona started out as being snowbirds. Now, I am going to remain an honest snowbird for the rest of my life because I am a Wyomingite number one and always. Really, that is my home and that's where I will always be. I'm kind of proud of the fact that I'm a snowbird because I get the best of two worlds this way. A lot of people say, "How can you live your life in a one-season situation where you don't see the different seasons?" And of course my answer to them is, "I saw thirty of those seasons horseback trying to calve cows out in the middle of twenty, thirty, forty-mile-an-hour winds with snowballs hittin' me in the face. So I guess I figure, in a way, I put in my time and we enjoy living this way."

No, I don't get kidded that much. I get kidded more by my friends in Wyoming and my rancher friends in Wyoming, I guess, than I do by the people down here. And I think there is probably a little jealousy there. I've had a lot of people when we really got down talking that said, "Gee, I wish I could do something like that, but I did not structure or build my ranch to the situation that I was able to do that."

I don't know. Neither my son or my daughter . . . they were both born, both raised, on the ranch. They were both in 4-H. They both rode horses all of their lives. They both helped in the hayfield. When my son said to me, "You know, Dad, I don't know that I'm interested in the cattle business. I wouldn't mind being a golf pro and then having the ranch on the side." I said, "No way in the world. A ranch is not only full-time for one person, you have to have a wife right there helping you all the way through, too." But as I said to him at the time, "Your great-great-grandfather Krueger came from Germany and blew the bugle for the North as a conscripted soldier at fourteen years old." In other words, he came over and a doctor made him go in his place. He blew the bugle at Appomattox, then came on west and was a butcher, or ran a meat shop. My grandfather Krueger was a clothier. My father was a geologist. I was a rancher. And my son's a golf professional. You know, this is America. This is the United States of America. This is where it is, you know.

I think there certainly has to be improvement each generation. I feel that you cannot improve if you follow in the footsteps of your father and you don't want to do it. I have good, good friends—and I'm not gonna name names in this situation—but good friends in Wyoming who basically were forced into the cattle business by their fathers. They didn't want to be a cattle rancher or a sheep rancher any more than they wanted to be a man in the moon, but they had to. Many times the minute that the father passed away, or was gone, they left. And I hate to say it but some of 'em were very successful in the cattle business. They didn't really want to be, but they were because their father had taught them how to be successful, had left them a successful ranch. But they weren't happy with it. The minute that the father left they sold the ranch. But it was still a well-run ranch. They had run it along, maybe, with their father.

I think that [mine] is not the norm for ranching families in Wyoming. I think most of the ranching families are very, very proud of the fact that they have been on the land, on the same ranch, and they have passed it on from son to daughter, to son to son, to son to daughter, to whatever, however it goes on down the line, not realizing that many times those sons and daughters are not happy on that ranch. I guess what I'm saying is, it doesn't mean that much to me. I really feel that many times a person's true gift, or what they really give this world that they live in, is never really brought out because they're not really doing what they want to do.

It's snowbird, really. I say sunbird. Sometimes I use both of the terms because I'm here for the sun. Not because I'm a sun worshipper, necessarily. But my wife and I put in a good number of years in Wyoming during really nasty winters. We were out of doors the majority of the time, and in the wind, and the snow and the cold. Back in those days we didn't know what a chill factor was. We knew it was damn cold.

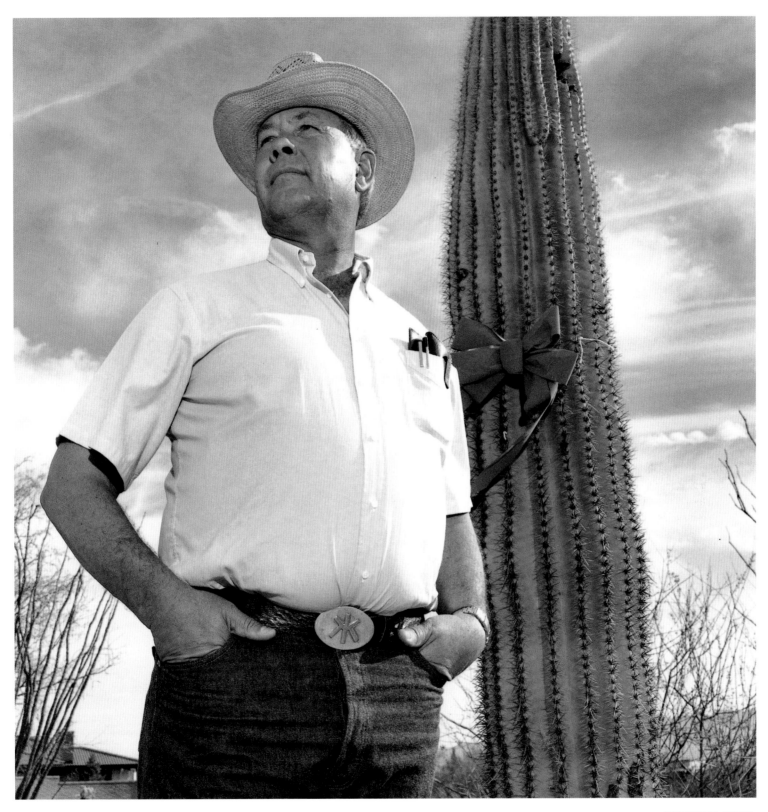

GREEN VALLEY, ARIZONA
b. AUGUST 31, 1936, LOS ANGELES, CALIFORNIA

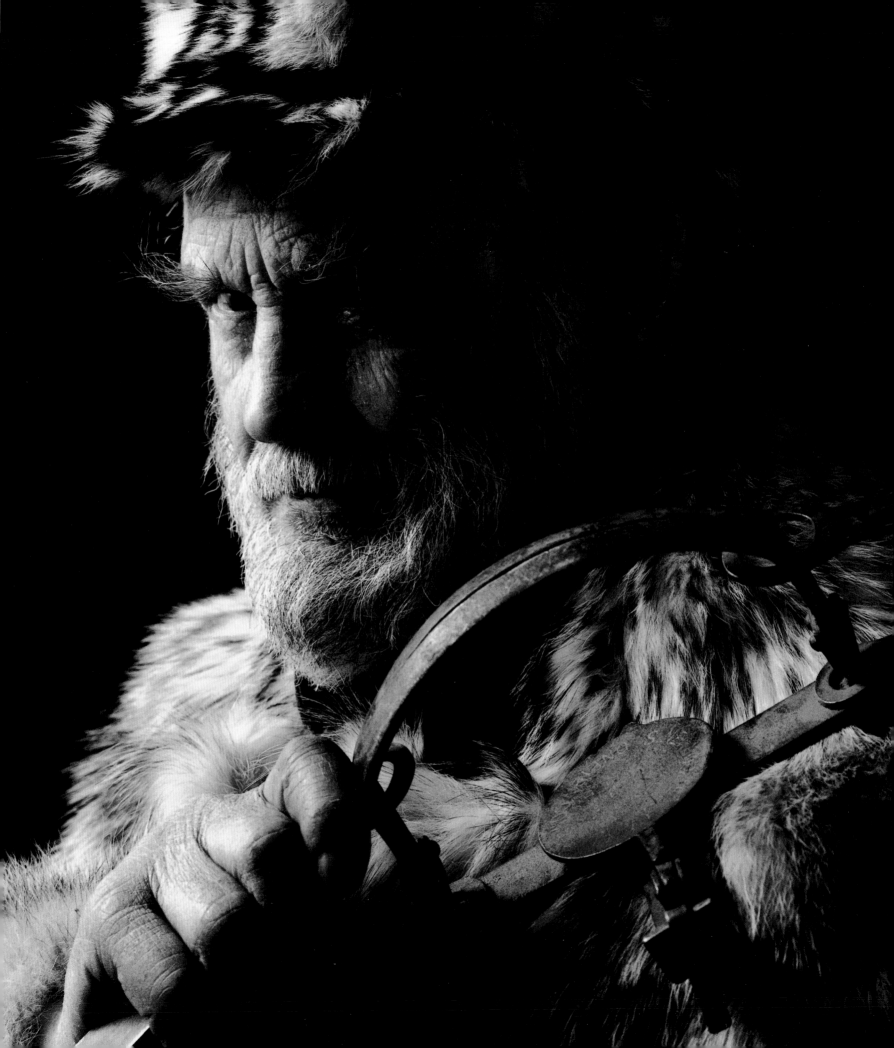

FRIENDS, NEIGHBORS
& ACQUAINTANCES

I've heard other guys say, "Hey, you were born a hundred years too late, boy. You shoulda been right there. You'd a showed 'em somethin'." Everybody says that about me.

You know they talked, they begged me for ten years, that buncha muzzle-loaders. I said, "Hey, fellas, I don't have to go play mountain man. Shit, I live it!" That's what I kept tellin' 'em. Finally, I felt sorry for 'em. They needed help. They ain't a goddamn one of 'em knew how to set a trap. They'd want trap displays and they wanted fur displays. So they kept botherin' me, anyway. And I felt, "Well, hell, I just as well join 'em and help the guys out," you know. But I'm the only one that knows how to trap and set a trap. You know, out of that whole damn bunch, about thirty-five of 'em down here.

Oh, no, they ain't no more mountain men . . . they wouldn't make a pimple on my butt, none of 'em. You know, I kinda think some of those early guys they write all this history about, I kinda think that some of them'd had a helluva time keepin' up with me. I really do. I know they were tough, but by God, so was I.

NORTH OF RIVERTON

JAKE KORELL
FUR TRAPPER
b. APRIL 22, 1914, LINCOLN, NEBRASKA

UFOLOGIST
DAN LILL

When we were first out here, we didn't have water and everything. We used to go over to our neighbor's well over here in the corner and get water. Dad and I and Mom were probably the only people living in this area. This was sort of a virgin experience out here. I took a bobsled and put our five-gallon water containers on it, and I says, "You stay here." And Dad says, "Yeah, I'm gonna be cookin' in the kitchen." I says, "Okay." So I took my bobsled and went up the hill, went over to this doggone well, and [was] pumpin' water. All of a sudden I heard this beautiful, low, melodious hum comin'. It was just a slow drone and I thought, "Well, God, this is weird." Sure in hell—a snowy day and everything like it was—it couldn't be a low-flying airplane in here. It just ain't so. I'm pumpin' more water, freezin' to death, and this hum keeps gettin' louder, and louder and louder. I thought, "Now, just a dad-gum minute. This ain't right." So I start lookin' for it and out of nowhere came in—within 150 to 200 yards I'd say, easily—one of the prettiest, doggone, long, cylindrical, cigar-shaped craft that I have ever, ever laid eyes on. It was just like a torpedo going through the air. Right up at the very front of it you could see a cockpit with windows. You could see a fin sittin' on the back of it very, very nicely shaped. I stood there with my mouth open lookin' at this doggone dude, and all of a sudden, out of nowhere, here was about six faces lookin' back at me. They had very tight-fitting helmets on. There was no hair. Very tight-fitting helmets. And they were very intently watching what in heck I was doin'. I was very intently watchin' what the heck they were doin'. So I sort of waved at 'em and I seen this one sort of wave back at me and I thought, "Well, for cripe Pete, is this darn interesting!" That dude went to just about where I-80 is, and instead of goin' up like an airplane it just rose very gently, and then got on our tail and just . . . pffft! Right straight out. That's one of my most, memorable experiences that I've ever had with them darn things.

They've been very, very benevolent. They've been very kind. Okay, let's get into that. Now I want this for a record. There's something that's extremely interesting. Most people's concept of a UFO entity is some sort of a gobbledygook type of monster, like the blob or whatever, that has some poor, helpless female stretched out on a table and he's putting probes into her belly and every doggoned thing else. That sells magazines. That sells papers. That sells your TV programs. These people that I've had close encounters with are just like you and I. They are very, very athletic in stature. They have an aura about 'em that is much more elevated than the earth being. They radiate a sense of— and boy, this is a hard term to use—love, if that's what you want. There's a rapport that is given that is very, very interesting.

As far as race is concerned, I will say that they are probably of the same body type of structure to a certain degree. I have never ran across a reptilian. I have never ran across these king-sized-headed type of creatures. I never came across any of these green people that they were supposed to come across. And very much like the Olympic type of athlete. Very, very . . . more graceful. I guess a very fair term would be more angelic to a certain degree, but they were more of the perfect body type, sort of like a deal that Hitler was after: the super race. They were more of that type of gender and every doggone thing else. Women were beautiful. Women were out of this world. Oh, God!

One of the greatest desires that I got, and this may sound very cynical and sarcastic, but one of the greatest hopes that I got is to be able to prove beyond any doubt that this particular thing, the UFO world, exists, and take the learned people that are sitting at the top—sixty-five, eighty-thousand, hundred-thousand-dollar-a-year jobs—that say, "I know it, this is it, there is no other," and prove 'em wrong and make 'em eat their own tie. That's exactly what I want. That'd be the greatest thrill of mine, is to say, "Well, brother, here it is. Now, dad-gum you smartasses, deny it!"

I've been asked this many, many times and everything: "Aren't you petrified? Aren't you totally afraid of dealing with outer space entities?" And my simple answer is no, because they run by a natural law of earth science or universal science. The thing that frightens me more than anything on the face of this earth, right at this present moment, is man's inhumanity to man.

Sure as I'm sittin' here there must be a master architect that has set everything into motion. So many people have said, "Well, heaven's upstairs, hell's down below." Okay, we have taken jets up to 180,000 feet. We have taken our spacecraft way out into outer space, to the moon and beyond. So you can really say then—truthfully—that spaceship passed through God's living room. So therefore the concept of God would be that he could hold the whole doggone thing in the palm of his hand to a certain degree, like grains of sand.

If the book is right, the statement "Seek and ye shall find" is the deal. If you seek in sincerity, if you seek with purpose, and you have a childlike innocence, I think the whole thing'll come to you. I really do.

I use it as a UFO detector and weather indicator. It's one of my own inventions, if you want to call it an invention. I can't call it an invention. I call it a blessing in many, many senses of the word. I tried—this may sound weird—to receive impressions from these entities, or my dad, and I just sat down here one day and just started putting the doggone thing together, and tried it and, by God, it works.

WEST OF CHEYENNE
b. OCTOBER 31, 1932, CHICAGO, ILLINOIS

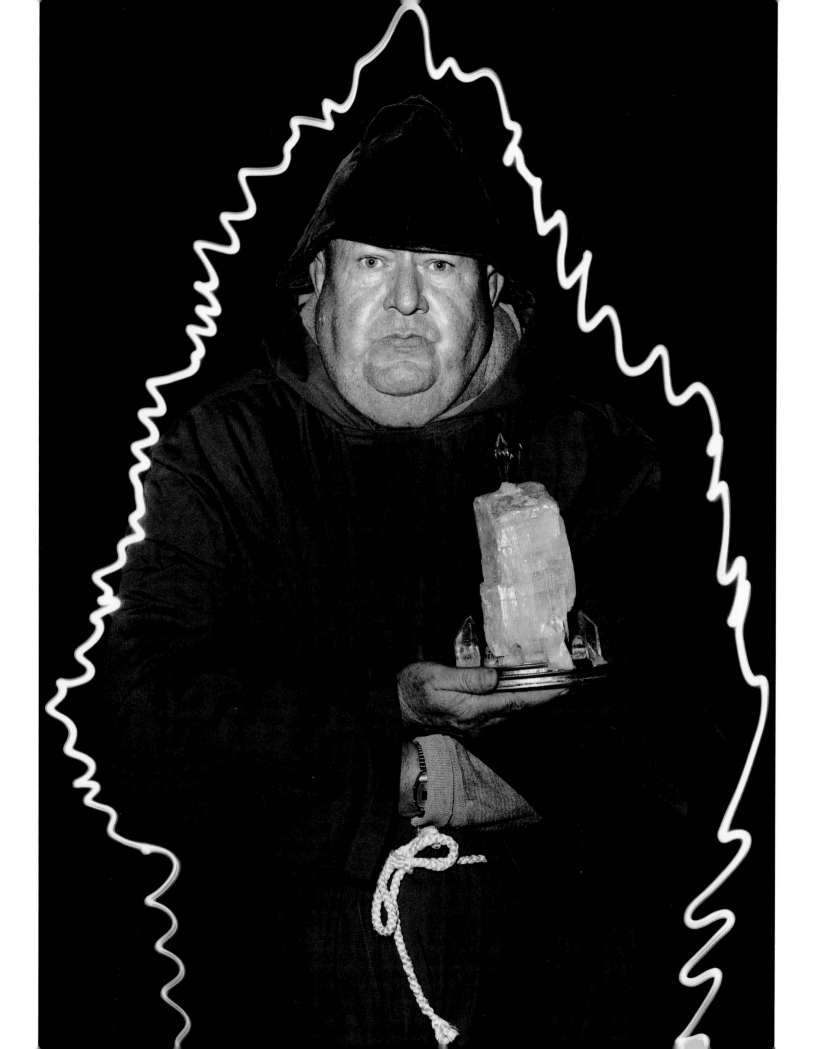

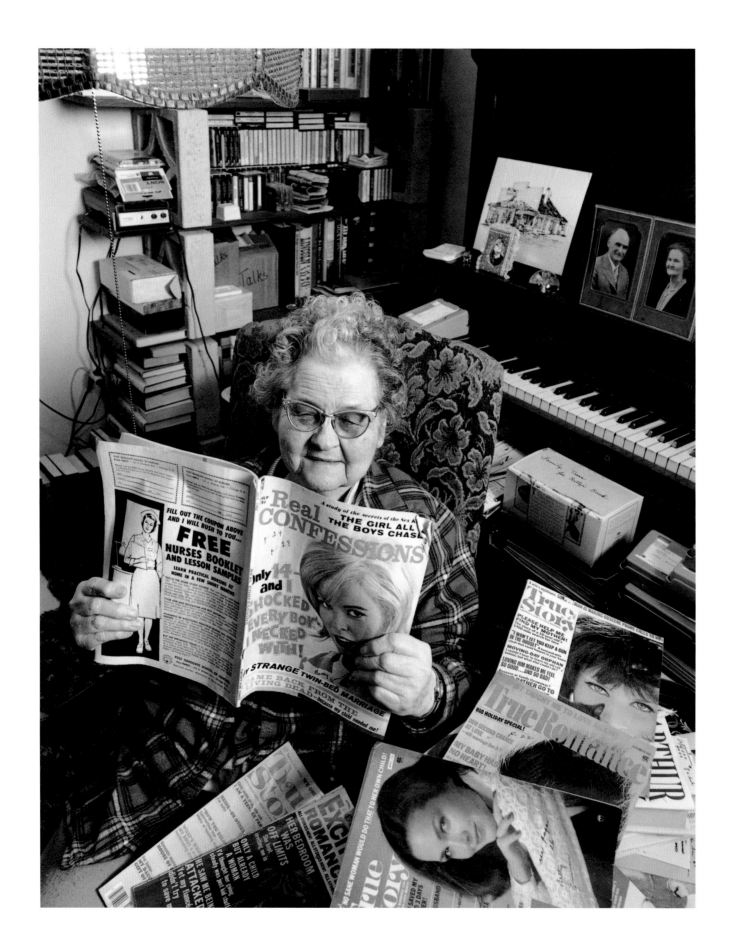

I never read romance novels at all until I started to write for the confession magazines. I never read that kind of stuff. I thought that was trash. I was a literary snob. I wouldn't have been caught dead reading that kind of stuff. [Laughs] Had to eat my words.

CASPER
b. MARCH 16, 1910, OSAWATOMIE, KANSAS

After I got through high school, after I got married, I decided the time had come for me to seriously start to write. So I writes all these stories for these—oh, for everything. I wrote stories that I thought were good enough for the *Saturday Evening Post*, and *Atlantic Monthly*, and *Harpers*, and all those really classy magazines. I'd send 'em away. They'd send 'em back, of course. I got so many rejection slips that I papered the inside wall of our outside potty with my rejection slips. It made a very colorful collage. Made a good conversation piece. Different colors, you know. Green for *Good Housekeeping* and pale gray for *Atlantic Monthly*.

Anyhow, so then it began to come to me that maybe I wasn't a very good writer. [Laughs] I wasn't writing well enough for those magazines because I was writing love stories about things I knew absolutely nothing about. I wrote about how this girl had gone to Bermuda. I didn't even know where Bermuda was, exactly, to tell ya the honest truth. She was on a ship and she had this romance. Then I wrote another one about a romance at the country club and I didn't even know . . . I'd never been inside a country club or even seen one from the outside, I don't think. So what I knew about the social life of people at the country club was pretty nil. Finally, in despair I saw an ad in the *Writer's Digest* so I sent one of my stories to a critic. And he wrote back and said, "The only thing I can think that your stories would be any good for would be the confession market." Well, I considered that a bitter blow. I thought, "Oh, my goodness!" 'Cause, as I said, I was a snob, a real literary snob. But then I got to thinking it over. I thought, "Well, if that's all I can do, that's all I can do. I'm gonna get in there some way. If I have to come in by the back door I'll come in by the back door." So I came to town and bought all the confession magazines that were on sale at the newsstand. I had never read one before, never even seen one hardly. Read 'em all. Started writin' 'em. Sold the fifth one I wrote. It was "I Was a Piker." I got forty-five dollars for it and I sold it to *Personal Romances*.

It was about a lady that wouldn't go out to sheep camp with . . . see, I finally decided to use a background I knew something about. Which had never occurred to me—that I could use [the town of] Hiland for my background. I didn't think it was exciting enough. So anyway, she had camped with her husband. They had a house in town. She wanted to stay in town because she liked her bridge parties and everything. And he was going out for lambing. She wouldn't go out to sheep camp with him during lambing and stay in the sheep wagon. So of course, he got tick fever and nearly died. So she was very regretful. Although why her being with him would have made a darn bit of difference, whether that tick bit him or not, whether she was there or not. . . . But that was a minor matter and nobody paid any attention to reasonable things like that. The editors didn't seem to mind it, either.

Oh, I was in Seventh Heaven. I just couldn't believe it. I didn't cash that check for a long, long time. It was so wonderful. I just couldn't believe that I'd actually made forty-five dollars. I told everybody I saw about it. You know me. I'm not the shy, retiring type. But I don't know if my husband ever read it or not. He was not one much to read my work. He didn't think much of it.

If you're really looking for story ideas, Hiland was a wonderful place because people talked to you. Because lotsa times they were the only ones in there. Over their coffee, a salesman or somebody'd talk to ya and you could use it.

This one bus driver sure got mad at me. [Laughs] I used one of his . . . I made up the situation pretty much. He was the worst philanderer in the world, that guy was. He was something else. I remember I asked him

once, "But how many women do you think you've had in your life?" "Omigod!" he said. "I don't know." He said, "How could you ask me a thing like that?" And I said, "Well, don't you have some idea?" And he said, "Well, you know, that's an occupational hazard when you have to stay all night at the other end of the line." So I said, "Well, would it be more like ten, or would it be like twenty, or would it be like two hundred?" He said, "Oh, my, I been driving for, oh, twenty years," he said. "Probably more like two hundred." [Laughs] He was honest. He was bein' honest with me. But anyhow, what he got mad at me about was 'cause I told this story, and I did tell a pretty good picture of him in it—you know, good description of him. But I didn't figure . . . his wife was a schoolteacher and I didn't think she'd ever, ever see it. But then she picked up a copy of the magazine in a beauty parlor and it happened to have a picture of a bus driver on the front. So she was intrigued by it, and read the article, and she kinda thought it sounded suspiciously like him. Of course, she couldn't prove it. But he said, "Oh, yeah! That Betty! Sure! She says, 'Just tell me anything. It's just like talkin' to a priest or a doctor. It's all confidential.' Then the next thing you know it's splashed all over the front page of some magazine!" [Laughs]

Oh, I suppose I probably wrote about a hundred. I think I sold a majority because after I once got started writing and began to get onto this style real well, and they began to get onto the fact that I was contributing. . . . The general formula is "Sin, suffer, and repent." But then, the way they say that you're supposed to write 'em is, "First you tell 'em what you're gonna say, then you say it, and then you tell 'em what you did say so that they can't possibly miss the point." It's a little bit like the way the news commentators do on the president's speeches: First they tell ya what he's gonna say, then he says it, and then they tell ya what he did say.

From 1935, when I sold my first confession, until about 1965 or '70 when I gave up on writing, they're much more liberal with their "sinning" now than they were then. I mean, boy, they didn't allow any sinning at all. Really, confession magazines are not terribly explicit. They may be more so now. I've kinda quit reading 'em lately. But when I was writing 'em they were not explicit, anything

like the modern novels of today. I think in about the sixties they started to allow them to live together without being married, without considering it a sin. But they had to be committed to each other, see. They couldn't do it casually. I mean they had to be sincere, or whatever. In the first place they were really severe about any kind of sexual . . . slippin' from grace was pretty harsh. But you didn't describe it in detail at all. You just said, like, "Oh, darling . . . We were alone in the deserted mountain cabin. He pulled me close. Oh, darling, I've waited so long for this night. And his lips met mine." And then there's some dots and it says, "The next morning dawned bright and clear." [Laughs] Kinda that idea.

Everybody, especially the men, would say, "Oh, you write confessions!" Then at the press conventions they'd say, "I suppose, uh, some of them are taken from your own experiences?" I'd say, "Yeah, most of 'em, but of course I have to clean 'em up a little before I can send 'em in." [Laughs] Like I said to this man in New York City that was at a bar . . . I knew I shouldn'ta said it at a bar in New York City. I knew you weren't supposed to sit at a bar, but there weren't any tables in that hotel where I was staying so I went into the bar for a nightcap. I was sittin' down next to this guy, and I was talkin' to this other lady next to me, and I was telling her I lived in Wyoming. And he said—he looked at me with this frigid look—"In New York City ladies don't sit at the bar." And I said, "Oh, what a shame! How do they ever pick up any men?" [Laughs] Oh, the look he gave me coulda killed you.

Some of my stories weren't bad. Really, they weren't. I got better at 'em as time went on. One of the last ones I wrote, after I came to town, that I got the inspiration for, was from church. It's about the only thing I do since I've come to town, is go to church. But anyhow, I got this idea because the minister's daughter had had a baby and they announced it from the pulpit. You know, they always announce a new baby. She didn't live here, but I could just see all the women mentally calculating. It wasn't long enough from the time that she'd been married, see? So I got this idea about how the grandmother must be feeling, sitting up there in the choir with all the women down there kind of condemning her, you know. So I wrote it from her point of

view, and how she must have felt—kind of angry at the people and everything. Then how, as she sat there and looked at the other people, she saw the kindest man that was passing her the communion plate . . . looked at her with these kind eyes. Then she saw this woman who had a little handicapped child, a little, halfwitted child, and she thought how she would love to have a child anytime it was born. So when she got up to sing—it was an Easter background—the Easter anthem, she thought she really appreciated the gift of life, or something like that. There's nothing trashy about the story whatsoever except just the fact that the woman had this child out of . . . you know, too soon. They almost always have to have a moral. The moral in that one, for instance, was that she should have appreciated the fact that she had this new grandchild instead of feeling ashamed about the other.

I think the better part of 'em is that they sort of help take ahold of some problem that somebody that isn't very sophisticated may have, and it might even help them. I got a lot of letters from people who read the stories. They would send 'em to the magazine, and the magazine would send 'em to me because they didn't have any address or name for me, of course. They would say things like, "Tell the author of 'Weekend Love' that she saved my marriage. I wouldn't go out with my husband when he was on a construction job just like Jennie wouldn't go with hers, and then after I read your story I went, and we've been so much happier ever since." Or something like that, you know? So that kinda makes you wonder if maybe you do do some good somewhere along the line.

Well, you'd be surprised. The audience is bigger than you think. I think they say that the audience is basically blue-collar workers' wives. Like beauty parlor operators and lots of college kids. You'd be surprised. Kids used to come in there to buy 'em from the store when I had magazines in the store. College kids. Young married people that aren't terribly busy. Most of the young married people now don't have time to read that sort of thing 'cause they're workin' and got kids to take care of, too. But I think back in the days when women were home more, they had more time.

I think the reason I liked to write confessions, now that I think more about it, is because they are emotional. That's really

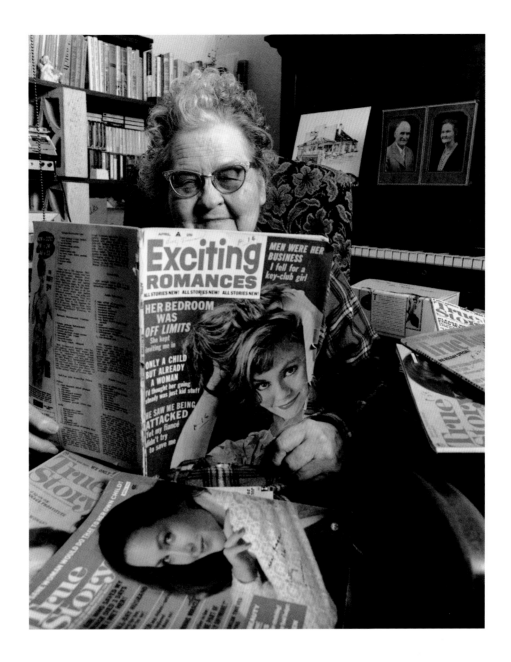

their basic thing. And that's why I was good at writing them because I liked to write about emotion, you see? 'Cause I was that incurable romantic. That's the reason I think I did well at that kind of writing. Because I was not a good enough writer, really, to write for a better market.

I think I do understand men's feelings, really, better than women's sometimes. Women puzzle me sometimes. I don't know how to describe it, exactly, but I noticed that all the stories that I wrote for the confessions

that were from a man's point of view always sold. Because there weren't very many of those. They don't have hardly any from a man's point of view.

As I was saying, it's part of my nature to just want to probe into—not necessarily with them knowing it—why people do things, and what motivates them, and why they think the way they do and all that. I just like to know about people. I just have an insatiable interest. I don't think it's curiosity, really, because I care about it. I think it's just an

interest in what makes people tick. I just like to know about people.

Yes, I wanted fame very much. I wanted success. And really, I can't say that I haven't had it. I mean, anytime anybody who could be on both the To Tell the Truth and the Phil Donahue Show, and on the front page of the Wall Street Journal . . . I guess probably I was more famous than a lot of people. More people knew me after that Wall Street Journal than knew who the governor of Wyoming was, I'm sure. [Laughs]

DIRECTOR EMERITUS
GENE GRESSLEY
AMERICAN HERITAGE CENTER

LARAMIE
b. JUNE 20, 1931, ANTIOCH, INDIANA

. . . But back to your Texas story, hitchhiking there. When you had $400 in the travel budget you had to go out and stay out because the biggest expense was travel fare. So I went for six weeks, two times in a row. One time I left Joyce with a four-year-old who had chicken pox and a newborn baby. She's never forgiven me or forgotten that one, either. It didn't bother me as much as it should have bothered me. I wasn't mature enough. I was too interested in what might be in Texas. The only guy that ever went to Texas with great anticipation for paper.

I went through Kansas, stopped off, and incidentally interviewed the man that did the first drilling for the British in Salt Creek oil field. He died three years later, but that's why I had this tape recorder along. I had an old Ampro, forty-pound tape recorder, one of these old accordion briefcases—you

know the old type that bulge out at the bottom—and two suitcases. This is the way I traveled. You're gone for six weeks, you gotta have a lotta stuff, especially then because I was going do oral history. I later quit that, which is too bad, just because I didn't have the time. But I taped many pioneers of the early oil industry. The big problem was that I didn't know enough to ask them the right questions. I let them tell their stories when, if I'd known enough, I could've interjected more questions and collected more history.

Anyhow, I was outside Dallas. I had this little row of luggage and I was standing at the head of it hitchhiking. This '57 Chevy—I remember it had those fins on it—pulled up and the driver loaded all this luggage in his trunk. That's why, he said, he picked me up. He said, "God, I couldn't be scared of a man that has four major pieces

of baggage and dressed in a suit." He said, "I just was curious what the hell this was." [Laughter] So we were going down the highway and I told him what I was doing. He was intrigued and kept asking questions. He poked at me on this, and he poked at me on that, and my background, and he asked me as many questions as Mark Junge has. It went on and on. When we came to some second-rate, fleabag hotel in Houston—I can't remember the name of it but we couldn't afford anything else—he got all that baggage out on the sidewalk and shook my hand. I shall never forget his parting words: "Gressley," he said, "all I can tell you is, if you ever get out of a job at the University of Wyoming, Lone Star Steel can do a helluva lot better for you." [Laughs] And he was right. They could have, up until the depression of the oil industry a few years ago.

190

You told me a story one time about going up to the door and a woman answered in a bathrobe.

Yes, and do I remember that one! [Laughs] This occurred in Great Falls, Montana. I was after the papers of a political figure who Montanans will know, who was quite a liberal in his day. Later he became a conservative and married this young gal who I didn't know was a young gal.

I went out to see her one Saturday morning—called her up, asked if I could come out to see her, and set an appointment for ten o'clock. There was a sprinkler system on the front lawn. I went over the hose, came up to the door, and rang the bell, and she appeared in what I shall best describe as a very frilly negligee. Well, you may not believe this, but Gressley's not that worldly, never has been. I simply don't know how to handle

situations like this. [Laughs] I don't expect anybody to believe this, but I never even thought of it. Anyway, I took one look and I was so aghast—at ten o'clock on Saturday morning—all I could do was say, and I gasped out, "I'll come back when you get dressed!" [Laughs] I bolted down the stairs, tripped on the sprinkler, slid across the grass in the mud, fell on my face, got up . . . and she was roaring. I could hear laughter behind me. I was laughing, too. I stumbled around the car, got in, and went back to the hotel to clean up. Yes, that was one visit I shall never forget. Needless to say, I never called her again. And that was a mistake because I think probably I could have had the files.

You don't know what kind of society or intellectual interests you're going to have one hundred years from now. Maybe we won't have a society that's interested in the

past at all. If that's true, then, of course, this collection is worthless. But if we do have a society that is interested, yes, it's going to be very valuable. As a research tool. Because we have done something very few archives in the United States have done. We have collected the twentieth century.

I used to tell my kids this. I said, "I don't want to wake up at fifty and wonder what I've done with my life. I want to wake up at fifty and say: 'It's been a good race. If I drop over dead tomorrow I gave it my all.'" But as far as I'm concerned, it's sure as hell not ended, either. Because the minute you say that, it is ended.

ARTIST
NELTJE

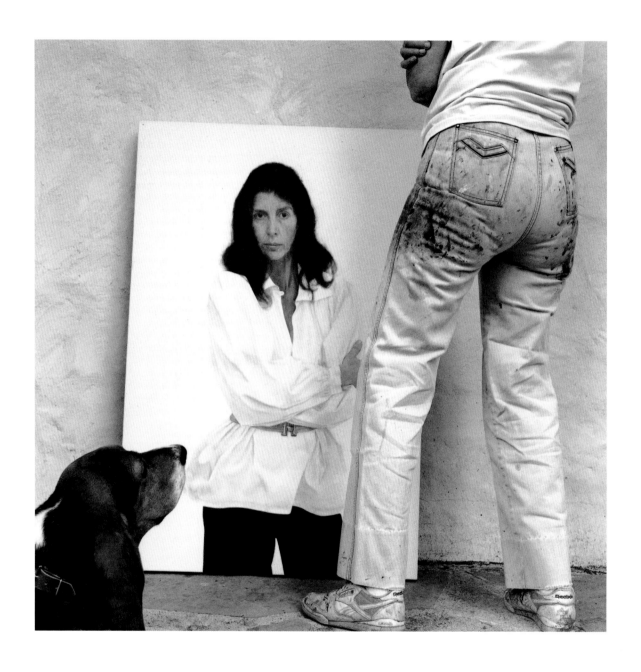

I wore miniskirts and black net stockings, smoked cigars and—you know—lured men to sin. God knows what I did. When I had the Sheridan Inn I went up to the judge at one point and said, "I got sixty-three rooms in this Inn, Judge, and you know what it's good for? They're all tiny rooms." I said, "Now how much of a cut would you like?" And he looked down at me from his big height of six-foot-six and said, "Neltje, I don't see payin' for what I can get for free." And that was the end of the discussion.

I think I've spent most of my life proving that I could endure a lot of stuff, including running the inn for eighteen years. I don't need it anymore. I can give it up.

I've changed enormously. I could no more have done what I did here if I stayed back there [New York]—I couldn't have possibly done it. I would not have had the nerve to get involved, and buy the inn, and redo it and run a business of that size. Or to become a painter without background or an education in painting. I mean, I would have been laughed out of the house much too early. There is so little room at the top that nobody allows you the space to do very much. Back there you have to be awfully tough. And I wasn't that kind of tough. I'm still not that kind of tough.

I decided to come out here because I needed to find myself again. I had stopped knowing who I was. I had lost any sense of the inner integrity that I had had at some point in my life. I had become somebody else's patsy. I had become a performer. I was miserable. I didn't have the lifestyle that I wanted. And by the lifestyle, I mean I didn't have anything that was nourishing me. My marriage was cold. I was a performer. There are a lot of women who can live with men and who can have liaisons on the side and give nice dinner parties and do that. I can't do that. So I was just at the point where I had to find a place where I could feel psychically comfortable.

I need to have, always liked, mud under my toes. I like country as opposed to city. I didn't want the sophisticated life anymore. I'd always had the dream about running a farm. I loved the story of The Egg and I. I liked living in a trailer. We lived in a trailer for a year because I'd seen Lucille Ball and Desi Arnaz in a movie called The Long, Long Trailer, which was a riot. And I thought it would be fun, gay, witty, amusing, and charming to do. Loretta Young was my other hero and she always came swirling into a living room being charming, gay, witty, and amusing. I thought life was gay, witty, amusing, and charming, and I refused to believe my mother that it was one goddamn thing after another, you know? I just wanted to make it wonderful.

There's something about nature that gives me great strength. When I have been the most depressed, most flattened, and close to suicide, I've looked at those mountains and I've thought, "If you can make it one more day, I can make it." I've looked at those trees and thought, "You lived for seventy-five years." I listen to the wind howl through them and I think, "Hey, you stood up to that. Somehow or other I can make it through the day." That's been my source of strength, and to me that's very important. I think most of us who live here in Wyoming have that thing of wanting in a very primal way to deal with nature. And nature—that's a huge thing. It's more than the sagebrush. It's more than the mountains, it's more than the trees and it's more than the weather. It has to do with all of life. It's a very primordial feeling. Somehow, I think, most of us have that somewhere, and that has a great spiritual quality to it. It's very hard to articulate, and certainly in this macho state one articulates it very carefully in hidden places.

Space. Space. It's still very much frontier country. There is little here. There's one part of it that's very clear. You can be a big fish in a very small pond. And that makes it much easier to do things. Because one: You have much less competition. But there also is not people to knock you down so fast, to say, "No, no, that can't be done." There's also something about just the physical space there is here that allows you the psychic space. It gives you room to be able to think that, "Yes, I can." I can survive a winter here in Wyoming. I deserve spring when it gets here. When you get through a winter here you think, "I've gotten through something." You know?

Oh, I think women in today's world are just beginning to have a sense of themselves and just beginning to have a place in the world. I think if you look at most businesses, there are very few women who are in the top echelon. There are very few women who are in the top echelon of government. There are very few women who are in the top echelon of many, many professional fields. For instance, there is not a woman gynecologist in the state of Wyoming. There is one in Montana, thank heavens, but there isn't one in Wyoming. That's extraordinary.

I've found the women, even in the business and professional women's group here in town when I was involved with the inn—I wasn't in the business and professional women—they're scared. They don't confront men. They do not want the boat rocked. They don't want to fight for what they could have. Because many of them still want very much to be protected by men and not to be responsible for themselves. They don't want to disturb the old values. And that's fine. So when you say they're tough, they are to a certain degree but they still want to be protected, they want to be taken care of. Well, you see, I wouldn't call them women in the traditional sense; I would call them women who were protected and who were unrealized.

I don't know that it's in Wyoming more than anywhere else. I think there's a lot of them all over the world who are unfulfilled, who don't know, who haven't got the ability to find out. There's a ranch wife fairly close by who does some writing. And she never tells . . . her husband won't read anything that she writes until such time as she has sent it and it's been published somewhere, and then he'll read the story. That gives you a little kind of idea.

There really isn't very much here for women. This particular state is a very macho state and the wife is talked about as "the wife," as "the coffeepot," or "the teapot." There's not much regard given to her as a human being. Oh, I think that the men are scared of the women here.

I think there a lot of women who are very happy being housewives. And that's fine. I haven't got any problem with that. I think there are an awful lot of women who are not . . . or even if they are happy being housewives, who perhaps would be happier as individuals if they nurtured their own talents more.

Oh, no, we're not an Equality State at all. That's bullshit. I think of those old sour dames who were the originators of that "Equality State" and I think they would come up, rise from their graves, and put hatchets through all of us—men and women. Because I think the women in this state have been terribly lazy, sitting in their living rooms and their polyester suits and not being responsible.

Wyoming? It's hard because I can wax sentimental about it. Wyoming, you know, gave me my home, gave me my life, and gave me a way of being. Wyoming, also, I find outrageously conservative, and backward and ungiving. I think by "ungiving," I mean that there is in one breath great tolerance and in another breath no tolerance at all. It's such a paradox.

MARK SETRIGHT

HISTORIC
WYOMING STATE PENITENTIARY

It's the first time I ever put the mask on inside there. I felt it was kind of an interesting visual effect because I could see through. I could see shadows, and it almost felt like a pall of darkness going over my soul as I put the mask on. There's something not necessarily mystical, but something ineffable, something beyond ordinary consciousness, as far as this touching the edge of death.

It would be all artificial light. All the executions took place after midnight and before three a.m. Imagining that artificial light is interesting to me. A little lightbulb. It'd kinda be a yellow light in the early sixties. It wouldn't be a white light. It would be, I think, a lot different.

There's six cells altogether. They never needed six cells. The most they had on death row at a time was two in 1916. There's an exception later on. They had three in the early eighties. The condemned didn't have far to walk.

The first time the gas chamber was used was 1937: Perry Carroll, who had killed his boss in the middle of the Union Pacific Depot in Cheyenne in front of about five hundred people. At the time they switched to cyanide gas. It was first used in Nevada in 1924. But it was pretty controversial.

States around us, in editorials, were calling Wyoming barbarian—newspapers in Utah, Montana, and Idaho. And they never switched. But Wyoming was looking for something less painful, more humane, so they switched to this and then just used it five times. Stanley Lancer. Harry Ruhl was a federal prisoner. I thought because of the war years, maybe it was something like treason or something. It was not. He had just killed one man on federal land. Notice the disproportionate number of minorities here. There were two black people, one Indian, a Chinese, and Andrew Pixley was part Indian. Out of fourteen total. So five were in a minority. Andrew Pixley—the last execution here on December 10, 1965—was also the youngest to be executed. Twenty-two years old. And boy, there's a lot of strange stuff about that guy.

The warden did the executing. Drop this lever, a cheesecloth bag full of cyanide pellets fell into acid below the chair. The prisoner would be unconscious in ten to fifteen seconds. And all except for Andrew Pixley were dead within three minutes. There's a hole in the back wall where two doctors had a stethoscope. When the doctors pronounced the prisoner dead they'd neutralize the cynanide with ammonia, pump fresh air into the bottom. The warden locked down the suction fan, which took about thirty minutes to clear out the gas. In the meantime,

I can tell you this. You can take my picture while I'm sitting in the gas chamber with the door open. It's no big deal. I mean, it's kinda like, laughs. And people feel that way too. People taking tours sit down and take their picture in the gas chamber. But when the door is closed and you're sitting in there, it's a totally different feeling.

RAWLINS
b. JUNE 19, 1958, RAWLINS

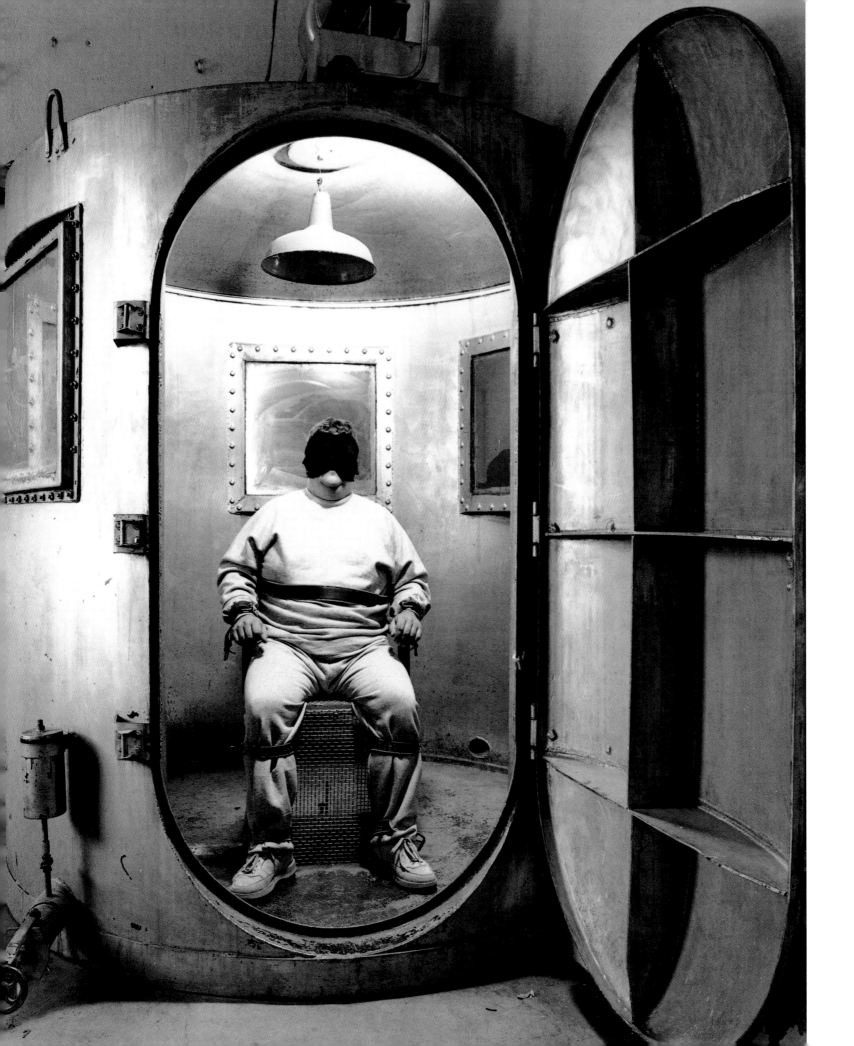

the back room was pretty well packed with witnesses. Witnesses came up the back stairs and filled the room. There were less each time. They started out with forty-nine witnesses. Victims' family members were occasionally invited, and the prisoner could invite up to ten witnesses of their choice. Surprisingly, some of them did. Andrew Pixley had only thirteen witnesses. He had the least witnesses of anybody executed. Andrew Pixley had the most ministers of anyone executed—four ministers just praying constantly right up to the time of his execution. Andrew Pixley wasn't pronounced dead in the gas chamber for five and a half minutes. I have no idea why he lived almost three minutes longer than anybody else in the gas chamber.

Two doctors were standing right there at that window. They put a seal around there. You can even see where the seal was. Then the stethoscope was hooked to the prisoner with a little pin and they came in. It went in there and was already hooked up to the prisoner before he walked into the room. Then they just connected the two pieces to the chair after he was strapped in. The leather straps are for muscle contractions. Cyanide gas paralyzes the muscles. I had an anesthesiologist on a tour tell me that cyanide gas is actually less painful than even a lethal injection because it puts you to sleep first. They told the prisoners to hold their breath. It made the prisoners feel better. It made them feel like they weren't breathing in the gas. But actually the gas goes through the pores of their skin.

Someone said, "Well, maybe Andrew Pixley held his breath to live five and a half minutes, three minutes longer than anybody." I don't know. I'm convinced there was something evil about this guy. There was something demonic. I'm not kidding you. Andrew Pixley had committed one of those horrible murders in the history of Wyoming. In 1965 you couldn't have found very many people in Wyoming opposed to his execution. He had raped and murdered two little girls in a motel room in Jackson. He cut them into pieces. He was found in the motel room covered with blood. His defense was, he didn't remember doing it. He later said, when he was on death row, if he had done what they said he

had done, and after seeing the pictures and things, he deserved to be executed. But he said he blacked out and didn't come to consciousness until the little girls' father walked in and found him in the room. It's interesting. The little girls' father was a district court judge from Chicago who had been opposed to capital punishment. And after the incident, perhaps like any father would, he became kind of a hanging judge.

I don't know. This superstition mumbo jumbo, the thirteen witnesses . . . Oh, another thing: They tested the gas chamber. They changed the seals, and brought in a pig and killed the pig in here to make sure the gas chamber was working alright. Deputy Warden Johnson didn't want to go all the way to the farm to get a pig, so they brought a cat in here that they were gonna execute. I don't know if it was black or not, but, again, the superstitious stuff. So I think there's something evil about this.

[One night] when I was up here, it was late. It was not dark, but getting kind of dark, so I had a flashlight. I was gonna look up some of the other executions in the newspapers, had already made up my mind about Andrew Pixley. I mean, this was a clear-cut case of evil in my mind. But my flashlight happened to catch his eyes, the photograph in the hanging room there. As I looked at his eyes I thought to myself, "Boy, that guy has really strange eyes." And as I thought that, I heard two little girls crying behind me in the hanging room. My heart leapt. My hair's standing up on the back of my neck. I'm more frightened than I could ever remember being, and I'm runnin' to the front door thinking that I was haunted or something. It wasn't until I got to the outside front door that I realized there wasn't anything supernatural. Just at that time, I opened the front door. Fifty feet over on the other side of the wall was a volleyball area. These kids were playing volleyball. It was getting late and they were fighting. And the sound of crying, when the wind's blowing, comes right over the wall into the hanging room like it's right there. Since then I don't come up here at night. And just at that moment! . . . Man!

The feeling was, it [gas chamber] was more humane. It was cleaner, neater, less

painful. It's interesting because if you read the newspapers at that time, it's not like they're real concerned about what happened to the prisoner, but they're sort of worried about what the witnesses have to watch. It was at a time when funeral homes and mortuaries were really kind of gaining a footing of their own. I know in this town one of the big lobbyists for the gas chamber was the Rasmussen Funeral Home. They were saying, "Well, you gotta do this instead of this hanging." Also, there was a stigma attached to hanging, that it was in some ways kind of a vigilante justice. This was something clinical, scientific, that the state did, where hanging is something that a mob group would do down at the railroad tracks. And in this town that was certainly part of the feeling. Part of the argument, these other states were saying, was that the gas chamber wasn't like the electric chair. I'm told that the electric chair, there's such a terrible inrush of pain at first—the first shock. And also the contortions that go with it, the stuff that goes on . . . they caught fire. They were still maintaining this [gas chamber] in 1985. The state still owned the property intending to use this on Mark Hopkinson. Finally, they debated in the legislature. Wyoming became a lethal injection state.

I am personally opposed to capital punishment. When I first did the tour, I came up here and I just wasn't interested in this stuff. I was a little worried about my own interest in it, but I think it's historically interesting why they changed from hanging. I personally feel that it makes us as barbarian as the criminal. I haven't killed anyone and would never kill anyone. The case of Andrew Pixley is a good example. I'm convinced that the man was evil. I'm not convinced that he needed to be executed. Call me cruel. I'd want him removed.

I remember arguing against capital punishment, and I think successfully, in college ethics classes. But the gas chamber is not something most people see every day. Since I've taken this job I see the gas chamber all the time. It's changed my thinking a lot about it. I certainly have softened my views. I mean, when I started this job I was radically opposed to capital punishment. I would say

sixty percent of the people on tours are in favor of capital punishment, at least. So I just don't say, "Well, I'm opposed 'cause I think it's terrible." I just try to tell 'em the methods they used and what I think is interesting about it.

Watching the people leave the prison kind of awestruck by the magnitude of it all, it's the first time a lotta people have ever set foot in anything like a prison. They seem to come to terms with their own values of freedom. Just the excitement and enthusiasm of the people as they're leaving the prison. It's always a thrill for me to start out a tour with people who are sort of, "Well, I'm not sure I really want to go to a prison." Sort of half-hearted, half-interested. And when they come out they just want to get all the information they can. "What do you have on this?" "What do have about this guy?" "What happened to McDaniel?" And that's exciting.

I mean, people are frustrated with the prison system as it stands today and they say, "Well, this is the way prisons ought to be, this is the way they used to be." It's interesting. I think by the end of the tour they're pretty much dissuaded from that, especially by some of the cruelty we talk about that actually went on here. I've argued this with Mr. Schillinger [Wyoming State Penitentiary warden] who was one of the leading reform wardens in the country. His prison was considered very reform-minded. He said that this system didn't work, either. A good example is Stanley Hudson, who kept coming back to even this system. His argument is that, of the prisoners he has out there now, he can think of four, maybe five or six guys that'll never be out. The rest of 'em are coming out sooner or later. So as a society we need to be ready. And I think it's a decent argument.

CHARLES ARAGON, RANCH HAND
b.MAY 11, 1905, WYOMING
EXECUTED DECEMBER 8, 1928

STANLEY LANTZER
b. APRIL 16, 1902, COLORADO
EXECUTION SCHEDULED JANUARY 20, 1939
SENTENCED SUSPENDED DECEMBER 15, 1938

CLEVELAND BROWN, JR.
b. MAY 17, 1917, MISSISSIPPI
EXECUTED FEBRUARY 11, 1944

GLENNA MADDEN

WYOMING WOMEN'S CENTER

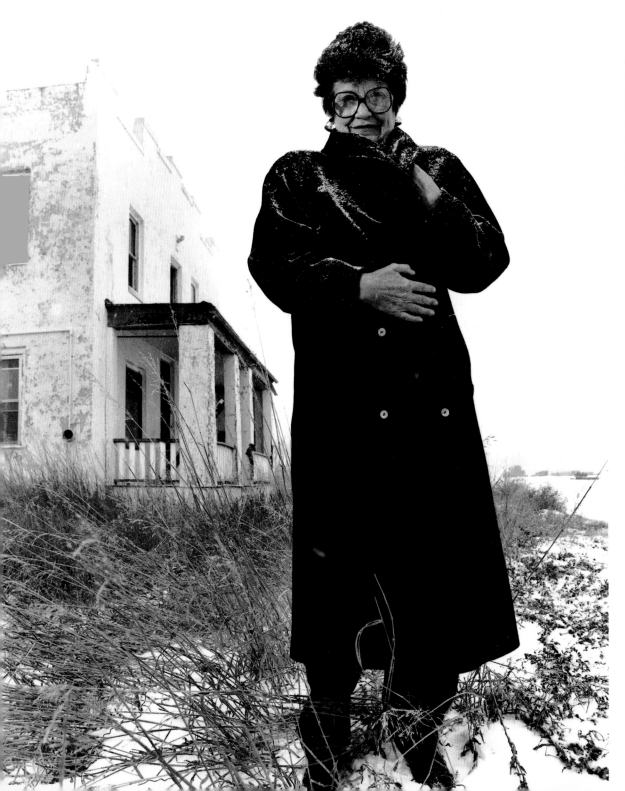

Dell Burke was the madam of the house of prostitution here in Lusk. When I moved here it was just, "Oh, and that's Dell's. That's the Yellow Hotel." I visited with her many times. She told me she came from Juneau. But actually, I think she came from South or North Dakota. She had never married, to my knowledge. Her name was Marie Law.

LUSK
b. JULY 30, 1931, NEW HAVEN

She kept it in good repair and she used to paint it yellow. In fact, between Cheyenne and Torrington she advertised "Dell's Hotel." Someone stole those signs. There was also one down by Nebraska. She kept her house, I mean the outside appearance, in very good condition. Except she was a pack rat. She never threw one thing away, not even a Safeway garbage sack. The building next to the Yellow Hotel was just full of garbage sacks and things she had saved. Living through the Depression, I think she saved everything. I think she was very frugal.

You don't know how many conventions we used to have that women showed up down there. She told me that herself. At the hotel. Not being aware that that was not the place. She was very gracious to 'em, and would say, "I'm sorry. We are full. There are no vacancies." That was it. I had women tell me that from church groups that went down there. She was very gracious. I think people left her alone because she left them alone. She was the butt of many jokes. Sure she was.

There is that old story and everybody tells it. I can't tell you the way it actually was, but she did own a lot of stock in the city light plant. And when the city father says, "We're gonna close you down," she says, "Okay, your lights are going off." Now I don't know that that's the way it happened. That's been the story here forever. I think she did give, or sell, her stock back to the city of Lusk. But she did own quite a bit of stock in it at one time, and I think those may not be the same words. That sounds kinda Hollywoodish to me, but I think that's kind of what happened. She was a businesswoman and she invested—wisely, I should say that.

I don't think she ever had any trouble telling anybody off, but she never went out of her way to look for trouble. I think she was low-profile. Smart, smart. I know a story I just loved. I won't use the name, but the boy told us. He was in high school, and he made a trip down to Dell's. He was going upstairs with this lady, and on this narrow stairway coming down he met his dad. He said, "Hi, Dad." And he says, "Hi, Rick." [Laughs] I loved that one. I thought, "Oh, of course that might have happened in a small town like this." And I don't think she made any waves.

She was very quiet and everything. Except, when she got older. I think probably some senility was coming in and she became less inhibited. She would come to more social functions. She would sit in the park and visit with you and she would be indiscreet about things that she was saying. "Oh, well, so-and-so from Douglas . . . " And so-and-so, and so-and-so . . . "and they were at my house." And, "What do you think of that?" Until Lisa, this prostitute that had been with her for many, many years would say, "Dell, watch that! Dell, you shouldn't be saying that."

But I will tell you, this is what I thought. And I've talked to a lotta people over the years. I was grateful for Dell Burke's house of prostitution. I think it stopped a lot of crime; I think it stopped rape. I think it stopped a lot of problems. I thought it was okay that it was there. I did. And I think that more all the time, as I see more by working in a prison. When I see the sexual abuse, and the rape, and the victims that we have here, I see that [prostitution] as okay under specialized circumstances. I know this for a fact. I was a nurse. Dell sent her girls— I think they came in once a week—and had smears to check to see that they didn't have gonorrhea. They were tested for venereal disease. She didn't allow 'em to go into the community and go down to the bars, or be on the streets or loud. I mean, she controlled 'em. This was a business with her. I think she saw it as all business. Her girls were clean. I can remember people talking about so-and-so got kicked out of Dell's because they went down there and were drunk and rowdy. She didn't put up with that, either.

I think people thought that she was a businesswoman that ran the house of ill repute, that minded her own business. That's what I think. You know, it's not that I'm not a Christian, but then there was the faction where those people just thought it was terrible because she was a prostitute and we had that here. I never did like it when the politician said, "Well, let's kick her out, or because the reverend came to dinner and said, "Well, we can't do this." Or his wife sat there, "We gotta get rid of this," when the guy actually was probably down there a time or two a week. Oh, absolutely. It was like Jane Kaan said— she worked for the city in Lusk—she went back through the old records and each one of Dell's ladies paid fifty dollars each month to the city of Lusk. Now why did they pay

'em? They were cleaning out, going back through old records, and there were the receipts for the fifty dollars that Dell's ladies each paid the city of Lusk. She told me that.

I don't think they [Lusk] cared that much. I think, for one thing, a helluva lot of men in this county went there. And I know a lot of men may not have gone there for sex, but they went there to drink and to visit and to talk. It was low-key. 'Cause you can't tell me that this town couldn't have been big enough or tough enough if they wanted to get rid of her. I don't think they wanted to get rid of her. Absolutely not. There probably weren't over twenty people in town that wanted to.

She may have donated because I think Dell was very good about donating to things. I know the Fagan boys swear by her, and I think she probably did help them. A lotta people say, "Oh, she was so generous. She gave this, she gave this, she did that." I do not believe that. She was not a philanthropist. That was all baloney.

She had no heart of gold. Uh-uh. She didn't. She may have had a few that she did something for, or they may have helped her. I'm not saying that she was a witch, or the pits, but she was no. . . .

Personally, I think that so many prostitutes couldn't make a living [today]. There's so much free stuff. [Laughs] Now what do you think of that? I mean, that's a terrible thing to say. I think they'd go broke. I think it is a matter of economics.

DELL BURKE
WYOMING DIVISION OF CULTURAL RESOURCES

I like a little excitement. Jesus, you know, I hate to be bored, sit around bored. But, you know, I don't treat people bad. I try to be good to people. I try to be courteous. But if I pull a little trick—aw, what's the difference? It's nothin' really. It's nothin' bad. But some people think that's real terrible to do somethin' like that. But, heck. . . .

I run—what?—three times for president. Last year, four years before, and the four years before that. My dog run in '84. And I run with him. Woofer E. Coyote. He made national publicity. *Radio Free Europe* used him as a propaganda tool. It said to the people behind the Iron Curtain, "Well, you people can't run for nothin' but here a dog can run in the United States for president." *People Magazine* came out and took his picture. I was in the picture with him but they took his picture. He was on all these radio stations and the radio announcer said, "What did your dog say today?" I said, "He said this and that." [Laughs]

At first I wanted a publicity thing. Well, last year in '88 at least I got in one primary election in California. That was the only election I was in. It was on the Peace and Freedom Party, though. And then '84 it was for my dog, really. He was really runnin' and I run, too. Everybody says, "Well, it's crazy about your dog runnin' for president." But Woofer E. Coyote—he's dead now, I've got him buried back here, he's got a little tombstone—he spoke out about animal rights when the army was usin' dogs for target practice, how a bullet would affect that dog. Well, he spoke out about things like that.

Just like I told Mikey, my boy. I said, "You want to run for president?" He said, "Yeah." I said, "Well, then, just fill this out and we'll send it to the Federal Election Commission." He was listed as a candidate,

mostly with my dogs, you know. I got letters from the FEC. When I tried to get on the ballots, I remember several secretaries of states from different states sent me letters and said, "We don't put dogs on ballots." But the state of Missouri, they said, "Well, get enough ballots and get enough petitions there and we'll put him on the ballot." [Laughs] So, you know, it's just different. I mean, if a state government is gonna put a dog on the ballot, if they're willing, if he gets enough petitions here, well, that don't sound crazy then.

I run a snake for Congress. See, I had this bull snake, big ol' big snake we found once up where we was paintin' on a house. A great big ol' long bullsnake, five foot long. So I had it in my house. I used to feed her a mouse. And I called her Sandra Snakey. She was my housekeeper. So, I thought, "Well, I'll run her for Congress." Thyra Thomson was secretary of state. I filled out this application for Sandra Snakey to run for the U.S. House. So what did she do? I put down her employment that she took care of the house and she worked for her board and room. So, they tell the attorney general, "Let's go check this case out." So he sends that same stupid DCI [Division of Criminal Investigation]. He comes down. I'm workin' in town, and he's with the police chief and another policeman. The chief comes over and says, "Hey, this DCI guy wants to talk to you." I said, "Well, tell him to come over and talk to me." He said, "Well, he wants to talk to you in private down at the police station." I said, "Okay, I'll come down there." So I went down there. He had this application and he said, "Now, what about this application here?" He said, "This girl here is runnin' for Congress. Does she live at your house?" And I said, "Yeah." Then he was lookin' in there and readin' it. He said, "Well, I have to

investigate this. She works for her board and room?" I said, "Yeah, I feed her a mouse once a week and she takes care of my house." He looked at me kinda funny, said, "Feed her a mouse?" I said, "Yeah, she's a bullsnake. Bullsnakes eat mice and eggs, raw eggs, and warm eggs, you know?"

So they thought they were gonna charge me with somethin' but they thought that it'd be too much of a joke. I guess they thought it would turn into too much of a laughing thing. Well, she didn't get to run for Congress but they kinda just dropped it. [Laughs] The *Rocky Mountain News* did have a page obituary on Sandra Snakey when she died. It was about her runnin' for Congress and how she died. I said she was hibernatin' in my house, and that winter I fixed her a little bed. I looked at her one day and thought she looked kind of funny and picked her up, and a mouse had chewed a hole in her side while she was hibernatin'. Killed her. I thought, "Oh my God! She ate all them mice and the damn mouse got her while she was hibernatin'." This gal asked me about it. I said, "Well, yeah, we had a funeral. I buried her." I just told her what she wanted to hear about how I was cryin' and put flowers on her grave and all that, you know. She wrote up all this bullshit.

How am I regarded? When I was runnin' for governor, [Wyoming governor] Mike Sullivan told this reporter, and that reporter told me, he said, "Al Hamburg is a disgrace to the Democratic Party." [Laughs]

The trouble is, the Democratic Party leadership fools people into thinkin' that they're representin' the little people, but they're not—here in Wyoming and a lot of places. A lot of rich people are runnin' this party. They're really more for certain people helpin' their own leadership thing. But as

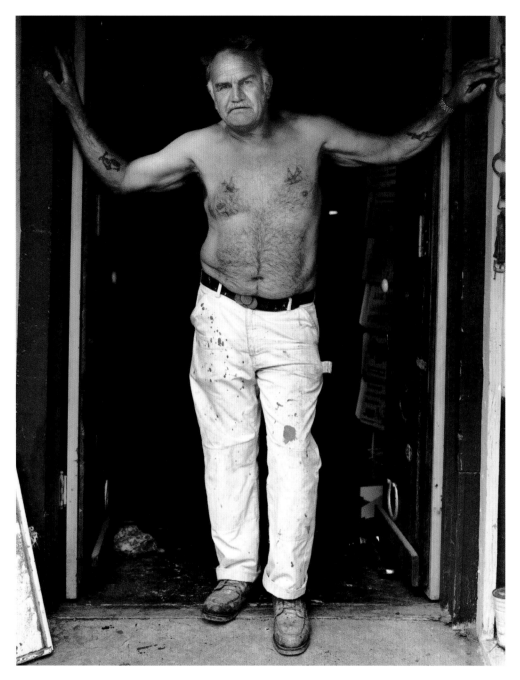

far as the little people, the little people get jerked around and screwed up.

The Republicans, you know who they stand for. They stand for the rich people. At least you know who they stand for. When I run into the Republican Party they treated me better. When I run into the Democratic Party they tried to pull tricks on me—you know—for office. When I run as a Republican candidate they treated me better. They give me equal access to the news and an equal chance to speak out on somethin'. In the Democratic Party they always tried to pull sneaky stuff on me.

I think there's too much forgettin' about the little people. People of privilege and wealth . . . well, it's always been that: They have their position, they have their world, and hell with all the little people down there. Hell with 'em! That's the way they look at it. I think that's wrong.

. . . If you don't want people to criticize you, then you better just shut your mouth and not say anything. And you better not side with nobody and things like that. I can't do that. If I don't go to the pen, I'll be running next year. [Laughs] But if I'm in the pen, well, I won't be runnin', that's for sure.

What are you gonna write on your epitaph?

Here was a guy that tried to live without being controlled or somethin' like that. Without being controlled by people or the world. Or tried to live his own life. [Laughs] I hope I'm not gonna die in two weeks. Jesus Christ!

My dad said, "You'll never make it to twenty. I'm gonna kill you, shoot you." And then I made it to twenty. He said, "Well, you'll never make it to thirty." And then he'd always say, "Goddamn, I shoulda hit him in the head with a hammer when he was born."

"Crazy, crazy guy." That won't hurt me. It just washes off like water on a duck's back. That don't bother me. Nah. I knew this girl. She was with some other girl. I said, "Hey, introduce me to your friend there." She said, "Okay, Al." She said, "This is crazy Al." [Laughs] I said, "God! Give me a break!"

TORRINGTON
b. FEBRUARY 17, 1932, GERING, NEBRASKA

201

HISTORIAN

MIKE ROBINSON

The "Black 14" incident occurred in 1969 when a group of black students—there's a lot of preliminaries to it but, basically—asked Coach Eaton if they'd be able to wear black armbands during a game with Brigham Young University in a protest against what they felt was BYU's, and the Mormon Church's, racist policies when it came to Black people. They went to the coach. And at that time there was a policy within the athletic department that athletes could not engage in any sort of protest on campus. So what occurred was the coach—who at that time was without a doubt the most popular man in the state because of the success of his football team—kicked 'em off the team, precipitating this episode which acquired a great deal of national attention and raised great passion within the state. It really polarized the state and the university, particularly the academic side of the university, and unleashed a lot of strong feelings and—in my way of thinking—probably destroyed Wyoming's football program even though it had brief flourishes after that under Fred Akers and, once again, fairly recently.

The program was pretty well devastated by this episode, and football in Wyoming was at that time an icon. It was the one thing the state could really look to with pride, aside from its natural endowment. So when this whole episode occurred, it was striking really at the heart of this sort of Wyoming ethos, I guess. Because football was absolutely an icon and Lloyd Eaton was God to a lot of the people in the state. And the fact that it is a fairly violent sport, the fact that it's a macho-type sport pitting man against man in a state where pitting man against animals and against nature is a very important part of the culture and mind-set of the people. When this occurred, any who were involved in supporting the Black 14, I think, were regarded pretty much as traitors and pariahs.

I'm a Mormon now. But at that time I can remember no interaction. I didn't even know who the Mormon students were. I mean, I wasn't even aware of that sort of thing, and the protest. I assumed the Mormon Church was racist. We weren't really protesting the Mormon Church. We were protesting what the university had done to these students. We regarded the Mormon Church as kind of a conservative, backward, racist institution, but that isn't what, really, our conversation was focusing on. What we were focusing on was what the university had done to these students, which was basically deny their right to free speech. That's the reason we were so aroused. We saw that as a far worse issue than anything the Mormon Church was doing. We felt they should be able to protest in any way they deemed appropriate. And so we supported them unequivocally in that respect. It was part of the generational thing that was going on. It was in the midst of the Vietnam War. It was in the midst of this whole time of challenging authority figures and all of the rest, and we did it with great passion and self-righteousness, and with a great sense of what we had done was right.

I guess my only hope would be—even though I'm an official in the Mormon Church now—that I would still have enough commitment to the Constitution of this country, that I would defend the rights of those black students to protest. And I think I would still do that. I would defend that right. I may not participate directly in it because other people in the church are people who—my own family or somebody—may not understand what I was doing. It's a little different when you don't have other responsibilities. But I would still defend their right to do what they did, even now, even though they may have misunderstood to some degree the Mormon Church's position on things and so forth. That's all in retrospect.

VICKSBURG, MISSISSIPPI

MIKE ROBINSON
b. OCTOBER 28, 1943, KINGMAN, KANSAS

DIANE ROBINSON
b. OCTOBER 28, 1951, McCOOK, NEBRASKA

RANCHER

CHARLES SCOTT
STATE LEGISLATOR

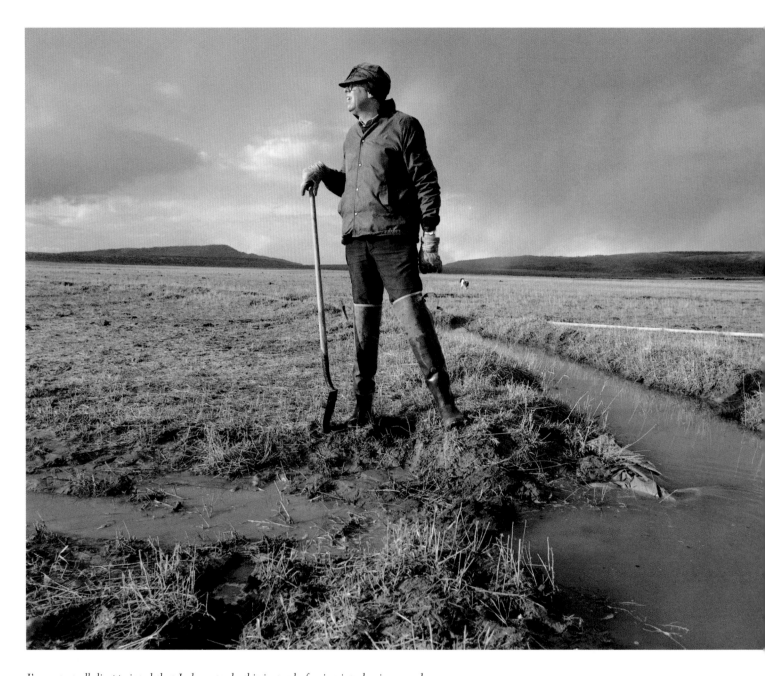

*I'm not at all disappointed that I chose to do this instead of going into business and
being transferred all over the place or living in New York City. This is a small business.
In one respect I'm like a lot of my business school classmates because I'm running my
own business. It's just, the nature of the business is a little unusual.*

BATES HOLE
b. AUGUST 19, 1945, KLAMATH FALLS, OREGON

I've been active in politics. There've been a number of Harvard graduates that have been active in Wyoming politics, and a number of them have kept it pretty quiet. Very few people know that Milward Simpson was a graduate of Harvard Law School. You never saw it on his campaign literature. He thought there might be a prejudice against eastern Ivy League schools, I presume. I have not done that. It's only come up one occasion that I can remember. When I went to the Senate, Tom Stroock was my running mate. He's a Yale graduate. Somebody wrote a nasty letter to the editor of the [Casper] *Star-Tribune* about how these two Yale graduates didn't understand what really went on in Wyoming, or something to that effect. It gave me an opportunity to write back—and they published it—saying that it was a false and malicious libel, that I was not now and never had been a Yale graduate, that it was true that Senator Stroock was a Yale graduate, but it didn't seem to have done him any real harm. I can testify to that. And [I] got 'em to put a little editor's note on it that I was a Harvard graduate. It was considered pretty funny. That's the only time I've seen that come up, politically, and I had a chance to make a joke out of it.

They [Bates Hole people] probably think we're a little different. We don't do things necessarily the way all of 'em do. On the other hand, we've been here now . . . well, twenty years we've had the Two Bar here. We've been successful at it, and that probably means a lot more than education and all that sort of thing to those people. Your income comes from selling your product at public auction. The buyers could care less what your background was. They want to know what the calf'll do.

Wyoming is a citizen legislature. You know, we have a mix of people from just about every background and occupation down there you could think of. And that is very useful. We're not professionals. Most members of the Wyoming legislature would be money ahead to lose their next election and stay home and stick to business. Not universally true. Heck, the ground's frozen. I can't do a lot in the middle of the winter here. And you do have a legislature that's much closer to what you would have seen in colonial times, the successful people in the community getting elected to represent the community in the legislature and having to come back and live with the results. It really does work that way. Funny, the number of lawyers goes up and down. Right now it's a little up. Not as many as you would see in a professional legislature, though—full-time, or people making a living being a legislator, which you can't do here in Wyoming. When it's your living, and if you lose your next election, you've got to change your occupation. That's scary. That affects the way people behave. They become much more risk-averse. They become much more sensitive to special interest groups that might have threatened them in an election. Here you call 'em as you see 'em and if the voters don't like it, well, you know. . . . We're there 'cause we enjoy it and we want to be elected but. . . .

You're dealing with a big committee and it behaves the way human committees behave, okay? That's true whether it's the U.S. Congress or the Wyoming legislature. The Wyoming legislature, I think, does a better job of getting things done than any other I know of. Certainly better than the U.S. Congress. They're a standing disgrace. Legislatures, because they're big committees, do not do well at leading. They're much better taking a coherent program that somebody else has proposed, typically the executive, and meshing so's it'll fit with all the diverse interests of the society, so it doesn't do tremendous harm to any one particular group or individuals. It's something that the majority of the whole society can live with. That's what a legislature does best. Since we have had a series of weak executives here in Wyoming, the legislature has been trying to lead, as well as do the "make everything fit" job, and it doesn't do that as well in the nature of things.

What I'm saying is that the government sector, as opposed to the private sector, is never gonna be as well managed or as productive because of the fundamental difficulties in the system whereby you manage—the control system. But that's basically the system whereby it's managed. That's not to say that you can do without a government. You've got some fundamental things that have to be done by government. The government sets the climate and the structure in which the private enterprise system works. So I'm interested in politics. It makes me a conservative, but I'm not the "big business is always right" type of conservative. What I'm suspicious of is the government trying to do things that the private sector could do better. At the same time you need the government to set some bounds and some limits on what can be done and what can't.

One of the diseases of capitalism is extreme short-term focus. Because ranching is a family business—and there's some fundamental reasons it's not gonna be large, corporate—a family business can be much longer-term oriented. In fact, many of them are. I think we have a much more appropriate, much longer-term focus. I think most people in ranching do. They are able to see that they need to look beyond just this year's results. You know, you build a quality cow herd, you try to get your land in good productive shape. The ones that have survived have been the ones that do those kinds of things and do look long-term. You want to have the place around when the kid's ready for it.

RON "SUDS" CLINGMAN

GUBERNATORIAL CANDIDATE

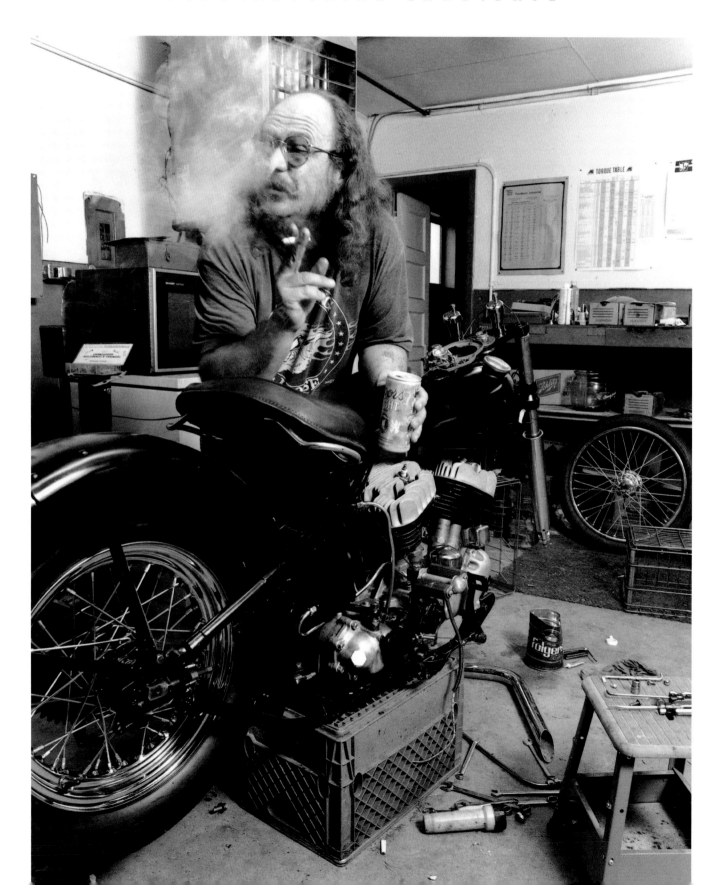

I mean this is the way I am, asshole to the hilt. A lotta people, it scares 'em to see themselves. And they see themselves in me, and it scares 'em. I don't care where you're at, it'll scare ya.

Where'd I get my name? True story. [Laughs] I just remembered a joke. You know the difference between a fairy tale and a biker story? Fairy tale always starts . . . "Once upon a time. " Biker stories always start out, "Hey, this is no bullshit!" [Laughs] Alright, this is no bullshit. No, this is what happened, is that I was a prospect for the Freedom Riders. I was a new member to the club. I had to go through initiations and all that. They wanted to tag a name on me—"Rags"— 'cause I had an oil rag on me, cleanin' up the bike and everything else. And I didn't like it. And Pony—his other name is Dwight— what happened is that . . . well, we went out that Memorial Day weekend runnin' to Central City from Cheyenne. And everybody else is thinkin' the same thing—Cheyenne, Wellington, stop and get a beer. But I was the first one to say anything. I'd pull up from the back, get up to the guy that was road captain. I'm going, "Time for a beer! Time for a beer!" You know, thirty miles. So we stop in and have a couple beers in Wellington. Pony, he says, "Well, I'll just call you 'Suds' 'cause everytime we go someplace you gotta have a beer." From Wellington after we had a couple beers we got to Fort Collins, had to put gas in. Stopped in, got some gas, went over to the bar, had a few beers. Got to the middle of Fort Collins, stopped and had a few beers. Got to the end of Fort Collins, we stopped, got a few beers [Laughs] and then got some gas and went on down. And it just kinda . . . "Yeah, Suds! This is what it is."

It was one evening after I was comin' out of the bar [Laughs] and I needed somethin' to eat to sober up a little bit, and I'm readin' this and goin', "This is it! I can do a better job. I can do a damn better job than this sonbitch in there." And I got to thinkin' about it, goin' . . . "I could! All's I have to do is just get around and talk to the people." And everybody I talked to agreed with me— young, old, middle age. They were votin' for me. They asked me what I believed in and what I wanted to do. I told 'em. And they agreed with me.

I want to do this job. Dead serious. I want to be governor. The governor now is making over $70,000 a year. Alright, fine. Twenty-thousand dollars goes back to the state. I'll make $50,000. Fuck it! I never made $20,000 in my life in a year! I'll take that $20,000 a year, put the rest of that money back into the state. Make every government office do the same thing. We spend so much money paying these son-of-a-bitches to do nothing. It's useless. We don't need no congressmen, and that's a fact. For two hundred years we've been makin' laws. We don't need no more fuckin' laws! We got enough to handle the whole goddamn situation no matter what comes up. The only thing we need lawmakers for is to get rid of the laws that we got. There's so many stupid laws. We need to repeal the drinking age. I think eighteen-year-olds—because they have the right to vote—for that reason alone they should have the right to drink if they want to. Goddamn choice. Women, that's a hard goddamn line for abortions. I think abortions should be legal but not for birth control. I mean, a woman should have the right to say "yes," "no," "yes." A woman has that goddamn right to say yes or no.

What I was talking about and what I was thinking about is that Wyoming should secede from the Union and we could control the United States. Because we got most of the nuclear weapons. 'Cause he [governor] controls the National Guard. And the National Guard can take over the state. You can do it. I don't think it's a good idea. But the government's been blackmailin' us for so many fuckin' years. I mean, Bush has done it. Reagan. All of your goddamn presidents done it. It's extortion. Say, "Well, we don't want this law." The helmet law. It says you gotta wear your helmet or all you legislatures, you ain't getting no money, no highway funds unless you pass a helmet law bill. Then he comes up and goin', "Well, you don't get no money for the Highway Department unless you raise the drinking age. Fuck 'em!

You can't do that! That's against the Constitution. You cannot control what other people want to do. People control the government, not vice versa. The government does not control the people. The government should be the people but it's not. It's just a handful of assholes. Professional politicians.

There's people out there goin' to school to become politicians. And they're not supposed to be that way. What I wanta fuckin' do is let the people control everything. 'Cause I have this thought about . . . alright, if, a big if, I got in office, there's gonna be telephone lines. Anybody in Wyoming can call a toll-free number.

I knew I wouldn't win. All's I wanted to do is get the points across to people the way it should be. I just played it by ear. And I got invitations from different organizations and everything else. And I'd like to have gone to 'em but I just couldn't do it, didn't have the money. I wanted to get my points across. And I wanted to make a stink. I got so pissed off about what the government's doing to the state and the people of Wyoming, I didn't like it. I got my word out. I got to talk to a few people. People wanted to listen but only a few people wanted to hear. But I ain't givin' up.

This state has so much to offer. The desert is so fuckin' purty. I mean, people say that deserts are ugly. Hey, wake up before the sun gets up and you can watch these goddamn flowers just . . . [makes a birdlike whistling noise]. It's purty. And it's different than trees. You gotta enjoy it. If you don't fuckin' enjoy it, then get the fuck out of Dodge. You know what I mean? Like I was tellin' you earlier, is that, see, people in Wyoming . . . I love anybody that's a Wyomingite. A Wyomingite is the people that love this state. There's some people that's been born and raised in this state that don't like it. Then get the fuck out of Dodge. But I seen a lotta people that's only been here months that's goin', "This is where I want to live." I want that man here because he's goin', "This is a good state, this is good people." And he's right! I've met a lotta people that's been born and raised in New York and they hit Wyoming, they don't wanta go noplace else. This is their home. They're a Wyomingite. It's just like they were born and raised . . .

I hope the people of Wyoming have enough sense even to get down to bare tactics of fuckin' shootin' people to get 'em out. Because this state has got so much to offer. Just leave it alone.

ROCK SPRINGS
b. SEPTEMBER 21, 1950, TORRINGTON

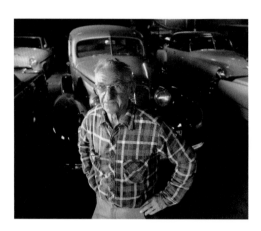

There isn't anything that I don't know about an engine. You can blindfold me and I can repair anything. Any part on the old cars I've got, if I can't buy 'em I can make 'em. What else do you want? I'm a body man, I'm a painter. You name it, I can do it. I'm the kind of a guy that's always said, "There's nothing that's impossible." When they tell me it's impossible, I'm gonna prove to you that it is possible. I guess that's the reason why I'm like I am.

ROCK SPRINGS
b. MARCH 5, 1914, SUPERIOR

I don't like to tinker with 'em. I like to work on 'em and get 'em running. This tinkering, to me that's a lot of baloney. I don't believe in tinkering. I either do it or I don't. And myself, I like to have my cars as close to original as possible. I can get a car like this and in two weeks have it out lookin' like new.

I used to weld gas tanks full of gas. Yes. I filled 'em with gas and then welded 'em. It's crazy but I used to do it. I wouldn't do it anymore now. I know better now. I'm lucky I'm here. And that's one thing I've always said—and you can ask any of my employees— if it's a job that's risky to do, I'll make my employees stand back. I'll do it! If anybody's gonna get hurt I'm gonna get hurt, not them. I don't want 'em to do anything that's dangerous if they can hurt themselves. No way that I'll have my employee do something that I won't do myself. And if it's that dangerous, I want to do it and not them, because I know that if I do it the risk is minimal. If they do it they could goof just a little bit and then we'd have a problem. I've got more knowledge than they have, so why shouldn't I do it? I always say if there's something to be done, I go ahead and do it. And that's me. It isn't theory. Because if I use theory I don't know that it's gonna work or not until I put it into effect, right? Now, I have another philosophy, too, that I learned many, many years ago. And, again, I had a good teacher. Like I say, I always have teachers. That's how I learned. And I'd listen. If I have a problem, on a bus or on a car, or anything, the easiest way to solve it is to go to bed. Don't worry about the problem. Think about it. Go to sleep and while you're sleeping, it'll solve itself. Yeah, because then your mind is blank. That's the only thing that you got on your mind. See, your mind never is functioning all the time, twenty-four hours a day. That's why you dream and everything. The mind is never blank. So if you can go to bed and train yourself to put your mind blank except for the one item, then the brain'll function

and it'll solve the problem because it isn't thinking of anything else but that.

Now I taught my manager that. He couldn't figure out how I did things, so I told him how to do it. It took him over a year. We were up in Riverton and we had a bus up there. We were having a problem on a clutch 'cause we had changed the engine we had in. So I told him, "When you go to bed tonight, you go to bed with a blank mind except on that clutch, and you let your mind work it out for you." He woke up at four o'clock in the morning, he grabbed paper and pencil, and he drew out just what he was gonna do with that clutch, took it down to the machine shop that morning, had it done, and that was it. It works. That's what I do. I do that all the time. If I want to solve something, that's the quickest way to solve it. Go to bed, put your mind blank, just think about that. Don't worry about it because if you worry about it, it won't work. If you just think about it and go to sleep with that on your mind, it works.

I don't believe in a pat on the back and that kind of crap. That's a lot of baloney. I don't buy that, never have. I don't want a legacy. I'll be darned if I want a legacy like, for instance, the cemetery up there, Wataha Cemetery. [Laughs] I don't want anything. What I've done, I've done because I wanted to do it. I don't want a pat on the back, and I don't want any recognition for it or anything of the sort. I never did want it. I've made a helluva contribution to all of it, the whole state and the town both. What good is it when nobody appreciates it?

My days have been tough all my life. Everything I've got so far in my life I've had to fight for. I wouldn't change one minute of my life if I had to live it all over again. If I changed it I don't know what I'd be, what I'd do. I know what I went through. I was fortunate, strong, and capable of accepting everything. But regardless of what it is, there's nothing that's bad.

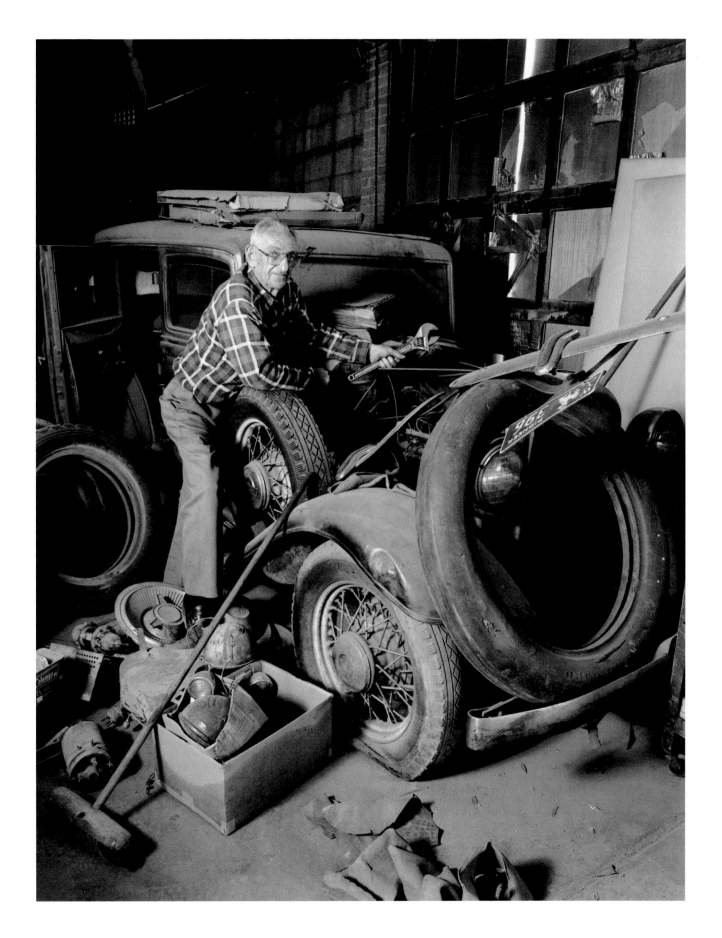

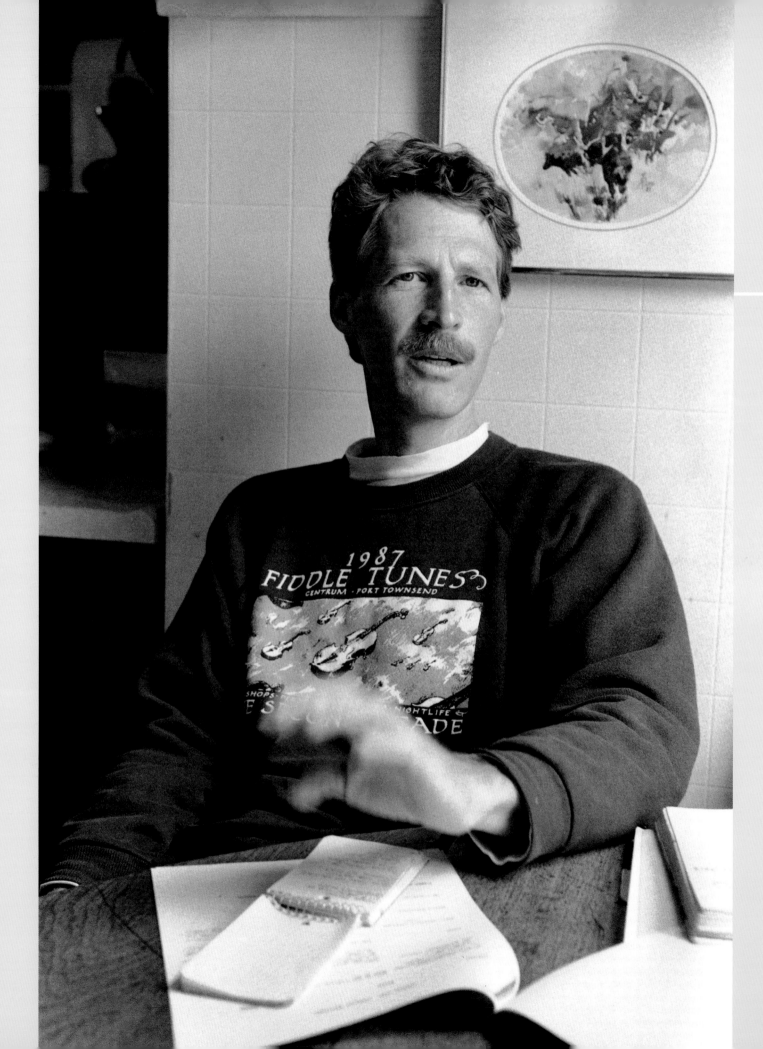

It's hard for me to sit down in the chair. It's hard to start. In some ways, if the choice was to talk to the horse or write about the horse, I'd rather talk to it. But once I get going, once I'm started with the writing, I'm in that little space and it's quite magical and timeless. You kind of wake up at the end and realize you've been gone for two hours, or five hours, or thirty minutes, or however long it turns out. And I usually don't know how long it is. That's a great feeling, that quality of timelessness. And that's true for most people being fully engaged in anything. They live in a place that isn't governed by time. That's one of the great moments of human life.

BUFFALO
DAVID ROMTVEDT
WRITER
b. JUNE 7, 1950, PORTLAND, OREGON

LAWYER
GERRY SPENCE

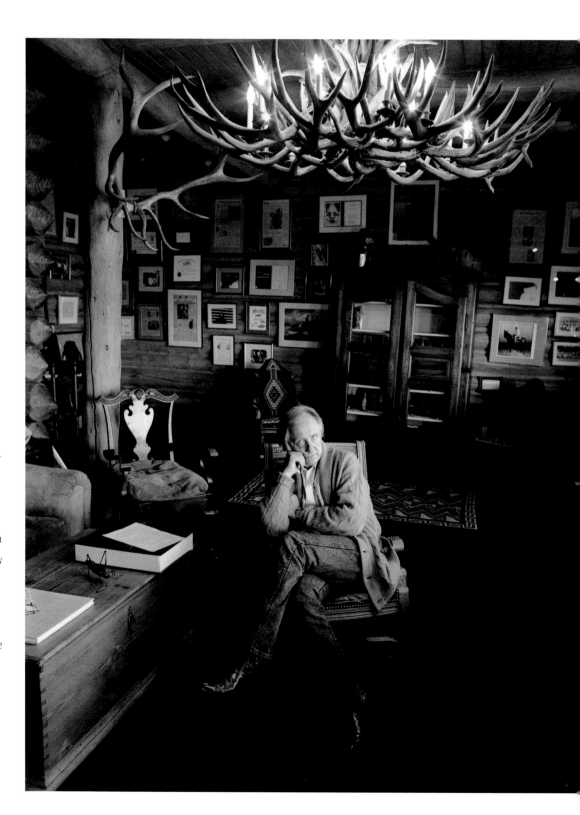

And I say this to young lawyers everywhere. They say, "How can I be successful?" And I say, "Well, you have to care about your client. You have to love your client. If you can't love your client, you can't care about your client, you can't win." And all of this pain and all of this fear that we have in the courtroom—which is a place of battle, and of death and dying, truly a place of battle, death, and dying—emanates out of caring. You can't really, ultimately, care about anybody. You can only ultimately care about yourself. And as a consequence of that, the phenomena where you become the client, you become the accused, you become the maimed, or the forgotten, or the damned, is the means by which you ultimately can win.

It may be a tortured existence, but I will tell you that there is no doubt in my mind that I am very much alive. And there are grave doubts in my mind as to whether or not many people that I come in contact with are alive at all.

One of the ways that we are told that we can live in this world is to defend ourselves against all of these raw, passionate, primary feelings—these feelings of fear, and of love, and of caring, and of worry, and of terror, and of compassion, and loss and helplessness. All of those primary feelings we can protect ourselves against by, quote, "not becoming involved." But it's another way of being prematurely dead. In a sense we're going to be dead a good long time. It seems to me that one ought to take every opportunity that he can to stay alive, to be alive.

I really believe that people don't really see the trial of cases as they are. The trial of cases is truly a trial for the lives of other human beings. And people are truly killed in courtrooms. Their throats aren't cut but blood is let. The red blood doesn't flow in the courtroom on the floor but it is sucked out of the body—the life and the spirit and the soul of those people—as surely as if it actually flowed. And people die there. They are sentenced to horrible holes there. Their children are wrenched from them there. Their futures, their good names, are preserved or lost there. Their lives are changed there. And can never be reconstructed there. And nobody ever goes through a trial or a lawsuit—win or lose—and comes out of that experience the same. The human stakes are so high, and they are dealt with in such a shoddy way so often, and so insensitively and so uncaringly so often, in a courtroom. And when I'm in a trial I am there fighting for my life and for the life of my client, which you suggested may become one and the same, and the loss of that is too painful. And so the victory isn't a victory of having won. The victory is the huge release of not having lost.

There is a basic point from which I make judgments of others. And that is . . . I think most of us, no matter how ugly we are, or how we have failed as we see ourselves in our lives—doesn't make any difference whether he's a murderer, or a robber, or a fraud, or a prostitute or a whatever, a bum on the street—the truth of the matter is that those people would surely like to trade places with me and you. They'd surely feel that they knew how to do what we have done—they would do it, and that those of us who are more fortunate are really, just simply, more fortunate. I don't believe in the ideas that are prevalent in this country that the poor are poor because they want to be poor, bad people are bad because they are inherently bad, or that they could do different but they don't.

And I'll tell you why I believe that. I had nothing to do with the choice of my parents, but you can already see what an important role they had in forming my attitudes and my values. I could never have done any of the things that I have done without having had those parents. Supposing I didn't even have those parents. Supposing I only had been given their genes and had been raised by somebody else. The genes that I got from those parents was a gift that I had nothing to do with. It was given to me. The genes that I have that gave me good health, that gave me reasonable intelligence, that gave me the ability to be sensitive and all of the other things that go into making whoever we are and whoever I am, were gifts to me that I had nothing to do with. My parents were gifts to me. The fact that I was raised in rural Wyoming in a little community, at the time that I was raised there, were gifts to me that I had nothing to do with. The fact that I went to the University of Wyoming and had a good education in grade school—the fact that I had that—were gifts to me.

But people say, who have been successful—they say this so arrogantly and it's disgusting—"But, you know, I did it. I did it." But the answer is that I didn't really do it. Even the will that I have was a gift to me.

It was something that was given to me. One time I said to my father—I wrote about this in one of my books one time when I was feeling bad about the way I was unable to relate to lots of people . . . and I was often smart-alecky, and a show-off, and often obnoxious to the point where I didn't make friends easily—I said, "You know, this is your fault. You should have done something about this when I was a kid. You could have made me a person with manners. You could have taught me to be socially proper. You could have taken all of that ugly arrogance out of me." And his answer was, "Well, that's true, Gerry." He says, "It's pretty easy to kick it out of a pup but it's awful hard, once you kick it out, to put it back in again." It was never kicked out of me. And that was a gift. That was a gift to me. The will, the concept to succeed, the idea that I could succeed, the belief that I was alright, that I could succeed, that I was able to do all of these things, some of which I could do and some of which I eventually couldn't do. But the idea that I was wonderful were gifts to me. And so when people say to me, "You did it," I didn't do any of it. Not any of it.

They were all gifts to me. In one way or another. All gifts, every one of them. And even the ability to take advantage of the gifts, even the will to take advantage of the gifts, even the idea that I ought to take advantage of the gifts, even the concept that I ought not to waste the gifts, were gifts to me. You only need to look at it honestly. The truth of it is that we are all creatures of the gifts that have been given to us or taken from us.

JACKSON
b. JANUARY 8, 1929, LARAMIE

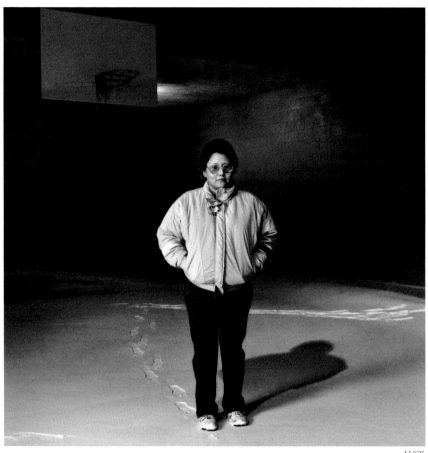

LUSK
b. MARCH 13, 1960, LANDER

Somewhere along the line I used alcohol to deal with everything. In my relationships I couldn't handle what was going on, and my first two marriages ended in divorce. My first marriage ended up, when I was drinkin' I killed my husband. I just got tired of it. I got tired of all the abuse. This comes from the whole of my life. When I think about it, the alcohol and all the abuse in my past were all factors which led up to it. And the lack of communication, or not knowing how to deal with my problems in an appopriate way, led up to it.

I was just numb. I cried. In a way it was like, "Well, you deserve it. You deserve it, Vic." And I says, "Well, you're gonna go to the prison. You might as well accept that fact. You got thirty to fifty years." So I hated myself, and I hated everything in my life, and I hated who I was. There was nothing I liked about myself when I came here.

One of the things that people always been tellin' me is that, "You know, you gotta quit feelin' so much guilt over what you did." But, to me, that's part of being human. I know that I'm gonna feel guilt about what I did for the rest of my life. And I'm always gonna carry that with me for the rest of my life. That has taught me a lot, right there. I could think of the places where I would have been right now if it hadn't happened. And I'd probably be underground, too, you know. When I think back to the days before I got here, to remember how miserable my life was, there's nothin' there. And now it's like I have a chance. I have a chance to make somebody of myself.

One of the important goals for me is that when I get out of here, I want to go back to school. I want to get a degree in nursing. An RN. I want to be a nurse. I want to be there. I want to help people. I have to try it on my own. And I know I can make it. I really believe that I can make it. I always say that life is what you make it. And I believe those words. You can make it interestin', you can make it fulfillin', you can make it meaningful, or you can just make it the pits. I think you have to grow into it, and if you really wanta make some changes in your life, you can, you have the opportunity to here.

When I think back, it was like I really wasn't too aware of things like that. Things didn't really matter to me. Now that I've been through seven years of this, I've finally been able to put my life into perspective and think of things like family, and know what my values are and my standards. I'm findin' out that I have to learn about me and what I feel towards the world or towards anything else. Once you know what your values are, that's kinda like knowin' where you would best be put, what occupation you can go into it. You can make goals from that. You can go a long ways with it.

MIKE HAYES

WYOMING HONOR FARM

It [farming] has a therapeutic effect for me, in particular goin' out, takin' a field that's absolutely bare and startin' from scratch. You plow it, you disc it up and you get the soil just right. Then you go through with a grain drill or a corn drill. You plant a crop into it. You go through and you put furrows through it. You bring water over to it. All of this stuff is a challenge that I'm talking about. Every little step is a challenge. 'Cause there's always some little thing that doesn't work exactly right. Water's gonna run uphill a little bit, or there's a high spot, or there's somethin' wrong. You get water to run through it. Then all these little plants start shootin' up out of there. Then the next thing you know it's covered. And it's just . . . it's beautiful. The whole process, from beginning to end, is just beautiful. Then in the fall when you harvest that crop you just have such a feeling of accomplishment, of actually doing something, of producin'. . . . You treat the land right and the land treats you right. You don't hurt it. You don't damage it in any way. You want it to keep workin' for you and you keep workin' for it. It is real therapeutic -a lot of creativity, a lot of patience, and a lot of reward . . . a lot of reward.

It gives you a sense of self-worth. You've seen yourself as somebody that could drive a truck up and down the highway, or could operate a piece of equipment or could do something. But when you can actually get down and get your hands dirty, and go from the grassroots things . . . people were doin' this hundreds of years ago. That's how we all got here and that's how we all lived. To raise somethin' up out of the ground that you can eat or that your livestock can eat. It brings a sense of experience into yourself that you can do this. You can do the same thing. You're not dependent on a supermarket. You know a little bit more about where milk comes from. It doesn't come out of a gallon jug. It comes from a cow who ate some alfalfa and some grain and produced the milk.

It is terrific. I get up about five. Not that I really have a whole lot to do, but I just like to get up early in the morning. I never did that before. But there are mornings when I can walk out here and the air is just so still. And there'll be a lotta moisture in the air. So there's a fog. And it hangs down. You know, you can stand over here and you can look down in the valley at the farms below us. And it's just beautiful. This place is just beautiful. It's quiet. You can hear a mile down the road . . . as it goes by can hear the pigeons that are flying over. You can hear all kinds of birds singing and carrying on around here.

I feel extraordinarily lucky to have, not the prison experience, but the knowledge, the opportunities, the education, the insight about myself that I've been able to gain through having been here. I coulda lived to be a hundred years old out there as a free man and never, never learned what I've learned having been in here. I absolutely regret having done what I did, but I also do feel lucky, very lucky, blessed, to have been able to participate in some of the things that have happened.

RIVERTON
b. DECEMEBER 5, 1951, DOUGLAS

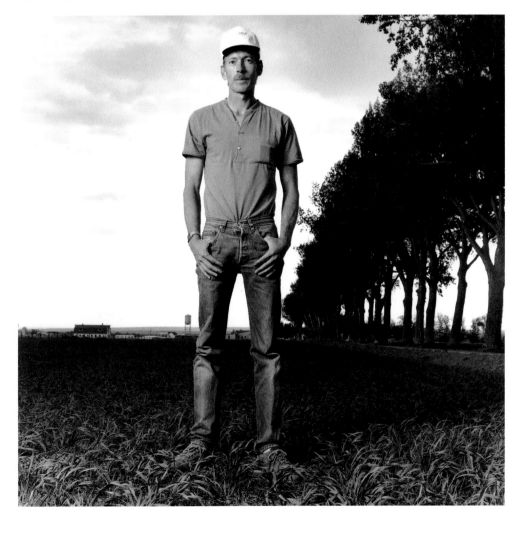

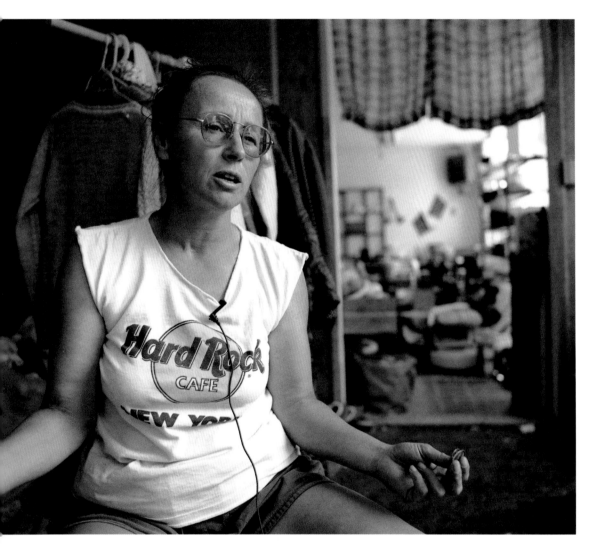

We have one whole room in our store that's free. Anybody that's alive can come in and get it. This is the room that our overflow, that we haven't kept up with sorting, goes in. This is also my law office. Can you tell? Here we are. When you come in here and you want to see me, this is it. We don't even have a phone.

CASPER
b. APRIL 20, 1935, FARIBAULT, MINNESOTA

When I was in Colorado I got married to this guy and dropped out of school, did not go to law school. I started selling real estate. I started out as an assistant to the closing secretary but I eventually got my real estate broker's license. In that time period I got involved in pretty high-stress stuff. I don't know if you talk to very many business types. I was of the impression that I was about as good as how much real estate I sold the next day. You know, you get involved in this whole thing. It was real high stress. I always drank more than I should, started getting terrible headaches, and started going to different doctors, and pretty soon I had three or four prescriptions for valium, and librium and other drugs. I was mixing it up with alcohol and it just got to where I was just addicted. Then my whole life revolved around how many drugs I could take. For a while I could keep making real good money and keep it together. But my marriage broke up and I started to realize seven years ago that drugs and alcohol were not the way to go, that I had to make some serious changes in my life. I got involved in the program of Alcoholics Anonymous, quit doing drugs, quit drinking, met a guy who had just gotten out of the treatment center in South Dakota. He was working for a company that put in bridges on the interstate. He was trying to stay sober.

We started going together and living together, and one thing and another. He ended up working up here at Pathfinder Dam five years ago when they were puttin' in the new needle valves. So I moved up here with him because I felt like I could find a job anyplace. He had to go wherever he could do the work. So I ended up moving up here and then he started drinking again. I couldn't deal with the idea that he was drinking so I moved out. It was in February and I had a one-year-old baby, and no money, and a 1968 Chevrolet pickup truck, and I just packed all my shit in the back of the truck and took off. He was living at Alcova. I ended up over

here across the street at the Berry Hotel. I didn't even have five dollars to stay in the hotel, so I ended up sleeping in my truck behind the hotel. And that's how I got here.

The person that ran the place over there, named Barbara, she was the resident manager of those apartments that got tore down. She said, "I'd let you stay here and not charge you, but the owners have really been on my case about trying to get more money." But she let me use her pay phone as a message phone number when I was job-hunting. And she let me use her showers and things like that.

So I'd go in there in the morning and I would get kinda cleaned up and dressed up. Then I would pack me and my son in the truck and we'd go around, and I put in applications and gave that phone number. She would field messages for me. Then she came back and said, "Well, you don't seem to be as lazy as most of the people that come in here. If you will help me do some cleaning here, I've made a deal with the owners that you can stay in one of our houses." They had four houses that were vacant, that were just trashed—just trashed. So she gave me a little one-bedroom house to stay in, and it was real substandard. I mean, you think this place is bad. So I left my son in the car while the car was running and I cleaned the kitchen. I didn't want to bring him in there till I cleaned it. This is February. She let me have this place in return for helping her. So I started helping her do some cleaning and stuff. I was systematically calling everybody that had a cheap ad in the paper, looking for a beat-up apartment building that they would let me move in and have a place to live, in return for cleaning it and doing the maintenance. 'Cause I had all this real estate background. Didn't want to use any of my references in Colorado because the drinking and drugging had got me to the point that nobody in Colorado wanted to hire me.

But I knew some things. In the course of events I came across the owners of this place. This was all vacant down here and upstairs had maybe four apartments rented. So I made a point of meeting them and told them that I was staying across the street and helping Barbara, but that I needed something permanent. They said, "Well, we have a person upstairs that's managing this place that isn't

doing her job. We'll think about it." They were real reluctant to just hire me. But it was like, "Well, we'll see what's goin' on. You're working for Barbara, we'll see how it goes." So about two weeks after that, the dentist that was in charge of this place came over to the house and said, "Look, I got together with my brother who's a medical doctor in town, and his sister. You can manage the place across the street and we'll give you a place to live. We'll give you one-tenth of the rent we collect and we'll pay you $3.35 an hour for the first two weeks to get things cleaned up. Your first job is to evict the motorcycle gang that has taken over."

So next morning I came over here with my little son and went upstairs. They had been told that they were fired and they had to get out. I went upstairs. There was dog shit in every room. There was more dogs than people. And they had done things like overhaul their motorcycles in the living rooms of the apartments. I said, "You guys have to leave." Well, the first thing they did was load up all the good furniture from upstairs and drive down the street with it. So I followed 'em down the street and made 'em give it back. Hell, yes! They weren't gonna fuck with me! See, if you let somebody get away with stuff like that, then they'll walk all over you, so I followed 'em down the street and made 'em give me the furniture back.

We took it off of their truck and put it in my truck, and I turned around and drove back. They cussed me the whole time. I said, "Fine." I made a big deal of writing down their license numbers. I said, "I'll just go up and knock on this door and use this woman's phone and dial 911." I was counting on the police wanting them for enough other stuff that they weren't gonna argue too much. They didn't do very much damage upstairs but they kicked in doors. They sprinkled roach-proof everywhere. Which, all it is, is boric acid. They sprinkled it on the furniture, up and down the halls, on the dressers. They took lipstick and wrote "Fuck you" all over the place. I kept tellin' 'em, I kept sayin', "You guys really think this is neat, but you're not gettin' back at the owner because I'm the one that's gonna clean it up and he's payin' me to do it." I said, "What are you guys gaining?"

So I spent two weeks, eight-hour days back to back, and kept track of my time

cleaning and getting everything picked up, and started gradually renting the apartments. That was four years ago. Then I came down here and these places were all cleaned out and vacant. They weren't filthy dirty and trashed. They were just vacant, in need of a lot of repairs. I started trying to rent the downstairs once I got some of the upstairs apartments rented. Somebody came along and wanted to start a consignment shop. So I rented one of the spaces down in the middle of the block to them. They ran this consignment shop for a while. Couldn't make any money. One day they just locked the doors and never came back. People that had things on consignment started tracking me down 'cause there were signs that say "Manager" in such and such an apartment, asking me about the place. Well, I didn't know where they'd gone or what they were doin'.

So there was a couple of winos down here that had kinda befriended me. They liked my truck. They didn't care about me. But they liked the idea I had a truck. What they did every morning, and I'd go with 'em, we'd go up and down the alleys and if there was anything that we thought we could sell, we put it on consignment. About a third of the stuff in there was ours. Then we'd go through trash and pick up aluminum cans and we'd hide behind the Albertsons and the Safeway stores and go through their dumpsters. We'd find food and other stuff and bring it home. We'd divide the food up amongst whoever was in the neighborhood. Then we put the stuff we thought we could sell on consignment. So when they quit keeping the store open, we started keepin' this store open.

We tried to keep track of who did what, who had what account. We tried to go through the bookkeeping, and anytime anybody came in that said they had an account there, we'd say, "Good, will you try to identify your stuff?" 'Cause there was a lot of stuff that wasn't marked. And then we cut a deal with 'em. "How much do we have to give you to just close out your account? 'Cause we don't want to have to keep track." We let people work in the store in return for things from the store 'cause we couldn't afford to pay wages. And that's how this started, basically. How our foodbank started is, we'd go through the dumpsters and sometimes we'd get cases and cases of stuff that hadn't been opened.

So we just put it in the refrigerators and started givin' it away to people. Then we started going out asking the stores, "Don't throw it away, just give it to us." Sometimes they would and sometimes they wouldn't. And that's how we got ourselves started here.

There's a lot more to this than what I told you. For example, when I was livin' in my truck I tried to go down and get food stamps and AFDC [Aid to Families with Dependent Children]. Barbara said, "Why don't you go down to DEPASS [Wyoming State Department of Public Assistance and Social Services] and see if you can get some help?" They wouldn't give me anything until I'd been in the state for forty-five days. They just wouldn't. No food stamps, nothin'. I have learned, since I have been in law school, that they're mandated to give emergency assistance to people like me. They're mandated by the federal government, 'cause they get most of their money from the feds, to give me food stamps within three days if I'm going hungry. They said, "Well, we'd refer you to Interfaith, but unless you have a job lined up, Interfaith won't help you." Interfaith Task Force. It's an agency that was at first funded by the churches in town.

Interfaith's attitude was that "Well, we pay your rent for two weeks or a month, but if you don't have a job and you don't have a paycheck coming in, then two weeks from now you're still gonna need help and, gee whiz, it seems like a waste of time to us. So our policy is, we only help people that have a job lined up or know they're gonna have some income coming in before we'll help you at all." So Interfaith wouldn't help me. I didn't bother to go to Salvation Army because I heard that they would only pay rent to somebody that had an eviction notice. I was already out on the street, okay? Then by that time I had this little job upstairs. This was within the first two weeks I was here that this happened. And I said, "Well, fuck 'em."

Brother Wine and Terp were the two winos that liked my truck. They called him Terp because he liked terpinhydrate cough syrup. He had to have about two, four-ounce bottles a day to just keep himself even, and you can only buy one bottle every other day legally in the state. So he spent most of his time scrounging money and convincing people like me to go buy it and sign the book so he

could get it. A bottle of terp cost him seven bucks, and seven bucks was what it cost me to buy a bag of diapers. I'd go about once a week and sign for him, but I wouldn't go any more than that because the police look at those lists periodically. See, if your name's on there a lot you're gettin' the money somewhere. If you don't have a job you're a good bet for the petty theft that's goin' on in town. So I didn't want my name on that list very often. But I'd go down and sign every once in a while for him, and buy a bottle.

And we knew which druggists kinda looked the other way and which ones didn't. Anyway, they started clueing me in on the system. "Well, you want food stamps, this is what you gotta tell 'em. You want AFDC, this is what you gotta tell 'em." So I got my information on how to get help off the street. I eventually did get AFDC and food stamps. I started learning the rules a little bit at a time on how you did things. But they are the ones that kept me alive for that first winter I was in Casper, Wyoming—Terp, who had to have eight ounces of terpinhydrate, and Brother Wine. We'd go out and pick up cans and we'd fill up the bed of my truck. Took us all morning to do it, the three of us workin'. We'd get about twenty-seven bucks for those cans. So we'd put in five dollars of gas and we'd split three ways what was left. Brother Wine went over and bought white port, what he liked. I'd go buy diapers or baby formula, whatever I needed. Plus we put the first five bucks in the truck so we could go out again. And then Terp'd go scrounge his terpinhydrate. Plus, he had all kinds of other little scams to get more money, which I will tell you about if you ever care to know. And then Barbara—I can't think of her last name now—but her and her husband started drinkin' about ten o'clock every day whether they needed to or not. And that's who kept me alive and off the street the first winter I was here. It wasn't the people that get paid to do it. See, and I never forget that. And that's why you'll see I take a lot of flak because of who I take in. Because I take in people that no other agency will help.

There is the attitude that we don't have enough money to help everybody, so we should only help the people that truly need it. Define "truly need it." The definition of "truly need it" at the state level does not

include people like Terp and Brother Wine. It does not include people who are chronic alcoholics and drug addicts. The official thing is, alcoholism is a disease just like diabetes. However, when it comes right down to the bottom line, guess who is gonna get shorted? Single women with children who have no intention of getting married, who would rather not work—they'd rather be with their children—who have perhaps more than one father to their children, are not as needy as . . . You want to follow this logic? Just like sex might happen at the Rescue Mission, and that's why they divide husbands from wives. We tried to get the Rescue Mission when they were looking for a new building to take over across the street. We said, "You can put the families in the cabins and the single men in the hotel." "Oh, no, we couldn't do that. We have to have better security than that." Bottom line: Sex might happen. There's a definitional thing.

There's this old "Pull yourself up by your bootstraps" attitude . . . And it's such bullshit. Let's look at Wyoming's history, okay? The first people that settled here got their land for free from the government through the Homestead Act. Most of 'em couldn't survive on forty-acre parcels. So very quickly the big ranchers got the homestead lands because of foreclosures, and one thing and another, and the banks. Very quickly the big ranchers said, "Wait a minute. Forty-acre exemption?" And they sent all their family members and crew members out to get their forty acres on the waterholes so that they could control millions of acres of government-owned land. Which even now, today as we speak, they are leasing for a couple bucks an acre. Now the government wants to raise the grazing fees to something more comparable to something like what you would pay, and what are these rugged individualists in Wyoming saying?

Now, would you like to talk about the irrigation water projects? I don't know if you've been following the argument with the Indians and the Indian water, but apparently it has cost at least three times as much per year to maintain our irrigation systems in this state as the actual economic production. How much money did we spend for this government water to irrigate these lands that these guys all got for nothing to begin with,

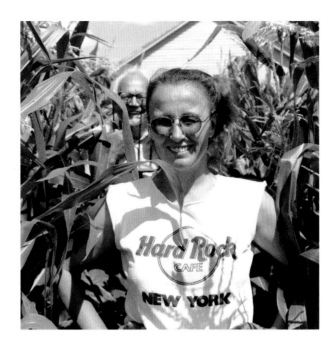

that we stole from the Indians, a lot of it the best land? Now the government is payin' to irrigate it and you're payin' very nominal irrigation fees while BurRec [Bureau of Reclamation] is gettin' millions and millions. These are the same self-sufficient people that you mentioned to me, right? The people up at the Midvale Water District, for example, that don't want their water cut off now? Should we talk about grain subsidies?

Should we talk about subsidies for the farmers and the beef industry? How about the fact that we're always talkin' about sub- sidizing the coal industry? We don't wanta reduce the severance taxes that the federal government's giving us, but in certain industries like uranium we wanta reduce the amount of money that we charge in our taxes. We don't wanta make Pathfinder— which, by the way, is a French-owned com- pany—pay the money up front for a bond to guarantee reclamation of their uranium sites because we want to make uranium economi- cally feasible. But everybody can be a rugged individualist and pull himself up by the boot- straps. Do you want me to go on? Do you want to know how much government sub- sidy True Oil gets? I mean, think about this.

They all get subsidy. If they're doin' any kind of oil exploration in this state, they're gettin' subsidy. Whether it's a direct payment or a reduction in taxes, they're get-

tin' somethin'. But the other thing is that when they get it, it's subsidy for economic development. When poor people get it it's welfare. Quite frankly, I'm tired of welfare for rich people. Welfare for rich people is what's makin' it so damn difficult for poor people to get out of poverty, because there's so much money that's going to the top that nobody thinks there's anything left.

What I'm tryin' to do here is develop kind of a community center. What I envision in the future is that one of these vacant places in this building will be a drop-in center where people can get books and pamphlets, and watch TV, and maybe shoot a game of pool—stuff like that. I think I would like to have a place for kids to play, with a sandbox and playground equipment. Get more flowers and trees to landscape it. Clean up the front of this building. Get some awnings or some- thing. Do some landscaping like they do downtown where they dig up squares of sidewalk and put in trees. And then have transitional housing upstairs, and over that other boarded-up building. What we always say is, "One eight-hour day gets you one free week of living"—where people can work there eight hours and then have a free week. They can do that indefinitely till they get on their feet.

Because it's gonna take more than the thirty days you get to stay at the mission.

And then if they earn money they can save a little bit of it or get a little ahead 'cause they're not dishing it out in rent. Then, in return they would maintain what's around here, do the work in the store, do work in the garden, do work in the foodbank. I'm trying to teach people that have already given up on themselves—and society's given up on them, too—that it doesn't have to be that way.

People have called me the Mother Teresa of Casper, which is so much shit. [But] I don't make money off of this, and live in a fancy house, and come down here and slum with the poor people. Mother Teresa lives that kind of poverty lifestyle herself. Whereas, so many people that do this kind of work go home at night to nice houses and nice places to live, and they get real callous on the job. They'll help you if you fit the guidelines, but they spend most of their time worryin' about continuing their grant with United Way so that they can get their salary next year. You know what I mean? I think the other thing, too, is that I work with a lot of people that other agencies have rejected. And that's where Mother Teresa . . . the untouchables in India is where she started. I was interviewed for the *Casper Star Tribune* and they asked me the same: how do you characterize yourself? Well, I don't know. I guess I'm a bum that likes it.

RONNALD JEFFREY

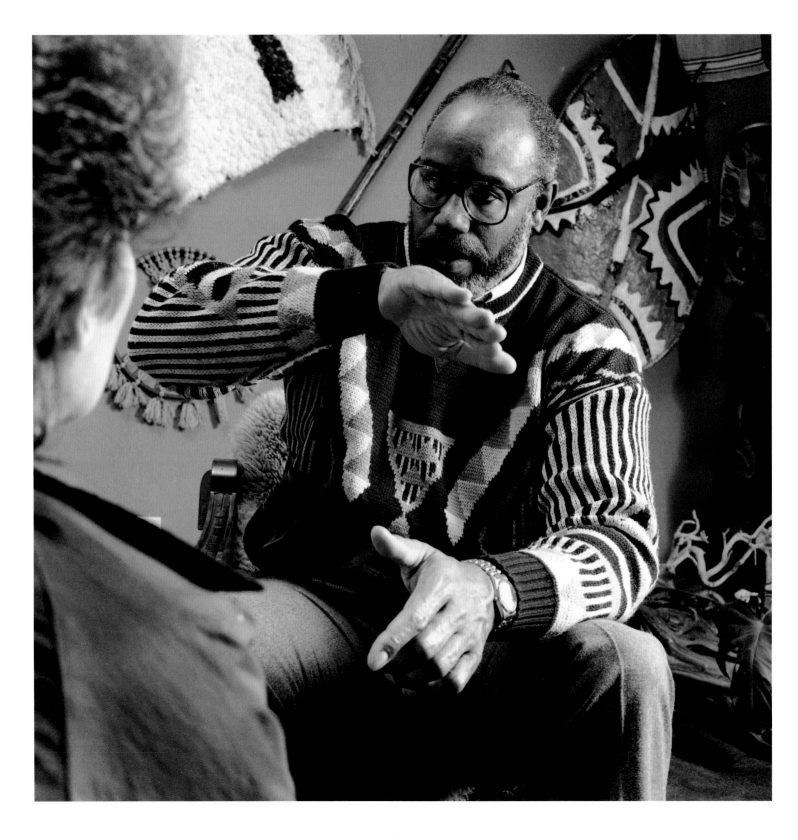

If you're askin' me, "Why am I doin' the work that I'm doin'?" I've always wanted a great story to tell someone. You know, "I was a lost child. I was on drugs and I was stealin' and rippin' everything off. Then finally someone showed me the light and I turned to this new light." Naw. I did some stuff. I was in things. I was an ornery kid. But the bottom line for me was that I was looking around for somethin' one day. I was home on a break from college. Summer vacation. The opportunity to do somethin' in this area just kinda worked out, and I was just lookin' for a summer job, that's all. Twenty years ago. [Laughs] I was lookin' for a summer job.

CHEYENNE
b. MARCH 11, 1949, CHEYENNE

The reason Youth Alternatives is the name of the program is, simply put, we think that's the whole concept. We're trying to help people discover better ways, more positive alternatives, for dealing with problems that they have. In other words, instead of smokin' a joint to feel better about yourself, maybe we can give you another way to feel better about yourself. 'Cause one thing we have learned: You don't just tell someone to quit doin' somethin' they're doin'. We have a tendency to think if someone's doin' somethin', and we think it's bad, that it's also bad for them. Not necessarily. The guy that's out there smokin' that dope gettin' high may feel good about smokin' that dope. What you've gotta do is figure out what's the payoff for that behavior, then give them somethin' positive, another way to fulfill that same need. I mean, if I want attention and if I'm the best ripoff person in school—I can steal your coat when you're wearin' it—if I'm good at that, I get a lot of attention bein' successful at stealin' things. So you can't just tell me, "Quit stealin' things and you'll feel better about yourself." What you've gotta do is tell me, "Quit stealin' things and here's another way that you can still accomplish that."

I have a kid that comes to mind that I've talked about a lotta times 'cause he taught me a lot. Had all kinda problems with him. He was really involved with drugs and a lotta other things. And I did all the horror stories. I told him he was gonna turn into a freak, his brain was gonna be fried, everything in the world was gonna be wrong, he better quit usin' all that dope. I tried everything I could to try and stop him. Didn't stop. Then all of a sudden, one day there was no more drug usage. It wasn't just like one day, but over a period of time. He started doin' better in school, ended up graduating—the whole works. He came back years later and was talkin' with me. He wrote me some nice letters and thanked me . . . how—as he put it—I'd "saved his ass" a number of times and stuff like this. He had a conversation with me and said somethin' that made a lot of sense. He said, "Ron, remember when you used to talk to me about gettin' high, and how it was frying my brain, and all the bad stuff it was gonna do to me? I used to laugh at you. I used to think,

"This guy doesn't know what he's talkin' about." I mean, "I liked gettin' high." He said, "I enjoyed it. When you talked about how bad it was, all I could think about was how good it felt for me." He said, "You know what's caused me to stop messin' with dope? Really, it was a girl. I found a girlfriend that told me if I smoked that dope I wasn't gonna have her. So I had to make a choice."

That's what really brought me to the whole concept of the alternatives. You don't just tell someone it's bad, don't do it. You give them somethin' better. See? We don't change a behavior that feels good for us. We don't change a behavior that's doin' somethin' for us. I mean, if you have a guy out there that's rippin' off houses and he makes a thousand dollars a week, two thousand, three thousand rippin' off houses, and he gets busted, and he goes to court, and he looks at it and says, "Well, I went to court and I'm gonna pay." First offense, maybe I'd pay a thousand-dollar fine. I made twenty thousand dollars to pay that thousand. That's probably not gonna deter me from doing it again.

I'll use anything it takes if I have to. I worked with a kid who was suicidal once, and the only thing I could get from that kid, that he really tied into, that made him feel good, was a dog he loved. So I told the kid, "Well, you know what? You kill yourself, you know what I'm gonna do? Same day I find out that you killed yourself I'm gonna go get your dog and I'm gonna kill your dog. See?" Sounds real cruel, doesn't it? Wasn't trying to get him mad. The one thing that was important to him was that dog. I was tellin' him, "I will do anything it takes to keep you alive. And if you kill yourself I'm gonna kill your dog." We went through a whole discussion about that. What I ended up basically saying to him was, "Look, it's not a black-and-white situation of your dog and you. What I'm trying to tell ya is, your life is so important to me that I will do whatever it takes. If I gotta sit on you, hold you, tie you up, I will do whatever it takes to keep you alive."

. . . Somehow or another I feel good about doing something that keeps me in touch with what I think life is. See?

LINDA KIRKBRIDE

Ranchers for Peace was a citizens' detente approach. It was a grassroots approach. Not revolutionary. Because if we were revolutionary we would have done, maybe, more like what the women did in England when they camped by the nuclear sites. They wanted the missiles out of England and off of English soil. So they camped in the borrow pits by the bases there, and blocked the gates and did things like that, saying: "This is English land. We don't want these nuclear weapons here." They left their families, they left their husbands and kids, and they had twenty-four-hour shifts there all the time. That's more of a revolutionary kind of thing. What we did was just a real grassroots, ultra-American thing because we were using the rights that we all have to speak out. I didn't realize how much more patriotic I became during this time, in some ways thumbing my nose at the government that I realized was lying to me in certain instances, defending the principles that this stood on. Because I was speaking out about things that I couldn't have spoken out about if I lived in the Soviet Union. I would have been thrown in jail. And I began to realize that a lot more.

One of the most hurtful times was when U.S. Attorney Richard Stacy wrote a letter about Linda Kirkbride and her little band of liberals, or whatever he called us. "Peaceniks," something like that, "and the likes of her." But his response was just totally degrading. It would have been okay if he had signed it just, "Richard Stacy, citizen." But he signed it "Richard Stacy, U.S. Attorney." I thought, "Wait a minute, that's not fair." I mean, you can certainly think I am the worst thing that ever hit, which a lot of people did. I remember this drunk lady called me up: "Are you the missile lady?" Boy, she was really loaded. "I want to talk to you," growl, growl. I got death threats and everything else. Somebody said,

"I'm gonna blow you away." "Shut up. Quit talkin' about this. Quit makin' an issue." Well, I'm not gonna do that. I liked living out in the country then. Who I really felt for was Sister Frances [Russell] who really took the heat. She was in Cheyenne and she was the one who—bless her heart—was doing a lot more than just the dirty work and the trench work. She got more death threats than I did . . . a nun! Because "Who did she think she was, this little nun coming in here and trying to confront the military-industrial complex?" My own father called me "Jane Fonda of the Plains." It was stupid. I said, "You know, things like that are like racist comments. I don't want to hear 'em and I don't really appreciate 'em, so cool it." And he did. He did it sort of in a joking way. I said, "I'm not amused. I'm really not amused."

I hope that this is a chapter of a book that we will look back on and say that we will have been quite a bit enlightened in a hundred years. That we can say, "Well, they did the best with what they could do at that point in time. It's too bad that they poisoned a lot of the ground and that they thought that these nuclear weapons were the thing that helped them." Maybe by then we will not be using any kind of mass system of destruction.

I'm out of the limelight. And I've gone on. I'm doing League of Women Voters stuff. I tried desperately after my involvement to just be sort of a normal person and do normal things so that people didn't see me as a one-issue kind of thing and that I was just this rabid, liberal kind of person. And so I've tried so hard to be the good mommy that goes to all the ball games, and bakes cookies and does that. Almost to make myself crazy I would do stuff like that.

It's chilled out. It's different now. My father-in-law has a lot more respect for me now. We respectfully agree to disagree on

certain issues, but there's not a "we can't talk about it" sort of situation, which there was at certain times. Now we can talk about it. In fact, time always heals. Time is very healing. And we've had other things in our family. I just lost a sister-in-law a month ago from breast cancer. Battling that brought us all closer together. Life is too short to let ideas and ideologues get in the way, so we've all tried to be a little more compassionate on that, I guess. The fact that I am not in the limelight every day, either—that was very difficult and it was hard to sustain that level of energy.

I had a significant role as far as being part of a movement that really was able to affect public policy. I really feel good about that—people wanting to know what their government's doing, wanting to know about the defense of this country in a way that they've never been involved before. I think that is absolutely vital. I hope I have shown that. And I hope my kids have the courage to take on whatever it's gonna be that will come along in their life. It may be this, it may be something totally different. It just takes a little bit of risk. Also, I just think going back to a lot of prayer, and willing to be used . . . I think that anybody can do it. Sometimes you just happen to be in the right place at the right time, too.

I wished they smoked and belched flames, and made horrible noises and did all kinds of stuff. Then we'd realize that these aren't just representatives of some big defense policy, that these are the real thing.

MERIDEN
b. OCTOBER 7, 1948, DENVER, COLORADO

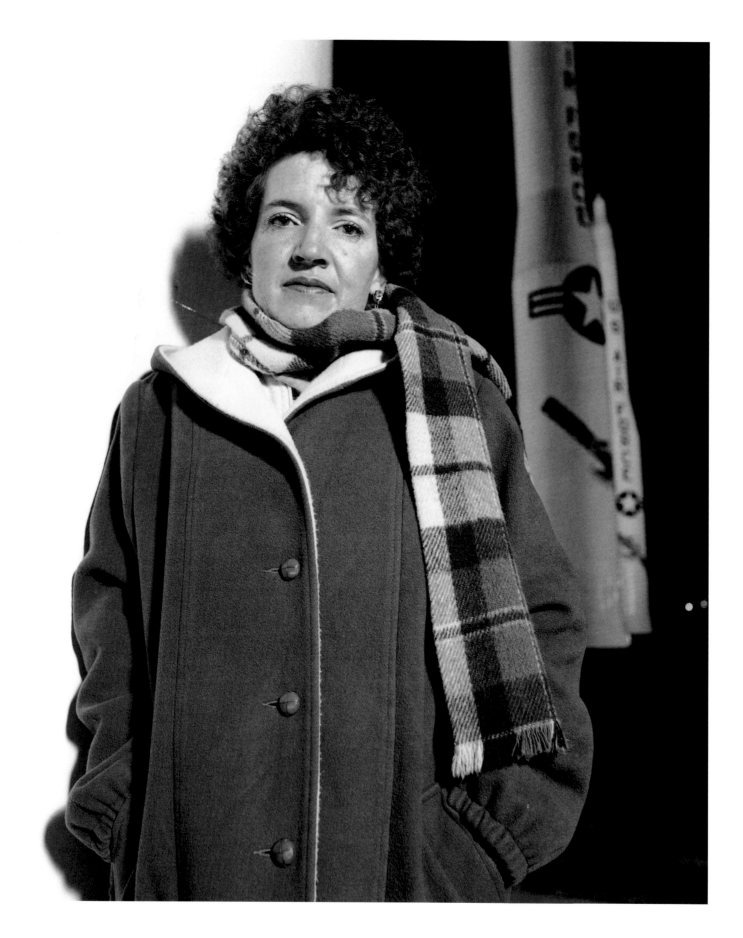

ARAPAHO
PIUS MOSS
LANGUAGE TEACHER

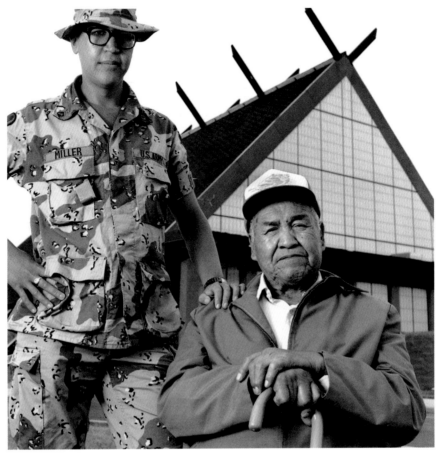

ST. STEPHENS
WIND RIVER RESERVATION

left: DAVID MILLER
b. JUNE 1, 1970, FALLON, NEVADA

right: PIUS MOSS:
b. MAY 3, 1914, ARAPAHO
WIND RIVER RESERVATION

Today I'm gonna give my grandson a name. I have that authority to give names. So he will get a name and he will get the chief's name, Chief Black Coal, the last chief of the Arapahos. That'll be quite an honor to give him that name. That is my name now, so I will pass it on to him. Black Coal. No child can be named that. It has to be a person that acquired fame or whatever. It has to be a grown person. So since he went to war—the ground war that he was involved in, Saudi Arabia, the Desert Storm—why, the name fits him.

When I was out there [Wind River Reservation] I was able to do what I had to do, able to speak my language. But when I came to school, that all stopped. They wouldn't allow me to speak or say anything about my culture, my language. That was all taken away. The consequences were brutal as far as punishment's concerned. We were whipped, heads shaved, because we talked Arapaho, our native language. And I don't have to talk too much on it because I get emotionally upset. I've seen kids cry needlessly just because they talked their own language.

I'm trying to get the language exposed through them because they're the ones that will carry the language where it's supposed to be. The younger you are, the language

that you learn, you'll never forget it. We do have it in the classroom but it don't belong in the classroom. It belongs at home. But they don't get it at home so we have to establish a place where they can get it in the classrooms. A good many of the young people do not know the language so they speak English. Very few, if any, speak Arapaho to their little ones. It's mostly English. The kids that we're teaching now are the ones to carry the language wherever it has to go, and we're succeeding in the way we're doing it.

You have the four points of life. You were a youngster at one time, a baby. Then you are a youth. Then you come to be an adult. And like I tell the kids, I say, "I'm the only old one here." [Laughs]

ANGIE HENDRIX

I have a lot of eventual goals. I want to be in the 1992 Olympics—if not those, at least the '96s. I just want to keep getting better, and one day I want to be known as the woman who's the best in the United States. It'll be fun tryin' even if I don't get there, as long as I can be up with the lead pack of women, maybe win one here, lose one there, in the top three or four. I'd be very happy.

The fact that I'm doing it in Wyoming is unique. I'm the only one doing it. The roads are great around Riverton for training. Not a lot of fast traffic where I go. The air's clean . . . don't get smog in my eyes and gunk in my lungs when I go out. There's some great scenery, great view of the mountains off in the distance.

They think I'm such an inspiration. I've heard so many people say, "Well, I've thought about running for so long and, gosh, one day I saw you go by, and I was just inspired, and there's no reason why I shouldn't be out there doin' that if you can do that in your wheelchair." In a way I guess that's a compliment. And people say, "Oh, gosh, you go all over town. I've seen you up on the west end of town and way out north and, my gosh, you sure get around in that thing." It's like, "Yeah, I sure do. I put in my miles."

I don't think people in wheelchairs sometimes are allowed to feel like they have crappy days. A friend of mine was sayin', "Oh, Angie, I'm so depressed. But I shouldn't be, should I?" Like, sure. I mean, if you feel depressed, you're depressed. You shouldn't feel one way or another. You are or you're not. But she's so used to puttin' on a smiley face, making everybody think that everything's fine. I'd also like to be a consultant to an architectural firm when they're building buildings. I used to get so upset, go down to a hotel room that's supposed to be accessible. And they put the towel racks where you can't reach 'em. Or, they do everything really nice, and everything's great, everything's down low . . . then light switches are up high. They'll do pretty much everything okay and then

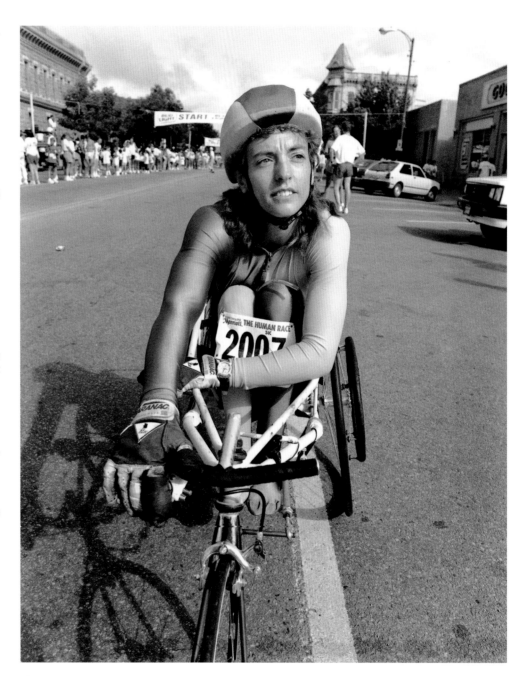

they'll screw up in one place. It just used to piss me off. And now I just sort of laugh at it 'cause I'm pretty versatile. I'm a lot more adaptive than I used to be.

RIVERTON
b. OCTOBER 17, 1961, CHEYENNE

TEACHER

SYDNEY SPIEGEL

EAST HIGH SCHOOL

If the high school wants to train 'em for passivity, then that's what they'll be trained for: passivity. I remember once, Governor Hathaway made a commencement speech at the Storey Gym and he said something like, "Whatever you students do when you graduate, please don't be one of these people running around carrying a picket sign and marching in demonstrations." And I think about this recent conflict in Washington. I think it was a very American thing to do for the pro-choice women to be out there, and the right-to-life people be out there trying to influence the Supreme Court decision. It's a wonderful thing about this country. People are struggling to get their point of view across like that.

CHEYENNE
b. JUNE 18, 1923, MINNEAPOLIS, MINNESOTA

If they come into the classroom after having seen Roseanne on television last night, and after having talked with their friends about what the strategy was for the Michigan team to win the NCAA basketball championship—if that's been their whole mind-set and also the mind-set of their intense personal life, and they're going through adolescence and all the problems of dating—if you want to tell them about World War II you have to try to break through there somewhere. It's like the Christian missionaries trying to preach to the animists of central Africa, tell them about Jesus Christ. It's something very remote. Some way or another you've gotta try to reach them. And if the principal would try to indicate to them that he believes that this is a school where they are to learn some things that they didn't know before, and it's not hard, and it's interesting,

and it's fun, and it's beautiful, and it's true, that might help change the orientation of their minds. I tell them, sometime in the morning, "Prepare your minds for history and politics this morning." Just say that to them, that we're gonna turn their attention away from all the other things that are in their life. I can do that sometimes if I keep relating it to them.

Let me give you an example. I had a pretty successful lesson trying to teach the causes of the Great Depression. I showed 'em one line on a graph which was gross national product. That line was red. Underneath it was another blue line which was personal income. I said, "Okay, the personal income line is down lower than the gross national product, so we don't have enough money to buy all this junk back. That's the basic cause of the Depression. But it's worse than this graph shows you because personal income does not include only wages and salaries. It includes rent, profits, dividends. Is there anybody in this country that earns a million dollars a year?"

"Sure! . . .Yeah! . . . [Orel] Hershiser. Lotta people."

"How about two million a year? Alright, Chrissie, let's say that you are one of these rich people and you're getting $200,000 a month. Are you going to spend all of that on chewing gum, and haircuts, and bicycles, and hats and coats?" She said, "Sure. I'll spend it all." I said, "Look, Chrissie, let's be intelligent. If you save half of it, put $100,000 away, you get money on interest without working. You can lay on the beach."

"She said, "Okay, I'll save half of it."

So I said, "Okay, now let's figure out. Here is the gross national product. . . ."

And then I gave 'em another thing out of a Federal Reserve bulletin with the actual figures: Two trillion gross national product for 1978 were the figures. Two trillion gross national product, one trillion in wages. Wages and salaries was about 700 billion. Then we just took it, and it came out after we did all the calculation that the rent income—half of it—would go to buy consumer goods. We still were left with about 800 billion in the warehouse unsold. And they said, "Well, we'll export it." So, okay,

flip over to the export. It was 143 billion. Alright, subtract that. And we still had about 700 billion in the warehouse unsold. "Now, whatta you gonna do with it?"

"Burn it!"

I said, "No, be serious now. Whatta you gonna do with it? If you can't sell it, you gonna have the workers still makin' more hats and bicycles in the factory? The warehouse is already full. You gonna build more warehouses?" I just kept jabbing at them, and probing with them, making them the millionaire and them the warehouse manager. They really got into it and I think they learned that lesson.

It's not enough to teach those kids in the ghetto school that kind of thing, and it's not enough in these academic subjects. It's not enough just to have those kinds of good, sound educational practices. For the history classes you need to have some dramatization. You have to say, "You don't know about Churchill? You're Churchill, now, alright? And Hitler has attacked seventeen countries in Europe. Now what are you gonna do about it?" You've gotta bring it to 'em some way. You gotta scare 'em into thinking a new war or a new depression is going to come. And I think even all of that is hothouse. For history and politics they've gotta be involved in it. Now we've got some very good teachers in our English classes who are getting the kids to write books and getting 'em published . . . those *Foxfire* books of Appalachia—how to cure warts and how to make moonshine. But history is more difficult because if you want to get students involved in politics, it will be perceived as dangerous by some authorities. "Why don't you just teach 'em about George Washington and don't try to get 'em involved?"

One of the things I tried a year ago was to get all my classes involved in a program to change the names of our schools in Cheyenne. We had two boys go to the school board. One of 'em spoke very well. I forgot his name. I remember the name of the other boy who did not speak very well. But he got up and he said, "East is a direction. Why not name it Isaac Newton High

School or something that will relate to what we're learning?" They went through that experience. The day after that happened, the superintendent and the principal came walking down the hall of the high school and Iverson said, "Well, I think the school board received your delegation very well. What did you and the students think about it?" I said, "Well, I told the students next day, 'Wasn't that great? That was civil participation. You were participating in government, trying to help make a decision. And that's what this stuff is all about.'" But if it's all just studying George Washington and Napoleon, it's all dead and past, they question it, you know? They say, "Why do we have to know that? I wanta be a barber. All I need to know how to do is cut hair. Mr. Spiegel, why do I have to learn Chinese philosophy? I don't understand it. What good is that gonna do me?" I said, "Well, if you ever go to China the girls will all love you. They'll say, "Oh, Bobby, you know Chinese philosophy! You're a wonderful man, we 'ruv' you."

You know, I remember when the president of Mexico confiscated all the oil properties of American oil companies in Mexico. It was March 18, 1938. And in his statement justifying his seizure of these oil properties, he said things like, "Where in these work areas do you find that the Mexican workers have mosquito netting and screens to keep out the insects? And what about medical care? And where do you find, in any place, where these oil refineries are building an athletic field?" I thought, "Well, that's pretty interesting. He wants oil refineries to build an athletic field. We've got an oil refinery in Cheyenne. Have they ever built an athletic field?" And so what the statement says there is, that you should have some corporate responsibility.

I know that probably a statement like that would frighten many school administrators. "What is Spiegel trying to do? Stir up the students? Make 'em activists?" Well, why not? That's what they're supposed to be in America—the democracy with active citizens.

JOHN OSTLUND

I would never consider running for the office as blind man, never. First of all, I think that people would say, "Good, God! We're not gonna elect a blind man as governor!" They wouldn't say that to me, but I have a feeling that that's what they would think. The other thing about it is campaigning. I know what an arduous thing that statewide campaigning is. You have to remember people. And when you're sighted it's tough enough to remember names, but it's important. It's important when you go into a community, if you're running for statewide office, and you see someone, you can call their name, and speak to them, and ask them about their wife and so on, and their kids, and remember all these little details. People like to know that you care. You can't do that as a blind person until they come up and speak, and then most of the time if they do that, they'll say their name, you know. But it's very difficult and I don't want to go through that. I've been there, anyway, and I have no ambition. I wanted to be governor because I really wanted to get some things done for the state of Wyoming. I didn't run for governor because I thought it would be prestigious. I really had certain things I wanted to do.

After that last operation I had hope. I always had hope. I've always been optimistic. But it finally dawned on me that I was blind. I was sitting out on the back patio in the summertime. I could feel the sun. And I took my arm and I passed it over my face this way, hoping I could see a shadow. Nothing, nothing. And it finally dawned on me: "Well, by God, I'm blind, I guess." I didn't panic but I sure got depressed. I really got depressed. If I knew then what I know now, I think I would have . . . if somebody would have said, "Man, you're depressed. You ought to go and talk to somebody." But I didn't have that kind of sense. I just kind of swallowed it inside.

I started taking Braille without enthusiasm. I used to go up to the Hathaway Building. Mary [wife] would drop me off there after bank meetings on Thursday and I would have a Braille lesson. That was in '85. It was during June of '85 and my teacher said, "You know, you ought to go to the blind camp up in Casper in July. They have a lot of blind people go up there and it's a wonderful program." She coulda just as well hit me in the stomach with a ball bat. I said, "Blind? Me? That's for blind people!" I didn't say this, but I'm thinking, "That's for blind people, I'm not blind! I'm gonna get my eyesight back!" But finally in '86 I did go to blind camp and I got a lot out of it. It's a great program.

It came to me just like a bolt out of the blue. I never, never would ever say to someone that I was depressed when I was depressed. I never would ever unburden myself that way. Never. Kept it bottled up, which is not a good thing. But I was involved in my church. I go to the Catholic Church, to St. Mary's Cathedral. For the last, about, three years they've had a Renew Program where parishioners get together in groups of eight, ten, or twelve and they have a regular study program. They meet in somebody's home. It's kind of a nice thing. They have a regular Bible study kind of a thing. I was invited to join this group, my wife and I, and we did. Our group got along very well. It was in '86 that this occurred to me. One day the lesson from the Scripture was how Jesus healed the blind man. Somebody was picked to read the Scripture and then we were all supposed to comment on it. And I wondered when that was being read, I thought maybe my group might be a little uneasy to comment because there's a blind man sitting there. But it came to me just like turning a light on in a dark room, because it's the first time it ever really occurred to me. So I volunteered to speak

about the Scripture. I said, "Well, the way I look at it is that Jesus healed the blind man and that was a wonderful act of kindness. So here I am a blind man and how do I feel about that?" I said, "It just dawned on me that I've also been healed." I said, "I can't see, but I've been hurting on the inside for months and months. I mean there's been a pain in there. And it just dawned on me that my pain is gone." It was true. The pain was gone and I was so happy I said, "I feel like I've been healed, even though I can't see because it's a wonderful feeling to have that pain gone inside." I'm not suggesting that some miracle had been worked. It just was the first time that it had occurred to me: The pain's gone, and isn't that wonderful? Because as long as you're hurting inside you can't heal yourself.

I don't sit around and think about what I'm missing by the loss of my vision. Let me tell you, I used to sit at this desk and then think about everything in this office that I used to love to look at, and the view out my windows. And the view of those trees. And the deer walking across the yard. And all the time I'm thinking about what I can't see. Now I don't waste my time that way. I think about what I can see. I can't see anything, of course; it's just a monotonous black void. If I let myself dwell on that great, black void I could drive myself crazy. But I have too much to do and I realize that. I've got this book. I don't know when I'll ever get done with my book, but I've gotta get it done because I promised that to my grandchildren.

All my life I've always said, "I'd like to learn something new every day." And I still do. In other words, when I go to bed at night I say, "Well, now, what did I learn new today?" I'm always trying to keep an open mind because there's so much happening out there. It's an exciting place and time to live, so much new happening.

If I had been elected in '78 I think I could have served two terms. 'Course I didn't go blind until '85, and '86 would have been my final term. But I think that I would have had things well organized, and I think I could have been a very effective governor even though I was blind.

REMOUNT RANCH, WEST OF CHEYENNE
b. SEPTEMBER 29, 1927, GILLETTE

PHOTOGRAPHER
PENNY WOLIN

We're adapters. We've been chased around for four thousand years. How do you think we got to this point? 'Cause we're adapters. But we also hang onto what we've got.

SANTA MONICA, CALIFORNIA
b. JUNE 5, 1953, CHEYENNE

I would tell people where I was from and that I was Jewish. **A**: People never met anybody from Wyoming. But **B**: More incredibly is that they said, "There's no Jews in Wyoming." Or, "Oh? All two of you?" or "Who? You and your father? Is that it?" So people really looked at it as an oddity. I looked at it as a blessing, that those forces that shaped me had given me a lot of really good tools with which to be in the world.

I felt a need to document this culture. This culture was good to me. I didn't want to see it go undocumented. I think that it answered many of my own questions about what it meant to be a Jew. Because being a Jew was just handed to me, and I didn't necessarily understand what it really meant. So I started doing a little bit of research. Is there any documentation about this eastern European wave of Jews that came to the West? In fact, there was very little. I started snooping around a little bit and talking to people. I started photographing people and interviewing people. And it became obvious that I was just really scratching the surface. So I wrote a grant proposal.[*Fringe of the Diaspora: The Jews of Wyoming*] Mostly people thought I was out of my mind.

In the back of my mind I knew that what I was doing had value. Man! I couldn't get it going to save my life. I couldn't get funding. . . . "Sure, kid, you want money? Go for it! Jews? Wyoming? Nah, sorry, we don't have any money. This is stupid. Nobody cares. Who cares?" But I realized that this community would, in fact, in some ways be reflective of the larger Jewish community in the West, yet unique because shaped by the forces that shape Wyoming.

Years ago there was maybe six, seven hundred throughout the state in its heyday . . . say, the forties were the golden years. Now, of course, the numbers have diminished. Maybe there's seventy in Cheyenne and maybe there's twenty in Casper. Now maybe there's 150 in the state. I'm only guessing. There's two synagogues. In Casper is a Reformed synagogue which the community

there built. It was helped by Fred Goodstein, Harry Yesness, those people. In Cheyenne this is an Orthodox synagogue.

The first wave was the German Jew in the mid-1800s: Levi Strauss, Guggenheim . . . Max Idelman, the Idelman Block [Cheyenne], the Idelman Building, liquor. They weren't Orthodox. They didn't look the way the eastern European immigrants did. They had reformed. They had, kind of, fit more into society. Max Meyer—the Stetson hat, Cheyenne, Wyoming, German Jew—that's the first wave. Not too many, but enough, that came here. Then the second wave, the massive wave that really came to America in large numbers. It was eastern European, these people that came from Poland and Russia. These were Orthodox Jews. These were Jews that, I can only imagine, looked like they came out of the fifteenth century or something.

The German Jews just couldn't look them in the eye. They thought they were just heathens 'cause they were very Orthodox. I mean this happened all over the country. But the wave here was so large that the Germans got engulfed. It was a tidal wave here, so it didn't much matter what they thought, seems to me. So then the second wave came and my father got here at the tail end of it. Actually, sort of scientifically or whatever, he is first generation and I'm second generation. But in another way to look at it, I am the first generation that was born here.

My grandfather, Abraham Wolinsky—who I never knew—left Russia. He came before World War I. Free land in America, right? So he got out to come here to get free land. Okay, so this free land was in Wyoming. He wanted to farm the land. So he gets the land—now it's Warren Livestock out on Otto Road—and sends for the rest of his family. Well, when he left, my father was in the womb. My grandmother was pregnant with my father. And there was five or six older kids. So he sends for the family. Somehow they had to wait. World War I happened and he couldn't send for them till the war

was over. My father was a boy of six or eight. There's no records on his birth date . . . comes from Kossovo, Russia, to Warsaw, to Belgium, to Ellis Island—they caught the measles so they were quarantined in Chicago—to the Cheyenne, Wyoming, depot. There he is. He's never seen his father. He's never seen his brother. He's in Cheyenne, Wyoming. It probably looked the same. It was cold, it was windy, the snow was blowing, and they lived out on the land. But you couldn't live on the land. You couldn't farm the land. So he moved into town. So the title of my father's picture is "Proof of the Bootstrap Theory."

My father came here not knowing the language. Really, his family had no status in Russia. They were peasants. They lived in a house with a thatched roof and a sod floor. And he had a lot of ambition. He had his businesses. He did well. He had five kids. If we wanted to go to college, to "Gold-Plated University," that was fine with him, as long as we went to college. So we all went to the finest schools in the country. We had from everything. He worked and he was happy working. My father was an entrepreneur. He had a lot of things going on, so in my lifetime what I remember is, he had basically one long block in Cheyenne on Main Street. He was in the finance business, insurance business, he had a car lot, he had a service station, he had a liquor store, he had property.

My father was a Yiddish-speaking, observant Jew. I mean, we had this quasi-Orthodox, conservative upbringing. We always heard the stories about . . . you know, like, if we'd cut our finger or were crying about something, he'd say, "Well, okay, in the old country they'd cut it off. What do you want to do? You want to cry about it or you want to cut it off?" So there was always the stories of the old country. Absolutely.

They maintained a very high degree of orthodoxy. They maintained many ideals

MORRIS WOLIN: PROOF OF THE BOOTSTRAP THEORY

I have a very strong Jewish identity that I'm very proud of, and I think that he [father] knows that. I think he realizes that in terms of instilling Judaism in us he was successful. I think he's glad about that, you bet.

of their original culture. They maintained dietary laws. They maintained religious observance. They in many instances maintained their Yiddish language. Judaism is very prescribed as to how to do it, and how to live and what, and holidays, and these people observed all that. They were remarkably Jewish. They kept it even though they functioned very well in the culture here. They were presidents of banks, they were presidents of the Lions Club, they participated in the rodeo. But that was their left pocket. In their right pocket they had their Judaism.

People here accepted them. They weren't pushed to assimilate. Sure, there's always anti-Semitism. Somebody's always gonna get picked on. But they weren't pushed to assimilate. I don't think they encountered it [problems] in the people. They encountered it, certainly, in the environment. How do you make a living? What do you do? You got nothing anyway, and now what? But nobody was trying to kill 'em here. I think I also said, this is a quote from somebody else: "Listen, when you're in a three-foot snowdrift, you want to get dug out, you don't care if the guy next to you is Jewish or black or a cowboy. You just want out." So Wyoming has always been a very tolerant state in that way.

I was always looking for the answers. In other words, I don't remember formulating it as "A guy oughta be asking the big questions" or anything like that, but . . . why? You see, as a faithful Latter-day Saint, growing up in the church and that reference, they had all the answers. Where did you come from? . . . "You're a child of God and you came down here for the purpose of getting a body, and working out your salvation, and going back and peopling worlds for eternity" . . . if you were faithful. That all just made sense to me. Abraham had done it and all the prophets down through time. That's what it was all about. And so a large family. The blessings that God gave Abraham: His posterity would be as numerous as the sands of the seashore. I can remember my father quoting that. So his ten children, my nine children—all of that was a pattern of seeing life and reality in that reference of Mormonism.

It [Mormonism] was very important. It was the social thing. In other words, the church gave structure to social activities and it was very prominent within school. Classes and prayer in the classroom. And the teachers were all Mormons. I don't think I had a non-Mormon teacher. Those value systems were very prevalent. But I could get away from work to go to Primary, which was the young people's organization, a chance to be with your friends. Go to Sunday school and church. Otherwise, you had to work. It was a way of breaking out of what was a very heavy work schedule. And so I went.

I mean, it gave answers. I had answers to things that I didn't even have questions for. And so much of it was that way. I found the questions developing later on. The answer about what life was about. Why did it storm and wash out somebody's field of crops? Wash out the dam, you know? Well, it didn't have to do with some meteorological or scientific explanation. It had to do with whether or not a person was righteous. Why did the grasshop-

pers hit your crops? To test you? Or because you hadn't been faithful enough? Have you paid your tithing? You see, there were Mormon answers for all of these things. And I bought 'em. I'd hear people bear testimony when they planted their grain. They'd go out and bless the crop and turn it over, dedicate it to the Lord. And they raised all these bushels and so forth. To me the answer lay not in more fertilizer and careful irrigation and planting at the right time, but in righteous living. That's where you got the answers. Even in raising your crops. You see? "The earth is the Lord's and the fullness thereof." We're stewards and He'll bless you.

I can remember my father's old teacher, Heber Snell, coming up and visiting with Dad. He taught at the Big Horn Academy, which became Cowley High School. The church set up a whole bunch of academies in the 1880s, 1890s, and 1910. Heber Snell was his name. He later went to BYU. He was one of these educated Mormons that went through a theological seminary and got a liberal theological education. So they got into a discussion with my oldest brother Roland, who for some reason or other was much more questioning from day one, it seemed like. What made the difference I don't know. He was raising questions about the Flood, whether or not it [the earth] was actually covered, and the whole thing. And I'm—what?—sixteen or seventeen years old when this discussion is going on. I'd been doing some reading myself, and taking seminary and so on. But I found myself immediately jumping in to defend the very conservative interpretation of this. "Well, it had to be so because the earth has to be baptized by water. And you've got to have it all covered." [Laughs] That it was logical or not logical was not the issue. From my reference, that it has to be, it was logical.

I used to wonder, as I began to question much later in life, "How could somebody be so smart and so logical and yet so blind

Well, I'm a historian by profession, but now I'm kind of a gentleman farmer, retired, trying to decide who I am and what the world's all about.

MT. PLEASANT, UTAH
b. JUNE 15, 1928, COWLEY

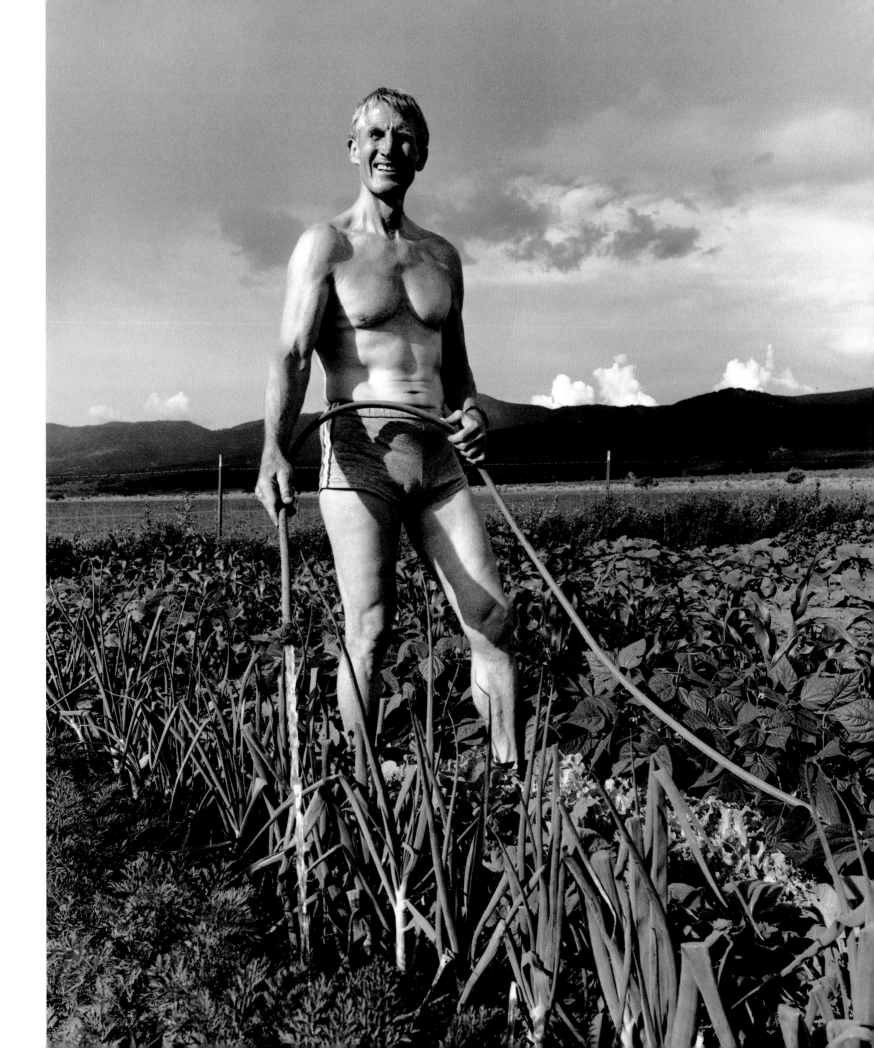

sided on some of the religious issues in terms of the kind of arguments they'd make?" I began to analyze this for myself. And what I found within me . . . the mind works from knowns, from assumptions, and builds its case from an assumption or a presumption that becomes a premise or an *a priori* base. Then you make the argument. If you accept the premise, then the argument's very logical. I look at very religious people, and if you buy their assumption or their premise to begin with, it follows logically as it did in my life. You see? The reason this man had a good crop was not because he was such a good farmer. The real reason was because he was righteous. He had dedicated to the Lord and the Lord inspired him to know what to do.

Most of that I went into denial on, because to see an unrighteous man prosper . . . the *Book of Mormon*, the reference again: "The righteous prosper and the wicked will be destroyed in their pride." I just would kinda go into denial in terms of thinking it through. If there's a logic to this, then why isn't it working? And it was amazing how many situations I would simply cut off the logical extension. In other words, I shut down and rationalized why it was the way the church and my family said it was.

Growing up Mormon, to me, anybody who smoked was a bad person. Anybody who drank was a bad person. My father was very much under the Word of Wisdom. And I picked up that prejudice against people, which was very unfortunate for me. I didn't like that. It was a long time before I could really, really own the bias that I have there. But on the other hand I've never tasted tea or coffee, or smoked a cigarette, or drunk any kind of liquor. Because Dad said to us, "If, when you're eighteen you can honestly tell me you haven't done any of those things, I'll give you a gold watch." Which, at the time, was about a fifty-dollar thing. Then he changed it to a heifer calf, which is a little more. I remember dealing with that. I remember we had a little Shetland pony . . . riding her home from Cowley, the store. Lot of times we'd tie our horses to a tree there along the ditch. The ditches used to run along the street—you know, the Mormon town. I'd tie her up there and then make that last block. They had a hitching post right in the main street and they used to ride right up on the south part of

the main street, then walk across the street into the store. But anyway, I remember coming across that ditch and seeing a pack of cigarettes, gettin' off, pickin' 'em up, takin' one of 'em out, and puttin' it in my mouth.

And I guess if I'd a had a match right then, I mighta gone to it. [Laughs] But you're gonna be asked when you're eighteen, and you're gonna have to lie about it or whatever—in other words, talking myself out of the curiosity of the moment. And I've been very grateful for the fact that I never got into those type of things. Drinking was never a temptation for me. I just never liked the smell or anything. But the cigarettes. I mean, I tried to pump wood, and roots of willows, or something like that—enough air come through, you know—and hay leaves and a piece of catalog paper. It was probably ten times as bad for you as just a good, clean cigarette. At least I never got into that. But there was a bias about people who smoked and drank that was a long time for me to overcome and be able to accept. I still don't like to be around the smoking environment. But that's for health purposes. In terms of the moral fiber of the person doing it, I've overcome that. But it's been a long time for me to deal with that.

The reality that I knew as a true believing Mormon was that God was in heaven, and the earth was created for mankind to come down here and get a body and work out his salvation . . . eventually become like God. Part of that process was the Ordinances and authority within the Mormon Church, and having a large family because there were spare children up in heaven waiting to come in his last dispensation. My parents had ten children and so I end up having nine children. It was acting out the pattern and the formula: "Straight is the gate and narrow is the way that leadeth unto life and few there be that find it." And such statements as, "There is no reward in life that makes up for failure in the family." All of these kinds of things.

And so the myth and teachings of the Mormon Church answered all the questions: that God's in heaven, he created the world, he created it for a reason. They had missionaries' tracts that said, "Where do we come from?" "Why are we here?" and "Where are we going after death?" The plan of salvation—

it all fit together very, very precisely. If you did what was right, then you could have the Holy Ghost in your life and you could perform the Ordinances, and through the Ordinances and obedience receive the grace of Christ for your redemption and salvation and exaltation. That to me made sense. And part of that was going on a mission, being married in the temple for time and all eternity, being morally clean, and observing the Word of Wisdom, the health code, and being active in the church. And if you were faithful God would open the windows of heaven and pour out a blessing you wouldn't be able to receive, and so forth. So I was very diligent in being that. I was always a leader within the organization of the church and was made a high priest as a young man in the bishopric while I was a student at the University of Wyoming, which was evidence that they were recognizing that I was a good Latter-day Saint.

I'm still a Mormon. That's my heritage. And I take some pride in that identity. But I'm not active in the church, nor do I believe what the church teaches. In fact, there's some things about church teachings that I think are very dysfunctional and even negative.

What is interesting, at one time I felt the need, the moral imperative to find the truth. Of course, who hasn't been looking for that in Western culture, including Mormons? I had to come up with something that could be true for me, my truth, and that could be true for you and I didn't have to change you. I realized that your history and your makeup, the instrument that is conscious called "Mark," is different than the instrument that is "Melvin," both in terms of makeup and experientially. So how could we perceive things the same? You build a radio differently. We have a radio that picks up one thing. The television set picks up something else. Because it's made differently. One of the things I found is that it began to quiet me down. I was able to pick up things that the static of life . . . you see, one of the reasons I moved here was to get the static of the institutionalized life out of my life so that I could listen to me, this thing I was experiencing. I needed to have a quiet environment in which to experience that. And if you've always got a clock and everything regulating your life, there's too much static to hear the beautiful music that's coming in. Simply the

static of business and so on. And much of why we aren't using the brain at the level we are, is that people can't shut it out, you see? The static overrides.

I'm very comfortable with the Mormon lifestyle. No smoking and drinking and that type of thing. I like to go to a dance but I wouldn't want to go to a bar to dance. I don't like the environment. But I associate with people at dances, single dances. I'm single now but I don't go to their church meetings. [Laughs] I have disconnected more. And yet I find that most of the people I associate with and the women I date now are all Mormons. I just find that I like what—the word that comes is "clean". But I also find that if a person is orthodox, she is pretty rigid, then in the longterm—like a marriage relationship—I find myself discounting that as a possibility. I don't think that I could marry a really orthodox woman.

I do not believe that the Mormon Church has any particular divine or special mission, that there is authority residing in the priesthood and the church authorities. And while there seems to be some flexibility showing up in the Mormon Church institution and which I would welcome—in terms of priesthood to the blacks and some modifications of temple ceremonies and other things—to me, for my needs, I just simply don't want to drag the vehicle along. I don't have to. Now, some of my children are still very believing and active in the church, and I find myself being able to accept that without any rancor. If it's real and meaningful to them, you know, I can live with that. Because my reality is my reality, their reality is their reality. And they are who they are, and they are where they are, in their lives at this time. So I'm comfortable with that for my children. And I'm able to relate to them. I'm honest with them how I feel. I talk to my children just like I've been talking here now. So they know exactly where I am as far as the church is concerned. But they also know that I don't know that they're wrong. Or I don't know that God doesn't exist, you see. My position would be basically agnostic at this point.

But the direction I take it is that, "Hey, I'm part of the creative force. I am part of the cosmos. And I can make a difference." I don't know how important that is, but Melvin Smith does make a difference.

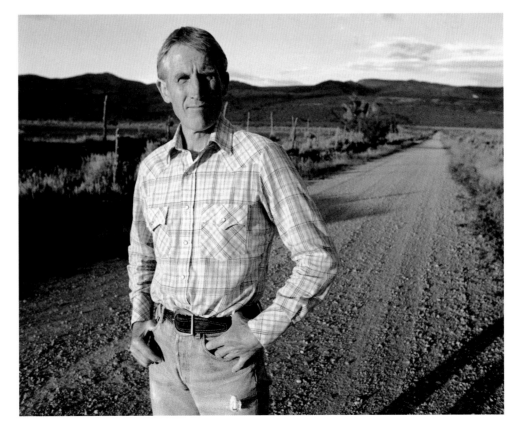

RENEE ASKINS

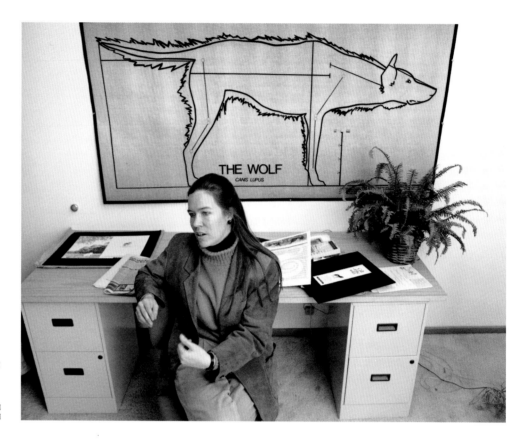

One forgets that these are public lands. Yellowstone National Park and the forests that surround it do not belong to Wyoming. And that's a tough one for people here to stomach. This is a place that belongs to the nation, and it is one of the few places in the Lower 48 where we can see an intact ecosystem. The policies that are implemented on those public lands are a discussion of national interests, not only local interests. That's why we have a national park system. That's why we have an endangered species act. That's why we have national forests.

JACKSON
b. JANUARY 19, 1959, GAYLORD, MICHIGAN

One's relationship with wolves, I think, is like a mirror. It's like one's relationship with oneself. I mean, what can a relationship really be with something as wild and singular as the wolf? You look, and it looks back, and you see something. And probably you see something about yourself. There's a wonderful line, I think Lewis Simpson said it: "At the end of the open road we come to ourselves." It's ourselves that we must face here in the West. I think what's important is not what I see in the wolf, but what reflection each of us sees independently in those yellow eyes. What is it that everyone feels? I may have my own individual response to the animal, but I think more often than not it's just a humbling experience. It's being in the presence of something that is completely independent and singular, much like our response to

grizzly bears. Only, we have that response in Yellowstone to grizzly bears because we have them there. And we don't with wolves because we don't have them.

I think I had a deeper and deeper sense of commitment to it. What was at stake was not only the wolf and, I feel, its rightful place in Yellowstone—which is a very compelling and symbolic place for this country, let alone Wyoming—but also a way of looking at both of those entities: at a creature that we have tremendous ambivalence about, and a place which we have a sort of a love-hate relationship with. We love it, we want to preserve it, but we also want to exploit it. I was telling someone the other day, it's like you mention Yellowstone or the wolf separately and they're both very powerful entities. But you put them together and it's something

much larger than the parts. I use the analogy: it's kinda like Yo Yo Ma and a cello. Something much more profound and extraordinary happens when you begin to unite those two things. Not only on a cultural and psychological level, but certainly on an ecological level. So the plane of the humanities, and history, and certainly the driving force of place and ecology all are combined in one thing. And what's happening is—very, very slowly—this changing of values. What does the wolf mean? What does it mean to people in Wyoming, particularly? What did the predator wars mean?

We didn't just kill wolves. We didn't just go out and try to exterminate them. We went beyond that. We tortured them. The methods used for exterminating wolves are extraordinary. They would trap wolves alive,

then they would tie them between four horses, and at a fairground pull them apart by their limbs. They would douse them with gasoline and set them on fire. They would wire their muzzles shut and turn them loose so they'd die of starvation. Now what does that signify? What does that mean? Something much deeper than just trying to protect livestock, which was always the rationale for the predator control campaigns, or the idea that wolves killed game so they were competition. Not that those variables didn't exist, but what I'm saying is something much deeper was happening.

I feel like it's closely associated with a sense of control and Manifest Destiny, the moving to the West, what defined Wyoming and the great conquering of the land. It was that expression of control, of taking over, of being able to "manage." Boy, do you hear that word a lot. Now you hear "manage," and to me that means control. You don't say "integrate," you don't say "balance"; you say "manage." I'm working on an essay right now called "Women, Witches, and Wolves," which is an exploration of the parallels between the predator control campaigns and the witch trials, and the same kind of cultural hysteria that accompanied both. One was human life, one was wildlife. The same sense of conquering and the same hideous . . . and not in all situations. But it was still existent and it dominated our attitude toward wolves.

It's supremacy. It's not just killing. It's not just getting rid of it. It's setting the example. I mean, control doesn't have just to do with manipulation. It has to do with dominance. In this case, the wolf, as it was in the medieval mind, was a symbol of wildness, of wilderness. Go back to those linguistic origins. Go back to werewolves. An interesting concept, in reading about these witch trials, is many women were persecuted for their alleged relationships and their love affairs with wolves. So there's always this kind of alignment between the wolf and what is wild, and what we can control.

Here you see it in 1990. You can read any of these newspaper articles and they talk about the insanity of bringing back these wolves that are killing machines—you hear that a lot—are hideous killers, and the kind of hysteria that accompanies this. John Turner, state senator, tried to change the status, the

classification of the wolf in Wyoming—I think it was in '78 or '79—from a predator, which it's now listed as, to a protected species which is listed throughout the country. Of course, because it's listed as an endangered species the federal listing supersedes the state listing. But John Turner tried to change that in the State Senate. He said, "Renee, I could never have anticipated it. Grown men stood up and wailed, hollering." Apparently in Cheyenne that day—I'd love to go back and find the records—all the shops closed and everybody came to the State Senate to tell their wolf story. This is the kind of energy that accompanies this issue.

It is a way of measuring. It's a test case because it's a controversial, difficult animal. It's a free-ranging predator and it's a difficult animal to restore. It's not like a peregrine falcon or a bald eagle. It's a much, much larger-than-life entity, and all of its history and what it represented, for us to eradicate it. What I find so compelling is that it's not only the creature, it's the place. I told this story on a program the other day. It's sort of a silly story but I think it says a lot. When I was a kid—I was probably seven or eight years old, and maybe this has something to do with my idea of Yellowstone—I was sitting on the front porch with this friend of mine and we were talking at the time about nuclear war, which all kids talk about incessantly because they're terrified of it. We were talking about the bomb and where they would bomb. I made the point that we weren't safe because they would bomb Detroit because it was where they made all the cars and the machines and things. This other kid said, "That's not true, that's not the place they're gonna bomb first." I said, "Oh, yeah? Well, where are they gonna bomb first?" And he says, "My daddy said that they're gonna bomb Yellowstone National Park first. Because my daddy said that it would break this country's heart." And I think it would. You know, when you think about a place that is symbolic of what we love, and what we believe that's sacred. There it is. Evidenced by the fires. I mean, who would have believed that fires in Yellowstone could have stayed on the national news night after night, after night after night? And there'd be this public outrage and fury? Just the sheer weight of emotion that accompanied the idea that we were losing our

park, that it was being. . . . Think about it: what kind of cultural statement that is about "place." Then take that and put it together with just what you know, even in your own belly, about the wolf, how you respond to it, how your children respond to it, how your mother responds to it. You put those things together and something bigger than itself is happening. So as you move through the day-to-day grind of this issue—the bills, and the rhetoric, and the shouting matches, and the angry people, and the meetings—underneath it there's always this theme, this calling out, the shifting of bedrock.

If I really felt strongly about saving the world or saving endangered species, I'd either be in Washington working for zero population growth or down in South America trying to effect policies that would preserve rain forests. But I believe that sometimes you have to look at the heart of the country, and how values change and shift, and realize that sometimes there are events that are more significant than what they seem to be. I mean, an example I use is Rosa Park's refusing to walk to the back of the bus. That was a very insignificant event in the flood of life events. But for the Civil Rights movement it had a monumental impact. Reintroducing wolves to Yellowstone is a very minor matter in endangered species recovery. But I think for wildlife and preservation of wild places it has enormous significance.

Again, it's a metaphor. But there are some things that inspire and galvanize a public. Right now I feel America is very demoralized. I just clipped out an article this morning about middle-class America and its sense of doom. It was a wonderful little essay by a woman from the *Washington Post*. I think America is really . . . I think we feel helpless. The environment is in such a drastic kind of catastrophe and the problems are so enormous that you don't know where to start. I feel that daily when I step away from the wolf stuff and say, "God! Where do you start?" I mean, you start at home. You start with one thing that is accessible. Yellowstone and the wolf is accessible. For me, my own commitment has to do with the fact that I love this place. I have a very strong sense of the animal, and somehow you put those together and it seems important.

DICK RANDALL

PHOTOJOURNALIST

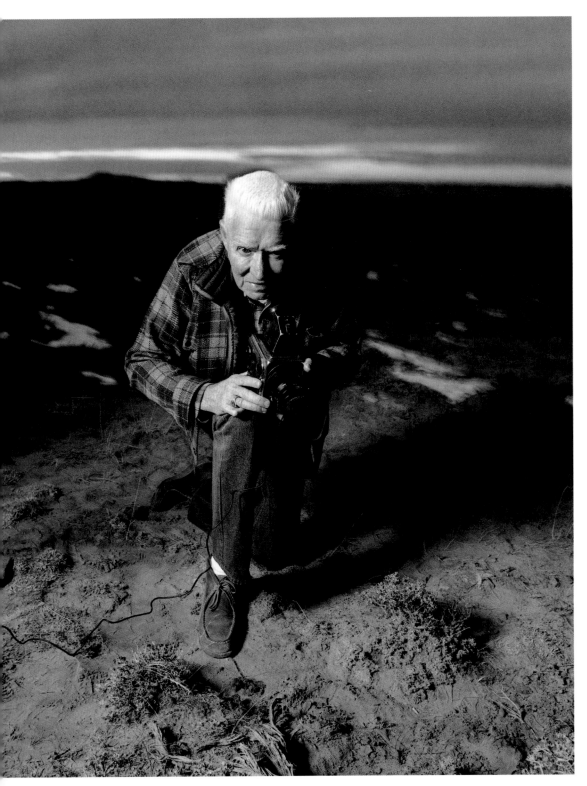

You learn a lot more trying to photograph an animal in his natural habitat—sneak up on him, live with him for a while—than you do by killing him. I've found that it's so fascinating compared to flying in a helicopter and shooting the hell out of something. You learn more about 'em.

ROCK SPRINGS
b. DECEMBER 3, 1924, POWELL

That's what I was with, was predator control, for so long. It was a government operation. I didn't know anything about Congress or any of our senators or representatives. But I believed if it was a government program, if the government said this, this was correct. A predator controller in those days, you spent most of your time out in the boondocks, out in the range, up in the mountains. No supervisor looking over your shoulder. Doing your duty for the government, saving the livestock industry. And at the same time having a wonderful life out there, cooking for yourself, sleeping out. Lotta people wouldn't like that, but a lotta people do.

I worked for five years for Fish and Wildlife stationed in Baggs, Wyoming— some people call it "Udders." I was a good controller, a good killer, I guess you'd say. The first month I think I took twenty-four, twenty-five coyotes. Got a letter from the state supervisor saying, "Right on," "Uptown," and all that. I did very well.

In September we would start poisoning the forest. Taking 1,080 baits up to the forest and kill everything up there that ate

meat. We put the baits out before the bears hibernated, so, of course, we killed lotsa bears. And I think we wiped out the wolverine up there. The wolverine—the Indians call him carcajou, which means "glutton." And I'm sure we took care of all the wolverine. We killed a lot of the pine marten. Anything that would feed on carcasses, we got 'em. And lots and lots of golden eagles.

As far as killing from the airplane, I killed as high as forty-two or forty-six [coyotes] in six hours one time in the '71/'72 winter. And the reason for that: the snow was deep. It was terribly deep. All the gullies were filled. The sagebrush was covered. So you get in an airplane and you fly at 500 to 1,000 feet and you can see a coyote out there a mile, mile and a half away . . . little spot moving. There's no way he can escape. If you're a poor shotgunner you can bang, bang, bang until you kill him because he has noplace to go. So that was when I killed so many in such a short time, which was a state record. It was interesting. At one time we had three aircraft operating out of Rock Springs that winter, all going different directions, all killing coyotes. When spring came it was time to go denning. You find dens usually by tracking coyotes and spooring. You understand what the coyote is doing. Is he coming? Is he going? Lotta tracks heading one certain direction? And this is mostly horseback. You track him in to find the den, to kill the pups. You could hardly find a coyote track the next spring, we killed so many. And yet, the reported predation, the phone calls I would get—"They're eating me up! They're putting me out of business!"—was actually a bit more than the year before when we had a lot of coyotes. I think it goes back to Congress, in that if the livestock operators don't keep reporting that the coyotes are putting us out of business, the bear are eating our sheep, things like that, Congress won't keep appropriating millions of dollars for predator control. Now there's some ranchers that, if they told me that a skunk got in and killed four of their ewes the night before, I'd believe 'em. There are some very good, honest ranchers. There's others that overinflated their losses, lied. Still do.

You killed anything that was legal. This goes back to Congress, 19 . . . —I don't remember when it was for sure— . . . 15,

when they listed the animals that were unwanted. They started with the mountain lion, the wolf, the coyote, bobcats, and then they get down to gophers, ground squirrels, jackrabbits. And this is still—the designation for the unwanted—what predator control pursues. Jackrabbit's a predator in Wyoming. He eats grass. That's terrible. A porcupine's a predator. Stray house cats are predators. The designation "predator" in Wyoming means that you can kill 'em anytime of the year with any legal means.

I remember—I don't know if it was '67 or what—that the Fish and Wildlife killed about 200,000 animals. Now about fifty percent of these were coyotes. At the same time they put out, I think, 1.4 million pounds of rodent poison. And there were 300,000—or something like that—den smokers used on rodents . . . little smokers of phosphorus sulphur you throw in the den or in a hole, and it kills the rodents, which could be prairie dogs, or ground squirrels, or whatever. So what they're doing is, they're killing animals that would help balance an ecosystem. That is, they eat rodents. The coyotes eat rodents. So do the fox. So do the bobcats. But you kill enough of those, then you have to go spend millions and millions of dollars to poison rodents which all of these varmints would have eaten for free. Now that's pretty crude thinking. People are beginning to realize what this is all about. It's a joke.

Strychnine is fairly fast-acting. The way we used the strychnine, we would grind up fish and suet and perhaps something else, some kind of meat, usually in the fall when it was cold. We didn't keep it in refrigerators. And then to make the baits you would take a little pinch and roll up a large-sized marble in your hand, punch a hole in it with your thumb, and put a strychnine cube in it. Now the strychnine cube was partially strychnine and three-fourths bicarbonate of soda. Strychnine, when it hits your stomach, will make you nauseous. And the idea of the bicarbonate is to settle your stomach enough so that the poison will get a chance to get into your system. At one time it was legal. A trapper could make eight hundred, a thousand of these in a day if he would sit there and work at it. At one time it was legal to fly in a fixed-wing aircraft up over the mountains with thousands of these in the

backseat behind the gunner, scoop 'em up with a coffee can, hold 'em out in the slipstream, and dump 'em. This was predator control. And it was legal. Anything that ate one of those little baits would die. Now, later on we became more sophisticated in that, instead of making eight hundred or a thousand a day, Fish and Wildlife came up with a machine that would make four hundred a minute. We ran those into garbage sacks, passed 'em out to the trappers, put 'em around horse carcasses, dead sheep, dead anything, and kill anything that would pick up one. Predator control. Your tax money at work.

I doubt if there's much secondary poisoning concerning strychnine. There was with 1080. When I first started with the Service they were using thallium sulphate, which is a metallic poison. They get that from the smokestacks of smelters. I could never understand why they called it a sublethal dose. But coyotes that wouldn't eat quite enough of that, in the winter they would lose their fur, and the only fur they had left would be a little ring around the neck and some on the tail, and they would even lose their footpads. They would come in around the haystacks or even in the barns, freezing to death, and people would kill 'em with a pitchfork. Well, they said this was a sublethal dose. Oh, God! But it was a very slow-acting, terrible poison. You'd kill an animal, a sheep, a horse, whatever, and you would cut long slits in the legs, in the body and all that, and sprinkle this thallium sulphate in there. And that was your poison bait. Then they switched to 1080. It's a powder that you mix with a certain amount of water, and you use the old Morton's meat syringe which they used to sugar cure hams with. You kill a sheep and inject it with this stuff in about ten, fifteen different places, a little bit here, a little bit there, and then you have a poison carcass. And anything that feeds on that dies. Except, it's fairly slow-acting as far as canines. It works on their nervous system. I've tracked coyotes four, four and a half miles from poison stations. And you'll see where they run and fall down and run into a bush, hit a rock, something like that, get up, stagger, go some more. Death doesn't come very fast. I've seen coyotes—been up on a ridge once where a coyote had fed on a 1080 bait. He came down below me going like hell, falling

down, and yelping, screaming. So, it's not a nice way to die.

This was shortly before I left the Fish and Wildlife Service. We shot two coyotes out near Flaming Gorge. Adults. At the right time of the year. I knew they had a den. So I went out and I found the den and there were four pups in it. And goddamn, I couldn't kill 'em. I got 'em out of the den, dug 'em out, and thought about it for a while. "Hell, they're gonna die if I leave 'em there." So we brought 'em home. And Rita [wife] raised 'em. It was kinda interesting in that the first thing she did . . . they had fleas so she gave 'em a bath in detergent. And they lost half their hair. Well, it grew back pretty fast. [Laughs] But oh, we had a lot of fun with those little buggers. I took 'em out, after they got large enough, back to an area where there's very little predator control. And I turned 'em loose. I'd pick up roadkill jackrabbits and put 'em out in the area for 'em. They would avoid me but not completely. They would hide in the sagebrush, look out. I remember we had a pretty good infestation of grasshoppers that year. And their droppings were just completely full of grasshoppers. They were the best grasshopper catchers in the country, probably. That's common with a coyote. They love grasshoppers, they love insects. Later, I started taking a rifle out, a pistol, and every time I'd see one of 'em I would shoot near 'em to spook 'em so that maybe they weren't quite so damn friendly and maybe they didn't get shot, I don't know.

There are some coyotes that kill sheep and a few cattle, a few calves—very damn few. Most don't. When we go out and kill a lot of coyotes, take a lotta dens, we've created a void in a predator community. Now Mother Nature says, "Get busy, reproduce, fill this void." So what happens? In Yellowstone you're gonna have maybe four pups per litter, maybe a little bit less than that. Down here you're gonna get six or seven, average, per litter. Yearlings ordinarily, in Yellowstone— maybe ten, twelve percent—would breed the first year, maybe less. In an area like this down here where you have predator control, maybe seventy percent of the yearlings will breed the first year. And litter size is larger. So when you kill a lot of these animals the first thing you do is increase reproduction up to twenty-five, thirty percent, which you

have to kill more animals to get on top of. Which doesn't seem logical.

Predator control should try to protect livestock rather than kill wildlife. There's so many things we've come up with—the guard dogs that have maybe three thousand years of genes under 'em from Spain—that work wonderful. Yet, so many ranchers resist even trying these things. Ranchers that have tried 'em, and know something about dogs, and can work with 'em, have been highly successful.

There are other means of protecting livestock. But there are some sheep ranchers that demand that we go back to the poison years. One reason for that: poison is the cheapest way to kill massive amounts of wildlife. A couple hundred dollars' worth of 1080 . . . they furnish the sheep—old ewes and stuff for carcasses—and you can poison the entire state of Wyoming.

I can sit down and visit with a lot of ranchers and we get along fine. And we'll agree on a lot of things. But when it comes to their lobbying organization—the Wool Growers, the cattlemen's association—you have a completely different tone there. They demand more money for predator control. They demand that we get the poison back. On and on and on. I think part of it is tradition. Since 1915 this is the way we've done it. Very hard to change. I mean, predator control means killing varmints.

For a long time I didn't understand anything about ecosystems. But I have found out that small changes, taking out one animal, one kind of animal, can change things completely. That's why they poisoned the rodents, because we killed too many coyotes. The more you get into this, the more you realize that this is so fruitless. You're upsetting Mother Nature and you're not gaining anything over it. All you're doing is destroying, and there are other answers to protecting livestock. And further, on our public lands the grazing fees are so low that sheepmen should accept a certain loss to make up for the low grazing fees that they're paying. You can't expect 'em to be put out of business by some coyotes that are killing the hell out of the sheep. But if you have a trapper that's worth his salt, and you're doing selective control, he'll stay with those sheep until he gets that coyote or coyotes that are causing the problem.

We had two trappers up in the Farson

area—brothers—that worked for us for a while. And their head count was awfully low. That's the way, generally, you're judged— by how many coyotes you kill or how many other predators you kill. These guys weren't killing very many. But they were sure as heck stopping the predation. If a rancher was having problems, they would lay out with the sheep at night. And if a coyote came in early morning, it was probably dead. They were fired because they weren't getting a big enough head count. They went to a ten-dollar bounty on coyotes, a bounty system which . . . "Any coyote's bad so shoot it and we'll give you ten bucks."

It took me forever to step back far enough to take a look at myself, take a good look. And I didn't like what I saw. It came about, I think, very slowly. I left because I couldn't do my duties very good anymore. I was in two airplane crashes. One was a midair collision that killed my pilot and left me seventy percent disabled. And left the other pilot . . . well, put him back in diapers. Brain injuries. And the second one, we came in upside down on Steamboat Mountain, wiped out the airplane, and walked out, pretty well broken up but still alive.

We hit what they call dead air going up the side of the mountain chasing four coyotes. And all at once the plane starts to drop, you pull full throttle, you pull full flaps, and it still keeps going down. We hit, turned over, wiped the cockpit out. We're up on the side of the mountain hanging upside down from our seatbelts. It looked like we had it made, and then all of a sudden that wing started acting like a ski and down the side of the damn hill we come, which broke it up some more. It was kinda interesting. When we finally came to a stop my pilot was smoking a cigar, and snow all around us coming in where the windows used to be, and he reaches out and puts his cigar out in the snow and he says, "I think I broke my airplane."

Oh, I could start a religion based on the great coyote gods. In a midair collision? I should have been killed but I wasn't. Then, another one . . . come in upside down. Wiped the airplane out. I wasn't killed. Both times I was out shooting coyotes. Maybe the great coyote gods that the Indians believe in saved me so I could defend the coyote.

You think about it a lot. [Laughs] Well, J. Frank Dobie's book, *Voice of the Coyote*, the first half was about the coyotes. The second half was the Indian lore. Some tribes believe that the coyote is a reincarnation of their ancestors. The Indians could live in their environment and not destroy their environment, and we haven't reached that stage yet. We *homo sapiens* think we're at the top of the brain chain. And yet, if you look at what we're doing to our planet and to ourselves through so-called progress, through overpopulation, on and on and on, we're not at the top of the brain chain. The Indians, I think, were much smarter than we were. The animals are much smarter than we were. They didn't destroy their own backyard.

It's very interesting. When I first went with Defenders [of Wildlife] my first article was on denning, that is, jerking coyote pups out of the den with treble hooks, barbed wire. Burning 'em to death in the dens. Which is still going on today. Shortly after that I started getting phone calls. "We're gonna getcha." "You haven't got long to live." On and on. Obscene. Sometimes you could hear the background—maybe the noise from a bar, nickelodeon and so on. You knew that it was somebody that was canned up a little bit, but still you didn't know how to take it. You'd get a phone call, now and then, that sounded plumb serious: "You're dead." Occasionally my son or my wife would pick up the phone and be on the end of this, and that riled me quite a lot because it upset them terribly. I could handle it, except I did start packing a pistol every place I went. Which wouldn'ta made any difference because if someone is out to get you, why . . . you're driving by out in a little canyon somewhere, they can put a shot through your windshield and take care of you right now. But no one ever tried it.

My wife and I sat around for a year thinking, "I want to tell this story." And Defenders of Wildlife seemed like the ideal place to do it. But we knew if I did this, jumped the fence, I would tear out all of my roots or most of my roots—the people that I knew, the people that I worked with. Finally I decided, "To hell with it." And I sent a bunch of photographs to Mary Hazel Harris, who was then president of Defenders of Wildlife, and told her I wanted to work for 'em. She hired

me on the spot. That was interesting, too. That winter a guy from Arizona came up who worked for Defenders of Wildlife. Steve Johnson—used to be a ranger in Teton Park. He said he just wanted to go up to Yellowstone with me, and look around and get acquainted. Come to find out the board of directors thought I was the Fish and Wildlife Service plant, and they wanted him to check me out. [Laughs] And he found out I was uptown, I was honest. But even today, if I'll hit a really good lick in the newspapers or something concerning predator control, I'll get some of these phone calls.

I was the black sheep of Fish and Wildlife when I jumped the fence. It was interesting afterward, in that the people that I had worked with would stand back ten feet when they would talk to me. I mean, they wouldn't have much of anything to do with me. Except later on I started getting some phone calls, and occasionally I'd run across one of these fellas, and we'd have a beer or something like that, and they would say, "Right on, Randall!" Since then, some of the guys that have retired or quit Fish and

Wildlife have come out saying the same things I'm saying about the subsidies, about the waste of money, about the war on the species that's never accomplished anything. So I don't feel all that alone anymore.

I think the main thing is to take a look at what you're doing, and in my case I thought I was doing the right thing. I backed off far enough to take a look at myself and didn't like what I was doing, and I had the guts to change. I think many times people that are doing something that they're making a living at and all that, they're not looking at what they're doing. And I would include some ranchers in this, the predator-control people, some of the government people who don't speak up enough when it comes to our public lands and things like that. I think we have to have people who will stand up for maybe what they believe in. And I hope people remember me as someone who decided what I was doing was not right, and had enough gut to go around telling people what I believed, what I felt, and what I knew, and what I'd learned.

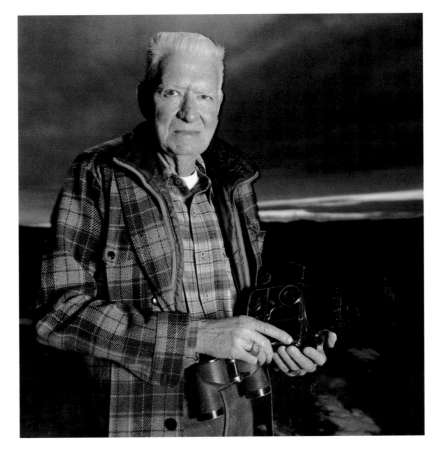

CATHARINE HARRIS

UNITARIAN UNIVERSALIST CHURCH

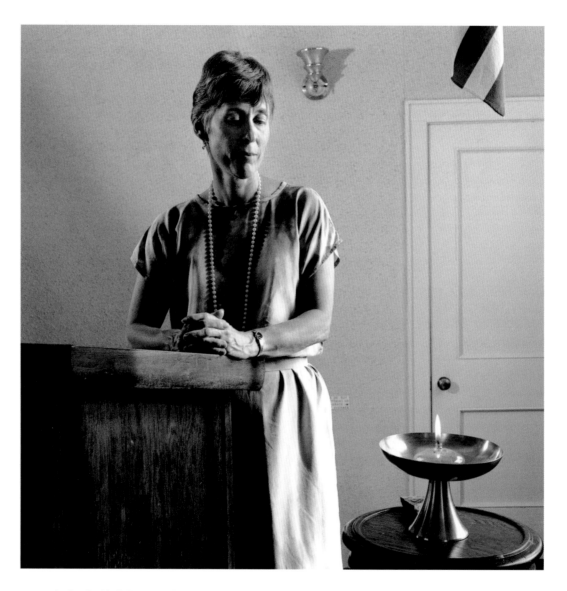

I was the kind of kid that would remember a religious experience from age four. I've always been pretty introspective, and analytical and reflective about things

CHEYENNE
b. DECEMBER 9, 1942, DES MOINES, IOWA

There's a woman theologian—Fiorenza was her name—from Harvard, who's written a book, *In Memory of Her*. She points out that Paul was a product of his culture. And I think the question that I come up with is, "Why is it that we want to continue patterning our culture of the 1990s, and the year 2000 and beyond, on the culture of the beginning of our dating system? Does that mean that our culture and we don't grow in consciousness over the years?" Paul was reflecting the patriarchal culture of his time. We have a book which I've never finished. It's based on the Iowa Sisterhood—I think they were Unitarian rather than Universalist ministers in the Midwest after the Civil War and before the 1920s—who were very effective women ministers out here on the frontier. What they were doing was bringing some of their, quote, "female nurturing skills" into the congregations and bringing their relational skills into congregations of both men and women. Also, they did a good job of fundraising within their congregations and they created community in their congregations. They created very effective religious growth and learning programs for children. These are the skills that I feel women draw on and I think are making us very successful ministers. Unitarian Universalist ministry has been favorably impacted by the women. I think the men will say this, too, even though it's a little unsettling and disconcerting sometimes. Because we preach differently—more experientially, more personally. I preached about woman spirituality yesterday, which tends to be, probably, less principle-oriented, less abstract like "justice" and "rights" and "truth" and "God," and much more into how that creative energy is working in our lives, and how life is working through us, and how we are working with life, with each other and in the world, for transformation.

In this city and this culture it is different being a woman. I went to the ministers' meetings in Cheyenne pretty regularly. I didn't miss many meetings the first couple years I was here. And the sexist language. The interfaith service on Palm Sunday was not interfaith by my definition. It may have included both Roman Catholics and Protestants but it was decidedly Christian. It was on Palm Sunday. There were no Jews involved. All the images of God and Jesus were "king," "lord"—feudal language, hierarchical, very painful. I'm in Cheyenne two and a half days a week and I had to decide at that point: Do I have time to educate the larger religious community in Cheyenne? And I decided, no. Really, even serving my church on two and a half days a week is more than I can do. So I didn't take that on, and I haven't been going to meetings much anymore. I didn't go to the Palm Sunday service this year and some of my congregation isn't very happy about that. But you have to set priorities.

I do not think God is this narrow script of beliefs. I think God is loving, and so loving that God encompasses where each one of us is in terms of our understanding of life and God. And that God is multifaceted, that God is so much larger than we can comprehend. That's why we use the word "God," because it's only a symbol. It's an anchor for all that we want to express about the mystery of life.

I can't visualize God most days. The best I can articulate it is . . . seems like God is that creative energy within each of us and within the universe. That is a force for life. That has a lot of ramifications for me. It means that we are to work with that force. And also there is that lure. That creative force is pulling us. I believe that people want to be healthy and that people want to do what is right and good. I believe that's bred into us by our humanness.

I like to use the word "God" sometimes because the word "God" for me—and this will sound like blasphemy to some people—is a poetic concept that expresses more than I can put into words. But when I use that word "God," and there are people listening to me, I know that many people are thinking of the blue-eyed God who's a male. That's shutting off what I'm using the word "God" to mean. So when I say "she," at least people realize, "Hey, God's different than I'm thinking." And whether God's a she or a he, at least people are thinking, "Hey, wait, God might be larger than I'm thinking of." And that's really my purpose. I want people to think, "Well, now, what is God for me? Is that a concept? Is that a word that has any meaning to me? And if it does, and is, who or what is that?"

There's another whole Jungian concept which I found helpful to me in thinking about Jesus: that Jesus is really important for people because God can be so large. God is often our name for the mystery of life that we don't understand. Jesus is a symbol of the self, the higher self, and Jesus is this picture of who we aspire to be. So that's made sense for me. But, of course, as a woman, that's a man as my image. And that's why I think the Virgin Mary is really important to Roman Catholics. Because it offers another kind of semi-divine person who can be the image of that self. But, of course, what that image is for women and men is problematic.

I just know that's going on for women in the church. In fact, there are a few women who are using a U/U curriculum now called "Cakes for the Queen of Heaven," which is really exploring early goddess and matrifocal religion. Exploring the idea that maybe at one time, if the gods weren't mainly female, there was at least a balance of male and female gods. Because Jung also talks about how our gods really reflect where we are in consciousness. And if we're only a male consciousness, then we're gonna create male gods.

I think women have been working on this stuff since the sixties, especially. It comes up in different periods of U.S. history, at least . . . sixties and seventies and eighties. And now if you look at bookstores, there's explosions of books about men and their fathers, and male spirituality. I think both men and women are exploring and finding new ways of being—which I find tremendously exciting—outside of some of our cultural definitions of what a male has to be and what a female has to be.

I feel like God's speaking to us to grow, to change, to move beyond that patriarchy. So that all humans, male and female, can live to their best potential. Blacks, whites, young. old, gay, straight—all people.

THOMAS FAHEY

Mother Teresa said, you know . . . I thought it was very good. I thought it applied to me. They said to her, "Well, you're not really solving the problem, the problem of poverty. All you're doing is taking a person here and a person there, and taking care of them, where the important thing is taking care of the root problem—poverty." She said, "Well, that's fine but that's my vocation. My work is to just take care of the individuals as I find them. And that's all I can do." And they said something like, "Well, do you think you're successful in your work?" She said, "God didn't call me to be a success. He called me to be faithful." To be faithful. And I would like to think that I was a faithful priest. Even though I didn't do any great . . . I didn't write any books. Nobody asked for copies of my sermons. [Laughs] Nobody comes up and says, "Father, can I have a copy of your sermon?" I've seen that with other guys, you know. I've seen some of the other priests get that done to them.

You know, I always wanted to be a priest from the time I was about fourteen and a half years old. I went to the high school with the intention of becoming a priest. I was the oldest in the family, the oldest boy. And by right, I should have my father's farm. See, I was cheated out of my rights. [Laughs] And yet, I must have decided that even then that there was an easier way to make a living, an easier way to make a living than farming in the west of Ireland. So I went to high school with that intention and, you know, I never backed off. Never backed off. I always had that goal to become a priest. I just wanted to be a priest. I'd say when I was a kid, I just felt that was a good way to get to heaven. [Laughs] I think so. I think that I wanted to get to heaven. Of course, a priest can go to hell quicker than anybody else. [Laughs]

They were very simple [people in Ireland]. And if the church said it, that was it. That was the law. This happened not too long ago. My mother . . . I don't know whether it was Jehovah Witnesses or Mormons came around to the house to sell her a Bible. She's an old woman, you know. She was about seventy or eighty years old at the time. They wanted to sell this old woman a Bible. She was the only one in the house. And she says, "No, I don't want the Bible." They said, "Well, you won't know how to serve God if you don't read the Bible." And she said, "Well, the priest tells me every Sunday what to believe, what to do." See, that's it: "The priest tells me." She didn't have to read the Bible. [Laughs] That's a fact! She didn't have to read the Bible to get to heaven! The priest led the way and she followed the priest. If he went to hell she went to hell. That's what I told 'em last Sunday. Matter of fact, they said in the seminary, they used to tell us: "Wherever the priest goes, you lead your people. If you go to hell they'll go to hell with you. If you go to heaven, they'll go to heaven with you."

I always said, I always still say, that I hope up in heaven they have a hurling pitch. That was the old Irish game. You played ball with this hurling stick, you know, and a green field with goalposts. And I hope they have a nice one up there. Matter of fact, I said this at a funeral the other day. That a lotta people think when you go up to heaven you get wings, and you get a long shirt like those guys in the clouds, with a long nightshirt, and wings, and a halo, and a harp, you know. Well, if that's what heaven is, I don't want to go there. [Laughs] I don't want to play the harp. I don't want to hear the harp. I just want to play hurling. [Laughs] Or maybe a garden. Maybe the Lord says, "Well, why don't you go out to that old planet over there?" Or, "There's a planet down there, nobody has ever worked in it. It's a good and fertile planet. Why don't you go down there and see what you can do with it?" Now, I would love the Lord to say that to me.

'Cause I don't want to go up there where angels and saints are just singing. As long as there's some tools . . . we'll have to build some greenhouses. But he says, "You can be over there four or five thousand years if you want to." Why not say that's good, huh?

I've enjoyed being a priest. I have. If I had to do it all over again, I would choose to be a priest. I would. Maybe I wouldn't be able to do anything else but . . . [Laughs] Old McIntyre [Cheyenne greenhouse owner], he used to kid me—you know, the old man, he was from Ireland—he said, "Well, anytime you want a job I'll give it to you." [Laughs]

I'd say I've been very happy as a priest. I haven't done anything very great, now. I haven't done anything very great, I would say. I haven't been a great preacher, I haven't been on television, I haven't been a great organizer, or anything like that. I haven't done anything very big. Still, I think I did small things, maybe every day. I think I did the best I could.

CHEYENNE
b. DECEMBER 6, 1919, COUNTY GALWAY, IRELAND

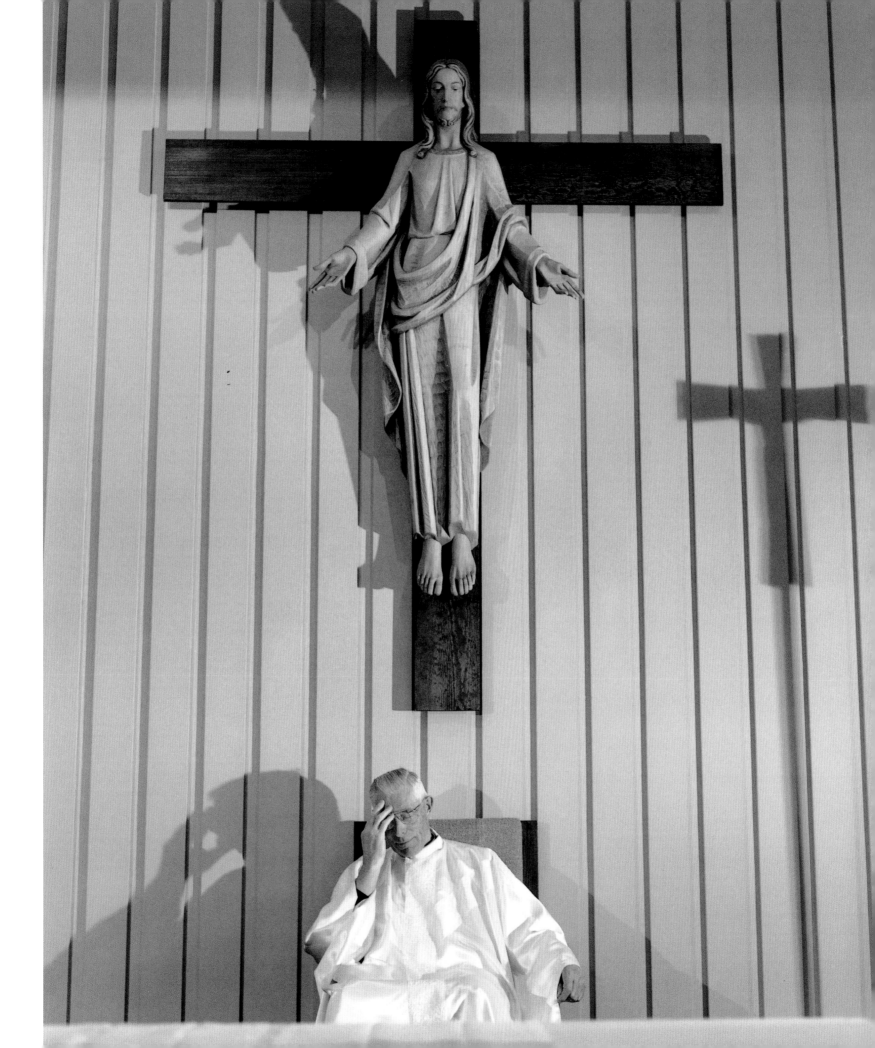

ABI GARAMAN

PHOTOGRAPHER, MAYORAL CANDIDATE

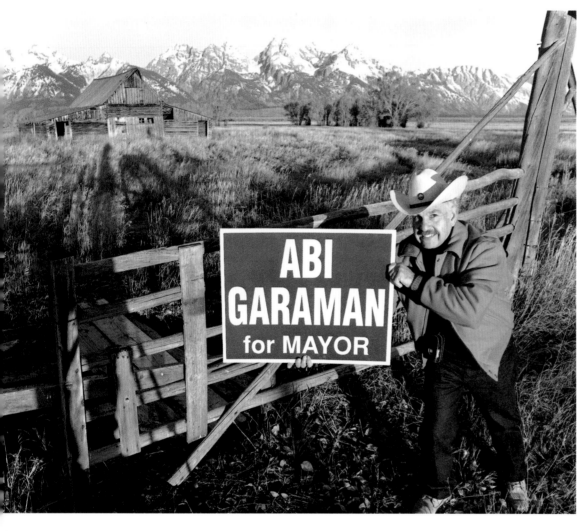

It's a shame that every time that I run for an office, any kind of an office, they have to have some crisis in Persian Gulf. It has never failed. Every single time they seem to manage that perfectly, timewise.

JACKSON
b. JUNE 3, 1929, TEHRAN, IRAN

My family ruled Iran for three hundred years and I was kind of a runaway. The idea was for me to come and get an education and go back and help the country. At that time the only way that the government would allow you to come to this country—and they would also exchange dollars for you, otherwise you have to go through a black market—was if you were in medical school or you were in engineering school. That was the only way you could come in. I didn't particularly want to be a doctor, so I went to engineering school at the University of California at Berkeley and then Davis. Then I went back a year to Davis and got my degree in agricultural engineering.

My hope was someday going back and really doing a lot for the country, but unfortunately when I went back, it did not really work out that way. The country was in such a mess and it just seemed hopeless. I am quite certain if I had stayed there, I would have been a dead prime minister. That would have been as high as I would have gone and that would be the end. I am very outspoken and because of that I'm sure I could not have lived in that country.

I remember when I was in San Francisco I was very, very depressed. I could not sleep. I even had to see the psychiatrist at school because I was just extremely homesick. It seems that the world, really, was just pretty bad. You can't speak English. I took my first midterm at UC in Berkeley. I told the professor that I couldn't even read the questions. She said, "I'm sorry. That's the rules. That's

just tough." So I had to learn. I went to movies. Sometimes I saw six movies in one night. Just sat there and took notes. There's still, from time to time, a few words come about that I don't know what it is. But of course, I know a lot of Americans that don't know what those words are, either.

I used to have a lot of accidents in the car. Ever since I've been in Jackson, for thirty-six years, I've never had an accident. But I had so many accidents constantly. I remember once—my wife was my girlfriend then—I made a U-turn. One of the city police in San Francisco stopped me. I was telling him I was just "manuring around." "Manuring around" instead of "maneuvering." And she just died of laughing.

Everything I think is in English. I don't think in Persian—or they call it Farsi, the same thing. Not even twenty years ago I didn't. See, what you do, really, when you come to this country you interpret everything from Persian into English. And now when I want to talk, I have to do it from English to Persian.

My family told me that I have no emotions anymore and I'm become a different person. That's true. I am a different person. My emotion is not the same as it once was. Once in a while it runs away with me. But as a general rule I am pretty much in control of my emotions. See, over there they take pride in being very highly emotional. That's why they have trouble over there. They don't use their heart. They think they use their heart. I got news for them. They use their stomach. That's not heart that they use. This is the way they live. I always have told them, "I cannot live in this country and be what I was then." Because of that, actually, I feel as though I have become a very logical individual. I analyze everything. And a great deal of that I owe to my wife.

Yes, it was rags to riches because . . . let me also tell you something. When I went back there in the country [Iran], and settled everything and came back, I didn't come back with money. I came back with me. I just wanted to settle everything and I told everyone they can have everything they want. I don't want anything from anybody. I came back over here. We used to have a penny piggybank. And movies, they were fifty cents. We used to get our pennies out and take it to the store, get fifty-cent pieces and then

go to the theater with them. That's how we really lived.

There was all kinds of things. One of them was . . . well, my family's all so rich in oil. The other one was, I was part of the Mafia. Everything except working sixteen hours a day, seven days a week. They all have figured it out how I got my money. And frankly, everybody thinks right now that we got a helluva lot more than we have. No matter what I tell 'em they don't believe me. [Laughs] So I say, "Okay." Also, I hear from other people, "And whatever he doesn't own he doesn't want." Frankly, people think we own much more than we do. If something was available, and I thought it was good, we were in a financial position to buy, I bought that.

People talk about "lucky." So and so is really a "lucky guy." Well, I don't believe in luck. I believe everyone, you and I both, have equal opportunities in this world. The opportunity comes, knocks at my door. I don't take advantage of it and I'm considered unlucky. The opportunity comes and knocks at your door, you recognize it, and you take advantage of it and you're considered "lucky." I don't believe in it. I believe you saw the opportunity and you acted upon it.

As a general rule people resent successful people. Take it, for example, in a bigger scale. Take Donald Trump. People resent him. He's probably a very bright, brilliant man in what he has done. And sure, many people hope that he'll go bankrupt. Why? He has provided jobs for all these people. Everything he has done is nice. In our small scale, everything we have done, there's nothing that we have done here that says we did it in a shoddy way. Everything we do, it has to be right because we want to be proud of it. I don't want to associate it with myself if it's not right, nice. I've always said that I cannot become a failure to become popular.

Frankly, I feel I have done more for this community than anyone. And I think mostly because I really care. I can quote you one letter that came as a letter to the editor by someone who never says anything good about anybody. Everything he has is bad. I put my name down as a candidate for mayor this time. This man hates everybody and everything, and his letter is never a compliment to a soul. He wrote—this is just word for word—"We need that radical Iranian for mayor. He is

conscientious and he's not for sale." Knowing the guy, I felt really good. "Radical" . . . anything he wanted to say, coming from him. 'Cause right now they think that's what the mayor is . . . selling himself right now. And that's a pretty bad thing. Lots of people think of me as being a very fair and very firm person. I don't threaten. I say something, I'll do it. And if I tell anyone I'll do anything, I will do it. And they know that. I've proven that before. I never promise. When I ran for the office I told 'em, "The only promise I'll give you is that I will not give you a promise." And that's what I did. I do everything to the best of my ability. I told the editor: "There is nothing I have done that I would say, 'I'm sorry I did now. I wouldn't want to do it again.'" I said, "I'll do the same thing again if I had the opportunity."

It's not just this community. I've done for the state. I was the one that came up with the 1 percent optional sales tax. That saved twenty-three counties of the state of Wyoming. Teton County this year will get four million out of that. I remember when I talked to Stan Hathaway, he said, "It'll never work." I said, "Have you tried it?" He said, "No." I said, "Then how the hell you know it won't work?" When I was in the council I brought the concept of town administrator. I hired the first town administrator here. I found his application in a garbage can because the mayor didn't want it, didn't want anybody there. He thought he'd lose his $400 a month. When I was elected to the council my job was the garbage department. I had 336 cars removed from this town. The compressor came and compressed 'em. This town was the messiest town, the ugliest-looking thing you've ever seen. Dirty. There wasn't a street that was paved in this town. And it didn't get paved until I got on the council.

You really have to be aggressive. You have to believe in yourself and what you're doing. I don't know if you heard about the annexation of us over here. You know, they're talking about annexing 840 acres, doubling the size. My comment on that was, "Unless you have a goal and you are headed for that, you're never gonna get there. You have to know where you're going if you want to get there." I knew all the time where I was going.

CAPTAIN

CARMEN SINGLETON

HULETT HIGH SCHOOL FOOTBALL TEAM

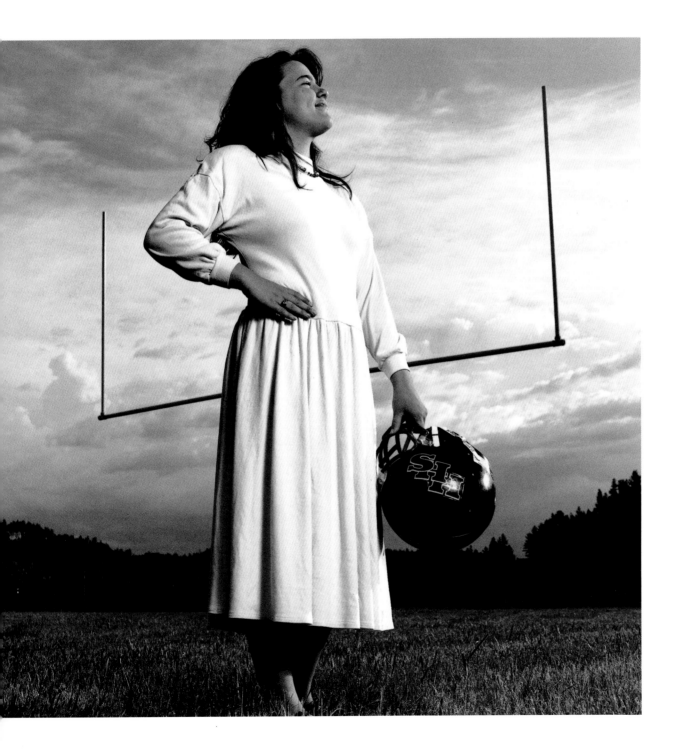

One-hundred-thirty pounds, five-foot-two. I'm a defensive end on the football team. I'll be the first girl to play all four high school years. There was one girl who took a year of junior high football and quit. But I haven't heard of anyone who's gone as far as I have. I'm supposed to be captain of the football team just because I'll be a senior—seniors get that honor—and because I played all four years and some of the other seniors haven't, and because if I do I'll be the first girl in the United States to be a captain of a high school football team.

HULETT
b. APRIL 16, 1974, RIVERTON

248

My dad wanted a boy. [Laughs] So I had the best trucks on the block when I was little. Every birthday I'd get a new cowboy shirt and new cowboy boots. I was never interested in dolls or anything like that, anyway. But I wanted my dad to pay attention to me. My mom was working as a bookkeeper at that time and she was never home. Dad was home more often than she was. I loved to go fishing and all that kind of stuff and I didn't wanta be left behind. 'Cause all my friends were boys.

All my life I'd rather play football. I took wrestling during grade school. I had an older cousin that I always looked up to, and he kind of pushed me this way. He said, "You're no different just because you're a girl." He told me that I was just as good as any boy. We played football all the time with him, and I'd go lift weights when I was staying with him in Riverton.

In towns like Hulett you're pretty much everything. Everyone has to participate in everything to have anything. I'm on the speech team, I'm in Honor Society, I'm in drama club, I take football, and I'm gonna take track next year.

Eighth-grade year, a paper was going around in my classroom. They weren't gonna have enough people to have a team the next year. I was just kidding at first. I said, "I'll play." Then this kid in my class—I'm not gonna mention any names—he said, "A girl can't play football." [Laughs] So that's all it took. I signed up. Then the school didn't want me to play football, so we had to take it to the school board. They said that there wasn't anything that said that a girl couldn't play football.

I was really scared [at practice]. They all sat there and stared. Then they were having bets on how long I could last. There were, like, hundred-dollar bets in some places. And some people would do anything to get their bets won, you know? They'd hit me so hard that I could barely walk, but I knew I had to keep on going. So I went and I went. The

first two weeks were the hardest. The first week we were all in training. Running and stuff like that. I was out of shape, of course. The next week we were in pads. It was terrible. There was a lot of resentment at that time. Then one of the captains of the football team and one of the biggest, most popular guys in the school, he stood up one day when people were teasing me—I'd just ignore 'em, you know, and walk away—and said that if anyone wanted to say anything else, they could talk to him. So that got me through a lot, right there.

I heard all this stuff later and I can't even remember some incidents, but, like, one time two people hit against me—this was always happening—and I got up laughing. That's one thing that everyone remembers because it was two of the biggest guys on the team and they both hit me at the same time, one from the front and one from the back. They said I got up laughing and that's just kind of what changed everything for them.

Some teams are really nice, you know. Like there was this one guy last year, he was from Big Horn. They came by and he said, "You're still at it, huh? I'm so proud of you." It was his senior year and he's gone now, but there's been a few other ones that've always been really supportive. When you go through the line—you know, shake hands after a game—a lot of teams usually don't even figure out I'm a girl until they're going to the line afterwards. We were playing a South Dakota team who just started having a football team. We went to the line and this guy says, "That is a girl!" I had taken off my helmet and I had a French braid in my hair. None of 'em had known that before 'cause Carmen can be a boy or a girl's name. That's what my coach has been saying to the reporters who call. "Do you have a girl on your team? Isn't Carmen a girl's name?" is how they put it usually. And he'll say, "Yeah, it can be a girl's or a boy's." He'll just kind of skip around the question.

My goal was to be accepted, and to try

out, and show 'em that I could handle it. And that's what I've done. I never made a goal to be a star. I wished I could but, actually, I don't think I'm very good. Everyone else around says I'm so good, I'm one of the best. I think that's more just because I'm proving something. I didn't want to be the best, you know? They outsized me and everything like that. I've tried lifting weights and running to get bigger, but I think the only way I could get bigger is fatter, and I don't want to do that. [Laughs] I've pretty much stayed at 130 from the very beginning.

I have just as good friends that are boys as I do that are girls. Like, a guy out for the football team one day, he was sitting there putting down girls, and I got mad. He said, "I wasn't talking about you, Carmen!" [Laughs] I said, "Well, what am I if I'm not a boy and not a girl?" They come and tell me their problems about their latest girlfriends and stuff like that.

I don't only get along with the boys. I get along with all the girls, too. They're completely behind me, too, and they say that they wish they had the guts to do something like I've done. I don't think it's guts. They say it's guts and determination. I think it's pride and stubbornness, or something. [Laughs] A little pride in being a woman, too. I said, "You could if you wanted to. If you want something just go for it, you know?"

Football has given me a lot of confidence in myself and I think that's probably helped the most. Speech has helped me in schoolwork 'cause I used to be really shy. I couldn't really go up in front of people and talk, and I've really improved in that now. I feel like I can do almost anything I try to do, you know? After thinking of all the trouble I went through to get into football and stuff, when I get to feeling bad and thinking, "I can't do this," I think about being able to go through football and all the problems I've had there. I think, "If I could go through that, this'll be easy."

THINGS WE LOVE

I think there's a lot that goes into a quilt, more than just the fabric and the stitches. Quilts are love, I think . . . just a lotta love.

HEART MOUNTAIN
LESLIE OTTO
HOMEMAKER, QUILTMAKER
b. SEPTEMBER 1, 1955, GREYBULL

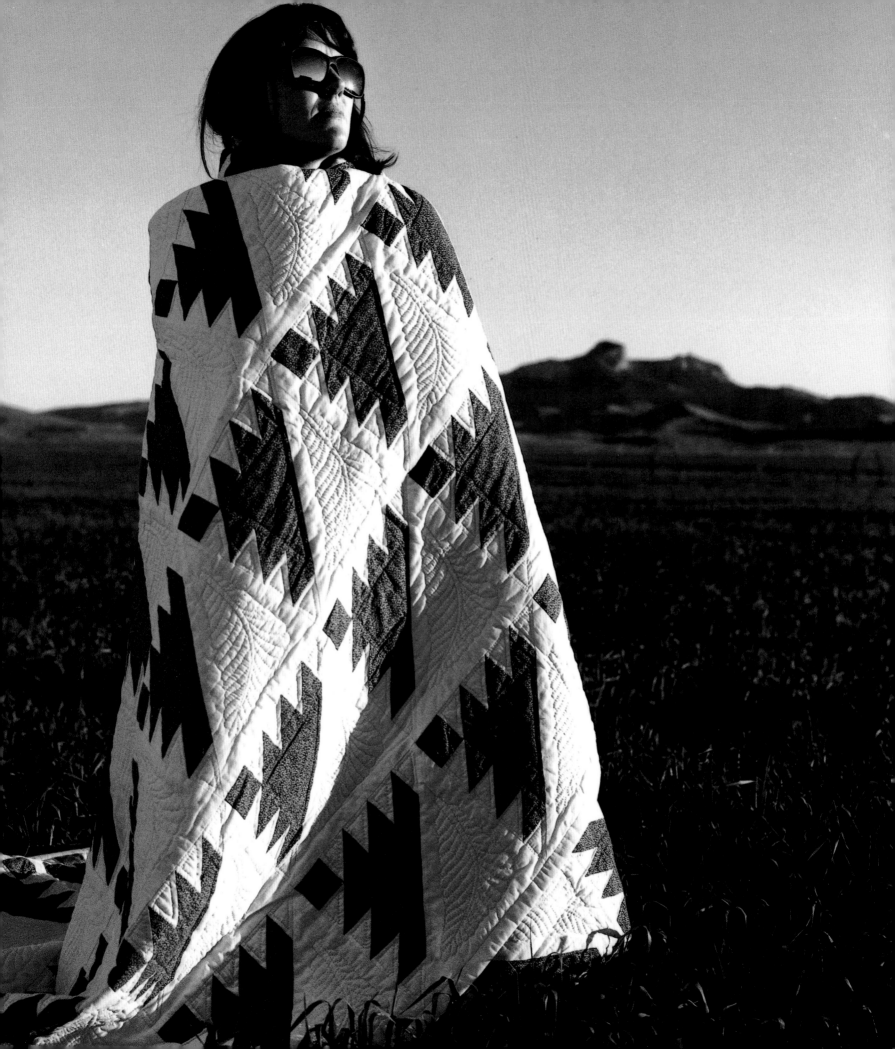

RICHARD CLARK

CHEYENNE LIGHT, FUEL & POWER

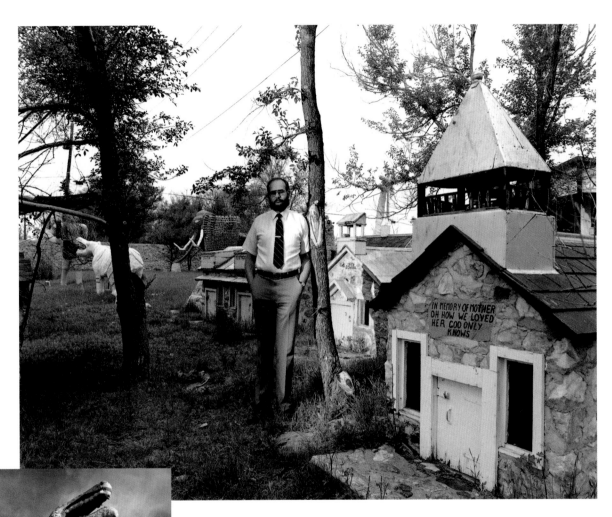

My grandma and grandpa would look down from heaven and they'd love the dickens out of it. I couldn't demolish this place. They could give me a bulldozer in a minute and say, "Go demolish that." I could in no way do that. That'd be like killin' my wife. That's somethin' I love. I mean, Good Lord, this is part of my life! How do you kill part of your life?

CHEYENNE
b. AUGUST 14, 1949, CHEYENNE

This is called Dinosaur Acres. Saraville . . . Sara, my grandma. They bought this place in 1947. It was the first place out here. They just put up an old tarpaper shack and it grew from here. This is twelve years of my life. I grew right here.

It's kinda interesting. I love to see all the people driving up and down the road gawkin' their eyes out. When people would say, "Where do you live?" I says, "The dinosaur farm." They says, "Oh, Good Lord!" Some of 'em said, "What a weirdo!" Course, they said that about a lot of things I've done in my life, too. Then other people said, "God, it must be great livin' there!" Well, it was great, except my parents were so much older than I was that I had nobody to cope with. I grew up very much a loner. Now I'm a very social person. I get involved in everything because I like to interact with people. But when I grew up I was kinda by myself a lot. Half my classmates at East High School and Carey Junior High thought, "This kid's a weirdo! I mean, he lives in a spook house. That's like the Addams Family and the Munsters." Good Lord, yes! But there was so many positive things.

It all started in 1955. In 1955 my granddad built a rosebed and a little arbor, and we used to grill these hotdogs and stuff on a Sunday afternoon and have a picnic. And that's all there was till 1961. They went on vacation in 1958 or '59. They went to what they call Petersen's Rock Garden. They drove their '53 Ford Custom Line, two-door hardtop out there, which I later cut up into a stock car. Anyhow, they drove that thing out there and they found Petersen's Rock Garden. Apparently Petersen's Rock Garden was some big, humongous bunch of property that the guy had just filled full of rock sculptures. And my uncle come back like a man possessed. He said, "I'm gonna do that, by Gadfrey." I says, "Oh, yeah? The only question I got for ya is, Why? What's your goal?" He said, "I don't know. I don't know what I want to do with this thing. I just

want it to develop as it develops." So he started buildin' dinosaurs. Why, I have not the slightest idea.

My grandma was alive at that time. She passed away in February of '62. She told my uncle, "Don't be fillin' the yard full of statues 'cause people are gonna tear 'em to pieces." My uncle says, "No, I have been to California to Petersen's Rock Garden and I'm gonna have my own rock garden." And he undertook to build these dinosaurs. This Gertrude that's standing out in the old dog yard, that's the number-one dinosaur. That was half built when Grandma died. Then he got on a kick. He wanted to re-create all the biblical scenes. So he went into what's called "God's Garden." My granddad, not to be outdone, said he was gonna build something in memory to my grandma, which is Saraville. And that's the little houses which are out here. They're all furnished. At least they were. I don't know who's broken into 'em and stolen everything out of there. The little train station's got an antique train in it. The airport's got an airplane in it. There's everything in there. I used to have to crawl in those things every summer and clean 'em. But I was much younger and thinner at the time. I could never even fit in those things now.

This place is his wife. He built this for Grandma. Then Grandma did the ultimate sin. She died. I mean that was the most horrible thing that happened. Grandma had asthma and it killed her heart. It wiped her heart out. She died in February 1962 and that was the ultimate blow to my uncle's psyche, basically. He could not handle that. He idolized his mother. She was a fantastic lady. Just very kind, very gentle, very loving. Everybody loved her.

They were perfectly normal people. They were just people that wanted to leave . . . Okay, I'll sum it all up: They wanted to leave their mark on the world. In a way they denied their mortality, in a way they admitted to it. They knew they weren't gonna be here forever. But they wanted to leave something

here that people could enjoy years after they were dead.

I call it somebody's broken dream. That's really what it is. It's something that they hoped would stand forever, and it has fallen apart and deteriorated to the point where it just hasn't worked out, you know. Their health . . . they thought they were gonna live forever, basically, and nobody lives forever. We know that.

I'm gonna tell you right now. I don't want a dime out of it. I couldn't care less if I don't make any penny. All I want in my entire goal is to see this place enjoyed by people again. You know what I'd really love to see happen here? You know the recent problems the state's had with acquiring a nice museum site? I'd like to see a nice museum put right out here and just have this as a testimony of Wyoming life and two men's creative genius. It is my uncle and grandfather, and I just hate to see it totally disappear from the face of the earth. 'Cause you can see the erosion that time and weather has done to it. I'm open about this place because my ultimate goal would be to get it restored or taken care of somehow.

. . . History, uniqueness, somethin' that you're not gonna find anywhere else no matter what. You could travel this globe thirty million times and never find a place like this. Nobody knows about this place 'cause it's been walled up away from the world. I'd like to see it preserved. I'd like to see somebody come in and take care of it that would appreciate it, that would have the ability to fix it up. You can't duplicate history. History is gone. How you gonna duplicate it once you throw it away?

JIM COTTERELL

EXXON SHUTE CREEK GAS PLANT

I started stoppin' at all these historical markers and there's a bunch of 'em between here and South Pass. I started stoppin' and actually saw the ruts. And it thrilled me! I couldn't believe it. I couldn't believe that for 150 years in this sagebrush . . . and you can still see the damn ruts!

Oh yes, oh yes. I walked in 'em and cried. You can't believe it. If these ol' ancestors, if the Mormon fathers out of Salt Lake City—or whoever has put up these signs, "Mormon Trail"—if the Mormon fathers and these people would walk this trail and just tried to set themselves back 150 years. . . . If they'd walk it, what a feeling they'd get, or at least I'd hope they'd get that feeling. And I'm not knockin' Mormons. I'm not, I'm not, I'm not. If I was as strong, if my convictions were like they say theirs are—and they're strong on their history, on their background—if their convictions were half as strong as mine are, my God, they'd guard it with a shotgun. You know? They would.

And there are Mormon boys out there at work that don't even know this exists? They don't even know there's tracks out here. I says, "Your ancestors, the people that went into the Salt Lake Valley, pulled their damn two-wheeled carts up these dirt roads, or up this track." I says, "You need to bring your kids out here and see this. Bring your children with you. If you're that into your church, bring your children out here."

People drive on the trail. They act like it's just another damn dirt road that runs out through the sagebrush. I mean, it's not. It's . . . it's . . . it's my history and your history. It's the Mormon people's history. It's everybody that lives in Oregon, Washington, California's history. And I see these goddamned 1100 X 15s, tire tracks, goin' up right by these concrete posts. I get so goddamned mad I could kill. You know, you see in the mud—ol' bentonite layin' on top of the ground—he leaves these damn ruts and shit. I see that goin' right up places where, my

God, nobody's traveled since them wagons. And now it's ruined. It's desecrated. It's like shittin' on the grave of Mohammed. It is no different than Moses leadin' the Jews out of Egypt. It's not different. I shoulda been a Mormon then, probably, you know? But I'm not. You see what I'm saying? It's no different.

You can go anywhere in the world and see mountains. I've seen 'em in New Zealand and I've seen 'em in Australia. I've seen mountains in Japan and they're nice. They're prettier'n these sometimes. But the anguish! There's no country in the world, none . . . think about it. Think about it! There's no country in the world that ever expanded its horizons like the United States has. Think about it. Never have. Never. Australia possibly comes close, but they didn't have the hardships we've had, you know?

I leave here in the morning. You know, in the wintertime it's dark when I leave, it's dark when I get home. Especially this time of the year I start thinkin' about it. I see the ol' prairie greenin' up. And they all came through here. They came through here about the third week of July. I get to thinkin' about it and I think, "My God!" 'Cause the old prairie dries out. It dries out bad. The ol' hot winds, you know? And I think about the dust. I see them ol' dust devils. I think about them poor people troddin' along behind. And you know what really pisses me off? You see *Wagon Train*. Did you ever watch *Wagon Train* on television? Makes me sick. I'm not sayin' I know all about it, but I know damn good and well they didn't do that. They made ten miles a day, these poor people did. Mosquitoes? Didja ever walk down on the Little Sandy in the late summer? Deerflies just chew the shit outta ya. Mosquitoes and just . . . it's terrible. I often wondered why the hell they didn't follow the Little Sandy till I walked down to it one day and I couldn't get away from it quick enough.

It's unbelievable. And we were talking about the kids. I mean, how would you like

to leave 'em in a cold grave? Out here in this . . . God, it'd be unbearable! And to go on with your cattle, and your cats, and your dogs, and all this crud, and leave something that precious, you know?

Sometimes I think people think that I get on my high horse, my soapbox, and start preachin'. And God, I probably shoulda been a Baptist preacher. But boy, I tell ya what, if I felt as strong about my religion as I do this . . . And people tearing it up? Omigod, you can't . . . people do not understand. They do not understand. They have no idea of the hardships.

Nobody knows what's in my heart. I tell you what, I can sit here and just . . . ooooooooooh, it's an overwhelming . . . God, it's hurting me, an ache, to know that one hundred years from now this will be gone. It will be gone for my grandchildren or my great-grandchildren. If I could have a great-grandchild live out here and say, "Well, you know, my ol' daddy or my ol' great-grandpa . . . see that ol' sand bank right here along the Little Sandy? He had a place right here." This place'll be rotted to the ground, but wouldn't that be a thrill to you? I mean to me it would be. And for them to have the love for this one hundred years from now and say, "Two hundred and fifty years ago wagon trains rolled out along here." It would be amazing. And we could have that.

I just . . . I can sit out here and look at this trail. Oh, you can't believe it. I don't want to sit here and start bawlin' in the tape recorder but it's unbelievable. I can't believe it. You know, I've set here and ranted and raved for two hours, three hours, now about the Oregon Trail. And it's somethin' that I just don't think anybody can understand the way I feel. And I feel that way. I just do. I do.

And I tell you what, I hope it's here for the next hundred and fifty years.

FARSON
b. OCTOBER 30, 1953, LAWRENCE COUNTY, ILLINOIS

ATTORNEY

LAWRENCE ENO

I was always interested in the westward migration. Even when I was a kid, I remember going to see The Covered Wagon. *Just a tremendous thrill. Great movie. Then when I studied some American history in college, you realize that this was one of the great migrations of history, one of the great folk migrations. You read about something that happened like the migration of the Israelites out of Egypt. Happened thousands of years ago. And here was a folk migration that took place just a short time ago. More people involved. The whole center of gravity of the United States changed when the people moved from the East to the West. I think it's a fact of primary importance in considering our country's history.*

NEW YORK CITY
b. JANUARY 19, 1914, NEW YORK CITY

I have friends in New York who are interested in the West. We had a Westerners' group, actually, for a number of years. And we had some very distinguished people in that group. One of them was Mari Sandoz who wrote *Old Jules*. Another was Al Josephy, who was probably the most knowledgeable man on the American Indians or the Indians in this hemisphere. And Jim Horan—a little later period—it was the desperado era that he was interested in. Harry Sinclair Drago, Peter Decker. Peter Decker was the man who was responsible for the assembly of the Beinecke [Yale] Library. He was a dealer in old rare books, particularly in Western Americana books. So I would get a lot of help from them.

Now, I got into the group through Peter Decker because he used to have a place here on 57th Street. He had a lot of rare books, and books that were not so rare, and a lot of Western Americana. He was a crotchety old fella but a great man. And I went up there . . . the first time I met him I said, "Do you mind if I look around?" He said, "No, go ahead." I went around. Sure enough, I spotted a book I wanted. I came back with a book and I said, "I'd like to buy this book." He says, "I don't know that I want to sell it to you." [Laughs] I said, "I thought everything here is for sale." He said, "No, you can look all you want." So I said, "Well, when will you make up your mind whether you'll sell it to me?" He said, "Call me in a couple of days and I'll let you know." He sold me the book and we became good friends. He was the one who said, "Come on up to the Westerners. You'll like it."

I guess it was just about '56 that I took a trip with my wife and children—two kids, two boys. And we drove across country. During that trip I began to see things I didn't believe existed anymore—artifacts of past American history, places that I had assumed would have been plowed under. I became interested, thinking about what I could find if I began to look around in the American West. I started off with studying, to some extent, the fur trade. During the winter I would read and plat out a trip that we could take. I really tried to see whether we could find these various sites while they were still there. And that's how it started. My wife would come with me. I don't think she was as excited about it as I was. I'm sure she wasn't. She's a wonderful wife, Ruth.

I think psychologically it's important to understand the migration. It's important to understand the kind of people who made the migration. And they were very diverse people. They weren't all the same kind of people. In recent years more and more study has been given to it, more and more books have come out, more and more compilations. When I started, there was very little. There was an author by the name of Irene Paden. She wrote a book, The *Wake of the Prairie Schooner*. Well, I got hold of that book and it was a wonderful book. She was a wonderful author. I fell in love with that woman just by reading her book. She was so good-humored. She took things that happened in stride. She never was fazed. She kept everything on a sensible scale. That book showed you what the real romance of the migration was.

I think what's happened, though, insofar as these things are concerned, is that they're becoming commercialized. Now, what I'd be interested in is the preservation of the trails. And the best way you can preserve something is to let it alone. Course, there has to be some rehabilitation sometimes. If a grave seems to be vanishing, just prop it up or something like that. But when you get hordes of people they trample over everything and it loses its character, and sometimes it loses its quality as well.

BARBARA MADSEN

We had looked at some other ranches that didn't have the history, and we would have bought one. I mean, it wasn't a prerequisite for owning a ranch, but the fact that it was historic just really caught my interest. We looked at it and said, "Ahh! These buildings! They need so much work!" They really needed to be preserved and we felt like we could do it.

SOUTH OF BUFFALO
b. APRIL 26, 1941, OMAHA, NEBRASKA

The TA was an important site in what may have been a local [Johnson County] war, but it was an important conflict that happened in the West. And by preserving the TA Ranch we can at least preserve part of that. It's kinda like the Civil War, I guess, in a small scale. But to the people here it wasn't small scale. It was a very serious business. And there still are people who feel as strongly about it now, I bet, as they did in 1892. It really is amazing.

Therefore, we're trying to be very careful about how we go about doing this because, frankly, I don't know who was on what side of the fence. Nor do I really care. I don't want to stir up any old feelings, but I think this ranch should be preserved. I don't want to do it for one side or the other, or anything like that. It just was a fact that happened. But there were some pretty awful things, you know. The shooting of Tisdale and a lot of things.

And I'm sure that there were things

on the other side that I haven't heard about—cattle rustling—that happened, although that's certainly different from taking a human life. This is just something that should be saved, and the state of Wyoming really deserves to have this ranch kept as close to what it was like then as possible.

We still use the barn. It's very usable and it still functions well. I guess if it got to the point where something is in your way and you couldn't function with it, then it becomes a problem and you'd have to make some decisions on priority. It's actually going to be better to use the buildings as they are now than it would be to try and tear them down and put up a new building. They're absolutely wonderful buildings, and they functioned well, and have functioned well, for at least ninety years. So I have absolutely no conflicts at all on that. I have seen a lot of preservationists who want to save everything that was ever put up. I don't really agree with that, either. People should

be able to walk into this yard and recognize the ranch house and say, "Well, I've seen that ranch house in *Banditti of the Plains*. I've seen it in *War on Powder River*. And the barn. Everyone recognizes the barn because it hasn't changed. It has a couple additions to it, but basically it's exactly the same barn. So that's my feeling about historic sites. But if it isn't an important event, if it's just an old hotel that was built in . . . I'm too practical a person to say you just have to save it because it's old.

I like old things if they're well done, but not every old thing is well done, either. I like to preserve what's good. For instance, the logs in those buildings, a lot of 'em are square-cut and there are some hand-hewn ones. They show a craftsmanship that took place back in that day and age that was practical and beautiful at the same time. And there are a lot of things about this ranch that are that way. I think if you destroy that . . . But why destroy it? It's wonderful to see.

BILL ROUSE

We got up about five o'clock, started walking about five-thirty, got up on top about two or three minutes after we could see to shoot. We saw a bull elk, and he spooked and ran right toward us and I shot him. Very easy hunt. I don't know why he ran toward us but he did. I thought there was probably somebody behind him. Maybe with the wind and the scent up there, he got confused. I saw one cow but there were probably more, from the noise. Shot twice. I think I hit him twice. It was just too early. It was pretty dark. I had the scope turned up too high for that distance. I was lucky. Just a white blur in the scope. He went about a hundred yards. I ran after him. I didn't run very far and I saw him. He dropped. It was all over. Two or three minutes of hunting and four or five hours of work.

I'm doing what I want to do. I'd probably like to go huntin' more, maybe be an outfitter. But maybe not. If I want to go huntin' I want to shoot the animal. I want to find the animal and shoot it. I don't want to go find the animal and say, "Here it is. You shoot it." I'm not into that. I like people but I don't like 'em that much. If they paid me $10,000 it might be different, but I don't think it would.

Huntin's the most fun you can have. You know, I can do a lot of macho things. That's not why I hunt. I hunt 'cause I love to hunt. I just do. It's a thrill.

RIVERTON
b. JULY 19, 1943, GUNNISON, COLORADO

HANSEN WHITEWATER
DAVID HANSEN

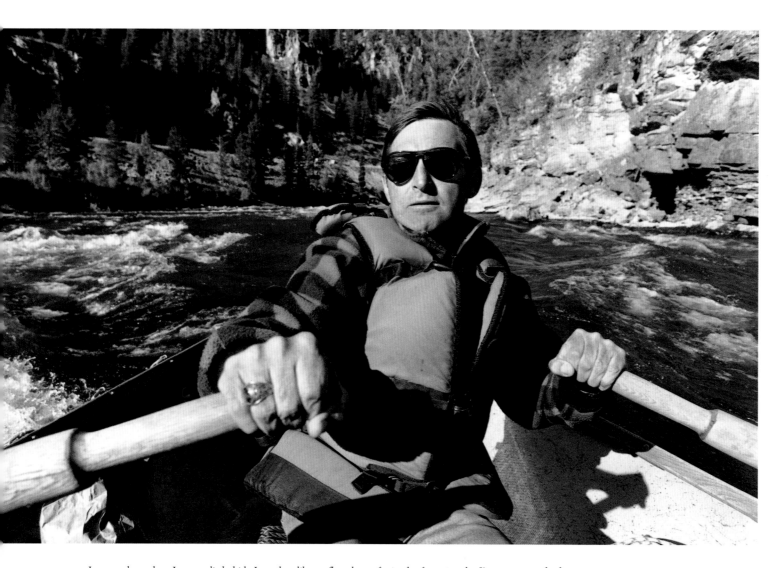

I remember when I was a little kid, I used to like to float log rafts in the farm ponds. I'm sure everybody did. Everybody thought there was a little Huck Finn in 'em, you know. And I always used to think about Huckleberry Finn and floatin' down the Mississippi. I get emotional about the river. It's really a beautiful place and especially this little stretch of water right here. The Snake River, this canyon. I don't think that there's a nicer, short stretch of water than this little particular spot [Champagne Rapids]. The water's outstanding. I don't know what it is that hooks you, but I like the river. I've put trips down this river every year since 1964 one way or another. I think it's probably everybody's wish to do something that they would do on their day off, too.

JACKSON
b. JULY 6, 1940, BRITT, IOWA

I don't have to catch a twenty-inch fish to have a good time on the river. I can't think of a better place to go fishin' and not catch a fish. I still get a dry mouth in the spring makin' the first run at Lunch Counter [Rapids]. When you have those six big, standing waves there? It's as big a rush to me now as it was then. And the nice thing about it is, the first time I went over it I can still remember that feeling. I can appreciate people when they turn around and look, and their eyes look like saucers. Because I know what they're going through. It's a special place. It really is.

The summer of '66 I went back to the river. By that time I had kinda fallen in love with the river. I ran some fishing trips during the first two years that I was at Signal Mountain and got a job on a boat floating the scenics. At that time there was nothing down here. Or, it was all here, it's just that nobody was enjoying it and nobody was floating it. First outfitter that I worked for on the river was Solitude Float Trips. He's still there, same guy's still there. That was in the [Grand Teton] Park. We did one of those terrible, long trips that everybody wished would sink about three hours out so we could call it off. It's too long. This trip was about five hours, twenty-five miles. And that's a long time in the flat water and the sun. That got my appetite whetted for the river, and the next year another friend of mine from Jackson, Henry Tomingas, and I decided we were going to find somethin' else to do.

We were doing float trips by ourselves and Henry had a little shop in town. I came back up for the summer of '67. I guess Jackson just started to be the natural place for me to come in the summer after that. I liked the area, the mountains. You spend a little time on Jackson Lake and you're going to get hooked because those mountains are just overpowering. I spent a lot of the summer trying to convince Henry to float the canyon. All I had was the desire to do it. I didn't have the skill.

At that time there was no whitewater being run here. It wasn't really a big thing. There were a few of the big rivers—the Colorado, and the Salmon, and the big-name rivers. It didn't have the popularity that there is now, by any means, and there wasn't anywhere near the number of people. So we just messed around with it a little bit and did some special trips. We set ourselves up as

whitewater river outfitters. There was no permits at that time. The Forest Service could care less who was down here takin' a bath in the Snake River. There was no reason to really need a control on it at that time. We would do special trips out of dude ranches and some fishing trips. We'd do fishing with it and just run the rapids. We used mostly the old surplus military rafts, the old assault rafts, as they called 'em then. It was a great raft. They were tough and heavy.

These rapids not only didn't have names, they didn't even have a use by that time. I was in a pretty good scenic business on the upper river. But I had worked one long summer in the scenic, and I knew that after a certain number of those trips that I was getting to feel a lot like I would feel later at teaching school, that I just didn't really have my heart in this. I knew there had to be something better.

I had heard about the canyon. I had talked to people. And yet I didn't know anybody who had ever been down here, and I couldn't find anybody to go down here. I had now just become a budding river guide and I was ready to take on some stuff and look around. So I was trying to get Henry to go down. Henry was more or less balking at the idea. I was quite sure that he had been down. He was a native of this country and just the type of personality who would have done this type of thing because he was a good outdoorsman. He was a hunter and he was just somebody who was into everything—the kind of guy who would wire together a Jeep and take it to Canada or something, you know. So I thought if I could convince him to come down, he could show me the ropes a little bit.

So I took a few liberties with the truth. [Laughs] I told Henry, as a matter of fact, that I had been down here with a mutual friend of ours, Jimmy Guest, who is also a Jackson native, and that this was just a tremendous little ride, and this is what we ought to be doing rather than cooking chicken on Gros Ventre Island and trying to hide our eleven herbs and spices from the prying housewives who were on our trip. So one day it was hot and everybody needed a break, and I convinced him to come down here with that Jimmy Guest story, knowing full well that he could carry the mail and we'd have a great trip. We took this little seven-man assault raft

and started down the river. We were going through some great water, and the waves were bucking and I said, "Now this is what running a river ought to be like." We came around the corner and the wind was blowin', and the caps off these waves started comin' up the river, and it looked something like the rolling surf on the ocean. I'm sure, being our first-time whitewater trip, that the eyes were a little bit bigger than the waves, but it was still pretty formidable-looking water ahead. I couldn't tell what it was, so I turned around to Henry and I said, "Henry, uh, what in the hell is that?" I guess you had to know Henry to know that look on his face—he had kinda that little cat-that-ate-the-canary grin—but he looked back and he says, "Hell, I don't know." He says, "I've never been here either." And right then I said—I guess that happened to be the vernacular of the day—"Well, if we're ever gonna get our lunch we're gonna get it right now." We went over that first wave and I swear it looked like it was forty feet down the other side of the next wave, which, again, my eyes were way bigger than the waves. But we got through that thing. It was such a rush, an adrenaline rush. We looked at each other and both of us just started hootin' and hollerin'. And I was hooked. I mean, that was it. And he was too. We knew that we had a good thing goin'. If we could just get this thing under control to keep the boat right side up, we had a real good thing goin'.

Of course, legal climate in the country at that time wasn't anything as it is now, and I suppose that insurance and things like that were the farthest things from our mind. We just wanted to get a boat that would hold air, and a van that would run from here to there and get down the river. And that's how we went out and sold it. We used to just kind of laugh and joke about it when we'd come by. We'd look at that thing and we'd just call it "The Old Lunch Counter" waitin' to gobble 'em up, waitin' to serve it up. I guess if we'd been more aesthetic . . . I always wanted to call it Calamity Jane. In fact, I even named a boat that. But it was too late. It was the Lunch Counter Rapids. Somebody wrote it on a map or something, and so it's been the Lunch Counter ever since.

RICHARD KAUMO

Around the state they call it "Wop Springs." Lotta Italians here. I know when we was in high school you'd go to Cheyenne or someplace, like on a track meet or whatever. Or just go down there and introduce . . . "Yeah, I'm so-and-so from Cheyenne. I'm so-and-so from Casper." And you say, "My name is so-and-so." And they said, "Rock Springs." They could just tell by the name where you was from. [Laughs] Lotta Italians, Slav, German. There's every nationality in the world here. It's a melting pot.

I always wanted to play the accordion. My uncle played it. Seemed like everybody in Rock Springs played one. Lot of accordions in this town. I grew up with the sounds of the Slavs, Italians. My neighborhood was all Slav and Italian. Still is. Some of them people are still livin' down there—old-timers. They're in their eighties now.

Accordion's comin' back. It's like it's gettin' rediscovered. It's been pushed off to the side so long, and then all of a sudden somebody brings it on and it catches on. Joey Miskulin is doing wonders with accordion down in Nashville. Down there in a country-western business. There are a lot of country-western stars that have the accordion. Even the old Sons of the Pioneers had it. Your movie themes. Galla-Rini played in a lot of movie themes. One was *High Noon*. He did the accordion in that. Accordion's been around. Anthony Galla-Rini said in his book he wrote, and he told me in person, he says, "Accordion's been sinned against more than it has sinned." 'Cause people don't understand it. They never did understand what it was. It wasn't hip, it wasn't electronic, it wasn't the sound of the age: rock and roll. But what is American music? Closest thing to American music is polka. Jazz is a break-off from Africa. Country-western is not true American.

When you make people happy that's the thing. That's what it's all about. Music. Doesn't matter what kind of music. Big-band stuff. Anything. If people enjoy it, that's what it's all about.

There's a lotta people that love the music. Now, like the Polka Festival, you get 'em from five years old all the way up to eighty. That's where it all starts, is that young. Somebody's got to keep it going and that's where you start it at. Basically, I'd say probably the average age at a polka festival is between forty-five and fifty-five. Somewhere In that area. Some are older. Some are a lot younger. Lotta people come that heard so much about it . . . say, "Well, I'm gonna go take it in." We had a bunch of motorcyclists one time come out there. You know, I thought they was like Hell's Angels–type stuff. I couldn't believe it. Boy, they had a good time. Never bothered nobody. And that's somethin' else you never see at a polka festival. You never see any trouble. The people that come there, they come there for a good time. They don't come there specifically to drink or whatever. They just come for the good time. The music dictates your mood. Drinkin' is a part of it but you never see 'em really get soused 'cause they're so busy. They dance it off. They're not there to, like, go in a bar and sit down . . . "Yeah, I'm gonna go out and get drunk tonight." That's not their attitude. They go out to have a good time. Sure, it's family. You bet. It's a family get-together. Friends. If you don't know somebody, you will know 'em.

"Richard Kaumo Polka Band." That's what I go by. We never rehearse. We never practice. We just go to a job and play. My label is *Coal Town Records*, from Rock Springs. Yeah, coal. See, no matter how tough times get, I know with that accordion I'll never go hungry.

When you do somethin' you like, and then you happen to get paid for it, that's just a bonus. When music becomes a job to me, I'll get out. I'm done. When it gets to the point where it's not fun anymore, forget it.

Somebody says, "When you go to heaven you get a harp. When you go to hell you get an accordion."

ROCK SPRINGS
b. NOVEMBER 29, 1947, ROCK SPRINGS

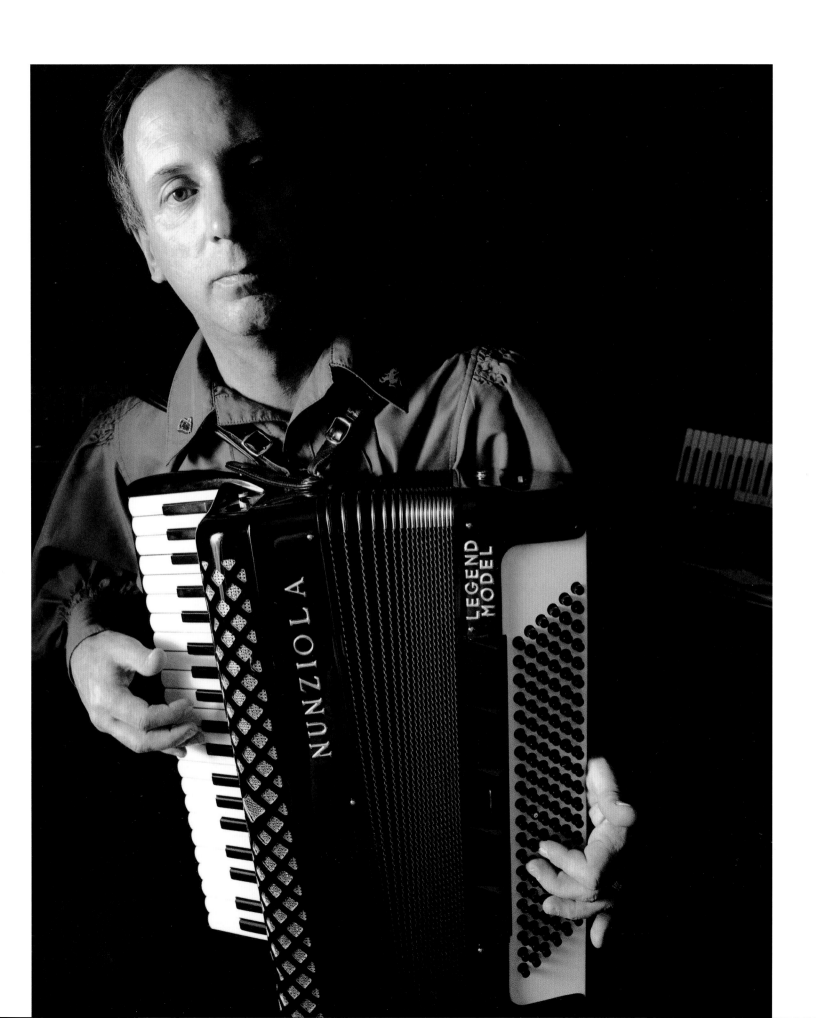

BROADCASTER

KEVIN McKINNEY

SPORTS INFORMATION DIRECTOR
UNIVERSITY OF WYOMING

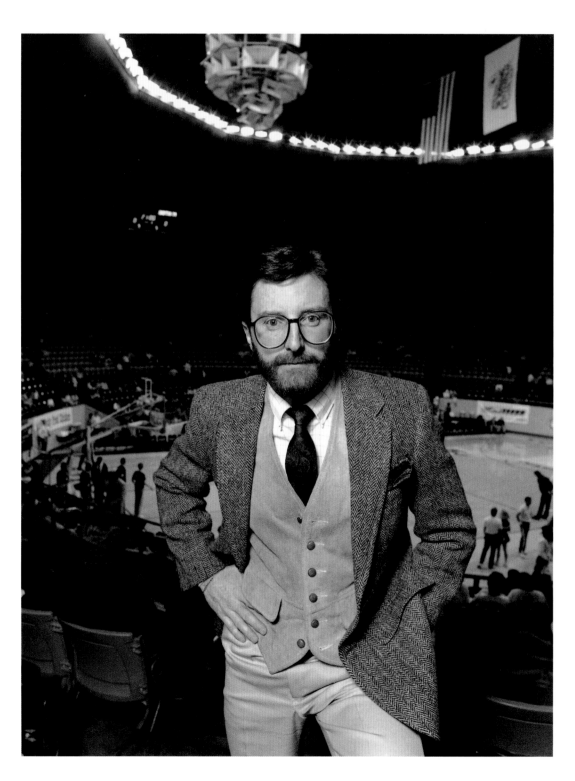

If somebody said to me, "If you could do anything you wanted to do, what would you want to do?" I would still to this day say, "I would like to play for the [St. Louis] Cardinals." I can't think of a better life.

LARAMIE
b. JUNE 4, 1949, CHEYENNE

264

Lotta people think I have a great job and they would love to do that. Going out and playing ball every day in the parks, and the game, that's my greatest fantasy. Now, I am doing about as close as I could to what the fantasy is. I think a lot of people in my business are that way. Weren't good enough to play, couldn't coach, and so they wanted to be associated, they wanted to be involved. And that was the way it came about for me.

I think that about the first SID they had was about '53, '54. Bill [Young] came in '60. I officially took over as the SID in '75. I'm the third SID ever in the school's history. Wiles Halleck was the first one. Wiles Halleck became the commissioner of the PAC-10. It gives you a little sense of history and pride to know that you're one of the few.

It's become much more of an administrative job than it ever was before. Before, I did everything in terms of layout and design of things and the writing. I'm getting less of that. It's more dealing with the phone, which is a big part of administration. I don't like it. That's [writing] what I was trained to do and I love doing it. I love sitting down to write. I love to work on things like that. But I have no time to do it anymore. The broadcasting does not cut in or I wouldn't do it.

It's great excitement. But I feel, every time this [current UW basketball success] happens, I can go back. Maybe only a few of us can. I sit there and I say, "I will never get over this." Because I was at the field house when we maybe had a thousand people or two thousand people. Everybody thinks this is great but they don't know how great it is. I do. I was there. And I'm excited, and I'm proud of it. Those are probably my two biggest feelings. I want to get it going. I want to see how we're gonna do. But I have got the history behind me. We couldn't get anybody at those games. We were poor teams and we were getting killed. And now I see this thing. At that time you said, "Well, basketball, wintertime, so many games . . . you'll never draw." We built a 15,000-seat arena and you sit there and you say, "It's too big." And there it is. Right down there. We're gonna have a bunch of sellouts. It can be done. And it has been done. It may never again. But it did happen.

I'm proud of what I've accomplished and I'm proud to be a part of this program. But there are people who have gotten into lines of work where they're dealing with life and death every day . . . that are stories. If they stopped athletics tomorrow at this school, the school would still go on. But it wouldn't be the same. It wouldn't be as good, I don't believe. It wouldn't be as interesting. It wouldn't be as exciting. But the institution and academics would live on and does so. A lot of places don't have athletics. If they stopped our operation tomorrow, we'd get a little flak about it. And there'd be somebody else who they'd bother and call. But the thing that's always bothered me through the years about administrations is, they feel like promotion and information can be cut when, in reality, it really can't. But they'd never know it until they did it. So they'd cut, and we wouldn't have a job, and you'd go on.

We could become a Nebraska. See, the population holds you back a little bit. Therefore you don't have as much money to recruit with and do some things with. But I think that Wyoming—really why, I'm not sure—has always been considered a quality program. And we had some real bad years. But it's always been considered quality because we had the feeling in this state that every time you played somebody, you felt like you were in a game. And that's what Wyoming does. Wyoming may not win, but they'll knock the crap out of you. And people appreciate that effort. And that's how Wyoming plays. You don't come here unless you're willing to play that way. Because it's a tough place. You gotta be pretty much mentally tough to live here. You know, we go to San Diego or Florida. How much mental toughness does that take? And Miami's done a great job. But most of the time it's that we're mentally tough. So, we may not be as fast—we're more mentally tough than you are.

I think that's why we'll always have the opportunity, the potential to be good. Because it means so much to Wyoming. I can't explain, seeing these people and the pride they have. You can't explain it. You can't put it down on paper what a guy feels like because the name of his state is out there in the national limelight. I know. I am one of 'em. I can say that because I was born here. And I love this state. I wouldn't be here if I didn't. I love it. I just love this state. I'm very offended so many times by what is said about it. And I get it all the time. But it's beyond belief what it means to Wyoming to have us out there on television against UNLV in Seattle, Washington. Or to have Brent Musburger interviewing Fennis Dembo. Or to have the football team playing Iowa in a national game. You can't explain it. You can't put a monetary figure on it. It just means more than you could . . . And they've hung in there and they've supported us. Not to the degree they are now. But there's been a lot of people that have seen a lot of games out there when we were lousy. And those people are the ones I'm happy for. Those are the guys that'll always be that undercurrent in your state that want to have a good program. That is the nature of the beast. It'll never change. People love the whole thing surrounding athletics.

I think that it's one of those deals from our standpoint—you gotta let it happen. If you start dissecting and finding out . . . "Well, why would you sit there all Sunday and do nothin' but watch football?" And millions of people do that. It's fantasy. It's a fantasy world. They still perceive it as a fantasy world. Who doesn't like to go to Disneyland? Anybody? Do you get sick of Disneyland? No. It's that kind of a deal. You wanted to be an athlete and you weren't, or you were and now you're not. Or you want your kid to be one. Why? Because you get the notoriety. There's the money. There's the women. All the things that basically drive us, these guys have. So there's always that motivation. When you don't have the chance for it, you still say, "God, I wish I could." And, "I wanta watch it." But there's pride of city, there's pride of state, involved.

The Denver Broncos are a great example. Denver has great pride in that. The state of Colorado has great pride. And it's a regional deal. The Kansas City Royals are the best example of a regional deal. So are the Cardinals. Everybody rips Pittsburgh. Everybody rips Cleveland. But you know what? Cleveland's good in football. All the Cleveland people and all the Ohio people, they're proud of that. There's nothing they can do about the perception of Cleveland. There's nothing I can do about the perception of Laramie. Everybody's always gonna perceive Laramie as they do: frozen tundra, windy. But you know what? I sit there at the games and say, "We just kicked your butt."

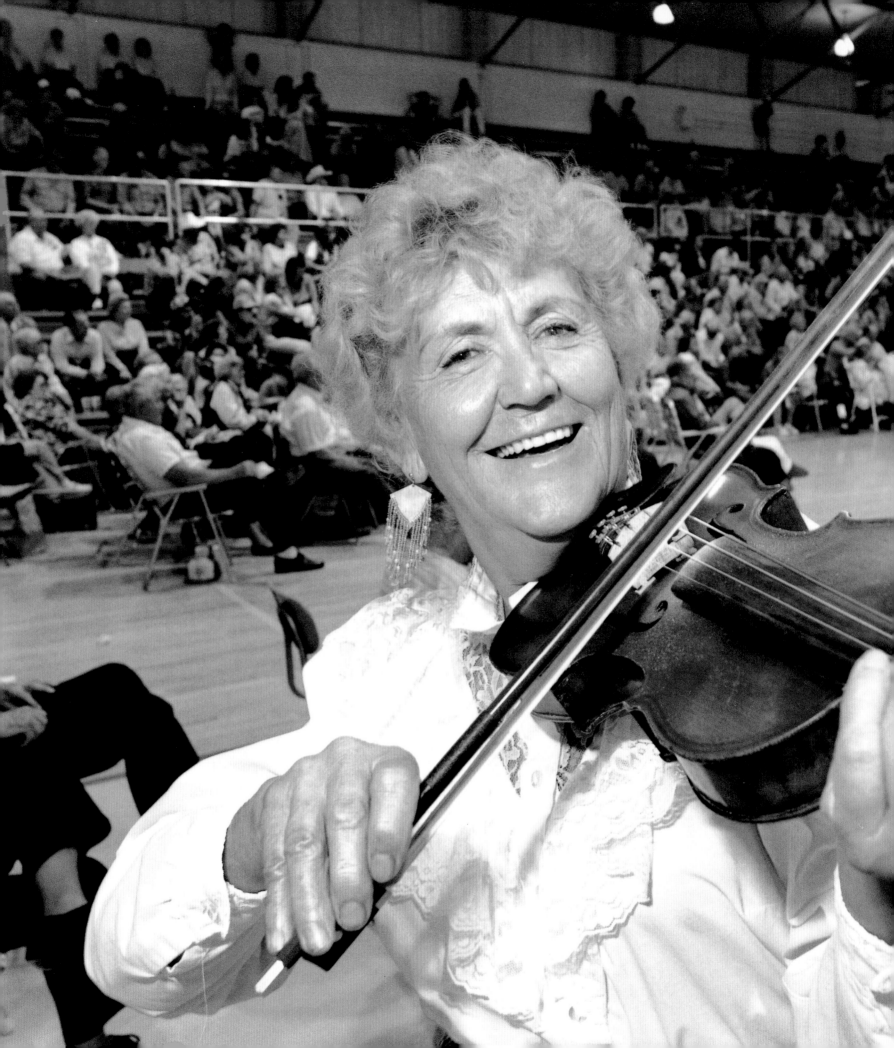

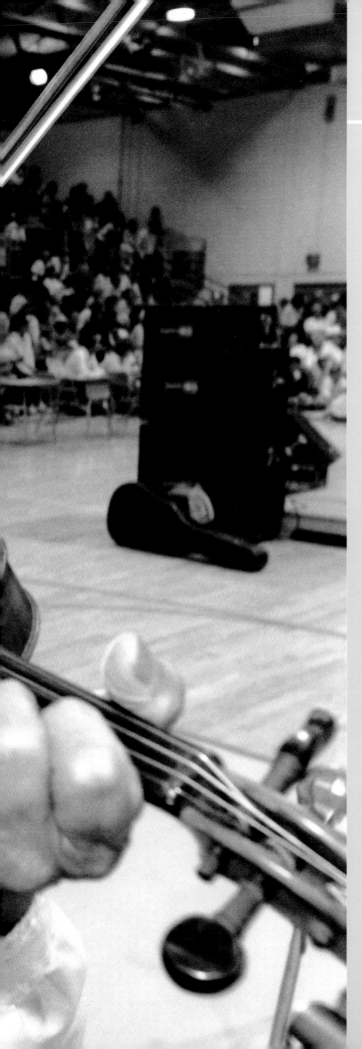

Really, I guess I'm not gonna ever be retired. I'm retired enough. I'm very independent. I can do what I want to all summer long. So I guess I'm about halfway retired. I'm havin' more fun in my life than I ever have with my music now. I don't have any kids that I have to worry about finding a babysitter for, and I don't have a husband setting there gripin', tellin' me, "get home."

I think I'm doing much better in this period of my life than I ever have 'cause I know what I'm doin', and where I'm going and . . . well, like, if I wanta go out and do more with my music I can do that. All those people that come down to our senior citizens' dances, they got the same attitude I have. They may have heart attacks but they're gonna have smiles on their faces 'cause they're gonna drop dead out there on the dance floor.

There's lots of things I'm still planning on doing and I've really gotta crowd 'em in. I wanta be one of these bunnies at a Playboy Club (Laughs). I can dream. I'm gonna go to Nashville, get on the Grand Ol' Opry, you know, things like that. Yes, I'd like to. I know I'll never make it but I can always look forward to it just to prove to myself I could do it, just to prove to everybody else I could do it.

GREYBULL
CLARA McINTYRE
FIDDLER
b. AUGUST 6, 1926, FROMBERG, MONTANA

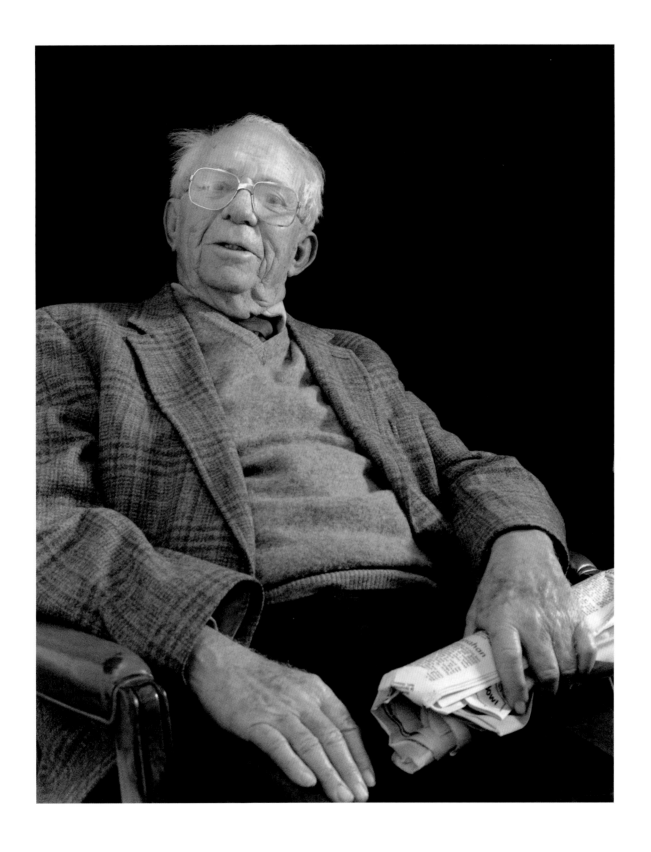

RODNEY GUTHRIE
JUDGE
WYOMING SUPREME COURT

I always wanted to be a judge. I think, probably, people that practiced with me knew that. I can remember in law school we used to sit and think that was the high aspiration. Now they think, "Hell, they don't make enough money. I wouldn't want to be a judge!" Now that's their attitude. But at the time I was in law school, well, things were different.

I liked being a district judge. I'd be lying to you if I said I didn't. But I would say the majority of district judges were happy with what they were doing and didn't want to be on the Supreme Court. They thought I was kind of a screwball wanting to be on the court. I used to say, "If I hadn't wanted to be on the court I wouldn't have become a district court judge in the first place!"

Oh, I'm retired now. The last six months I've been just loafing. I don't care much for compulsory retirement. It's always been my view that a fella that should be forced to retire at seventy probably wasn't competent when he was sixty. I've known a great many people, smart people, and some of them at eighty were as sharp or sharper than they ever were, and some of them at sixty-five commenced wandering. It's an individual thing. Course, maybe in order to eliminate those that should retire, you have to have a compulsory retirement system. But I don't believe in it. I think the federal system, where you can take a senior status, is much superior to compulsory retirement. Although, may I say, I have known a judge or two that should have retired before they ruined a good reputation. They were good judges, and they became bad judges, and didn't realize it, and hung on like, well, . . . just like a bulldog. They should have quit.

But it won't work because nobody thinks they're stupid. I mean, if they ever did have any confidence in themselves, probably the more senile they got the more they might have thought that other people were getting senile. It's just one thing that age does for you. And you have to admit, it slows you down. It takes me three times, or four times, as long to do something as it should. You lose just a little of the confidence in yourself. You could say to yourself when you're sixty, "Well, this is right" and close the door. You may do that now and in five minutes say, "Well, now . . . **was** that right?" I say you're not as decisive and don't do as much work, although I don't think the quality of your work is necessarily affected.

About the time I graduated from the University, I had a conversation with an old sheepherder. He was a noisy old fella. I said, "How ya doing, Ran?" And we visited. He said, "Rodney"–and he'd been drinking–"I always been wanting to see you and tell you somepin'." I said, "What?" He said, "Well, the way you're talking to me now and the way you talked to me last time." And I said, "What the hell ya' talking about, Ran?" He said, "You know, you go to law school, ya get all these honors. People say, 'Gosh, he sure did well in school.' But you haven't done the most basic thing that there is." I said, "Well, Ran, I . . . what the" He said, "You never have learned that self-praise is the very lowest form of flattery." He said, "You better take that to heart." (Laughs). I've told that story hundreds of times. And here's a guy that my family wondered, "Why the hell do you stop and talk to people like that?" Well, say, there was more real worth in that. In retrospect maybe that's the reason I always told my children, "Believe you're smarter and better than anybody else, but for God's sake don't let people know that's what you think. Now, you keep it to yourself."

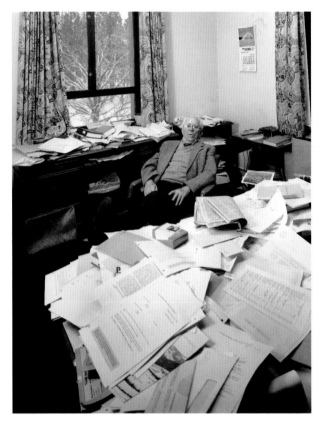

I enjoyed being a supreme court judge. I don't know, maybe it's just an aberration that I got when I was younger and didn't know what I was thinking. But I wanted to be a judge and I got to be a judge.

CHEYENNE
b. JUNE 10, 1908, NORTH OF MOORCROFT

RUBY MERCER
VOLUNTEER

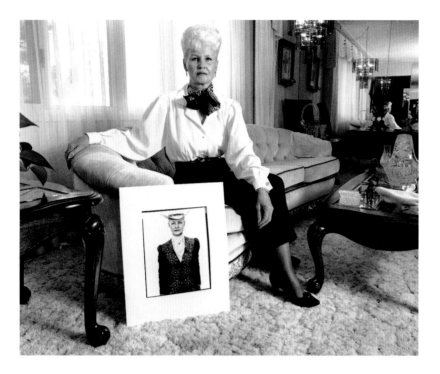

I was dressed in a glitzy western outfit, denim outfit. This gentleman [Richard Avedon] came over and wanted to take my photograph. He said, "I don't want you to smile. I just want you to look at this point right out here . . . and with a rather solemn face." I thought it was an awful photograph of me. [Laughs] He had something that he was trying to get from me and I guess he was happy with what he got.

CHEYENNE
b. JUNE 11, 19--, DENISON, TEXAS

I'm 109, how's that? I do that often when they ask my age . . . "109."

I have dismissed two words from my vocabulary. And that's "retirement" and "senior." "Senior citizen"—I don't use that. I can't fit myself in that category. I will never retire as such. I will always be doing something. I have devoted my time more, since I'm alone, to volunteer work. I really jumped into that heavily. More in Cheyenne than on the West Coast. I'm talking about the Cheyenne Frontier Days, and I'm talking about being on the Board of Trustees for the Memorial Hospital Foundation. I'm very much involved with Denim and Diamonds, a fund-raiser for Memorial Hospital.

Age is a state of mind. I firmly believe that. I see people my age and they're old. And I think, no way will I ever be that way. [Laughs] Sometimes I kinda rein myself up and say, "Wait a minute. You're a lady and you shouldn't be out movin' boxes around, or tuggin' on some bushes, or trimming trees." And then I think, "Well, as long as I can do it, I'm going to do it." I have talked to women that have experienced the loss of a husband as I have, and they sit and get sick. They have operations and they feel sorry for themselves. It's a shame that they get into this rut that they're in. They say, "Ruby, I don't know how you do things." I say, "Number one, you get off of your backside and you get up and you do. Do something during this time of the day and get out and do." Not that you don't have your moments that are so rough. But I've talked to many women that just go downhill. Naturally, the loss—your whole system goes through crazy, crazy, dumb things. I broke out with acne, and sleepless nights and all that. But if you dwell on those things, then it's gonna eat you up.

Cancer. He [husband] had an operation. It was in the upper stomach. He went the way he wanted to. He said, "I never want to be a dawdling old man." Now this is on tape, but it's the truth, so why not say it? He said, "I never want to be a dawdling old man." And I said, "I don't want to be a dawdling old woman." So we had an agreement. If we ever saw one another getting to that state, put the bottle of pills here on the night table and leave the room. We had that agreement a long time ago. He never got to that state. He was not ill. Thank God for that. No pain. The only pain, I think, was recovering from the surgery. He lasted thirty days. He chased me around the house the last two days he was alive. Yes. And I'm glad he did.

VOLUNTEER

STATE LEGISLATOR

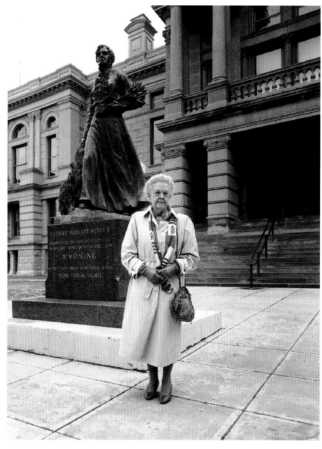

CHEYENNE
b. MAY 28, 1912, RAWLINS

Retirement to me means changing your way of living. You quit what you've been doing and you either move away to a nice, quiet retirement spot, or you go to your home and start reading more and maybe taking more trips, doing something different than you've been doing. That's not what's happening to me. I won't be in the legislature anymore. Maybe I wouldn't be if I ran again. There's never any assurance you're gonna get reelected until you do. But the legislature didn't take up the majority of my time. I'm involved in a lot of projects and interests in this community, and I'll continue doing that for as long as I feel comfortable doing it.

I said, after the last campaign for Vinich, that I was through with politics. I didn't wanta even know anybody that was running for office. I said this to [Governor] Sullivan. He says, "You talkin' about me?" I said, "Yes, even you. I don't want anything to do with politics." But, of course, I will.

Yes, I think I've had enough of that. I really think people stay in politics much too long. And I think even though you might be able to continue for another four years, for what purpose? Let somebody else do it.

There isn't one problem that would be why I was getting out. I just feel that sometimes it's time to leave something behind you. I firmly believe that people stay too long in politics. I just think that unlimited terms with the same ideas isn't a good idea. I don't think anybody ought to be there for more than two terms. Now I know that does something to a seniority system, but maybe that isn't all bad. I always said that I wouldn't be there more than two terms. The reason I

was there ten years: Reapportionment made one term of mine two years and I would have had six years instead of eight. So I decided to run again for another four-year term, which made it come out ten instead of eight.

I know a lotta people say they're going to do things, and then when the time comes they don't. It's a lot more fun to go out while you're ahead than to have somebody say to you, "I think you've been there long enough. I think you're too old. I think it's time for a change." Nobody came and said that to me, and I think I could've been reelected, but I just had to feel that it was time to let somebody else do it.

I think some of the younger ones look pretty good. It's not the younger generation

that bothers me, it's some of the old ones that have been hangin' around too long. They didn't get the message like I did.

I've got friends all over the state. I'll miss it. But it's sorta like maybe banging your head against the wall. Feels kinda good when you quit.

I think everybody needs a real reason to get up in the morning, a reason to feel wanted in the community and in your family, in your way of living. When the time comes that I'm not needed to do any of these jobs, then I suppose retirement will really set in. But as long as people ask me to help with something that I feel I can do, and it's something that interests me, I'm willing to continue doing that.

They call you "B"?

Yeah.

What's your full name?

Full name? I hate to tell anybody that. My full name is Raymond Paul Howard Evans. Now if that isn't enough to make 'em throw that away and call me "B," I'll give up.

When were you born, B?

I have to take several people's word for that. But it was June the 20th, 1904, as they tell me. At Adel, Iowa. My dad homesteaded and he didn't want to leave me behind, so he brought me along.

How many years have you been involved in this business?

I've been on my own fifty-four years. I worked for this man twelve years.

Do you like being your own boss rather than working for somebody else?

Oh, yeah. It's lots more fun. If you pull a boner, you know who to cuss. No, I wouldn't want a boss anymore.

Why did you ever get into fixing in the first place?

The fella I was workin' for sold 'em [tractors] and he told the customers we'd see that they were serviced. And he pointed at me and said that was the guy to do it.

Is this motto true you have on your sign out here?

Yeah. "If you farm with it we fix it." Well, you oughta see some of the funny things they bring in here that they farm with. Back in the early times they used to have a lotta trucks made over into tractors. Some poor fella that couldn't afford to buy a tractor—had an old truck—why, he'd make him some kind of a tractor out of a truck. And there's a lot of 'em that needed a bigger tractor that they couldn't afford. They hooked two smaller ones together. There was quite a bit of that.

Were those machines a lot more simple in the early days when you first started working on 'em?

Oh, yes. They didn't have any of this electrical, sophisticated stuff on it. The nearest thing they come to a cab on a tractor was an umbrella to keep the sun and rain off of you.

Do you rely on books? You know, manuals? Or do you just have it all up here in your head?

I don't use a manual very much unless it's something new that I haven't seen before. When I learned this business there was no manuals. There's been automotive manuals for a long time but they didn't get 'em on farm machinery until, oh, the last thirty years or so. I've got quite a stack of manuals, but about all I do is loan 'em to farmers that want to do their own work.

Are there little tricks to working on a tractor that maybe you've picked up over the years that other people don't know about?

Well, the biggest thing is, if there isn't something the matter with it, don't fix it. I've seen so many of 'em that will fix something that don't need fixing . . . and then it does need fixing.

Have you ever come up against anything you couldn't fix?

Well, not that I've heard of. There's been things that I've refused because I knew I didn't have the wherewithal to fix 'em . . . refused to take the job because I knew I couldn't do it. But I never started anything that I didn't finish that I know of.

Sooner or later, though, aren't you gonna run out of old tractor parts?

Heavens knows, that'll happen sometime.

What's your reputation around here, B?

Well, they come from miles around and even foreign states for information. I don't guess there's any adverse feeling about reputation. I haven't heard it yet.

Did you ever have any humorous incidents happen to you in all those years?

Yes, but I can't think of very many. I did tell one fella that come in that he dropped something on the floor. He stooped over to pick it up and he had a little age on him. It was a little chore for him to reach over there. And I says, "You notice my floors are sinkin'?" He says, "What makes you think so?" And I says, "Well, it's harder to reach than it ever was before." He says, "I know now what you mean."

I'll bet you've seen some characters come in here.

With the help of a chain hoist I was a-puttin' a big bull gear in the back end of a tractor. Farmer come in and he saw I had a pretty big job. So he come back to help me and he was a pretty forceful fella. He started to help me and he says, "Well, what can I do?" And I says, "Well, best thing for you to do is go home and feed the cows." He looked at me funny-like and he says, "Okay." And he went home. No offense, but there's some things that a helper is a hindrance.

You didn't like people lookin' over your shoulder?

That's disgusting. The worst thing, they tell you how to do something when they don't know.

Maybe they think they're gonna get it cheaper.

Well, I like the sign that the fella put up in his garage: "Our labor charge is five dollars an hour. If you watch it's twelve and a half. If you help it's fifteen."

What's been your typical workday?

Well, I get up when I want. I wake up. I work till I'm too tired to work and go home. That's all I know. I've put in long hours all my life.

Are you open on Sunday?

Not officially. I'm here nearly every Sunday but if I want to leave, why, nobody can say, "You're supposed to be here."

Shouldn't you be retired?

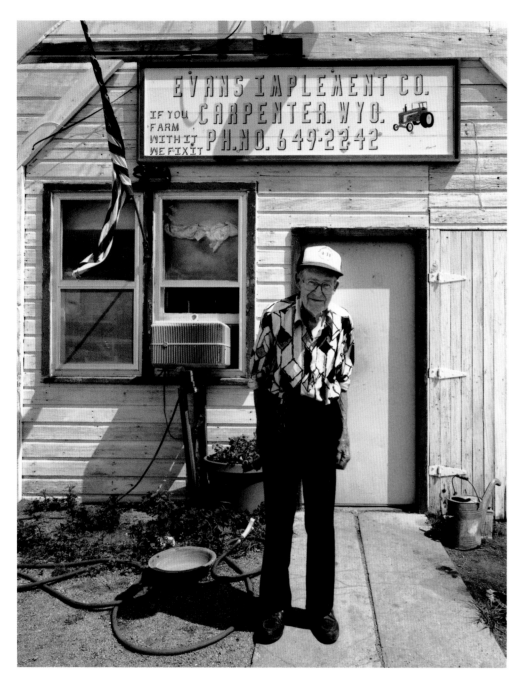

Retired? Like I tell ol' Warren Wisher, I've been retired for forty years.

How do you figure?

If you do what you enjoy, isn't that it? If I couldn't serve the community I wouldn't be happy.

How many more years do you plan to work?

Till I can't move. That's all I know. It'd take me another ten years to get caught up with what I'm behind on the work now.

You have seen a lot of change, haven't you, in the farming business?

All the difference in the world. It started with practically hand labor, hand or animal labor. I know the first tractor I ever saw was a real novelty. Now they got tractors that'll do darn near anything except take care of themselves.

If you had it to do all over again, would you do the same thing?

Do the same thing, only I'd do it sooner. But I guess I shouldn't kick. I've been here when there's been an awful lot of changes took place. When I first started, why, the biggest part of this farming was done with horses and mules. And I've taken horses and mules and cows in trades for down payment on tractors. Tractors for a long time you started by hand and then they got so they had starters on. And there was no such thing as pesticides and insecticides. Then if you wanted a weed killed, you either got him with the cultivator or the hoe. If you got ready to go to the field, why, you'd harness up the horses. So I guess that's all one guy should ask for, to see the advancement that's made in farming, manufacturing, technology, or what have you.

Do you think there'll still be farming here?

I don't know. I always liked farming. That's real life, I think. If anybody can make a decent living at it, he ought to be a real happy guy.

You never expected to get rich in the first place. You just wanted to make a good living, you said.

Yeah, I never did see that the rich had any more, or as much, fun as I did.

I went to Laramie for twelve weeks and was gonna teach school. I had a school all lined up for me, but I had to get a little more schooling in at Laramie. I was waitin' for the train, and I was helpin' out in the boss's store while I was waitin'. He asked me why I was going up there and I said, "Well, I didn't think there was enough around here for all of us." He says, "Oh, yeah, we'll find work." So I said, "Alright." And I hung up my hat, and I unpacked my suitcase at noon, and I've been here ever since.

CARPENTER
b. JUNE 20, 1904, ADEL, IOWA

BETTY SABLE

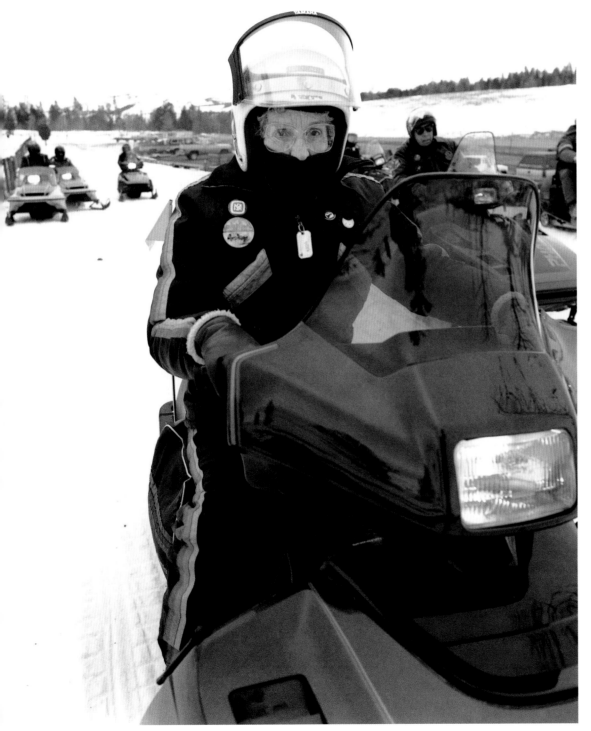

I think it's probably more of a love than it is a hobby. Like, Jimmy [husband] paints pictures. Now that to me is a hobby. And that's been really good because that keeps him real busy, keeps him out of my hair. I think you have to love the outdoors. There's people snowmobiling—even in our group that kind of always ride together—that I never thought would ever set foot in the cold weather. And they love it. They love it! Can't wait to go. But you gotta be dressed for it and you gotta be ready for it. This one gal, I mean, she's always been kinda prissy, I guess you'd say. I never could feature her on a snowmobile. And she dearly loves it since she got started with it. So I think this is why I say . . . like older people, if there was some of 'em that would show an interest in it and I felt would be able to go, I would like to take them out and give 'em a little ride, encourage 'em to get out.

You know, when we first started snowmobiling, there was a couple from Pinedale that was almost seventy years old. And I thought, "My Lord, how do those people do this? There's no way they can do that." Well, now we have eighty-year-old people. They're snowmobiling. We have disabled people snowmobiling. Yeah. It's just amazing. I really admire them and I hope that I can keep moving when I'm eighty—get on a snowmobile and go.

I wanted to take our grandkids through Yellowstone this year, and I made the remark that I might not be able to do it next year. My grandson said, "Grammy, now you know that you're gonna be riding that snowmobile for many more years."

LANDER
b. MAY 28, 1923, EDGEMONT, SOUTH DAKOTA

ELSA SPEAR BYRON
PHOTOGRAPHER

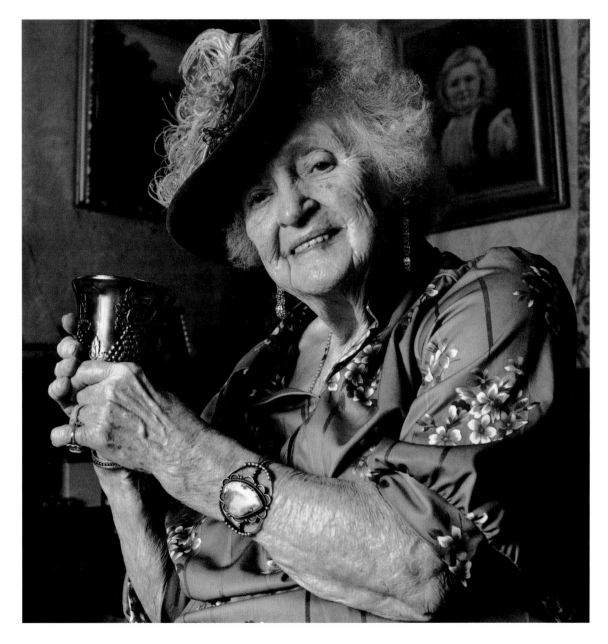

I'm still driving. This year—I mean in '88—I have to have a new license card. I was wondering if they're gonna let me have it. I had my exam the other day and sent it in. And they sent back word for me to go down here at the check station, and turn my card in, and have 'em do what they have to do to get me a new one. Well, I've had a license all my life, ever since they've had licenses. Nineteen-fifteen? '13? . . . '13, I think, is when the first license was out. I don't think there's anybody in town that's driven as long as I have.

SHERIDAN
b. JANUARY 21, 1896, SPEAR RANCH, BIG

EARL HARDEMAN
RANCHER

I hate to see the ranching go. But the people's got the ranches, and when they can get the money out of it, then they worked all their life . . . You can set here and raise a whole bunch of kids, and big ol' stout boys ready to go to work, but you can't go buy the neighbor out 'cause he can get fifteen, twenty thousand dollars an acre. Well, it don't make sense to try to get two hundred dollars a year off of some darned old cow.

I can't complain. This country's been good to us. I feel like the Hardeman family's worked hard. They started out here with nothing and went all these years. I don't apologize to anybody. But now my brother and I are gettin' a little old, our folks are both passed away, and the ranch is divided up now with our sisters, and everybody's got their own piece of ground. It's just not feasible to stay here.

People just loved us feedin' cows and everything out here. They've seen it for a number of years. They've took pictures of us and every guy said, "Boy, on a good day I'm gonna help you feed." He would come, but when it's snowin' and blowin' nobody stopped on that old highway and took a picture of them old horses and them old frosty cows when it's forty below. They just stayed in their car and went on down the road. Nobody left Hoboken, New Jersey, to come

see Hardemans' or Hansens' or Lucases' open space. They come here to see the Tetons and all the other mountains and everything. The people that lived here is the ones that didn't want us out. But they was trying to be a little selfish, in a way. They just wanted us to keep ranching. Yet, they understand. When you get sixty-five years of age and not too good a health, well, then you look for the easy way out.

I was in Salt Lake and he [doctor] told me he thought I had Lou Gehrig's, so I come back. I wanted to hear for sure so I went to Mayo brothers in Minnesota. Spent five days there with them and they told me, "Yeah, that's what you've got and there isn't a damn thing we can do for you. It just comes out of your brain, and your muscles just kinda deteriorate. There's no need of you going out here and trying to exercise and build up your muscles. They're just gonna kinda linger away." They told me, "Go home and get your affairs in order 'cause you probably won't live two years." Hell, that's been four or five years ago and I'm still around.

They never even told me to quit smokin'. I thought, "Well, hell, they think you're gonna die in two years so it don't matter." So I didn't quit smokin', and I'm still alive, and I'm still gettin' up, and still can ride a horse. I can't saddle one. I have to have somebody push my leg over. But I can run a tractor. I irrigate this place all summer, and drive my pickup, and I can get up to the table three times a day. Hell, I still drink a bottle of beer, and smoke this ol' pipe, and get up, and read the paper and my name's not in the obituary. I say, "Hell with her. Just go for another one." So I ain't gonna worry about her. [Laughs]

There'll always be cow people, and if I could come back and start over again I'd still be cow people. 'Cause I think that cow people are the finest bunch of people as a whole. It's like anything else. There's a few that'll rip you. But, you know, my dad raised purebred bulls for fifty years and I think

when he went to his—went upstairs—there was only one guy that owed him probably sixty, seventy-five dollars on a bull—and that was back in Depression times—that he didn't get his money out of him. I've seen him let cattle go out . . . course, you got to know the people. But he really had a good judge of kinda figurin' out people, whether they was cheats or not. I think he was kinda born with that. But I've seen him let cattle go out of here to go to Colorado . . . young guys wanted to get started. He'd say, "Oh, give me half of it and pay me the rest this fall." And he always got his money.

I've done a lot of work and kept up with my work pretty well, I think, but if somebody come along and I wanted to talk to 'em for a hour, I did. I mighta worked an hour later that night to catch up 'cause I got a little behind, 'cause I visited that much that day or something. But there's nobody gonna can me or fire me, or nothing else. Hell, I've seen that with my dad. Somebody'd drive up, and the boys and all of us'd stop and visit for an hour or so with our neighbor. Or somebody come along and we'd all stand around and talk. Well, we just automatically knew that we was gonna have to stay a little bit later that night if we was gonna get this crop in before it snowed.

There's so many things when you're a rancher. You take the cows. They can go along and all at once there's a new disease come along that you didn't even plan on. The cows abort their calves. Like, we went through the Bang's deal years ago. There's always new diseases comin' along. Old Mother Nature out there, you can have a helluva good hay crop all ready to go, it can hail on ya. It can kinda ruin your crop, take it away from ya, or it can turn so dry that you don't raise a crop. But in a lifetime you go through that. You roll with the punches. I mean, it's not the end of the world.

JACKSON HOLE
b. JANUARY 4, 1925, JACKSON HOLE

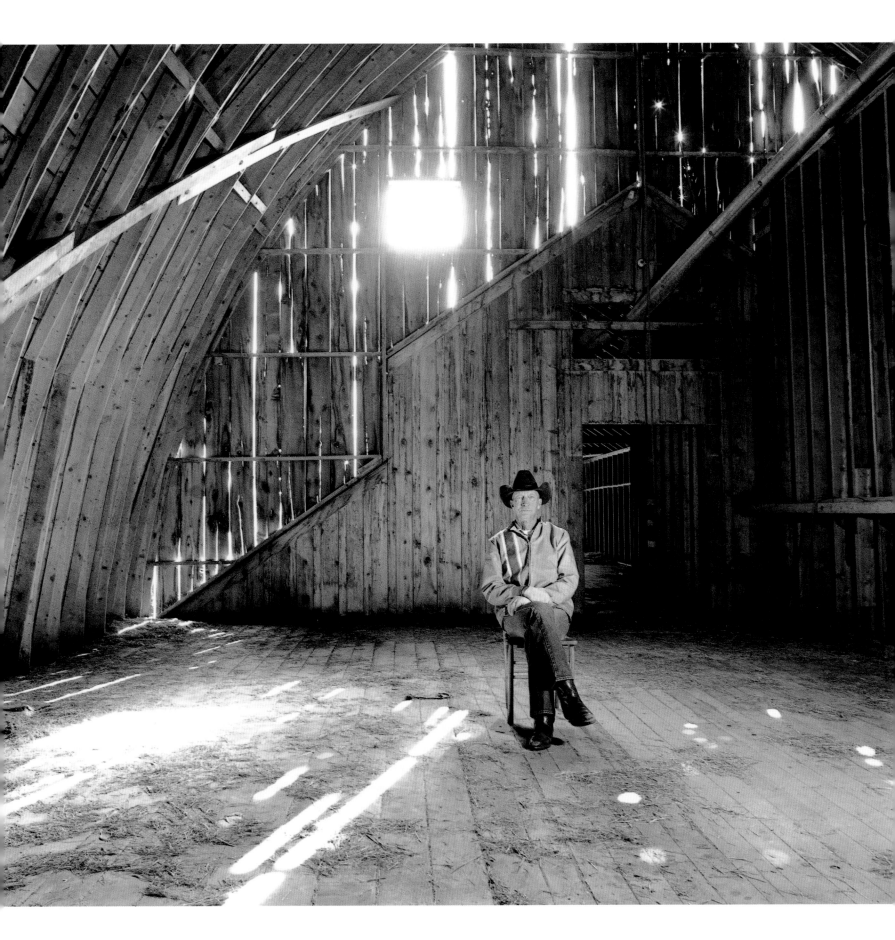

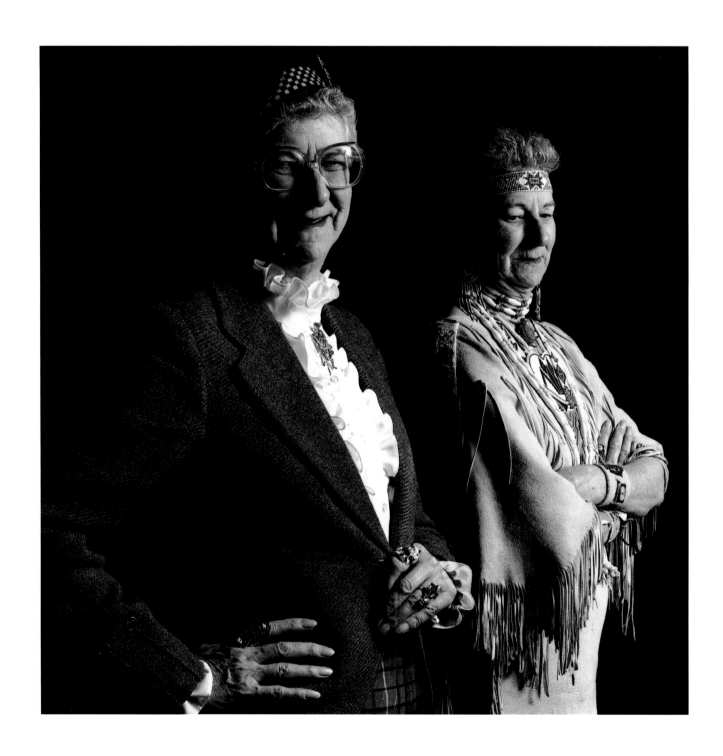

DOCENT

When I'm in Wyoming, Scotland is home.
When I'm in Scotland, Wyoming is home.
I've got the best of two worlds.

Our history's very old. You know, we were goin' when the Normans came over. When the Romans came—before 55 B.C.—into Britain they built walls to keep the Scots out. They never quite could get a handle on us. Same with the English. They spent centuries trying to beat us down. But we've always come back. Resilience. Stubbornness. A great deal of it is plain stubbornness. Oh, God, are we stubborn!

The Scots have always been wanderers. Always. From way, way back. You'll find Scotsmen all over the world. And wherever they go they leave a mark. Because they're that kind of people. They're very hardworking. They are always proud of their heritage. They never forget they were Scots. And they leave a mark on the country where they've been. Look at this country. Everybody's heard of Andrew Carnegie. He came out here as a very young man because there was opportunity in this country. He made a fortune. He went back to Scotland. But he never forgot this country he came to, that had given him an opportunity. How many towns and cities in this country have a Carnegie Library? We had a beautiful one here which we tore down.

Many of the signers of the Declaration of Independence were Scots and Scots-born. A great many of the Scots who came over here, particularly your trappers, married full-blooded Indians.

I have this great admiration and love of the American Indians here. We've got a lot in common. We've even got some words in common, which is fantastic. They lived in tribes, we lived in clans. We had chiefs over us. We were both run off our lands. They had a wonderful culture which, like ours. . . . After the Battle of Culloden the English tried to stamp out the Scots. We weren't allowed to wear the tartans, we weren't allowed to wear the kilts, we weren't allowed to play bagpipes. All our weapons were taken from us. They tried to stamp us out. It's what happened to the Indians over here.

I've always loved museums. And I love Wyoming history. I've studied it ever since I've come here. This was a way to get into it, really get into it. I saw they were going to have a training session for docent guides and I went.

I love working with kids. I've never had any kids of my own. I'm "Aunt Dot" to many kids, particularly over in Scotland. I've always gotten along with kittens and puppies. I got along with wee people, too. [Laughs] I love 'em. You learn from them all the time. It's a wonderful age, fourth grade. The kids, you know, they wonder where I'm from. The fourth-graders often say, "You talk funny."

They often call, and I take the Indian box out to the schools and give programs at the schools themselves. Then very often we also have the wee folk—the three and four-

year-olds. Now that's a challenge to hold their attention. You don't give tours to them. I have my hands-on box. I make them all Indian princesses or Indian braves, give them something to hold, tell them little stories. I really enjoy it.

People will say to me, when I talk about Scotland, "Well, why did you come over here?" And I say, "Opportunity. A new life." And, "Well, you always talk about Scotland." I say, "Yes, because that's where I was born. That is my roots." They say, "Oh, you should go back there." And I say, "When I became an American I was probably a better American than an American-born because I chose to be an American. But I'm not going to forget my heritage."

We all came from somewhere, and isn't it nice to have an interest in what you started out as? Why did your great-great-grandpeople come to this country? Why? Why didn't they stay where they were born?

We're not keeping them [identities] separate. We're just reminding ourselves of it. I'm an American and very proud to be an American. But I'm also very proud of my Scottish birth and heritage. I'm not gonna forget that 'cause that's what makes me a good American.

CHEYENNE
b. FEBRUARY 5, 1922, EDINBURGH, SCOTLAND

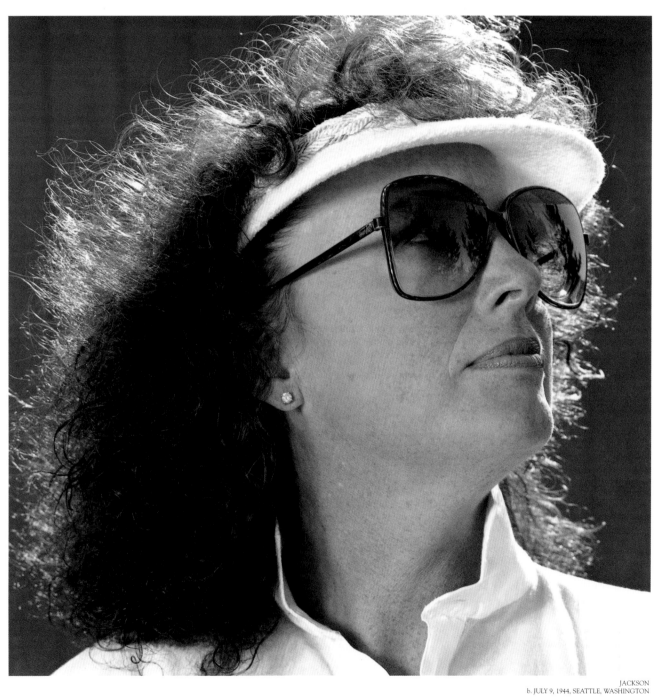

JACKSON
b. JULY 9, 1944, SEATTLE, WASHINGTON

280

KATHLEEN RAMEE
BUSINESSWOMAN

You know, they always say you marry someone like your father. He was in engineering at the Boeing company. But I didn't marry right because I knew no better for that time. You got married because you were supposed to get married. That's what all women did. All of your girlfriends are married so, you know, it's time for you to get married. So you pick somebody and say, "Well, they look like they'll work," and then you get married. And that's why there's so many women my age now who are either remarried or on their own. Because we all did the same mistake at that time.

Whenever I think of retired people I think of people who are twenty years older than me, and above, who are off on their own in their RVs or so on. I don't think of myself that way at all. So, no, I don't think of myself as retired. But if the definition is: "You don't have a formal job so you're retired," then you would put me in that category. There should be another word, but I don't know what it would be. It's kinda like women who choose to be housewives, and raise the children and are at home. What do they say? Are they retired because they don't have a formal job, either? What do you call that?

There's an aspect out there, that hard-working type, twelve hours a day, and if you don't put your dues in through your late life then they resent it. They've been brought up with the work code that says, "If you don't work you go to hell." I think that we're all on this earth to enjoy it, and whatever our life is we make the best of it, and whatever circumstances come our way we make the best of it. The more we enjoy it and the more we love, the better off the world is and the people are around us. So I think it comes down to your basic outlook, me being single, me having a lot of independence that a lot of married women probably would like to have. There's probably some feelings there. But there's also a lot of support and there continues to be more support. So I think the world is changing on that aspect.

No matter how we have come across our money, women are becoming more and more wealthy, more financially secure on their own. We don't depend on the men so much as we used to, and that's because women are establishing careers now. Women are learning how to manage finances. They want to have that independence of their own. That's the same thing that, of course, men have done in the past, too. And with that happening we will be retiring early. We will have our own freedom the way the men traditionally in the past have had their freedom. I do think that's gonna be happening more and more in the future with women in this country.

I don't think you have to be wealthy. You have to, of course, be able to manage yourself so that you can do the basics: the food and your home and entertainment. That doesn't necessarily mean wealth but that includes the wealthy, and it includes those who travel in mobile homes now like the retired do. They don't have that much money coming in, but they've got a certain amount coming in each month that allows them to do that.

I think I'm on the edge, definitely. This is 1991. Things were changing in the eighties. Women's lib changed things a lot. But now it's all settled down to the fact that both men and women work in this country and everyone is catching up now. Women now are finding that they are wealthy enough to be able to do it. They're not stuck to just raising the children. And when the children are grown they're not stuck to just being with their husband and doing what he wants to do. They have a life of their own. Yeah, this is the edge of a revolution, a very positive one.

I've seen too much unhappiness around me, too many women having to lead a life that isn't exactly what they would have if they had their choice. This is the first time women have a choice, you bet.

You know, I've worked most of my life, so I've seen the prejudice out there and I've seen the difference in wages. I'm still concerned about those things and I support those things. So anything that would support equality, I'm really for equality. And it's not just men-women, it's for everyone. I think it's time we all became one in this world and we all work together. I may be an American citizen but I'm also a planetary citizen, and we all are. And that's very, very strong within me.

If things stayed stagnant I would go crazy and you would, too. I love being able to grow. And maybe that's one of the nice things about being an independent, single woman. You can grow your own way. One of the scary things about being in a relationship is that, that growth is gonna stop. You get used to that growth. You get used to growing your own way and getting stronger. I like that. I don't ever want to lose that.

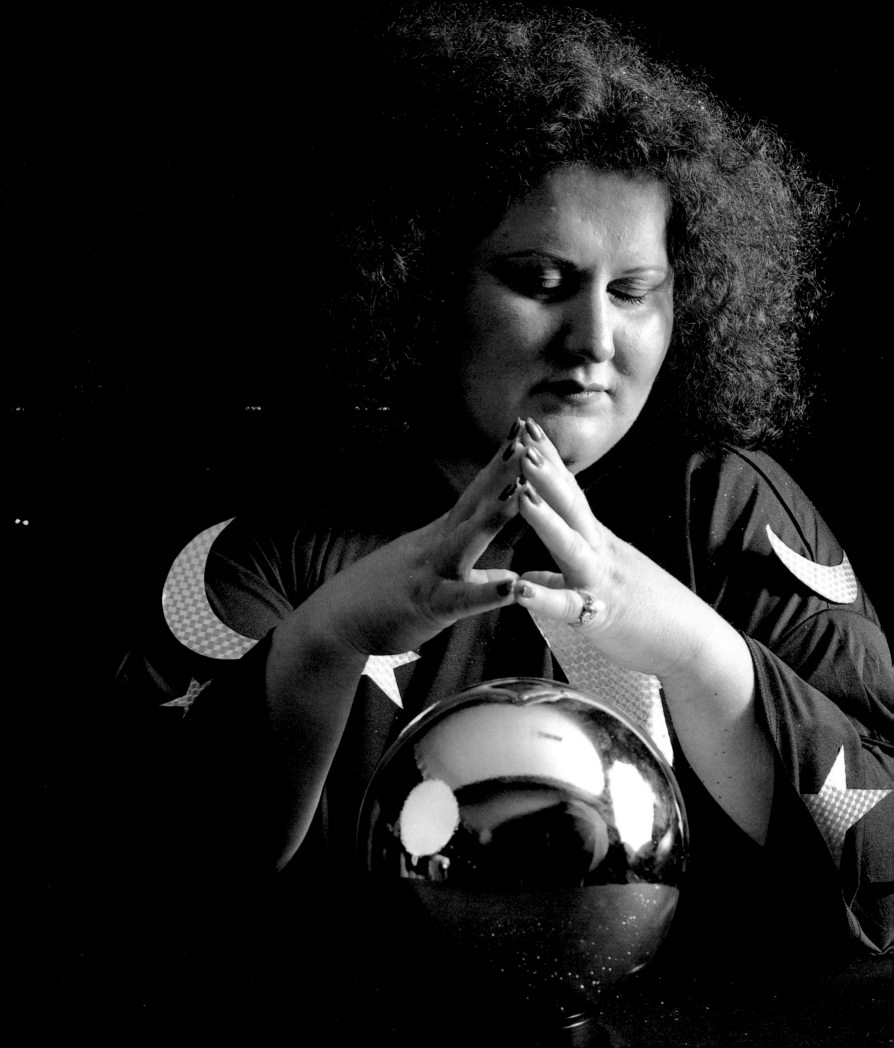

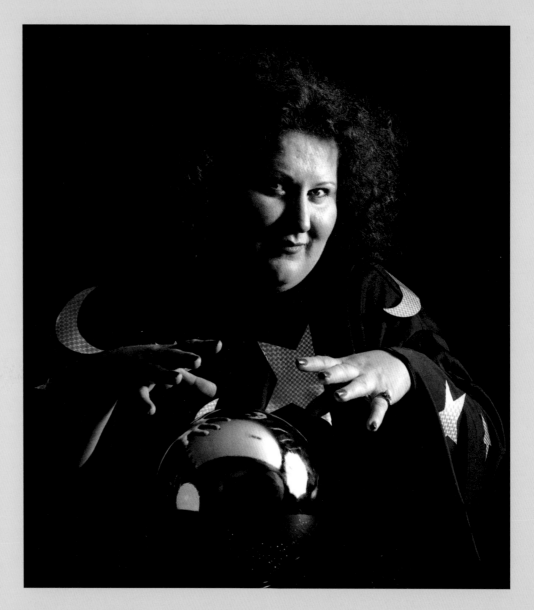

I think the things that will be happening for Wyoming are very, very positive. The state will come back as far as the economy goes, but still have its ups and downs, still cyclic as it has been before. Let's ask these cards what will be happening. [She shuffles the Tarot cards] Wyoming can attain anything that it wants, anything that we choose for the state. We can do it. We're not held back from anything....

There might be a hardness because of the hard weather. I think that the environmental part of it, sparsely populated, gives people a chance to really work on themselves, really become spiritual, really live to their full potential. ...We can have everything.

CASPER
VICKI GREGORY
SPIRITUAL COUNSELOR, PSYCHIC
b. JANUARY 8, 1953, BRAINERD, MINNESOTA

CHENEY
RICHARD

SENIOR FELLOW
AMERICAN ENTERPRISE INSTITUTE

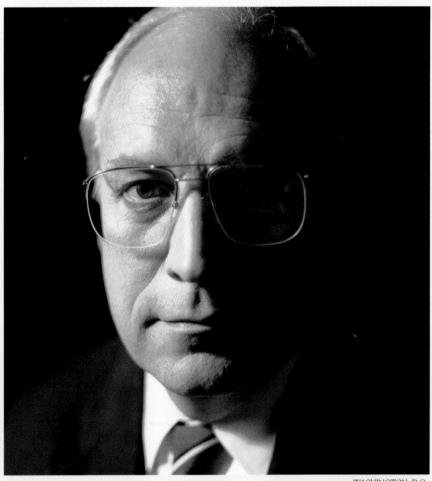

WASHINGTON, D.C.
b. JANUARY 30, 1941, LINCOLN, NEBRASKA

A hundred years from now . . . Boy, it's hard to see a hundred years into the future. There's some phenomenal changes under way in the world that are visible now. They're gonna have an impact, and are already having an impact, far sooner than a hundred years out. In a hundred years . . . when you think back a hundred years, think of what the world was like in the 1890s, what Cheyenne was like in the 1890s. Unbelievable, in terms of communications and transportation and energy and computing power. I mean, if you look at the rate of change that has characterized the last century and project that into the future . . . and probably the rate is going to pick up. It's gonna move even faster. It's gonna accelerate. It's mind-boggling what might happen.

When you talk to Americans about Wyoming, they don't think of Wyoming as oil and gas and coal. We may sit out here and occasionally feel that that's all the rest of the country wants from us. But that's what we sell them. And we do very well selling it to them, too, by the way. We've got a very successful fiscal policy. No state income tax. And it's an important part of our economy. But the rest of the country doesn't even know we are the leading coal producer in America. They associate us with the West. And the West is more than just a geographical location. It's part of our culture. It's part of our history and the values that we associate with the West: freedom and independence, self-reliance. When people think about Wyoming they think about wide-open spaces. They think about the beauty of the state, they think about Yellowstone, and Frontier Days, and those things that I think many of us see in our state. For us to believe the rest of the country looks at us as a place where they simply come to mine coal simply isn't accurate. It's not the way they look at us.

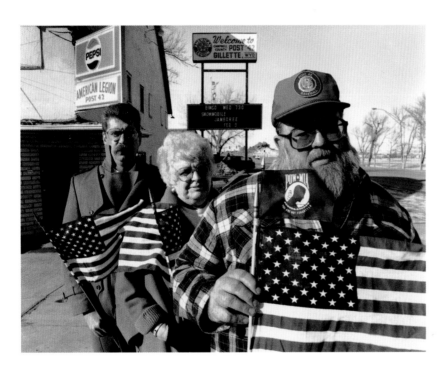

GILLETTE

left to right:
BUTCH BYRAM:
b. FEBRUARY 6, 1954, IOWA CITY, IOWA

JO ANN VAN ALSTYNE:
b. OCTOBER 27, 1933, SPEARFISH, SOUTH DAKOTA

EVERETT DESMARTEAU:
b. MARCH 2, 1948, GREAT BEND, KANSAS

What will Wyoming look like one hundred years from now?

JO: I would hope it looks just like it is right now. I just went through ten years of throwing Styrofoam things away, aluminum away, plastic containers away, and I understand that that's ruining our environment. So now we're going the other way and we're going to what we call "permanent ware" and we're not going to do that anymore. I would hope that it would be the same. I just love to go to the Bighorns and sit up there with my little fishing pole, and I don't care if I catch a fish in two weeks. Just set there. I hope it doesn't change. I hope my great-great-great-grandkids can go there and enjoy it.

BUTCH: Mecca. We don't have pollution. We don't have a lot of polluted thinking in the state of Wyoming. Different views, maybe. But I think people in Wyoming are independent enough and ambitious enough that they won't allow some of the atrocities that have come to, say, Colorado. Hopefully, we'll have a fairly conservative government. My only concern is that this state was truly poverty-stricken for so many years and has enjoyed the fruits of its own minerals. However, those minerals are becoming depleted every day. So it may be tough for people to eat in this state. However, those people are the ones that started this state, and those people will probably still occupy the state a hundred years from now when the rest of us are gone. It's gonna be small ranch communities like it has been in the past. The people are still gonna eat beef, I think. And where they might come up with some alternative energy sources, I still think it's gonna be smaller. The winters are too darn cold to get too many people that aren't hardy and, more or less, strong-type individuals to live in this kind of country.

EVERETT: I'm basically the same. I hope that we elect enough good officials in the state government to keep the rest of the United States from dumpin' on us and bringin' their trash in here. When you only got 460,000 people in the whole state, it's kinda tough, when New York City's got more people in one city block than we got in the whole state. I just hope that the people have the time. You know, we're so "me-me" oriented. We still get good people in government—in city government and state government—that will take care of the state. I'd like to see it the same, you know. My family, I'd like to see 'em grow up with less than 500,000 people in the whole state and not worry about the traffic jams and the pollution and the problems I'm seein' elsewhere. But I think in order to do that we're gonna have to get some good, commonsense-type people in our governments. I think we did a pretty good job so far. I hope we can still find 'em.

Unless some tragedy happens to mankind, I expect people to be living much longer, to be much more healthy and enjoy their years for a much longer period of time . . . to not suffer. It's such a tragedy now. People spend all their lives accumulating information and at the time when they can use it best, they begin to lose that information or can't coordinate it in a way they used to be able to coordinate it. If that could be maintained, that's an enormous resource. And there's progress coming in that particular direction. I would anticipate diseases of aging will be conquered. I think Alzheimer's will be beat. They'll beat cancer.

One of the biggest things they find that increases vulnerability to cancer is a bad repair system. Individuals with bad repair are most prone to cancer. One of the steps in carcinogenesis is DNA damage that's unrepaired, and then an interaction with a gene element some way that's not really understood. But yes, that's a very likely outcome of the research that I'm doing and the research that many of my colleagues in the field of gerontology are doing in aging—that one of the diseases that increases with age, like cancer, might be cured I don't want to cure aging, but I do want to intervene in the suffering that comes with old age and distinguish very clearly between diseases of aging and natural changes, and try to have us be as healthy as we can for as long as we can. My goals are to heighten people's awareness of how wrong it is to say, "Well, they're old" . . . to not accept a facial disfiguration in a teenager, but say it's okay for an older person. To say, "Oh, no, that twenty-year-old shouldn't be hurting, but it's okay if your grandma's hurtin' 'cause she's old." This is a mind-set we have. It's okay if she can't use her fingers, if they're tied up with arthritis.

There are people who would believe that would be interfering with God's ways. There are people that don't think you should give diabetics insulin 'cause that's interfering in God's plan, right? There are people that believe that. But I'm not one of those. I think that there are genetic disorders, and there are vulnerabilities that come with age, and there are family vulnerabilities that come with age. One of the biggest is cancer. I think cancer is a disease. I think it's odious in a teenager and odious in a sixty-year-old. My intolerance for suffering is not age-dependent. I find it intolerable at any age and I don't think it's God's plan.

There's no question I believe in God. No question at all. Very firmly. And I believe that I am fulfilling my role for him. And a good role. I was told in my Catholic training, "You can change the world." I don't know if the nuns told you that. They sure told me that.

The social consequences are going to be quite positive. People say, "What are we gonna do when people are living longer?" Well, they're already living longer. We're not out to extend the life span. It's already extended, and even if we cure cancer we're not gonna extend human life beyond the normal span, anyway. What we're gonna say is, they're not gonna go through that torture and deterioration. What we're trying to do is give quality life. The goal is really to have quality existence and to intervene in the diseases of aging.

Right now our people are elderly and many of them have these pathologies, so they're consuming an enormous amount. I think I saw six billion [dollars] a year for Alzheimer's. They're expecting that to double in the next ten years. I'm saying we can't afford not to intervene in the aging process. Medicare, Medicaid cannot cope with these diseases. The analogy I like best is [Roy] Walford's. He said that when polio hit, the government had two choices: They could build the best iron lungs possible or they could do research to try to cure the disease. Now aren't we fortunate that they tried to cure the disease? Otherwise we'd have the best iron lungs today that are possible. That's what we're doing in the field of aging. We're making the best care possible for the elderly. I'm the last to say we should cut back on that care. We need that care. But that care should not make our conscience be clear, right? We need to go back. Otherwise the suffering will be unbelievable for our generation coming into those years.

The financial burden on society need not be that. That's why I say this is not going against God's will. These are diseases of aging. If you don't disagree with treating tuberculosis or diabetes or any of these other diseases, then why would you object to stopping the changes that occur with age, robbing you of your function as you age?

I just saw some experiments—and these are all mind things that are terribly fascinating—they're doing with rats and mice. I just recently, for my aging class, got a film on the mind. They showed this rat that had been in a single cage all his life—male rat. He was very old. He looked very unhappy. His little red eyes were sunken and his little fur on his cheeks was all worn. They took him out and put him in the rat equivalent of Disneyland. He had things, toys, that he could play with and things he could roll around on. They showed him the next day and he was, naturally as you would expect, in the corner shaking. I mean he was scared to death—and there were other rats in the cage, too—just frightened, and his little whiskers were shaking. But in time they showed him climbing up on the things and playing with toys. And because he was moving around in his cage, he lost weight, he was mobile. As they said, he looked happier. He could learn better. He had more control over his environment. Of course, the analogy is clear: You take an old person, you put him in one room in the nursing home . . .

Then there's another experiment

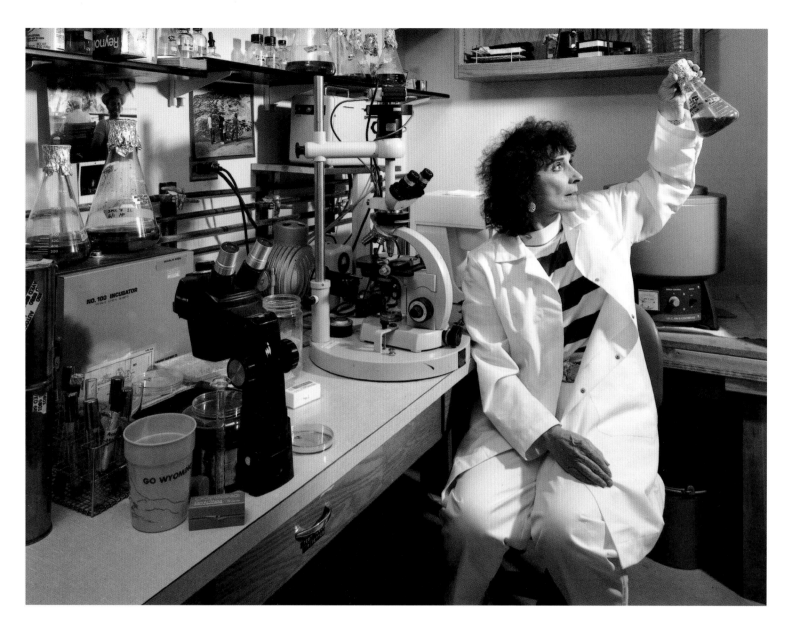

that they showed with learned helplessness where they yoked two animals together, and only one of the two animals could control an electric shock that was unpleasant that was coming into the cage. The other one had to depend on the one that had real control over the electric shock for pleasant or unpleasant sensation. He very quickly learned that there was nothing he could do about what was happening. But his buddy who he was yoked to had control over the switch. And that's learned helplessness. They found that if they challenged these two animals with cancer cells, 80 percent of them that didn't have any control got cancer and only 20 percent of those that had some con-

trol over the environment got it . . . the issue between the mind and the immune system.

They've done experiments, and they're just beginning to do much more in nursing home facilities, where in one case the benevolent dictator comes in and says, "Well, welcome to our nursing home. Meals will be at such and such a time. We'll do this. You can watch your TV at this time. And everything will be wonderful." That was one set. In the second set they said, "Welcome to the nursing home. You will have control over this part of the program. You may eat when you like. You'll have choice of foods. There will be these options available for recreation. If you'd like to be a couch potato,

there will be these TV series. If you like sports there'll be this. But it's up to you which of these options you would like to choose." Within some short interval of time the one that had nice things was already deteriorating, and those given choices were flourishing—there weren't any problems.

We only have so much time and we live a short life. So we should live it in what we enjoy doing. I enjoy being in the laboratory. I'm also tempted by politics. The common thread that bridges that tremendous gap between those two things, of course, is "for the sake of humanity."

LARAMIE
b. NOVEMBER 5, 1935, ALBANY, NEW YORK

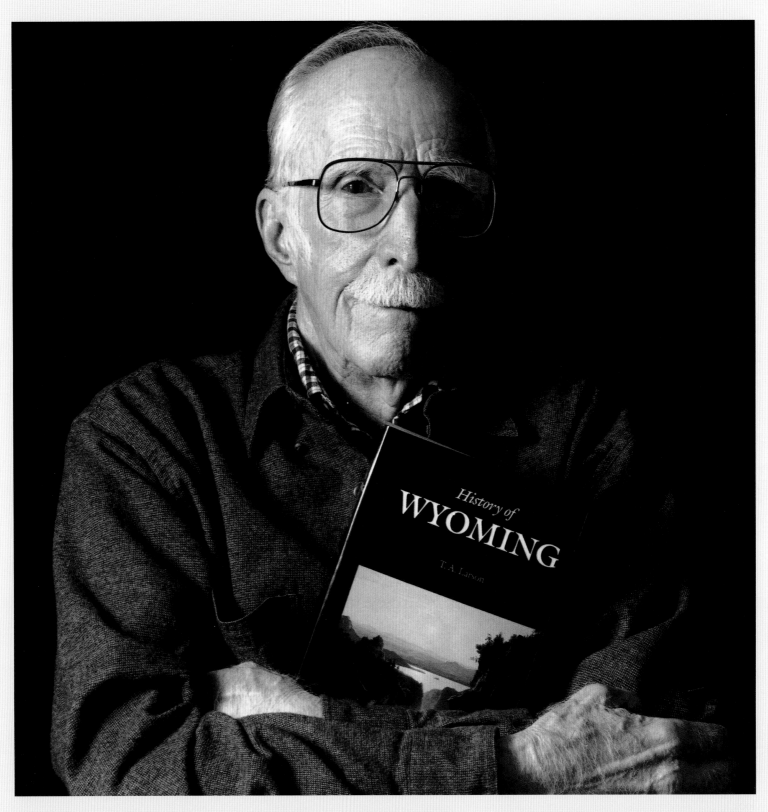

My inclinations were in the Republican direction. We used to recite, "Fried rats and pickled cats are good enough for the Democrats." That was a common expression around my hometown during election campaigns.

LARAMIE
b. JANUARY 18, 1910, WAKEFIELD, NEBRASKA

T. A. LARSON

UNIVERSITY OF WYOMING

I think the time is coming, within the next thirty years, probably, when the WASPs —the White Anglo-Saxon Protestants— will not outnumber the other people in this nation of ours, and people who've been discriminating against the nonwhite people will find themselves discriminated against.

I don't know whether the United States is going to continue to have open immigration. Of course, we still shut out some people, send them back to Haiti, and so on. But at the rate that the Hispanics and Asians are flooding in, and the blacks are increasing in population in this country, the WASPs may not be running this country much longer.

The only reason that some people think that we're not as racist is that there are relatively few minority people. And the problems are different when you have just a very few. I know in my little hometown in northeast Nebraska, when I grew up we had one black boy. He was the only black in town. And there was only one Jew. They were sort of oddities and conversation pieces. We didn't discriminate against them particularly, but certainly we didn't consider them our equals.

I'm a believer in assimilation, if possible, and maybe intermarriage is the only answer. I got the wild notion one time that one way you can solve nationalistic and racial problems is to adopt international laws. The United Nations, given enough influence, could require that you cannot marry anybody of your own race. [Laughs] I don't know how else we're gonna solve all these ethnic, racial, and nationalistic problems. And the race problem seems to be getting worse in some parts of the world.

One thing we do know almost certainly is that there are going to be great changes, and many of them you cannot predict. If we look at the things that happened in the world and in the United States this century—more industrialization, more new ideas, more things happen, more productivity, tremendous improvements in health and medical care,

scientific and technological development— more of these things happened in this one century than in all previous history. It's staggering! Mind-boggling!

These things have really developed elsewhere, practically all of them, and we were affected by them. But think of the changes in communication, manufacturing, and agriculture. When I was born and grew up, the assumption was I was going to be a farmer. Most people became farmers in that period. Now, maybe only 3 percent of the people in the country live on farms and ranches. In 1910 when I was born, most of the people did. Tremendous change! All the development in agriculture made that possible—the hybrid corn, chemical fertilizers, great machines, no till, and all the other scientific developments. Think of the changes in manufacturing and the development of petrochemicals, the new inventions: television, radio, the automobile, the airplane, computer, and all sorts of gadgets like the zipper, Velcro, ballpoint pen.

The changes in education! How relatively few people went to college when I was a boy. The lengthened life of people, the medical wonders. It's just incredible. Communication. They talk about the Information Age. We've got one hundred times as much information gathered all over the world, stacked up, far more than anybody can hope to use. There used to be a few "universal men" back in the sixteenth century who could comprehend all the knowledge there was, or at least have some conception about it. Now we can't hope to master one discipline, let alone the many related disciplines. Computers and various offshoots, space travel. Who would think we would send someone to the moon when I was a boy? When you project twentieth-century achievements into the next century, who can sensibly speculate about what we're going to see?

We can accept as a fact, however, that there's going to be tremendous changes— not all of them for the good. I just talked about some of the things that generally are

regarded as progress. But some things that have come along since I was a boy have caused many of us to lose our confidence in progress and the idea of progress, perfectibility, and that sort of thing, things are getting better and better. A lot of this is not only because of the current recession—call it depression if you will—but because of what's happened to the family and morality and crime and so forth. The AIDS business. And who would have thought when I went to college and came to the University of Wyoming, we'd by now have coed dormitories? Much more sexual freedom.

I used to apologize whenever I started getting pessimistic. I would say people of my age tend to say things have gone to the dogs. Some of the older people said so when I was a boy. But a lot of things have happened since then. Families, for example, held together better in those days. On the farms the family worked together, for example. More people are living in the cities now. Youngsters running around at nights—there wasn't so much of that. You were out on the farm, kids were all working, and so on. They went to bed early so they weren't introduced to a lot of temptations.

Women wanted to have influence in politics, and the vote, and so on, and they wanted the opportunity to work outside the home—for those who were so disposed—so that some of them did get jobs. When I was a boy we had our "old maids." And a woman who didn't get married by the time she was twenty-five . . . people thought she was in an awful position. And in a sense she was. She was certainly discriminated against and looked down upon, and I think that's one of the big improvements we've had: the opportunity for single women to remain single without scorn.

I look for nuclear fusion to be controlled, and that will provide unlimited energy. That will shake up the whole world. Thirty, forty years ago I was told by people whose opinion I respected that by now we

would be able to take a handful of material that would provide energy for an automobile to run a year, the amount of energy that's available if you could manage fusion as opposed to fission, which we have controlled now pretty much. The hydrogen atom . . . enough energy in that if you can just fuse like amounts of what the sun is providing. Boy, it'll shake up the whole world! Maybe by that time we'll be able to save what little oil we've got left for lubrication. We're terribly wasteful in our use of our petroleum because it's so much more valuable in some petrochemicals, and for lubrication. And temporarily we've got almost a surplus of coal and natural gas, but that's not going to continue. We need to conserve some of those things. Alternatives would be controlling the sun, using more energy directly from the sun, and wind energy. Population growth will depend on that energy problem. Water is, of course, one limiting factor, and there's nothing we can do about water unless we desalt the oceans. And if we get enough energy we could pipe water back to Wyoming and irrigate more of our land. In short, if we had unlimited energy through nuclear fusion, why, all sorts of things are possible.

We've always been, even to the present day, the least industrialized state. We have fewer people employed in manufacturing than any other state. It's always been sparsely settled and probably will continue to be sparsely settled because of the relatively poor soil. Early in the twentieth century, farmers flocked into Colorado, the Dakotas, and Montana. Likewise, surrounding states, except for Nebraska, have had much richer deposits of precious metals. God knows, prospectors poured an awful lot of sweat over the mountains of Wyoming looking for gold, but except for a couple of summers in South Pass, there was really no rush into Wyoming like these other states had. That has held us back. We didn't get that start. And oil—well, we found that early. Markets were unavailable, so until World War I that didn't develop. There was some development and then it lapsed afterwards because Texas, Oklahoma, and Louisiana, Illinois—those places—they could supply all the oil needed. The circumstances were just not favorable for rapid population growth in Wyoming. The jobs just haven't been here.

We've been treated as a colony pretty much, although there is argument about whether Wyoming is still a colony. But basically there's no question that we have been dominated more than most states by outside forces. Partly because of our small population. We are last among the states in population. Not so many years ago we were ahead of Vermont, Nevada, and Alaska. But that's no longer true. We are to the present day, and we're going to be for the foreseeable future, dominated by international developments, by national developments, by big corporations doing things when the recession comes along, or depression, or whatever you want to call it. The corporations cut down their activities. What did they do? They pulled people out of Casper. They put them in Denver. And the government even pulls people out of here and concentrates them elsewhere. It's been true for Wyoming and it'll continue to be true that we're going to be dominated by outside. Wars have influenced us more than anything else. The ups and downs alone. This past century's been a century of great wars: World War I, World War II, Vietnam, Korean War, and this Gulf War—all of them have had great influence on Wyoming, but none left us with significant industrialization.

I think we're not going to be a heavily populated place. I would hope we value what assets we have, our unique aspects. I hope that we put a high enough value on our wildlife, our mountain scenery, our wide-open spaces, our parks, our trails, our historic forts, and things like that, and our forests and what water we have, that we will treasure them, and preserve them, and give opportunities for a limited number of people to enjoy them.

Because the way things are going, most of the country's gonna be so crowded that the multitudes will relish an opportunity to see our rare treasures. Our problem, on the other hand, is that this tourism is sort of a fragile thing. It can be overdone very easily, and we can't stand too many people without losing it. I'm reminded of the fabled dog that stood on the bridge with a bone in his mouth, and looks in the water and sees his shadow, and drops the bone grabbing for the image. You know, you push this tourism too hard, too fast . . . it's not a perfect economic development in some respects. For one thing it's so seasonal, and in the second place there's so

many poorly paid jobs in the tourism business. You can't build a first-rate society on a lot of seasonal, minimum-wage jobs.

There are a lot of people who live in Wyoming who have turned down opportunities to go elsewhere. They like it the way it is. They think Wyoming is a delightful, uncrowded commonwealth, so to speak. There's bound to be conflict between the boosters and the knockers. There have got to be a few knockers to keep the boomers honest because they want to bring in things that are not going to be worthwhile in the long run. They want to make a quick buck, make their money and get out. Many of them are of that inclination. I foresee an opportunity for a limited number of people to have a good life in Wyoming. But there is a ceiling on that. Even if we wind up being the only place in the country that has these wide-open spaces and spectacular scenery, we can't accommodate millions of people.

I think a lot of Wyoming people feel the way I do about this. We have the Powder River Basin people. We have the Sierra Club. We have the Wyoming Outdoor Council. We have various preservation groups and they're getting more and more influential. People who want to maintain our wilderness, people who are interested in buying this ranch from Gerry Spence and Moriarity and want to save it.

I think it's a good move starting to charge fees for going into the parks. We ought to have better facilities than we have in our parks. We ought to figure out some way to solve this problem of what people in southeastern Wyoming call the "greenies." We shouldn't just be an overcrowded, weekend recreation area for Colorado to come up here with their trailers and groceries, not spending any money here, really . . . fill up with gasoline in Colorado and come up here and enjoy their recreation in the Medicine Bow Range and so on. Utah, Idaho, and Montana exploit northwestern Wyoming the same way. If we're going to have a decent society in Wyoming, we cannot accept unlimited tourism of that kind. We've got to control it some way, and I don't know what the solution is.

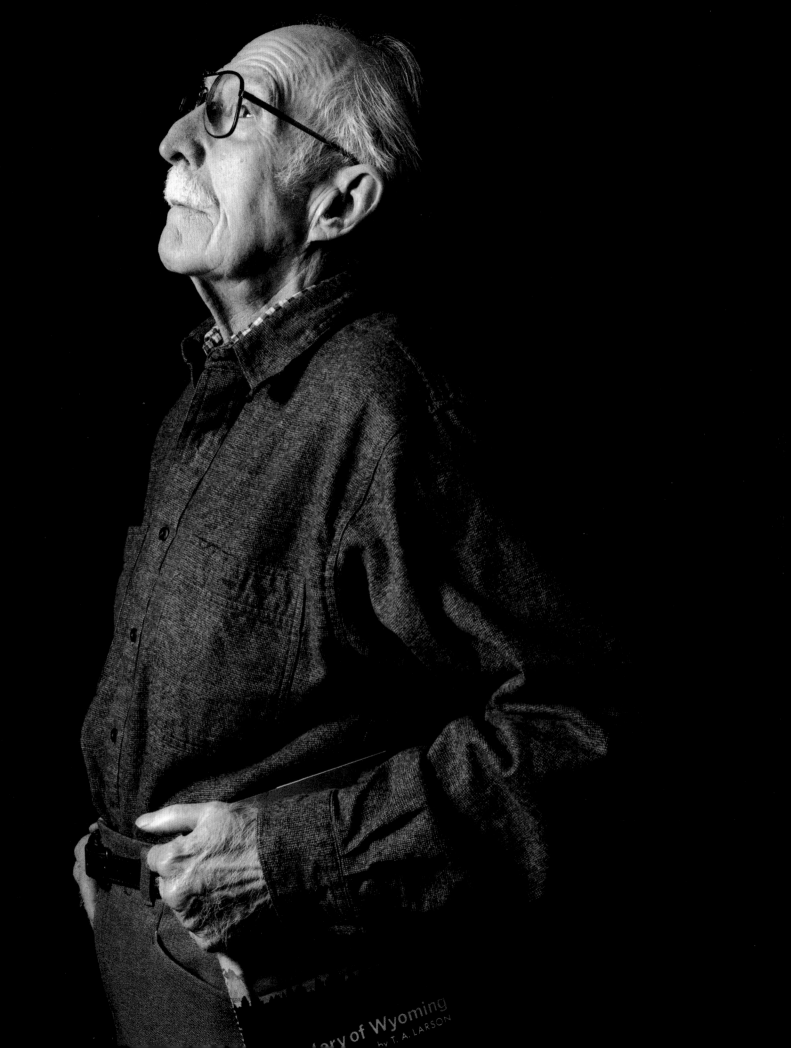

ory of Wyoming
by T. A. LARSON

FOSTER
JOE
HOLISTIC RESOURCE MANAGER

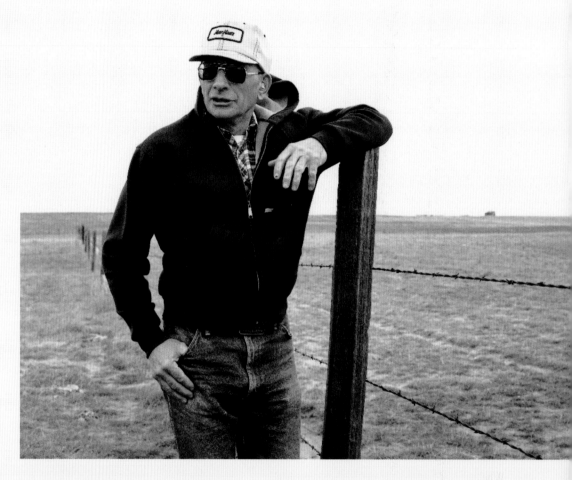

What we mean by "holistic resource management" is the idea of taking the whole thing—and that's the people and anybody that might be affected by the ranch—into consideration when you're planning your management moves. And also the grass. It's just a different way of looking at management. Whereas, mostly in agriculture we was brought up to think if we didn't know what it was, we killed it. If we didn't plant it we killed it. We never stopped to think of why it was there. I mean, most anything in nature has a reason for being there.

Actually, I think it was the most important discovery for mankind that has yet been discovered. Because all of our wealth comes from the sun. All this paper money, it's really phony when it comes right down to the end. 'Cause if we lose our agricultural base we're done. And we're well on the road to losing it. People don't want to believe it. Over half of our soil in the farmbelt is gone. We're losin' six tons of soil for every bushel of grain we're producing. The Soil Conservation puts these figures out, and yet they tell everybody we're doing a good job. [Laughs] When the wind blows across the field and you see dust moving, that means that you're losing about a ton an hour per acre.

What they've found out . . . that the weakest link in resource management is people. And in ranches it's families. If you just look. The biggest reason why ranches are sold is because families—second and third generation—all of a sudden they all want their money. And then we're losin' those people that know. That's what's sad, is we're losin' those people that have been brought up on the land.

What I see happenin' a hundred years from now, on the public lands, the government will be payin' the ranchers to bring cattle instead of chargin' 'em. I think this is going to happen. There's not enough cattle, and I think the main product from the public lands is going to be water because there's gonna be so many people. Beef is going to be a by-product of the public lands.

I think it's [holistic resource management] gonna be the salvation for the world. I mean, if we don't change . . . I ain't gonna say it's gonna happen real quick. Personally, I ain't gonna never see people starvin' to death in this country. But I think that within 100 to 150 years people would be starvin' just like Bangladesh if we don't change.

The change is real hard. I mean, it's real hard to change. It's just like changin' the furniture in the house, you know? Most men don't like their wives to move the furniture even.

EAST OF CHEYENNE
b. DECEMBER 11, 1932, GREELEY, COLORADO

MARGARET MURIE

NATURALIST

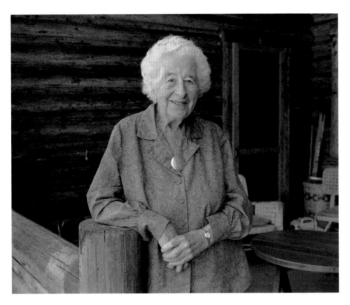

I think a lot of people just don't realize, don't have a feeling, that Jackson Hole is a very special place. There aren't very many places like this in the whole world. And that's why it needs and deserves protection. I feel that very keenly and I know a lotta people who do, but maybe some of them don't. I've been in Africa, I've been in New Zealand, I've been in Australia, I've been to Europe, and there's nothing quite like this.

What do you think is so special about the valley?

Well, the mountains, of course. But I think right along with that there's also the foreground to the mountains. The foregrounds are the splendor. And that's what Olaus [husband] testified before congressional committees and all kinds of groups during all those years of fussing and fuming about Jackson Hole and how much of it should be a national park. The whole scene is the whole valley and the mountains, Sheep Mountain and all the others on the east side of it. It makes a complete world.

I think the valley means, first of all, beauty and an example of what the great earth forces can accomplish. It is as though some great spirit, somewhere, some time ago,

had this idea: "Let us see if we can invent a valley that'll be the most beautiful in the world. Well, we'll need some mountains, we'll need some lakes, we'll need some streams, we'll need some lower hills, and then we'll need some animal life." This is a fantasy, of course, but I think it expresses as well as I can my feeling about what the valley should be.

Oh, I think more and more people are conscious of the fact that the beauty of the valley is also the economy of the valley. And we don't want to do what . . . as Aldo Leopold said, "Man is tempted to kill the thing he loves."

I think there are gonna be lots of big [conservation] battles if our population keeps growing the way it is. That's really the crucial thing. There's just gonna be too many people. And if we saved every scrap of wilderness—large or small—that we have, say, in the United States, let alone all the other countries, it wouldn't be enough to give a satisfying feeling or a satisfying experience to too many people.

Well, it's gonna come to a grinding halt pretty soon because there's only so much private land left in the valley. I think whatever's left at this point oughta be kept as open

space. I really do. I think we have almost enough people coming in and building huge houses. I really don't understand some of these huge houses. When you consider the amount of traffic during the summer months—the tourist traffic which, of course, is the economy of the whole valley now, I guess—I just think enough is enough. Better stop.

In all these things that I'm talking to young people about, the background of it is Olaus's work for wilderness and how all his natural history accomplishments tie right into the wilderness. Because, as he said, the more time he spent studying the animals, the more concerned he became about their habitat. And the habitat means wilderness in most instances. So the two things are just tied together, and that's the idea I guess we sort of hope would be tied in with the idea of habitat, and the world, and what we're doing to the planet.

MOOSE
b. AUGUST 18, 1902, SEATTLE, WASHINGTON

The Cheyenne Decency Committee came in here one time. And they came with their clipboard. They went back there and saw what I sold, and the guy came back and said, "You're not only selling pornography here, you're selling occult books." And I said, "Yes, they're right next to the religious section."

I think my ideas are hard to describe. It's not easy being like that. I'd much rather be able to drink beer, which I don't like; drink coffee, which I don't like; and be able to go into the bar after work and talk about "nuking" Iraq. I think, basically, when there's a group that looks like they're a majority or they're trying to get their things to be passed as though they were the majority, I just react automatically and say, "No, that's wrong."

I always considered myself conservative. For example, I want a balanced budget. I don't want to go around and tell the world what to do. I don't like welfare. I believe in the goodness and the equality of man. I'm a secular humanist. I believe that the only problems that we face are problems that are man's problems, that men can solve. I believe in the spaceship earth, lifeboat, mentality: that this is our little spaceship and no one's gonna come from outer space to help us. And that by limiting the population to get down . . . say, like, by the year 3000, America has a hundred million people. But do this in the whole world, so the whole world isn't just rich and powerful and big, and comes and takes us over. 'Cause that's what's gonna happen to Wyoming. When Colorado gets big they're gonna dump up all their garbage up here because we have the space. The United States is gonna dump their nuclear waste here because we have the space.

What do you think Wyoming's gonna be like a hundred years from now?

Just like this, except the downtown will have more empty stores. I'm serious. What makes you think something's gonna change? When all these old people die off it's not gonna change. I like the idea of not a lot of people and I like the idea of not a lot of cars. Traffic. You know, when you get

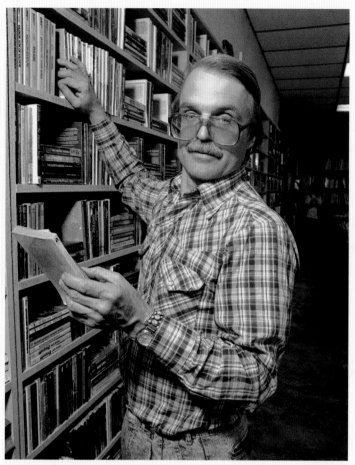

CHEYENNE
b. JUNE 30, 1940, NEW YORK CITY

older you're like that. I'd like to see enough growth that the people who live here, who like this environment, have children that graduate from what are very good schools here—high school, college, community college—would stay and be able to find a job if they so choose.

But do you envision that?

Probably not. No, I don't think so. 'Cause we elect people who are echoing the philosophy of the rich and powerful, not the philosophy of the poor. If you would think for one minute that Thomas, Wallop, Simpson, and our Gov Mike as he is now known—or Gov Ed as he was known before

Gov Mike came—care about that poor bugger trying to make a living at minimun wage? With no insurance? I mean, they may care in their philosophy, but when it comes to action they do not care. They're very happy for this state to stay the way it is. I would like to see a one percent growth. So if you have 500,000 people you would have 5,000 new people working or being born in your state, increasing your population one percent. So that would take you probably eighty years to double your population.

They don't want minorities moving here and they don't want liberals coming here with a new idea. Suppose I was rich and my store was not a bookstore, but was some

big business like a furniture store that I made a million dollars a year on, and I wanted to sponsor a half-an-hour radio show to espouse my unorthodox views. I don't think the radio station would go for it even if I paid for the time. Because they would have all these other people calling up threatening to pull their sponsorship out. You know, I heard an interesting statistic. You know what has moved into the number-one position of our exports? Do you know what the leading export of Wyoming is now? Our young people. There's a survey a man told me about. He appeared in our local paper and said by the year 2000 expect us to have less than 400,000 people. That we would be the only state in the union with a negative growth. Some business organization and magazine voted us the least attractive to new businesses. That's not because of our taxes, our low cost of living, and our good schools. We've got fresh air, hunting, fishing, healthy climate. It's got to be because people who are in control want it that way. Because if you suddenly had growth here like they had in Las Vegas, or Arizona, or Florida, or California, you'd have all these people with liberal ideas. Guys like Sullivan couldn't get elected with this homespun humor. They'd throw him out on his butt. Governor Mike would actually have to do something. But you know, he did campaign for making new jobs and I'd like to know, on a scale of one to ten, where the people would rate him on this. He campaigned to bring businesses to town, but he has done one thing his first term. He has found a job for himself. They spent a million dollars to elect someone for a job that pays $70,000 a year. There must have been some vested interest in those people that made those contributions. Why does the mayor spend $25,000 to get elected to a job that pays about the same as what his wife gets paid, and she gets three months off? People are in love with that power.

I think power's the most important because when you have power you have money, and you have sex or fame. Because this country worships rich people. Even though our tax laws are designed to keep poor people poor and make rich people more money, the poor people would still vote to keep it the way it is now because they feel they're gonna be rich someday. They're

brainwashed to think that God is gonna help them. Look at the black people in this town and the black people in the United States. Statistically those are the most churchgoing people, the highest percentage of any group. I don't care if you take age, religion, or politics, race, religion, whatever, the black people cross the economic structure, and any religion they belong to they are the most active. They go to church more, probably twice as much as white people. And where did they pick up this religion? The white man who kidnapped them, put chains on them, tortured them, castrated some of them, cut their feet when they tried to run, broke up their families, had sex with their women, used them like you breed cattle . . . told them that they should take Christianity up? Because "We're gonna torture the hell out of you while you're on earth, but when you're done, God is gonna help you." Oh, that's a wonderful god. That's a terrific religion.

Once you're raised in a religion you keep it. Why do people in countries like South America that are Catholic, generation after generation, the money leaves to go to Rome and they're poor? Why don't countries like Israel read the Bible and recognize that Christ is the Messiah? Why don't the Muslims convert? Obviously we're more technologically advanced, and if their god was powerful why wouldn't he have helped Iraq win? What you're raised at you stay, I think. You may change a little denomination. You may become a little religion. I would bet that most people who are raised Mormon die Mormon. And sometimes the people that convert are even more fanatical.

If we had two generations of unchurched people—no God, no religion— we went around and solved our problems as secular humanists, as human beings and as educated people . . . But it will never happen. Things will get worse because of overpopulation. Well, don't you think? I mean, how are you gonna educate people and solve your problems when every year there are more people born than jobs? And more people with AIDS? And more people who are putting their children into garbage cans while they're alive—the infants—and let them die? I don't like abortion. Let's change abortion by really giving people an education and giving them methods of birth control.

If you want to compare life in the United States in 1950 when I was ten, and life in the United States here when I am fifty in 1991 . . . okay? You have more people, you have more efficient weapons at killing people, and you have more expensive technologically advanced toys like Nintendos and stuff like that. And we're into space and rockets and all. You tell me: Are people happier than they were in the United States in 1950 when there was 145 million people? Are they happy? I never knew about drugs. I never knew about teen suicide. There were very few people shooting their wives. Every single thing that's negative is going up either as fast or faster than the population is. You have women who used to nurture children at home and teach them not to steal and not to lie—now the teachers are supposed to do that. And the parents are both working, and when the kid comes home nobody's there. And what do the parents do when they go home? They either take drugs or they drink, or they go out and dance and party. My parents stayed home.

Like the bishop in this town . . . what right does any news media have to get his opinion on the death penalty or anything else when he represents an organization that tells people in the Third World and in Mexico that they should not use birth control or planning—family planning—because it's a mortal sin? You show me where it says it's a mortal sin in the Bible. Where does it show you shouldn't have a vasectomy? Where does it say you shouldn't have sex for enjoyment? It's like these people that rent videos that have nothing but Nostradamus's predictions on it, so they know what's gonna happen a hundred years from now. Well, his predictions are changed and redone so many times. They're so vague. They talk about a country in the North. Well, that must be the Soviet Union. And they talk about the days when it's gonna be Armageddon and all that. I'm just sorry Armageddon didn't come because if I had a . . . really, my philosophy is that if there was a button on this thing here that would destroy all the human life on the planet, including myself, but would leave the planet intact and all the animals alone, I think I'd push the button.

History as we've written it, history as separate from myth—which is the way they used to do it and I think was a lot more accurate in its understanding of what was going on—is based on the supposition that there is a free-standing reality that is completely coherent and intact, independent of us, that we can report on. And that's only partially true. I mean, there is something out there, but it's something that is so vast and complex that anything you say about it will be true. Any slice you take through there will have its own validity but it's not necessarily gonna be the take.

But you see the whole thing about history, the real bogus thing about history, is that it places such an enormous assumptive element on causality: This causes that. That's not how it is. It's synchronicity. It's the mutual arising of things. They don't cause one another. They arise together.

Two things are happening here. First of all, the narrative, the cultural narrative that has been in the hands of historians in a fairly academic subset of humanity, is now being broadly distributed so that everybody is a source and everybody is a narrator. And what this creates is a kind of cultural white noise. You know, I think that people will look back at the nineties and not be able to come up with any coherent sense of what took place during this next ten or fifteen years. I mean it's just gonna be gobbledygook. Because there won't be a narrative that anybody can focus on and say, "Well, this is what happened."

The real challenge is to have one's own moral sense in a completely unhinged universe. That's the point. It's not enough to say, "Alright, it's all relative." That's not enough. I mean, out of that leads the wrong kind of anarchy. But the challenge is to have your own compass, and to follow it and not be cosseted and insulated by the moral compass of your society. 'Cause your society has lost its moral compass. That may not be an entirely bad thing, because we have done some horrible things in the service of what we

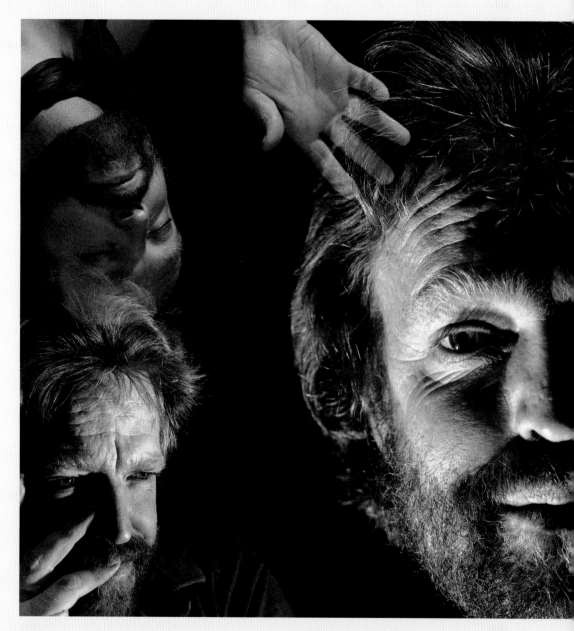

I think that there's a great work under way that has always been under way, which is to connect everything to everything else. You know, to create this organism that will be all the human minds operating in parallel. And in a sense, it's always been there in the sort of Jungian collective unconscious. But that's so dreamlike and hidden and inexplicit, that what we really want is the collective conscious. And I think that's what we're in the process of making here with this technology, making it so that we are all in continuous electronic contact with one another.

PINEDALE
b. OCTOBER 3, 1947, JACKSON

thought was right and we thought we were under some kind of divine authority to do.

My take on technology at this point is that we've now advanced so deep into it that we have no choice but to continue and solve the problems that it's created, by the same tools that created those problems. There's an old English nursery rhyme that I think about a lot.

> There was a man who lived in town,
> And he was wondrous wise.
> He jumped into a bramble bush,
> And scratched out both his eyes.
> And when he saw what he had done,
> With all his might and main,
> He jumped back in the bramble bush,
> And scratched them in again.

And I think that's what we gotta do here is scratch our eyes back in. I think that the bramble bush that scratched out our eyes was the ability to create a map of existence that would make it possible for us to conceptually manage other people in this removed, banal kind of way. It's like what Hannah Arendt says about the Third Reich—the banality of evil, the bureaucratization of evil in which the Jews were simply a problem. They weren't six million people. They were a "problem."

I think it's gonna be a real fight to the finish here. I think that humanity has got the choice now. It's the ultimate passion play. We did eat the apple. Well, we've been chewing on the apple for a long time now— you know, the apple of knowledge. And it's now brought us to this condition where it'll either be our annihilation or the stepping-stone that we use to become something transcendent. I'm fundamentally optimistic. And my optimism is the best kind in the sense that is completely groundless. It has no rational justification whatsoever. It's just faith.

. . . I come from a long line of people that were always on the edge. As soon as the place got settled they moved until they ran out of places to move to. I mean, Daniel Boone is a forebear of mine. They were always right on the frontier. So they finally come to Sublette County, Wyoming, which is the last place settled in the Lower 48, and settled that. And then what? Where do we go from here?

Human DNA has an incredible amount of information in it, much of which we don't know the purpose of. I mean, 50, 60 billion bits of information in one DNA molecule. And I assume that there's a lot of stuff in there—what has harbored that molecule before and what that molecule has experienced. I think that all those collective experiences are coded in some way. I assume I have this urge that is not so different from my grandfather's. It's just that his was based on a physical world. And we have run out of places to go in the physical world where you can indulge that urge. So I spent a lot of time trying to figure out what I was gonna do with it, and for seventeen years as a rancher trying to accommodate myself to the idea that we had run out of stuff to do it with.

The reason that I haven't left Wyoming is because Wyoming has this grounding quality. Wyoming is so incredibly vested in the physical world. This is gonna be the last place the Information Age actually breaks out because people are so totally focused on the production of real things: minerals, oil, cattle, sheep, junk.

That breeds a lot of different things. I mean, some of them are sort of sociopathic— like alcoholism and suicide and child abuse and wife beating, and all that stuff. But it also breeds this kind of "don't tread on me" independence and an amazing ability to tolerate eccentricity—you know, the idea that a self-proclaimed acidhead could almost become a Republican state senator in the most conservative place in the non-Islamic world. I mean people can't figure that out, usually. But it makes perfect sense to me.

I mean, you can't become really disagreeable with one another because you might be down by the road broke down and the first person that comes along is the guy that you've been in a real pissing match with. I don't think that's the whole story. I think that when you've got a group of people that understands freedom in the visceral sense as well as the people of Wyoming do, then they're gonna understand that John Stuart Mill notion of liberty, which is that it resides in the rights of that person with whom you disagree most. I mean, if you want to be as weird as you are, you better let him be as weird as he is.

I think Wyoming is somewhat protected by the natural austerity of its conditions. It's a cold, remote, difficult place that I think is never gonna be terribly populous. But it has these great beauties and virtues that it has not particularly played to in the past . . . always willing to sell itself cheap for the depletable reserves that lay under its surface. What I think Wyoming really has to offer people is solitude, sanctuary, nature, and all those things that people desperately need.

You know, one of the things that I'm trying to create here is—even though I'm in this electronic world—I wanta make it possible for people to do the work that they do, anywhere, and not be attached to suburbia and not be attached to the physical commute to the physical office. I want the physical office to go away. I want to be able to sit in this room, and jack in, and do anything that I could do in the corporate world, and be just as effective with my body here in Pinedale as I could be in Silicon Valley. And I think that's not so far away. I think that Wyoming has a lot of opportunity to become the kind of place where people in the information field do their work through the net, and go out and watch the sunset, and hunt elk, and fish and live in small towns. I really look at this as being something that can resurrect the small town because the small town was totally focused on agriculture. Well, agriculture is gone. We can produce all the food we need in this country with half the people who are still doing it and we've chased a lotta people out. So what is gonna be the thing that is the economic focus of small towns? I think it can be information. A community can be based on people just wanting to come together out in the country. The way in which we're connecting ourselves up right now has nothing to do with place at all. It's just person to person. Where your body is located is no longer relevant.

But, you know, I want Wyoming to be here for the people who can dig it—if you're willing to put up with all that cold weather and wind in order to have that sort of distance from the maddening crowd— and have something to do, have a means of livelihood. I think the economic future of Wyoming is in its beauty and its solitude, and not in its oil and gas, and not in its attachment to the tangible things of the world.

GARDNER
DUDLEY

HISTORIC ARCHAEOLOGIST

J. Ross Toole said this about Montana: "They're making more people, and there are more and more people every day." He gave the number that were being made at that particular time when he gave his speech. Toole says that what we have that the world's gonna want is, to quote Gretel Ehrlich, the "solace of open spaces." The quietness. The vast, uninterrupted skyline. We have taken too much out of the state and it's not gonna last. They might continue to change what we extract but there's always gonna be a search for cleaner fossil fuels. They're always gonna try to find a cold fusion. They're always gonna try to find something cheaper to burn than gasoline. And when that occurs our economy is gone. Our basic energy-extractive economy is set on its heels. We can't be so shortsighted that we don't begin to reach out to those alternatives now. Our politicians who don't look for alternatives to the future should be judged very severely by the future. And those people in the future that find out that they can't make a living in Wyoming because they've extracted everything of value should judge our generation harshly.

Some of them are very today-oriented. They would call themselves pragmatists and they'd say, "Well, we're pragmatists. You gotta feed the dog today or the dog dies tomorrow." The pragmatists say that this is the only day that you have. Well, in some ways that is true. But we as a people know, from six thousand years of written history—at least in China—that people have lived, and continue to live and feel, the same emotions and passions that we do. This is not the only day that we have. Even with nuclear war looming on the skyline. You know, we have the MXs in our state and we probably

should be more aware of this than in other states, but even with nuclear war as one dimension of modern history, there is going to be a world after in the future. What that world is we can shape and change.

I find that the miners are too pragmatic sometimes at the management level. They're futurists in projecting for their family. They want enough money for their kids. They want to set aside a trust. They want to establish a wealth of money for their kids and for their families so their family can succeed into the next generation. So the corporate owners are building these nest eggs and becoming extremely wealthy for their future. They're future-minded for their children. They're not future-minded for the state of Wyoming. They're extracting the resource and sending it to coal-fired plants in Indiana and Illinois, or wherever else they send it. They're sending their banking funds outside of the state, too. They're building a nest egg for somewhere else, or if they're building a nest egg so they can have a home in Jackson, they're still transferring that money from where it was extracted. Sweetwater County and Campbell County provide the bulk of the funds for the state of Wyoming today. Natrona County in the past was more important for providing funds, but when the oil industry skidded it hurt. But still, you could take Natrona County, Campbell County, and Sweetwater County and we're paying for the state government from our taxes on the severing of resources. Where does that money get dispensed to? Where is that money spent? Is it spent on improving those counties? Is it spent on cultural centers in those counties? To some degree you can say, "Yes, you built Western Wyoming

College with mineral royalties." Well, that's good. That is investing in the future. That's a positive effect.

The people at the top, however, roll over. The people at Peter Kiewit out east of us, and the people at Black Buttes Coal out east of us—Peter Kiewit owns it—and Bridger, those managers are here for a short time. They're gonna roll out of here. The big plant managers are gonna roll out of here, take the funds that they have. And so are the stockholders. The stockholders take their funds out of the state of Wyoming and use it elsewhere. Their future-mindedness is wherever they live at. If it's Union Pacific, it used to be in Boston where the Adams lived. Their money was going back to feed the corporate investors in Boston and the East. It's not going for the development of the state of Wyoming.

The people who are farsighted for the future are these people who are raised here by coal miners or by oil workers who have been educated, in some cases, at junior colleges here or elsewhere outside the state. Or from people who have come into this state and have a vested interest in the land. I find that the person who makes a day-to-day living in this state is more concerned about the wildlife, about the environment, about the water, than are those big corporate investors. So the futurists, the people that are projecting the future in trying to preserve the wide-open spaces, are maybe sometimes the common or mid-level management. I don't know how to explain. I don't know if I did a good job.

ROCK SPRINGS
b. OCTOBER 26, 1952, DENVER, COLORADO

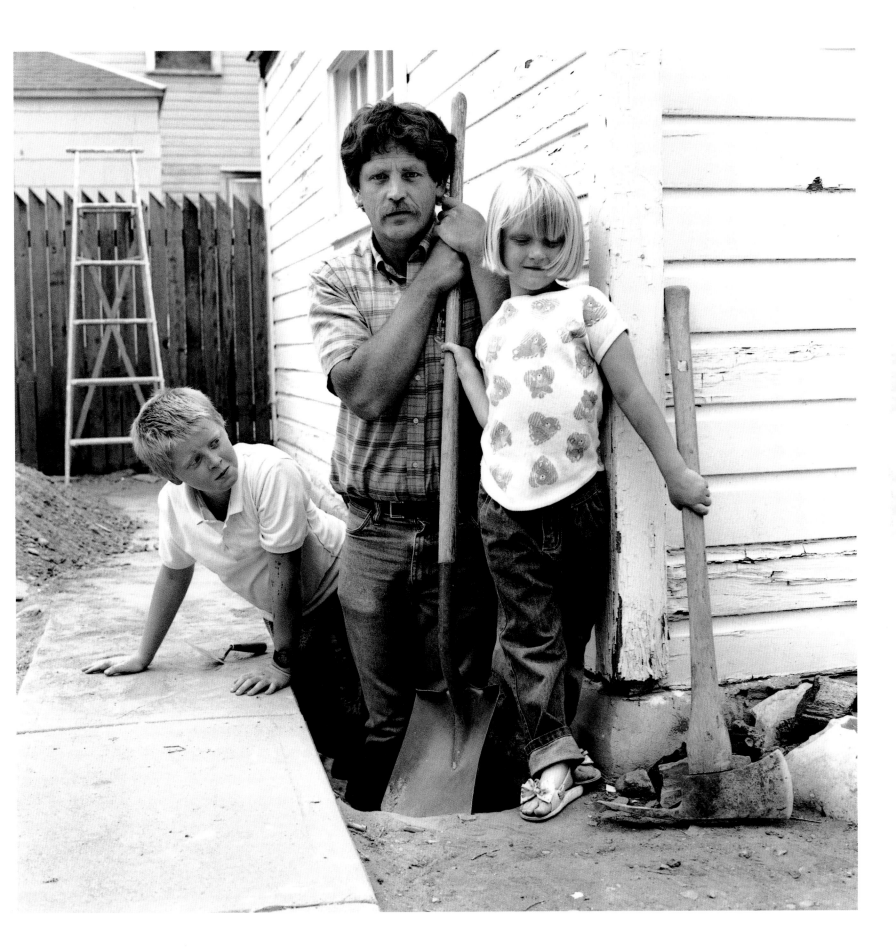

Acton, Darryl
Adams, Nancy
Adkinson, Jim
Aksamit, Joanne
Aldrich, Jim
Allen, Boots (44)
Allen, Joe
Alley, Homer (91)
Alley, Lucille (91)
Anderson, Jeff
Antelope, Gary (145)
Aragon, Charles (197)
Askins, Renee (236)
Atchison, Phyllis
Axsom, Mike
Axtell, Clare (30)
Aydelott, George
Bailey, Darren
Bailey, Remington
Baker Monte
Baker, Wayne
Bama, Ben
Bama, James (122)
Bama, Lynne
Banks, Kandi (74)
Bard, Elsie
Bard, Fred
Bardo, Gerry
Barlow, Brad (69)
Barlow, John (296)
Barndt, Jan
Barndt, Jep
Barnes, Roy
Bartek, Steve (146)
Bartling, Leona
Barto, Louis
Bates, Heidi
Bates, Stephanie
Bay, J.J. (68)
Bebout, Dessie (100)
Bebout, Hugh
Beebe, Ruth (50)
Bender, Fern
Bengtson, Brian (105)
Bergstrom, Charlie
Bieg, Ethel
Bigler, Ken
Bille, Ed
Bille, Fern
Birleffi, Larry (22)
Black, Willie
Blair, Quintin
Blair, Ruth
Blankenship, Brent (69)
Blevins, George
Body, Susie (102)
Bonnar, Katie
Bose, Colleen
Bower, Elizabeth

Brainerd, Jean
Bricher, Joseph
Bricher-Wade, Sheila (64)
Bridgeforth, Brian (60)
Briggs, Jared (69)
Brimmer, Howard (303)
Brown, Cleveland (197)
Brown, Gary (145)
Brown, Maurice (95)
Brown, Russell (95)
Brown, Steve
Budenske, Mary Ann (216)
Burke, Dell (199)
Burke, John
Burke, Tina (106)
Burnett, Lynn (145)
Buss, Jerry
Butkovich, Bill
Byram, Butch (285)
Byron, Elsa (275)
Call, Shane (135)
Canoso, Paul (13)
Capellen, Warren
Capron, Nathan
Carlsberg, Barbara
Carlsberg, Rebecca
Carlsberg, Richard
Carrigen, Eleanor
Carter, Howard
Castellan, Ricardo
Casull, Dick
Chastain, Deborah
Cheney, Dick (284)
Chenoweth, Carol
Christensen, Earl
Cinquambre, Jean
Clark, Jake (98)
Clark, Richard (252)
Clark, TJ (98)
Clingman, Ron (206)
Cochrane, Jason (69)
Collier, Richard (9)
Conkle, Kevin (69)
Connell, J.R. (171)
Cotterell, Jim (254)
Cottet, Doug
Cowger, Bob
Cox, James (43)
Craighead, Frank
Dalgarn, Ruth (20)
Danforth, Terry
Daniels, Bob (130)
Davis, Don (69)
Davis, Dorothy
Davis, Tim (9)
Decker, Robert (294)
Dembo, Fennis
Deming, W. E.
DeMoss, Julie

DeNayer, Sharon
Deshler, Terry
Desmarteau, Everett (285)
Deutch, Ann
Dewberry, Steve
Dicken, Oliver
Dixon, Victoria (214)
Domhoff, Annelise (96)
Domhoff, Stephan (96)
Downing, Robin (124)
Draney, Cally (62)
Draney, Gregg (62)
Draney, Joni (62)
Draney, Lenna (62)
Draney, Magen (62)
Draney, Minde (62)
Draney, Sage (62)
Draney, Tawna (62)
Draney, Taya (62)
Draney, Tennyson (62)
Draney, Ty (62)
Dull, Gerald (86)
Dunham, Merle
Eberle, Herb
Ebony (138)
Eddins, Lael (165)
Egolf, David
Egolf, Jamie
Egolf, Sarah
Eliot, Joel (37)
Ellis, Bill
Eno, Lawrence (256)
Ervin, Theola (46)
Etbauer, Billy (134)
Etbauer, Dan (134)
Etbauer, Robert (134)
Evans, Howard (272)
Evans, Joe
Evans, Tim
Evenson, Betty (186)
Fahey, Thomas (244)
Farthing, Charles
Farthing, Merrill (16)
Fauver, David
Fauver, Jeremiah
Fauver, Luke
Fellon, Ken (61)
Ferris, Craig (145)
Flinchum, Jim
Flitner, Tim (128)
Floutin, Brett (69)
Floyd, Billie
Floyd, Dolan
Floyd, Lonnie
Foreman, Dave
Foreman, Ed
Foster, Joe (292)
France, Ben
Franck, Mario

Freeman, Scott (104)
Freudenthal, Nancy (160)
Fross, Zack
Fross, Zane
Frymire, Marjorie
Frymire, Shari
Galliver, E. Luella (18)
Gamble, Roy
Garaman, Abi (246)
Gardner, Dudley (298)
Gardner, Emma (299)
Gardner, Kathy
Gardner, Will (299)
Garrett, Mark (135)
Garrett, Marvin (135)
Garry, Jim (156)
Geis, Kevin
Geis, Walt (132)
Gibson, Marcus
Godina, John
Golden, Charles
Good, Jim
Good, Steve (72)
Goodwin, Colby
Graves, Norris (135)
Greene, Lisa
Gregory, Victoria (282)
Gressley, Gene (190)
Grewal, Alexi
Guthrie, Rodney (268)
Guymon, Patricia (178)
Haas, Hubert
Haas, Kevin (58)
Haiming, Lin
Hairston, Nycoca (82)
Halverson, Katherine
Hamburg, Al (200)
Hamilton, Cary (84)
Hamilton, Pat
Hanify, Brian (105)
Hansen, Dave (260)
Hanway, David
Hardeman, Earl (176)
Harkness, Tom (154)
Harris, Catharine (242)
Hartman, Tara
Hauser, Bruce
Hawkins, Dan
Hayes, Mike (215)
Hays, Carolyn
Headlee, Rick
Headley, Arnold
Healy, Stuart (84)
Hendricks, Terence
Hendrix, Angie (225)
Herman, Marshall
Herschler, Ed
Hettinger, Betty
Hickey, Win (271)

Hill, Alta
Hill, Rick
Himmerich, Elmer
Hinckley, Frank
Hiscox, Carolyn (117)
Hiscox, Fred (116)
Hogarth, Kristin (71)
Hosokawa, Bill (28)
Hove, Terrilyne
Howe, Carolie (80)
Howell, Charlie (144)
Hruza, Olive
Iberlin, Dollie
Iberlin, Simon
Ice, Clyde (52)
Ice, Howard
Irving, Tom
Jackson, Phil
Jamison, Odette
Jaschik, Nils
Jay, Mike
Jaycox, Warren (110)
Jeffrey, Ronnald (220)
Jenkins, Dorothy
Jensen, Chuck (99)
Jensen, Cody (99)
Jessen, Eric (68)
Johner, Pat (69)
Johnson, Louis
Johnson, Steve (126)
Jones, J.R. (162)
Jones, Lisa
Jones, Randy
Jones, Scott (162)
Josendal, Harold
Junge, Andy
Junge, Ardath
Junge, Dan
Junge, Mark (9)
Kading, Frank
Kading, Joye
Kail, Elizabeth
Karst, Jim (168)
Karst, Judy (168)
Kassel, Mike
Kaufmann, Amanda (170)
Kaumo, Richard (262)
Keeler, Lisa (172)
Kell, Jacqueline
Kendrick, Manville
Kent, Raymond
Kerr, Ewing (19)
Keyser-Caswell, Trudy (178)
King, Bruce
King, Donald
King, John
King, Robert
Kingston, Emily (142)
Kinneberg, Bill

Kirkbride, Linda (222)
Klein, David (141)
Klein, Garrett (141)
Klein, Richard (140)
Knight, Betty
Knox, Kirk (48)
Knutson, Maurice
Korell, Jake (182)
Kotzakis, Lukas (136)
Kristy, Mary
Kristy, Joseph (54)
Krueger, Kim (180)
Lamb, Bill (150)
Lamb, Delia (150)
Langan, John
Lantzer, Stanley (197)
Larson, T.A. (288)
Lasco, Edwin
Latham, Craig (135)
Laubach, Nate (69)
Laubin, Gladys
Laubin, Reginald
Lejardi, Mayra
Lejardi, Tomas
Lill, Daniel (184)
Lindsey, Chad
Lineberry, Bill (114)
Lineberry, Joan (114)
Love, Christy
Luczak, Steve
Lujan, Larry
Lyman, Annette
Lyman, Dwight
Madden, Glenna (198)
Madsen, Barbara (258)
Marker, Karla (178)
Marocco, Frank
Marshall, Joe
Martinez, Maria
Martirena, Domingo
Mattes, Merrill
Mavrakis, Sam (152)
Maxwell, Jeanette (164)
Maybee, Allan
McCartney, Kenneth (92)
McCartney, Lorie (93)
McCleod, Nadine (168)
McConigley, Nimi (147)
McCranie, William
McDonald, Judd
McGuire, Shane
McIntosh, Pauline
McIntyre, Clara (266)
McKee, Lisa
McKibben, Florence
McKinney, Kevin (264)
McKinney, Valda
McLaughlin, Arlinda
McWhinnie, Ralph (14)

Meike, Pete
Mercer, Ruby (270)
Messick, Alice
Miller, David (224)
Miller, Grayce
Miller, Major
Mitchell, Emma
Mitchell, Finis
Mokler, John
Moore, Bill (94)
Moore, Frankie (94)
Moore, Richard
Moreno, Maria (174)
Morgan, Chandi (90)
Morris, Judi (143)
Morrison, Burnette
Morrison, Ian
Morrison, Tim
Mortensen, Deborah
Moseley, Virginia
Moss, Pius (224)
Moulton, Clark (24)
Moulton, Veda (24)
Mumford, Mary
Murie, Margaret (293)
Nelson, Earl
Nelson, Lee
Nelson, Robert(40)
Neltje (192)
Nunzio, Charles
Oberg, Charles
O'Bryan, Beula
O'Bryan, Doug
Ockinga, Jerry
Okano, George
Olds, G. Leone (88)
Olds, Ralph (88)
Ostlund, John (228)
Otto, Charles
Otto, Leslie (250)
Ourada, Tom (8)
Pacheco, John (174)
Parker, Randy
Patel, Ambalal
Patel, Dilip
Patel, Savitaben
Peery, Bill
Peery, Jordan
Pence, Corrine
Perue, Dick
Perue, Marty
Petefish, Andy
Pette, Edward (176)
Pfeifer, Bessie
Pfeifer, Gerald
Phipps, Jim
Pickering, Cliff (34)
Pickering, Shirley
Pierce, Bernard

Pierce, Melissa (70)
Poelma, Larry (166)
Popham, Colleen
Powers, Mickey
Prather, David
Pugh, Charles (110)
Queen Ida
Quinn, Elizabeth
Ramee, Kathleen (280)
Randall, Dick (238)
Redman, Alfred (144)
Redman, Tessa
Reed, Bobbi
Reinmann, Richard
Rennard, Sam
Repass, Andy
Richardson, Dorothy (278)
Richman, Geoffrey
Roberson, Ron (131)
Robert, Mark (104)
Roberts, Brendan
Roberts, Kurt (86)
Robertson, Allan
Robinson, Diane (202)
Robinson, Michael (202)
Rockwood, Brian (60)
Rodriguez, Helen (174)
Rodriguez, Norma (139)
Rodriguez, Paul
Rolfsness, Ken (173)
Romtvedt, David (210)
Romweber, John
Roncco, Leo
Roncco, Leo, Jr.
Rotellini, Lisa (78)
Rouse, Bill (259)
Rowe, Rosemary
Roy, Echo (106)
Roybal, Ernie
Rubeck, Patsy
Runyan, Sam (69)
Russell, David (168)
Russell, Jessica (168)
Russell, John
Russell, Joshua (168)
Russell, Sharon
Sable, Betty (274)
Sable, Jim
Sailors, Kenny (32)
Sandoval, Bobby
Sandvick, Larry (135)
Sauer, Bill
Sawyer, Eric
Schaffer, Shawn (84)
Schlaht, Tanya (83)
Schlattmann, Dean (75)
Schneider, Bill
Schneider, Glen
Schneider, Velma

Schwaiger, Pat
Scott, Charles (204)
Seaton, Merle
Seaton, Virginia
Setright, Mark (194)
Setright, Paul
Shane, Carmen
Shannon, Christopher (86)
Shaver, Wiley
Shaw, Ian (79)
Shaw, Jackie
Shoemaker, Alice (36)
Shoopman, Amber
Shoopman, Tamara
Shoopman, Travis
Shuguo, Zhang
Simons, Lynn
Simpson, Matt
Simpson, Nolan
Singleton, Carmen (248)
Skelley, Brian
Slames, Gus
Smith, Angela (118)
Smith, Christy
Smith, David
Smith, Dee
Smith, Emily (68)
Smith, Jerry
Smith, Julie
Smith, Lee
Smith, Malcolm (118)
Smith, Melvin (232)
Smith-Sonneborn, Joan (286)
Snow, Marit
Speight, Jack
Spence, Jerry (212)
Spiegel, Sydney (226)
Spillman, Bud
Spoonhunter, Bob
Sporkin, Terri
Spratt, Asa (148)
Spratt, TJ (148)
Sprinkle, Leo
St. Clair, Darwin (175)
St. Clair, Owen
Stickley, Scott
Stiegler, Pepi
Stone, Zella
Stubing, Lawrence
Sullivan, Jane (112)
Sullivan, Michelle (76)
Sullivan, Mike (112)
Svilar, Sophia (100)
Swartos, Leland
Swartos, Nancy
Switch, Sam (37)
Takeda, Nancy
Takeda, Roy (146)
Taubert, Lou

Taubert, Louis
Taylor, Wilma (146)
Terkel, Studs
Thaxton, Edith
Thomas, Al
Thomson, Thyra
Thorson, Inga
Thunander, Hank
Thurman, Keith
Tisdale, Tom
Todd, Margot
Tolerton, Elizabeth (137)
Tomingas, Bob (146)
Tophia, Royal (56)
Townsley, Leisa
Trosper, Gregg (144)
Ulrich, Carl
Ulrich, Shirley
Utter, Sandra (83)
Van Alstyne, Jo Ann (285)
Vehnekamp, Bill
Vigil, Manny
Vignati, Valerio (103)
Villescas, David (174)
Voiles, Claude
Voiles, Kat (2)
Von Olnhausen, Jami
Von Olnhausen, Jeremy
Wagner, Randy
Walker, Beulah
Walker, Cornelius
Walley, Drew
Wambeke, Melissa
Wambeke, Melvyn (120)
Wambeke, Sally
Ware, Joe
Washakie, John
White, Missy
Whitehead, Blondell
Whiteman, Mary Ann
Whitman, Rick
Whitt, Slim
Wilde, Bevan (90)
Williams, Reva
Wilson, Dan (84)
Wilson, Shelley (84)
Witherspoon, Helen (178)
Wolf, Daniel
Wolff, Orville
Wolin, Morris (231)
Wolin, Penny (230)
Wright, Dante
Wright, Rana (33)
Yankovic, Frankie
Yarborough, Ryan
Young, C. Marlene
Yuku, Jiang
Zachary, Merle
Zanetti, Pete (208)

PHOTOGRAPHS

Tape-recorded interviews and photographs of 450 project participants are located
at the Wyoming Division of Cultural Resources in Cheyenne.

CHEYENNE
HOWARD BRIMMER: b. SEPTEMBER 12, 1895
PITTSFIELD, MASSACHUSETTS

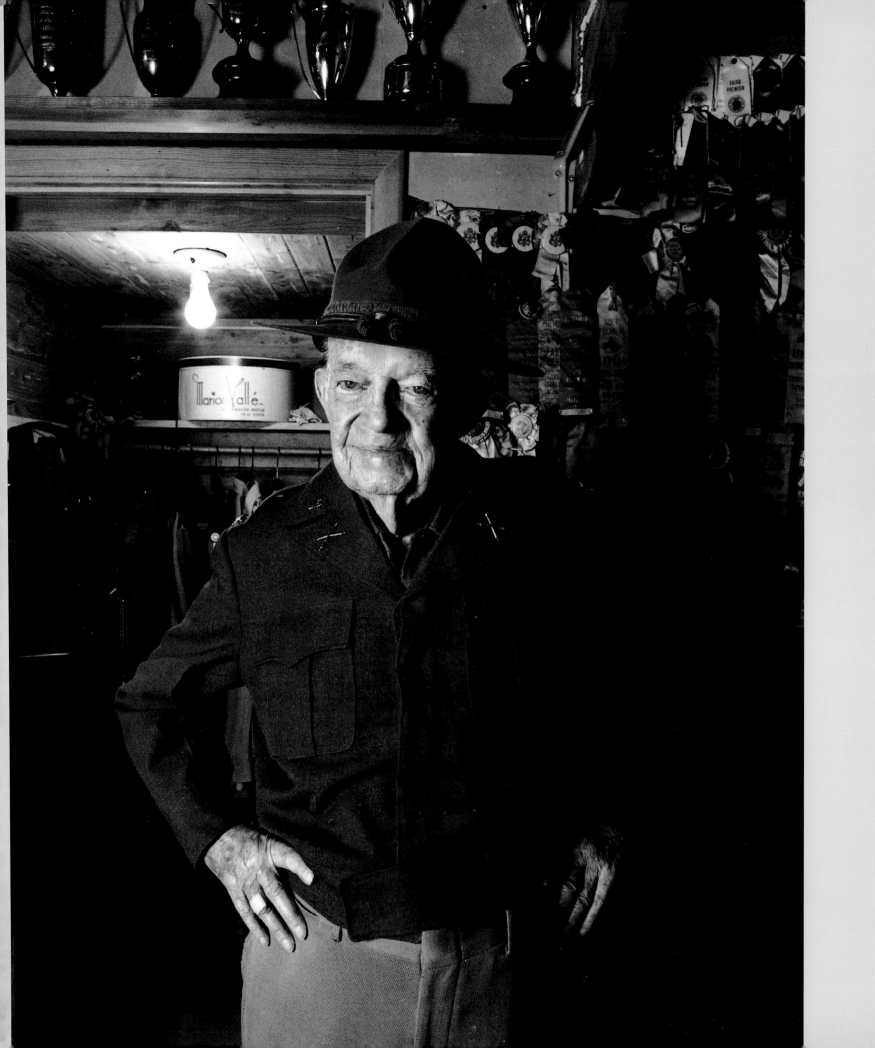

Rodney Guthrie Darwin St. Clair Ken Rolfsness Craig Latham Pat Guymon Cary Hamilton Brian Hanify Howard Brimmer Ia
Hiscox Sandra Utter Brent Blankenship Bill Hosokawa Carolie Howe Charlie Howell Ken McCartney Ronn Jeffrey Cody Jen
u Sophie Svilar Bob Tomingas Ewing Kerr Trudy Keyser-Caswell Emily Kingston Catherine Harris David Klein Jim Cotterell G
Frankie Addington Moore Kevin Haas Sam Switch Stephan Domhoff Dudley Gardner Roy Takeda Cally Draney Tennyson Dra
Mel Wambeke Elsa Byron David Romtvedt Penny Wolin David Russell Clyde Ice Boots Allen Minde Draney Sam Mavrak
Warren Jaycox Joshua Russell Leone Olds Mark Setright Tina Burke Lynn Burnett Al Hamburg Sydney Spiegel Butch Byram
kle James "Tip" Cox J.R. Connell Steve Johnson Ruth Dalgarn Bob Decker Angela Smith Vicki Dixon Annelise Domhoff Ama
h-Sonneborn Helen Witherspoon Lukas Kotzakis Kurt Roberts Brad Barlow Kim Krueger Bill Lamb Joni Draney Dessie Bebo
Norma Rodriguez Lucille Alley Lisa Rotellini Jim Bama Ruby Mercer Echo Roy Sam Runyan Jessica Russell Betty Sable Mage
Joni Draney Dessie Bebout T.A. Larson Brian Bridgeforth Scott Freeman Betty Evenson Bill Lineberry Earl Hardeman Shaw
Ralph McWhinnie Bob Daniels Tommy Harkness Mark Garrett Maria Moreno Walt Geis Rana Wright Bill Moore Gerry Du
Kandi Banks Luella Galliver Chris Shannon Ruth Beebe Mel Smith Asa Spratt Kevin Haas Frankie Addington Moore Sam Sw
sen Mark Garrett Diane Robinson Steve Good Emily Smith Norris Graves Dean Schlattmann Vicki Gregory Jane Sullivan Rodn
Tawna Draney Pete Zanetti Carmen Singleton Dave Hansen Alice Shoemaker Maury Brown Malcolm Smith Stuart Healy An
eda Moulton Carolyn Hiscox Scott Jones Craig Ferris Jim Karst Judy Karst Clare Axtell Richard Kaumo Everett Desmarteau
Ken Fellon Jerry Spence Jake Korell Joan Smith-Sonneborn Helen Witherspoon Lukas Kotzakis Kurt Roberts Brad Barlow .
haffer Craig Ferris Joan Lineberry Gregg Draney Glenna Madden Win Hickey Susie Body Karla Marker T.J. Clark Nycoca Ha
Gerry Dull Gene Gressley Shelley Wilson Judi Morris Clark Moulton Margaret Murie Bob Nelson Neltje Richard Collier Jo
Melissa Pierce Sage Draney Jake Clark Larry Poelma Renee Askins Kathleen Ramee Dick Randall Alfred Redman Dorothy Richa
es Helen Rodriguez Echo Roy Sam Runyan Jessica Russell Betty Sable Magen Draney Thomas Fahey Kenny Sailors J.R. Jones
Carmen Singleton Ruth Beebe Mel Smith Sydney Spiegel Asa Spratt Kevin Haas Frankie Addington Moore Sam Switch Dudley
te" Kristy Leslie Otto David Villescas Kat Voiles Lisa Keeler Mel Wambeke Elsa Byron David Romtvedt Penny Wolin David
cher-Wade De Lamb Tim Davis Nimi McConigley Barbara Madsen Kristin Hogarth Norma Rodriguez Lucille Alley Lisa Rotelli
a Schlaht Craig Latham Charley Scott Andy Junge Emma Gardner Jeannette Maxwell Chandi Morgan Kandi Banks Chris Shan
ally Draney Tennyson Draney Wilma Taylor Nate Laubach Elizabeth Tolerton Roy Tophia Linda Kirkbride Jo Van Alstyne Jose
therine Harris Minde Draney Sam Mavrakis Brian Bengtson Theola Ervin Sheila Bricher-Wade De Lamb Tim Davis Nimi Mc
Butch Byram Kirk Knox Shane Call Kevin McKinney Homer Alley Sam Mavrakis Paul Canoso Pat Johner Richard Clark Ron
Domhoff Stephan Domhoff Amanda Kaufmann Charlie Howell Ken McCartney Ronn Jeffrey Cody Jensen Veda Moulton J.R. J
gas Ewing Kerr Trudy Keyser-Caswell Emily Kingston David Klein Jim Cotterell Garrett Klein Clara McIntyre Russell Brown
Kim Krueger Bill Lamb Joni Draney Dessie Bebout T.A. Larson Brian Bridgeforth Scott Freeman Betty Evenson Bill Lineberry
artney Nadine McCleod Ralph McWhinnie Bob Daniels Tommy Harkness Mark Garrett Maria Moreno Walt Geis Rana Wright
s John Ostlund Mike Sullivan Larry Birleffi Tom "The Tireman" Ourada Edward "Stovepipe" Pette Nancy Freudenthal Cliff Pick
n Jared Briggs Dick Cheney Ron Roberson Steve Bartek Mark Robert Jim "Tex" Garry Don Davis Lael Eddins Gary Brown
cho Roy Sam Runyan Jessica Russell Betty Sable Magen Draney Thomas Fahey Kenny Sailors J.R. Jones Tanya Schlaht Cra
Ruth Beebe Mel Smith Sydney Spiegel Asa Spratt Ken Fellon Jerry Spence Jake Korell Joan Smith-Sonneborn Helen Witherspoo
nson Bill Lineberry Earl Hardeman Shawn Schaffer Craig Ferris Joan Lineberry Gregg Draney Glenna Madden Win Hickey S
Maria Moreno Walt Geis Rana Wright Bill Moore Gerry Dull Kevin Haas Frankie Addington Moore Sam Switch Dudley Gardner
sty Leslie Otto David Villescas Kat Voiles Mel Wambeke Elsa Byron David Romtvedt Penny Wolin David Russell Clyde Ice E
Tim Davis Nimi McConigley Eric Jessen Gregg Trosper Mary Ann Budenske Warren Jaycox Joshua Russell Leone Olds Mark S
rk Setright Tina Burke Lynn Burnett Al Hamburg Butch Byram Kirk Knox Shane Call Kevin McKinney Homer Alley Sam M
er Angela Smith Vicki Dixon Annelise Domhoff Stephan Domhoff Amanda Kaufmann Robin Downing Howard Brimmer Ian Sh
ox Sandra Utter Brent Blankenship Bill Hosokawa Carolie Howe Charlie Howell Ken McCartney Ronn Jeffrey Cody Jensen Ve
ob Tomingas Ewing Kerr Trudy Keyser-Caswell Emily Kingston David Klein Jim Cotterell Garrett Klein Clara McIntyre Russell
rts Brad Barlow Kim Krueger Bill Lamb Joni Draney Dessie Bebout T.A. Larson Brian Bridgeforth Scott Freeman Betty Ev